Arrival Cities

Arrival Cities

Migrating Artists and
New Metropolitan Topographies
in the 20th Century

Edited by
Burcu Dogramaci, Mareike Hetschold,
Laura Karp Lugo, Rachel Lee
and Helene Roth

Leuven University Press

Extended publication of the conference "Arrival Cities: Migrating Artists and New Metropolitan Topographies", organized by the ERC Research Project "Relocating Modernism: Global Metroplises, Modern Art and Exile (METROMOD)", Institute for Art History at the Ludwig Maximilian University in Munich, in cooperation with ZI – Zentralinstitut für Kunstgeschichte, Munich and Kunstverein Munich, 30 November – 1 December 2018. For more information see https://metromod.net.

This project has received funding from the European Research Council (ERC) under the European Union's Horizon 2020 research and innovation programme (grant agreement No 724649 – METROMOD).

Published with the support of
KU Leuven Fund for Fair Open Access

Published in 2020 by Leuven University Press / Presses Universitaires de Louvain / Universitaire Pers Leuven. Minderbroedersstraat 4, B-3000 Leuven (Belgium).

ISBN 978 94 6270 226 4 (Paperback)
ISBN 978 94 6166 324 5 (ePDF)
ISBN 978 94 6166 325 2 (ePUB)
https://doi.org/10.11116/9789461663245
D/2020/1869/34
NUR: 654

Layout: Friedemann Vervoort
Cover design: Bureau Johannes Erler GmbH, Hamburg, Germany

Table of Contents

Mobility, Transfer and Circulation

Sites, Spaces and Urban Representations

Arrival Cities: Migrating Artists and New Metropolitan Topographies in the 20th Century

An Introduction

Burcu Dogramaci, Mareike Hetschold,
Laura Karp Lugo, Rachel Lee, Helene Roth

Under the title "The World Becomes a City", Manuel Slupina's contribution to the *Atlas der Globalisierung* (Atlas of Globalisation) links migration, both internal and cross-border, with urbanisation:

> Worldwide, people flow into cities. In 2007, for the first time in human history, there were more urban than rural inhabitants. [...] By 2050, the world's population is expected to grow by a further 2.1 billion to around 9.8 billion. Above all, it will be cities that will have to accommodate the extra human population. [...] The cities are growing because the lack of prospects in the countryside is driving many people into the urban centres. (Slupina 2019, 120)

In its report, *Cities Welcoming Refugee and Migrants*, UNESCO describes migration primarily as an urban phenomenon: "[m]igration in the current era is markedly urban and falls increasingly under the responsibility of city authorities, encouraging cities to adopt new and hybrid approaches on urban governance" (Taran et al. 2016, 10). The close interdependence of migration and the city should be considered in both directions. Not only do cities constitute themselves through migration and are unthinkable without it, but migration itself is also visible in the present primarily as a movement into the cities. The sociologist and migration researcher Erol Yildiz summarises this in a simple formula: "city histories are always also migration histories" (Yildiz 2013, 9). Contemporary post-migrant research in particular emphasises the importance of cities as identity-forming,

just as it understands migration as a metropolitan movement (Yildiz/Mattausch 2009; see also Bukow 2018; Hill 2018). The understanding of urban development as migrant-led leads to questions about urban planning and architecture (Carstean 2011), life and everyday practices, community building and social networks, as well as cultural or artistic work processes. How can all this be conceived of in relation to a plural and diverse urban society?

This volume takes these current observations and questions as its starting point, but shifts the perspective. Assuming that the respective present leads to new perspectives on history, the relationship between historical migration, exile, flight and metropolises is examined. This is done through a focus on cross-border relocations of artists, architects and intellectuals in the first half of the 20th century.

During that period global metropolises including Bombay (now Mumbai), Buenos Aires, Istanbul, London, New York, and Shanghai were metropolitan destinations for refugee artists, photographers and architects. This era encompasses unprecedented mass migration movements as well as phases of return or remigration. For numerous artists who fled their native countries due to changes in political systems, dictatorships and wars, repression, persecution and violence, these cities were places of entrance, transition and creativity. The Balkan War (1912–1913), World War I and the Russian Revolution of 1917 resulted in the exile of numerous artists to Istanbul and Paris. In the 1920s the Hungarian dictatorship under Miklós Horthy forced many more artists into exile. The seizure of power by the National Socialists resulted in the exodus of many artists and architects from Germany after 1933 and from Austria after 1938. World War II led to the emigration of artists from occupied countries like Czechoslovakia, Belgium, the Netherlands and France. These political eruptions led to the following long-term paradigm shift: established European hubs of artistic innovation such as Paris, Berlin and Vienna gave way to a more decentralised network of cities, as diverse artistic movements and artists with different geographic backgrounds gathered in centres such as Bombay, Buenos Aires and New York. While some cities, such as London and Shanghai, were temporary places of refuge (indeed some artists left London because it was a bombing target during World War II), others provided a base for more long-term stays. Following the end of World War II some exiled artists and architects returned to their home countries although the majority chose to stay in their new homes. The period of artistic exile analysed in the book closes with a study of Latin American artistic exile in Central Europe in the late 1970s.

Cities were changed by the presence of exiled artists and – vice versa – the urban topographies shaped the actions and interactions of artists. The changes caused by migration are particularly visible in these cities; their urban topographies contain neighbourhoods, places and spaces that were populated, frequented and run by

Burcu Dogramaci, Mareike Hetschold, Laura Karp Lugo, Rachel Lee, Helene Roth

migrants. In addition to providing the émigré artists with income, employment and exposure, urban institutions, academies, associations, museums and galleries were crucial settings for interaction and exchange between the local and migrant populations; in some cases they were founded and run by émigré artists. The numerous exhibitions curated by and including the work of these artists were also connected to specific sites and spaces in the urban fabric, as were the circulation of media and dissemination of discourse pertaining to them. In their stations of exile and their final destinations the émigré artists attempted to continue their artistic production, to build up new networks for their art, as well as collaborations and exhibitions between exiled and local artists and artist groups. But it should be considered that certain neighbourhoods not only often became home to large numbers of migrants, but also supported segregation and isolation. Thereby there were inspirational *and* conflict-laden encounters. En route and within these cities new theoretical concepts were developed and elaborated upon, pushing the boundaries of art theory and practice.

Focusing on the intersections of exile, artistic practice and urban space, this volume brings together researchers committed to revising the historiography of 'modern' art. It addresses metropolitan areas that were settled by migrant artists in the first half of the 20th century. The artists often settled in certain urban areas – due to low rental costs, because other immigrants lived there and/or because they were artists' quarters where new contacts could be established. These so-called "arrival cities" (Saunders 2011) were hubs of artistic activities and transcultural contact zones where ideas circulated, collaborations emerged and concepts developed. Taking cities as a starting point, this volume explores how urban topographies and artistic landscapes were modified by exiled artists re-establishing their practices in metropolises across the world. It addresses questions such as: how did the migration of artists to different urban spaces impact on their work and the historiography of art? How did the urban environments in which the artists moved and worked affect professional negotiations as well as cultural and linguistic exchange?

In this volume the term 'topography' is used not only to describe the surface characteristics of places or the physical features of urban areas. It is also employed to refer to modes of adapting to surroundings, of living and working in certain urban environments, of arriving in and leaving cities – it is not without reason that migration researchers Erol Yildiz and Birgit Mattausch refer to "migration as a metropolitan resource" (Yildiz/Mattausch 2009). Topography in the sense of our volume includes spatial and social relationships between émigré and local artists and architects, but also interrelations between institutions and actors, actors and objects in the context of urban matrixes. The conception of topography in this book is grounded on the definitions of the "Kunsttopografien globaler Migration"

(art topographies of global migration) special issue of the journal *kritische berichte* (Dogramaci et al. 2015, 3):

> Since migration is primarily defined as the experience of a change of location, whether it is the experience of losing one's homeland, of relocation and displacement, of borders (or boundlessness), of wandering through and crossing spaces, or of multilocality, the individual contributions [of the journal] seek to trace the processes of de-, re- and translocalization at those neuralgic art locations where migration movements are concentrated concentrically. It is only in the reference to a location, i.e. in the situating, bundling and selective immobilization of migratory movements, that it becomes manifest how migration phenomena generate meaning in the field of art.[1]

Following this understanding, the contributions to this volume consider mobilities and trajectories, neighbourhoods and networks, social spaces and artscapes, as well as infrastructures and artistic practices. Neighbourhoods like Galata in Istanbul, streets like Calle Florida in Buenos Aires or Finchley Road in London, which became home to or working places for a large number of exiles, are examined in relation to how they supported segregation, exchange and inclusion. How accessible were these areas in terms of public transit? What institutions and social spaces did they offer? Did the foreign artists create their own informal structures or rely on existing venues? How important are migration and flight for the self-perception of migrant actors in urban societies? And how important is it for research to distinguish between migration, exile and diaspora?

This leads to different notions of displacements and translocations: although a distinction is made in the literature between *exile* and *emigration*, with the former attesting to a desire to return, while the latter implies the intention of a final shift of residence, it is impossible to make a sharp separation between the terms. Motivations and decisions change too much in the temporal span between emigration, arrival and the point of a possible return; even those affected have often used the terms differently (Krohn 1998, XII). It is also important to be aware of the meaning of *immigrant* as "a person who comes to live permanently in a foreign country"[2] or *migrant* as someone moving from one place to another, within a nation or crossing borders, in order to find work, better educational opportunities or living conditions (Berking 2010, 293). Also, *displacements* and *diaspora* and their different meanings, etymologies and histories should be considered when rethinking the history of modern art as a history of global interconnections, spurred

Burcu Dogramaci, Mareike Hetschold, Laura Karp Lugo, Rachel Lee, Helene Roth

by trans-border movements of artists. The contributions in this book deal with these different dislocations from urban and global perspectives.

Groups and Networks

Every metropolis or urban hub has a structure of social networks in which human ties are forged and groups are created, fostering professional integration and everyday life. For migrant and exiled artists, networks enable faster integration into social and professional environments (galleries, magazines, associations, meeting places). Analysing networks allows light to be shed on mechanisms and strategies of integration and acculturation of exiled and migrant communities. The place the cities of arrival give to the networks and the internal evolution of social structures testifies to the capacity of metropolitan areas to accommodate the new population. In many cases newcomers increase the urban population density. This has often caused cities' physical and social physiognomies to change at a dizzying pace. Neighbourhoods are transformed and places of sociability are created, including clubs, associations, schools, hospitals and places of worship (Traversier 2009; Charpy 2009).

People may gather by national origin or common language and religion, but often it is rather the profession that brings them together (Heinich 2005). Depending on the city and the period, neighbourhoods were more or less delimited or exclusive. Different challenges and possibilities were offered by the metropolis to incoming artists and architects. But in any case, the cities change: social structures get richer, social networks develop, artistic production becomes more diverse. Modernity explodes in a thousand nuances.

Extremely broad, the concept of a network can refer to a family, a group of friends, an association, a school, a newspaper, a trade, a defined neighbourhood, etc. It does not have a precise border, the ties of its members are essentially informal and roles can be plural (Forsé 1991, 249). According to the sociologist Michel Forsé, "[s]ociability is considered as a 'total social phenomenon' that can constitute an autonomous and significant object, and can then be effective in explaining a wide variety of social problems" (ibid., 248). A network analysis studies the relationships between a single person (i.e. an artist or an architect) and a group (i.e. a society or a magazine). It reveals both direct and indirect relationships (a friend of a friend could become a friend) which should be considered since they have "a positive effect as long as the context allows them to be conceived as being able to be activated" (ibid., 251). Very often however the analysis becomes complex with multiple connections, which makes this approach extremely rich.

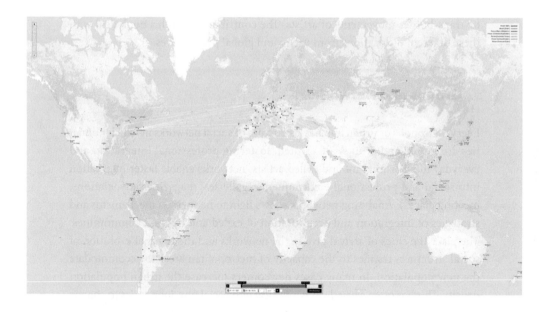

Fig. 1: Geographical visualisation of networks based on data of the METROMOD project entered into nodegoat, 2019 (Van Bree/Kessels).

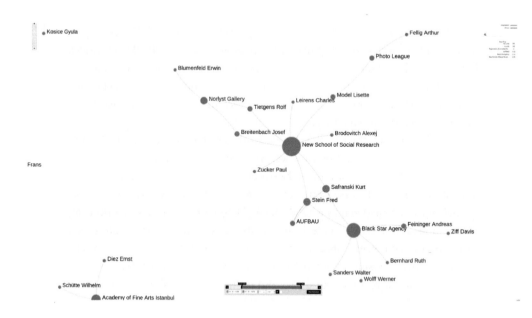

Fig. 2: Social visualisation of networks based on data of the METROMOD project entered into nodegoat, 2019 (Van Bree/Kessels).

Burcu Dogramaci, Mareike Hetschold, Laura Karp Lugo, Rachel Lee, Helene Roth

The Groups and Networks section echoes the increasing concern with these topics shown by researchers in the humanities in the past ten years. Sociologists and anthropologists have been working with networks for three decades (Lemercier/ Zalc 2007) and their studies offer a useful methodology for new research fields in which networks constitute the context in which individuals evolve. Artists, writers and architects are no longer seen as geniuses moving alone through time and space, but as pieces in a huge puzzle where multiple individual histories are entangled. The context – socio-political, economic, cultural – facilitates the artists' trajectories, production, diffusion and circulation. In our work on exiled artists, network analysis helps us to understand the geographical and social situation in the cities. Social ties matter. In every city, in every neighborhood or contact zone, there was a world of connections that made the most possible of the exiled artists' trajectories (figs. 1 and 2).

Aiming to shed light on the historical meaning of relationships, we analyse documents that allow us to reconstruct a detailed social network. Of course, ties interact in different ways. Both individual and collective strategies of networking exist, mixing together all sorts of social relationships. Certainly, the point is not only to conclude that networks did exist, but to try to reconstruct interactions, qualify them, and quantify them when possible. How were these networks created, and how did they grow and persist? Can we detect patterns within them? How did networks in exilic situations affect the artists' practices? In the context of exile and flight, networks have a special meaning: displacements often lead to the break-up of old networks; new networks have to be created first. But there are examples in which old relationships were fundamental for an escape and a professional arrival in a foreign country (Dogramaci/Wimmer 2011).

There are of course many ways to study the historical dynamics involved in social relationships: analysing groups of friends (people, places, objects), communitarian associations or societies (memberships), schools (students, professors), magazines (editors, collaborators, subscribers) are some of them. Naturally, networking concerns people but also associations and objects. All forms of proximity are to be taken into account. For example, when there are many galleries located in the same street of a city, it may be that one person visits several of these galleries, sees the exhibited artworks, and meets different artists, gallerists and other visitors. Thus, gallery owners, artists, audience, artworks, institutions and places are entangled. With often fragmentary sources, investigating relationships at the city scale is not easy, even if the goal is not to describe a complete network but to reveal existing ties around one person, or between a group, a magazine, an association or an institution. However, even if a comprehensive study is out of reach, studying the

internal dynamics of exile networks serves to write the entangled history of these diverse populations.

The GROUPS AND NETWORKS section contains six essays which address questions related to the interaction between individuals, the establishment of collaborations, the organisation of events that create spaces for exiled artists to gather in several cities of arrival or hubs, including Bombay (now Mumbai), Buenos Aires, New York, Rio de Janeiro, Shanghai and Tianjin.

In the section's first essay, "Alone Together: Exile Sociability and Artistic Networks in Buenos Aires at the Beginning of the 20th Century", Laura Karp Lugo analyses migrant and exilic networks which were joined by people already living in Buenos Aires. The development of social entanglements made most exiled artists' trajectories possible. Laura Bohnenblust's contribution, "A Great Anti-Hero of Modern Art History: Juan Aebi in Buenos Aires", focuses on the Swiss artist Hans Aebi's position inside existing structures of the modern art scene in Buenos Aires.

Shifting the geographical focus to Asia, in "From Dinner Parties to Galleries: The Langhammer-Leyden-Schlesinger Circle in Bombay – 1940s through the 1950s", Margit Franz deals with alternative ways of presenting and supporting the new creations of avant-garde artists in Bombay. In "Austro-Hungarian Architect Networks in Tianjin and Shanghai (1918–1952)", Eduard Kögel surveys the architecture projects of exiled architects including Rolf Geyling and Ladislaus Edward Hudec, analysing how they contributed to producing modernism in Shanghai through designing Art Deco residential and commercial buildings.

Back in the Americas, Cristiana Tejo and Daniela Kern's essay, "Art and Exile in Rio de Janeiro: Artistic Networking during World War II", studies emigrant artists and art professionals in the Brazilian art scene in the 1940s. Gathered around hotels and other spaces of sociability, the exiled artists, architects and intellectuals wove networks that facilitated their integration. The section closes with "Kiesler's Imaging Exile in Guggenheim's Art of this Century Gallery and the New York Avant-garde Scene in the early 1940s" by Elana Shapira, studying an exile network with the gallery Art of this Century as its epicentre.

Mobility, Transfer and Circulation

Not least owing to new means of transport, since the end of the 19th century at the latest travel had become a matter of course and played a central role in the formation of modernity (Kaplan 2002, 32). Many artists led their lives between different artistic centres and thus made global cultural exchange possible. According to Caren Kaplan, the term *travel* also implies multiple aspects of an enlarged field

Burcu Dogramaci, Mareike Hetschold, Laura Karp Lugo, Rachel Lee, Helene Roth

of different forms of transport, communication technologies, workspaces and also power relations. "Travel in this expanded sense leads to a theoretical practice, to theorizing subjects and meaning in relation to the varied histories of circulation of people, goods and ideas" (ibid.). In *Routes,* James Clifford writes that "*travel* emerged as an increasingly complex range of experiences: practices of crossing and interaction that troubled the localism of many common assumptions about culture" (Clifford 1997, 3).

Focusing on the first half of the 20th century, the times before, during and after the World Wars are characterised by political, religious, economic and cultural migration movements in which various aspects of mobility, transfer and circulation are inherent. If we look at cities and the metropolitan topographies where emigrated artists fled from or arrived in, these aspects are articulated via different forms of displacement. Mobility, transfer and circulation are terms which imply dynamic processes that cannot be interpreted as static, absolute and perfectly fulfilled, but rather as changeable, open-ended and often unpredictable states (Greenblatt 2010, 2). In MOBILITY, TRANSFER AND CIRCULATION the lives, artistic careers and production of the emigrated artists, architects and intellectuals point out various and different forms. One point here could be the different modes of transport with which these routes into exile were managed. The examples in this section clarify the passage between different continents, as well as illustrating that the departure, arrival and movement within the cities themselves marked important moments of mobility. In many cases the sea and ships played important roles for the modes of mobilities into exile. The image by the photographer Erich Salomon entitled *Überfahrt nach Ellis Island, New York* [Passage to Ellis Island, New York] (fig. 3) shows a ship's passage, here between Manhattan and Ellis Island, which served as a detention and immigration centre during the 20th century. After days at sea, all emigrants fleeing across the Atlantic to New York were met with the view of the harbour with Ellis Island and the skyscrapers of the metropolis. Therefore this photograph can also be interpreted as a picture reflecting terms of mobility, circulation and transfer.

Through a multinational, global and also broad temporal perspective aspects of mobility, transfer and circulation are examined here in different and heterogenic ways that are often closely linked. As movements of emigration and exile depend on various factors, power relations and networks, these different forms of mobility, transfer and circulation can be accompanied by upheavals, detours and failures, but also coincidences. Often artists were not able to emigrate as desired or were also confronted with limited mobility factors in their destinations. Even if a path into exile was forced for political, economic or religious reasons these processes could provoke cultural and creative exchanges between the abandoned country/

city and the new country/city. Mobility can refer to profession, place of residence and social position and imply spatial, spiritual, creative as well as artistic (in-) flexibility. 'Circulation', which derives from the Latin *circu(m)latio*, is generally understood as the circulation and exchange of goods, knowledge or even art and cultural goods. The word 'transfer' is also based on a general meaning of dynamic processes and transmissions. In semiotic terms transfer involves generating a new sign by combining two existing ones. With regard to emigration and exile, not only is a change of residence understood, but the transfer of knowledge, artistic activities, language, values, symbols and cultures is also embedded in circulation and mobility (Eckmann 2013, 25).

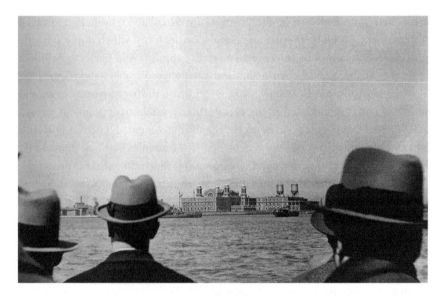

Fig. 3: Erich Salomon, *Überfahrt nach Ellis Island*, New York, 1932, 23 x 33,6 cm (Erich Salomon Archive, Berlin).

The essays in the MOBILITY, TRANSFER AND CIRCULATION section analyse these questions in the context of the urban artistic work and production of different global arrival cities such as Calcutta, Istanbul, Lisbon, Paris, Rio de Janeiro, São Paulo and Saint-Louis. In the essay entitled "Rabindranath Tagore and Okakura Tenshin in Calcutta: The Creation of a Regional Asian Avant-garde Art", Partha Mitter discusses the practices and networks of Pan-Asianism, a non-hegemonic, non-European avant-gardist artistic movement. The transfer and circulation of artistic and technical principles due to exilic mobility is the topic of Joseph L.

Burcu Dogramaci, Mareike Hetschold, Laura Karp Lugo, Rachel Lee, Helene Roth

Underwood's essay, "Parisian Echoes: Iba N'Diaye and African Modernisms". He focuses on the transcultural exchange of the African artist Iba N'Diaye between Saint-Louis in Senegal and the French capital Paris, where N'Diaye first emigrated in the 1950s. He adapted modernist styles and themes upon his return to Senegal in 1958 and finally relocated to France around 1964.

Margarida Brito Alves and Giulia Lamoni focus their essay, "The Margin as a Space of Connection: The Artists Mira Schendel, Salette Tavares and Amélia Toledo in Lisbon", on the city – here Lisbon – as a cultural centre and transfer point for emigrated artists and writers, using the examples of Mira Schendel, Amélia Toledo and Salette Tavares in the 1960s. During this time Lisbon was shaped by the transfer and circulation of transcultural artistic practices and became an important urban space characterising 20th-century Portuguese art. Rafael Cardoso offers a useful connection by focusing on the Brazilian culture between 1937 and 1965. In his essay, "Exile and the Reinvention of Modernism in Rio de Janeiro and São Paulo, 1937–1964", he focuses on the transformation of Brazilian culture and art which was shaped by emigrants, many as exiles and refugees fleeing from World War II. Cardoso argues that the contribution of exilic movements played an important role in the (trans-)formation of modernity in Brazil's cultural and artistic landscape. Not only did culture and art imply factors of mobility, transfer and circulation but also the arrival city itself.

Finally, Burcu Dogramaci's essay, "Arrival City Istanbul: Flight, Modernity and the Metropolis at the Bosporus. With an Excursus on the Island Exile of Leon Trotsky", analyses the specific and locally given urban mobility of an arrival city using the example of Istanbul. In this context, its location on the Bosporus between the two continents of Europe and Asia and also the offshore Princes' Islands plays a special role in the transfer of architectural and cultural knowledge as well as the circulation of information.

Sites, Spaces and Urban Representations

Cities tend to project permanence and stability. Despite destruction wrought by natural disasters or war, periods of demise and reconstruction, or erasures caused by redevelopment, they can endure through centuries, and in some cases even millennia. In contrast, migration is characterised by its transience and lack of fixity. It is then perhaps ironic that cities are invariably the product of the movement of people. Whether it be forced or voluntary, internal or international, circular, chain or step, cities would not exist without migration (World Economic Forum 2017).

Migrants leave their imprint on cities in various ways. One means is by contributing to the building of the city itself. Itinerant labour is often involved in the construction of a city's edifices, as Irish immigrants were in post-World War II London (Mulvey 2018) or as rural immigrants currently are in China (Bronner/ Reikersdorfer 2016). At the other end of the social and economic spectrum, in some places migrant communities become part of the local elite and contribute to the developing urban landscape by commissioning and financing the construction of civic infrastructure, such as schools and hospitals, as the Parsis did in Bombay, for example (Chopra 2011). In addition, migrant and exiled architects contribute to the built environment by continuing their practice in their new surroundings, as Mies van der Rohe famously did in Chicago.

Migrants also make a very visible spatial impact on their target cities through their housing. While some workers live on building sites, more permanent if still precarious forms of urban migrant accommodation include self-built housing in 'informal' settlements. Although these are often associated with cities of Latin America, Africa and Asia, during the 1960s and 1970s several *bidonvilles* housed immigrants in Paris: a shanty town in Champigny-sur-Marne, an eastern suburb of Paris, accommodated around 15,000 Portuguese immigrants, many of whom worked in the building industry (Urban 2013) (fig. 4). In West Germany in the 1960s Turkish *Gastarbeiter* (guest workers) were often housed in cramped and regulated dormitory accommodation provided by their employers or in *Ausländerwohnheime* (foreigners' dormitories) constructed by the German state (Miller 2018, 81, 84).

This sort of social exclusion through spatial segregation is very much at odds with Henri Lefebvre's demand that all urban dwellers have the right to be an integral part of urban life; to be present in, to appropriate and to use places of encounter and interaction. Rather than operating from a marginalised position, he argued that urban dwellers should be central to the city's resources and circuits of communication, information and interchange and asked: "Would not specific urban needs be those of qualified places, place of simultaneity and encounters, places where exchange would not go through exchange value, commerce and profit?" (Lefebvre 1996, 148). Perhaps even more so than for the working class of Lefebvre's case, migrants find satisfying these urban needs particularly challenging due to the already mentioned spatial and economic exclusions, but also because of cultural, social and linguistic barriers. Thus, grasping where and how migrants make and appropriate urban places to facilitate exchange and cultural production could contribute to understanding urban processes of inclusion and exclusion. Do certain neighbourhoods enable transcultural communication? Are there particular spatial typologies that encourage interchange?

Burcu Dogramaci, Mareike Hetschold, Laura Karp Lugo, Rachel Lee, Helene Roth

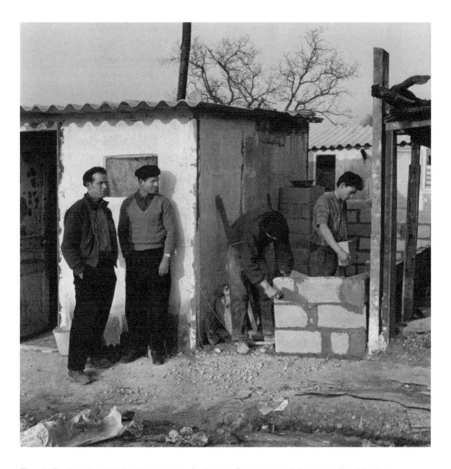

Fig. 4: During the 1960s thousands of migrant Portuguese labourers lived in the Champigny-sur-Marne *bidonville* in the east of Paris (Musée national de l'histoire de l'immigration, Paris).

Taking Lefebvre's argument forward, David Harvey has argued that the "right to the city" should involve not only access to the existing city, but an active right to make the city different (Harvey 2003). A passage in Harlem Renaissance writer Claude McKay's book *Banjo*, which follows a group of multicultural black drifters in the imperial French port city of Marseilles, illustrates how migrants can impact on urban space, making it different. Set in "the Ditch" (*la Fosse*), an area near the harbour whose bars, cafés, brothels and hotels were popular with migrants, McKay describes a scene of celebration, conviviality, solidarity and difference in a newly opened café:

The opening of the Cafe African by a Senegalese had brought all the joy-lovers of the darkest color together to shake that thing. Never was there such a big black-throated guzzling of red wine, white wine, and close, indiscriminate jazzing of all the Negroes of Marseilles. [...] It was a big café, the first that any Negro in the town had owned. [...] All shades of Negroes came together there. Even the mulattoes took a step down from their perch to mix in. [...] All the British West African blacks, Portuguese blacks, American blacks, all who had drifted into this port that the world goes through. (McKay 1929, 45f.)

As well as drinking with the revellers, the book's main character – the eponymous Banjo – provides the music to which they dance, making them "boisterously glad of a spacious place to spread joy in" (ibid., 46).

With examples like this in mind, the SITES, SPACES AND URBAN REPRESENTATIONS section explores how exiled and migrant artists created and used spaces within cities to exchange and interact, to produce culture, and, indeed, how they made cities different. As well as addressing the meaning of architectural styles and building forms in relation to exile and migration, the essays collected here also explore social aspects of space. Mary Louis Pratt's concept of the 'contact zone' (Pratt 1991) is interpreted in new ways both through its embodiment in urban spaces, including bars and hotels, and in artworks.

While several of the essays deal with specific places in different cities around the world, others concentrate on the artworks created by exiled and migrant artists, interpreting how the artists' experiences of the cities are reflected within them.

Rachel Dickson and Sarah MacDougall's "Mapping *Finchleystrasse: Mitteleuropa* in North West London" explores the neighbourhood of Finchley Road in London that played a vital role as a place of sanctuary for refugees and as a locale for the social, cultural, religious and educational spaces and organisations initiated during and immediately after World War II.

A specific architectural typology – the hotel – is discussed in Rachel Lee's essay, "Hospitable Environments: The Taj Mahal Palace Hotel and Green's Hotel as Sites of Cultural Production in Bombay". Positing hotels as significant places for local cultural life, she analyses two hotels in colonial Bombay as contact zones and sites of artistic production.

In her contribution, "Tales of a City – Urban Encounters in the Travel Book *Shanghai* by Ellen Thorbecke and Friedrich Schiff", Mareike Hetschold focuses on the urban representation of Shanghai through her close study of an unusual book produced by an exiled photo-journalist and an illustrator. Exploring the

depictions of typologies such as hotels, as well as the portrayal of the city's urban dwellers, she argues that the book can be conceived of as a contact zone.

Shifting to New York's Bowery neighbourhood, in her essay, "The Bar Sammy's Bowery Follies as Microcosm and Photographic Milieu Study for Emigrated European Photographers in 1930s and 1940s New York", Helene Roth investigates the work of European émigré photographers who documented the social life of a bar, embedding her analysis within an urban history of the neighbourhood.

Changing Practices: Interventions in Artistic Landscapes

Besides transforming urban spaces, artistic migration also deeply affects the local artistic landscape of the new urban environment as well as artistic practices of the 'local' and the 'arriving' artists in multiple ways. Migratory processes oppose linear or one-dimensional narratives of any kind, challenging the 'western' history of modern art. Moreover, the manifold revisions in the artistic field triggered by those who 'come in between' fuel fruitful artistic discourses and prove to be constitutive to modern art. By offering different methodological approaches, the CHANGING PRACTICES: INTERVENTIONS IN ARTISTIC LANDSCAPES section emphasises changes and interventions in different urban contexts, including Buenos Aires, Dublin, New York and Plovdiv. These transformations are multidimensional, reciprocal and stimulated by the encounter of individual artistic practices and related discourses as well as by the migration of cultural knowledge, including scholarly knowledge, institutional forms, publishing and display strategies and forms of collaborative organisation or professional exchange (Deshmukh 2008; Dogramaci/Wimmer 2011). Thus, migratory changes and interventions can be studied and analysed in various forms throughout the artistic landscape, stimulating new ways of approaching the cultural production in modern cities. Furthermore, cultural processes offer significant traces referring to shifts in socio-political and economic conditions which strongly affect the careers of the (migrated or exiled) artists and thus to a large extent its impact: economic and social capital, participation, visibility and reception are fundamental to it. In addition, the conditions of flight, personal background (age, gender, race, education, class, and so on) as well as diverse and changing urban topographies must be considered. Donald Peterson Fleming pointed out in his 1953 publication on refugee intellectuals and their impact in the United States:

> Previous occupational training is significant, since all skills are not equally transferable. Those occupations having a body of knowledge internationally known and applicable [...] or those arts having a medium of expression universally accepted, like music or painting, fare best in the transplanting (Deshmukh 2008, 474).

It is crucial to remember that the experience of alienation, displacement and exile as an existential experience of crisis also carries with it the potential of failure, stagnation and disability of artistic expression. However, Vilém Flusser's and Georg Simmel's evaluations of exile which underline the creative potential ascribed to the experience of displacement, alienation and exile must be equally considered (Simmel 1908, 764; Flusser 2007). Linda Nochlin states:

> For artists, on the whole, exile, at least insofar as the work is concerned, seems to be less traumatic [in comparison to writers]. While some art is, indeed, site specific, visual language, on the whole, is far more transportable than the verbal kind. Artists traditionally have been obliged to travel, to leave their native land, in order to learn their trade [...] (Nochlin 2006, 317–320).

Quoting Janet Wolff, Nochlin continues:

> Displacement can be quite strikingly productive. First, the marginalization entailed in forms of migration can generate new perceptions of place and, in some cases, of the relationship between places. Second, the same dislocation can also facilitate personal transformation, which may take the form of "rewriting" the self, discarding the lifelong habits and practices of a constraining social education and discovering new forms of self-expression. (Nochlin 2006, 317–320).

The essays in this section exemplify how artistic interventions by exiled or migrated artists engaged fruitfully with the local art scene and affected it in multiple ways. Kathryn Milligan focuses on a specific part of a city – the area around Baggot Street in Dublin – in her essay, "Temporary Exile: The White Stag Group in Dublin, 1939–1946". By investigating the art works, exhibition venues and local reception of a group of exiled artists, she sheds light on the development of Dublin's art

scene in the mid-20th century. "Inner City Solidarity: Black Protest in the Eyes of the Jewish New York Photo League" by Ya'ara Gil–Glazer analyses the artistic practice of the New York Photo League and the use of photography as a tool of visual protest by black activists and Jewish photographers and as a major visual harbinger of the emergence of the Civil Rights Movement.

Brian Bockelman's contribution entitled "Bohemians, Anarchists, and Arrabales: How Spanish Graphic Artists Reinvented the Visual Landscape of Buenos Aires, 1880–1920" focuses on the popular early 20th-century Argentine cultural magazine, *Caras y Caretas,* and the two draftsmen Manuel Mayol and José María Cao and a host of other Spanish illustrators. By encountering the marginal urban landscapes, the *arrabales* (outskirts), and the bohemian underground, it introduces a new, anti-establishment kind of humour and deepens the application of caricature to the many-sided Argentine metropolis.

Katarzyna Cytlak's "The City of Plovdiv as a New Latin American Metropolis: The Artistic Activity of Latin American Exiles in Communist Bulgaria" explores the example of Latin American refugees in Bulgaria as an exception in the history of East European migration and analyses cultural production and public interventions by two exiled artists: the Uruguayan Armando González and the Chilean Guillermo Deisler, whose artistic careers were interrupted in 1973 by the *coups d'état* and arrival of military dictatorships in their home countries.

The last essay in this section, Frauke Josenhans' "Hedda Sterne and the Lure of New York", explores how the exiled Romanian painter Hedda Sterne gradually came to terms with her new home in New York, outlining how the city became key to her aesthetic practice and expressed itself within her artworks.

Arrival Cities: A Roundtable, and a Conference

Arrival Cities: Migrating Artists and New Metropolitan Topographies in the 20th Century concludes with a discussion between Rafael Cardoso, Partha Mitter, Elana Shapira and Elvan Zabunyan moderated by Laura Karp Lugo and Rachel Lee. This conversation addresses some points raised in a number of the foregoing essays. These include the problematic of researching elites (as migrant artists often were), the significance of different generations of migrants, the relevance of an aesthetics of exile, as well as issues relating to translation and terminology.

The book *Arrival Cities: Migrating Artists and New Metropolitan Topographies in the 20th Century* is the outcome of an international conference of the same name held in November 2018 in Munich.[3] The conference and its proceedings are part of the "Relocating Modernism: Global Metropolises, Modern Art and Exile

(METROMOD)" research project which was established in 2017 at the Ludwig Maximilian University in Munich with support from an ERC Consolidator Grant. Six global metropolises, acting as arrival points for exiled modern artists, are the focus of the five-year-long undertaking.

Buenos Aires, New York, London, Istanbul, Bombay and Shanghai are closely examined as connection points for ever more globalised modern art. Those cities acted as destinations, transit points and places of artistic creation for numerous artists who left or fled their home countries, many of them in the aftermath of system transformations, to escape dictatorship and war or due to repressions, persecution or violence in the first half of the 20th century. The selection of six 'arrival cities' illustrates the global spread of migrant artists and takes into account various political systems – from the Turkish Republic to cities shaped by colonialism, like Bombay and Shanghai. The six cities also represent various climatic zones, topographies, different traditions, languages and artistic preferences. The key question concerns the challenges and possibilities that those cities offered to incoming artists and, vice versa, how the experience of displacement and new metropolitan environments shaped the work of émigré artists. The project examines forms of multilocality and pluralism, transfers and network formation, reflecting the concepts of polycentrism, contact zones and trans-cultural relationships. The methods of the research project combine urban studies with art history and exile studies: the aim is to build a conceptual triangle of migration, modernism and metropolis to investigate how modern art changed in interrelation with local metropolitan cultures and artists.

This volume includes contributions that expand the project's geographical reach and explore diverse urbanities from different methodological perspectives. The book aims to encourage exchange between scholars from different research fields, such as exile studies, art history, architectural history, architecture and urban studies. We are confident that this volume will contribute to the expansion of the historiography of modern art, urbanism and architecture by addressing topics that open new perspectives on the intersections of exile, metropolises and modern art and architecture.

Notes

[1] "Da Migration primär als Erfahrung eines Ortswechsels definiert ist, sei es als Erfahrung des Heimatverlustes, der Ortsverschiebung und Deplatzierung, der Grenze (oder auch Grenzenlosigkeit), des Durchwanderns und Durchkreuzens von Räumen, oder aber der Multilokalität, suchen die einzelnen Beiträge die De-, Re- und Translokalisierungsprozesse an jenen neuralgischen Kunstorten

Burcu Dogramaci, Mareike Hetschold, Laura Karp Lugo, Rachel Lee, Helene Roth

aufzuspüren, an denen sich Migrationsbewegungen konzentrisch verdichten. Erst in der Ortsreferenz, das heißt in der Situierung, Bündelung und punktuellen Immobilisierung von Wanderbewegungen manifestiert sich, wie Migrationsphänomene im Feld der Kunst Bedeutung generieren." (Dogramaci et al. 2015, 3).

[2] https://en.oxforddictionaries.com/definition/immigrant. Accessed 27 November 2018.

[3] The conference was held on 30 November and 1 December 2018 at the Zentralinstitut für Kunstgeschichte (ZI) Munich and the Internationales Begegnungszentrum (IBZ) Munich. For more information see https://metromod.net.

References

Antonsich, Marco. "Searching for belonging: an analytical framework." *Geography Compass*, vol. 4, no. 6, 2010, pp. 644–659.

Berking, Helmuth. "Der Migrant." *Diven, Hacker, Spekulanten: Sozialfiguren der Gegenwart*, edited by Stephan Moebius and Markus Schroer, Suhrkamp, 2010, pp. 291–302.

Bronner, Ulrike, and Clarissa Reikersdorfer. *Urban Nomads Building Shanghai: Migrant Workers and the Construction Process*. transcript Verlag, 2016.

Bukow, Wolf-Dietrich. "Urbanität ist Mobilität und Diversität." *Postmigrantische Visionen: Erfahrungen – Ideen – Reflexionen*, edited by Marc Hill and Erol Yildiz, transcript, 2018, pp. 81–96.

Callon, Michel (interview with Michel Ferrary). "Les réseaux sociaux à l'aune de la théorie de l'acteur-réseau." *Sociologies pratiques*, PUF, vol. 2, no. 13, 2006, pp. 37–44.

Carstean, Anca. "Migration und Baukultur. Das baukulturelle Erscheinungsbild der internationalen Stadtgesellschaft. Migration and Building Culture. The Building Culture Aspect of International Urban Society." *Metropole: Kosmopolis. Metropolis: Cosmopolis*, edited by Internationale Bauausstellung IBA Hamburg GmbH, Jovis, 2011, pp. 88–95.

Charpy, Manuel. "Les ateliers d'artistes et leurs voisinage." *Histoire urbaine*, vol. 3, no. 26, 2009, pp. 43–68.

Chopra, Preeti. *A Joint Enterprise: Indian Elites and the Making of British Bombay*. University of Minnesota Press, 2011.

Clifford, James. *Routes: Travel and Translation in the Late Twentieth Century*. Harvard University Press, 1997.

Degenne, Alain, and Michel Forsé. *Les réseaux sociaux: Une approche structurale en sociologie*. Armand Colin, "collection U", 2004.

Deshmukh, Marion F. "The Visual Arts and Cultural Migration in the 1930s and 1940s: A Literature Review." *Central European History,* vol. 41, no. 4, 2008, pp. 569–604.

Dogramaci, Burcu, and Karin Wimmer, editors. *Netzwerke des Exils: Künstlerische Verflechtungen, Austausch und Patronage nach 1933*. Gebr. Mann, 2011.

Dogramaci, Burcu, et al. "Kunsttopografien globaler Migraton: Orte, Räume und institutionelle Kontexte transitorischer Kunsterfahrung." *kritische berichte,* vol. 43, no. 2, 2015, pp. 3–4.

Eckmann, Sabine. "Exil und Modernismus: Theoretische und methodische Überlegungen zum künstlerischen Exil der 1930er- und 1940er-Jahre." *Migration und künstlerische Produktion: Aktuelle Perspektiven*, edited by Burcu Dogramaci, transcript, 2013, pp. 23–42.

Forsé, Michel. "Les réseaux de sociabilité: un état des lieux." *L'Année sociologique (1940/1948-)*, vol. 41, 1991, pp. 247–264.

Flusser, Vilém. "Exil und Kreativität." Idem. *Von der Freiheit des Migranten. Einsprüche gegen den Nationalismus*. eva, 2007.

Granovetter, Mark. "The Myth of Social Network Analysis as a Separate Method in the Social Sciences." *Connections*, vol. 13, no. 1–2, 1990, pp. 13–16.

Greenblatt, Stephen, editor. *Cultural Mobility: A Manifesto*. Cambridge University Press, 2010.

Harvey, David. "The Right to the City." *International Journal of Urban and Regional Research*, vol. 27, no. 4, 2003, pp. 939–941.

Heinich, Nathalie. *L'Élite artiste: excellence et singularité en régime démocratique*. Éditions Gallimard, 2005.

Hill, Marc. "Eine Vision von Vielfalt: Das Stadtleben aus postmigrantischer Perspektive." *Postmigrantische Visionen: Erfahrungen – Ideen – Reflexionen*, edited by Marc Hill and Erol Yildiz, transcript, 2018, pp. 97–120.

Kaplan, Caren. "Transporting the Subject: Technologies of Mobility and Location in an Era of Globalization." *PMLA*, vol. 117, no. 1, 2002, pp. 32–42.

Krohn, Claus-Dieter, et al., editors. *Handbuch der deutschsprachigen Emigration 1933–1945*. Wissenschaftliche Buchgesellschaft, 1998.

Latour, Bruno. *Changer de société: refaire de la sociologie*. La Découverte, 2005.

Lazega, Emmanuel. *Réseaux sociaux et structures relationnelles*. PUF, "Que sais-je ?", 2014.

Lefebvre, Henri. "The Right to the City." *Writings on Cities*, edited by Eleonore Kofman and Elizabeth Lebas, Wiley, 1996, pp. 147–159.

Lemercier, Claire, and Claire Zalc. *Méthodes quantitatives pour l'historien*. La Découverte, 2007.

McKay, Claude. *Banjo: A Story Without a Plot*. Harcourt, Brace & Co., 1929.

Mitchell, James Clyde, editor. *Social Networks in Urban Situations: Analyses of Personal Relationships in Central African Towns*. Manchester University Press, 1969.

Miller, Jennifer A. *Turkish Guest Workers in Germany: Hidden Lives and Contested Borders, 1960s to 1980s*. University of Toronto Press, 2018.

Mulvey, Michael. "'Once Hard Men Were Heroes': Masculinity, Cultural Heroism and Performative Irishness in the Post War British Construction Industry." *Studies in*

the History of Services and Construction, edited by James Campbell et al., Lulu.com, 2018, pp. 443–462.

Nochlin, Linda. "Art and the Conditions of Exile: Men/Women, Emigration/ Expatriation." *Creativity and Exile: European/American Perspectives*, vol. 17, no. 3, 1996, pp. 317–337.

Pratt, Mary Louise. "Arts of the Contact Zone." *Profession*, 1991, pp. 33–40.

Roldán, Vera Eugenia, and Thomas Schupp. "Network analysis in comparative social sciences." *Comparative Education*. vol. 42, no. 3, 2006, pp. 405–429.

Saunders, Doug. *Arrival City. How the Largest Migration in History is reshaping Our World*, William Heinemann, 2010.

Simmel, Georg. *Soziologie. Untersuchungen über die Formen der Vergesellschaftung* (1908), edited by Otthein Rammstedt, Suhrkamp, 2016.

Slupina, Manuel. "Die Welt wird Stadt. Hohe Geburtenraten und Perspektivlosigkeit auf dem Land treiben die Urbanisierung voran." *Atlas der Globalisierung: Welt in Bewegung*, edited by Stefan Mahlke, Le Monde diplomatique/taz Verlags- und Vertriebs GmBH, 2019, pp. 120–121.

Taran, Patrick, et al. *Cities Welcoming Refugee and Migrants: Enhancing effective urban governance in an age of migration*. UNESCO, 2016.

Traversier, Mélanie. "Le Quartier artistique, un objet pour l'histoire urbaine." *Histoire urbaine*, no. 26, 2009/3, pp. 5–20.

Urban, Florian. *Tower and Slab: Histories of Global Mass Housing*. Routledge, 2013.

Van Bree, Pim, and Geert Kessels: nodegoat: a web-based data management, network analysis & visualisation environment, 2013, https://nodegoat.net from LAB1100, https://lab1100.com.

Wasserman, Stanley, and Katherine Faust. *Social Network Analysis: Methods and applications*. Cambridge University Press, 1994.

World Economic Forum. *Migration and Its Impact on Cities*. World Economic Forum, October 2017.

Yildiz, Erol. *Die weltoffene Stadt: Wie Migration Globalisierung zum urbanen Alltag macht*. transcript, 2013.

Yildiz, Erol, and Birgit Mattausch, editors. *Urban Recycling: Migration als Großstadt-Ressource* (Bauwelt Fundamente 140). Birkhäuser, 2009.

Groups
and Networks

Alone Together

Exile Sociability and Artistic Networks in Buenos Aires at the Beginning of the 20th Century

Laura Karp Lugo

Arriving in Buenos Aires[1]

In the first half of the 20th century, Buenos Aires was a major urban centre where hundreds of exiled artists – mainly European – settled, as they were looking for better economic and socio-political conditions. Even though the development of the steamship had facilitated transatlantic relations since the 1870s, the transnational flow of people and cultures intensified after 1900. 1914 comprised the climax of this migration period, and for every fourth Argentinian citizen one European migrant could be counted (Comisión Nacional del Censo/Martínez 1916, 203–204). Under the motto 'Governing is populating', the Argentinian leaders implemented significant immigration policies which declared that all Europeans under the age of 60 were welcome. Those who arrived by boat with second- or third-class tickets and had nowhere to go could spend up to five days in the Hotel of Immigrants (Avenida Antártida Argentina 1355), built in 1911. There, migrants received food, medical assistance to cure diseases caught during the journey, and a bed. They also obtained help with their residence permits, were taught how to use machines to work in the fields or in factories, and were supported in finding work. As the Spanish writer Francisco Ayala mentions in his memoirs of his exile in Buenos Aires after the Spanish republic collapsed in 1939: "Buenos Aires was a coveted place for several reasons, but above all for the economic prospects it offered to those who had to rebuild their lives outside of Spain"[2] (Wechsler 2011, 190).

Since the 16th century Europeans had been travelling to Latin America, and some settled in Buenos Aires when it became the capital of the Virreinato del Río de la Plata in 1776.[3] From that time, European immigration to Argentina intensified, especially in the 19th century when, just after decolonisation in 1810, Argentina allowed free entrance to immigrants. After that, civil wars and repression curtailed

the arrival of foreigners until the 1870s when President Nicolás Avellaneda invited people under 60 years old to live in his country, provided they did not have an "immoral background". In Avellaneda's immigration law the category of *immigrant* is defined as follows:

> … every foreign day labourer, craftsman, industrialist, farmer or teacher who, being less than 60 years of age and accrediting his morality and his aptitudes, arrived in the republic to settle in it, in steam- or sailing ships, paying for second- or third class tickets, or having the trip paid for on behalf of the Nation, the provinces or private companies, which protected immigration and colonisation.[4] (Avellaneda law 1876)

From then onwards, boats loaded with hundreds of Europeans – Italians, Spaniards, French, Germans, Russians and many others – arrived at the main Argentinian port, Buenos Aires. Between 1890 and 1904 there were an average of 46,000 entries of Europeans a year; from 1904 to 1913 160,000 (Blancpain 2011, 26). Thus, from 2,500,000 inhabitants in 1880, the population in Argentina rose to 7,800,000 in 1914, one-third of whom were immigrants, mostly Italians and Spaniards (González Lebrero 2011, 20).[5] A large number of artists, architects and intellectuals made up a substantive number of these immigration waves. During the integration process different strategies were at play, depending on both the newcomers' language skills and how large the community of others from the same country was. Many of the newly arrived could reconnect with relatives or friends in Argentina who had arrived earlier, during the mid- and late 19th or early 20th century (Wechsler 2005, 279). Most of these migration stories need to be approached as inextricably entangled: in manifold ways immigrants constitute individual links in a "chain of solidarity" (ibid., 278) each one helping others to arrive, settle and grow roots in their new homes.

In his book, *Arrival City: How the Largest Migration in History is Reshaping Our World*, Doug Saunders studies the interaction between the city, neighbourhoods and migrating flows which leads to urban and social upheavals and transformations. Analysing urban space from this angle is essential for a comprehensive understanding of the city-migrant relationship and for assessing the reception capacity of the destination city. While research literature exists on the topic, it is often limited to specific cases. Indeed, no global reflection about the relationship between immigration and the city of Buenos Aires has yet been developed. This paper, thus, focuses on the exilic networks and practices of migrant artists gathered in Buenos Aires in the first half of the 20th century. It addresses the extent to which

social ties and networks[6] play a role not only in the integration of exiled artists but also in the artistic landscape of Buenos Aires. Introducing the reader to the Buenos Aires of the time, as if looking through a peephole, this article will follow those artists to art galleries, activist and dynamic associations, and circles where bonds of friendship went hand in hand with collective creation. Far from pretending to assemble an exhaustive repertory, this essay instead explores the networks of immigrants through case studies, and the extent to which these connections stimulated, affected or enabled exilic artistic productions. To clarify my usage of different terms of displacement: in early 20th-century Buenos Aires the word 'immigrant' was used without distinguishing between those who had fled violence or persecution (exiled) and those who had come to improve their living conditions or even make a fortune (immigrants). Of course, a detailed analysis reveals the causes of displacement and separates those who can go back whenever they want from those who would risk their lives if they decided to return home.[7] In this paper, this distinction will operate for the individual artists whose paths I retrace, but when referring to whole population groups migrating from Europe to Argentina terminologies can overlap, especially when one is examining the networks of those who have left their homes, work, friends and often even their identity behind. Indeed, exiles and immigrants intermingled in Buenos Aires and moved in the same circuits, sharing economic, linguistic and integration-related concerns.

Gatherings in Buenos Aires: Galleries, Associations and Private Spaces

The city's specific demographic led to the establishment of institutions and meeting spaces which were founded by immigrants in order to encourage socio-cultural encounters. Associations, leisure centres, schools, hospitals, foreign-language newspapers and clubs were set up for and by many exiled communities, bringing together newcomers with shared national or linguistic roots to make them feel at home. Thus, a rich social, cultural and institutional atmosphere welcomed and fostered the integration of immigrants in Buenos Aires. Some examples of how such institutions facilitated contact are, for instance, the Société Philanthropique Française du Río de la Plata (1832), the Deutscher Klub aus Buenos Aires (1858), the German Hospital (1867), the Circolo italiano (1873), the Vorwärts Klub (1882), the Club for the protection of German immigrants founded by the journalist Ernst Bachmann (1882), the Casal de Catalunya (1886), the Argentinian Centre of German Engineers (1913), the Argentine-German Cultural Institution (1922),

the Casa Polaca (1929), the Österreichischer Sozial- und Sportclub (1930) and Das Andere Deutschland association (1937). However, this article does not aim to explore the artistic production of artists exiled in Argentina within national communities. This would be misleading, as Buenos Aires is an example of an open city which, since the arrival of the first settlers in the 16th century, has never stopped receiving immigrants. Indeed, Argentina relied on the immigrant population to build itself up. Diversity was (and still is) reflected in the identity of its inhabitants, which is plural by definition. For convenience and proximity, newcomers often settled in the neighbourhoods that were occupied by their compatriots. Links were usually woven directly or indirectly even before their arrival and often explained the choice of Argentina as a destination country for both forced and voluntary exiles. But for others, their profession was what brought them together.

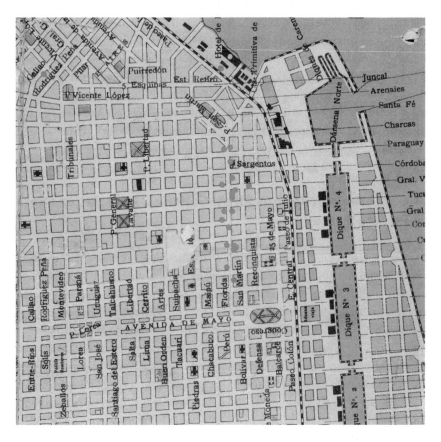

Fig. 1: Map of Buenos Aires (detail), 1895, showing gathering places on Florida Street (Original map: Archivo General de la Nación, Buenos Aires).

Laura Karp Lugo

The old district of Buenos Aires, with the central zone located in Florida Street (Calle Florida), functioned as a contact zone[8] where a rich artistic life developed: it featured galleries, shops for artists' equipment, photography studios, institutions and different associations (fig. 1). In this street and its surroundings local and migrant artists gathered, exchanged ideas and exhibited their work together. Moreover, European migrants were to be found among the city's successful merchants, bar owners, but also gallerists, and members of many liberal professions such as writers, artists and architects. The mutual aid networks of European immigrants in Buenos Aires had a significant impact on the art scene. Some migrants set up as art dealers: José Artal, José Pinelo Llull, and Justo Bou Álvaro, Spanish merchants, worked hard to make visible the art produced in Buenos Aires by their compatriots (Baldassare 2008; Karp Lugo 2016). In the same way, German gallerists exhibited their compatriot artists – this is what enabled Grete Stern to have her first solo exhibition at Müller Gallery in 1943, for example (Bertúa 2017, 9). The gallery's owner, Federico C. Müller, was born in Wiesbaden (Germany) in 1878, and after spending time travelling within Europe (Paris, Barcelona, London), he emigrated to Buenos Aires (Gutiérrez Viñuales 1998, 103–105). In 1909 he opened a shop of decorative objects in Calle Florida 361. In the basement, in a dimly lit room, he exhibited art works, sometimes old paintings, sometimes works by modern German artists. This changed in 1910, when he was asked by the German government to curate a German section at the International Exhibition of Fine Arts of the Centenary of Argentinian Independence (*Revolución de Mayo*). After that, in 1912 and 1913, he organised exhibitions of German painting in the German Club of Buenos Aires (Fernández García 1997, 80). Then, in 1913, he decided to move to a better place in the same street, to Florida 935, where the other main Argentinian galleries were located (Witcomb and Van Riel, among many others). After that, Müller focused his activity on exhibitions of Fine Arts, presenting mainly German artists. By 1914-1915, due to the difficulty of obtaining German (and, more generally, European) works in the context of World War I, Müller also opened his gallery to other nationalities. Most of the time, he personally selected the artists and artworks he exhibited, but sometimes he let the space out to other gallerists. In 1954 the gallery closed permanently.

A few metres away from Müller's gallery, facing the Sociedad Fotográfica Argentina de Aficionados[9] (Argentine Photographic Society of Amateurs, founded by Francisco Ayerza in 1889 in Calle Florida 365), the English photographer Alejandro Witcomb had opened an exhibition space in 1897 (Florida 364), before moving to Calle Florida 900, a large gallery with a glass ceiling. Witcomb sought to attract an affluent audience, the upper class of Buenos Aires. In 1911, Calle Florida became pedestrianised and commercialised, linking the central district to Retiro,

in the north. Shops, galleries and studios multiplied on either side of Calle Florida, which was and still is one of the city's most central and well-known streets. One of those galleries belonged to Frans van Riel, who was born in Rome in 1879 and disembarked in Buenos Aires in 1910. After having worked for several years as a magazine illustrator, in 1913 he eventually opened a photography studio in Calle Viamonte, between Maipú and Florida. In 1924, he moved down to Calle Florida 659 and opened a gallery. There, artists and intellectuals gathered as the gallery hosted not only the Asociación Amigos del Arte, which was a popular association among artists (founded the same year), but also the magazines *Ver y Estimar*, edited by the Argentinian art critic Jorge Romero Brest, and *Augusta*, founded by Van Riel together with the Argentinian writer and journalist Manuel Rojas Silveyra. In 1950, when Van Riel died, the gallery passed into the hands of his son.

Those galleries were grouped together on Calle Florida because the street constituted a strategic metropolitan connecting line and axis. Since the birth of Buenos Aires, Florida had acted as the nodal point for the social life of the city. In the days of Independence, Salons were held there, including those of Mariquita Sánchez and Flora Azcuénaga which gathered together local and foreign elites (Lanuza 1947, 12). Located about 400 metres from the Río de la Plata which opens out to the Atlantic Ocean, Florida rises parallel to it, until it merges into Plaza San Martín (the former Plaza de Marte) which also faces the river in its northern part. At the turn of the 20th century many other establishments were located there, such as Galería Londres, Salón Chandler y Thomas (1913), Jockey Club (1897), Galería Philipon (1912), Salón Eclectique (1912), as well as the most prestigious commercial buildings: Galerías Pacífico (1890), Galería Güemes (1915), Galería Jardin, Harrod's (1914) and Confitería Richmond (1917), among many others. Clustered on this 1.3 kilometre long pedestrian street, art galleries, shops, clubs and associations could expect a consistently high number of shoppers, visitors, aficionados and *flâneurs*. This stimulating social and professional environment led the artists of Buenos Aires to practise forms of self-organisation by setting up societies and associations, and by opening private spaces where they could gather.

The Asociación Amigos del Arte (Friends of Art Association) was a central association within the artistic milieu in Buenos Aires: particularly beneficial for migrant artists, it provided them with a space for exchange and exhibition.[10] It promoted programmes in different areas (art, music, film, literature, theatre, conferences and publications), allowing a wide range of activities linked to both traditional and avant-garde, and to both nationalism and cosmopolitanism. The photographer Gisèle Freund, who arrived in Argentina thanks to the writer Victoria Ocampo's support, exhibited for the Association at Van Riel's gallery – Calle Florida

659 – in 1942. Annemarie Heinrich was also familiar with this association. Born in Darmstadt, she arrived with her family in Buenos Aires in 1926, at the age of 14. She received a camera from her uncle and taught herself photography. From Entre Ríos where they first settled, the Heinrich family moved to Villa Ballester in the province of Buenos Aires. Once in the city, by 1927 Annemarie Heinrich was apprenticed by the Hungarians Rosa Kardofy, Rita Branger and Nicholas Shönfeld, the Australian Melita Lange and the Pole Sivul Wilensky (Wechsler 2015, 16). Through the Argentinian filmmaker Luis Saslavsky, she may have met well-known actors, singers and dancers, photographing many of them. In the 1940s, she had established a photography studio for actors, dancers, and intellectuals in Callao 1475 which is still open and run by her children, Alicia and Ricardo Sanguinetti.[11]

Among the institutions that helped migrants to integrate into Buenos Aires' cultural life, the Agrupación de Intelectuales, Artistas, Periodistas y Escritores – AIAPE (Association of Intellectuals, Artists, Journalists and Writers) must be mentioned. Founded in 1935, the AIAPE brought together European artists and intellectuals exiled in Argentina, as well as Argentinians committed to contemporary aesthetics and current political issues. The AIAPE published a magazine called *Unidad por la Defensa de la Cultura* (*Unit for the Defence of Culture*); its illustrations sought to accompany and facilitate the written texts and to develop people's libertarian imaginaries.

The magazine featured exiled artists such as the Spanish Luis Seoane, Pompeyo Audivert, Juan Batlle Planas and José Planas Casas, as well as the German caricaturist Clément Moreau (Carl Meffert) who published their artworks with the social impetus of engaging with contemporary political issues (fig. 2). Most of them had a migrant background and had arrived in Buenos Aires *in extremis,* like Moreau, who fled his country in 1933 and who succeeded in obtaining documents to travel to Argentina from the port of Marseilles with his wife Nelly Guggennbühl in 1935 (de Rueda 2004, n.d.). Exile, for him and for others, meant engrossing oneself in a symbolic struggle by working in publishing and other creative institutions. Moreau worked as a political caricaturist for several magazines, German-speaking journals as well as Argentinian ones, such as *Argentinisches Tageblatt, Crítica, La Vanguardia, Noticias Gráficas, Fastrás, Argentina Libre* and *Nervio.* In 1938 he founded Truppe 38, a theatre group with a strong satirical slant. Its cast was made up of German immigrants such as the pianist Walter E. Rosenberg, the singer Hellmuth Jacoby and the dancer Renate Schottelius. The first performance of Moreau's troupe took place in the Vorwärts Association and was promoted by the *Argentinisches Tageblatt.* The money they collected was allocated to subsidising activities carried out by Das Andere Deutschland, an anti-fascist organisation (Friedmann 2009, 71–72).[12] In

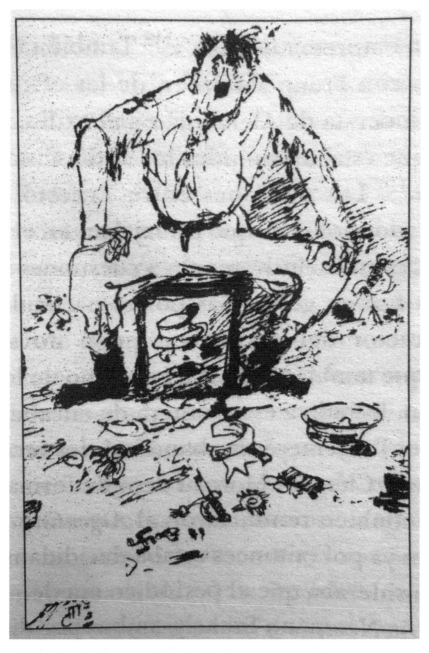

Fig. 2: Clément Moreau (Carl Meffert), "Wer sich mir entgegenstellt, den zerschmettere ich!" (Whoever opposes me, I will smash to pieces!). *Argentinisches Tageblatt*, 6 February 1938 (Friedmann 2010, 73).

Laura Karp Lugo

1936, the Italian Attilio Rossi wrote about the importance of artistic immigration for the Argentinian cultural panorama:

> The great immigration flows and the increasing intensity of the exchanges have displaced the gravitational centre of Argentinian life towards the realm of universal concerns. For the artists, notions of universalism became even more prevalent. If as individuals they had been removed from any kinds of local roots, as artists they now belonged to a land without borders.[13]
> (Rinaldini 1936, 93)

Attilio Rossi was a close friend of Victoria Ocampo, who played a crucial role in developing networks wide open to exiled artists and intellectuals. In 1913 she founded *Sur*, a magazine and publishing house aligned with the anti-fascist cause, which – for almost two decades – was to become a major meeting place in Buenos Aires. At its editorial headquarters, the German photographer Grete Stern and her Argentinian husband Horacio Coppola, a photographer and filmmaker, exhibited their work for the first time in October 1935 (Romero Brest 1935). Stern and Coppola had met in Berlin, through their mutual friend Fritz Hensler, in October 1932 (Coppola 1994, 12). Three years later, fleeing Nazi persecution, they decided to leave Europe for Coppola's native Argentina. Facing the news of death in Germany of her mother, who had committed suicide under the threat of imminent deportation by the Nazis to a concentration camp, Stern decided to settle in Buenos Aires for good with her husband and their one-year-old daughter. She went back to London only to close the studio she had set up there and to give birth (Príamo 1995, 20). Clearly, Stern's integration into the cultural scene of Buenos Aires was facilitated by her husband. When Coppola left Argentina for Europe, where he met and married Stern, he had already achieved recognition in Argentina for his photographic work, which was regarded as innovative and modern even before he had travelled to Europe. Through Coppola, Stern met Victoria Ocampo who was surrounded by artists and writers, among them the Spanish painter, engraver and designer Luis Seoane, the Czechoslovak sculptor Gyula Kosice, the Austrian painter Gertrudis Chale, the Chilean poet Pablo Neruda, Clément Moreau, Renate Schottelius, who fled Germany in 1936 following an uncle who had settled in Argentina, and Annemarie Heinrich, who portrayed many of the abovementioned people. Thus, Buenos Aires brought together artists who stemmed from different backgrounds, facilitating their successful integration and acculturation. In 1937, together with Coppola and Seoane, Stern opened a photography studio at Avenida Córdoba 363 which specialised in advertising and

which eventually had to close two years later due to the low demand for the advertising productions they offered (Marcoci 2015, 30) (fig. 3). A few years had passed, and Grete Stern was fully integrated into the Argentinian artistic and cultural scene. She would continue in the same way as Ocampo – gathering and providing space for exchange to the European intellectual diaspora in her house at Calle Ascasubi 1173 (today Calle Hilario Ballesteros 1054, Villa Sarmiento district) in Ramos Mejía, a suburb of Buenos Aires, where she moved in 1940 with Coppola and Silvia, their first child. The house was built in 1939 by the Russian architect Vladimir Acosta (born in Odessa), another close friend of Victoria Ocampo who had arrived in Buenos Aires in 1928.

Fig. 3: Brochure of Stern-Coppola's advertising studio in Avenida Córdoba 363 (Archive Grete Stern, Buenos Aires).

Ocampo probably helped him to find a position in the studio of the architect Alberto Prebisch (Borghini et al. 2012, 121). A two-storey atelier, the main space of Stern's house, joins the ground floor with living spaces (bedroom, living room, bathroom and kitchen) and the first floor which contains the terraces, an office and a guest room. The house was called 'the factory' because of its style and building material – reinforced concrete and masonry. It was very different from other, more standard constructions built around the same time. Stern's place was a meeting point for foreign artists and intellectuals, but also for Argentinians such

as María Elena Walsh, Sara Facio and Jorge Luis Borges. In 1945, Gyula Kosice curated a concrete art exhibition there with the Madí group, the Argentinian avant-garde. Kosice asked Stern to design the logo for the group he had just founded (fig. 4), as we can read in his memoirs:

> From 1942, Grete took photos of my work, and a little later we began to hold the meetings of the Concrete Art-Invention Association in private homes, and one of them was in her place. Among other things, she took pictures of the members of the group. When I founded the Madí group I commissioned from her a collage for the logo. I asked her to take a photo in front of the Obelisk, where there was an advertisement for Movado watches. I was interested in the letter M of that poster, which was illuminated with neon gas, because at that time I was working with this material. (Archives Kosice)[14]

Thus, galleries, associations as well as private places allowed artists to meet, to collaborate. These various spaces turned into a sort of informal gathering spot that helped artists to blend into and coalesce faster with the city. Taking into account such contact zones which fitted into the gaps of public infrastructure, we can advance our understanding of the entangled trajectories of exiled and migrant artists in Buenos Aires.

Fig. 4: Grete Stern, *MADI*, fotomontaje, 1947, 2006, Impresión de Gelatina de Plata, 30 x 24 cm, Colección Ella Fontanals-Cisneros (*Grete Stern: Obra fotográfica en la Argentina* 1995, 48).

Producing in Buenos Aires

It seems as if the shared experience of both common (national, geographic) origins and exile galvanised the gathering of and exchange between multi-faceted groups of artists. Several case studies reveal that these interactions had either been established even before migrating to Buenos Aires or they were accelerated by the mutual experience of exile in Argentina. In this sense, an artistic group called La Carpeta de los Diez (The Folder of the Ten) is an interesting case study as it sheds light on the networks and the circulations of a group of people gathered together because they share a common medium: photography. It also reveals the heterogeneous nature of the population that characterised Buenos Aires at that time (fig. 5).

Fig. 5: The "La Carpeta de los Diez" group's folder (Archive Annemarie Heinrich, Buenos Aires).

The group was begun in 1953 and featured three members from Argentina (Pinélides Aristóbulo Fusco, Eduardo Colombo, Augusto Valmitjana), three from Germany (Annemarie Heinrich, Hans Mann, Max Jacoby), two from Italy (Giuseppe Malandrino, Juan Di Sandro), two from Hungary (Georges Friedmann, Alex Klein), one from Switzerland (Ilse Mayer), one from Russia (Anatole Saderman), one from Austria (Fred S. Schiffer) and one from Poland (Boleslaw Senderowicz).[15] The group had ten members but in total 14 photographers were involved in it: when four had to abandon the group for different reasons, four others joined. They met monthly to exchange ideas, practise together, and prepare exhibitions. Their main task was filling a so-called folder with photographic material that they then later discussed. After deciding together which topic or style they would work on (nude, flower, hand, solarisation effect, etc.), one member inserted a single photograph into the folder and brought it to circulate between the members so that they could discuss and criticise the work. Each member wrote a commentary on the work and placed it in the folder before

Laura Karp Lugo

passing it onto the next person. Once everyone had commented, the photo was discussed in a group meeting (Karp Lugo 2018). Once, Annemarie Heinrich submitted a photograph of a woman sitting on a kind of chaise longue, which stands out against a monochrome and dark landscape. The framing shows only a part of her bust, face and right arm. Bold lighting from the left falls on her body, revealing smooth and luminous skin (fig. 6). Her work provoked very different reactions. Anatole Saderman approved, despite remarking, "I think your outdoor portrait should be found rather than searched for; and certainly not retouched. More to the 'as it falls'. In all other respects, as always, excellent"[16]; while Georges Friedmann was more sceptical about the parallel line created between the nose and the edge of the chair. This detail seemed to bother him, as did the fact that the hand disappears behind the head. He finished his comment with a critical statement: "below, the cut also stops being favourable. Annemarie, I don't agree with this picture of you"[17] (fig. 7).

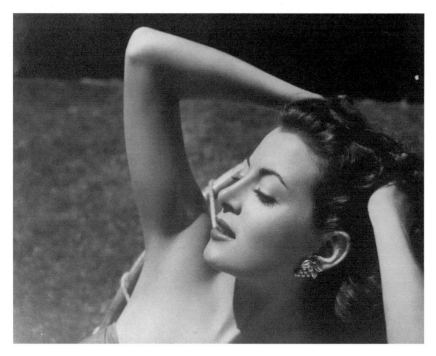

Fig. 6: Annemarie Heinrich, Portrait of Piru Bullrich, c. 1946 (Archive Annemarie Heinrich, Buenos Aires).

Fig. 7: Critiques of Annemarie Heinrich's picture in the *The Folder of the Ten* (Archive Annemarie Heinrich, Buenos Aires).

In most cases, the folder reveals the way these artists in exile had mastered the local language, as a lot of them wrote in Spanish with absolute fluency and accuracy, testifying to their successful integration into Argentina. What the group's members valued most, though, was creating, being stimulated, having their own photographic work reviewed by experts in the medium. A speech celebrating the opening of the 1st Exhibition at Galería Picasso in September 1953 pronounced the following:

The Folder turned out to be more than a living school for us: as it was founder (builder) of critique, opinions and discussions among the different persons who were keen on photography; it also remained as an exercise of professional emulation (increase) and aesthetic improvement to achieve a better level in the production and creation of all and every one of its members through the active practice of critique, the mutual encouragement of auto criticism, the incentive to individual self-improvement through collective education and influence. The Folder has helped us to enjoy, above all, the pleasant experience of working together, of appreciating interchange and reciprocal support [...].[18]

Without any external funding, every month La Carpeta de los Diez collected money for exhibitions: to buy racks on which to exhibit the photographs, to print the catalogues. In the exhibitions each member could show up to seven works: five of them could be chosen freely, and two had to come from the folder. Innovatively, the photographs were displayed on racks, without frames, and were printed in a 50 x 60 cm format, which was large for the time. The group held six exhibitions: in the Galería Picasso (in Calle Florida 363, 1953), at Salón Kraft (in Calle Florida 681, 1954), at Salón Siam (in Calle Florida 936, 1956), at Salón Harrod's (in Calle Florida 877, 1957), at the Office of Foreign Affairs (1958), and in the Opera Theatre (Avenida Corrientes 860, 200 metres from Calle Florida, 1959). They never succeeded in selling their work (Karp Lugo 2018). That Buenos Aires had then no existing market for artistic photographs explains the need for gathering together with the goal of creating a space for their work. Within the group, at a micro scale, networks are revealed to be crucial once more.

Although diverse and multi-directional (Argentinian-born together with non-Argentinian-born), their exilic networks were fully operational. One of the members, the Russian Anatole Saderman, was born in Moscow to a Jewish family. After a long pilgrimage with his family looking for a place to settle, including Minsk (Belarus), Lodz (Poland) and Berlin (Germany), he arrived in Montevideo (Uruguay) in 1926 with a German camera. He decided to stay, although his family continued their journey to Asunción (Paraguay) whose government had promised them land. He learned the technical basics of photography from Nicolás Yarovoff, who was also Russian, and became his assistant. Getting a job obliged him to leave the Hotel of Immigrants for a rented room in the home of a Russian Jewish family (Caparrós 2017, n.p.). After a detour to Paraguay where he opened his first photography studio, he decided to settle in Buenos Aires for good. There, he became a well-known photographer. He had a Spanish assistant, Leonor Martínez Baroja,

and started getting involved with La Carpeta de los Diez.[19] Two other members, Georges Friedmann (born György) and Alex Klein, came from the same city in Hungary. In 1947, Friedmann became a collaborator on *Idilio*, the magazine for which Grete Stern was also providing photomontages. Being together in exile, forging ties and engaging in collective production processes helped these artists to move forward (fig. 8). This also happened with other groups, often involving insiders and outsiders, such as Grupo Tartagal,[20] where the connections between the exiled/migrant and Argentinian-born artists opened up work opportunities and sometimes generated collective experiences.

Fig. 8: Ricardo Sanguinetti, Portraits of Boleslaw Senderowicz, Anatole Saderman, Juan Di Sandro and Annemarie Heinrich, c. 1985 (Archive Annemarie Heinrich, Buenos Aires).

As this article shows, social and artistic relationships played an essential role in the integration of exiled artists into the local art scene. Communality and conviviality seem to have been the key to integration and to subsistence, and Buenos Aires was certainly a good place to experience that. Indeed, as stated above, the city

Laura Karp Lugo

provided an economic, social and infrastructural scaffolding strong enough to absorb and contain new arrivals – be they exiles or immigrants. The city does not seem to have confined immigrant artists to a specific aesthetic, as has been the case in other metropolitan areas that have, in some way, governed the production of foreign artists.[21] It is worth noting that the influx of migrants to Argentina had also provided a potential clientele group to support these artists who were, like them, foreigners. The fact that Buenos Aires was initially built by colonial authorities, and then further developed and expanded by flows of immigrants that increasingly intermingled with locals, allowed the city to open up towards plural forms. Moreover, ties previously established to people who had already settled in Buenos Aires made the decision to emigrate to the city more bearable and promising for new immigrants, not to mention the rather favourable migration policies. Because the city prevailed and still prevails as such a heterogeneous, diverse, polyglot, multicultural contact zone, meeting others with similar interests and gathering together communities was undoubtedly made all the easier.

> When it came to deciding, given the circumstances, where I could best rebuild my life after the catastrophe, I sought to head towards Buenos Aires, a city that I already knew and in which I could count on some friends […] For me it was not excessively arduous, although not easy either, to obtain entry and residence there, thanks to the previous personal ties that on that occasion made my bureaucratic procedures easier.[22] (Ayala 1982, 235)

As Francisco Ayala reveals in his memoirs, within Buenos Aires, in each neighbourhood or contact zone, there lay a world of connections that made most artists' trajectories possible. By analysing the nature and intensity of such relationships we can retrace a detailed social network. Some networking strategies were individual, others collective, mixing all kinds of social relationships. What is clear is that the proximity of artists sharing social spaces – predominantly, although not exclusively, concentrated in the central areas of the city – enabled encounters and collaborations. This paper has attempted to reassemble these interactions of exiled artists in modern Buenos Aires and to highlight the multiple internal dynamics of migrant networks and local networks, as well as the role of these social constructions within the mechanisms of global mobility.

Notes

1 This article was enriched by exchanges with Diana B. Wechsler, Luis Príamo, Leonor Martínez, Alejandro Saderman, Alicia and Ricardo Sanguinetti (Estudio Heinrich Sanguinetti), Carlos Peralta Ramos (Archivo Grete Stern), Paula Hrycyk, Max Pérez Fallik (Museo Kosice), and the librarians and/or archivists of the Museo Nacional de Bellas Artes, the Museo de Arte Moderno, the Museo Sívori, the Fundación Espigas and the Archivo del Instituto de Investigación en Arte y Cultura "Dr. Norberto Griffa". I would like to express my deep gratitude to them.

2 In the original: "Buenos Aires era un lugar apetecible por diversas razones, pero sobre todo por las perspectivas económicas que ofrecía para quienes debíamos rehacer nuestras vidas fuera de España" (Ayala 1982, 235). All quotations have been translated by Laura Karp Lugo.

3 Buenos Aires was founded in 1580 by Juan de Garay, but at that time it was overshadowed by Lima, the Virreinato del Perú's capital.

4 Ley de inmigración y colonización, n. 817 (Avellaneda law), article 12c, chapter V, enacted on 19 October 1867. In the original: "Todo extranjero jornalero, artesano, industrial, agricultor o profesor, que siendo menor de sesenta años y acreditando su moralidad y sus aptitudes, llegase a la república para establecerse en ella, en buques a vapor o a vela, pagando pasaje de segunda o tercera clase, o teniendo el viaje pagado por cuenta de la Nación, de las provincias o de las empresas particulares, protectoras de la inmigración y la colonización."

5 For a general study on immigration to Argentina, see Devoto 2003.

6 For a discussion of this concept, see Forsé 1991.

7 See Nouss 2015.

8 Here I refer to the concept of "contact zones" (Pratt 1991) which is understood within this essay as a space – physical or not – of contact, and is not necessarily determined by asymmetrical power relations that are, of course, present in colonial relations.

9 For a complex study of this institution, see Pestarino n.d.

10 For an extensive engagement with this association, see Meo Laos 2007.

11 I am very grateful to Alicia and Ricardo Sanguinetti for being so helpful and for allowing me to publish photographs from their collection in this article.

12 Das Andere Deutschland was founded by a group of exiled Germans together with other Germans already living in Buenos Aires. Opposed to the Nazi regime, the organisation sought to represent 'the other' Germany, the one that was tolerant, peaceful and humanist. It carried out cultural and political activities as well as solidarity actions and played an important role in the integration of German newcomers (Friedmann 2010, 32).

13 In the original: "Las grandes corrientes inmigratorias de penetración y la intensidad creciente de los intercambios han desplazado el centro de gravitación de la vida argentina hacia el ámbito de las preocupaciones universales. Su condición eventual de artista los distancia todavía más. Si como individuos han sido sustraídos a todo antecedente de arraigo local, como artistas pertenecen a un país sin fronteras."

14 The original: "A partir de 1942 Grete hacía fotos de mi obra. Un poco más tarde empezamos a hacer las reuniones de la Asociación Arte Concreto-Invención en casas particulares, y una de ellas fue en la suya. Entre otras cosas, ella sacaba fotos de los integrantes del grupo. Cuando fundé el Madí le encargué un collage para nuestro logotipo. Le pedí específicamente que tomara una foto frente al Obelisco, donde había una publicidad de los relojes Movado. Me interesaba la eme de ese cartel, que se iluminaba con gas neón, porque yo en ese momento estaba haciendo obra con ese material." I would like to thank Max Pérez Fallik, curator of the Museo Kosice in Buenos Aires, for his help.

15 I would like to thank the Spanish photographer Leonor Martínez Baroja, Anatole Saderman's assistant, for all the fruitful time we were able to spend together, and for sharing her memories with me.

16 In the original: "Creo que su retrato al aire libre tendría que ser más encontrado que buscado; y desde luego sin retoques. Más a lo 'como caiga'. En los demás aspectos, como siempre, excelente." Archivo Annemarie Heinrich.

17 In the original: "[…] enfin, abajo el corte también deja de ser favorable. Annemarie, yo no estoy de acuerdo con esta fotografía suya." Archivo Annemarie Heinrich.

18 Speech at the opening of the 1st Exhibition at Galería Picasso, Florida 363, Buenos Aires, 2 September 1953. Translation of the original found in the Archives of Annemarie Heinrich: "Porque La Carpeta de los Diez […] no vino a ser sólo una escuela viva, constructora, de crítica, de opiniones y debates entre distintos cultores de la fotografía; no se redujo a ser un medio más de emulación profesional y perfeccionamiento estético, ni otra manera mejor de levantar el nivel de la producción y la creación de todos y de cada uno mediante el ejercicio activo de la crítica, el estímulo mutuo a la autocrítica, el acicate a la superación individual por la influencia y la educación colectivas. La Carpeta de los Diez nos ha hecho gustar, por sobre todo, las gratas experiencias del trabajo en común, del intercambio y del apoyo recíprocos […]."

19 I am grateful to Alejandro Saderman for sharing his family memories with me.

20 The Grupo Tartagal included the Austrian painter Gertrudis Chale and the Argentinian artists Raúl Brié, Héctor Bernabó and Luis Preti.

21 Paris, for example, foregrounded the work of Catalan artists who settled there at the turn of the 20th century, demanding traditional Spanish artworks – a far cry from what the artists wanted to do spontaneously. See Karp Lugo 2014.

22 In the original: "A la hora de decidir, dadas las circunstancias, dónde mejor pudiera rehacer mi vida trasla catástrofe, procuré encaminarme hacia Buenos Aires, ciudad que conocía ya y en la que podía contar con algunos amigos […]. Para mí no fue arduo en exceso, aunque tampoco fácil, obtener entrada y residencia allí, gracias a las previas vinculaciones personales que en la ocasión me allanaron los trámites burocráticos". Quoted in Wechsler 2011, 190.

References

Ayala, Francisco. *Memorias y olvido*. Alianza, 1982.

Altamirano, Carlos, and Beatriz Sarlo. "La Argentina del Centenario: campo intelectual, vida literaria y temas ideológicos." *Ensayos argentinos: De Sarmiento a la vanguardia*, by Carlos Altamirano and Beatriz Sarlo, Ariel, 1997, pp. 161–199.

Baldasarre, María Isabel. "Terreno de debate y mercado para el arte español contemporáneo: Buenos Aires en los inicios del siglo XX." *La memoria compartida: España y la Argentina en la construcción de un imaginario cultural (1898–1950)*, edited by Yayo Aznar and Diana B. Wechsler, Paidós, 2005, pp. 109–132.

Baldasarre, María Isabel. *Los dueños del arte: coleccionismo y consumo cultural en Buenos Aires*. Edhasa, 2006.

Baldasarre, María Isabel. "La otra inmigración. Buenos Aires y el mercado del arte italiano en los comienzos del siglo XX." *Entrepasados: Revista de historia, Buenos Aires*, year XVIII, no. 33, 2008, pp. 9–29.

Baldasarre, María Isabel and Silvia Dolinko, editors. *Travesías de la imagen. Historias de las artes visuales en la Argentina*. CAIA-Eduntref, 2011.

Berjman, Sonia. *La Victoria de los jardines*. Papers Editores, 2007

Bertúa, Paula. "Devenires de una artista migrante: el destino argentino de Grete Stern." *IAHMM Revista de Historia Bonaerense*, year XXIII, no. 46, 2017, pp. 6–14.

Blancpain, Jean-Pierre. *Les Européens en Argentine: immigration de masse et destins individuels, 1850–1950*. L'Harmattan, 2011.

Borghini, Sandro, et al., editors. *1930-1950, arquitectura moderna en Buenos Aires*. Nobuko, Buenos Aires, 2012.

Caparrós, Martín. *Larga distancia*. Malpaso Ediciones, 2017.

Comisión Nacional del Censo and Alberto B. Martínez, editors. *Tercer censo nacional levantado el 1 de junio de 1914: Ordenado por la ley 9108*. Talleres gráficos de L.J. Rosso y Cía, 1916.

Coppola, Horacio. *Imagema: Antología Fotográfica 1927–1994*. Fondo Nacional de las Artes, 1994.

de Rueda, María de los Ángeles. "Arte político y cultura visual en Argentina: Clément Moreau y la gráfica de la Alemania Libre." *II Jornadas de Historia del Arte Argentino*, 2004, http://hdl.handle.net/10915/39671. Accessed 15 May 2019.

Devoto, Fernando. *Historia de la Inmigración en la Argentina*. Editorial Sudamericana, 2003.

Fernández García, Ana María. *Arte y emigración: La pintura española en Buenos Aires, 1880–1930*. Universidad de Oviedo, 1997.

Forsé, Michel. "Les réseaux de sociabilité: un état des lieux." *L'Année sociologique (1940/1948–)*, vol. 41, 1991, pp. 247–264.

Friedmann, Germán C. "La cultura en el exilio alemán antinazi. El *Freie Deutsche Bühne* de Buenos Aires, 1940–1948." *Anuario IEHS*, vol. 24, 2009, pp. 69–87.

Friedmann, Germán C. *Alemanes antinazis en la Argentina*. Siglo Veintiuno editores, 2010.

González Lebrero, Rodolfo, et al., editors. *Estado y sociedad en el largo siglo XX: Argentina, 1880–2000*. Editorial Biblos, 2011.

Gorelik, Adrián. "Buenos Aires europea? Mutaciones de una identificación controvertida." *Miradas sobre Buenos Aires: Historia cultural y crítica urbana*, by Adrián Gorelik, Siglo veintiuno editores Argentina, 2004.

Grete Stern: Obra fotográfica en la Argentina, exh. cat. Museo de Arte Hispanoamericano Isaac Fernández Blanco, Buenos Aires, 1995.

Gutiérrez Viñuales, Rodrigo. *Fernando Fader: Obra y pensamiento de un pintor argentino*. Instituto de América-CEDODAL, 1998.

Karp Lugo, Laura. *Au-delà des Pyrénées: les artistes catalans à Paris au tournant du XXᵉ siècle*. PhD thesis, Université Paris 1 Panthéon-Sorbonne, 2014. (Forthcoming publication).

Karp Lugo, Laura. "L'art espagnol de l'Europe à l'Argentine: mobilités Nord-Sud, transferts et réceptions (1890–1920). " *Artl@s Bulletin*, vol. 5, no. 1, article 4, pp. 38–49. Online since 13 June 2016, http://docs.lib.purdue.edu/artlas/vol5/iss1/4.

Karp Lugo, Laura. Interview with Alicia Sanguinetti. (Studio Annemarie Heinrich, Buenos Aires, 2018).

Lanuza, José Luis. *Pequeña historia de la calle Florida*. Cuadernos de Buenos Aires, V. Municipalidad de la Ciudad de Buenos Aires, 1947.

Malosetti Costa, Laura. *Los primeros modernos: Arte y sociedad en Buenos Aires a fines del siglo XIX*. Fondo de Cultura Económica, 2001.

Malosetti Costa, Laura. "Arte, humor y política de un gallego en Buenos Aires: José María Cao Luaces." *Anuario del Centro de Estudios Gallegos*. Universidad de la República, 2004, pp. 143–164.

Malosetti Costa, Laura. "Los 'gallegos,' el arte y el poder de la risa. El papel de los inmigrantes españoles en la historia de la caricatura política en Buenos Aires (1880–1910)." *La memoria compartida: España y la Argentina en la construcción de un imaginario cultural (1898–1950)*, edited by Yayo Aznar and Diana B. Wechsler, Paidós, 2005, pp. 245–270.

Marcoci, Roxana. "Photographer Against the Grain: Through the Lens of Grete Stern." *From Bauhaus to Buenos Aires: Grete Stern and Horacio Coppola*, edited by Roxana Marcoci and Sarah Hermanson Meister, exh. cat. The Museum of Modern Art, New York, 2015, pp. 21–36.

Meo Laos, Verónica Gabriela. *Vanguardia y renovación estética: Asociación Amigos del Arte (1924–1942)*. Ediciones CICCUS, 2007.

Nouss, Alexis. *La Condition de l'Exilé*. Éditions de la Maison des sciences de l'homme, 2015.

Palomar, Francisco A. *Primeros salones de arte en Buenos Aires*. Municipalidad de la Ciudad de Buenos Aires, 1972.

Pestarino, Julieta. *La mirada antropológica en la imagen fotográfica. El caso de la Sociedad Fotográfica Argentina de Aficionados*. Master thesis, Universidad de Buenos Aires supervised by Carmen Guarini, n.d.

Pratt, Mary Louise. "Arts of the Contact Zone." *Profession*, 1991, pp. 33–40.

Príamo, Luis. "La obra de Grete Stern en la Argentina." *Grete Stern: Obra fotográfica en la Argentina*, exh. cat. Museo de Arte Hispanoamericano Isaac Fernández Blanco, Buenos Aires, 1995.

Rinaldini, J. "Notas. Crítica de Arte. Experiencia de una exposición de arte." *Sur*, no. 22, July 1936, pp. 92–94.

Romero Brest, Julio. "Fotografías de Horacio Coppola y Grete Stern." *Sur*, no. 13, October 1935, pp. 91–102.

Saderman, Anatole. *Secretos del jardín*. Vasari, 2009.

Saunders, Doug. *Arrival City: How the Largest Migration in History is Reshaping Our World*. Pantheon Books, 2010.

Tell, Verónica. "Sitios de cruce: lo público y lo privado en imágenes y colecciones fotográficas de fines del siglo XIX." *Travesías de la imagen. Historias de las artes visuales en la Argentina*, edited by María Isabel Baldasarre and Silvia Dolinko, CAIA-Eduntref, 2011, pp. 209–233.

Wechsler, Diana B, editor. *Desde la otra vereda: Momentos en el debate por un arte moderno en la Argentina (1880-1960)*. Ediciones del Jilguero, 1998.

Wechsler, Diana B. *Estrategias de la mirada: Annemarie Heinrich, inédita*. Universidad Nacional de Tres de Febrero, 2015.

Wechsler, Diana B., and Yayo Aznar, editors. *La memoria compartida: España y la Argentina en la construcción de un imaginario cultural (1898-1950)*. Paidós, 2005.

Wechsler, Diana B. "¡No pasarán! Formas de resistencia cultural de los artistas republicanos españoles exiliados en Buenos Aires." *El exilio republicano español en México y Argentina: historia cultural, instituciones literarias, medios*, edited by Andrea Pagni, Iberoamericana: Vervuert, 2011, pp. 189–208.

A Great Anti-Hero of Modern Art History

Juan Aebi in Buenos Aires

Laura Bohnenblust

This article focuses on the network the Swiss artist Hans Aebi – or Juan Aebi, as he called himself in Spanish – developed in the 'arrival city' of Buenos Aires in the middle of the 20th century. A photograph of the opening of the Grupo de Artistas Modernos de la Argentina's (GAMA's) exhibition of June 1952 (fig.1) serves as a starting point for analysing Aebi's position within the already existing structures of the local art scene. When the photograph was taken, Aebi was 28 years old. He had arrived in the port city about three years earlier, in December 1948, trying to make a name for himself as an artist. In contrast to that of most immigrant artists of that period, Aebi's emigration was not directly war-related. The exact reasons for his departure are unclear. What is almost certain, however, is that those reasons were of a private nature and probably entailed an escape from certain social circumstances and obligations in his home town (Kieser 2018).

Fig. 1: *Grupo de Artistas Modernos de la Argentina (GAMA),* June 1952, Galería Viau, Buenos Aires. F.l.t.r.: Alfredo Hlito, Claudio Girola, Sarah Grilo, Miguel Ocampo, Tomás Maldonado, Hans Aebi, Enio Iommi, Aldo Pellegrini (*Jóvenes y Modernos de los años 50: En diálogo con la colección Ignacio Pirovano* 2012, 21).

Aebis' oeuvre cannot be categorised as belonging to one particular stylistic direction. In different periods he worked both figuratively and abstractly, produced oil or acrylic paintings, aquarelles, drawings and serigraphs as well as wall paintings. Nowadays, his name has almost been forgotten, in both Argentina and Switzerland. As the exhibition photograph proves, however, he played an active part in the modern art scene of 20th-century Buenos Aires. This and other material in the historical archive in the Museo de Arte Moderno de Buenos Aires (MAMBA), in the Swiss Art Archives in Zurich as well as in his private estate detail his career in Argentina. Based on correspondence and documents including journal articles, invitation cards and exhibition catalogues, in the following I will examine Aebi's professional network, his collaborations and the reception his work received, as well as the possibilities and difficulties he faced when connecting with the Argentinian art scene. Apart from Aebi's successful integration into 1950s' artist circles in Buenos Aires, he never really carved out a career and his position in the art world was not considered important enough to affect the history of modern art in any significant way. After his death nobody was interested in his work. For more than 30 years, his widow Renate Kieser kept a large number of his paintings and all his belongings in a rented basement space in the Swiss shoe factory Bally, where Aebi had been employed as a print worker after his return to Switzerland in 1963 and until his death in 1985 (ibid.).

Juan Aebi's life as an artist can be summed up as that of an anti-hero.[1] One might ask why an investigation of his oeuvre is worth pursuing. I argue that a story about failure such as Aebi's can provide fertile ground for discussing the parameters of the art world, its specific localisation – in this case in the urban space of Buenos Aires – as well as its global connectivities and dependencies. Rather than evaluating Aebi's work or mining it for talent, this article examines the mechanisms of inclusion and exclusion within the art scene of Buenos Aires in order to expand and revise the history of modern art, and to critically question the processes of modern art historiography.

In her outstanding article, "When Greatness is a Box of Wheaties", the art historian Carol Duncan (1975) poses crucial questions about the notion of artistic quality and value and the canonisation of 'great artists'. Although Duncan's critique is situated in 1970s' feminist art theory, it is still relevant today and constitutes an important reference when it comes to an artist who cannot be assigned to the canon of modern art and who has never been described as 'great' – even if, or precisely because, he was male. In her article Duncan criticises the way we often fail to understand how quality or genius is attributed, and states that such attributions are always "conditioned by historical or educational experience" (1993, 122). Moreover, she interrogates "the authority of those notions of achievement" and argues that

criteria of value originate from an outdated, established and conservative art historiography which is based on patriarchal structures (ibid., 123).

Processes of Inclusion: Group Exhibitions and the Biennial

Instead of trying to identify 'greatness', another approach could consist of exploring the extent to which migrant artists were incorporated into already existing cultural structures in their respective arrival cities. What were the strategies and procedures used to gain a foothold, to finance one's life and to gain access to the art scene? Which people and institutions played an active role in the processes of artist integration?

Before migrating to Argentina, Aebi studied at the Kunstgewerbeschule in Basel and at the Académie de la Grande Chaumière in the Montparnasse neighbourhood of Paris, where he might have already come into contact with Argentinian artists who studied there, too.[2] His emigration to Argentina in December 1948 must have happened relatively abruptly and without his announcing it to many of his friends.[3] The first evidence of his preparations to leave Switzerland can be found in Aebi's correspondence with Pierre Jaquillard, a Swiss diplomat and art historian who had formerly worked as cultural attaché of the Swiss Embassy in Buenos Aires. In a letter to Aebi in June 1948 Jaquillard disclosed the address of the Bureau argentine d'immigration and provided a first link to the art scene in Buenos Aires by mentioning the name of the artist Juan Batlle Planas: "un peintre abstracto-surrealiste de Buenos Aires […] fort sympatique".[4] A few months after Aebi's arrival Jaquillard forwarded to him the address of Señor F.R. Torralba, secretary of the Editorial Atlántida.[5]

The first evidence that Aebi seemed to be gradually gaining a foothold in the art scene of Buenos Aires can be found in an exhibition brochure for the well-known Galería Van Riel,[6] most probably from October 1949, where – according to the exhibition catalogue – Aebi showed two of his paintings.[7] Galería Van Riel ran an exhibition programme called *Consorcio de Artistas* (Artists' Consortium); this is of particular interest because, as the brochure's introduction outlines, it was dedicated specifically to immigrant artists:

> Based on their own countries' cultures, these artists strive to become involved with their new home by offering up their expertise and artistic efforts. They will always be fighting for the great goals of art, which are the same all over the world. Such a

worthwhile and honest expression of art can only be constructive. The artists united in the above-mentioned consortium will always strive in that sense – by their spirit and in their art.[8]

In fact, this support programme for immigrant artists must have had a very positive effect on Aebi's further integration. The same building which housed the Galería Van Riel also accommodated the Instituto de Arte Moderno (IAM), which operated from 1949 until 1952.[9] This privately run institution was dedicated to all kinds of modern art, ranging from painting to dance and theatre. Its programme focused on international trends. Thus, the *Arte abstracto: Del arte figurativo al arte abstracto* exhibition, organised by the Belgian art critic Léon Degand in 1949, featured works by Wassily Kandinsky, Sophie Taeuber-Arp, Sonia and Robert Delaunay and Georges Vantongerloo, exhibited for the first time in Buenos Aires.

Under the patronage of the architect and patron Marcelo de Ridder, it was this institution that planned Argentinian participation in the first Biennial in São Paulo in 1951. Juan Aebi's integration into the art scene of Buenos Aires seemed to have been so successful that he was selected along with 32 other artists to represent Argentina in the biggest international exhibition in Latin America (fig. 2).[10] The fact that Aebi was actually Swiss and not Argentinian does not appear to have played a role in the selection.

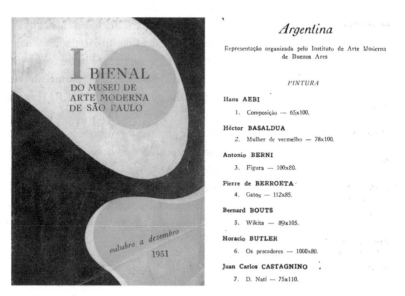

Fig. 2: Cover of the *I. Bienal do Museu de arte moderna de São Paulo*, and a part of the list of Argentina's participation, 1951, p. 191 (Arquivo Histórico Wanda Svevo / Fundação Bienal de São Paulo).

Laura Bohnenblust

However, luck was not on Aebi's side, as can be read in a letter from Pierre Jaquillard: "I hope that you will be able to do the planned exhibitions; I'm very sorry that your participation in São Paulo was not possible, that's very sad [...]."[11]Socio-political adversities under Perón and financial problems prevented the Instituto de Arte Moderno from sending the works to São Paulo, and Argentina was consequently not represented at the first Biennial in Brazil (García 2011, 94ff.). The second edition of the Biennial's exhibition catalogue no longer lists Argentina.[12] What today is seen as a significant milestone in an artist's career – the presentation of one's work at an international biennial – Juan Aebi could have achieved within three years of migrating to Buenos Aires. Due to organisational problems, however, this never translated into reality.

Nevertheless, in April 1952 Aebi had his first solo exhibition in Galería Van Riel's *Sala V.* At this point in time, his work was characterised by paintings which, although composed in an abstract way, allude to figurative elements. A large number of his artworks show, for example, surrealistic-looking imaginary landscapes or figures which emerge from an abstract segmentation of coloured shapes. The specific use of distinct colour contrasts gives the paintings a spatial depth and must be understood as an essential element of the compositions.

The Argentinian art critic and poet Aldo Pellegrini wrote the text in the exhibition brochure, describing Aebi's work as "imaginación libre [free imagination]" (Aebi 1952, n.p.). Pellegrini, who introduced Surrealism to Argentina in the 1920s, was a driving force in the artistic scene of Buenos Aires in the middle of the 20th century. The art historian María Amalia García argues convincingly that Pellegrini's approach to Surrealism and Concrete Art shows both positions as much more closely related than has been described in the historiography of modern art: "Pellegrini suggested new interpretations outside the canon of modern art acting as a great conciliator of those apparently irreconcilable opposites" (García 2017, 11). Pellegrini's interpretation of Aebi's work is therefore especially interesting to read, because he saw aspects of Surrealism and Concrete Art united in his art (Aebi 1952, n.p.).

Juan Aebi and Aldo Pellegrini must have been in close contact, since Aebi's papers contain the programme for Pellegrini's courses on Surrealism, and a letter from Aebi's mother testifies that during his trip to Europe Pellegrini visited Aebi's parents as well as Max Huggler, then director of the Art Museum, in Bern.[13]

It was also Aldo Pellegrini who founded the Grupo de Artistas Modernos de la Argentina (GAMA) and who organised its first exhibition at the Galería Viau in June 1952 (fig. 1). Pellegrini described the group's configuration as an amalgamation of two tendencies in contemporary art: concrete artists and independent artists with a poetic approach.[14] From the 1940s on, concrete art

had become very prevalent in Buenos Aires. Characteristic of this art movement dedicated to geometric abstraction was a break with figurative representation and in some cases experimentation with shaped canvases.[15] During the 1940s, a variety of associations and subgroups were writing manifestos and publishing magazines that reflected their political ideologies. In 1944, together with other artists, Tomás Maldonado, Lidy Prati, Alfredo Hlito and Enio Iommi published the first and only edition of one such magazine, *Arturo: Revista de Artes Abstractas*. This constitutes an important event in Argentinian art history (cf. García et al. 2018; García 2018, 76). Interestingly, concrete artists from Switzerland served as vital points of reference for modern art in Latin America – of special note here was the active involvement of Max Bill in the Argentinian and Brazilian artistic circuits (García 2011).

In the Grupo de Artistas Modernos de la Argentina (GAMA)'s exhibition of 1952 the concrete art movement was represented by Maldonado, Prati, Hlito, Iommi and Claudio Girola. The so-called "independent artists" – Hans Aebi, José Antonio Fernández-Muro, Sarah Grilo and Miguel Ocampo – were dedicated to abstract experimentation vis-à-vis a "poetic or emotional" approach (Grupo de Artistas Modernos de la Argentina 1952, n.p.). Just like in his solo show, Aebi's works were positioned at the threshold between figuration and abstraction. The exhibition catalogue contains an introduction by Pellegrini[16] and a double page for each artist with a brief biographical text, records of some works and a portrait. In Aebi's case, he is depicted seated in front of his own paintings (fig. 3): four aquarelles can be identified in the background. The two larger ones in vertical format show surrealistic appearing figures, composed of abstract fields that cross or adjoin or are divided into each other. The two smaller non-representational works combine an array of coloured shapes intertwined in perspective. The accompanying biography in the exhibition catalogue emphasises Aebi's education in Paris and in Basel with Walter Bodmer (1903–1973), an abstract artist, who represented Switzerland at the first Biennial in São Paulo in 1951.

The Argentinian art magazine *Ver y Estimar*, edited by the influential Argentinian art critic Jorge Romero Brest, dedicated an article to GAMA's first exhibition.[17] Blanca Stábile, who was an art historian and a student of Romero Brest at the time, describes how abstraction and geometric forms invade painting and sculpture, displacing representations of objective reality (Stábile 1952, 106–117). Discussing Aebi's work, Stábile emphasised the connection between approaches of free imagination and geometric analysis, just as Pellegrini did (ibid., 108). The illustrations in *Ver y Estimar*'s 11-page report feature works by Alfredo Hlitos, Enio Iommi, Tomas Maldonado and Miguel Ocampo, artists who belonged to the concrete group. The magazine *Nueva Visión*, which was founded by group

Laura Bohnenblust

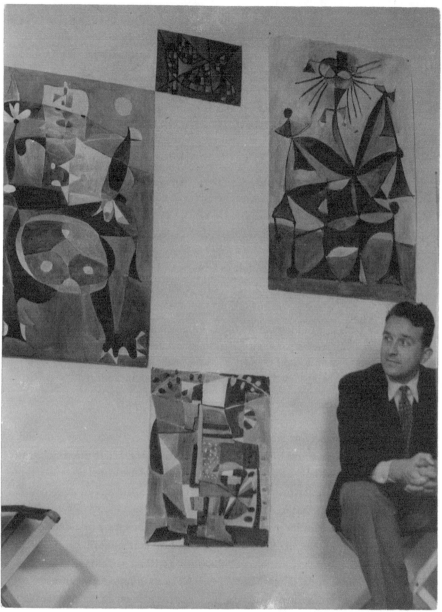

Aquarelle 1951-52 - in meinem Besitz

Fig. 3: Hans Aebi in the *Grupo de Artistas Modernos de la Argentina*, 1952
(Schweizerisches Kunstarchiv SIK–ISEA, Zurich).

A Great Anti-Hero of Modern Art History: Juan Aebi in Buenos Aires
61

member Tomás Maldonado in 1951, also reported on the exhibition and – as Maldonado himself wrote the text – praised it exceedingly. Individual artistic positions, however, are not discussed in detail.[18] In one photograph a painting by Aebi is visible, but here, too, the focus is clearly on the geometric-abstract works of the other artists.

Mechanisms of Exclusion: Neglecting Figurative Artists

During his first years in Buenos Aires, Juan Aebi integrated well into the local art scene, relying on already-existing venues and collaborating with different protagonists. However, when it came to presenting 'Argentinian art' abroad, Aebi's role became subject to question. In 1953, GAMA held two international exhibitions: at the Museu de Arte Moderna do Rio de Janeiro in August and at the Stedelijk Museum in Amsterdam in October, with a show entitled *acht argentijnse abstracten*. Aebi was not represented in either exhibition. As a letter in Aebi's private estate, dated September 1953, proves, he was no longer part of the group:

> What I don't quite understand is what you mean by writing that you were kicked out from the association. From which artists' association? Do you mean those petty opportunists who imagine being kissed by the muse and walking in the footsteps of Gris and Klee?[19]

What were the reasons for Aebi's expulsion and subsequent exclusion? How did these exclusion mechanisms function and how were they related to micropolitical power hierarchies within the art scene? According to María Amalia García, the exhibitions in Brazil and Amsterdam were "significant for the consecration of the development of abstraction in Argentina" (2017, 12). As documents in the archive of the Stedelijk Museum prove, these travelling exhibitions were first developed for Amsterdam. Jan van As, director of the Dutch information office for Latin America in Buenos Aires, initiated contact in July 1952, just one month after GAMA's exhibition opened in Buenos Aires.[20] A few months later, the director of the Stedelijk Museum, Willem Sandberg, wrote to the influential Argentinian art critic Jorge Romero Brest and asked him for his expert opinion on the Grupo de Artistas Modernos de la Argentina.[21]

Romero Brest, a member of the International Association of Art Critics and a juror of the first São Paulo Biennial, answered as follows (fig. 4):

Laura Bohnenblust

argentijn

JORGE ROMERO BREST

VICEPRESIDENTE DE LA ASSOCIATION INTERNATIONALE DES CRITIQUES D'ART
PROFESOR DE LA UNIVERSIDAD DE MONTEVIDEO Y DE LOS CURSOS DE HISTORIA DEL ARTE
DE BUENOS AIRES
DIRECTOR DE LA REVISTA "VER Y ESTIMAR"

Buenos Ayres, le 25 mars 1953

M. W..Sandberg
Amsterdam.

Cher ami,

Je viens d'arriver à Buenos Ayres pour faire front,
comme toujours quand on voyage, à beaucoup de problemes et de
situations. Malgré ça, je m'occupe de votre proyect d'exposi-
tion de quelques peintres modernes d'ici.

Et bien, j'ai trouvé une exposition presque entière-
ment faîte, les tableaux deja choisis et près pour l'embalage,
avec la participation de quelques peintres que je ne crois pas
interessants, ni vous même. C'est pour ça que je vous propose
deux solutions:

1) Que l'exposition soi faîte avec tous les peintres
choisis, sans intervention de moi;

2) Que l'exposition soi organisée pour moi. Dans ce
ca, je vous demanderai d'écrire à M. Van Has, en le dissant
que les peintres choisis pour vous sont les suivants, en rai-
son de qu'ils sont non-figuratif: Maldonado, Hlito, Prati,
Fernández Muro, Ghilo, Ocampo, Testa y Magariños. Je crois
que de cette facon on pourrai encore organiser bien l'exposi-
tion sans froisel les exclus.

Vous savez, cher ami, que vous pouves compter sur moi.
J'espère instrutions de vous pour commencer à travailler. Ne
oubliez pas de me dire à quelles epoque de l'anneé vous voulez
faire l'exposition.

Croyez à mes sentiments les plus devouées

CALLAO 555 BUENOS AIRES

Fig. 4: Letter from Jorge Romero Brest (Buenos Aires) to Willem Sandberg (Amsterdam),
25 March 1953 (Unpublished correspondence, Archiv Stedelijk Museum Amsterdam).

I found an exhibition almost entirely made, the paintings already chosen and ready for packaging, with the participation of some painters that I do not think are interesting, nor would you.

That's why I propose two solutions:

1. That the exhibition will be done with the already chosen painters, without any intervention on my part.

2. That the exhibition will be organised by me. In this case, I will ask you to write to Mr. Van Has [sic], saying that the painters chosen by you are the following, because they are non-figurative: Maldonado, Hlito, Prati, Fernández Muro, Grilo, Ocampo, Testa y Magariños. I believe that in this way we can still organise the exhibition well without offending the excluded […].[22]

Romero Brest, who – as García points out (2011, 98f.) – claimed to define which line of modern art resonated with the contemporary world, thus called on Sandberg to present the selection of artists as his own, on the grounds that only non-figurative artists were to be featured. Aebi, whose artistic approach was dedicated to abstraction but also infused with figurative elements, was consequently excluded.[23] In the preface to the exhibition catalogue *acht argentijnse abstracten* (fig. 5), Romero Brest argues:

Among all of them, the ones I present with fervour stand out, not only for the quality of their works, not only for the combativeness they demonstrate, but also for their determination to obtain forms that configure a *universal language*. This empowerment connects them with the most progressive movements in the Occident and justifies the exhibition.[24]

'Universal language' clearly meant non-figurative abstraction. As Andrea Giunta has stated in various publications (2001; 2005), Jorge Romero Brest was probably the most powerful advocate of Argentinian art in an international context. He was aware of how to achieve international recognition and obtain support, acting according to unwritten rules defined by hegemonial art centres such as New York, which themselves were guided by political interests in connection with the Cold War. Giunta's arguments concerning the "Internationalization of Argentinian Art"

Laura Bohnenblust

in the 1960s (2005, 145–161) can equally be applied to Romero Brest's intervention at the beginning of the 1950s – at least in connection with the Grupo de Artistas Modernos de Argentina.

Tomás Maldonado's report in *Nueva Visión* No. 5 about the exhibitions in Rio de Janeiro and Amsterdam makes the directional change to abstraction clear: "[t]his international recognition, the significance of which we certainly do not intend to exaggerate, proves the maturity reached in our country by the most innovative tendencies of contemporary art, in particular by the abstract and concrete ones".[25] Aebi with his abstract-figurative works simply did not fit in. In addition, as number nine of the *acht argentijnse abstracten* (eight abstract Argentinians, fig.5)[26] the Swiss artist would have been a questionable representative of Argentina's "exportable proposal" (García 2017).

Fig. 5: Cover of the *acht argentijnse abstracten*, 1953 (Archive Stedelijk Museum Amsterdam).

Canon Formation in Buenos Aires

Aebi's exclusion can be read as paradigmatic of the canonisation processes of modern art historiography. As 20th-century art history shows, exhibitions in established institutions were crucial for canon formations.[27] In their investigation of the canonisation processes of modern art, Miriam Oesterreich and Kristian Handberg convincingly describe the global dominance of MoMA founding director Alfred Barr Jr.'s well-known diagram of the *Cubism and Abstract Art* exhibition at the Museum of Modern Art (MoMA) in 1936 New York (2018, 2ff.). The diagram shows various currents in modern art which culminate in only two distinct categories: non-geometrical abstract art and geometrical abstract art (ibid.). With his selection of Argentinian artists, Jorge Romero Brest refers, though not literally, to this diagram: the "universal language"[28] of each selected artist fits into either one category or the other. Romero Brest applied the ideology of development in modern art – evolving from figuration to abstraction – to the production of art in Argentina.[29] He thereby tried to prove that artists abroad could legitimately be

positioned within "universal"[30] advancements and evolutions of modern art. In this exclusionary 'either/or logic' of modern canon formation there was no space for positions such as those described by Pellegrini as "free imagination" (1952, n.p.), or for artists such as Juan Aebi.

According to Oesterreich and Handberg, the canonisation process of "Western" modernism in the 20th century was a European and North American phenomenon and did not reflect Latin American positions (2018, 1–20). The impact of the *acht argentijnse abstracten* in Amsterdam was indeed limited and the attempt to show the exhibition in other European museums proved to be unsuccessful, the reasoning being that the pictures were uninteresting because they did not convey 'Argentinian' peculiarity.[31] For the canonisation of abstract positions within the Argentinian art scene, however, the exhibition abroad was decisive. Andrea Giunta posits that this process of internationally-oriented national canon formation was exemplified by the *Argentina en el mundo* (Argentina in the world) exhibition, curated by Romero Brest in 1965, which featured precisely those stances that had received recognition abroad (2005, 145–161).

Ironically, current exhibitions which aim to break down the "Western canon" in the context of global art history often feature artists who had entered the so-called "minor canon" of national art histories (Oesterreich/Handberg 2018, 19) years before, due to participating in international exhibitions. In this respect, artists like Juan Aebi have missed out twice. They have been unable to find a place in either of the two "worlds".[32]

After Aebi's exclusion from the Grupo de Artistas Modernos de la Argentina, he continued to paint and create lithographs, and he still featured in a few exhibitions of the so-called *arte nuevo*, also initiated by Aldo Pellegrini. However, he was never internationally recognised and never had a breakthrough. With the political shifts in Argentina in the mid-1950s – the overthrow of President Juan Perón by the self-proclaimed *Revolución Libertadora* – major changes in the cultural landscape became apparent. In 1955, Jorge Romero Brest was appointed director of the Museo de Bellas Artes (the public museum for fine arts in Buenos Aires), which made him even more influential in the Argentinian art scene. From 1961 onwards he was in charge of the newly-founded Centro de Artes Visuales at the Torcuato di Tella Institute, which functioned as the leading institution of contemporary art in Argentina.[33] Tomás Maldonado emigrated to Europe in 1955 and became a lecturer for Max Bill and later director at the Hochschule für Gestaltung in Ulm. The cultural-political changes in Argentina were accompanied by the establishment of new institutions, such as the Museo de Arte Moderno which was founded in 1956 on the initiative of Rafael Squirru. Although Squirru had different curatorial views from Romero Brest and included the works of figurative artists in his first

exhibition, *La Primera Exposición Flotante de Cincuenta Pintores Argentinos*,[34] the name Hans or Juan Aebi no longer played a significant role in the art scene of Buenos Aires. As Aebi's financial situation and health grew worse, he returned to Switzerland in 1963 (fig. 6).

Fig. 6: Portrait of Hans / Juan Aebi back in Switzerland, around 1980 (Photo: Renate Kieser).

If, in Duncan's words, "the primary needs of all great artists are fame and prestige" (Duncan 1993, 125), Juan Aebi was undoubtedly never a 'great artist'. But fortunately, the discipline of art history is not limited to discovering only 'great artists' or continuing to entrench old tropes yet more deeply. Because history is always constructed, our discipline may take the liberty of recounting the stories of anti-heroes.

Notes

[1] An anti-hero is defined as "the antithesis of a hero of the old-fashioned kind who was capable of heroic deeds, who was dashing, strong, brave and resourceful. [...] The anti-hero is the man who is given the vocation of failure" ("Antihero"). I am referring here to Katharina Helm et al.'s anthology *Künstlerhelden? Heroisierung und mediale Inszenierung von Malern, Bildhauern und Architekten* (2015), which examines the way hero figures are constructed and how art historical canons emerge. This of course can also be applied to the reverse figure of the anti-hero.

The art historian Viktoria Schmidt-Linsenhoff, for example, has productively reformulated Kris and Kurz's arguments concerning the constructed character of the artist and the cult of genius (Schmidt-Linsenhoff 2004, 191–202).

[2] Founded in 1902 by the Swiss painter Martha Stettler, the Baltic painter Alice Dannenberg and the Spanish painter Claudio Castelucho, the Académie de la Grande Chaumière was one of the best-known art academies in Paris at the beginning of the 20th century.

[3] In a letter from January 1949 a friend wonders about Aebi's return address, because he thought he still lived in Paris. Letter from 'Hermann' to Aebi (unpublished correspondence, Private estate of Juan Aebi/Renate Kieser, 2 January 1949).

[4] Juan Batlle Planas was one of the most important representatives of Surrealism in Argentina. Letter from Jaquillard to Aebi (unpublished correspondence, Private estate of Juan Aebi/Renate Kieser, 22 June 1948).

[5] Editorial Atlántida is a publishing house and one of the biggest magazine publishers and distributors in Argentina, founded in 1912. Letter from Jaquillard to Aebi (unpublished correspondence, Private estate of Juan Aebi/Renate Kieser, 5 March 1949).

[6] Frans van Riel (1879), a painter and printmaker who emigrated from Rome to Argentina in 1910, inaugurated the Galería Van Riel art gallery in 1915. In 1924, the *Asociación Amigos del Arte* began to operate on its premises. It was followed by *Ver y Estimar*, the Instituto de Arte Moderno and the first independent theatre in Buenos Aires.

[7] The exact date of the exhibition is unclear but it must have taken place in 1949. Aebi's work *Avenida de Mayo*, which was shown there, was bought by Father Wildli, who published an article in the magazine *Helvetia* in 1949. Wildli writes that he had recently acquired the work and that it was now hanging in his house: clipped newspaper article (*Helvetia*, Private estate of Juan Aebi/Renate Kieser, 1949).

[8] My translation of "Estos artistas, basándose en la cultura de su país de origen, desean encontrar el contacto con su nueva patria poniendo al servicio de ella su experiencia y sus esfuerzos artísticos. Siempre estarán luchando por los grandes fines del arte, iguales en todo el mundo. Esta expresión del arte dignamente honrada puede ser únicamente constructiva. Los artistas unidos en el consorcio arriba mencionado se esforzarán siempre en ese sentido – por su espíritu y en sus obras": *Consorcio de Artistas*, exh. cat. Galería Van Riel, Buenos Aires, most probably 1949. Private estate of Juan Aebi/Renate Kieser.

[9] For more information about the Instituto de Arte Moderno, see María Amalia García. *El arte abstracto: Intercambios culturales entre Argentina y Brasil*. Siglo veintiuno, 2011, pp. 94–101; María José Herrera. *Cien años de arte argentino*. Biblos, 2014, p. 118.

[10] *I. Bienal do Museu de arte moderna de São Paulo: Catalogo general*, edited by Departamento da 1. Bienal de São Paulo, exh. cat. Biennial, São Paulo, 1951, p. 191.

[11] Letter from Jaquillard to Aebi (unpublished correspondence, Private estate of Juan Aebi/Renate Kieser, 2 February 1952).

[12] *I. Bienal do Museu de arte moderna de São Paulo: Catalogo general*. Second Edition, edited by Departamento da 1. Bienal de São Paulo, exh. cat. Biennial, São Paulo, 1951.

[13] An undated letter from Aebi's mother describes Aldo Pellegrini's visit to Bern and the meeting with Max Huggler (1903–1994), the art historian, professor of art history at the University of Bern (1945–1973) and director of the Kunstmuseum Bern (1944–1965). Letter from 'Mother' Aebi to Aebi (unpublished correspondence, Private estate of Juan Aebi/Renate Kieser, 27 January n.d.).

[14] See also María Amalia García. "Informalism between Surrealism and Concrete Art: Aldo Pellegrini and the Promotion of Modern Art in Buenos Aires during the 1950s." *New Geographies of Abstract Art in Postwar Latin America*, edited by Mariola V. Alvarez and Ana M. Franco, Routledge, 2017, pp. 11–24.

[15] For more information on Concrete Art in Argentina, see García 2011; García 2018.

[16] In his introduction to the exhibition Pellegrini refers to Cubism and how it has undoubtedly led to abstract art as it exists today. Nevertheless, other schools such as Expressionism, Fauvism and especially Surrealism should not be forgotten as "precursors of today's situation" (*Grupo de Artistas Modernos de la Argentina* 1952, n.p.).

[17] The magazine *Ver y Estimar,* published between 1948 and 1955, was led by the influential Argentinian art critic Jorge Romero Brest. According to Andrea Giunta and Laura Malosetti Costa, the magazine served as a platform for international exchange and debates on new aesthetic values, negotiating problems and ideas of abstraction, social realism, modern art museums, prizes and international biennials, Argentinian and Latin American art (Giunta/Malosetti Costa 2005).

[18] The magazine *Nueva Visión* was conceived as a discussion and distribution platform for concrete art, focusing on Latin American cultural urban centres such as Buenos Aires, São Paulo and Rio de Janeiro, as well as on art events in European cities such as Zurich, Milan and Paris (García 2018; García 2017). For more information about Tomás Maldonado, see Gradowczyk 2008.

[19] "Wo ich nicht ganz steige, das ist an jener Stelle, wo Du schreibst, man habe Dich aus der Verbindung ausgestossen. Aus welcher Künstlerverbindung? Meinst Du etwa jene läppischen Opportunisten, welche sich einbilden, von der Muse geküsst und in den Stapfen des Gris und des Klee zu wandeln?" Letter from Wissmann to Aebi (unpublished correspondence, Private estate of Juan Aebi/Renate Kieser, 29 September 1953), translated by Laura Bohnenblust.

[20] Letter from Dr. Jan van As (Oficina de Información Holandesa para América Latina = Dutch Information Office for Latin America) to. H.F. Eschauzier (Hoofd Directie Voorlichting Buitenland, Ministerie van Buitenlandse Zaken = Ministry of Foreign Affairs), Subject: planned exhibition of modern Argentinian art in the Netherlands (unpublished correspondence, Archiv Stedelijk Museum Amsterdam, 31 July 1952).

[21] Letter from Willem Sandberg to Jorge Romero Brest (unpublished correspondence, Archiv Stedelijk Museum Amsterdam, 5 September 1952).

[22] Letter from Jorge Romero Brest to Willem Sandberg (unpublished correspondence, Archiv Stedelijk Museum Amsterdam, 5 September 1952).

[23] In the end, the following artists were listed in the exhibition catalogue: Miguel Ocampo, Alfredo Hlito, Tomas Maldonado, José Antonio Fernández-Muro, Lidy Prati, Sarah Grilo, Rafael Onetto, Clorindo Testa. The sculptors Hlito and Iommi were not represented because the exhibition showed only paintings for

organisational reasons. Onetto and Testa were invited as new exponents, see Sandberg 1953.

24 Romero Brest in Sandberg 1953, n.p.

25 My translation of: "Este reconocimiento internacional, cuya significación, por cierto, no pretendemos exagerar, prueba la madurez alcanzada en nuestro país por las tendencias más renovadoras del arte actual, en particular, por las abstractas y concretas, que son las dominantes en el grupo." (Maldonado 1954, 36).

26 How rigorously the exhibition was planned and coordinated can be seen when examining the catalogue which features the letter as an alliterative symbol referring to the exhibition's title (fig. 5).

27 See for example, *The Canonisation of Modernism: Exhibition Strategies in the 20th and 21st century*, edited by Gregor Langfeld and Tessel Bauduin, special issue of *Journal of Art Historiography*, no. 19, December 2018.

28 Romero Brest in Sandberg 1953, n.p.

29 For a discussion on Romero Brest's understanding of modern art, see Andrea Giunta. "Rewriting Modernism: Jorge Romero Brest and the Legitimation of Argentina Art." *Listen, Here, Now! Argentine Art of the 1960s: Writings of the Avant-Garde*, edited by Inés Katzenstein, The Museum of Modern Art, 2004, 78–92; Silvia Dolinko. "Jorge Romero Brest." *Entre la academia y la crítica: La construcción discursiva y disciplinar de la historia del arte: Argentina – siglo XX*, edited by Sandra M. Szir and María Amalia García, EDUNTREF, 2017, pp. 294–301.

30 Romero Brest in Sandberg 1953, n.p.

31 To demonstrate this line of argument, I paradigmatically quote – and translate – the rejection of Hildebrand Gurlitt (Kunsthalle Düsseldorf): "What we need in Germany, I believe, is not less testimony to the fact that abstract art is gaining ground all over the world, but only the sources and stages of development that were never to be seen in our country." Letter from Hildebrand Gurlitt to Willem Sandberg (unpublished correspondence, Archiv Stedelijk Museum Amsterdam, 16 October 1953).

32 The term chosen refers to the questionable exhibition title *A Tale of Two Worlds: Experimental Latin American Art in Dialogue with the MMK Collection 1940s–1980s*. The exhibition was organised in 2017–2018 as a collaboration between the MAMBA (Museo de Arte Moderno de Buenos Aires) and the MMK (Museum für Moderne Kunst Frankfurt) in the context of the "Museum Global" programme. See the exhibition catalogue: *A Tale of Two Worlds: Experimental Latin American Art in Dialogue with the MMK Collection, 1940s–1980s*, edited by Klaus Gröner et al., exh. cat. MMK Museum für Moderne Kunst Frankfurt and Museo de Arte Moderno de Buenos Aires, 2018.

33 See *Listen, Here, Now! Argentine Art of the 1960s: Writings of the Avant-Garde*, edited by Inés Katzenstein, The Museum of Modern Art, 2004.

34 For the first exhibition of the MAMBA in 1956, see Sophía Dourron. "El Museo de Arte Moderno: 1956–1960: Cuatro años de fantasmagoría." *Revista Materia Artística*, 2015, pp. 151–166; Laura Bohnenblust. "Flottieren und die Grenzen der Ordnungsstruktur: Die exposición flotante des Museo de Arte Moderno de Buenos Aires (1956)." *kritische berichte: Zeitschrift für Kunst- und Kulturwissenschaften*, vol. 2, *Das Museum als Wirkraum*, edited by Anna Minta and Yvonne Schweizer, 2018, pp. 74–84.

References

I. Bienal do Museu de arte moderna de São Paulo: Catálogo general, edited by Departamento da 1. Bienal de São Paulo, exh. cat. Biennial, São Paulo, 1951, http://www.bienal.org.br/publicacoes/4389. Accessed 7 December 2018.

I. Bienal do Museu de arte moderna de São Paulo: Catálogo general. Second edition, edited by Departamento da 1. Bienal de São Paulo, exh. cat. Biennial, São Paulo, 1951, http://www.bienal.org.br/publicacoes/4390. Accessed 7 December 2018.

acht argentijnse abstracten, edited by Willem Sandberg, exh. cat. Stedelijk Museum Amsterdam, Amsterdam, 1953.

Aebi, edited by Aldo Pellegrini, exh. cat. Galería Van Riel, Archivo Histórico Museo de Arte Moderno de Buenos Aires, 1952.

"Antihero." *A Dictionary of Literary Terms and Literary Theory*. Third edition, edited by J.A. Cuddon, Blackwell, 1991, p. 46

Bohnenblust, Laura. "Flottieren und die Grenzen der Ordnungsstruktur: Die exposición flotante des Museo de Arte Moderno de Buenos Aires (1956)." *kritische berichte: Zeitschrift für Kunst- und Kulturwissenschaften*, vol. 2, *Das Museum als Wirkraum*, edited by Anna Minta and Yvonne Schweizer, 2018, pp. 74–84.

Cuddon, J.A., editor. *A Dictionary of Literary Terms and Literary Theory*. Third edition, Blackwell, 1991.

Duncan, Carol. "When Greatness is a Box of Wheaties." *The Aesthetics of Power: Essays in Critical Art History*, edited by Carol Duncan, Cambridge University Press, 1993, pp. 121–132 (first published in *Artforum International*, vol. 14, no. 2, 1975, pp. 60–64).

Dolinko, Silvia. "Jorge Romero Brest." *Entre la academia y la crítica: La construcción discursiva y disciplinar de la historia del arte: Argentina – siglo XX*, edited by Sandra M. Szir and María Amalia García, EDUNTREF, 2017, pp. 294–301.

Dourron, Sofía. "El Museo de Arte Moderno: 1956–1960: Cuatro años de fantasmagoría." *Revista Materia Artística*, 2015, pp. 151–166.

García, María Amalia. *El arte abstracto: Intercambios culturales entre Argentina y Brasil*. Siglo veintiuno, 2011.

García, María Amalia. "Informalism between Surrealism and Concrete Art: Aldo Pellegrini and the Promotion of Modern Art in Buenos Aires during the 1950s." *New Geographies of Abstract Art in Postwar Latin America*, edited by Mariola V. Alvarez and Ana M. Franco, Routledge, 2017, pp. 11–24.

García, María Amalia, et al., editors. *Edición facsimilar de la revista Arturo: Ensayos y traducciones*. Fundación Espigas, 2018.

García, María Amalia. "Between the Climax of Autonomous Language and the Life Crisis of Experience: Concrete Art in South America." *A Tale of Two Worlds: Experimental Latin American Art in Dialogue with the MMK Collection, 1944–1989*, edited by Klaus Gröner et al., exh. cat. MMK Museum für Moderne Kunst Frankfurt and Museo de Arte Moderno de Buenos Aires, 2018, pp. 74–81.

Giunta, Andrea. *Vanguardia, Internacionalismo y Política: Arte argentino en los años sesenta*. Siglo veintiuno, 2001.

Giunta, Andrea. "Rewriting Modernism: Jorge Romero Brest and the Legitimation of Argentina Art." *Listen, Here, Now! Argentine Art of the 1960s: Writings of the Avant-Garde*, edited by Inés Katzenstein, The Museum of Modern Art, 2004, pp. 78–92.

Giunta, Andrea, and Laura Malosetti Costa, editors. *Arte de posguerra: Jorge Romero Brest y la revista Ver y Estimar*. Paidós, 2005.

Giunta, Andrea. "'Argentina in the World': Internationalist Nationalism in the Art of the 1960s." *Images of Power: Iconography, Culture and the State in Latin America*, edited by Jens Andermann and Wiliam Rowe, Berghahn Books, 2005, pp. 145–161.

Gradowczyk, Mario H. *Tomás Maldonado: Un moderno en acción: Ensayos sobre su obra*. EDUNTREF, 2008.

Grupo de Artistas Modernos de la Argentina: Pinturas, esculturas, dibujos, edited by Aldo Pellegrini, exh. cat. Galería Viau, Buenos Aires, 1952 (Schweizerisches Kunstarchiv, SIK-ISEA, Zurich).

Helm, Katharina, et al., editors. *Künstlerhelden? Heroisierung und mediale Inszenierung von Malern, Bildhauern und Architekten*. ad picturam, 2015.

Herrera, María José. *Cien años de arte argentino*. Biblos, 2014.

Jóvenes y Modernos de los años 50: En dialogo con la colección Ignacio Pirovano, edited by Laura Buccellato and María Cristina Rossi exh. cat. Museo de Arte Moderno de Buenos Aires, Asociación Amigos del Museo de Arte Moderno, 2012.

Kieser, Renate. "Personal interview." Conducted by Laura Bohnenblust. Unpublished interview, Schönenwerd, 21 May 2018.

Langfeld, Gregor, and Tessel Bauduin, editors. *The Canonisation of Modernism: Exhibition Strategies in the 20th and 21st Century*, special issue of *Journal of Art Historiography*, no. 19, December 2018.

Maldonado, Tomás. "El Grupo de Artistas Modernos de la Argentina." *Nueva visión: Revista de cultura visual*, nos. 3/4, 1953, p. 26.

Maldonado, Tomás. "Exposiciones del Grupo de Artistas Modernos de la Argentina." *Nueva visión: Revista de cultura visual*, no. 5, 1954, pp. 36–47.

Oesterreich, Miriam, and Kristian Handberg. "Alter-Canons and Alter-Gardes: Formations and Re-Formations of Art-Historical Canons in Contemporary Exhibitions: The Case of Latin American and Eastern European Art." *The Canonisation of Modernism: Exhibition Strategies in the 20th and 21st Century*, edited by Gregor Langfeld and Tessel Bauduin, special issue of *Journal of Art Historiography*, no. 19, December 2018, pp. 1–20.

Saunders, Doug. *Arrival City: How the Largest Migration in History is Reshaping Our World*. Knopf Canada, 2011.

Schmidt-Linsenhoff, Viktoria. "Die Legende vom Künstler: Eine feministische Relektüre." *Wiener Jahrbuch für Kunstgeschichte*, vol. 53, no. 1, 2004, pp. 191–202.

Stábile, Blanca. "Grupo moderno de la Argentina." *Ver y Estimar: Cuadernos de crítica artística*, nos. 29/30, 1952, pp. 106–117 (Fundación Espigas Buenos Aires).

From Dinner Parties to Galleries

The Langhammer-Leyden-Schlesinger Circle in Bombay – 1940s through the 1950s

Margit Franz

Walter and Käthe Langhammer, Rudolf and Albrecht von Leyden and Emanuel Schlesinger were essential in promoting an avant-garde art movement in Bombay: the Progressive Artists' Group. Together with Indian visionaries, these Austrian and German refugees from National Socialism initiated new ways of evaluating, generating and looking at fine art. Besides creating a new audience through the media and sustainability through collecting and other forms of financial help, they consolidated the movement by generating exhibition spaces – from private venues to public galleries. In the following I analyse their contributions to Bombay's art world, arguing that they were catalysts in the development of post-colonial Indian art.[1]

Modern Metropolis Bombay: Merging Europe and Asia

In Bombay colonial modernity met with industrial capitalism: India's first industrial manufacturing boom, cotton production, transformed the important harbour and trade hub on the Arabian Sea into one of the foremost industrial and commercial cities of the British Empire. There was a powerful middle class of skilled workers and a cohort of working-class people growing with a constant influx of migrants from all parts of India.

The innovations in transportation (steamships) and communication (telegraph), the opening of the Suez Canal in 1869 and the consequent rise in shipping accelerated global trade and exchange. Bombay's role as international warehouse opened the way to its "powerful, semi-autonomous place within the imperial hierarchy" (Hunt 2015, 12) with international funds pouring in for infrastructure and investments. Bombay was the only city in India where its commercial elite "had significant stakes in its industry, finance and banking" (Prakash 2003). Local entrepreneurship, in

several cases combined with philanthropy,[2] joined hands with science, innovation and technology to build a spearhead for modern India.

In the interwar period, accelerating international trade, travel and tourism forced advancements in the metropolis. A continuing stream of international experts in industry and commerce as well as visitors to Bombay and the increasing travel opportunities to Europe for an Indian elite changed the social and cultural ambience in Bombay. This was "represented in new hotels and theatres and brought a touch of glamour and new forms of entertainment to the city" (Dwivedi/Mehrotra 2001, 246). Bombay was modern in attitude, and was open to international inputs, exchanges and negotiations. As Sharada Dwivedi and Rahul Mehrotra put it:

> The upper class and the business community of entrepreneurs and managers happily imbibed contemporary trends in western culture to create a *bon vivant* lifestyle, that symbolized gaiety and colour and encompassed western cuisine, dress, ballroom dancing, jazz, cabarets, horse-racing and the cinema. (Dwivedi/Mehrotra 2001, 246)

Modern music like jazz and swing also "echoed the optimism of a new era" (Fernandes 2012, 15) with Indian political independence in sight.

Western music and arts were adjusted, rearranged, interpreted and transformed by Indian artists to create a new spirit. The growing film industry in Bombay also generated employment, opportunities and dreams. After the decline of Calcutta, Bombay had become the cultural capital of British India in the early 20th century. The city offered entertainment and income-generation opportunities for artists, education facilities to improve industrial and crafts production, innovative start-ups and entrepreneurs producing and selling modern consumer goods. Migrants from all of India flocked in, as well as Western people, marketing modern goods and technology, trading or being employed in this modern and hybrid metropolis.

For these reasons Bombay became the "gamut of dualities" (Dwivedi/Mehrotra 2001, 338): crammed workers' settlements contrasting with airy modern Art Deco buildings; Manhattan-like business areas like Nariman Point differing from backyard factories, industrial textile mills and an international port; an educated elite diverging from illiterate migrant workers. National agitators as well as local peer-groups were campaigning for decolonisation and independence, labour rights and better living conditions. Socialist and communist movements were strong; progressive writers' and theatre groups were discussing the shape of a new nation to come.

Margit Franz

The Langhammer-Leyden-Schlesinger Circle: Promoters of modern art in wartime and early post-colonial Bombay

Walter Langhammer as an art teacher, Rudi von Leyden as an art critic and Emanuel Schlesinger as an art collector, along with Käthe Langhammer as an informal art critic, were important supporters of the Progressive Artists' Group (PAG).[3] Together with an informal circle of Indian art connoisseurs, including the manufacturer of picture frames and later gallery owner Kekoo Gandhy, the scientist and art patron Homi Bhabha, the writer Mulk Raj Anand, they supported the young avant-garde artists against the British-dominated artistic mainstream. Other collaborating supporters were: Hermann Goetz, German-born exile responsible for the arts of the Principality of Baroda, and Albrecht von Leyden, as a German emigrant manager for photographic supplies in India. He was a commercial networker, but also an art collector, photographer and amateur painter.

Albrecht Robert (known as Lolly) and Rudolf Reinhold (known as Rudi or Rudy) von Leyden were born into an art-loving, bourgeois German family in Berlin. The German Agfa Company sent Albrecht as its representative to India in 1927. His brother Rudi, a doctor of geology, had to leave Germany due to his communist sentiments after the takeover by the National Socialists in early 1933. Rudi joined his brother in Bombay.[4] When his initial efforts to follow his geological ambitions failed, he started pursuing his artistic inclinations. His efforts met with success. In 1934 Rudi founded the The Hand. Commercial Art Studio Rudolf von Leyden, and remained employed in Indian enterprises for 40 years, becoming an established publicity manager and advertising expert. In 1937 he became the manager of the advertising department of the *Times of India*, the biggest English newspaper company in India. In 1952 he joined Volkart Brothers, Switzerland's leading retailer of colonial goods in India, as publicity manager and in 1957 became a general manager of Voltas, a collaboration between Volkart Brothers and Tata Sons specialising in cooling technology.

He was central in the Bombay art scene from the late 1930s until the 1950s as an art critic for the *Times of India*. "Rudy Von Leyden was perhaps the first ever art critic in Mumbai who was able to influence opinion in favour of modern art with his regular writings in Mumbai newspapers and journals" (Parimoo 1998, 63).

On an ad hoc basis he focused on modern and contemporary Indian art, trying to support the avant-garde movement of the PAG, but also wrote about ancient Indian sculptures. In the late 1970s he reflected on his work and admitted, "When I wrote my reviews it was with a definite bias for the new talents, trying to give them

the benefit of constructive criticism while I just reported on other exhibitions" (Rudi von Leyden, quoted in Dalmia 2001, 62). For Yashodhara Dalmia Leyden pushed Indian art criticism in a "modernist direction", setting scholarly standards and "parameters for reviewing and assessing art" (Dalmia 2001, 231). For Ranjit Hoskote, he used formats of Western modern art criticism to make Indian artists aware of what was internationally intelligible, exposing their reflections to a global art movement (see Hoskote 2018).[5]

Emanuel Schlesinger had already been a devoted art collector in Vienna where he befriended, among others, Oskar Kokoschka. With the insurgence of the Nazi regime in Austria, his shop and Engelmann Huterzeugung hat factory were expropriated, and he made arrangements for his family to leave Vienna for London. In spring 1938 he escaped with the help of a friend via Switzerland to Italy where he managed to board a passenger ship heading out to the East with Shanghai as its final destination. On board he obtained a visa for India with the support of the Jewish Relief Association in Bombay. In internment after the outbreak of World War II, he befriended the Austrian pharmacist Hans Blaskopf from Vienna; together they founded the Indo-Pharma Pharmaceuticals (INDON) pharmaceutical company in Dadar, Bombay. With the rapid economic and financial success of the company he was able to pursue his art collecting activity again and started buying modern Indian paintings. As a distinguished art collector he had the finances to set trends in Bombay with his purchases in favour of the artists of PAG. He built life-long friendships with some of the artists, for example Raza and Husain, and also supported them financially on a temporary basis (see Raza 2010).[6]

Walter Langhammer was an academic painter educated at the Academy of Fine Arts in Vienna. He exhibited his paintings and caricatures in Austria in the 1930s; gave private painting tuition and augmented his income by teaching art at a Viennese grammar school. The married couple Käthe and Walter Langhammer were part of socialist groups as well as art circles of Vienna in the late 1920s and 1930s. Käthe's Jewish origin and their political commitment forced them to leave Austria for Bombay in 1938. Due to contacts with influential and prosperous Parsi circles, Walter Langhammer became the art director of the *Times of India*. Winning the Gold Medal of the Bombay Art Society in 1939, he made an impressive entry into the art world of Bombay. Through his artwork, his art-political activities and his art-related communication skills, disseminating art issues publicly in radio shows, talks and film screenings, he engaged with Bombay's art world until he left India in 1957. He also regularly shared his experiences in small private circles. Every Sunday Rudi and Albrecht von Leyden, Kekoo Gandhy and young local artists such as Raza, Ara, Hebbar and Gaitonde met at Walter and Käthe Langhammer's residence to discuss art and review paintings, of renowned artists and of the

young local painters. Walter Langhammer was an art teacher by education, but had developed his very own style as a painter celebrated and acknowledged by the elite of Bombay. "Langhammer brought into India the Austrian-born Expressionist painter, Kokoschka's style of panoramic landscapes of the great European cities in pure hues" (Parimoo 1991, 74) with the strong colourful strokes of Post-Impressionism and Fauvism according to Rudolf von Leyden (see Leyden n.d.).

Käthe Langhammer (née Urbach) was an art connoisseur, an art critic and an amateur photographer, but historically she has been given the reduced role of socialite and the female caretaker during the weekly meetings at her home. Nevertheless, growing up in one of Red Vienna's leading households, she had experienced a highly progressive political socialisation and had run an underground art salon in Vienna with her father and her husband Walter in the era of Austrofascism.[7]

Art as a means for political upheaval united the Langhammers and the communist student leader Rudi von Leyden ideologically with the young artists of the PAG, but was no hindrance in gaining financial support from Bombay's economic elite. Being privileged due to their white race, their prestigious employment, their high social status and the appreciation they received in the art circles – as artist, art teacher, art critic and art collector – they were able to promote and patronise the young, experimenting penniless artists. According to Ranjit Hoskote the Central Europeans and the young emerging artists maintained a "dialogic relationship" (see Hoskote 2018), whereas Yashodhara Dalmia also recognises some paternalistic features in their relationship with the young artists.[8]

The Progressive Artists' Group: Pushing towards modernity in Bombay

> We came out to fight against two prevalent schools of thought of these days [...] the Royal Academy, which was British-oriented, and the revivalist school in Mumbai, which was not a progressive movement. These two we decided to fight, and we demolished them. The movement to get rid of these influences and to evolve a language that is rooted in our own culture, was a great movement, and our historians have not taken note of [it]. It was important because any great change in a nation's civilization begins in the field of culture. Culture is always ahead of other political and social movements. (M.F. Husain, quoted in Nath 2006, 200)

In 1947, the year of India's independence from colonial rule, the young, often poor but idealistic painters Sayed Haider Raza, Maqbool Fida Husain, Sadanand K. Bakre, Hari Ambadas Gade, Krishnaji Howlaji Ara and Francis Newton Souza formed the Progressive Artists' Group (PAG) in Bombay (see fig.1). They borrowed the name "progressive" from the Progressive Writers' Group, many members of which, including Mulk Raj Anand, were closely associated with the Communist Party of India. The PAG members were very left wing and displayed the kaleidoscope of Bombay society; these "six young firebrands" (Jumabhoy 2018a, 17) were migrants from all over India, from different regions, castes and social backgrounds. Whereas Bakre, the sculptor-cum-painter descended from a rich family in Baroda, initially science-trained Gade originated from Maharashtra and indulged in semi-abstract landscapes; Ara, born into the Dalit family of a bus-driver in Andhra Pradesh, never received a formal art education, and worked from the age of seven as a domestic servant in Bombay. While Husain from a Sulaymani Bohra family painted billboard advertisements for Bollywood, his fellow Muslim,

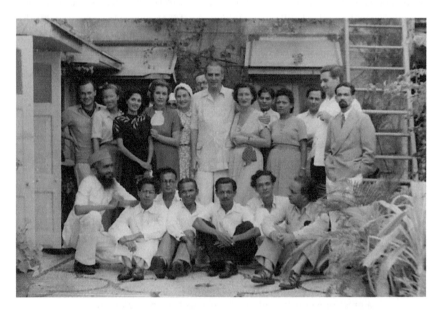

Fig. 1: Progressive Artists' Group. Francis Newton Souza's farewell party in the house of Rudolf and Nena von Leyden, Bombay 1949. Front from left: PAG = M.F. Husain, S.K. Bakre, H.A. Gade, K.H. Ara, F.N. Souza, S.H. Raza with writer Mulk Raj Anand (1st right front). Back: Käthe Langhammer (in lace collared dress), Rudolf von Leyden with his wife Nena (centre), Walter Langhammer (2nd right), Ebrahim Alkazi (theatre pioneer, 1st right back) (James von Leyden archive, Lewes).

Margit Franz

Raza, son of a forest officer from Madhya Pradesh, joined the JJ School of Art in 1943 on a scholarship from the Government of the Central Provinces. The most radical and political of the group, Souza, came from an impoverished Catholic family in Goa. Expelled from the JJ School of Art in 1944 for his participation in anti-colonial, left-wing political activities and the Quit India movement, he joined the Communist party for a short time. But he left soon afterwards, looking for "complete freedom in expressing his art", to found PAG with the objective "to find a new artistic identity for Indian art" (*Mumbai Modern* 2013, 336). Later, the artists Vasudeo S. Gaitonde, Krishen Khanna, Ram Kumar, Tyeb Mehta, Akbar Padamsee and Bal Chhabda were also associated with the PAG. The newest research also indicates the inclusion of Abdul Aziz Raiba, G.M. Hazarnis, H. Chapgar and the only female painter, Bhanu Rajopadhye (later well-known as the Academy Award-winning costume designer Bhanu Athaiya), as they all participated in the 1953 PAG exhibition in Bombay (see Jumabhoy 2018a, 19; Jumabhoy 2018b, 197).

The late 1940s showed an "undeniable influence of the West and together with a renewed sensitivity to Indian tradition" in arts "rebelliousness" was in the air, as were "a quest for new forms" (Dalmia 2003, 191) and the challenge to build a new, modern India. The PAG became a mouthpiece for this new, independent, post-colonial India, by integrating old Indian art techniques and iconography as well as absorbing, reflecting and integrating foreign art developments and international perspectives. They located Indian identity in the present "infused with issues of individualism" (Dalmia 2003, 188) and became a symbol of Nehru's modern vision of India. Today's highest selling painters have been exhibited internationally. Most of them lived abroad for several years where they were exposed to international trends and art hierarchies. The masters of post-colonial Indian art stand for a radical change and departure from the colonial cast of art and culture. Their inclusiveness was an expression of an Indian modernity in art beyond Indian traditions and international modernism, generating hybrid styles, forms, presentations and objects (fig. 1).

A network of individual networkers and their instruments of art promotion in Bombay

All five emigrants, Käthe and Walter Langhammer, Emanuel Schlesinger, Albrecht and Rudolf von Leyden, had a strong belief in modern Indian art and became active members of the Bombay Art Society. In some years they were also active in the Bombay Art Society Committee, and some even served on different selection

committees for the annual exhibitions. Their network merged art presentation, art advertisement, art criticism and review and even art sale in a few cases. While Langhammer was a kind of artistic role model for some of them, he was an art teacher to many. Rudolf von Leyden as a learning-by-doing advertisement expert and public relations manager could build his work on the corporate network of his elder brother Albrecht. As an advertisement manager of *Times of India* he joined hands with *Times of India*'s art director Walter Langhammer to open these newspapers for the young artists, with favourable art critiques and photos depicting the paintings of the Indian artists. The *Times of India* became a virtual showcase for the PAG.

The collection of PAG paintings by the Central European art connoisseurs, in addition to favourable art critiques, social interaction and exchange with the young artists, and some direct financial support, set an example for local art collectors. Moreover, financially potent networks of big companies started acquiring paintings by the artists. Corporates like the *Times of India*, Tata Bombay House, Tata Institute for Fundamental Research (see Chatterjee/Lal 2010), Air India and Grindleys Bank started collections of Indian modern art. Rudolf von Leyden was a member of several art purchasing committees. He was also one of five to select for the First National Art Exhibition in Delhi in 1955. At that time Indian art patronage was in the private hands of wealthy art connoisseurs or companies.

Schlesinger with his company INDON was a spearhead for other companies in purchasing and collecting, but also in using art in corporate advertisements. He started using some of those acquired paintings in newspaper advertisements, generating a virtual window-shopping space. Leyden und Langhammer within *Times of India*'s art department were the graphic masterminds behind this and other art-advertisement coups.

Real places to showcase art were still in demand; the Bombay Art Society started lobbying for a permanent gallery in the early 1930s. The artists met at the Bombay Art Society Salon, the Chetana restaurant and the Wayside Inn restaurant on Rampart Row, bemoaning the fact that they all needed more gallery space to show their work. Informal private salons organised poetry-reading sessions, plays and discussion groups. These included the Three Arts Circle and the Nalanda society, formed by Hilla and Dossan Vakeel in their Bandra residence (see Dalmia 2001, 53). Temporary exhibition spaces were available at the Taraporevala Sons & Co bookshop at 210, Hornby Road, at the Cowasji Hall in the Science Institute and the JJ School of Arts.

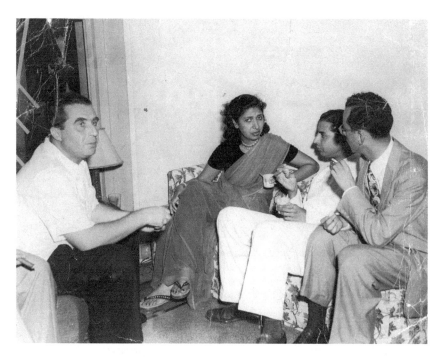

Fig. 2: Dinner party at the Langhammers'. From left: Walter Langhammer, unknown woman, Kekoo Gandhy, Wayne Hartwell (American cultural affairs diplomat) (Margit Franz's digital collection, authorised by the late Kekoo Gandhy).

"Every Sunday, it was open house at his studio on Nepean Sea Road", stated Kekoo Gandhy, remembering Walter Langhammer (Gandhy 2003). The Langhammers ran a salon at their home at 20 Nepean Sea Road on Malabar Hill. Here young artists met, dinner parties were held, people from different classes, castes, religions and professions mingled, high society encountered poor artists, art was discussed and analysed, paintings were displayed and sold.[9] Also the Leyden brothers maintained hospitality in the British colonial society cultural style of dinner parties, but brought people from different social backgrounds and origins together; first at the family residence at 17, Palli Hill in the outskirts of Bandra, and later, when Rudi was married to Nena, in their private apartments at Jaiji Mansion, 41 Merewether Road, in Apollo Bunder, and later at Belmont and Seabelle, Nepean Sea Road, each just one kilometre from the Langhammers (fig. 2 and 3).

Fig. 3: Dinner party at Langhammer's studio admidst his paintings (Margit Franz's digital collection, authorised by the late Kekoo Gandhy).

A more public, but quite elite, presentation space for paintings for the PAG artists was found in the corridors of the exclusive Taj Mahal Hotel at Apollo Bunder; here the Indian elite mixed with Western elite. Walter Langhammer re-designed the interior of the French restaurant The Rendezvous on the ground floor of the Taj (see Gandhy 2007) and Rudolf von Leyden had his wedding reception in the hotel; it was a fashionable and a modern place to hang out in style.[10]

The corridors in another international venue were also filled with fine art: the Institute for Foreign Languages (IFL), founded by the Austrian ex-pat and exiled journalist Charles Petras in the Menkwa Building in 1946. As well as offering language courses, Petras started an international club for exchange and organised international evenings, opened a bookshop, a translation bureau and a travel agency. He edited and distributed the *IFL Newsletter,* full of art-related topics and translations of Indian and international literature. In 1950 he moved the IFL to a "very grand" place in the Jehangir Building at 133 Mahatma Gandhi Road (Petras, in Franz 2015, 259). In both houses he used the corridors of his language school to display international art; for example three exhibitions of expressionist self-portraits of European artists from the Feldberg collection[11] and Indian paintings.[12] Petras, the Langhammers, the Leydens and Schlesinger got together and succeeded in exhibiting some of the PAG artists in the IFL's rooms, including Gade's solo exhibition in 1948 (see newspaper clippings in fig. 4) and Raza's Farewell Show in September 1950 before his departure for France (see Chatterji 1950; *Mindscapes* 2001, 41).

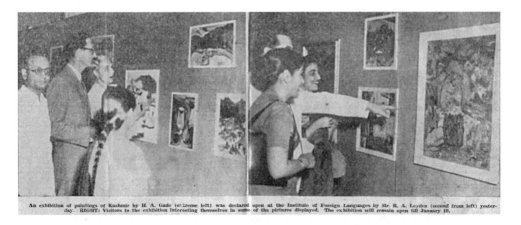

An exhibition of paintings of Kashmir by H. A. Gade (extreme left) was declared open at the Institute of Foreign Languages by Mr. R. A. Leyden (second from left) yesterday. RIGHT: Visitors to the exhibition interesting themselves in some of the pictures displayed. The exhibition will remain open till January 19.

Fig. 4: Newspaper report of Gade's Kashmir exhibition in the rooms of the IFL, January 1950. From left: H.A. Gade, Albrecht von Leyden, Margit von Leyden, unknown. Photo right: from left: unknown woman, Walter Langhammer, Khorshed Gandhy (James von Leyden archive, Lewes).

A more formal and public form of art display in the centre of the bohemian district of Kala Ghoda is the Artists' Centre at Rampart Row in the Ador House building. Formally known as the Bombay Art Society Salon, it calls itself the "mother of galleries in Bombay".

> The founder members of the institution were A.R. Leyden and Rudi von Leyden who were artists and more notably great patrons of art. The stated objectives included the encouragement of contemporary art, providing a meeting place for artists and art lovers, setting up a library, providing scope for lectures, film shows, exhibitions etc. Even some financial aid to needy and deserving artists was envisaged. (Gopalakrishnan 2001)

Funds for the Centre were raised through a sale exhibition on 21 May 1948 that offered artworks by four members of the Leyden family: Rudi was showing his caricatures, Albrecht his watercolours, while mother Luise von Leyden sold her watercolours and father Victor Ernst von Leyden displayed and sold his wooden sculptures.[13] The income was generated to set up the Artists' Aid Fund, which was transformed into an official institution in 1950 (fig. 5).

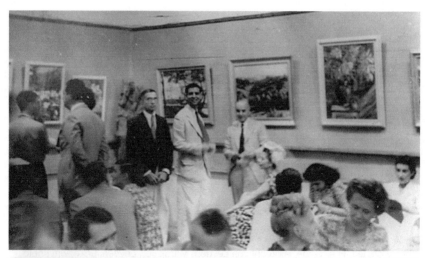

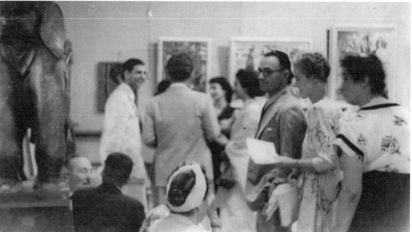

Fig. 5: Pictures capturing the mood of the Leyden exhibition in May 1949; from the Leyden family album (James von Leyden archive, Lewes).

All these efforts to generate venues for art presentation in a democratic manner led, after six years of negotiations with the local government, to the foundation of the Jehangir Art Gallery at Kala Ghoda in 1952. Bombay Art Society exhibitions had been held at the Government Secretariat, and then in the JJ School of Art, followed by the Town Hall, the University's Convocation Hall and the Cowasji Jehangir Hall in the Institute of Science between 1889 and 1951 (see *The Bombay Art Society (1888–2016)* 2016, 43f.). Until the 1940s the Art Society's activities in Bombay were mainly directed by Europeans. Its first Indian president was Sir Cowasji Jehangir, a humanitarian and art patron who also used his personal fortune to cover losses made by the Society (see Mehrotra/Dwivedi 2002, 27).

> The official history of the Jehangir Art Gallery states:
> Dr. Bhabha, who encouraged modern painters by purchasing their works of art was primarily responsible, together with Walter Langhammer, the von Leyden brothers and painter Krishna Hebbar in persuading Sir Cowasji to fund a city art gallery. (Mehrotra/Dwivedi 2002, 27)

Sir Cowasji Jehangir recognised the need for a public space for art already in 1946 and offered 250,000 Indian rupees if the Government of Bombay would provide a suitable plot for the gallery. But it took four years for the municipality to accept Cowasji's offer and to decide on the grounds of the spacious Prince of Wales compound in the heart of Bombay.

The gallery building, "a wonderful fusion of classical planning and space conception with the plasticity of modernism" (Mehrotra/Dwivedi 2002, 29) was named after Sir Cowasji's late son, Jehangir, who had died in London in 1944. Bombay Chief Minister B.S. Kher formally inaugurated the Jehangir Art Gallery on 21 January 1952 and unveiled an oil portrait of Jehangir Cowasji Jehangir by Walter Langhammer in the entrance hall (Mehrotra/Dwivedi 2002, 33). The Auditorium Hall and the Exhibition Gallery combined provided a "total of 3,400 square feet of floor area and approximately 5550 running feet of hanging wall space" with a capacity to accommodate over 1,700 people (Mehrotra/Dwivedi 2002, 29). Housing a café as a meeting point and the office of the Bombay Art Society, applying a presentation concept of twice monthly changing exhibitions by artists from all over India and later housing the Chemould Gallery (see Zitzewitz 2003), the building symbolised the non-elite character of the newly founded institution unique in all of India (fig. 6).

Fig. 6: Art talk and film screening by Walter Langhammer in the Auditorium Hall of the Jehangir Art Gallery, 1952 (Margit Franz's digital collection, authorised by the late Kekoo Gandhy).

Spatial art patronage for a post-colonial Indian avant-garde

The primary goal of this article has been to show the impact of German-speaking exiles on the creation of spaces and venues for modern fine art in Bombay of the 1940s and 1950s. Their spatial art patronage – the specific generation, rearrangement and exploration of private, semi-public and public places and spaces – was one key instrument in modernising and democratising Bombay's young post-colonial art circles. This promoted the artists' activities and brought their art to the people.

The particular setting of Bombay in early post-independence India and the networks of these exiles and emigrants played a significant role in establishing exhibition spaces. For the period when there were no permanent showrooms for modern art, the interaction between artist and art lover / art collector / art buyer was mainly restricted to the short period during the annual exhibitions of the Bombay Art Society. The dialogues with these German-speaking art connoisseurs in Bombay generated opportunities for meetings and exchanges with contemporary artists buying modern art. Private initiatives in homes became semi-official by the exhibition of modern art in hotels, clubs and language schools.

With the opening in 1952 of the Jehangir Art Gallery as a public venue to exhibit contemporary art in a democratic manner, the modern art scene became Indian and plural. The quintet of Käthe and Walter Langhammer, Albrecht and Rudi von Leyden as well as Emanuel Schlesinger was an intertwined network equipped with Western ideas of art, art representation, art publicity and low-hierarchy communication creating exposure for the international art scene in Bombay. Together with many local art aficionados and promoters they contributed to the democratisation of access to knowledge, expertise and presentation of modern art in Bombay. The city of Bombay had prepared the ground with its unique history, role and distinct open location. Socialist ideas in privileged post-colonial settings characterised the openness of Bombay in the late 1940s and early 1950s, its diversity and its opportunity as an 'imagined city' with its cosmopolitan features of a global metropolis. The emigrant circle of Langhammers, Leydens and Schlesinger with their cosmopolitan attitude supported this momentum of modernity in arts in Bombay of the late 1940s and 1950s.

Notes

[1] This article was written as part of project 16842: "Rudolf von Leyden: Wegbegleiter einer indischen Avantgarde im jungen postkolonialen Indien" of the Jubilee Fund of the Austrian National Bank.

[2] The Baghdadi-Jewish family of the Sassoons, the Tatas and Birlas, among others, built landmark buildings in Bombay to service health, education and social issues (see Sapir 2013; Nath 2006).

[3] For general information on the PAG: see Dalmia 2001; Dalmia 2003; Dalmia 2018; Hoskote 2011; Jumabhoy 2018a; *Mumbai Modern* 2013.

[4] The Visa Abolition Agreement between British India and Germany respectively Austria was in force between 1927 and May 1938, making it easy for Germans and Austrians to travel to and work in India.

[5] For more information on Leyden: see Dalmia 2001, 53–76, 231–306; Franz 2014; Franz 2015, 288–302; Parimoo 1998, 63–66; Singh 2017.

[6] For more information on Schlesinger: see Dalmia 2001, 64 f.; Franz 2014; Franz 2015, 288–302.

[7] For more information on the Langhammers: see Franz 2008; Franz 2010; Franz 2014; Franz 2015, 288–302; Dalmia 2001, 57–62.

[8] Discussion on the occasion of my presentation "Walter Langhammer (1905–1977): 'The man who brought Kokoschka to India'. Memorial Lecture on his 40th Death Anniversary" in New Delhi, 17 February 2017.

[9] This is an important reason why early paintings by PAG artists can be found in the homes of descendants of former exiles in Bombay–a fact that has been confirmed in interviews and visits (see Ross 2010; Hitchman 2010).

10 For more on this, see Rachel Lee's essay, "Hospitable Environments: The Taj Mahal Palace Hotel and Green's Hotel as Sites of Cultural Production in Bombay" in this volume.

11 Siegbert Feldberg had joined the family business of a flourishing gentlemen's outfitter in Stettin at the beginning of the 1920s. When artists fell on hard times due to depression and inflation, he exchanged art for clothes. By 1933 he had acquired more than 150 works on paper, among them self-portraits of 69 artists. Among them were Käthe Kollwitz, Max Liebermann and Oskar Kokoschka, all classified as producers of 'degenerate art' by the National Socialists. Siegbert left Germany for India in 1933; his wife Hildegard joined him with their sons at the beginning of 1939. She was able to bring the whole collection to Bombay (see Mülhaupt 2002).

12 For more information on Petras: see Franz 2015, 234–252.

13 The Leyden parents had joined their sons to Bombay in 1939 after their house in Garmisch-Partenkirchen had been expropriated. The Nazis persecuted Luise von Leyden because of her Jewish background; they had forcefully retired her husband as Ministerial Director in the Prussian Ministry of Interior and Senate President already in 1933.

References

Allen, Charles, and Sharada Dwivedi. *The Taj: At Apollo Bunder.* Pictor Publishing, 2010.

Chatterjee, Mortimer, and Tara Lal. *The TIFR Art Collection.* Tata Institute of Fundamental Research, 2010.

Chatterji, R. "Raza's Farewell Show." (1950) *A Life in Art. S.H. Raza*, edited by Ashok Vajpeyi, Art Alive Gallery, 2007, p. 51.

Dalmia, Yashodhara. *The Making of Modern Indian Art: The Progressives.* Oxford University Press, 2001.

Dalmia, Yashodhara. "From Jamshetjee Jeejeebhoy to the Progressive Painters." *Bombay: Mosaic of Modern Culture.* Third edition, edited by Sujata Patel and Alice Thorner, Oxford University Press, 2003, pp. 182–193.

Dalmia, Yashodhara. "The Rise of Modern Art and the Progressives." *The Progressive Revolution: Modern Art for a New India*, edited by Zehra Jumabhoy and Boon Hui Tan, exh. cat. Asia Society Museum, New York, 2018, pp. 29–39.

Dwivedi, Sharada, and Rahul Mehrotra. *Bombay: The Cities Within.* Eminence Designs, 2001.

Fernandes, Naresh. *Taj Mahal Foxtrot: The Story of Bombay's Jazz Age.* Roli, 2012.

Franz, Margit. "Transnationale & transkulturelle Ansätze in der Exilforschung am Beispiel der Erforschung einer kunstpolitischen Biographie von Walter Langhammer." *Mapping Contemporary History: Zeitgeschichten im Diskurs,* edited by Margit Franz et al., Böhlau, 2008, pp. 243–272.

Franz, Margit. "Graz – Wien – Bombay – London: Walter Langhammer, Künstler und Kunstförderer." *Historisches Jahrbuch der Stadt Graz,* vol. 40, 2010, pp. 253–276.

Franz, Margit. "Exile Meets Avantgarde: ExilantInnen-Kunstnetzwerke in Bombay."
 Going East – Going South: Österreichisches Exil in Asien und Afrika, edited by Margit
 Franz and Heimo Halbrainer, Clio, 2014, pp. 403–431.

Franz, Margit. *Gateway India: Deutschsprachiges Exil in Indien zwischen britischer
 Kolonialherrschaft, Maharadschas und Gandhi.* Clio, 2015.

Gandhy, Kekoo. "The Beginnings of the Art Movement." *Seminar Web-edition*, no. 528,
 August 2003, www.india-seminar.com/2003/528/528%20kekoo%20gandhy.htm.
 Accessed 15 April 2019.

Gandhy, Kekoo. "Interview with the Author." (Mumbai, 30 April 2007).

Gopalakrishnan, V.S. "'Art is Man's Nature; Nature is God's Art'. Philips James Bailey
 (1816–1912)." *Jubilant Gold: 50 Years of Artists' Centre: A Celebratory Exhibition of
 Works of K.H. Ara, S. Bakre, H.A. Gade, M.F. Husain., S.H. Raza, F.N. Souza*, exh.
 cat. Artists' Centre, Mumbai, 2001, n.p.

Hitchman, Roy. "Interview with the Author." (Zollikon, 30 August 2010).

Hoskote, Ranjit. "The Progressives Revisited." *Continuum: Progressive Artists' Group,*
 edited by Kishore Singh, exh. cat. Delhi Art Gallery, New Delhi, 2011, pp. 22–27.

Hoskote, Ranjit. "Interview with the Author." (Mumbai, 17 November 2018).

Hunt, Tristram. *Ten Cities that Made an Empire.* Penguin, 2015.

Jumabhoy, Zehra. "A Progressive Revolution? The Modern and The Secular in Indian
 Art." *The Progressive Revolution: Modern Art for a New India*, edited by Zehra
 Jumabhoy and Boon Hui Tan, exh. cat. Asia Society Museum, New York, 2018a, pp.
 17–27.

Jumabhoy, Zehra. "Chronology of Historical and Art Events, 1947–2014." *The Progressive
 Revolution: Modern Art for a New India*, edited by Zehra Jumabhoy and Boon Hui
 Tan, exh. cat. Asia Society Museum, New York, 2018b, pp. 195–202.

Leyden, Rudolf von. "Wien und die moderne indische Kunst." (unpublished article,
 private archive, n.d.).

Mehrotra, Rahul, and Sharada Dwivedi. *The Jehangir Art Gallery: Established 21 January
 1952.* Jehangir Art Gallery, 2002.

Mindscapes: Early Works by S.H. Raza, 1945–50, curated by Geeti Sen, exh. cat. Delhi
 Art Gallery, New Delhi, 2001.

Mülhaupt, Freya. *Self-Portraits from the 1920s: The Feldberg Collection.* Berlinische
 Galerie 2002.

Mumbai Modern: Progressive Artists' Group, 1947–2013, edited by Kishore Singh, exh.
 cat. Delhi Art Gallery, New Delhi, 2013.

Nath, Aman, et al. *Horizons: The Tata-India Century: 1904–2004.* Second Edition, India
 Book House, 2006.

Parimoo, Ratan. "Profile of a Pioneer. N.S. Bendre." *Lalit Kala Contemporary*, vol. 37,
 March 1991, pp. 73–74.

Parimoo, Ratan. "Publications, Magazines, Journals, Polemics: Supportive Critical
 Writing from Charles Fabri to Geeta Kapur." *50 Years of Indian Art: Institutions,
 Issues, Concepts, and Conversations. Conference Proceedings 1997*, edited by Bina

Sarkar Ellias, Mohile Parikh Centre for the Visual Arts, Mumbai, 1998, pp. 54–75.

Prakash, Gyan. "Blitz's Bombay." *Seminar Web-edition*, no. 528, August 2003, www.india-seminar.com/2003/528/528%20gyan%20prakash.htm. Accessed 15 April 2019.

Raza, Sayed Haider. "Interview with the Author." (Gorbio/France, 20 August 2010)

Ross, Carol. "Interview with the Author." (Nére/France, 23 August 2010).

Sapir, Shaul. *Bombay: Exploring The Jewish Urban Heritage.* Bene Israel Heritage Museum and Genealogical Research Centre, India, 2013.

Singh, Devika. "German-speaking Exiles and the Writing of Indian Art History." *Journal of Art Historiography*, no. 17, December 2017, https://doaj.org/article/0971436ed0004ecfa1f89d7a6d9d0628. Accessed 15 April 2019.

The Bombay Art Society (1888–2016): History and Voyage: Volume I, edited by Suhas Bahulkar, exh. cat. National Gallery of Modern Art, Mumbai, 2016.

Zitzewitz, Karin. *The Perfect Frame: Presenting Modern Indian Art: Stories and Photographs from the Collection of Kekoo Gandhy.* Chemould Publications and Arts, 2003.

Austro-Hungarian Architect Networks in Tianjin and Shanghai (1918–1952)

Eduard Kögel

After World War I, the Russians detained many soldiers of the Austro-Hungarian army in labour camps in Siberia. Some of them were able to flee via Manchuria to China, where they found a new home in the international communities of the cities of Tianjin and Shanghai. To date, little research has been carried out on how they designed their networks and integrated into their new environment (Mervay 2018). The refugees included some architects who built their careers in the new host country and left a legacy which still partly shapes the historic parts of cities such as Tianjin and Shanghai today. In this article I introduce the networks of some architects and show that, thanks to the education they had gained at the beginning of the century in Vienna and Budapest, they were able to make a significant contribution to a modern understanding of architecture in China and to offer Chinese clients a new aesthetic programme that was distinctly different from the colonial mainstream.

The Austro-Hungarian prisoners of war who entered China from Siberia often headed for Tianjin in northern China, where the old Austro-Hungarian Empire had ruled a small concession between 1901 and 1917. Many foreign concession areas were concentrated in the port city of Tianjin at that time; Japan (until 1945), France (until 1946), Great Britain (until 1943), Germany (until 1917), Belgium (until 1931), Russia (until 1920), Italy (until 1947) and Austria-Hungary (until 1917) had urban areas under extraterritorial control. This internationality also made it possible for foreign architects to get involved, above all – as in the case of Austria-Hungary – because the state that had founded the concession had already disappeared, leaving the architects unencumbered by history vis-à-vis their Chinese customers. However, most of the architects moved on to Shanghai, which was a more interesting city from an economic point of view. With the fall of the Austro-Hungarian Empire after the war, the refugees in China lost their nationality and had other identities bestowed on them by such newly-founded states as the Republic of Austria, the Republic of Czechoslovakia and the Hungarian

Republic.[1] Some of the architects discussed here, such as Ladislaus Edward Hudec and Rolf Geyling, remained in China for economic reasons and because difficult times were anticipated in Europe after the war. However, their success depended not only on their talent, but also on their networks, which made contracts possible in the first place.

The young men discussed here came to the Chinese Republic at a time of internal transition, when the country's leading politicians and intellectuals were striving to find new ways towards economic and cultural development. After 1919, the advocates of radical modernisation along Western lines (or along the lines of the Japanese Meiji Restoration) fought in the so-called New Cultural Movement against traditional values, as embodied in Confucianism. Experts who did not belong to the still-active colonial powers, Great Britain and France, were therefore in a position to gain orders from Chinese clients. The well-trained Austro-Hungarian experts were able to fill a gap and become active for both foreign clients and Chinese reformers.

The following description of the networks is not so much aimed at a discourse critical of architecture, but rather attempts to show how the aforementioned individuals formed networks and how links to Chinese clients opened up opportunities for innovative solutions. The investigation is based primarily on reports in daily newspapers and other publications, since there are no localisable archives for many of the protagonists, or they contain only fragmentary information. The local Chinese archives are difficult to access and often it is not possible for foreigners to get the desired information (Mervay 2019).

Austrian Networks in Northern China

Rolf Geyling arrived in Tianjin via Siberia in 1920, and there he worked until his death in 1952. Geyling, who was born in Vienna in 1884, was enrolled at the Technical University (TH) in Vienna between 1904 and 1909, passing his first state examination in 1906 and his second in 1910. At the TH, the emphasis was on the engineering aspects of construction, which is why Geyling continued his studies at the University of the Arts for another four semesters, as a master's student of Otto Wagner. At the same time he also worked in Wagner's studio on the major light rail project for Vienna. After opening his own practice, he built residential buildings, pavilions and villas until the outbreak of the war. In his designs Geyling adopted the ideas prevailing in Vienna, which varied between Otto Wagner's decorative approaches and Adolf Loos' material-oriented designs (Scheidl 2014, 17–35).

Eduard Kögel

Having arrived in China in 1920, Geyling went first to the seaside resort of Beidaihe (Peidaiho) where he met the Chinese politician Zhu Qiqian, who had developed a great interest in planning and architecture. Zhu was not only Interior Minister of the young Republic between 1911 and 1916, but was also very involved in the urban transformation of the capital Beijing. In Beidaihe, he succeeded in introducing modern planning regulations to which all construction practices had to adhere. Geyling was responsible for the construction of the resort's roads and public facilities. His expertise was needed here because both the Chinese elite from Beijing (about 280 kilometres west of the coast) and Tianjin (about 250 kilometres southwest) and foreigners spent their summers in the resort's villas. Later, after he had been living in Tianjin for a long time, he received many commissions in Beidaihe (Kloubert 2016, 69).

On arrival in Beidaihe, Geyling, together with his German partners E. Wittig and K. Behrendt, founded a company, Yuen Fu Building & Engineering Co. Ltd., through which they were soon also carrying out projects in Tianjin. The first major public contract from a Chinese client was awarded in 1921, for the Northeast University (*Dōngběi Dàxué*) in Shenyang (then Mukden). The architectural concept for the main building was rather conservative, with a triangular gable in the front and two flat domes to the left and right. The main auditorium space, which was depicted in a perspective drawing, follows classical design ideas (Scheidl 2014, 205, fig. 1). A further important project, in connection with a coal mine in Shandong province, was probably an order from the politician Zhu Qiqian, who was General Manager of the Zhongxing Coal Mine Company in Shandong Province from 1916 to 1938 (Yang 2007, 5).

Fig. 1: Main Building at Northeast University in Mukden (Shenyang) in 1921 (Architekturzentrum Wien, Collection, Inv. No.: N15_019_001_F_01).

In 1921, another Austro-Hungarian architect, Josef Alois Hammerschmidt, came to Tianjin from Siberia and for the next three years worked for Yuen Fu, the company co-founded by Geyling. Hammerschmidt, who was born in Vienna in 1891, studied at the TH, where he was enrolled for three years and passed nine individual examinations. However, he did not pass the state examination as he was ex-matriculated in the 1913 summer semester "for non-payment of tuition fees".[2] According to a CV published in the 1930s (Nellist 1933, 158), he also studied at the Adolf-Loos-Bauschule, which was founded in 1912, and began to work in Vienna in the same year.[3] From 1913 until the beginning of the war he worked in his home town's public works department. He was captured during the war and lived in camps in Siberia until 1918. After working for Yuen Fu, Hammerschmidt ran a private practice in Tianjin from 1924 to 1931, before moving to Shanghai. In Tianjin, he was involved in designing the residence of the former president, Li Yuanhong, the residence of the former emperor, Pu Yi, and a power plant (ibid., 158).

The Yuen Fu company closed around 1924 because of financial problems and Geyling began a cooperation with the young engineer Felix Skoff, who arrived in Tianjin from Vienna in 1922. Born in 1889 in Vienna, he had studied civil engineering at the TH between 1909 and 1914, where he passed his first state examination in 1913 and his second in 1922. Besides planning the buildings, the partners operated their own construction company. The architects also participated in competitions, such as the tender for the national monument to Sun Yat-sen in Nanjing in 1925. The partnership between Geyling and Skoff lasted until 1929, after which Geyling continued working alone (Scheidl 2014, 197). In the 1930s, he was commissioned in Beidaihe and Tianjin, and his architectural expression was increasingly reduced to the functional language of modernism. Geyling worked on around 250 projects during his time in China, many of which have now disappeared.

By the mid-1930s, the modern formal language had apparently established itself in Tianjin, replacing decoration with the staging of material. The three apartment buildings designed by Geyling – *Cambridge Flats, Herakles Building* (today *Hong Kong Building*) and *Min Yuan Building* – have exposed brick walls, concrete surfaces and flat roofs. Geyling acted as both architect and investor for the *Cambridge Flats*. The complex consists of two three-storey wings that are vertically accentuated at the corner by a four-storey staircase. Flat cornices above and below the windows underline the horizontal design. The plinth is made of exposed masonry, while the main parts of the façade are plastered (ibid., 222–224).

The horizontal, three-storey *Min Yuan Building* is divided into several sections, each with a different design. The central part, which is plastered, has continuous balconies over the façade. The main part is made of exposed masonry and has large,

square windows, with cubic balconies of exposed concrete on the narrow side. The low demarcating wall to the street has a characteristic perforated pattern. With just a few elements, the architect succeeded in creating a diverse architecture (fig. 2).

Fig. 2: *Min Yuan Building* in Tianjin designed by Geyling (Architekturzentrum Wien, Collection, Inv. No.: N15_024_001_F_03_fr).

For the *Herakles Building* Geyling designed round windows at the corners, reminiscent of the ship motifs used in Europe by modernist architects. In addition, he combined horizontal window formats with an arch motif and cubic, abstract compositions using materials such as exposed bricks, simply plastered surfaces and exposed concrete. The four-storey block consists of two parts. In one, the façade consists of visible masonry, which is continued at the base of the second part of the building. The passage to the inner courtyard is an archway. The second part extends beyond the aforementioned plinth and is plastered in white. The horizontal window formats are taken round the corners of the building (ibid., 222).

Like other architects in China, Geyling initially adapted his designs to his Western or Chinese clients' wishes, designing more or less decorated buildings reminiscent of the turn of the century in Vienna and echoing the ideas of his teacher, Otto Wagner. In the 1930s European modernism found its way to China via magazines, returning students and architects visiting their respective homelands. Soon decoration was replaced by materiality. His client network included Chinese elites and foreigners who had their houses built both in the port city of Tianjin and in the seaside resort of Beidaihe. Zhu Qiqian was a key contact in this context, because not only was he interested in architecture, he was also part of an important political network centred in Beijing. However, Shanghai was too far away to accept orders from, and there were obviously local networks in nearby Beijing which commissioned their own architects.

Realty in Shanghai

Hugo Sandor was another Austro-Hungarian refugee. He came from the small town of Ungvar in the Carpathians (today Ukraine)[4] and had studied at the Vienna Commercial Academy (*Handelsakademie*). From 1912, Sandor worked for the Roman & Szivos Electricity Co. in Budapest. He served as a lieutenant during the war, becoming a prisoner in the labour camps in Siberia in 1917 (Nellist 1933, 336). He fled to China in 1920 and worked as a manager for Frank Raven's American Oriental Bank in Chongqing in 1923 (*The China Weekly Review,* 22 September 1923, 131). In the same year, he joined the Asia Realty Company in Shanghai, a realty company also owned by Raven (Nellist 1933, 326).[5] Josef Alois Hammerschmidt moved from Tianjin to Shanghai in 1931 to establish the architecture department of Asia Realty Company. Having set up the department, Hammerschmidt opened his own practice in Shanghai in 1933 (ibid., 158). Not much is known about Ferenc (Ferry) Shaffer, who had been trained as an architect in Budapest and had been a lieutenant during World War I. He had been with Sandor in the Siberian labour camps and fled with him to China. In 1922, Shaffer earned his living as a road engineer in Sichuan Province (Service 1989, 248 and 262) and later worked for the Asia Realty Company in Shanghai[6] (*The New York Times*, 1 February 1949, 25).

The Asia Realty Company commissioned another Austro-Hungarian countryman, Ladislaus Edward Hudec,[7] to design a series of garden villas on the Route Louis Dufour (1925–1926) in the French concession, immediately after he had opened his own office in 1925. Asia Realty also awarded him another contract for an estate with garden villas on Route Herve de Sieyes (1927–1930). He obviously already had a reputation as a young, promising architect in Shanghai, but it was certainly no disadvantage that his fellow countrymen held key positions at Asia Realty. Hudec had received his training at the Royal Joseph University in Budapest and came to Shanghai in 1918, via a Siberian labour camp. In his case, the question of nationality had a very personal aspect to it, as well as influencing his status and possibilities as an architect. He was born in 1893 in Banská Bystrica, in present-day Slovakia, into the family of master builder György Hugyecz and studied in Budapest, where he received his diploma as an architect in June 1914. At the end of that year, he was drafted into the army and became a prisoner of war in Russia in June 1916. He escaped from the Siberian labour camp and reached Shanghai in November 1918. In the labour camp the Russians had issued him with a 'Frontier Passport' in which they shortened his name from Hugyecz to Hudec. As all Germans and their allies in China were arrested after World War I ended on 11 November 1918, Hudec thought that it would be better to retain his Russian identity for the time being.

As a result of the war, the Austro-Hungarian Empire disappeared and independent nation states emerged. When his father died in 1921, the Czechoslovak consulate in Shanghai issued him with a new Czech passport. At home, however, he learned that the authorities had frozen his father's assets pending clarification of open questions in court. This obviously made it very difficult for him to accept the new Czech nationality, since he was convinced that the accusations against his father were politically motivated. Back in Shanghai in the summer of 1922 he married Gisela, the daughter of the German merchant Carl Theodor Meyer and his British wife. Hudec visited Budapest in 1927 and 1928 to promote his naturalisation in Hungary and received a temporary Hungarian passport in 1929, as until then there had been no Hungarian consulate, Hudec was appointed honorary consul. However, Czechoslovakia did not release him from citizenship and offered to decide the case against his father in his favour. Soon, however, he learned that the state authorities had de facto auctioned off his father's property. The matter remained in limbo until 1938, when the 'Munich Agreement' was concluded in which Hitler annexed Sudetenland to the German Reich. During this time, the Shanghai press were reporting that he was an architect with Czechoslovak citizenship and Hungarian nationality, which regularly led to problems. It took until the autumn of 1941 for the Hungarian embassy in Japan to issue him with a Hungarian passport, so that he could carry out his duties as consul from 1942 to 1944 during the war (Hudec 1941).

L.E. Hudec is today the best known of the architects with Austro-Hungarian roots. After his arrival in Shanghai, he joined the office of the American architect Rowland A. Curry as a draughtsman. In 1920, Hudec had already been named associate partner for the design of the Chinese-American Bank of Commerce in Shanghai. The newspaper reported, "The elevation shows the influence of a Palladian idea with an adaptation of Greek motives [*sic*]" (*Millard's Review,* 25 September 1920, 165). Hudec opened his own practice on January 1925 (*The China Press,* 3 January 1925, front page). The first building under his name became the Country Hospital, a donation from a "wealthy Shanghai resident" (*The North-China Herald,* 26 February 1926, 239). It had some special features such as a roof garden, but its architecture expressed conventional references to historical European styles. In 1927, Hudec built the "Luxurious Estrella Apartments", as *The North-China Herald* dubbed them; here too he provided a special roof garden, "divided into two parts, one being a Spanish garden with fountain, pergolas and verandahs. The other part is a children's playground and is protected from the north wind by loggias" (*The North-China Herald,* 5 February 1927, 192). In the same year, he also designed the *Moore Memorial Church* next to the racecourse, "which follows the older Gothic lines", as the newspaper reported (*South China Morning Post,*

12 January 1929, 14). It was a complex programme, with a cloister garden in the Chinese style, playground, hostel and social facilities. *The Joint Savings Society Bank Building* for a Chinese client was also completed in 1928 and the critics praised it for its unconventional style. "[…] [T]he architect has broken utterly with the classical design of pillars and pilaster, columns and capitals, so generally used throughout the world of banks […]." According to the newspaper critic, the design "borrowed from the American colonial dwelling house" (Bryant 1928, front page). A Chinese bank probably wanted a different aesthetic from that of the already existing foreign banks with their symbolic, classicist references. All the buildings designed by Hudec up to that point had been variations of Western architectural historical types in one way or another, without showing even a hint of the new design ideas of abstraction or modernism that his colleagues in Europe had been testing since the early 1920s.

In Shanghai, growing demand for luxury villas with large gardens led to new residential developments in the suburbs of the French concession, outside the densely populated city centre. The American investor Frank Raven, and his Asia Realty Company with people from the former Austria-Hungarian Empire in key positions, bought some 66,000 square metres of land for the Columbia Circle development, high-end real property with a business feel. The property was divided into more than 70 plots, each large enough for a garden villa. Asia Realty again commissioned Hudec to design some of the villas, built between 1929 and 1932, in a bouquet of different architectural styles. These include 'Dutch', 'English', 'Spanish' and various 'American' architectural styles. Between 1929 and 1931, he built a 1,000 square metre villa for himself in a kind of Spanish revival style, which he sold to the important Chinese politician Sun Ke, the son of Sun Yat-sen (Hua/Qiao 2016, 105). He then built a second house for his family in Colombia Circle in the Tudor Revival style, which was fashionable in Britain in the late 19th century (Hua 2016, 99). His education at the beginning of the 20th century in Budapest allowed him to build in many styles, as all possible variations had been discussed and implemented during the transition from historicism to Art Nouveau (Marótzy 2018, 110). The wide range of choices for creative expression in Shanghai was certainly connected to the multinational elite (including the Chinese), who could realise their personal dreams there without having to take account of local cultural sensitivities. On the contrary, it must even be assumed that 'exotic' design not only connected the customers with their roots in old Europe, but also clearly showed where the residents felt they belonged. Both Western businessmen and the Chinese elite rejected the local Chinese architectural tradition. Hudec's own Tudor Revival-style house on Columbia Circle was designed

in a complex three-dimensional shape, with various steep roof surfaces and characteristic chimneys that reflected the character of an English country house set in a garden (fig. 3).

Typical Plans of Seven Residences Under Construction
Four in the French Concession and Three in "Columbia Circle"
Property of

Fig. 3: Advertisement for Asia Realty at Columbia Circle, Shanghai, in 1928. Architect L.E. Hudec (Collage made by the author from various advertisements of the Asia Realty Company from 1928).

Art Deco as Fashionable Style

Around 1930, approximately 1.5 million Chinese and 70,000 foreigners lived in the core city of Shanghai. British architects built in the Victorian style of the Empire, with its neo-Greek and neo-Roman references. But then the commercial American culture reached Shanghai and Manhattan became a shining example of a new Art Deco skyscraper city. In addition, Hollywood films made their contribution to a change in aesthetic taste (Lee 1999, 11). The characteristic of

Art Deco as a "synthesis of classical symmetry and modernist simplification of form; zigzag terracing and projecting ziggurats on buildings; design symbolism that suggested both the ancient past and the distant future; [...]" (Striner 1994, 86) made it easy for the Shanghaiers to accept Art Deco. It could even be read as an alternative to the dominant British presence in the cityscape. It was therefore important for architects like Hudec to find the right architectural language for their Chinese clients in order to offer their own expression for the future beyond the aesthetic programmes of the colonial powers.

In 1930 Hudec's architectural expression changed with the *China Baptist Publication Society Building*. "The building as designed by architect L.E. Hudec, exemplifies the modern movement in architecture, the trend of the lines being vertical, and exterior free from any extra garnishment ornamentation" (*South China Morning Post,* 11 November 1930, 9). The architect also applied the explicitly expressionist design to the neighbouring *Christian Literature Society Building*, which was completed in 1932.

In 1930, his younger brother Geza Georg Hudec, came to Shanghai. He had studied in Budapest and then went to New York in 1929 to learn English before joining his brother's company. G.G. Hudec died three years later at the age of 26, after an operation in hospital. In the obituary an anonymous author wrote, "He was responsible for much of the detail work on several prominent buildings in this city" (*The China Press,* 25 February 1933, 4). The author did not provide any further details. G.G. Hudec studied after the mid-1920s in Budapest, which was still in close contact with the Viennese art movements. The local confrontations with Art Nouveau were enriched by German Expressionism, the art of the Vienna Secession and new ideas from the German Bauhaus. Farkas Molnár, one of the first Hungarian students to study at the Bauhaus, had returned to his home town in 1925 and received his diploma as an architect in Budapest (Bajkay 2005). Molnár had worked for Walter Gropius in Weimar and after his return to Budapest published his writings on the new ideas at the Bauhaus.[8] However, whether G.G. Hudec was influenced by these discourses remains unclear. His brother in Shanghai sent him to New York in 1929, even before he had completed his studies. As the world economic crisis was starting there, he could not find work in an architectural practice and went to Shanghai six months later. However, he certainly saw the new Art Deco skyscrapers in Manhattan during his time in New York (Poncellini/ Csejdy 2013, 112). If one looks at L.E. Hudec's practice after 1930 it becomes clear that there was a fundamental change in attitude. L.E. Hudec had himself travelled from New York to San Diego in 1927–1928 (Hietkamp 2012, 66). He also spent six months in Europe during the summer of 1931, "studying the latest developments in technology and architecture" in order to familiarise himself with the new trends

(Lewis 1931, front page).[9] He understood that a new era had dawned in Shanghai that required a new form of expression. Chinese artists, architects and designers were trying to find their own language, inspired by historical models and the latest trends in Western development. Art Deco was an excellent design direction for this, as the more transnational, streamlined shapes could be combined with local decorations. Not only Hudec, but almost all the foreign and Chinese architects in Shanghai, changed their designs from historicism to Art Deco that year (Lee, 1999).

Fig. 4: German-Protestant Church in Shanghai, 1930–1932. Architect L.E. Hudec (Bundesarchiv, Image 137-043236, Shanghai, Deutsch-Evangelische Kirche).

The funeral service for G.G. Hudec took place in the *German Protestant Church*, which he had helped to design and build (*The North-China Herald*, 1 March 1933, 335, fig. 4). The competition for the extension of the existing church had been decided in October 1930. Rolf Geyling from Tianjin received the first prize, the Chinese architect Fozhien Godfrey Ede[10] the second prize and L.E. Hudec was awarded the special prize for a sketch series (G. F. 1930, 298). Hudec's practice received the commission for the church tower with the elegant Art Deco solution based on vertical lines. This made the church one of the first buildings with a new aesthetic in Shanghai (Warner 1994, 132).[11] Hudec obviously was inspired by North German expressionists such as Fritz Höger, the architect of the *Chilehaus*

(1922–1924) in Hamburg, which he knew from his visits to the city (fig. 5). The dark clinker and standing lines dramatised the vertical, as expressed in Hudec's later works (Poncellini/Csejdy 2013, 109).

Fig. 5: *Chilehaus* in Hamburg 1922–1924. Architect Fritz Höger (Photo: Eduard Kögel, 2017).

L.E. Hudec's most striking buildings were designed and built between 1930 and 1934. These include the *Park Hotel* (1931–1934), the *Grand Theatre cinema* (1931–1933), the *Lafayette cinema* (1932–1933) and the *Union Brewery* (1933–1934). At the time, Hudec's work was very much in line with the local needs of a society that was becoming emancipated and searching for a contemporary expression. Since L.E. Hudec had subscribed to European architecture magazines on the one hand and, on the other, had seen the high-rise development in Manhattan and Höger's work in northern Germany, it can be assumed that he clearly opted for Art Deco in the competition for new ideas. Around 1930, several new Art Deco skyscrapers were built in Shanghai, all competing to be the city's tallest building.

The Highest Building in Asia

In April 1931, the Chinese Joint Saving Society, for whom L.E. Hudec had earlier designed the bank building, announced that it had commissioned him for a new

high-rise building (*The North-China Herald,* 21 April 1931, 87). In October of the same year, the well-known Danish engineer, Aage Corrit, started pile driving to test the particularly soft ground; a new idea for the foundations had to be found to ensure stability. At the end of that month, L.E. Hudec returned from the six-month study trip to Europe mentioned above, bringing with him new ideas about technology and architecture. The difficulties of building a tower of this size on the soft ground in Shanghai required good preparation and the best technology available. In January 1932, the newspaper reported that the building was to be the tallest in Asia. The consulting engineer was the Swede, Bengt J. Lindskog, who wrote, "The most interesting feature […] is the foundation" (Lindskog 1934, 1). The problems were solved by using special technology. "The building is standing on 400 Oregon pine piles, the average length of each being 110 feet" (ibid.). The two-storey basement, which was built as a reinforced concrete box, transferred the weight to the piles. For the first time in Shanghai, the walls in the basement were constructed as rigid, reinforced concrete beams. In order to make the structure really stable it was necessary to ensure that the natural consistency of the ground around the construction site was preserved. A watertight sheet piling system, developed by the German-Norwegian engineer Tryggve Larssen, was supplied by Siemens and used for this purpose. The construction management in Hudec's practice was in the hands of the young Austrian engineer Wilhelm Neyer, who joined in 1931. The German Dortmunder Vereinigte Stahlwerke supplied the steel skeleton for the building's construction. The outer façade was clad in a glass-hard, dark brown clinker, which was produced by a company in the province of Shandong, based on a German model. The lower three floors were clad in polished black Shandong granite. The safes and machine rooms were in the basement and the hotel lobby and a bank branch on the ground floor. The dining rooms followed on the second and the hotel kitchen, hall and cocktail bar on the third floor. Above came the hotel rooms from the fourth to the thirteenth floors, and the roof garden and the barbecue room on the fourteenth floor. The final tower began on the fifteenth floor and included private apartments up to the nineteenth floor, technical rooms on the twentieth floor, escape rooms and a viewing gallery for hotel guests on the twenty-first floor. The building measures exactly 91.44 metres (300 feet) to the top of the flagpole (Neyer 1935, 55). When the Park Hotel opened opposite the racecourse on 1 December 1934, not only was the Chinese mayor of Greater Shanghai in attendance, but magazine and newspaper reporters from around the world were also present and reported about the highest building in Asia (fig. 6).

Fig. 6: *Park Hotel* and *Grand Theatre Cinema* in Shanghai. Architect L.E. Hudec 1931–1934 (Der Baumeister 1935).

Conclusion

The architects mentioned above left a strong legacy in the cities of Tianjin and Shanghai, and many of their buildings are now listed as cultural heritage. They came from Budapest or Vienna with the late Empire style in their luggage and were among the first to introduce Art Deco or aspects of modernism to Shanghai and Tianjin, which still contribute to the city's historic identity today.

The Second Sino-Japanese War began with the Japanese invasion of 1937, and thereafter none of the European architects received major commissions. It was not until the mid-1940s, at the end of the war, that Geyling was able to build a villa for his family in Tianjin. The American allies of the republican government in China confiscated the building a short time later and tore it down. The family lost its fortune following the communists' rise to power in 1949; they fought in vain for its recovery until Geyling's death in 1952 (Scheidl 2014, 257 and 263).

Eduard Kögel

His archive was largely lost in the turmoil of the time. In 2002 the Modern Tianjin and World Museum was founded, in which his contribution to the architectural development of the city is honoured in a photo exhibition.

L.E. Hudec emigrated from Shanghai to Switzerland in 1947 and worked briefly in Italy before going to California the following year. The network of people who shared the same fate after World War I had enabled him to pursue a career in Shanghai. But his special position as an architect who was not connected to colonial Great Britain and France also gave him access to the Chinese elite, who found in him a congenial partner for their dreams of a big city. Without Hudec, Shanghai would certainly have been a poorer city today, even if his buildings have almost disappeared between the skyscrapers of recent years. He died in 1958 in California at the age of 65 and requested in his will that his ashes be taken to the family grave in his native Slovakia (Areddy 2010). He never forgot his roots and wrote in a letter, "It doesn't matter where I go, I will always be a stranger, a guest, a Flying Dutchman, who is at home everywhere he goes, but still has no fatherland" (ibid.).

In both Geyling's and Hudec's cases the network of Austro-Hungarian colleagues in various positions helped to obtain contracts. Equally important, however, was the fact that the architects did not come from a country operating in China with colonial claims. In this way, the architects could also work for important Chinese clients without being hampered by political or ideological problems.

Notes

[1] Upon arrival, the question of nationality had to be clarified so that they could open an office or travel. In some cases, citizenship of a particular nation could easily be clarified (e.g. Geyling – Austria) because the family had its roots in that country. In other cases there were difficulties with the new nationality, which led to individual solutions (e.g. Hudec – Hungary/Czechoslovakia).

[2] Information from Dr. Paulus Ebner, head of the archive of the Vienna University of Technology.

[3] However his name cannot be found in connection with the Adolf-Loos-Bauschule.

[4] Sandor was probably of Jewish origin, because Ungvar was a centre of Jewish culture and he commented together with others in 1939 on Sun Ke's proposal to establish a settlement area in southwest China for Jewish refugees from Europe (Sandor et al. 1939).

[5] Asia Realty Company operated between 1923 and 1941 in Shanghai.

[6] Shaffer died in New York in 1949.

[7] Often simply called Laszlo or L.E. Hudec.

[8] Molnár was also a founding member of the CIAM.

9 From the mid-1920s he had been to Europe many times and was obviously fully aware of developments in architectural expression.

10 After 1949 he used the name Xi Fuquan.

11 The church was demolished during the 'Cultural Revolution' between 1966 and 1976.

References

Anonymous. "Chinese American Bank Opens in Shanghai." *Millard's Review*, 25 September 1920, p. 165.

Anonymous. "Men and Events." *The Weekly Review*, 11 February 1922, p. 482.

Anonymous. "Marriage." *The North-China Herald*, 10 June 1922, p. 791.

Anonymous. "Men and Events." *The China Weekly Review*, 22 September 1923, p. 131.

Anonymous. "Notice." *The China Press*, 3 January 1925, front page.

Anonymous. "The Country Hospital, a Gift to Shanghai." *The North-China Herald*, 26 February 1926, p. 239.

Anonymous. "Shanghai Latest Flats, The Luxurious Estrella Apartments." *The North-China Herald*, 5 February 1927, p. 192.

Anonymous. "New German Country Club." *The North-China Herald*, 18 February 1928, p. 260.

Anonymous. "New Savings Bank Building." *The North-China Herald*, 12 May 1928, p. 242.

Anonymous. "Moore Memorial Church to Erect Modern Edifice." *South China Morning Post*, 12 January 1929, p. 14.

Anonymous. "Men and Events." *The China Weekly Review,* 27 September 1930, p. 150.

Anonymous. "Baptist Building." *South China Morning Post*, 11 November 1930, p. 9.

Anonymous. "A Nineteen Storey Building". *The North-China Herald*, 21 April 1931, p. 87.

Anonymous. "Funeral Rites are Held for G.G. Hudec." *The China Press*, 25 February 1933, p. 4.

Anonymous. "Mr. G.G. Hudec." *The North-China Herald*, 1 March 1933, p. 335.

Anonymous. "Ferenc Shaffer, Architect in China." *The New York Times*, 1 February 1949, p. 25.

Anonymous. "Ferenc Shaffer." *South China Morning Post*, 3 February 1949, p. 6.

Areddy, James T. "Hudec: The Architect Who Made Shanghai." *The Wall Street Journal*, 7 September 2010, https://blogs.wsj.com/chinarealtime/2010/09/07/hudec-the-architect-who-made-shanghai/. Accessed 11 February 2019.

Bajkay, Eva. "Hungarians at the Bauhaus." *Beyond Art: A Third Culture: A Comparative Study in Cultures, Art and Science in 20th Century Austria and Hungary*, edited by Peter Weibel, Springer, 2005, pp. 71–77.

Bryant, Percy L. "New Joint Savings Society Building Adds New Gem the Shanghai Structure." *The Shanghai Press*, 20 May 1928, front page.

Csejdy, Júlia. "From Besztercebánya to Shanghai. The Life of Architect L. E. Hudec (1893–1958)." *Hudec Cultural Foundation*, http://epiteszet.hudecproject.com/en/essays/besztercebanya-shanghai-life-architect-l-e-hudec-1893-1958. Accessed 11 February 2019.

G. F. "Zum Neubau der evangelischen Kirche in Shanghai." *Die Brücke*, vol. 6, no. 45/46, 15 November 1930, p. 298.

H. G. "Hochhaus und Kinobauten in Schanghai." *Der Baumeister*, Vol. 33, 1935, pp. 175–177.

Hietkamp, Lenore. *Laszlo Hudec and The Park Hotel in Shanghai, China*. Diamond River Books, 2012.

Hua, Xiahong, and Michelle Qiao. *Shanghai Hudec Achitecture*. Tongji University Press, second edition 2016 (first edition 2013).

Hudec, László Ede. "My Autobiography, 1941." http://hudecproject.com/files/hudec_autobio_1941.pdf. Accessed 30 January 2019.

Kaminski, Gerd. "Ein Österreicher baute den ersten Wolkenkratzer Shanghais: Wilhelm S. Neyer im China der zwanziger und dreißiger Jahre." *China Report*, no. 171/172, 2017, pp. 31–39.

Kloubert, Rainer. *Peitaiho. Großer chinesischer Raritätenkasten*. Elfenbeinverlag, 2012.

Lee, Leo Ou-fan. *Shanghai Modern: The Flowering of a New Urban Culture in China 1930– 1945*. Harvard University Press, 1999.

Lewis, Herb. "22-Story J.S.S. Building Facing Race Course, Will be Tallest Skyscraper on 4 Continents." *The China Press*, 5 November 1931, front page.

Lindskog, B. J. "J.S.S. Building In Construction. Described By Chief Engineer: Technical Obstacles Overcome." *The China Press*, 1 December 1934, p. 1.

Marótzy, Katalin. "Hungarian Aspects of the architecture of Lázló Hudec." *Sanghay–Shanghai: Parallel Diversities between East and West,* edited by Györgyi Fajcsák and Béla Kelényi, exh. cat. Ferenc Hopp Museum of Asiatic Arts, Budapest, 2018, pp. 107–122.

Mervay, Mátyás. "Austro-Hungarian refugee soldiers in China." *Journal of Modern History*, vol. 12, no.1, 2018, pp. 45–62. *Taylor & Francis Online*, doi: 10.1080/17535654.2018.1466512.

Mervay, Mátyás. "The secret of archival research in Mainland China: lower your expectations and be patient." https://wp.nyu.edu/habsburgiainchina/the-secret-of-archival-research-in-mainland-china-lower-your-expectations-and-be-patient/. Accessed 6.1.2020.

Nellist, George, editor. *Men of Shanghai and North China*. Oriental Press, 1933.

Neyer, Wilhelm. "Zur Eroeffnung des 'Grand Theatre.'" *Deutsche Shanghai Zeitung*, 19 April 1933, p. 4.

Neyer, Wilhelm. "Schanghais erster Wolkenkratzer." *Zeitschrift des Österreichischen Ingenieur- und Architektenvereins*, no. 9/10, 1935, pp. 55–57.

Poncellini, Luca, and Júlia Csejdy. *László Hudec, 1893–1953*. Tongji University Press, 2013.

Sandor, Hugo, et al. "Jüdische Auswanderer nach Südwestchina?" *Die Gelbe Post*, 16 May 1939, pp. 27–28.

Scheidl, Inge. *Rolf Geyling (1884–1952): Der Architekt zwischen Kriegen und Kontinenten.* Böhlau Verlag, 2014.

Service, Grace. *Golden Inches: The China Memoir of Grace Service.* University of California Press, 1989.

Striner, Richard. *Art Deco.* Abbeville Press, 1994.

The Comacrib Directory of China 1925–1926. Commercial & Credit Information Bureau Shanghai, 1925.

Wagner, Rudolf G. "Ritual, Architecture, Politics, and Publicity during the Republic." In *Chinese Architecture and the Beaux Arts*, edited by Jeffery W. Cody et al., University of Hawai'i Press, 2011, pp. 223–278.

Warner, Torsten. *German Architecture in China. Architectural Transfer.* Ernst & Sohn, 1994.

Yang, Tian. "Defining Building Traditions in Modern China: Zhu Qiqian, 1905–1930." PhD thesis, University of Virginia, 2007. https://www.researchgate.net/publication/302497964_DEFINING_BUILDING_TRADITION S_IN_MODERN_CHINA_ZHU_QIQIAN_1905-1930/download. Accessed 23 January 2019.

Eduard Kögel

Art and Exile in Rio de Janeiro

Artistic Networking during World War II

Cristiana Tejo and Daniela Kern

With Rio de Janeiro serving as an arrival city in the 1930s and 1940s, the impact of immigrant artists and art professionals on the Brazilian art scene has been immeasurable. During World War II, artists and other agents of the European art system headed to Brazil in order to escape conflict and Nazism/Fascism, thus initiating a new wave of immigration to the city. It is true that many fled to São Paulo, a city that coalesced industrialization and new opportunities, but it was Rio de Janeiro, the capital, that attracted the majority of immigrants. Most of them lived in other parts of the city, but locations like the Hotel Internacional, the Hotel Londres, the Pensão das Russas and the Pensão Mauá brought together artists from various cultural fields and origins and generated a social network (*Ciclo de exposições sobre Arte no Rio de Janeiro* 1986).

The presence of these artists and thinkers contributed not only to the dissemination of Modernist codes as well as to the circulation of Abstractionism and, as we would see later, Expressionism, but also to new models of professionalism in the Brazilian art world. These developments led to the creation of alternative art venues like Galeria Askanasy, informal art classes at studios and institutional art shows. When the seminal art critic Mário Pedrosa came back from his political exile in the United States in 1945, and when the Museum of Modern Art of Rio de Janeiro opened its doors in 1948, Modernism had long become a substantial part of the daily discussion of local artists.

It is important to highlight that Rio de Janeiro had functioned as an arrival city for artists at least since the Portuguese Royal Family moved there as a result of Napoleon's invasion of Portugal in 1807. The capital of Brazil since 1763, Rio had – for more than a century – acted as a center for all of the country's major cultural and artistic institutions. Due to the arrival and permanent settlement of the Portuguese Royal Family, it was the only city among all Portuguese, Hispanic, British and French colonies to become a focal point for the kingdom. However, what interests us in this article is the Modernist period. The country had already

shown signs of avant-garde activity, embodied in exhibitions by artists like Lasar Segall (1913) and Anita Malfatti (1917), as well as the São Paulo Art Week in 1922, but these instances were isolated initiatives with no structural adherence to the Modernist exuberance of the time (Durand 1989). The economic, social, political and cultural determinants for the development of the Brazilian modern art world would occur only after World War II, a turning point in the cultural fabric of Brazil with the arrival of immigrants, mainly Italians, to the city of São Paulo (Bueno 2012).

The diaspora caused by World War II has had an enormous impact on art and culture globally: it has affected everything from the production to the circulation of ideas, lifestyles, artworks, people and images, and has laid the foundations for a globalized and de-territorialized society on a hitherto unprecedented scale (Bueno 2012, 80). At the same time, for a few years the war interrupted the Brazilian (and American) elite's access to major European centers where they used to study, consume material and cultural goods and socialize. According to the sociologist José Carlos Durand,

> the compulsory stay in São Paulo or Rio de Janeiro of people who, without the crisis and the war would surely be in Europe, plus the expansion of the periodical press and the correlate professionalization of the journalists, drew attention to the art that was being created right here (Durand 1989, 99).

Despite the gradual transfer of economic importance to São Paulo from the beginning of the 20th century onwards and despite not being able to match the Art Week of 1922 in its avant-garde momentum until the 1840s, Rio de Janeiro gathered a lot of the country's cultural intelligentsia, attracting young artists and intellectuals from all over Brazil who would actively participate in the construction of the modern Brazilian art scene. Until the late 1940s all the main cultural institutions, like the Ministry of Culture and the SPHAN (Secretary of National Historical and Artistic Heritage), were situated in Rio when it was still the capital city of the country. The diaspora caused by two world wars and Nazi persecution also had an impact on daily life in Rio with the arrival of dozens of intellectuals and artists who brought to the city not only their cultural capital but also their connections to an international network.

We must bear in mind the situation of immigrants to South America during World War II. Between 1942 and 1945, most harbours were shut down for passenger transport as transatlantic trips became very dangerous due to the war

Cristiana Tejo and Daniela Kern

at sea. In Brazil, the number of immigrant arrivals drastically decreased to 2,000 per year (Lesser 2015). This situation coincided with the national politics of the New State, i.e. the dictatorship of Getúlio Vargas which lasted from 1937 to 1945 and which was influenced by fascist-leaning models and ideologies (including National Socialism and anti-semitism), economic centralism and the co-optation of workers. Vargas tried to remain neutral during the first years of World War II, but in fact gave some speeches favourable to the Third Reich; additionally, Germany was the major importer of national steel production. Brazilian immigration law had undergone a series of changes since 1938, all of them classified as confidential. According to the historian Izabela Maria Furtado Kestler, Brazil implemented a no political asylum policy during that time. "The European fugitives who have come here since 1933, of whom an estimated 90 per cent were of Jewish descent, were considered to be immigrants and not asylum-seekers" (Kestler 2003, 44). However, some people of Jewish origin found loopholes and were able to obtain entry visas as tourists, or as relatives or spouses of foreigners already legally resident in the country, offering credentials as scientists, artists or businessmen of value.

When the United States of America entered the war after the attack on Pearl Harbor, Vargas had to yield to American demands and eventually declared war on the Axis powers in 1942. This was a turning point in the lives of German-speaking exiles (Germans, Austrians, Jewish expatriates) and of the Japanese and Italian immigrants living in Brazil. It was no longer allowed to speak German, Japanese or Italian, and newspapers published in those languages were shut down. All 'Germans', 'Japanese' and 'Italians' started to be treated as enemies. As Kestler recalls, of the approximately 86,000 German refugees who came to Latin America between 1933 and 1945, 16,000 came to Brazil, most of them of Jewish descent. In Brazil, pseudo-scientific theories led to quota-based immigration policies aimed at creating a "Brazilian race", "whiter" and "improved". From 1937 on, "foreigners of Semitic ascendancy" were increasingly prohibited from immigrating into Brazil.

Defying restricted transport routes to the Americas and Brazil as well as the unclear legal circumstances and entry requirements between 1937 and 1949, artists such as Axl Leskoschek (Austria), Laszlo Meitner (Hungary), Árpád Szenes (Hungary), Maria Helena Vieira da Silva (Portugal), Roger van Rogger (Belgium) and Tiziana Bonazzola (Italy) succeeded in settling in the country. The historian and art sociologist Hanna Levy (Germany), the journalist Miecio Askanasy (Poland) and the gallerist Irmgard Burchard (Switzerland) also immigrated to Rio. Their presence contributed to the expansion of the avant-garde repertoire of the local art world.

Life for these foreign artists was not easy, but most of them entered the art scene by presenting in salons, exhibiting at art shows and teaching. Due to the lack of private investment, the almost non-existent art market and the strong presence of state capital (and its bureaucracy), the art world of Rio de Janeiro relied heavily on official institutions that represented the academic art system and were willing to accentuate a 'national identity' through art. In the period encompassing the 1930s and 1940s, a modern art system with new divisions in art salons for Modernist experimentations started to flourish. It was then that discussions about the importance of modern art museums for Brazil took place. Stylistic disputes about conservative and modern trends were going on in the official art institutions and the immigrant artists were confronted with these disputes. In fact, it was alternative initiatives like free courses at artists' studios, newly emerging universities and galleries that guaranteed some circulation of the ideas of this heterogeneous group: these newly developing contexts often enabled artists to make a living. We would like to highlight the importance of the art classes led by Árpád Szenes, Henrique Boese, Axl Leskoschek, August Zamoyski and Tiziana Bonazzola who taught a new generation of concrete, neo-concrete and neo-figurative artists.

For his studio the Hungarian painter Szenes converted a room in the main building of the Hotel Internacional in Santa Teresa; here he received approximately 200 students, among them Frank Schaeffer, Almir Mavignier and Polly McDonnell. The German painter Boese also taught at his studio and had students such as Almir Mavignier, Djanira, Gerty Saruê and Eduardo Sued. The Austrian engraver and painter Leskoschek devoted himself to teaching at the Getúlio Vargas Foundation, which was attended by the young Renina Katz, Fayga Ostrower, Edith Behring, Misabel Pedrosa and Ivan Serpa. The Polish sculptor Zamoyski's Brazilian path led along a different route: the Minister of Education and Culture, Gustavo Capanema, invited him to be the tutor of a Free Course on Sculpture. In March 1941, the President, Getúlio Vargas, appointed him professor of the Art School in Rio de Janeiro. His disciples were, among others, Franz Weissmann, Bellá Paes Leme, Vera Mindlin and José Pedrosa. The Italian painter Bonazzola was a teacher at the famous Art School of Brazil, founded by the artist Augusto Rodrigues in 1948, where she taught Luiz Áquila and Gerson de Souza.

Other important meeting places and informal centers for the exchange of ideas were the small hotels where immigrants had settled. Almost 90 per cent of foreign artists lived in the Santa Teresa neighborhood or used to visit it. The already mentioned Hotel Internacional was home to Árpád Szenes, Maria Helena Vieira da Silva, Frank Schaeffer, Carlos Scliar, Jacques van de Beuque, Djanira and Milton Dacosta. The studio of Maria Helena Vieira, for example, became a regular

meeting place for intellectuals and artists from Rio de Janeiro (*Ciclo de exposições sobre Arte no Rio de Janeiro: Tempos de Guerra – Hotel Internacional* 1986). Very often, the meetings and parties revolved around classical music. Frequent visitors were the poets Murilo Mendes and Cecília Meireles, the artist Athos Bulcão, the scenographer Eros Martim and the art critic Marc Berkovitz. Pensão Mauá, in turn, was home to Inimá de Paula, Flávio Tanaka, Tadashi Kaminagai (his framing business was situated in the basement of the house) and Manuel Bandeira. Kaminagai's studio also served as a meeting place for the art critics Mário Pedrosa, Antonio Bento, Quirino Campofiorito and Frederico Barata and the artists Lasar Segall, Di Cavalcanti and Roger van Rogger. Others who lived in Santa Teresa were Emeric Marcier, Jean-Pierre Chabloz and Henrique Boese. Beyond this neighborhood, the exile artist's geographies encompassed Flamengo – here the Pensão das Russas accommodated Jan Zach and, for some time, the Szenes/Vieira da Silva couple; Copacabana, where the Hotel Londres and the house of Laszlo Meitner were situated, and Ipanema, the area, where Roger van Rogger and Wilhelm Wöller lived, and Glória, where Axl Leskoscheck resided.

During World War II and its aftermath, very few of these artists succeeded in having solo shows at official institutions like the National Museum of Fine Arts. In fact, only Marcier and Vieira da Silva had solo shows, both in the same year: 1942. A lot of the artists instead exhibited at new venues like the Gallery of the Brazilian Press Association (ABI), the Institute of Brazilian Architects (IAB), the Institute Brazil – United States (IBEU) and the Galeria Askanasy.

It is important to highlight that the presence of foreign artists in Rio de Janeiro had an impact not only on the local art scene, but also on the artists' own thinking and art practice. At Wilhelm Wöller's New York show in 1957 the art critic Alfred Werner noted that the artist's decision to flee Nazi-occupied Europe to tropical Brazil "would have been reinforced by a desire to find a less rational, logic and mechanized society" (Morais 1986, 23) – a romanticized view of Brazil, indeed. Still, according to Werner, Brazil's flora and fauna and Afro-Brazilian culture had made a huge impression on Wöller.

Brazilian nature also greatly impacted on artist Jan Zach who said that intimate contact with nature during the 11 years he lived there had made him more aware of the interplay of shadow and light, an observation prompted by the brilliant radiance of light in Rio de Janeiro. In an interview with journalist Vera d'Horta Beccari published in the *Folha de São Paulo* newspaper in 1980, Henrique Boese said,

> Brazil had an enormous influence on the way my art changed.
> The atmosphere and the colors of the country were a surprise to
> me. When we disembarked in Rio, in the middle of summer, in

the month of February, coming from the European winter, I was dizzy with the radical change of climate and color. The streets were full of flowering Flamboyants, it was all very beautiful. The foreigner who seeks to immerse himself in the Brazilian environment is influenced and transformed by it. The very foundations of art shift (Morais 1986, 23).

Árpád Szenes was also positively impacted on by his Brazilian experience. In an interview with Carlos Scliar, he affirmed that "[t]he war provoked a great rupture, and in Brazil I began to believe in mankind, in the world, in life, perhaps" (Morais 1986, 21). His wife Vieira da Silva, on the other hand, said, "In fact, in Brazil I was very marked and depressed by the events, so that I lived a little with the head in Europe, so I knew very little of Brazil." And she added, "Everything felt very fragile. We lived like butterflies" (Morais 1986, 21).

One of the main contributions of this massive influx of European immigrants to Brazil, with their improvised galleries and small studios located in hotels, was the introduction of Expressionism to the Brazilian art scene. As evidence of this development, a search for the term 'woodcut' in the digital database of the National Library of Brazil throws up 16 occurrences during the 1920s, 39 during the 1930s, and 284 during the 1940s when German Expressionism was being written about in the Brazilian press. This makes it also much harder comprehensively to grasp the concept and technique of woodcutting.

Even before the 1940s there had been exhibitions of German art in Brazil. There were also printmakers of German or Austrian origin who had moved to Brazil after World War I. Theodor Heuberger (1898–1987), for example, was born in Munich and based in Brazil and promoted the First German Exhibition of art and decorative arts in Rio de Janeiro in 1924. In subsequent exhibitions organized by him the Modernist influence became more pronounced – the exhibitions in the 1930s, for instance, feature prints by Käthe Kollwitz, Max Beckmann and Otto Dix. Heuberger ran his own gallery in Rio Brnaco Avenua in Rio de Janeiro (Lacombe 2009, 481–482). In areas in southern Brazil where Germany had had colonial influence, such as in Rio Grande do Sul, Expressionist art prints had circulated relatively early on without ever really influencing the local art scene.

A watershed moment – and a sign of how new networks had developed and spread throughout the Brazilian art scene during World War II – was the opening of an exhibition at the National Museum of Fine Arts featuring six centuries of German engraving, and at least 700 original works. This was initiated by Osvaldo Teixeira (1905–1974), a critic and art historian, and director of the museum at the time. Teixeira claimed that his exhibition was the first of its kind to take place in

Cristiana Tejo and Daniela Kern

Brazil (Pastorino 1951, 4). Among the participating Modernist artists were Max Liebermann, Max Slevogt, Lovis Corinth, Käthe Kollwitz and Oskar Kokoschka.

The influx of immigrant artist and intellectuals into Brazil can be seen as a moment of monumental cultural change: their presence reinforced local voices demanding the advance of modern art and prompted the emergence of innovative networks that interconnected local artists and intellectuals with the newly arrived. A good example of this catalytic change is the Swiss artist and art dealer Irmgard Burchard, who had arrived in Brazil in 1941. In the same year, local newspapers began to publish articles about her which were based, it seems, on press releases prepared by Burchard herself. During her early years in Brazil she presented herself as Madame Koré, a promoter of modern art: "Madame Koré, the well-known organizer of modern art exhibitions, in contrast to the classic style" ("Uma exposição de arte aplicada" 1941, 1). She sought to call attention to her image as a stimulating patron of the arts: "In Switzerland, for example, she invited more traditional painters to exhibit their works together with those of young modernists." ("Uma exposição de arte aplicada" 1941, 1) She also highlighted the exhibition of modern German art which she organized with Herbert Read in 1938 in London. As a justification for her taking refuge in Brazil, we can read the following:

> Madame Koré, being of Swiss nationality, is not properly a refugee, but with many of her friends dead or lost beyond the seas she felt willing to accompany a group that had the happiness of obtaining documents and tickets to Brazil. ("Uma exposição de arte aplicada" 1941, 1)

Burchard's clear intention to promote modern art in Brazil is also evident in another passage on the same subject:

> Here, with insufficient material to organize an exhibition of Modern European Art, she nevertheless founded an atelier with the practical purpose of producing objects such as lamps, shingles, vases, glasses, etc. It is the result of these works that is currently being exhibited at Christmas time. ("Uma exposição de arte aplicada" 1941, 1)

The local press would soon praise Burchard for this role, as we can read in an article from 1942:

> Madame Koré is one of the most vigorous advocates of modern
> art. She has succeeded in converting the isolated attempts of
> modernist groups into a homogeneous and defined style that
> establishes clear boundaries between classical art and art that
> is inspired by today's vertigo ("A exposição dos trabalhos de
> arte aplicada suíca de madame Koré" 1942, 9).

This text continues to be adapted for Burchard's other exhibitions, such as the one at Galeria Askanasy ("Uma arte que é beleza e utilidade ao mesmo tempo" 1944, 7), the first gallery of modern art in Rio de Janeiro, founded by Miecio Askanasy, Bruno Kreitner, the Austrian journalist and writer Van Rogger, a Belgian painter of Polish origin, and perhaps other artists. We know from Burchard's correspondence with her friends, the writers Clarice Lispector and Lúcio Cardoso, that Galeria Askanasy became an important meeting place. What all this enthusiasm hides, however, is how difficult it was to live in Brazil as an immigrant. Due to the lack of an established economic market for art, Burchard was not able to keep on working as a gallerist – instead, she started to paint, realizing a lifelong dream, as she recounted to one of the local newspapers ("Exposição de pintura de Irmgard Burchard" 1945, 1). Antonio Bento, an art critic who wrote a column in the *Diário Carioca* and who, incidentally, also did much for the promotion of modern art in Rio de Janeiro, analyzed Burchard's paintings with a much darker attitude:

> [t]he painter is one of the many castaways that the present war
> has launched on the back of our country. The affliction, the
> fear of mystery and of the unknown, which in recent times
> have seized so many thousands of Europeans, appear in many
> of their paintings, and even in still lifes of flowers, completely
> devoid of joy (Bento 1945, 6).

The hardships of immigrant life similarly affected Van Rogger, who also exhibited at the Galeria Askanasy, and who faced financial difficulties:

> [w]e are glad to know him among us, and it is with affection
> that we accompany his struggles and disappointments and new
> illusions and enthusiasms that make him our compatriot, since
> he shares the same hopes, difficulties and misunderstandings
> that make up the true 'environment' through which the artists
> of Brazil move ("A pintura moderna" 1944, 210).

Cristiana Tejo and Daniela Kern

Like Burchard, Van Rogger supported art and Modernist values:

> Rousseau, le douanier, can be classic because his work displays
> such purity. Braque, Bonnard, Matisse and Van Gogh for
> example, are classics because their works of art answer to a
> cosmic necessity. They are classic, they have class, they are the
> nectar of healthy, traditional thinking (Van Rogger 1944, 210).

Antifascism, too, is something that unites a good number of the members of
these networks around Askanasy and Burchard, and it is not unlikely that Burchard
assisted in the conception of the *Exhibition of Art Condemned by the Third Reich*,
inaugurated on 10 April 1945 ("Exposições" 1945, 9) by Miecio Askanasy in his
gallery. Askanasy himself was the author of articles and a book critical of Nazism,
the latter written with Bruno Kreitner. Miecio and Kreitner were friends with
Stefan Zweig, and it does not seem to be a coincidence that Ernst Feder, a German
Democrat and a close friend of Zweig, had been invited to write for the exhibition
catalogue and to give the opening address, entitled "Why the Nazis condemned
authentic art". Feder lived in the same house as the parents of Hanna Levy, a
German and Jewish art historian who also contributed to the exhibition catalogue.

The exhibition, which mostly featured engravings by modern German masters,
was a success, but it is worth remembering that Brazil had already been prepared
in favour of modern art and against the idea that it was degenerate. This becomes
evident in an article entitled "Lasar Segall and the degenerate art", written by the
art critic Nicanor Miranda and published in *Diário Carioca* in 1944, in which he
recounts his experience of visiting the degenerate art exhibition in Munich in
1937 – Lasar Segall's work was part of the exhibition – and in which he mounts a
strong defence of modern art which is worth reading in its entirety:

> But "degenerate" why? Because he painted deformed human
> figures? Because the artist wanted to realize himself using
> his own expression? But cannot the painter free himself from
> academic and rancid formulas to surrender to the transcendence
> of a vision of nature and life? Is the deformation not also an
> expression of medium? And is the expression not fundamentally
> the essence of painting and other arts? Why can the artist not
> be transported to the work of art by printing out his aversions,
> his tendencies, his desires, his passions? Is this degeneracy? But
> have other painters of the past not been behaving in the same
> way? In the same Germany? (Miranda 1944, 1).

A defence of "degenerate art", similar in spirit to this, would be published later in the newspaper section of the *Exposition of Art Condemned by the Third Reich*:

> Let us see what they painted. The Exhibition of Art Condemned by the Third Reich is not something phantasmagoric that induces fear or shiver. This art is only 'degenerate' to the enemies of culture, the burners of books, those who fear that great free men will speak to their fellow men in a language of freedom and human respect. Going to the gallery Askanasy, we will see pictures of women, atmospheres of circuses, visions of cities that perhaps no longer exist, […], beautiful women, forests. At times, a cry of revolt appears: Ferdinand Learen fixes victims under rubble, bombers, the striking sight of Guernica. We will also see boyfriends, bridges, trees, dunes, gardens, still lifes, forgotten landscapes (*Exposição de Arte Condenada* 1945, 3).

The closing remarks of the *Exhibition of Art Condemned by the Third Reich*, "World and Art", were delivered on 15 May 1945 ("'Mundo e Arte'" 1945, 5) by Tomás Santa Rosa, an artist and catalyst of the artistic scene of Rio de Janeiro, as well as a communist. Santa Rosa moved with ease among the emigrés and cooperated with them in countless artistic projects. Santa Rosa in his speech highlights the antifascist character of the exhibition:

> This is an exhibition that showcases works of art, composed by famous artists, that offer in their artistic totality a deafening and persistent struggle against one of the most destructive enemy forces of culture. ("'Mundo e Arte'" 1945, 5)

Nor does he fail to recognize the emergence of social inequalities in the tragic events of World War II:

> The twentieth century, which had the key to extraordinary scientific progress, has also brought forth a tremendous amount of social inequalities. And the fatal result, the outbreak of so much conflict, was bringing this avalanche of ineptitude down on life, mankind, and culture. ("'Mundo e Arte'" 1945, 5)

Cristiana Tejo and Daniela Kern

In her future publications Hanna Levy would articulate similar social critiques. She and Santa Rosa had in common not only friends like Portinari and Axl Leskoscheck, an Austrian artist who played an important role in the Brazilian art scene, but also the fact that they were both communists. Communism would become an important connecting piece within and throughout the artistic networks of Rio de Janeiro, especially among those who promoted modern German art in general and Expressionism in particular.

Hanna and Santa Rosa, involved in the *Exhibition of Art Condemned by the Third Reich*, would also be at the nucleus of an event that was decisive for Brazil's art world: the graphic arts seminars at the Getúlio Vargas Foundation. These courses in 1946 were offered to both Brazilian and foreign art students and familiarized them with Expressionism, the consequences of which would be felt for decades, for example in the works of former students like Fayga Ostrower and Danúbio Gonçalves.

Connections and exchanges among local and foreign artists without doubt helped to build the very foundations of Modern Art in 1940s Brazil. While it is true that Brazil could not offer them an established artistic environment, European artists and intellectuals instead created alternative spaces by mobilizing their communities and by initiating local partnerships: they taught courses, ran workshops, prepared exhibitions, created galleries. They also confronted local artists with international artistic movements such as Expressionism. What it is also pertinent to note here, however, is that the immense mobility and sheer fluidity of these artistic environments is also the reason why such networks were not able to take root – and have been, until now, almost completely omitted from Brazilian art history.

References

A "arte degenerada" de Lasar Segall: perseguição à arte moderna em tempos de guerra, edited by Jorge Schwartz et al., exh. cat. Museu Lasar Segall, São Paulo, 2018.
"A exposição dos trabalhos de arte aplicada suíça de madame Koré." *O Jornal*, 18 July 1942, p. 9.
"A pintura moderna. Nota sobre Van Rogger." *Suplemento literário de A Manhã*, 15 October 1944, p. 210.
Beccari, Vera d'Horta. "Fayga Ostrower." *O Estado de São Paulo*, 19 October 1980, p. 8.
Bento, Antonio. "Irmgard Burchard." *Diário Carioca*, 2 August 1945, p. 6.
Bueno, Maria Lucia (Org.). *Sociologia das Artes Visuais no Brasil*. São Paulo: Editora Senac São Paulo, 2012.

Ciclo de exposições sobre Arte no Rio de Janeiro: Tempos de Guerra – Hotel Internacional, Pensão Mauá, edited by Frederico Morais, exh. cat. Galeria de Arte Banerj, Rio de Janeiro, 1986.

Cruzeiro, Cristina Pratas, editor. *Migrations: Migration Processes and Artistic Practices in a Time of War – From the 20th Century to the Present*. Centro de Investigação e Estudos em Belas Artes, 2017.

Durand, José Carlos. Arte, Privilégio e distinção. São Paulo: Perspectiva, 1989.

"Exposições. Conferências. Associações." *A Manhã*, 11 April 1945, p. 9.

"Exposição de Arte Condenada pelo Terceiro Reich." *A Manhã*, 18 April 1945, pp. 3, 7.

"Exposição de pintura de Irmgard Burchard." *A Manhã*, 5 August 1945, p. 1.

"Fala o pintor Santa Rosa sobre o curso de Artes Gráficas." *A Manhã*, 24 March 1946, p. 3.

IBEU: Sessenta anos de arte, edited by E.E. Carlos, exh. cat. Galerias IBEU, Rio de Janeiro, 2000.

Kern, Daniela. "Hanna Levy e a História da Arte Brasileira como problema." *Anais do 24º Encontro da ANPAP*, 2015.

Kern, Daniela. "Hanna Levy e a Exposição de Arte Condenada pelo III Reich (1945)." *Anais do 25º Encontro da ANPAP*, 2016.

Kestler, Izabela Maria Furtado. *Exílio e literatura: escritores de fala alemã durante a época do Nazismo*. EDUSP, 2003.

Lacombe, Marcelo S.M. "1924: uma exposição de arte e arte decorativa alemã no Brasil." *Baleia na Rede: Revista online do Grupo Pesquisa em Cinema e Literatura*, vol. 1, no. 6, 2009, pp. 464–487.

Lamego, Valéria. "Dois mil dias no deserto: Maria Helena Vieira da Silva no Rio de Janeiro, 1940–1947." *Vieira da Silva no Brasil*, edited by Nelson Aguilar, exh. cat. Museu de Arte Moderna de São Paulo, São Paulo 2007, pp. 53–71.

Lesser, Jeffrey. *A invenção da brasilidade: identidade nacional, etnicidade e políticas de imigração*. Editora UNESP, 2015.

Levy, Hanna. "Alguns Aspectos da Arte Contemporânea Alemã." *Catálogo da Exposição de Arte Condenada pelo III Reich*, edited by Miecio Askanasy, exh. cat. Galeria Askanasy, Rio de Janeiro, 1945, n.p.

Miranda, Nicanor. "Lasar Segall e a arte degenerada." *Diário Carioca*, 20 October 1944, pp. 1, 3.

Morais, Frederico. *Cronologia das Artes Plásticas no Rio de Janeiro: Da Missão Artística Francesa à Geração 90*. Topbooks, 1995.

"'Mundo e Arte': A conferência pronunciada ontem na Galeria Askanasy pelo pintor Santa Rosa." *A Manhã*, 16 May 1945, p. 5.

Pastorino, Torres. "A gravura alemã contemporânea." *Gazeta de Notícias*, 3 August 1951, p. 4.

"*Roger van Rogger*." *Van Rogger*, http://vanrogger.com/index.php?/roject/article/. Accessed 25 November 2018.

"Uma arte que é beleza e utilidade ao mesmo tempo." *A Manhã*, 9 December 1944, p. 7.

"Uma exposição de arte aplicada." *Diário Carioca*, 18 December 1941, p. 13.

Van Rogger, Roger. "La peinture et le peintre." *Suplemento literário de A Manhã*, 15
 October 1944, p. 210.

Vieira da Silva no Brasil, edited by Nelson Aguilar, exh. cat. Museu de Arte Moderna de
 São Paulo, São Paulo 2007.

Kiesler's Imaging Exile in Guggenheim's Art of this Century Gallery and the New York Avant-garde Scene in the early 1940s

Elana Shapira

On 20 October 1942 the American-European art collector Peggy Guggenheim opened her gallery, Art of this Century, on New York City's West 57th Street with a vision to challenge viewers' perceptions and offer new aesthetic experience tinged with an awareness of the political, social and psychological repercussions of Nazi Germany's looming occupation of Europe and the realities of World War II. The immediate neighborhood of 57th Street enabled the returning Guggenheim to integrate more quickly into the professional environment of the city's commercial art scene. The groundbreaking exhibition space would offer a novel strategy for acculturation into the urban setting through the confrontation of New Yorkers with the alienating experiences of displacement and exile that persecution and war had made prevalent.

Guggenheim was the daughter of a wealthy Jewish family and niece of the well-known art collector and founder of the Museum of Non-Objective Painting, Solomon R. Guggenheim. She had moved to Paris in 1920 and had been involved with avant-garde literary and artistic circles before moving to London in the late 1930s. With the help of revered advisors such as artist Marcel Duchamp, she began collecting modern art. She opened a modern art gallery, Guggenheim Jeune, in London in January 1938 (Gill 2001, 186–245).

Unable to realize a more ambitious plan to found a modern art museum under the directorship of art historian Herbert Read in London, however, she closed her gallery in July 1939. After her return to Paris in 1939, she further considered pursuing the idea of founding a modern art museum and even rented a place in April 1940 (Rylands 2004, 22). Yet, it was soon dropped following Germany's invasion of France. In July 1941, Guggenheim returned to the US after 20 years of absence. Having fled Nazi-occupied France she opened Art of this Century

feeling a social responsibility in her endeavor. In a press release for the opening of her gallery she explained its aims:

> Opening this Gallery and its collection to the public during a time when people are fighting for their lives and freedom is a responsibility of which I am fully conscious. This undertaking will serve its purpose only if it succeeds in serving the future instead of recording the past. (*Peggy Guggenheim & Frederick Kiesler* 2004, 179)

Guggenheim's Art of this Century would showcase a new exhibition model designed by Austrian Jewish émigré designer Frederick Kiesler. As this essay will explore, Kiesler's avant-gardist strategy in the gallery would be to "un-key" viewers' perception by challenging their expectations regarding modes of interaction with artworks, dismissing their need to orient themselves within a given space and questioning fixed notions of "place" and "time". Kiesler experimented with what Austrian émigré art historian to Britain Ernst Gombrich would later observe regarding visual perception, that "we respond differently when we are 'keyed up' by expectation, by need, and by cultural habitation" (Gombrich 1987, 304).

Gombrich would suggest in his book *Art and Illusion* (originally published in 1959) that viewers' perception of an artwork is a construction according to contextual expectations (ibid., 304f.). In order to disrupt viewers' projection of a hypothesis proper to the situation at hand (Gombrich's "schema"), Kiesler, independent of his fellow Viennese's later theoretical work, deliberately disrupted the viewer's contextual expectation, which would have guided the projection of a given (rationally justified or emotionally loaded) image in the process of reading the artwork (ibid, 231).

Kiesler did so by displaying artworks as 'exiled bodies'. He would stage artworks and visitors in such a way as to make them participants in a *tableau vivant* as though they were a group of exiles. Transforming two tailor shops Guggenheim had rented on 57th Street into a 'living performance' space Kiesler set artworks as part of the stage set, yet both the artworks and visitors were meant to participate in this grafted cultural action scheme as 'actors'.

Visitors could engage with and handle the artworks, granting them new meanings by participating in a constructed artistic unity (Guggenheim 1960, 100; Rosenbaum 2017, 14). It is suggested that through this Kiesler imaged the frightening experience of 'exile' – the state of being expelled or barred from one's native country or home – as a new 'cultural construction' that would be critical to the understanding of contemporary European and American art. He grafted this

'exile' template onto his exhibition display using a Surrealist language, while also turning it into a *Gesamtkunstwerk* (Total-Art-Work). It was a space that projected 'exile' on many levels – also mirroring the contemporary interrelations within New York's bohemian society, offering exiled ('displaced') European artists and local ('placed') American artists/visitors a cultural platform for a shared future. In this way, Kiesler envisaged and realized a new and radical perceptual experience of contemporary art. He set the stage for complicating what Gombrich noted, that perceiving art from the standpoint of experience is identical with observing differences, relationships, organizations and meanings (Gombrich 1987, 218). Furthermore, what is being stressed here is that Kiesler was participating integrally in creative dialogues occurring in parallel within émigré and American artistic networks and that these discourses would be critical to his career in the US.

In her essay "Concerning Exile Art in the US", art historian Sabine Eckmann argued that the mid-20th-century "art world that the exiles needed to develop was an international one, focused on gaining support for European modernism and its complicated aesthetic languages" (Eckmann 2011, 444). Guggenheim's achievement through the opening of Art of this Century, furthermore, was not only introducing European exiled artists to the public discourse but forging "aesthetic relations between the younger American artists such as Jackson Pollock and European surrealists like Max Ernst" (ibid., 445). It was the inspired dialogue between Guggenheim and Kiesler and their artistic networks of lovers of art and artists that successfully achieved this mission. The question arises how Kiesler envisaged this new community in this gallery. How did his own network contribute to his exhibition design? This essay further introduces the involvement of Americans art dealer Howard Putzel, art collector and patron Sidney Janis and gallerist Julien Levy, yet focuses on the close artistic exchange with the French exiled gentile artist Marcel Duchamp. All four would contribute creative input to Kiesler's design for Art of this Century in New York City's 57th Street.

Émigré designer Kiesler as a creative translator

Kiesler succeeded in reworking his dialogues with different artistic producers/art dealers, combining these with his impressions of the commercial and museum scenes, and translating a European Surrealist artistic language into a novel American exhibition design language – which is defined here as a chosen form of shared communication. In the early 1930s, aware of the rise of fascism in Germany and Austria and sensing that his visionary ideas may have more chances of realization in the US than in Europe, Kiesler decided to remain in the US. In December

1936, he received American citizenship (*Friedrich Kiesler: Life Visions* 2016, 196).[1] Nevertheless, he followed political events in Austria, informed by Austrian visitors, émigrés and refugees with whom he regularly met, and was aware of the persecution of Jews specifically after the Anschluss of Austria to Nazi Germany in March 1938. Furthermore, through letters he and his wife Stefi Kiesler received from his nephew Walter (for example from Bologna, Italy: Kiesler/Walter 1940), he was aware that his closer family was in danger. The recent wave of refugees, French artists arriving in 1941 and 1942, may have increased this sense of urgency to confront the topic of exile through a novel staging of artworks in the new gallery. Art historian and curator Lisa Phillips describes Kiesler's mediating work as a European in New York at the beginning of the 1940s:

> Kiesler's Greenwich Village apartment [...] was a haven for visiting and émigré Europeans. [...] symbols of America – the Statue of Liberty and the Empire State Building were clearly visible from his penthouse apartment. [...] Committed to fostering an active exchange of ideas among artists of all disciplines and nationalities, Kiesler also relished the potential drama of these encounters. The spirit of the old Vienna café days remained with him, and most of his evenings were spent talking with his friends at Romany Marie's or other Village haunts into the early hours. (*Frederick Kiesler* 1989, 27, 29)

Guggenheim's Art of this Century design project developed parallel to an ongoing cultural exchange between European and American creatives, such that, as in the case of Kiesler, a remarkable dialogue would be materialized through new artworks. For example, the Frenchman André Breton, who arrived in New York in July 1941, helped to select the works for Art of this Century's opening show. Breton and Guggenheim chose the works to be displayed, but it was Kiesler's close contact with and continual awareness of the New York art scene that secured that his design would be groundbreaking. He had been closely following the gallery scene in the immediate neighborhood of The Art of this Century, which was at 57th Street in midtown New York. The earliest commercial galleries were situated on and near 57th Street, possibly because of its proximity to the Museum of Modern Art. Already in the mid-1930s almost 40 commercial art galleries were situated on 57th Street, including ones devoted to old masters, international modern masters, Chinese Art, Modern paintings and sculptures of the American and Hispanic schools, French art, contemporary German art and Surrealist art. Renowned

émigré gallerists such as French émigré Pierre Matisse (41 East 57th Street) and German émigrés Curt Valentin (Buchholz Gallery, 32 East 57th Street) and J.B. Neumann (The New Art Circle, 35 West 57th Street) had their spaces among these (Anonymous 1934, 26–33). The number of galleries on this street tripled within the next decade.[2] A few minutes away from Art of this Century was the Art Students League building, shared with the American Fine Arts Society (215 West 57th Street), where the American Abstract Artists held their annual exhibitions. Kiesler regularly attended openings at the Modern Art Museum and established close ties with gallerists, as documented in his wife Stefi Kiesler's calendar. She notes, for example, that a few months before he started working on the design of Guggenheim's future gallery, he visited the Salvador Dalí exhibition at Julien Levy's gallery in April 1941, and, in May, he attended a lecture at Nierendorf's gallery by J.B. Neumann about the French émigré artist Amédeé Ozenfant, who was a close colleague and friend of Kiesler (Kiesler 1941, n. p.).The possibility of designing a gallery for Guggenheim granted Kiesler a specific visionary perspective, "[w]e, the inheritors of chaos, must be the architects of a new unity" (Kiesler 2004, 175). He chose to show the transformation of the 'chaotic' state of exiled artists through the representation of their works as 'exiled bodies' in his display choices for Guggenheim's Art of this Century. The displaced experience he projected, however, was ultimately meant to produce a unified *Gesamtkunstwerk* in the sense that he used the staging of artworks as 'exiled bodies' in a deliberate manner to stage interpersonal relations between visitors and artworks that would ultimately secure a sense of a communal union as a *Gesamtkunstwerk*.

Kiesler was an Austro-Hungarian from Chernivisti, Galicia (German Czernowitz after World War I in Romania, now Ukraine) who migrated to Vienna in 1908. In order to understand why he consciously avoided the idea of assimilation into American culture, as noted below, it is important to take a closer look at his special career which started with studying a year of architecture at the Technical University, followed by three years of painting at the Academy of Fine Arts in Vienna (*Friedrich Kiesler: Life Visions* 2016, 194):

> Shrewdly evading the twin authorities of autonomy and ideology, he exploited and amplified his hybrid identity as artist, architect, set designer, and visionary, as well as his ambivalent cultural position (as a radical European antagonistic to American versions of "modern decoration" and an iconoclast in regard to European avant-garde). (Linder 1997, 126)

Yet, Kiesler's first career breakthrough was with a theater stage-set in Berlin in 1924. With the exhibition design titled *Internationale Ausstellung neuer Theatertechnik* (International Exhibition of New Theatre Techniques) in 1924 in Vienna's Konzerthaus he achieved fame. A year later the modernist architect Josef Hoffmann invited Kiesler to design the Austrian theater section in the *Exposition international des arts décoratifs et industriels modernes* (The International Exhibition of Modern Decorative and Industrial Arts) in Paris. There, in 1925, Kiesler exhibited his groundbreaking *Space City*, an installation with a futuristic vision of a city in space. Frederick and Stefi Kiesler arrived in New York in 1926 following an invitation to arrange an *International Theater Exhibition* at the Steinway Building.[3] In 1928, he designed the Saks Fifth Avenue window display, and a year later he designed the Film Guild Cinema in New York. Around this time Kiesler received his architect's certificate from The University of the State of New York, and in 1930 he founded his own design firm together with Harriet Janowitz, the wife of art collector and later gallerist Sidney Janowitz, who later also changed his name to Janis (*Frederick Kiesler* 1989, 22). That same year Kiesler also published his book entitled *Contemporary Art Applied to the Store and its Display,* in which he identified the "Psycho-function" in architecture as "that 'surplus,' above efficiency, which may turn a functional solution into art".[4] This is all to say that his prior experiences in stage design and commercial design, as well as his developing theories on the psychological potential of the built environment, would contribute to his exhibition plans for Art of this Century more than a decade later.

In 1932, Kiesler joined AUDAC (American Union of Decorative Artists and Craftsmen) and regularly met with the group. In 1934, he designed the Space House commercial exhibition at the Modernage furniture store in New York. That same year he was hired by the director of the Julliard Music School and music professor at Columbia University, John Erskine, to design the stage setting. Kiesler worked at Julliard from 1934 to 1957. In 1936 he became affiliated with the government-sponsored Design Laboratory of the Works Progress Administration Federal Art Project (later Laboratory School of Industrial Design) for poor students, with its progressive design education based on the pedagogic theories of American John Dewey and the education model of the German Bauhaus. In spring 1936 he guest lectured at Design Laboratory together with art historian Meyer Schapiro, architect Percival Goodman and art patron Alfred Auerbach (Bearor 1993, 66f.). These collaborations further show how well Kiesler was integrated into New York's intersecting art, academic, cultural and commercial scenes. It may have been Erskine who introduced Kiesler to the dean of the Architecture of School at Columbia University, Leopold Arnaud.[5] Arnaud hired Kiesler to direct the laboratory for design correlation at Columbia University in 1936.

The Americans Erskine and Arnaud acknowledged the necessity of a scientific project that would allow the intervention of design in order to construct new relations between people and design, evoking new critical consciousness regarding the environment. Kiesler perceived the aim of his research, this scientific approach to architecture, design and urban planning, as "[… learning] to see everyday happenings with a fresh keen eye and to develop by that a more and more critical sense of our environment".[6] Architect and architectural historian Stephen Phillips notes that Kiesler proposed to study 'Biotechnique', the dialectical relationship between a human and the environment or, as Kiesler described it, "the interrelation of a body to its environment: spiritual, physical, social [and] mechanical" (Kiesler 1934, 292; Phillips 2017, 131). In Kiesler's design for Art of this Century he would explore these provocations, creating a radical imaging of 'anti-relations' of (art) bodies to a (constructed) environment.

It was a few months after Kiesler's contract with Columbia University finished, in 1941, that he received the following request from Peggy Guggenheim: "I want your help. Will you give me advise [*sic*] about remodeling two tailor-shops into an Art Gallery?"[7] Guggenheim made it clear that the gallery should be designed according to her collection and not simply as an adaptation of space. Considering the laboratory research he had just concluded on the interrelations of a body to its environment, could it be that Kiesler chose to continue his 'field research', creating a new 'out-of-the-frame' extreme environment in Art of this Century? Was his exhibit display, where visitors were confronted with 'exiled bodies', meant to force them to question their own interrelations not only to art but to each other and to their New York environment? When Peggy Guggenheim decided to found a new gallery to include her collection and temporary exhibitions, she envisaged it further in relation to her uncle Solomon R. Guggenheim's Museum of Non-Objective Painting/Art of Tomorrow, which opened in New York in 1939 (its first location was East 54th Street).[8] Kiesler's idea for exhibiting her collection, with its inclusion of abstract 'non-objective' paintings and sculptures as 'exiled bodies', would have been a radical statement about contemporary historical events but, beyond this, it would have been a demonstration of the heightened 'otherness' of her gallery within New York's – and 57th Street's – commercial and cultural art scenes.

The Art of this Century space had four gallery halls (each identified in the historiography with a capital G): the permanent collection of mostly European artists was shown in three galleries, in the Abstract Gallery, the Surrealist Gallery and the Kinetic Gallery, while the Day-Light Gallery showed temporary exhibitions and also promoted newly 'discovered' American artists. Guggenheim positioned her desk near the entrance to the Abstract Gallery (Guggenheim 1960, 101). In the

different galleries, the art objects appeared as 'uprooted' objects or, as suggested here, 'exiled bodies'.

In order to simulate the intra-psychic and interpersonal relations formed by the condition of 'exile', Kiesler displayed the art objects as 'exiled bodies'. Exiled bodies are identified here as occupying in-between spaces, literally separated from their supporting 'wall' background, devoid of historical narrative, deprived of a continuity with their environment and further 'cut' from relating in a familiar manner to each other. In the Surrealist Gallery, Kiesler mounted unframed paintings on baseball bats protruding from the walls, allowing viewers to manipulate them at angles (ibid.). In the Abstract Gallery paintings and sculptures were similarly 'detached' from a backing wall, and instead were displayed as 'hanging by strings' connected to ceiling and floor (fig. 1). The arrangement also involved tactile experiences for the viewer. Kiesler thus addressed the question of what can be learned about ourselves and about our environment from how we perceive artworks. Kiesler's design grafted new patterns of interaction between viewer and art that encouraged reflections on the sense of self and, further, on the relationship of the viewer to her environment. As described by media historian Erkki Huhtamo, the artworks "['rushed'] toward the spectator [...] [and] systems of strings [...] holding little sculptures in-between [could be] potentially elevated or lowered by the visitor" (Huhtamo 2006, 82).

Kiesler's 'exiled bodies' seemed to invade or float within the viewers' dreamworld. In the third, corridor-like space, the Kinetic Gallery, Duchamp's *La Boîte-en-valise* was displaced 'into the wall', as was a series of paintings by Klee. (More will be said about Duchamp further below.) For the Art of the Century gallery Kiesler also designed a chair which was reminiscent of the German French artist Jean Arp's sculptures, that could transform into a stand for artworks or that could extend to be a bench or a table.[9] Art historian Dieter Bogner compared Kiesler's stand/chair design to his stage set for the production of Georg Antheil's opera *Helen Retires* at the Julliard School of Music (1934) (fig. 2) (Bogner 2012, 125). Bogner further argued that the design of Art of the Century represented a radical break with traditional exhibition design conventions and provoked strong reactions. Viewed from the theatrical perspective, it is a staged set with light choreography (the artworks on both sides of the Surrealist Gallery were alternately illuminated at the very beginning, after the opening – heightening a sense of restlessness as against a sense of stability) and the 'stage directions' included background noise of a train passing through the room (ibid.). The noise of the train was meant perhaps to evoke an imaginary scene of both visitors and artworks waiting 'at a station' for their train to travel to another place or perhaps evoke a sense of threat, of being 'attacked' by a passing train. The artworks moved away from the wall, floating in

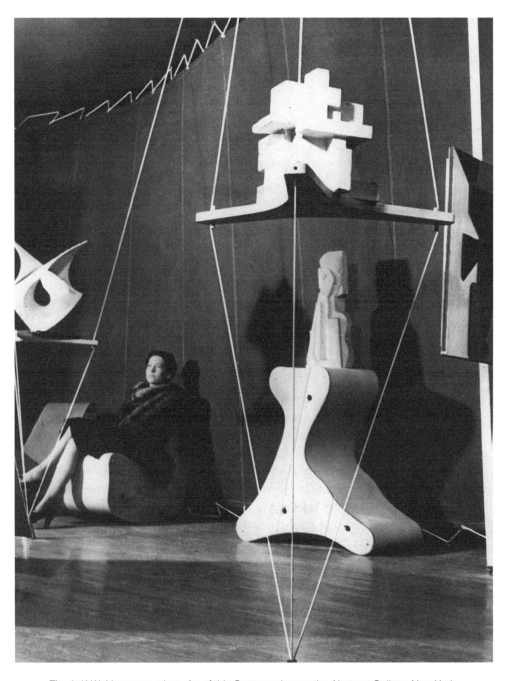

Fig. 1: K.W. Herrmann, photo Art of this Century, view on the Abstract Gallery, New York, 1942 (© 2019 Austrian Frederick and Lillian Kiesler Foundation, Vienna; ÖFLKS PHO 364/0).

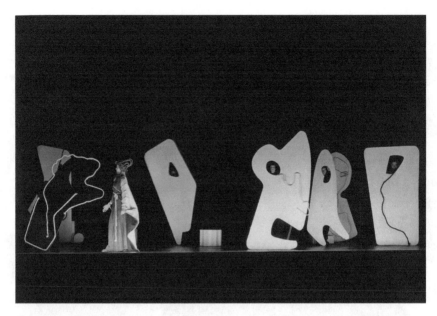

Fig. 2: Gottscho-Schleisner (Samuel H. Gottscho and William Schleisner), Stage scene with actors (2nd act) from Georg Antheil's opera *Helen Retires*, performance at the Julliard School of Music, New York, 1934 (© 2019 Austrian Frederick and Lillian Kiesler Foundation, Vienna; ÖFLKS PHO 2940/0).

space without the usual framework, and thus confronted the viewer with a new kind of critical dialogue about art (ibid.). According to Kiesler's action scheme, both artwork and viewer were actors on the stage he had designed. It is this aspect of his design, this transformation of both the viewer and the artwork into corresponding parts within a language of displacement that can be articulated as a post-modernist 'totality' and a *tableau vivant*. If the paintings would have been fixed to the wall they would have 'belonged' to 'the house', belonging to a different space and place – yet they were displaced from this. As designer of Art of this Century, Kiesler questioned established notions of the viewer 'self'. He eliminated the safe distance between the art object and the viewer's body, and further transformed the viewer's body into part of the display, prompting a new relationship (fig. 3). This change forced the act of seeing into a different act of consciousness, which to Kiesler was integral to the viewer's creative experience.

Elana Shapira

Fig. 3: Berenice Abbott, photo, Art of this Century, Surrealist Gallery (detail), New York, 1942 (© 2019 Austrian Frederick and Lillian Kiesler Foundation, Vienna; ÖFLKS, PHO 339/4).

The new art community of exiles and Americans in New York

In his 1944 book, *Abstract & Surrealist Art in America*, Kiesler's friend and patron, the American Sidney Janis, was aware of the critical role of exiled artists in the construction of a new art community:

> By their authorship, the artists in exile, many of whom have worked in their respective idioms for a generation or more, have produced that heightened activity which comes from personal contact, besides nurturing in American – painters and public alike – a reassuring sense of the permanency of our common culture. Because of this common culture the merging of artists in exile with our painters is a natural consequence of their being here together. (Janis 1944, 127)

Kiesler's staging of 'detached' artworks as 'exiled bodies' in a disruptive manner demonstrated that both the exiled artists and the American visitors were all part of the same artistic community, sharing the same (international-European-American)

culture. Kiesler had previously argued that "the only human experiences that can be inherited by children are those of customs and habits by way of training and education, thus 'social heredity'"[10]. Yet, what happens when exile disturbs the transfer of customs and habits? In the Art of this Century Gallery it seems that Kiesler shaped an environment to amend the émigrés' break with tradition and, in parallel, aimed to renegotiate the experience of exile as one that could offer a renewal of the New York art scene.

Significantly, it was the art dealer Howard Putzel who recommended Kiesler to Guggenheim and perhaps also contributed to Kiesler's access to key American artists. When Putzel moved to Paris in 1938–1939 he befriended Peggy Guggenheim, becoming an advisor to her as she accumulated her collection (Guggenheim 1960, 69). When Putzel relocated to New York in the summer of 1940 his interest turned to finding new, native talent. The Kieslers had socialized with Putzel since the early 1940s.[11] Putzel curated an exhibition of Surrealist art to accompany a 1941 lecture series at the New School of Social Research on the movement organized by Meyer Schapiro; among those attending were the American artists Robert Motherwell and Jackson Pollock (Bois 2005, 326). Knowing Kiesler's and his supporters' close links with the artistic spheres on two continents, the question arises, however, as to how Kiesler succeeded in converting the cultural languages of different artistic networks into a new futuristic artistic language for the Art of this Century Gallery. Kiesler's socializing with gallerist Julien Levy and collector Sidney Janis also had direct and indirect influence on his designs. A Surrealist inspiration could have been an exhibition in 1937 at Julien Levy Gallery in which paintings were hung on curving white walls. Another inspiration for Kiesler's design, noted by graphic designer and design historian Don Quaintance, was Bauhaus artist Herbert Bayer's design of the 1938-1939 Bauhaus exhibition at the MoMA, in which the designer "installed undulating floor patterns, suspended photographic panels, and a horizontal peephole" (Quaintance 2004, 209). A further interesting historical reference was a 1939–1940 installation that Kiesler and Sidney Janis together mounted at the MoMA's Penthouse Gallery in conjunction with the *Picasso: Forty Years of His Art* exhibition.[12] For both Janis and Kiesler it was important to reflect on art beyond the aesthetic experience. In this context, the concept of the *Gesamtkunstwerk* can be viewed as an expansion of what 'art' may encompass.

Elana Shapira

The 'eternal émigré' in Art of this Century: imaging exile with Duchamp

Guggenheim, Putzel, Janis and Kiesler knew Marcel Duchamp, and Duchamp offered a novel perspective on the notion of the *Gesamtkunstwerk*. In the early 1930s Putzel came to know Duchamp possibly through the collectors Walter and Louise Arensberg. By 1934 Putzel was familiar with Surrealism and it was largely thanks to him that it was introduced on the West Coast (Lader 1981, 146). Duchamp had been Guggenheim's advisor when she first conceived the idea of opening an art gallery in London and Janis had identified Duchamp's *La Boîte-en-valise* as representative of a work of an artist in exile (Janis 1944, 131). In Duchamp's Surrealist exhibition designs, he would stage a scheme of delegated authorship, which transferred action from exhibition designer to viewer – granting her creative license to be part of creating new meanings of the artwork. In the design of Art of this Century, Kiesler pursued this same transference, enacted through viewing that involved very specific conditioning, aimed at exiling the viewer's own body. Kiesler used the concept of *Gesamtkunstwerk* in order to create an 'imagined community' that expressed a shared sense of estrangement and experience of alienation – where people and artworks were together exiled into 'an alternative' dream world with its own rules.

Kiesler and Duchamp developed a relationship over 15 years. Duchamp had fled Nazi-occupied France in May 1942, eventually moving to Kiesler's apartment during the month in which Art of this Century was opened, and it remained his address for a year. Kiesler and Duchamp had met during the *Exposition Internationale des Arts Décoratifs et Industriels Moderne* in Paris in 1925. A year later they both arrived in New York to be part of two different exhibitions. In November 1926, the co-founder and driving force of the Société Anonyme, Katherine Dreier, opened the *International Exhibition of Modern Art* at the Brooklyn Museum and invited Kiesler to participate. In that exhibition Kiesler worked on the design of a 'modern room', later to become known as the 'television room', in which visitors at the touch of a button would be able to see masterpieces from all over the world. Kiesler envisaged 'exiling' the paintings from their 'home' museums/galleries metaphorically in order to make them available for everyone (Rosenbaum 2017, 8). Duchamp's *Large Glass* was exhibited in this exhibition for the first and the last time before it was broken and reassembled for a new "broken version" of the artwork (Gough-Cooper/Caumont 1989, 62).

A decade after Dreier's exhibition in 1926, Kiesler and Duchamp continued to collaborate. During 1936, Kiesler and Duchamp met frequently. Duchamp had spent the summer of 1936 repairing the *Large Glass* for Dreier and Kiesler,

who was impressed by *Large Glass* after its repair, wrote and designed the graphic layout of eight pages dedicated to it for the May 1937 issue of *The Architectural Record*. It was the first review of the artwork to appear in the US (Gough-Cooper/ Caumont 1989, 62). Kiesler's reflection on Duchamp's artwork would serve him later in his design of the Surrealist and Abstract galleries in Guggenheim's project. Perhaps most interesting are his remarks on the way *Large Glass* seemed to have contradictory values: "While dividing the plate glass into areas of transparency and non-transparency, a spatial balance is created between stability and mobility. By way of such apparent contradiction the designer has based his conception on nature's law of simultaneous gravitation and flight" (Kiesler 1937, 55). In his staging of the artworks as 'exiled bodies' Kiesler would reach for the psychological balance between stability and mobility – demonstrating how the chaos of exile could transform into a stable artistic unity. In Guggenheim's Kinetic Gallery, Kiesler installed Duchamp's *La Boîte-en-valise* (*Box in the Suitcase*, completed in January 1941) opposite a mechanical apparatus showing a group of Paul Klee's works. This corridor gallery that housed Duchamp's *La Boîte-en-valise* seemed to perpetuate the idea of the artist and the viewer as eternal travelers.

Duchamp chose his own way of confronting the subject of exile, but there were overlaps in his approach to displacement and Kiesler's. In 1942 fashion designer Elsa Schiaparelli asked Duchamp to install the *First Papers of Surrealism* exhibition for the Council of French Relief Societies at the Whitelaw Reid Mansion. Duchamp, Breton and Max Ernst chose roughly 50 artists – mostly known Surrealists but also some new American associates such as Joseph Cornell, Kay Sage, David Hare and Robert Motherwell. Art historian Yve-Alain Bois suggested that "the title, 'First Papers,' referred to application forms for US citizenship, and it could be read either as an optimistic statement of a new life or a bitter mockery of all official identification at the height of World War II" (Bois 2005, 332).

The extensive catalogue in the Surrealist spirit accompanying the show included a foreword by Sidney Janis (Lader 1981, 110f.). Duchamp's tangle of string, a mile in length, wound all around the main gallery in a way that not only obscured the paintings but also obstructed entry to the space. According to art historian David Hopkins, however, there was more to the concept than evoking a sense of displacement and causing obstruction:

> The cat's cradle-like installation, quite apart from its iconoclastic role in cancelling out some of the paintings, may have a more direct relationship to the children's games than has thus far been acknowledged. While Duchamp scholars have tended to see the 'mile of string' installation as alluding to the displacement and

Elana Shapira

disorientation of the surrealist group at this time – not least
because most of the artists had only recently arrived in the US
after difficult passages out of wartime Europe – the concept
of play was obviously central to the opening of *First Papers of
Surrealism*. (Hopkins 2014, n. p.)

For Hopkins, Duchamp offered the Surrealists a tangled cat's cradle as critical
opposition: "the return to the principle of play was the only means of reconnecting
with a genuine avant-gardism" (Hopkins 2014, n. p.). The element of play was
also critical to Kiesler's novel staging of artworks as 'exiled bodies' in Art of this
Century – in his case, however, we see 'play' in the form of the theater or the stage
play, where artworks and visitors are both transformed within an avant-gardist
tableaux vivant. In Guggenheim's gallery space, it is possible that Kiesler installed
Duchamp's work in coordination with the artist himself since, as noted, Duchamp
had been living at Kiesler's apartment at the time. Here it should be considered
that the two artists may well have coincided in wanting this work of Duchamp's
for this exhibit in order specifically to showcase the concept of the 'exiled' object.

Art historian T.J. Demos argues that Duchamp worked on *La Boîte-en-valise*
during the period of his displacement (between 1935 and 1941). It contained a
collection of 69 reproductions of Duchamp's artwork and the artist was quoted as
stating, "My whole life's work fits into one suitcase".[13] In the Art of this Century,
the mechanism of viewing the work through a peephole while operating a large
oversized wooden 'ship's wheel' – as if steering the 'vessel' and controlling its
course – allowed the viewer the illusion of moving in virtual (sea) space while
watching the landscapes of Duchamp's *Boîte,* and recapturing the sense of 'travelling'
through Duchamp's work. The oversized wheel rotated a second wheel mechanism
(concealed inside the partition) that brought, one by one, 14 images from the valise
into view through the peephole. The rest were displayed in a stationary manner
in the semicircular vitrine and were located between the viewer and the center
of the wheel installation (*Peggy Guggenheim & Frederick Kiesler* 2004, 258). The
American photographer Berenice Abbott captured an interesting moment of the
exhibit. She photographed a woman leaning on the wall as she looked through
the peephole, her shadow surfacing on the wall as another threatening figure
behind her shoulder.[14] The woman tilts her head as she nonchalantly holds the
spoke of the wheel with her fingers. The peephole in the wooden box is like an eye
watching her – parallel to her watching the work. Presenting another perspective,
K.W. Herrmann photographed an elegantly dressed woman standing in front of
the wooden box looking concentratedly through it (fig. 4).[15] Her shadow also
surfaces on the wall as a threatening figure, this time next to her. The woman's right

Fig. 4: K.W. Herrmann, photo Art of this Century, Viewing mechanism for Duchamp's *La Boîte-en-valise*, Kinetic Gallery, New York, 1942 (© 2019 Austrian Frederick and Lillian Kiesler Foundation, Vienna; ÖFLKS PHO 230/0).

hand, dressed now with a glove, lightly touches the spoke as if stroking it. In both photos, new works of art are produced through the viewers' own interaction with the wheel as they occupy this creative space. The women and the wheel appear as new *Tableaux Vivant*, yet their interactions with the mechanical installation highlight the notion of Duchamp's work as 'exiled body'. The artwork cannot be seen/accessed immediately, and as an eternal (not fixed) exiled body it can only be seen 'in movement'. Demos also makes a critical reference to philosopher Theodor Adorno's argument regarding measuring the exile's paradoxical status that has an impossible but necessary relation to space and possessions (Demos 2002, 9). Demos argues that through the "visualization" of collection, reproduction and portable storage, Duchamp's *Boîte* represents the artist's needs as an exile, "defined by the loss of possessions, homesickness, and unending mobility" (ibid., 10). The anonymous women in Abbott's and Herrmann's photos eternalize this sense of the cursed "unending mobility". Given the historical developments in Europe in the late 1930s, this portable museum became a representation of a certain unavoidable fate that led to forced emigration or what Demos, in referring to Duchamp's *Boîte,* identifies as a "homeless aesthetic" (Demos 2002, 12).

Elana Shapira

Conclusion – the power of renewal in staging of artworks as 'exiled bodies' in 1942

Austrian émigré Kiesler's artistic networks are critical to the understanding of his design of the Art of this Century Gallery in New York. His choice of creative enactments of Surrealist and Abstract artworks in space, which provoked viewer participation in a staged happening in which viewer and object performed a *tableau vivant* simulated and transformed the limiting and frightening experience of exile as part of an artistic encounter and furthermore produced a stimulating creative experience:

> Kiesler's diverse work and evolving identity were constructed and reconstructed. [...] Never lacking for techniques or tactics, Kiesler adopted the role of translator – continually reconstructing and revising various modernist idioms and restaging them theatrically as what could be called 'the display of the avant-garde'. (Linder 1997, 126)

In his design of Art of this Century, Kiesler conceived a novel scheme in which artworks, viewers and artists (many of whom were newly exiled in New York) existed as 'exiled bodies'. Kiesler's choice to display artworks as groups of relational objects released from the wall space prompted multiple ways of perceiving. It further evoked awareness of the relevance of the exile experience to the renewal of the New York art scene. Kiesler conceived his design as part of fruitful dialogues with Putzel, Janis, Levy and, last but not least, Duchamp, staging a radical creative action in which the viewer as 'an exile' herself needs to forge her own mental orientation while also confronted with 'un-settling' bodily sensations and spiritual thoughts. Through his design Kiesler succeeded in representing a progressive, unified art scene, focusing not only on gaining support for European modernism and its complicated aesthetic languages, but further developing a shared cultural platform between the exiled Europeans and the American visitors. Together Peggy Guggenheim and Kiesler aimed to create a new experience of seeing art that would radically showcase the novelty of the artworks in her collection. Staging the artworks as 'exiled bodies' – integrating the experience of 'exile' in terms of objects and participants – was an ultimate avant-gardist expression. Kiesler's *Gesamtkunstwerk* design of the Art of this Century Gallery in New York also raises questions on how artistic production can bind a community of exiles – or how different artistic networks could be transformed into a united artistic group.

Notes

[1] On this occasion he changed his name from the German Friedrich to the French Frederick and further his second name from Jacob to John.

[2] Women gallerists took part in fashioning the avant-garde scene on 57th Street, including Mrs Ehrlich (Ehrlich Gallery 36 East 57th Street), Marie Harriman (63 East 57th Street), Marie Sterner (9 East 57th Street) and Mrs Morton (Morton Galleries, 130 West 57th Street). In an article entitled "57th Street" in *Fortune Magazine* in September 1946, there is reference to 150 dealers "who control the art market of the country in an apparently unbreakable bottleneck." Quoted in Sonzogni 2004, 275.

[3] Stephanie Kiesler, née Frischer, is known also as Stefani, Stefi and Steffi; here she is noted as Stefi.

[4] Frederick Kiesler. *Contemporary Art Applied to the Store and its Display*. Brentano's, 1930, p. 87. Quoted in Phillips 2017, 113.

[5] In Stefi Kiesler's calendar book there are several references to socializing with Erskine during the 1930s.

[6] Frederick Kiesler. "First Report on the Laboratory for Design Correlation." 1937, p. 2 (Austrian Frederick and Lillian Kiesler Foundation). Quoted in Phillips 2017, 131.

[7] Letter from Peggy Guggenheim to Frederick Kiesler, 26 February 1942, in: *Peggy Guggenheim & Frederick Kiesler* 2004, 173.

[8] On the rivalry between Hilla Rebay, the advisor and first director of the Non-Objective Painting Museum, and Peggy Guggenheim, which had begun while Peggy was still in Paris in 1940, see Gill 2001, 236f.

[9] On the relationship between Kiesler and Jean Arp (originally Hans Arp) see Stephanie Buhmann, "The Friendship Between Hans Arp and Frederick Kiesler." *Frederick Kiesler: Face to Face with the Avant-Garde. Essays on Network and Impact*, edited by Peter Bogner, Gerd Zillner. Frederick Kiesler Foundation. Birkhäuser, 2019, pp. 219–236.

[10] Frederick Kiesler. "On Correalism and Biotechnique: Definition and Test of a New Approach to Building Design." *Architectural Record*, September 1939, p. 61. Quoted in Staniszewski 1998, endnote 11 of chapter 1.

[11] Stefi Kiesler's Calenders 1930–1952 (Austrian Frederick and Lillian Kiesler Foundation).

[12] Sidney Janis was appointed in the late 1930s as the chairman of MoMA's acquisition committee; he also lent three paintings by Picasso to the exhibition. It was at this point in his career that he closed down his shirt company and devoted himself to art collection and art writing (https://www.theartstory.org/gallery-janis-sidney.htm. Accessed April 18, 2019). A photo of the installation is in Staniszewski 1998, 79.

[13] Quoted in T.J. Demos. "Duchamp's *Boîte-en-valise*: Between Institutional Acculturation and Geopolitical Displacement." *Grey Room*, no. 8, Summer, 2002, 7. Original statement cited in Ecke Bonk. *Marcel Duchamp, the Box in a valise: De ou par Marcel Duchamp ou Rose Sélavy: Inventory of an Edition*. Translated by David Britt, Rizzoli, 1989, p. 174.

14 The photo is in the collection of Peggy Guggenheim Papers (Solomon R. Guggenheim Foundation, New York).

15 There is no further biographical information available at this point on the photographer Herrmann.

References

Anonymous. "A Descriptive Calendar of the New York Galleries." *Parnassus*, vol. 6, no. 3, 1934, pp. 26–33.

Bearor, Karen A. *Irene Rice Pereira: Her Paintings and Philosophy*. University of Texas Press, 1993.

Bogner, Dieter. "Alles Theater!: Kieslers Ausstellungskonzepte aus dem Blickwinkel seiner Bühnengestaltung." *Frederick Kiesler: Theatervisionär – Architekt – Künstler*, edited by Barbara Lesák and Thomas Trabitsch, exh. cat. Österreichisches Theatermuseum in Kooperation mit der Österreichischen Friedrich und Lilian Kiesler-Privatstiftung, Vienna, 2012, pp. 123–131.

Bois, Yve-Alain. "1942a, The depoliticization of the American avant-garde reaches the point of no return when Clement Greenberg and the editors of *Partisan Review* bid farewell to Marxism." *Art Since 1900: Modernism, Antimodernism, Postmodernism*, edited by Hal Foster, Rosalind Krauss, and Yve-Alain Bois, Thames and Hudson, 2005, pp. 324–328.

Buhmann, Stephanie. "The Friendship Between Hans Arp and Frederick Kiesler." *Frederick Kiesler: Face to Face with the Avant-Garde. Essays on Network and Impact*, edited by Peter Bogner, Gerd Zillner. Frederick Kiesler Foundation. Birkhäuser, 2019, pp. 219–236.

Demos, T.J. "Duchamp's *Boîte-en-valise*: Between Institutional Acculturation and Geopolitical Displacement." *Grey Room*, no. 8, 2002, pp. 6–37.

Eckmann, Sabine. "Concerning Exile Art in the US: Networks, Art Worlds and the Fate of Modernism." *Netzwerke des Exils: Künstlerische Verflechtungen, Austausch und Patronage nach 1933*, edited by Burcu Dogramaci and Karin Wimmer, Gebr. Mann, 2011, pp. 433–457.

Frederick Kiesler, edited by Lisa Phillips, exh. cat. Whitney Museum, New York, 1989.

Friedrich Kiesler: Life Visions: Architecture – Art – Design, edited by Christoph Thun-Hohenstein et al., exh. cat. MAK-Austrian Museum of Applied Arts / Contemporary Arts, Vienna, 2016.

Gill, Anton. *Peggy Guggenheim: The Life of an Art Addict*. Harper Collins Publishers, 2001.

Gombrich, Ernst H. *Art and Illusion: A Study in the psychology of pictorial representation*. Phaidon Press Limited, 1987.

Gough-Cooper, Jennifer, and Jacques Caumont. "Frederick Kiesler and The Bride Stripped Bare … ." *Frederick Kiesler: 1890–1965*, edited by Yehuda Safran, exh. cat. Architectural Association London, London, 1989, pp. 62–71.

Guggenheim, Peggy. *Confessions of an Art Addict*. André Deutsch, 1960.

Guggenheim, Peggy. *Out of This Century: Confessions of an Art Addict*. Universe Books, 1979.

Hopkins, David. "Duchamp, Childhood, Work and Play: The Vernissage for *First Papers of Surrealism*, New York, 1942." *Tate Papers*, no. 22, Autumn 2014, https://www.tate.org.uk/research/publications/tate-papers/22/duchamp-childhood-work-and-play-the-vernissage-for-first-papers-of-surrealism-new-york-1942. Accessed 19 February 2019.

Huhtamo, Erkki. "Twin-Touch-Test-Redux: Media Archaeological Approach to Art, Interactivity and Tactility." *MediaArtHistories*, edited by Oliver Grau, The MIT Press, 2006, pp. 71–101.

Janis, Sidney. *Abstract & Surrealist Art in America*. Reynal & Hitchcock, 1944.

Kiesler, Frederick J. "Notes on Architecture: The Space-House." *Hound and Horn*, January–March 1934, pp. 292–297.

Kiesler, Frederick. "Design – Correlation: Marcel Duchamp's Large Glass." *The Architectural Record*, vol. 81, no. 4, 1937, pp. 53–60.

Kiesler, Frederick J. "Note on Designing the Gallery." *Peggy Guggenheim & Frederick Kiesler: The Story of Art of This Century*, edited by Susan Davidson and Philip Rylands, exh. cat. Fondazione Peggy Guggenheim, Venice, 2004, pp. 174–175.

Kiesler, Stefi. *Calenders 1930–1952* (Austrian Frederick and Lillian Kiesler Foundation).

Kiesler, Walter (Bologna, Italy) to Friedrich and Stefi Kiesler (New York) 8 July 1940 (Austrian Frederick and Lillian Kiesler Foundation).

Lader, Melvin P. *Peggy Guggenheim's Art of This Century: the surrealist milieu and the American avant-garde, 1942–1947*. PhD thesis, University of Delaware, 1981.

Linder, Mark. "Wild Kingdom: Frederick Kiesler's Display of the Avant-Garde." *Autonomy and Ideology: Positioning an Avant-Garde in America*, edited by R.E. Somol, The Monacelli Press, 1997, pp. 122–153.

Peggy Guggenheim & Frederick Kiesler: The Story of Art of This Century, edited by Susan Davidson and Philip Rylands, exh. cat. Fondazione Peggy Guggenheim, Venice, 2004.

Phillips, Stephen J. *Elastic Architecture: Frederick Kiesler and Design Research in the First Age of Robotic Culture*. The MIT Press, 2017.

Quaintance, Don. "Modern Art in a Modern Setting: Frederick Kiesler's Design of Art of This Century." *Peggy Guggenheim & Frederick Kiesler: The Story of Art of This Century*, edited by Susan Davidson and Philip Rylands, exh. cat. Fondazione Peggy Guggenheim, Venice, 2004, pp. 207–273.

Rosenbaum, Susan. "Brides Stripped Bare: Surrealism, the Large Glass, and U.S. Women's Imaginary Museums." *Dada/Surrealism* vol. 21, no. 1, 2017, pp. 1–35.

Rylands, Philip. "The Master and Marguerite." *Peggy Guggenheim & Frederick Kiesler: The Story of Art of This Century*, edited by Susan Davidson and Philip Rylands, exh. cat. Fondazione Peggy Guggenheim, Venice, 2004, pp. 18–31.

Sonzogni, Valentina. "'You will never be bored within its walls' Art of this Century and the Reaction of the Press." *Peggy Guggenheim & Frederick Kiesler: The Story of Art of This Century*, edited by Susan Davidson and Philip Rylands, exh. cat. Fondazione Peggy Guggenheim, Venice, 2004, pp. 275–283.

Staniszewski, Mary Anne. *Power of Display: A History of exhibition Installations at the Museum of Modern Art. Museum of Modern Art*, The MIT Press, 1998.

Mobility, Transfer
and Circulation

Rabindranath Tagore and Okakura Tenshin in Calcutta

The Creation of a Regional Asian Avant-garde Art

Partha Mitter

The phrase 'avant-garde' is commonly associated with the transcultural revolutionary movement in western modernism that 'emancipated' 19th-century European art from its academic shackles and bourgeois conformity, creating an art that revelled in the constant pushing of formal boundaries. Avant-garde, which literally means vanguard or the advance guard in a revolution, was involved with cutting-edge experiments, inaugurating a new aesthetic expression that challenged tradition and made a central contribution to modernism as an aesthetic discourse. Therefore, modernist studies and avant-garde studies co-exist as part of larger developments of modernity.

We are all familiar with Picasso's formalist invention of Cubism, the primitivism of Expressionism and the irrational juxtaposition of images and the play of the unconscious in Surrealism. The avant-garde, initially confined to western Europe, quickly enjoyed global circulation. However, as recent debates indicate, scholars have begun to expand the hitherto narrow horizon of the heroic era of the avant-garde. Because of the imbalance between the global centre, that is the West, and the peripheries, such as Asia, Africa, Latin America, non-western avant-garde continue to remain under the radar in art historical discourses (Mitter 2008).

However, peripheries, Piotr Piotrowski reminds us, not only apply to the global colonial order but they also relate to the margins within the metropolis, in Eastern Europe, for instance (Piotrowski 2009).

As a recent major conference in Vienna "Concrete Media: Avant-gardes beyond Western Modernism" reiterated, we cannot afford to think of the global avant-garde discourse only in its present form, but must also recognise its global implications that go back to the beginning of the last century to regions beyond western Europe.[1] I need to mention an important publication in this context. An edited volume, *Decentring the Avant-Garde*, sets itself the task of uncoupling the

avant-garde discourse from its western moorings (Bäckström/Hjartarson 2014).

In this chapter, I wish to take up a half-forgotten avant-garde movement in Asia at the turn of the last century that threw a gauntlet down to the technologically and materially dominant West. This was the short-lived Pan-Asian movement in art, which produced a regional avant-garde discourse that represented a major transcultural event at the turn of the century. It was also an early example of the global circulation of artistic ideas. One word of caution here: western avant-garde is predicated on formalist experiments that we are all familiar with. The point to bear in mind is that the Pan-Asian art that I am about to discuss was not concerned with the formalist inventions of the West, such as Cubism, Expressionism and Surrealism. That is because the contexts of European and Asian art were very different.

So, in what way was this Asian movement avant-garde? I have turned to another, equally resonant definition that is also a key aspect of modernism: 'avant-garde' signifies innovation, rebellion and pushing the boundaries of art against the dominant tradition, ruffling the status quo as it were. As I hope to show, it is precisely this definition that helps to explain the importance of this particular trans-cultural movement that arose in Asia at the turn of the 20th century. To repeat, Pan-Asian art created a new radical language of art, though this language did not derive from the western formalist tradition. An equally important point, both the western avant-garde works of artists like Kandinsky and the Pan-Asian paintings were challenging 19th-century naturalist art going back to the Renaissance.[2]

But let us first examine the political and economic conditions that gave rise to such worldwide exchanges in art. Transport and communication revolutions – the railways, steamships, the telegraph and, for our purposes, print technology – enabled colonial empires such as Britain to secure global dominance; but this also had a contradictory global effect; it created the ideal conditions for conversations across the globe. Hegemonic languages, notably English, French and Spanish/Portuguese, circulated in areas outside the West through print culture, namely through texts and images (books, periodicals and art reproductions), encouraged a worldwide dissemination of ideas and artistic styles, giving rise to what I have called a 'virtual cosmopolis' in my recent writings (Mitter 2012). These conversations, generated globally among intellectuals in the East and the West, but with a strong Asian regional accent, were responsible for proposing an anti-colonial modernity in the face of western dominance (Hay 1970).

For students of art, our interest lies in the fact that some of the most resonant cross-fertilisation of Pan-Asian ideas took place in art, as networks were established, ideas exchanged and alliances formed between Indian and Japanese artists in particular. One notices similarities with the development and spread of modernism

through forms such as Cubism, Expressionism and Surrealism around Europe, which was also facilitated through wide and complex networks consisting of a variety of indviduals and organisations. The Vienna conference explored the various media, most notably magazines and journals, that enabled artists to exchange theory and practice across boundaries, thereby consolidating and universalising the different avant-garde movements. I would like to add that the meetings, friendships and intellectual exchanges between individuals also had a decisive effect on the spread of Pan-Asian regional modernism.

Pan-Asianism was essentially an urban phenomenon, in which the city of Calcutta played a crucial role. Global colonial expansion between the 16th and 19th centuries gave rise to the worldwide phenomenon of the 'hybrid' cosmopolis, often centring on port cities or entrepôts such as Calcutta, Shanghai and Hong Kong, for the circulation of material goods mediated by local merchants and middlemen (Abbas 2000, 775). These cosmopolitan cities emerged as flourishing centres of cultural exchange. As the capital of British India, Calcutta became the locus of colonial encounters, its Bengali inhabitants emerging as beneficiaries as well as interlocutors of colonial culture. The Bengal renaissance ushered in Indian modernity in the 19th century, a hybrid intellectual enterprise underpinned by a dialogic relationship between the colonial language, English, and the modernised vernacular, Bengali.

Let me now turn to the actual history of the Pan-Asian Movement in art that spearheaded Asian anti-colonial resistance. The background to the rise of the transcultural Pan-Asian movement was the relentless momentum of European expansion, conferring almost total military and technological superiority over Asian countries from the mid-19th century onwards. India was colonised, China's resistance crushed and, finally, Japan's isolation shattered. Western military expansion was sustained by Enlightenment rationality, the ideology of progress and technological revolution. In the 1820s, Jeremy Bentham and the English Utilitarian philosophers, as well as Christian missionaries, convinced educated Indians that the Hindus were a backward superstitious people. A little later, the profound impact of western science and learning caused grave anxiety in Japan. Even though Japan had not been formally colonised, the Japanese too suffered from western cultural hegemony and their anxiety was no less acute than that of India (Bearce 1961; Beasley 1990).

The Meiji Restoration had opted for the radical westernisation of Japan. In art, by the middle of the 19th century, salon or academic art had established its primacy in most parts of the world, including Asia. Academic art taught under the Barbizon painter Antonio Fontanesi at the Imperial Art Academy in Tokyo from 1876 had the effect of ousting traditional Japanese painting. India had been exposed to

academic art even before Japan. In the 1850s, the British rulers introduced western art as conscious state policy. Colonial art schools, art exhibitions and the process of mechanical reproduction transformed traditional art practices and patronage, contributing to the triumphal progress of academic art in the subcontinent. The celebrated nationalist exponent of academic history painting in the late 19th century was Raja Ravi Varma, who imagined India's past in a thoroughly Victorian mode.[3]

Asian nations started regrouping and hitting back intellectually, following their initial shock. The key year was 1893. The charismatic Hindu monk, Swami Vivekananda, won a rapturous ovation in Chicago at the World Congress of Religions with his 'ecumenical' speech, addressing his audience as "sisters and brothers of America".[4] Vivekananda's reception in Chicago was the climax of a long process that went back to the European discovery of Sanskrit in the late 18th century, known as 'The Oriental Renaissance' (Schwab 1950). However, what precipitated the counter-tendency was the Romantic anxiety about the excesses of western rationality and the crisis of Victorian industrial society, as expounded in John Ruskin, Karl Marx and William Morris. A widespread Romantic longing for a pre-industrial utopia gave rise to an international network of intellectuals – Russian Slavophils, members of the Arts & Crafts Movement, Theosophists, and finally Pan-Asianists. They poured vitriol on industrial capitalism and the ideology of the Enlightenment. They were no less hostile to 19th-century academic art, the handmaiden of colonial empires. Thus as the Indian nationalist painters sought to free Indian art from the stranglehold of academic naturalism, they found unexpected allies in western romantic rebels against relentless modernity (Mitter 1994).

Arguably, the myth of 'One Asia', propounded by Pan-Asianism was based in part on western stereotypes of the Orient, eloquently expressed in Edward Said's *Orientalism* (Said 1978).[5] It nonetheless provided a powerful rallying point for Asian intellectuals in their attacks on western materialism based upon technological superiority. In this age of the Hegelian *Zeitgeist,* nations, cultures and races were seen in terms of their essences. The Pan-Asian doctrine rested on the binary relationship between masculine/materialist Europe and feminine/spiritual Asia. Vivekananda, for instance, projected Asia as the voice of religion, even as Europe was that of politics.

Despite the assertion of difference, however, the American philosopher and art historian, Ernest Fenollosa, an influential Pan-Asianist, dreamed of marrying 'feminine' Japan with 'masculine' Europe in order to create a higher world order, while Vivekananda, in a true syncretic fashion, imagined a universal religion led by India.[6]

Partha Mitter

The key players of global connectivity – the architects of this powerful though short-lived Pan-Asian vision – were the Indian poet Rabindranath Tagore and the Japanese art ideologue Okakura Kakuzō Tenshin. Tagore's alternative cosmopolitan values based on ancient Indian thought, and Okakura's slogan 'Asia is one', formed the core of the Pan-Asian movement. The great Indian poet was arguably the most famous international personality in the inter-war years, 1919–1939. His reputation was nowhere higher than in Germany and Austria, his works inspiring intellectuals and creative individuals in a wide range of fields, among others, the Austrian composer Alexander von Zemlinsky, whose Lyric Symphony was set to his poems.

The satirical magazine, *Simplicissimus*, marked his visits to Germany with witty cartoons about him. Tagore took an active interest in modernism and was the inspiration behind inviting Klee, Kandinsky and other Bauhaus artists to show their works in Calcutta in 1922. A student of Joseph Strzygowsky, the Austrian art historian, Stella Kramrisch, joined Tagore's university at Santiniketan in 1919. She arranged for the works to be shown at the Indian Society of Oriental Art in Calcutta run by Tagore's nephews (Mitter 2010). Finally, in 1930 Tagore's radical expressionist paintings burst upon the western scene, prompting their enthusiastic reception in Central Europe (Mitter 2007, 65–78). However, even before he won the Nobel Prize in 1913, Tagore had become a trans-cultural figure and a cosmopolitan who spoke eloquently of the one unified voice of Asia (Hay 1970).

The aim of the Pan-Asian movement was to create an alternative mode of artistic expression that would pose a challenge to the western colonial aesthetics, which had dominated Asia from the end of the 19th century. Yet surprisingly, Pan-Asianism was a global tendency that fired the imagination of western intellectuals as much as it did eastern ones. For this powerful paradigm shift we need to look at what was happening in Euro-America that led a wide range of thinkers and creative personalities to seek an active dialogue with the eastern world.

The year 1900 – the *Exposition Universelle* in Paris held in that year symbolised the absolute triumph of the West – saw the genesis of the Pan-Asian doctrine and its expression in painting. It was the reaction of the East to the challenges of western rationality and material success. A new generation of artists and intellectuals in India and Japan constructed its own regional resistance by rebelling against western academic tradition. The creation of resistance was a joint project of easterners and westerners. In Japan, inspired by Ernest Fenollosa, his pupil Okakura Tenshin embarked on an ambitious plan of restoring the traditional art of Japan. He started by documenting the Buddhist art in the land. His first Pan-Asian move was to trace its origins to the 5th-century Ajanta Buddhist caves in India. During his directorship of the Imperial Art Academy, Okakura banned instructions in European art, a move that caused much bitterness among academic

painters. Okakura was soon forced to resign, forming the rival Nihon-Bijutsu-in (Japan Art Academy, Tokyo).

From the outset, Okakura had an eye for international networking, publicising his dismissal in the English art magazine, *The Studio*, complaining that westernisation in Japan had gone too far. He also made effective use of the magazine he founded, *Kokka*, in Japanese but with English summaries to address an international audience, to disseminate Pan-Asian ideas. Later the English-language magazine *Rupam* would become the chief mouthpiece of Indian Pan-Asianists (Mitter 1994, 262–266).

Okakura's next step was to galvanise support for his movement outside Japan. Having read about Vivekananda's triumph in Chicago, he set off for Calcutta in 1902, intending to bring the monk back to Japan with him. But this was not to be, as Vivekananda died soon after his arrival. While in India Okakura would take the opportunity to visit Ajanta in order to study at first hand the ultimate source of Buddhist art.

Okakura was a guest in Calcutta of the Tagores, whose mansion had become a meeting place of a host of European and Asian intellectuals. Okakura completed his book, *Ideals of the East*, in the Tagore residence in 1903 (Okakura 1903). The work, which described Japanese art as a synthesis of Indian religion and Chinese learning, became a classic Pan-Asian text, Indian nationalists listening avidly to his anti-colonial message of Asian unity. By 1913, on his last visit to Calcutta, Okakura was a broken man, his work in Japan discredited. The Pro-Western groups had won the day, leaving his Nihon Bijutsu-in movement seriously weakened. He died soon afterwards. The notion of 'One Asia' impacted on lesser Japanese figures as well. As recently shown by Miyuki Aoki Girardelli, the architect Itō Chūta travelled in Europe and Asia in this period, bravely seeking to trace, for instance, Indian elements in Ottoman Islamic buildings of Istanbul. In his treatise on the Horyu-ji Temple in Japan, Itō Chūta reiterates his opinion of "close relations between Islam and Buddhism" (Girardelli 2010, 101).

As Pan-Asian ideas were gathering force in Japan under Fenollosa, the English artist Ernest Binfield Havell, the American's opposite number in India, arrived in Calcutta in 1896 to take charge of the government art school. Havell belonged to a new generation in Britain who were exhorted by William Morris to return to the medieval ideal of decorative art for the community in repudiation of Renaissance mimesis. Havell endorsed the idea that India's spirituality was reflected in her 'decorative' art, because Indian art was not tainted by Renaissance naturalism (Mitter 1994, 279–283).

Havell faced violent local opposition to his plans for replacing western academic teaching with Indian methods. Colonial Bengal was simply too steeped in Victorian taste. It was at this moment that he met the young artist Abanindranath Tagore,

the poet's nephew, a nationalist artist who had turned to Indian miniatures for inspiration. Under Havell's guidance, Abanindranath discovered the works of Mughal masters, which led to his first political statement in art. In *The Last Moments of Shah Jahan* (1903), the artist carefully reproduced the Taj Mahal's *pietra dura* work, and the flat application of colours in this work as an exercise in authenticity. Abanindranath blended the fading grandeur of the Mughal Empire with the pathos of Shah Jahan's dying moments (Mitter 1994, 283–289).

However, the dramatic turning point in his life was his discovery of Japanese painting. He was deeply affected by Okakura who was a guest at the Tagore home at this time. In 1903, after his return to Japan, Okakura sent his favourite pupils, Yokoyama Taikan and Hishida Shunsho, to Calcutta to work with Abanindranath with the aim of forging a common oriental style of art. Shunsho died young but Taikan became a leading exponent of Nihon-ga, the nationalist style, as opposed to Yo-ga, the western mode. Okakura's brief stay in Calcutta led to an interesting symbiosis between Indian and Japanese artists that impacted equally on Indian and Japanese art. The Tagores were impressed with the simplicity of Japanese taste and design in household objects, and replaced heavy and ornate Victorian furniture with simple functional products.

The Japanese painters learnt the rudiments of Hindu iconography and Mughal painting. Abanindranath for his part watched with fascination how Taikan painted on silk with *sumi* ink and with a few deft brush-strokes, which displayed a mastery of understatement and significant gesture. The *morotai* technique inspired Abanindranath to invest his own watercolours with a pervasive melancholy that suited the nationalist nostalgia for the past glories of the nation. Significantly, Abanindranath named this fusion of Indian and Japanese styles 'oriental art' and not Indian art. The flat two-dimensional oriental painting was presented as the antithesis of western naturalism and a product of Indian spiritual culture, a culture that held sway in a large part of Asia from India right through to China and Japan. In Abanindranath's oriental art, the flat treatment of Mughal miniatures remained; the difference was in the rendering of light, as seen in the *Music Party*, which was reproduced in Okakura's journal, *Kokka* (Mitter 1994, 289–294).

The year 1905 witnessed the first anti-colonial political unrest in India centring on the Partition of Bengal imposed by the colonial regime, which had its implications for art. Invited by Havell to join the government art school, Abanindranath embarked with his first batch of students, Nandalal Bose, Asit Haldar, Samarendranath Gupta, Surendranath Ganguly and K. Venkatappa on 'recovering' the lost language of Indian art. The doyen of 19th-century academic painting, Ravi Varma's Victorian visual language came under attack as a cultural hybrid. In opposition to the hybrid language of academic naturalism, an 'authentic'

of oriental art sought to recuperate Asian indigenous artistic styles, in a blend of *morotai* and Mughal painting. Between 1900–1910 Abanindranath produced a series of serene atmospheric works that aimed at translating Pan-Asian ideals into painting: the subtle combinations of greys and chromatic modulations of pale shades were achieved through Japanese wash technique.

The visual language of 'oriental art' reflects Abanindranath's own contemplative temperament in tune with the spirit of East Asia. Significantly, the actual content of Abaninranath's oriental art was no different from that of Ravi Varma's nationalist historicism. Both of them ransacked ancient literary classics for inspiration. Exceptionally, the unrest of 1905 inspired Abanindranath to make a rare overt political statement with his image of Mother India. The artist presents the mother in the guise of an ascetic though modelled on a middle-class Bengali lady. She is bathed in a hazy orange-green background achieved with *morotai*. Her four arms however confer divinity on her though he substitutes the conventional attributes of a Hindu deity with four objects of national self-reliance: food, clothing, secular and spiritual knowledge (Mitter 1994, 295).

In the final analysis what was achieved by Abanindranath? With the exception of Mother India, Abanindranath's main effort went into creating a coherent Pan-Asian art through the Bengal School of Painting, the first nationalist art movement in India. He combined the Indian miniature format with the *morotai* technique that lent itself to an atmospheric mood suited to the nationalist narrative. The nationalist Bengal School insisted that the decorative quality of its paintings conferred an intense 'spirituality' to it, unlike the materialist Renaissance art. This was a powerful answer to the confident characterisation of the British rulers that academic history painting represented the pinnacle of world art. By this token, the Victorians observed, Indian miniatures, though pleasing in their colour schema and delicate lines, were merely the highest form of decorative art; while they had an undoubted appeal, that appeal was of a lower order than the intellectual content of Victorian painting. Since to the British the inferiority of Indian art consisted in its decorative quality, for the nationalists this very decorative quality of Indian art came to signify its spirituality, a quality supposedly shared by other Asian traditions. We should bear in mind here that decorative art did not simply mean the ornamentation of objects. The essential contrast here was between the flat treatment of shapes and colours in decorative art, as in Indian miniature painting, and western three-dimensional illusionist art.

I now return to the definition of avant-garde art that I had proposed in my introduction. Oriental art sought to create a new visual language that challenged hegemonic naturalism. The revolutionary implications of this new visual language become obvious once we compare these Asian artists with a very different kind of

anti-colonial art produced in Mexico for instance. Mexico was colonised by the Spaniards at an earlier date than India and both witnessed a period of nationalist resistance to European powers. In the 1920s, Marxist artists such as Diego Rivera contributed to the Mexican revolution with ambitious murals glorifying the Aztecs who had ruled Mexico before the Spanish occupation (Craven 2006). At the same time, formally these murals belong wholly within the Renaissance tradition, even though Rivera incorporated Pre-Columbian motifs in his work. To the Indian and the Japanese artists of the early 20th century, notably Taikan, resistance to the West took the form of an indigenous 'style' or visual language that challenged western three-dimensional illusionist art. The Bengal School deliberately flaunted the flat style of Indian miniatures that had been branded as decorative art by the Victorians.

The Pan-Asian movement, which set up an interesting dialogue among Asian intellectuals and artists, had run its course by the 1930s, as serious differences between Asian intellectuals surfaced. So what about its legacy? Okakura made a deep and lasting impression upon the nationalist art of Bengal with his assertion that in Asia influence flowed from India to China and Japan through the presence of Buddhism. There are however interesting tensions in Okakura's doctrine since his Pan-Asian doctrine also sought to absorb western ideas, though critically and selectively. He iterated three cardinal principles: nature, tradition and creativity.

While respecting tradition, he wrote, one must not neglect progress in art. Whatever was taken from the West must be blended with artistic personality. Originality counted for more than style because freedom and individuality kept 'the soul free'. This last principle, the European notion of the aura of work of art, was quite alien to Japanese art, in the same way that the Bengal School of painting quietly absorbed western notions of progress and originality (Mitter 2007, 80).

Finally, let us return to the question of the global links of the Pan-Asian avant-garde in its resistance to academic naturalism, viewed as the product of global colonial-capitalist hegemony. I want to end with some reflections on the links between the western avant-garde and the Bengal School. Abanindranath's anti-colonial strategies displayed significant parallels with the anti-establishment radicalism of the western avant-garde such as Kandinsky. As I suggested above, the modernist movements in Europe – be it the formalist experiments of Cubism, the raw emotions of Expressionism, or the Surrealist assaults on classical rationality – united in their rejection of the mimetic salon art of the 19th century. In short, the rejection of Renaissance ideals of order, balance and harmony brought these avant-garde figures in East and West together to create alternative visual languages. It is not that these European and Asian artists had anything in common in their formal concerns or in their choice of themes. What they shared was a common front against figurative painting as a hegemonic expression. And that may well

be the lasting legacy of Pan-Asian artistic ideology, which itself became part of the larger romantic challenge to global capitalism and the western concept of material progress.

Notes

[1] This was organised in 2011 by Christian Kravagna and Sabeth Buchmann at the Museum of Modern Art in Vienna (MUMOK) and the Academy of Fine Arts Vienna in connection with the *Abstract Space: Formations of Classical Modernism* exhibition.

[2] See Mitter 2007 on the ideological consonance between Kandinsky, Klee and other Bauhaus artists and the Bengal School of painting inspired by Pan-Asian ideas, 10, 12, 15–18, 25, 34–37, 68–70, 72–3, 74, 79, 117.

[3] On India, see Mitter 1994. On Japan see: Sullivan 1973, 117–118; Rosenfield 1971. For a general account see Mason 2005.

[4] "Swami Vivekananda." *Encyclopedia Britannica*, https://www.britannica.com/biography/Vivekananda. Accessed 10 February 2019.

[5] See for instance, stereotyped images of the Ottoman Empire in *Consuming the Orient* 2007.

[6] On Ernest Fenollosa see Chisholm 1963.

References

Abbas, Ackbar. "Cosmopolitanism De-Scriptions: Shanghai and Hong Kong." *Public Culture*, vol. 12, no. 3, Fall 2000, pp. 769–86.

Bäckström, Per, and Benedikt Hjartarson, editors. *Decentring the Avant-Garde*. Rodopi, 2014.

Bearce, George D. *British attitudes towards India: 1784–1858*. Oxford University, 1961.

Beasley, W. G. *The Rise of Modern Japan*. St. Martin's Press, 1990.

Chisolm, Lawrence W. *Fenollosa: The Far East and American Culture*. Yale University Press, 1963.

Consuming the Orient, edited by Edhem Eldem et al., exh. cat. Ottoman Bank Archive and Research Centre, Instanbul, 2007.

Craven, David. *Art and Revolution in Latin America: 1910–1990*. Yale University Press, 2006.

Das Bauhaus in Kalkutta: eine Begegnung kosmopolitischer Avantgarden, edited by Regina Bittner and Kathrin Rhomberg, exh. cat. Bauhaus Dessau, Dessau, 2013.

Girardelli, Miyuki Aoki. "A Red Cloud on the Bosphorus: The Ottoman Empire and Its Capital through the Eyes of Itō Chūta." *The Crescent and the Sun: Three Japanese in Istanbul: Yamada Torajirō, Itō Chūta, Ōtani Kōzui*, edited by Esenbel Selcuk et al., Araştırmaları Enstitüsü, 2010, pp. 89–128.

Hay, Stephen N. *Asian Ideas of East and West: Tagore and His Critics in Japan, Chinese, and India*. Harvard University Press, 1970.

Mason, Penelope E., and Donald Dinwiddie. *History of Japanese Art.* Pearson/Prentice Hall, 2005.

Mitter, Partha. *Art and Nationalism in Colonial India.* Cambridge University Press, 1994.

Mitter, Partha. *The Triumph of Modernism: India's Artists and the Avant-Garde, 1922–1947.* Reaktion Books, 2007.

Mitter, Partha. "Decentering Modernism: Art History and Avant-Garde Art from the Periphery." *The Art Bulletin*, vol. XC, no. 1, December 2008, pp. 531–574.

Mitter, Partha. "Bauhaus in Kalkutta." *Bauhaus global*, edited by Annika Strupkus, Gebr. Mann, 2010, pp. 149–158.

Mitter, Partha. "Frameworks for Considering Cultural Exchange: The Case of India and America." *East-West Interchanges in American Art: A Long and Tumultuous Relationship*, edited by Cynthia Mills et al., Smithsonian Institution Scholarly Press, 2012, pp. 20–37.

Okakura, Kakuzō. *Ideals of the East: The Spirit of Japanese Art.* John Murray, 1903.

Piotrowski, Piotr. "Toward a Horizontal History of the European Avant-Garde." *Monoskop*, 2009, https://monoskop.org/…Piotrowski_2009_Toward_a Horizontal History_of_the_European_Avant-Garde. Accessed 31 May 2019.

Rosenfield, John M. "Western-Style Painting in the Early Meiji Period and Its Critics." *Tradition and Modernization in Japanese Culture*, edited by D.H. Shively, Princeton University Press, 1971, pp. 181–200.

Said, Edward W. *Orientalism.* Routledge, 1978.

Schwab, Raymond, and Louis Renou. *La renaissance orientale.* Payot, 1950.

Sullivan, Michael. *The Meeting of Eastern and Western Art from the Sixteenth Century to the Present Day.* Thames & Hudson, 1973.

Parisian Echoes

Iba N'Diaye and African Modernisms

Joseph L. Underwood

Introduction

As creations of an artist living between Senegal and France, the paintings of Iba N'Diaye embody the transnational discourses that are now the focus of art history as we reassess the sources, influences, and legacy of Modernism. This analysis focuses on the stylistic and technical influences of N'Diaye through his lived experiences in Paris during the 1950s, followed by a demonstration of how he adapted Modernist styles and themes upon his return to Senegal in 1958 – a synthesis he would continue developing after finally relocating to France around 1964. In contrast to his colleagues at the École des Arts du Senegal, Professor N'Diaye encouraged newly liberated African artists to engage with international discourses of Modernism, believing that these young artists would discover cultural emancipation that did not manifestly occur with the end of formal colonialism. As N'Diaye's students learned formal studio techniques and studied art history – echoing the training and vision of modernity he absorbed in Paris – the students of other instructors intentionally ignored external (Western) referents and influences. N'Diaye's work represents both an engaging example of Modernism that is colored by actively living in different world regions, as well as a vehicle for transmitting Modernist styles to West Africa and the global Black Diaspora. To that end, this analysis will conclude by briefly situating N'Diaye within a larger network of African Modernisms that simultaneously developed in mid-20th-century Paris. In contrast to the concept of center or terminus, Paris – as a space that is significant to the career of N'Diaye and other African Modernists – is characterized here as a single node on a complex framework of exchange. Rather a touchpoint, launching pad, or crossroads, this arrival city is over-credited when we name it *the* destination, haven, or Mecca.

Cities: Saint-Louis to Paris

Iba N'Diaye (b. 1928, Saint-Louis, Senegal; d. 2008, Paris, France) was born to a Muslim Wolof father and a Catholic mother. Though he would later face discrimination as an African artist and feel pressure to convey an aspect of *Africanité* in his painting, N'Diaye grew up in a multicultural family in one of the most cosmopolitan cities of West Africa. As the first permanent French establishment in Senegal, dedicated in 1659, Saint-Louis would change hands between the French and British over the next several centuries. In the mid-19th century, colonial governor Louis Faidherbe led a landmark campaign to modernize Saint-Louis with projects that fostered new architecture, expansive train tracks, and miles of telegraph lines. Some scholars characterize Saint-Louis as a colonial city that embodies the style of creole architecture, and its attendant cosmopolitan urbanism, by the way the city reflects "systems of social control and economic exchange" (Carey 2016) rather than simply mixing African and European influences. The modern infrastructure and multicultural demographics of this city make it a bridge between cultures, just as the land mass connects the ocean and the desert. As N'Diaye grew up in the 1930s and 1940s, before ever setting eyes on Paris, he was already a student of the urban environment. Indeed, many of the pioneering African artists who would engage Modernism in their home countries before experiencing it in the urban centers of Europe were already familiar with the particular ways that historic cities are layered with juxtaposing cultural influences, eclectic styles, and diverse populations. Even this simple acknowledgement corrects pernicious stereotypes regarding these – and later – artists from Africa. They did not come from a village or jungle, and they were not stupefied by the wonders of civilized society upon arrival in Europe.

N'Diaye's primary education consisted of many sketches for M. Charlasse, in whose class he would win several awards. As a teenager, he worked for Cinema Vox, a popular film house in Saint-Louis, where he painted the movie posters for American, French, and locally-produced films. Given his close relationship with theater management, some of his first projects were bandes dessinées (comic strips) that he drew and projected onto the theater screens by candlelight. To experience this level of creative exercise was certainly unique for a young artist living in one of the French colonies. He completed his formal education in Senegal before winning a scholarship in 1948 that allowed him to move to Montpelier where he studied architecture at the École des Beaux-Arts. With an eye toward city planning and architectural development, N'Diaye was certainly aware of the impact of a city's physicality on the modern man, even though he never depicted cityscapes in his paintings. The urban environment is implied by the way it impacts his subjects and even how he builds his scenes through masterfully composed, highly-finished

Joseph L. Underwood

drawings: "For me, drawing is the tool by which all good work acquires its solid base; without these tools, nothing stands" (Kaiser 2002, 14).[1]

Continuing his studies at the École de Beaux-Arts of Paris in 1949, N'Diaye worked in the atelier of George-Henri Pingusson. During this time, Pingusson had just begun his tenure as chief architect for the postwar reconstruction of towns in the Moselle and Lorraine regions. Though N'Diaye may have worked on project drawings in the International Style, he found his most influential teachers after completing his degree in architecture. Spending some time in the atelier of sculptor Robert Coutin, N'Diaye settled on enrollment at the Académie de la Grande Chaumière where he studied with sculptor Ossip Zadkine, who would expose him to traditional African sculpture, and painter Yves Brayer, who passed on an affinity for painting. He would remain at the Académie through 1958, having been chosen as the *massier* for the painting section.[2] Though N'Diaye ultimately decided on a career in painting over sculpture, he was indebted to Zadkine for establishing his personal sense of rigor. He also recalled the significance of understanding that an artist must be very demanding on himself first of all, before expecting the same of others (Vieyra 1983).[3]

By the time N'Diaye met Ossip Zadkine, the Russian-born artist had relocated from London to Paris, joined the Cubist movement, gained his French citizenship, fought in the war, self-exiled to Manhattan for four years, and won the Venice Biennale grand prize for sculpture in 1950 (Strong 1956). His idiosyncratic style took inspiration from Greek statuary and African sculptures. It was Zadkine who encouraged N'Diaye to visit the museums of France and Europe that housed the spoils of the empire – in particular, the Musée de l'Homme. It was at this point that N'Diaye developed his penchant for sketching, amassing hundreds of drawings in notebooks over the course of his career. In fact, when art critics later read Africanisms in his paintings by way of his sketchbook, he insisted: "As for the formal relationship which may exist between my art and the visual arts of the African continent, I didn't research them in a systematic manner. I studied African sculpture just as I did Roman and Gothic and European sculpture: by drawing it when I saw it in the museums" (*Perspectives* 1987, 163). Across N'Diaye's training and career, it becomes even more evident that he deserves to be remembered first as a painter, and only secondly as an African – a sentiment echoed by a new generation of curators (Enwezor 2008, 46). Though Modernist art frequently looked to the abstracted, geometricized figurative sculpture from West Africa as a source of inspiration, N'Diaye's home country of Senegal is not known for historic sculptural traditions. Therefore, there was nothing innate or authentic about his journeys to see collections of African art in Europe's encyclopedic museums. As he studied and sketched, he took ownership of centuries of artwork.

For his studies under Yves Brayer, there is even less association with African elements; instead, we find a gestural painter from Versailles who synthesized international influences in a Nouveau Réalisme aesthetic. He had a particular affinity with the coloration of the Spanish masters – which N'Diaye would share – and traveled throughout the African and European coasts of the Mediterranean, making his way to Iran, Russia, and Japan. Always returning to Paris, Brayer offered an eclectic vision of the world to N'Diaye. Even his practice was expansive, moving seamlessly between oil paintings and more eccentric formats, like murals and tapestry designs. He frequently collaborated with artisans on the design and construction of maquettes, sets, and costumes for the Théâtre Français and various opera houses around the country. Perhaps this influenced N'Diaye's desire to study stage design upon his return to Paris in the late 1960s after his teaching stint in Dakar (c. 1958–1964); it certainly provided invaluable experience for his major mural and mosaic installations in Dakar at the Daniel Sorano National Theater and the new airport terminal (early 1960s).

Beyond his formal training in France with Zadkine, Brayer, and others, and his informal studies in the various museum collections, N'Diaye was indelibly shaped by the city of Paris itself. As a nexus for many artists from Africa, the Caribbean, and other parts of the Global South, Paris would influence the content of his paintings and shape the Modernist styles that permeated his oeuvre, even after his return to Senegal in 1958. As soon as he arrived in the 'City of Light' in 1949, he frequented the jazz clubs that animated Parisian night life. This music was intimately tied to the identity negotiation of its African-American creators and, therefore, a productive medium through which the Black expatriate population in Paris could consider their own Diasporic qualities. It certainly colored N'Diaye's conceptions of Blackness and modernity – namely, through the notion of filtration. As cultural production travels into new regions, it is filtered through the lens of whatever new ideo-geographic spaces it encounters. The subjects N'Diaye chose to paint, including a series of jazz singers and musicians, indicate his sensitivity to synthesizing cultural elements that have been displaced and replanted.

> I think that everyone is hybrid. Nobody, no matter what civilization, can say that his originality is simply an originality of place. Originality goes beyond original provenance, thanks to the acquisition from and contact with others. There is, therefore, always a mixing. The mixing is a universal part of being human. (Harney 2004, 64–65)

Joseph L. Underwood

N'Diaye was not lost between cultures. He experienced the sensations of hybridity common to all who are aware of the complex realities that make up the space around them. The artists and mentors who inspired N'Diaye boast their own unique stories of origin, relocation, and adaptation. As Elizabeth Harney argues, N'Diaye's case urgently asks us to rethink our strategies of labeling and categorizing Modernist artists from the Global South in favor of "polycentric modernities" (Harney 2010, 477). Whatever our new frameworks, they must not characterize him as deviating from an established school or as an aberrant genius, but reflect on "the varied ways of 'belonging to the modern' and on the densities and cartographies of modern cultural life" (ibid.). The following section addresses N'Diaye's move back to Senegal and the reverberations that his personal concept of Modernism had on the young nation's nascent art scene.

Ruminations: Paris to Dakar

Paris would serve once again as a launching pad for artists, writers, and cultural actors when it played host for a conference in 1956. A landmark moment for synthesis and reunion, the First World Congress of Black Writers and Artists brought luminaries of thought together under one roof. At this event, 28-year-old N'Diaye would meet authors Léopold Senghor (future president of Senegal), Aimé Césaire, Amadou Hampâté Bâ, James Baldwin, Manuel dos Santos Lima, and Richard Wright; philosophers Frantz Fanon and Édouard Glissant; performers Joséphine Baker and Bachir Touré; and fellow artists Gerard Sekoto and Ben Enwonwu, among other pioneering African, Caribbean, and Diaspora Modernists. Organized by Présence Africaine, this group discussed colonialism, emancipation, and a particular conception of valorizing the contributions of Black individuals to universal civilization – a philosophy known as Négritude. It was in this proto-liberation moment that N'Diaye reconnected to Senegal in a tangible way and felt a pull to foster his home country's transition into independence, even though he was skeptical that Senghor's vision of Négritude was the best vehicle to accomplish that.

Most published accounts of the dynamic cultural sector in independent Senegal begin with its inaugural president, Léopold Senghor. As a poet, he believed in cultural reclamation and valorization as key tools for building a new identity. He called together artists and thinkers – including Iba N'Diaye, Papa Ibra Tall, and Pierre Lods – to found the major cultural institutions, inviting them to share in his vision for Senegal by establishing a national school for fine art (Ebong 1991, 203; Welling 2015, 93). However, although Senghor had met N'Diaye in Paris, N'Diaye had actually already relocated to Senegal before the end of formal colonial

rule – not after national independence. What compelled him to leave Paris just as he was finding his artistic footing? He returned to Senegal in 1958 in order to set up an independent studio where he could teach night classes to young painters. For over a year, from 6–8 PM, he taught in the café of the very modest Théâtre du Palais (destroyed). Silmon Faye recounts how N'Diaye's makeshift courses began with four students, though their number grew steadily (*Iba N'Diaye* 2002, 5). His program would morph into the Maison des Arts du Mali by 1959 and it was absorbed into the larger École des Arts du Senegal in 1961 (renamed Institut National des Arts du Senegal in 1971, and École National des Beaux-Arts du Senegal in 1977). From this independent studio, the celebrated École de Dakar style would spring, its genesis shared with actors beyond Senghor. N'Diaye would only teach at the École des Arts from its foundation in 1961 until 1964 when he became frustrated with Senghor's discrimination against his program, and secured scholarships to send his best students to France for further tuition (Diouf 1999, 90). Even so, he had already mentored several important figures, including Bocar Pathé Diong and Souleymane Keïta, with a pedagogy derived from his cosmopolitan experiences. His students were versed in art history, learned the formal elements of artmaking, and drew from reality for subject matter. A certain taste was not prescribed and, like N'Diaye, many students took their fine art skills and pushed their themes into the abstract.

Work from this era captures what made N'Diaye so innovative as a Modernist. Even as he actively diversified the Senegalese art scene by mounting his first solo exhibition at the Masion des Arts in 1962, he continued to exhibit abroad, showing work at Paris' Salon d'Automne in 1962 and the Bienal de São Paulo in 1963 and 1965. A typical style and subject for this period is N'Diaye's *Portrait d'Anna* (fig. 1). Though some publications subtitle this work *Homage to the artist's mother*, N'Diaye identified the sitter as his niece. His portraits are based on individuals from his world, like family members or models, or are commissions from French expatriates living in Senegal. The act of rendering a person to canvas is, for N'Diaye, an act of poetic translation. Given the rise in photographic and digital technologies, he characterized painting as a humanizing act that forces us to confront the totality of a person. Sensitively building Anna in layers of color, N'Diaye offers us a portrait with equal measures of psychological depth and physical likeness. Alternating between clarity and obscurity, the young woman's form is wholly intertwined with her surroundings. The luminous blue of her collared dress comes alive against the tassels of red that peek out from her blanket. A dozen tones of brown and taupe show the play of light on her face and arms; these tonal variations are echoed in the cerulean, turquoise, and emerald interplay on the left side of the canvas. As he matured, N'Diaye took great joy in the materiality of his paints, experimenting

Joseph L. Underwood

with textures and impasto, savoring the application of pigment to canvas, and exploring its physical properties. Another hallmark of Modernism, the artist drew from the local quotidian and asked about his painting's potential to address the universal. As he created portraits of known individuals, he reflected on society's dependence on women and themes addressed in Laclos' *Les Liaisons dangereuses*. From flower vendors at Kermel market, to family in Saint-Louis, Anna is one of dozens of women he depicted as an homage to the African woman.

Fig. 1. Iba N'Diaye, *Portrait d'Anna*, 1962, 116 x 80 cm, oil on canvas, private collection (Iba Ndiaye 1977).

A second theme, the goats of the *Tabaski* festival, further distinguishes his practice from that of his contemporaries in Senegal and demonstrates one African's interpretation and application of Modernism. Like many artists before him, N'Diaye employed seriality to address the insufficiency of a single tableau to capture a figure or scene. He frequently spoke about the balance of conveying physical realities while also communicating his own sense of said objects. Somewhere

between reality and his aspirations for it, *Tabaski: Sacrifice du Mouton* (fig. 2), part of a multi-canvas series revolving around this annual Senegalese ritual, is representative of his oeuvre in both subject matter and execution. *Tabaski* is an annual festival commemorating the Qur'anic story of Ibrahim's willingness to sacrifice his son and Allah's faithfulness to provide a wild sheep as a substitute; this holiday is more widely known as *Eid al-Adha* (Festival of the Sacrifice). Celebrated widely throughout Islamic West Africa, the festival of *Tabaski* serves as an important reunion for both family and community. In this image, three sheep and one human form vaguely emerge from the gestural, muddied storm of paint. The subject matter becomes ancillary as N'Diaye uses the cultural ritual as a vehicle for his painterly experimentation. Before any considerations of his identity or *Africanité*, N'Diaye claims his role as painter. The *Tabaski* series embodies a persistent engagement with the materiality of his medium – at times thinly washed or encrusted in impasto. While his subject matter might refer to local customs he witnessed in his childhood or during various return trips to Senegal, his manner of handling paint speaks to his immersion in the expressionist styles popular in France. This series led to some of his first critical acclaim, with Judith Meyer of the Musées d'Art et d'Histoire de la Ville de Paris describing the series debut at the 1970 festival in Sarlat as a profound representation of life cycles and collective memory (*Iba N'Diaye* 1977, 12). She notes how the sheep's gazes implicate the

Fig. 2. Iba N'Diaye, *Tabaski: Sacrifice du Mouton*, 1963, 150 x 200 cm, oil on canvas, collection of the Senegalese Embassy in France (Iba Ndiaye 1977).

Joseph L. Underwood

viewer in the eventual *égorgement* (throat-slitting) and *écartèlement* (quartering) of these sacrifices, but she also allows for an aesthetic analysis of N'Diaye's impeccable draftsmanship against the unrestrained brushstrokes. As the series best remembered by art history, the *Tabaski* paintings are often afforded an aesthetic interpretation that proved elusive to many African Modernists. Questions of authenticity, multiculturalism, and Africanisms dominated scholarship throughout the 1990s and into the 2000s. For example, see how he is characterized in *Africa Explores*: "Citizen of two worlds, N'Diaye does not hesitate to treat an ostensibly Islamic subject, though he himself is not Muslim [...]" (Vogel 1991, 184). However, as early as 1970, N'Diaye lamented the undue pressure of reflecting Africanisms when his primary concern was painterly.

> I'm not interested in meeting popular taste. I refuse to give in to the folklorism that certain Europeans, hungry for exoticism, expect from me; otherwise, I would have to live according to the ideas that they hold for a contemporary African Artist, a segregated idea, which tends to confine the African Artist to the realm of naïve, bizarre, surrealist, and outlandish art. Painting, for me, is first and foremost a necessity of my inmost self, a need to express myself as clearly as possible where it concerns my intentions, subjects that have captured me, or to take a stance on vital issues and existential problems. (*Iba N'Diaye* 1977, 14)

The uniqueness of his practice becomes starker in work produced only two years later. *Torn Sheep* (*Senegaru* 1982, pl. 49) reprises the subject matter of *Tabaski: Sacrifice du Mouton* but takes an even more fragmentary approach to depicting the mammalian form. The legs are splayed in an almost impossible arrangement, a contorted pose that conveys the physical act and psychological repercussions of slaughtering an animal. The artist's frenzied paintbrush creates a shallow plane of overlapping marks that cover the canvas. With no spatial references, the lifeless sheep anchors the composition. The viewer is positioned above the corpse, gazing at the splayed form from an aerial viewpoint. The low value areas surrounding the body – itself strongly delineated by dark outlines – could then be read as the natural diffusion of blood onto the ground below. His raw imagery and manipulation of space have countless echoes with contemporaries in Europe, notably the work of Francis Bacon – a fellow artist profoundly inspired by Velázquez.

Based on *Portrait d'Anna* and the *Tabaski* paintings, it is clear that N'Diaye responded to modernity with his idiosyncratic mixing of source material, stylistic influences, and intellectual preoccupations. Neither an African who "also became

profoundly Parisian" (Diouf 1999, 93) nor an artist whose exceptionalism and authenticity made his paintings "truly African and done with great talent" (Doum 1966), N'Diaye is an artist whose life and work between Paris and Dakar exemplifies the circulatory, amorphous transnationality that typifies mid-century Modernism. Given N'Diaye's unwillingness to subscribe to rigid boundaries and identities, it comes as no surprise that his ideological clashes with President Senghor led to an untenable situation.

While the pupils in N'Diaye's division of Research of Fine Art practiced formal techniques, drew from live models, and studied art history, students in the other division, the Research of Black Fine Art, were sequestered from external influences that might hinder their supposed innate vision. Tall and Lods' protégés were given materials and expected to create freely; these students would not be stifled by a classical education and an art system that privileged a Western methodology. Tension rose at the École des Arts over the role of art history in a student's development. N'Diaye argued that newly liberated African artists should be familiar with the contributions of traditional African art, as Senghor so championed, but that the new generation should also aspire to surpass them. "The artists of new Africa will assist their compatriots in leaving the cultural 'ghetto' where certain others would like to – more or less consciously – trap them." (Sylla 2009)[4] This was a clear pushback against Senghor's Négritude that translated into essentialized, decorative tropes of Africa when expressed through the laissez-faire pedagogy from Tall and Lods' section of the École. This ideological divide could also be read as a microcosm of larger debates over the direction of African art in the modern era, from content and style, to its intended audience. Does it speak to the local realities or global dynamics? Is it an expression of the individual or the universal? Should it respond to the postcolonial moment or a timeless sense of *Africanité*?

Far from the celebratory tone of Senghor's Négritude and Tall's cosmic tapestries, N'Diaye questioned the value of flattening the Black experience. He chose to instead pursue a Modernist affinity for materiality and process, and an ever-evolving rapport between tension and synthesis in his cultural influences. Ultimately, N'Diaye left the École as Senghor's government favored works created by Tall, Lods, and their students, as evidenced by the trends in patronage and collecting. To his students in Dakar, N'Diaye issued a warning that should resonate with any young African artist negotiating modernity: "Watch out for those who would urge you to be an African before a painter or sculptor, those who still want to corner us within an exotic garden, all under the name of some undefined authenticity." (Diouf 1999, 91)[5]

Joseph L. Underwood

Fatigue: From Dakar to Paris

"I need to go back to Paris often [...]. If I remained [in Dakar] I would run the risk of falling asleep. But, for inspiration, I need Africa." (Mount 1973, 167) [6]

Historians contest exactly when N'Diaye left Dakar after resigning from his post at the school; some cite that he stayed in this post until 1967; others say that he spent three years in Dakar working on other projects after resigning in 1964; still others state that he left in 1964 to travel through Nigeria, but that he continually returned to Dakar for research projects throughout the late 1970s. We know that he was in Dakar for the planning of *Tendances et confrontations*, an exhibition of modern/contemporary art from Africa and its Diaspora that was organized as part of the 1966 First World Festival of Negro Art (or, FESMAN). Though the festival had been in development since 1962, N'Diaye was only handed the reins of curating this exhibition in 1965. Perhaps even the ambiguity of his departure could be read as a sign of the 'both/and' nature of his life and oeuvre.

By 1967, N'Diaye and his wife Francine relocated to Paris, where she took up a curatorial post at the Musée de l'Homme and he affiliated with Le Groupe de la Ruche. Since the couple had met in Paris and married in 1953, it was a fitting return to be immersed in not only that museum's collection of African objects, but also the field of museums more broadly. In a 1980 interview for P.S. Vieyra's documentary, N'Diaye's studio in Paris is decorated with posters, one of which advertised *African Terra Cottas South of the Sahara* (Detroit Institute of Arts, 1979), demonstrating how *au courant* he remained. N'Diaye's work of the 1970s and 1980s shows a deeper interest in abstraction as manifested in his landscapes, portraits, and mangled sheep, as well as certain paintings which have become iconic in defining his practice.

Juan de Pareja menacé par des chiens (Juan de Pareja Menaced by Dogs) (fig. 3) was painted between 1985 and 1986. This painting serves as a fitting conclusion to N'Diaye's Modernist engagement for the ways in which it returns to his affinity for the Spanish Masters and demonstrates a hyper self-awareness within the lineage of painting history. On the heels of his first exhibition in New York (1981), curated by Lowery Stokes Sims of the Metropolitan Museum, N'Diaye would finally have the opportunity to see Diego Velázquez's portrait of his African-descended slave, Juan de Pareja (fig. 4). Acquired by the Metropolitan Museum in 1971, this painting left the private sphere and entered the public imagination as a rare example of an Old Master painting with a named, known person of color as the subject.

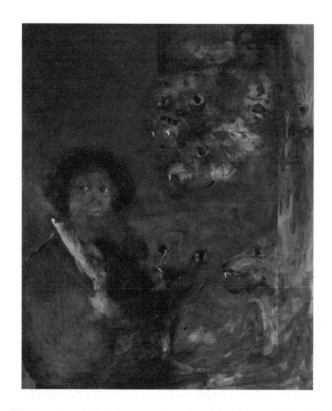

Fig. 3. Iba N'Diaye, *Juan de Pareja menacé par des chiens* (*Juan de Pareja Menaced by Dogs*), 1985–1986, 163 x 130 cm, oil on canvas, location unknown (Iba N'Diaye: L'Œuvre de Modernité 2008).

Fig. 4. Diego Velázquez, *Juan de Pareja*, 1650, 32 x 27.5 inches, oil on canvas, Metropolitan Museum of Art, New York (Metropolitan Museum of Art, New York).

Joseph L. Underwood

Just as he denied the ideological pressure to champion the rhythms of a Négritude-centric art, N'Diaye avoided compliance with European expectations of what an African should depict in style and subject matter. Actively grappling with the history of art, the strong line from Velázquez and Goya underpinned his paintings. In his reprise of Velázquez's portrait of Juan, N'Diaye makes an incisive commentary on a vision of art history where the art world is too keen to celebrate Velázquez for his pioneering, brave inclusivity. In depicting this colored man from another class according to the social mores of a gentleman, is the artist not transgressing an oppressive system and generously elevating the visual status of this slave? And yet, with N'Diaye's interpretation of the scene, the dynamics are visibly more fraught than Velázquez lets on. N'Diaye postulates that if the viewer were to pull away from the refined, serene subject, the larger context would reveal the menace lurking just outside the frame. Fanged beasts with bloodshot eyes make the scene claustrophobic; Juan is pressed down into the bottom left corner of the canvas. Every formal element that Velázquez employs to polish the portrait of Juan – the delicately textured lace on his collar, the cool greens that harmonize his garb with the background, the confident gaze of subject to viewer – is undermined by N'Diaye. N'Diaye's harried brushstrokes obscure the historical figure of Juan, the violence of the gesture evoking the violence that is masked by Velázquez's painstaking finish. He inverts the color palette with hellish oranges that emote an anxiety on the part of the sitter, whose gaze is pointedly averted from ours. As a painter, N'Diaye embraces the constructed, mediated nature of image-making. As a slave, what agency did Juan have in sitting for this portrait? Is fidelity to the subject's physicality truthful enough to capture that person in portraiture? N'Diaye pushes back on the canon of art and the assumptions that modern viewers bring to it. More than just an aesthetic or technical exercise, his paintings could be wielded: "Painting is not an art of leisure; it's a method of combat, a way to express my understanding of the world." (Vieyra 1983)[7] This is an artist well-read in art history, salient in discourses of power, and devoted to the medium of painting.

> When asked if he felt cut off from Africa since relocating to Europe, the artist reflected on the role of memory as a mediator that ultimately leads to a truer representation:
> [...] every time I'm back [in Senegal], I stock up on notes, as many as possible, so that even when I withdraw from that space, I am able to find things that are true. Even the act of withdrawing implies the process of memorizing, and re-memorizing, from a particular point of view. It permits me to more freely interpret, both the subject and my vision of it. (ibid.)

Over the last decades of his life, N'Diaye exhibited in almost every region of France and mounted retrospectives in Germany, Finland, and the Netherlands. In January 2000 and May 2008, major exhibitions were organized in Saint-Louis and Dakar, respectively, to honor his career and legacy. In 2013, his estate gave 154 works to the *patrimoine* of Senegal, with other paintings integrated into collections in Paris, Atlanta, Cleveland, Washington, D.C., and elsewhere – all nodes within his complex network of influence.

Reflections: From Paris to Dakar

I briefly want to return to N'Diaye's curatorial role for FESMAN in 1966. As previously mentioned, the artist was tasked with organizing the 600 works of art submitted for *Tendances et confrontations*, the first exhibition of modern/contemporary African art at such a scale. In this role, N'Diaye was an interlocutor between nations, just as this exhibition negotiated the shift from traditional art – as seen in the nearby companion exhibition, *L'art nègre* – to modern African art. Though Senghor envisioned a continuity between the past and the present, N'Diaye's discontent with the principles of Négritude guided him to curate as an artist and intellectual *for* artists and intellectuals. By making the space open for dialogues between the artists, N'Diaye moved away from the nationalist regimentation seen in the festival's call for participants. Based on his experiences in Paris, he would have been savvy about the transnational exchanges happening with contemporary artists who created in modes beyond reductive national identities.

For example, N'Diaye would have met Armenian-Ethiopian painter Skunder Boghossian at the Académie de la Grande Chaumière when they overlapped in 1957. Before creating his masterwork, *Night Flight of Dread and Delight*, in Paris in 1964, he had already studied with Canadian painter Jacques Godbout and at Slade in London. At that school, Boghossian overlapped with Sudanese painter Ibrahim El-Salahi and later met Afro-Cuban-Chinese artist Wifredo Lam in Paris. N'Diaye also met Paris-based South African artist Gerard Sekoto at the 1956 Congress. Ernest Mancoba, another painter from South Africa, who participated in CoBrA, recalled how Sekoto kept close tabs on both the English and French circles of African artists and intellectuals in Paris during the 1950s (Obrist 2003, 17). Sekoto has long been recognized as a Modernist forerunner and celebrated for his emotive scenes of quotidian life under Apartheid and in mid-century Paris after his self-exile in 1947. After a brief stay with Nigerian painter Ben Enwonwu – whom N'Diaye also met at the 1956 Congress – Sekoto found work as a music composer and used his free time to paint lively scenes of his new home city. Paired

with other Parisian encounters, N'Diaye benefitted from the cross-fertilization of African voices that sought new modes of expression.

And so these Diasporic artists that N'Diaye encountered in Paris found themselves together in Dakar in 1966 for this grand festival. As I have argued elsewhere, this exhibition was a collective redefinition as "individual thinkers and makers capitalized on the fluidity of definitions to carve a space for themselves in Modernist discourse" (Underwood 2019, 60). These artists rarely fit into the exclusionist and imperialist circles of European capitals; at the same time, reductive identity politics told them they were too tainted or Europeanized to be reintegrated into their native countries. Their journeys were wholly individualistic and yet notably resonant. To have N'Diaye's work in dialogue with other artists from Africa – artists who shared his Modernist training in equal part with his lived Diasporic realities in Europe – and to have this rendezvous *in Dakar* is a potent metaphor of the entangled nature of transnational art practice. While Paris as a city served as an important crossroads of influences, the city itself was not the determining factor in shaping African visions of Modernism. The credit belongs wholly to the artists who made this city just one of many junctions on their multi-sited stories.

Conclusion

Paris of the mid-century was a hub for such exchanges as artists from North and South collided in the ateliers, museums, and cafes of the city. Some scholars recognize "a focused internationalist dialogue in its art world" (Wilson 2016, 348) mentioning Zao-Wou Ki (China), Avigdor Arikha (Israel), Charles Houssein Zenderoudi (Iran), and Barbara Chase-Riboud (United States) in the same breath as Iba N'Diaye, Gerard Sekoto, and Ernest Mancoba.

In an era when many former colonies underwent rigorous nation-building and established nationalist art movements, N'Diaye was exceptional for his ability to maintain an individual aesthetic that foregrounded painterly abstraction even as he moved between Senegal and France. Far from a copyist who mimed the Modernist trends in Paris, N'Diaye was a participant in the movement as a student and young professional. He maintained his participation, even from Dakar. Whether or not he was recognized by critics and peers does not (in)validate his participation in the movement. In this regard, his practice could be read as an alternative not only to Senghorian conceptions of a modern artist, but also to the Eurocentric circuits of Modernism in the 1950s. Though critics prefer characterizations with succinct, bifurcating labels – like "African artworks [...] incorporating School of Paris painterliness" (McEvilley 1991, 270) or "the most European-oriented

in the new African art movement" (Mount 1973, 167) – N'Diaye's practice was marked by multiple influences that were masterfully synthesized. Beyond his own practice, as a curator for FESMAN, he also facilitated an important gathering for two generations of African artists. His generation had already begun transnational careers as Modernists living between Africa and Europe, but the generation who was coming of age would navigate the newly-established African schools of art and chart even more daring courses between the continent and new arrival cities.

Notes

1 Author's translation. Original French: "Le dessin pour moi est la base de tout travail, le moyen d'acquerir les outils sans lesquels rien ne tient."

2 The concept of a *massier* is unique to French schools. The *massier* is a student responsible for collecting dues from others in the atelier and monitoring the supplies shared in common.

3 Original French: "C'est d'être exigeant d'abord avec moi-même pour attendre des autres la même exigence."

4 Author's translation. Original French: "[…]les artistes de l'Afrique nouvelle aideront leurs compatriotes à sortir du 'ghetto' culturel dans lequel certains voudraient plus ou moins consciemment les enfermer."

5 Author's translation. Original French: "Prenez garde à ceux qui exigent de vous d'être Africains avant d'être peintre ou sculpteur, à ceux qui, au nom d'une authenticité qui reste à définir, continuent à vouloir nous conserver dans un jardin exotique."

6 Original French: "J'ai besoin d'y retourner [to Paris] souvent. Ne serait-ce que pour prendre un bain de théâtre, de cinémas; pour me replonger dans un climat. Au point de vue technique, l'école de Paris est très importante; elle offre à l'artiste une confrontation avec des peintres de tous les coins du monde. Si je restais ici, je risquerais me m'endormir. Mais, pour l'inspiration, j'ai besoin de l'Afrique."

7 Author's translation. Original French: "Elle n'est pas un art de loisirs mais un moyen de combat, une façon d'exprimer ma conception du monde."

References

Axt, Friedrich, and El Hadji Moussa Babacar Sy, editors. *Anthology of contemporary fine arts in Senegal.* Museum für Völkerkunde, 1989.

Carey, Dwight Anthony. "Building the Creole Empire: Architecture, Urbanism, and Social Space in the French Colonial World, 1659–1810." (unpublished dissertation, UCLA Electronic Theses and Dissertations, 2016)

Diouf, Saliou. *Les arts plastiques contemporains du Sénégal.* Présence Africaine, 1999.

Doum, Aly. "Interview with Fred Zeller, President of the French Federation of Beaux-Arts." *L'Unité Africaine*, no. 199, 1966, pp. 1, 13.

Ebong, Ima. "Negritude: Between Mask and Flag: Senegalese Cultural Ideology and the École de Dakar." *Africa Explores: 20th Century African Art*, edited by Susan Vogel, exh. cat. Center for African Art, New York, 1991, pp. 198–209.

Enwezor, Okwui. "Iba N'Diaye: At the Junction of Modern Art." *Iba N'Diaye: L'Œuvre de Modernité*, edited by Florence Alexis, exh. cat. Place du Souvenir Africain, Dakar, Senegal, 2008, pp. 38–46.

Grabski, Joanna. "Painting Fictions/Painting History: Modernist Pioneers at Senegal's École des Arts." *African Arts*, vol. 39, no. 1, Spring 2006, pp. 38–49, 93–94.

Harney, Elizabeth. *In Senghor's Shadow: Art, Politics, and the Avant-Garde in Senegal, 1860– 1995*. Duke University Press, 2004.

Harney, Elizabeth. "The Densities of Modernism." *South Atlantic Quarterly*, vol. 3, no. 109, Summer 2010, pp. 475–503.

Huchard, Ousmane Sow. "The First International Festival of Black Arts." *An Anthology of African Art: The Twentieth Century*, edited by N'Goné Fall and Jean Loup Pivin, Distributed Art Publishers, Inc., 2002, pp. 220–229.

Iba Ndiaye, exh. cat. Musée Dynamique, Dakar, 1977.

Iba N'Diaye, exh. cat. Galerie Nationale d'Art, Dakar, La Sénégalaise de L'Imprimerie, 2002.

Iba Ndiaye: Evolution of a Style, edited by Lowery S. Sims, exh. cat. African-American Institute, New York, 1982.

Kaiser, Franz W. *Iba Ndiaye: Peintre entre Continents*. Adam Biro, 2002.

McEvilley, Thomas. "The Selfhood of the Other: Reflections of a Westerner on the Occasion of an Exhibition of Contemporary Art from Africa." *Africa Explores: 20th Century African Art*, edited by Susan Vogel, exh. cat. Center for African Art, New York, 1991, pp. 266–275.

Mount, Marshall W. *African Art: The Years Since 1920*. Indiana University Press, 1973.

Ngom, Amadou Guèye. "Iba N'Diaye tel qu'en lui-meme." *Ethiopiques: Littérature, philosophie et art*, no. 83, 2ème semestre, 2009.

Obrist, Hans Ulrich. "An Interview with Ernest Mancoba." *Nka: Journal of Contemporary African Art*, vol. 18, no. 1, Spring-Summer 2003, pp. 14–21.

Perspectives: Angles on African Art, edited by Susan Vogel, exh. cat. Center for African Art, New York, 1987.

Senegaru gendai bijutsuten: senretsu na shikisai to hirui no nai zōkei kankaku (Art sénégalais d'aujourd'hui), exh. cat. Rafōre Harajuku and Rafōre Myūjiamu, Tokyo, Kokusai Kōryū Kikin, 1982.

Strong [Stone], Peter. "Ossip Zadkine," *Jewish Quarterly*, vol. 4, no. 1, 1956, pp. 26–27.

Sylla, Abdou. "Hommage à Iba N'Diaye." *Ethiopiques: Littérature, philosophie et art*, no. 83, 2ème semestre, 2009, http://ethiopiques.refer.sn/spip.php?article1686. Accessed 10 October 2018.

Underwood, Joseph L. "Historical Perspectives from Senegal: The Earlier View from Here." *The View From Here: Contemporary Perspectives From Senegal*, edited by Joseph L. Underwood, exh. cat. Kent State University School of Art Collection & Galleries, Kent, Ohio, 2018, pp. 19–29.

Underwood, Joseph L. "*Tendances et Confrontations*: An Experimental Space for Defining Art from Africa." *World Art*, vol. 9, no. 1, Spring 2019, pp. 43–65.

Vieyra, Paulin Soumanou. *Iba N'Diaye*, 1983, film, 34 minutes.

Welling, Wouter. "African Art After Independence: A New Chapter." *The Sixties: Worldwide Happening,* edited by Mirjam Shatanawi and Wayne Modest, exh. cat. Tropenmuseum, Amsterdam, 2015, pp. 90–95.

Wilson, Sarah. "New Images of Man: Postwar Humanism and its Challenges in the West." *Postwar: Art Between the Pacific and the Atlantic 1945–1965*, edited by Okwui Enwezor, et al., exh. cat. Haus der Kunst, Munich, 2016, pp. 344–349.

The Margin as a Space of Connection

The Artists Mira Schendel, Salette Tavares and Amélia Toledo in Lisbon

Margarida Brito Alves and Giulia Lamoni

Fig. 1: Photography of Lisbon, undated (Col. Estúdio Horácio Novais I Fundação Calouste Gulbenkian – Biblioteca de Arte).

When in Lisbon ...

There is no photograph which shows the artists Mira Schendel, Salette Tavares and Amélia Toledo together in front of a camera. If such a photograph existed, it probably would have been taken in Lisbon in 1966. At that time, Brazilian artist Amélia Toledo was living in the nearby coastal city of Carcavelos, teaching art at the Sociedade Nacional de Belas Artes (National Society of Fine Arts) in the Portuguese capital. Following the 1964 military coup in Brazil, the arrest of her

husband and his dismissal from the University of Brasilia, Toledo and her family migrated to Portugal in 1965. The following year, she was visited by her fellow artist and friend Mira Schendel whom she had met in São Paulo in the early 1960s. On this occasion, Toledo organised an exhibition of 93 works from Schendel's series *Monotipias* (Monotypes) at the Buchholz Gallery and Bookshop in Lisbon.[1]

Indeed, it was the first time that Mira Schendel, an Italian-Swiss Jew, had travelled back to Europe after migrating to Brazil with her husband in the post-war period. One of the reasons for her trip was her solo exhibition at Signals Gallery in London in 1966, where she had already presented some pieces in the *Soundings Two* collective show the previous year. According to Schendel, her solo exhibition in London was successful and her pieces were very well received.[2] On the other hand, things did not go as well in Lisbon. In a 1967 letter, the artist wrote, "The exhibition in Lisbon was very well installed. The catalogue, nothing special, and the visitors were perplexed".[3] An article by the Portuguese art critic Fernando Pernes, also close to Amélia Toledo,[4] confirms this assessment. "Unfortunately", wrote Pernes, "we do not think that this exhibition, of such grave modernity, was understood in Lisbon. That's our loss!"[5] (Pernes 1966, 71).

The exhibition brought together two friends, Toledo as organizer and Schendel as artist, who had been differently affected by experiences of migration. Yet its poor reception revealed a disconnect between Lisbon, the capital of a southern country under dictatorial rule and a peripheral city on the European cultural map of the 1960s, and 'swinging' London which was characterized by cultural effervescence and centrality. Nevertheless, it is important to acknowledge that in the Portuguese artistic milieu Schendel's exhibition in Lisbon did not go completely unnoticed. Featured at a relevant gallery, it was accompanied by a text by well-known art critic José-Augusto França, who also wrote a text for Amélia Toledo's solo exhibition at Atrium Gallery in São Paulo in the same year.[6] Besides, Pernes' review of Schendel's exhibition appeared in one of the key cultural journals at the time, *Colóquio. Revista de Artes e Letras*, published by the Calouste Gulbenkian Foundation.

In 1966, the Portuguese artist and poet Salette Tavares was living in Lisbon and collaborated in some of the activities organised at the Sociedade Nacional de Belas Artes. It is probable – although, to our knowledge, no document in her correspondence suggests it – that this is where she met Amélia Toledo. Still, no evidence confirms whether Tavares went to see Mira Schendel's exhibition at Buchholz Gallery or if she met the Brazilian artist at all.[7] Nevertheless, in 1971 Salette Tavares published an article in *Colóquio/Artes* dedicated to the work of Amélia Toledo, entitled "Brincar. A propósito de Amélia Toledo" ("Playing. Regarding Amélia Toledo"). Reflecting on the activity of playing, and revisiting some of the ideas advanced by Johan Huizinga, Tavares points out that the origin

Margarida Brito Alves and Giulia Lamoni

of the Portuguese word *brincar* – meaning "play" – derives from *brinco* – "ring" – which in turn originates from the Latin *vinculum*, meaning "bond, a binding element" (Tavares 1971, 31–32).

This etymological exploration – connecting *brincar* (playing) with the creation of bonds – is all the more significant when one considers that the text establishes a bond between the author herself and Amélia Toledo, who by then had returned to São Paulo and whose design pieces, which were discussed by Salette Tavares, had not yet been exhibited in Portugal. How did Tavares get hold of them? Interestingly, in his review of Schendel's 1966 exhibition, Fernando Pernes also evoked, among other elements, the 'ludic' quality of the artist's work and quoted Paul Klee: "Art plays, even without knowing it, with the deepest realities, effectively achieving them"[8] (Pernes 1966, 70f.). Considering the importance of *brincar* (playing) in the artistic work of Salette Tavares – after all this is how she entitled her 1979 solo exhibition organised at Quadrum Gallery in Lisbon – leads to the question of how far the process of 'playing' and its heterogeneous unfoldings could operate as a kind of 'binding element', a *vinculum* connecting the work of these three artists? And what would be the role 'played' by migration and by the city of Lisbon and its cultural scene in this artistic and affective triangulation?

Although Lisbon is recurrently referred to as a place of cultural exchanges, and as a crucial and strategic point for entries and escapes during World War II, it seems that in the following decades it lost its role as an international crossroad. In fact, in narratives of post-war art articulated in the context of Portuguese and international art history, the city has often been framed as a site of departure for local artists who predominantly went to Paris or London to study and/or live abroad. Although this migration towards European artistic capitals certainly heavily influenced 20th-century Portuguese art – a tendency that intensified from the late 1950s on – its centrality in critical and art historical discourses has tended to overshadow other transits to and through Lisbon.

As previously mentioned, in the 1960s Portugal was still living under the New State dictatorship (1933–1974), which caused the country's international isolation. Despite this long regime, and despite the outbreak of the Colonial War in 1961, the 1960s were less restricted, and the period between 1968 and 1970 was significantly referred to as the "Primavera Marcelista" (Marcelist Spring). This can be ascribed to Marcelo Caetano's role as prime minister (1968–1974) in which he, to a certain extent, softened some of the most rigid features of the government. Another key element to understand these years is the creation of the Fundação Calouste Gulbenkian in 1956, an institution which was often described as an 'oasis' in the Portuguese cultural scene, and which, fostering transits, soon started to award

scholarships to numerous artists – both national and foreign – thus enabling them to travel abroad and come into contact with other lived realities.

In fact, envisaging Lisbon during this decade as a site of artistic passage, residence and transnational connections renders the map of the artistic networks and transits drawn by international art historical scholarship more complex and open-ended, all the while exploring the roles played not only by peripheral cities in Europe and beyond but also by south-to-south circulations. Regarding, in particular, the travels of artists, exhibitions and ideas between Brazil and Portugal from the 1950s onwards, the visit of the poet Décio Pignatari to Lisbon in 1956, the subsequent publication of an anthology of concrete poetry by the Brazilian Embassy in 1962, and its reception by Portuguese poets have been the object of some attention (De Campos et al. 1962).[9] In contrast, less institutional and more volatile processes such as the passage of Brazilian artists Amélia Toledo and Mira Schendel to and from the city and their inscription into its art scene remain largely unexplored.

Evaluating the possible impact of Mira Schendel's short stay and exhibition in Lisbon and of Amélia Toledo's two-year exile on the city's artistic scene and cultural debates (of which Salette Tavares was an active agent) is quite a complex task which often lacks the archival evidence that would allow for such a comprehensive approach.[10] Acknowledging, instead, the fragmentary and incomplete character of our perspective, we propose to focus on an artistic and affective map of encounters and dialogues, and to explore the way in which they inform, in different ways, the artists' production. In this sense, we suggest looking at the connections between Salette Tavares, Mira Schendel and Amélia Toledo in Lisbon by way of a relational perspective – studying the multidimensional affective as well as artistic connections between the artists and between the artists and their cultural and political environment.

Playing with words

Following the birth of her child Ada in the late 1950s, Mira Schendel began an intense period of work in the early 1960s, characterised, among other things, by the use of rice paper. In 1962, she exhibited her series *Bordados* (Embroideries) at Galeria Selearte in São Paulo; here, rice paper was suffused with watercolour and featured a set of abstract signs. It was between 1964 and 1966 that Schendel worked on the series presented in Lisbon, the *Monotipias*.[11] Composed of around 2,000 drawings using rice paper and oil ink, these pieces stemmed from the artist's desire to use extremely thin rice paper without tearing it apart. Resorting to a monotype technique – using glass plates, ink, talc and sheets of rice paper – the

Margarida Brito Alves and Giulia Lamoni

drawing was traced with a pointed instrument.[12] This process resulted in striking works which combined transparency, fragility and brittleness, and which played with – often linguistic – signs and blank spaces.

Schendel's interest in the use of language played an important part in both her paintings and monotypes from the early 1960s onwards. In her rice paper works in particular, the limits between language and drawing became blurred as the artist attempted, in her own words, "… to surprise discourse at its moment of origin" (Schendel 2009, 60). If immediate individual experience, life and emotions are not communicable, thought Schendel, "[t]he realm of symbols, which seeks to capture that life (and which is also the realm of language), on the other hand, is antilife, in the sense of being intersubjective, shared, emptied of emotions and suffering" (ibid.). "If I could bring these two realms together," she wrote, "I would have united the richness of experience with the relative permanence of the symbol" (ibid.).

These preoccupations reveal the artist's singular exploration of language in philosophical terms, but they are also connected to a wider reflection on the visual dimension of writing as put forth by Brazilian concrete poets in dialogue with artistic concretism in the 1950s. After all, Schendel was a close friend of the concrete poet Haroldo de Campos, whom she met in the early 1960s in São Paulo and who considered her "a metaphysical calligrapher"[13] (Salzstein 2014, 251). Such an ambivalent relationship with concrete poetry – one of clear distance but also of possible conversation – may certainly have appealed to Portuguese artist Salette Tavares, if she ever visited the exhibition of *Monotipias* in Lisbon in 1966. In fact, a few years later, in 1974, the two artists exhibited their works together in a collective exhibition in Rome entitled *Artivisive Poesiavisiva* (Visualarts Visualpoetry), organised by artist and curator Mirella Bentivoglio.[14]

Salette Tavares had started her trajectory as a poet, publishing *Espelho Cego* (Blind Mirror), her first book of poems, in 1957. Playing with the graphical layout of the verses – by introducing gaps, breaks, misalignments and spaces in her textual compositions – this work explored the relationship between word and image, revealing her "taste for experimenting with signifiers" (Martinho 1995, 8). Over the following decade, Tavares kept writing poetry and published three more books of poems[15] in the years leading up to 1971; she also contributed to the *Cadernos de Poesia Experimental* (Experimental Poetry Notebooks), which were issued in 1964 and in 1966 by the Portuguese Experimental Poetry Group – a loose collective of poets, artists and musicians that had been informed by Brazilian concrete poetry in the 1960s and integrated an international dynamic that addressed language and words as visual elements.

Salette Tavares also started to attract attention as an artist who participated in the activities of this group, having contributed *kinetophonic* works and several

letterpress poems to the *Cadernos de Poesia Experimental* notebooks. In this context, two graphic poems stand out: *Efes* and *Aranha* (Spider), both dating from 1963 and published in the following year. Employing a semiological focus, their visual form corresponds to a "verbal body" (Tavares 1995, 17), as argued by Tavares' friend, the artist Ana Hatherly. As a member of the *Poesia Experimental* collective, Tavares also took part in *Visopoemas,* a shared exhibition at the Galeria Divulgação in Lisbon in 1965. This resulted in the presentation of *Concerto e Audição Pictórica* (Concert and Pictorial Audition) – a collaborative event which not only established a dialogue with John Cage's experimental concerts, but also is generally referred to as the first happening taking place in Portugal.

Between 1949 and 1963, Tavares produced several ceramic pieces that extended this exercise, testing the visual dimension of words by ironically inscribing phrases, letters or punctuation marks onto the surface of objects – as can be seen in pieces such as *Peixe* (Fish) or *Jarra Pontos e Vírgulas* (Semicolon Vase). This articulation between poetry and objects would lead her to explore a tri-dimensional and even spatial dimension (Brito Alves/Rosas 2014, 139–149) over the subsequent years. Interestingly, if for Tavares the testing ground to explore the possible tri-dimensionality of signs was the main objective, for Mira Schendel and Amélia Toledo it was transparency.

Amélia Toledo created her first collages as well as her well-known artist's book *Genesis* when she attended Basic Design courses as well as goldsmithing workshops at the Central School of Arts and Crafts in London in the late 1950s. As Agnaldo Farias indicated, the book which introduced the action of tearing "to contrast it with the monotony and rigidity of the square" (Farias 2004, 209) resulted from "exercises inspired by the Bauhaus and adopted by William Turnbull in his course" (ibid.). In these works, the artist tore sheets of coloured silk paper and rice paper to create subtle juxtapositions using either collage or the book form. "The collages", observed the artist, "began in London with transparencies. The gouaches were the movements of coloured water and the collages arose from tearing coloured silk paper, colour on colour, transparencies" (ibid., 267).

Exploring the dimension of transparency in rice paper, these works seem to anticipate those by Mira Schendel in the early 1960s. They similarly used elements such as colour and the book form to expand the work of art in real space by breaking its bi-dimensionality. On the other hand, the act of tearing – a non-specific artistic gesture that bound together creation and destruction – significantly revealed the very texture of the material used. Tri-dimensionality was further explored by Toledo in her 1959 *Livro da construção* (Construction book). In 2011, Toledo recounted that with this book she wanted "to construct works that could awake the will to make a gesture ..." (Neves 2011, 108)[16] and that what mattered

Margarida Brito Alves and Giulia Lamoni

to her was "the exploration of spaces created by paper and a dialogue with spaces through folding, geometric cuts, juxtapositions, in an open construction able to produce other forms in the hands of other people" (ibid.).[17] Toledo's affinity with neo-concrete preoccupations with space and the body seems noteworthy here.

As for Schendel, for whom materiality was also extremely significant, the transparency of rice paper acquired a new dimension when she started to incorporate transparent acrylic sheets in her *Objectos Gráficos* (Graphic Objects) in 1967. The rice paper drawings were placed between these transparent acrylic plates, and visitors could thus not only walk around but also look through them. This embodied participation in the artwork was to reconstitute an experience of time that the written sign had immobilised. Yet, as Geraldo Souza Dias points out, it was apparently in Lisbon, at the Buchholz Gallery, that Schendel for the first time exhibited her rice paper pieces between glass plates (Souza Dias 2001, 81). Was this type of installation a fruit of the collaboration between Schendel and Toledo, who organised the exhibition?

What we know for certain is that the use of transparent material, and specifically acrylic, became an extremely generative process for Schendel. As stated by the artist herself, beside showing "the plane's other side" and "the text's reverse" (Schendel 2009, 60), the acrylic "[…] allows a circular reading, with the text as the unmovable centre and the reader in motion, thus transferring time from the work to the reader, so that time springs from symbol to life" (ibid.). And yet, almost paradoxically, the physical involvement of the participant in Schendel's work began not with transparency but with opacity, with sheets of rice paper twisted and knotted so as to become a woven object. This well-known series of works was entitled *Droguinhas* (Little nothings), and was shown together with its sibling work, *Trenzinho* (Little train), at the London exhibition in 1966 – the same year in which *Monotipias* were presented in Lisbon.

Playing with space

Not surprisingly, it was the artist's daughter Ada, then 10 years old, who chose the word *Droguinha* to entitle these works. They have in fact a certain playfulness and simplicity to them. "Sometime in 1965", writes Luis Perez-Oramas, "Schendel called her young daughter, Ada, and some local children into her studio and asked them, under her instruction, to crumple and twist pieces of Japanese papers into ropes, which they then knotted and re-knotted to make the three-dimensional doodles that are the *Droguinhas*" (Pérez-Oramas 2009, 32). Like a children's game, the *Droguinhas* were, according to the artist, a "transitory object; it could be made

by anyone, twisting paper into knots like that ..." (*León Ferrari and Mira Schendel* 2009, 64).[18] Dealing with "the entire temporal problematic of transitoriness" (ibid.), these pieces were meant to be ephemeral. As a kind of counter-sculpture, they were fragile and precarious, elemental in their making. Also, they expanded drawing into space.

Interestingly, Amélia Toledo's son Mo remembers that some *Droguinhas* were created in his mother's studio in Carcavelos near Lisbon, when Schendel visited her friend in 1966 (Brito Alves et al. 2019). These same pieces were then exhibited at Signals Gallery in London. Schendel's exploration of tri-dimensionality developed at a time when Amélia Toledo herself, working in Portugal, was conceiving sculptural multiples like *Mundo de Espelhos* (World of Mirrors) and *Espaço Elástico I* (Elastic Space I). In the early 1960s, Toledo further developed the use of movement and activation of space – already explored in her artist's books – by creating kinetic jewellery. These pieces of metal and semi-precious stones suggested mobility while simultaneously playing with hollow space and its reflective capacities. As acutely observed by Agnaldo Farias, for the artist the jewels constituted at this time the possibility to "[...] deal with spatial problems on a small scale" (Farias 2004, 54). In fact, jewels, collages and artist's books were all small objects easy to manipulate, directly implying touch and representing "[...] a productive pretext for the artist to deal with constructivist questions" (ibid., 52). In this sense, instead of breaking the plane to extend into real space, the hollow reflective material incorporated its surrounding space, thus transforming its very perception. In 1966 the artist produced two larger-scale sculptures, *Espaço Elástico I* and *Mundo de Espelhos*; both were multiples and also used reflecting surfaces. While in the first work steel springs kept the curved steel plates in tension, in the second the construction was articulated through a number of similar modules arranged together. At the same time, the manipulation of reality through curved or juxtaposed mirrors evoked the ludic character of distorting mirrors.

In 1966, on the occasion of an exhibition of Toledo's jewellery in São Paulo, art critic José-Augusto França insisted on the sculptural quality of her design while metaphorically addressing her pieces as toys (França 2004, 298), thus highlighting their ludic character. The playfulness of Toledo's work, though having developed since the early 1960s, was particularly evident in the pieces exhibited in 1969 at her solo show at the Bonino Gallery in Rio de Janeiro. Often described by the press as ludic and technological (see Luz 1969, 5; Maurício 1969, 3), the exhibition presented sculptures as well as jewellery and decorative objects made with pvc, glass, water, oil, dye and foaming liquids. The transparency of pvc and glass was used to reveal to the public the behaviour of specific liquid substances when manipulated. Immersed in a colourful and surprising "spectacle"[19] (Maurício 1969, 3) – here,

Margarida Brito Alves and Giulia Lamoni

we are adopting the words of critic Jayme Maurício – the public was called to participate by putting the materials into action. These were the pieces that Salette Tavares explored in her article on Amélia Toledo's work in 1971.

The affinity between these two artists is palpable. As mentioned above, Tavares' artistic practice was increasingly mobilised by a tension between bi-dimensionality and tri-dimensionality, and it is no surprise that, over time, she started to describe her works not only as experimental or graphic poetry, but also as spatial poetry.

This spatialisation process is particularly evident in the early 1960s, in works such as *Maquinin*[20] from 1963, a sculptural piece constructed with anodised aluminiumletters that corresponds to the spatial expression of a poem she wrote in 1959;[21] or in *Ourobesouro,*[22] a word connected to her childhood, that in 1965 she sculpturally formalised into a geometrical object made from glass plates and gold lettering, exploring the space 'in between' by distributing the letters on different layers and therefore giving the word a sense of depth.

These possibilities would be further expanded during the 1970s, as is expressively evident in her previously mentioned exhibition, *Brincar* (Play), which was organised in 1979 at Quadrum Gallery in Lisbon and where she presented pieces such as *Bailia* – which turns text[23] into sculpture and involves an evident phenomenological dimension – and *Porta das Maravilhas* (Door of wonders) – a transparent acrylic door with a screen-printed poem that creates a body-to-body relationship with the viewer.

These works reveal a relational and playful dimension that Salette Tavares was by that point consistently exploring. In fact, in that period, notions of communication, participation and even interaction had become a core element of her work. As she had written a few years earlier, "… art is creation, and creation is the invention of the new by the artist and the one who reads it. And invention is activity. Never passivity"[24] (Tavares 1972, 44).

Teaching and playing

Under the direction of art critic Fernando Pernes, the National Society of Fine Arts in Lisbon reconfigured its artistic educational programmes between 1964 and 1965, – maintaining its traditional offering of drawing, painting and modelling, but adding a set of courses and conferences on art history, aesthetics and architectural subjects. The success of the new format led the institution to launch the *Cursos de Formação Artística* (Artistic Formation Courses) in 1966, coordinated by art critic and historian José-Augusto França. Including both a practical and a theoretical dimension, and setting up some of the Bauhaus educational practices as a reference, this two-year programme was taught by art historians, architects and artists,

such as Adriano de Gusmão, António Ferreira de Almeida, José-Augusto França, Conceição Silva, Manuel Taínha, Ernesto de Sousa, Rolando Sá Nogueira, António Sena da Silva – and Amélia Toledo.

Regarding that experience, art historian Sílvia Chicó, who had been one of the students at the time, remembers the way in which Amélia Toledo encouraged the class to meditate on form in order to stimulate them to test their ideas with paper constructions, sometimes using a poem as a starting point (Brito Alves 2018). Contrasting with other, more conventional educational formats of the time, those courses were marked by an exploratory dimension and by what Chicó describes as an "experimental" approach (ibid.). As for Toledo, her practice as a teacher was probably informed by the abovementioned Basic Design course which she had attended in London at the Central School of Arts and Crafts in the late 1950s. During that time in the United Kingdom, in fact, the Basic Design movement constituted an attempt to articulate a new approach to the teaching of art in higher education by artists-teachers such as Richard Hamilton, Victor Pasmore and William Turnbull. "The Basic Design movement", writes Richard Yeomans, "represented a very loose dissemination of educational ideas and principles inspired by the Bauhaus and European constructivism which challenged the prevailing Impressionist realism, propagated by the Euston Road painters, who dominated the teaching of many of the British art schools" (Yeomans 2009).

As we mentioned before, Salette Tavares was not involved as a teacher in the programmes of the *Cursos de Formação Artística* (Artistic Formation Courses), but held lectures on aesthetics throughout the 1960s and 1970s, in particular at Ar.Co – Centro de Arte e Comunicação Visual, an art school also based in Lisbon. It is important to bear in mind that Tavares not only worked as a poet and an artist during those decades, but also developed a very rich theoretical activity. One of her main interests concerned reception theory, and therefore her writings include not only references to thinkers such as Wilhelm Worringer, Heinrich Wölfflin, Max Bense, Henri Focillon, Gillo Dorfles, Maurice Merleau-Ponty and Umberto Eco, but also, most importantly, to Abraham Moles' information theory (Moles 1958). This theoretical activity, besides nourishing her artistic work, led her to write on the work of several other artists and even to become the president of AICA, the Portuguese branch of the International Association of Art Critics, between 1974 and 1976.

Her teaching approaches, like those of Amélia Toledo, were far from conventional, and it is quite telling how she blurred the lines between her activities as a teacher and as an artist. In fact, during the 1970s, Tavares developed performances that were presented as lectures – or, rather, lectures as performances. On those occasions, she dressed up and called herself *Sou Toura Petra* – a playful charade with a double

Margarida Brito Alves and Giulia Lamoni

meaning: in Portuguese, when heard out loud, those words mean "Doctor Petra", but in their written form their meaning is "I am bull Petra". After all, as she stated in the catalogue of her exhibition *Brincar*, playing would be a privileged way of going through life and not just an activity undertaken in childhood; it would correspond to "a natural and permanent state as it was at school and at home"[25] (Salette Tavares 1979).

Back to Lisbon

Mira Schendel had left Europe in 1949, embarking at the port of Naples in Southern Italy to head to Rio de Janeiro. In 1966, she arrived in Lisbon by boat and continued her travels by train. Her movements throughout Europe draw a map on which the Portuguese capital represents a margin, a point of entry – in a similar way to that in which, during World War II, it constituted a point of exit or escape from Europe for so many. But because of the presence of her friend, the artist Amélia Toledo, Lisbon also became a place of connections for Schendel. When juxtaposed to the city map, this network of relations reveals its spatial dimension. Evolving both inside and outside Lisbon, it encompassed the city of Carcavelos, where Toledo lived and worked, and Lisbon's city centre – the Buchholz Gallery in the street Duque de Palmela, and the nearby National Society of Fine-Arts in the street Barata Salgueiro, where Toledo worked as a teacher and Salette Tavares lectured at times. It is within the frame of this symbolic and spatial triangulation that the charted and uncharted encounters between these artists occurred.

Interestingly, like Mira Schendel's personal trajectory, the Buchholz Gallery also had a transnational history which intertwined with Nazi Germany and the World War II conflict. The Berlin art dealer Karl Buchholz founded the bookshop, which would later turn into a gallery, in Lisbon in 1943. As described by Jonathan Petropoulos, Buchholz was

> […] one of the four dealers initially selected by Goebbels's Reich Ministry of People's Enlightenment and Propaganda to sell "degenerate" art purged from German state collections …. When Buchholz received his formal contract with the Reich Propaganda Ministry to sell off "degenerate" art on 5 May 1939, the final provision was that Buchholz keep the contract secret: Buchholz received a commission of 25% in Reichsmarks for the works he sold. (Petropoulos 2001)

But in 1942, according to the same author, Buchholz's relations with the authorities became more problematic; he was searched and expelled from the Reich Chamber for the Visual Arts (ibid.). The following year, he migrated to Lisbon where he opened a new branch of his bookshop – a previous one had opened in Bucharest in 1940. In the early 1950s he left Portugal for Colombia.

As a gallery, the Buchholz branch in Lisbon began its activities in 1965. First directed by Catarina Braun, then by the Portuguese art critic Rui Mário Gonçalves, it launched with an exhibition dedicated to the Bolivian artist Maria Núñez del Prado (Rosa Dias 2016, 299).[26] It ceased to function as a gallery in 1975, a year after the revolution changed the country's political makeup for good. In the texture of this complex history, Mira Schendel's exhibition at Buchholz in 1966 and her real and virtual connections with Amélia Toledo and Salette Tavares in Lisbon represent significant nodes that are key for a transnational understanding of the contemporary histories of art in Southern Europe and beyond.

Notes

[1] The exhibition took place in November 1966 (*Mira Schendel*, 1966). Unfortunately, we have not been able to locate the archives of Buchholz Gallery, which closed in 1975. It is very possible that they were lost.

[2] Mira Schendel quoted by Jorge Guinle Filho (Guinle Filho 2014, 236).

[3] Our translation. Letter to Elizabeth Walther, São Paulo, 10 January 1967 (Souza Dias 2009, 193).

[4] As shown, for instance, in a photograph, probably from 1966, depicting Amélia Toledo with Pernes and with Portuguese artists Helena Almeida and Alice Jorge at the Venice Biennial (Farias 2004, 271).

[5] Our translation.

[6] As highlighted by Geraldo Souza Dias, José-Augusto França had already written about Mira Schendel's work in an article on the 1965 São Paulo Biennial, published in *O Comércio do Porto* on 22 March 1966 (Souza Dias 2009, 192).

[7] According to Brazilian artist Irene Buarque, who had been living in Lisbon since the early 1970s, Salette Tavares' name circulated in São Paulo in the gatherings organised by the De Campos brothers in the 1960s, often attended by both Amélia Toledo and Mira Schendel (Brito Alves /Lamoni 2019a).

[8] Our translation.

[9] See also Hatherly/de Melo e Castro 1981.

[10] Interviews with Amélia Toledo's son Mo Toledo (Brito Alves et al. 2019) and daughter Ruth Toledo (Brito Alves/Lamoni 2019b) have been important to our research process. To this day, for circumstantial reasons, it has not been possible for us to interview art historian José-Augusto França and artist Fernando Lemos, key mediators between the Portuguese and the Brazilian artistic milieus in the 1960s and 1970s.

[11] Biographical information on Mira Schendel is drawn from different sources, among them Souza Dias 2001, 77–85 and Avelar 2014, 257–279.

[12] Mira Schendel. Recorded statement to the Departamento de Pesquisa e Documentação de Arte Brasileira da Fundação Armando Álvares Penteado (FAAP), São Paulo, 19 August 1977. Quoted in *Mira Schendel* 2014, 266.

[13] Our translation.

[14] See *Artivisive Poesiavisiva*, exh. cat. Studio d'Arte Contemporanea Artivisive, Rome, Editrice Magma, March 1974.

[15] *14563 Letras de Pedro Sete* (1965), *Quadrada* (1967), *Lex Icon* (1971).

[16] Our translation.

[17] Our translation.

[18] Mira Schendel. Recorded statement to the Departamento de Pesquisa e Documentação de Arte Brasileira da Fundação Armando Álvares Penteado (FAAP), São Paulo, 19 August 1977. Quoted in *León Ferrari and Mira Schendel* 2009, 64.

[19] "Espetáculo". Ibid.

[20] The word *Maquinin*, invented by Salette Tavares, playfully combines the words maquina (machine) and manequim (mannequin).

[21] The poem was entitled "Maquinin" and was not published until 1967, in the volume *Quadrada*.

[22] The word *Ourobesouro*, created by the artist, combines the word ouro (gold) and besouro (beetle).

[23] The poem was entitled "Bailia das Avelaneiras", by Airas Nunes de Santiago, an 18th-century Galician troubadour.

[24] Our translation.

[25] Our translation.

[26] As a bookshop, Buchholz put on exhibitions from 1943 and it dedicated its inaugural show to Portuguese painter Carlos Botelho. See Fialho Brandão 2016, 15.

References

Artivisive Poesiavisiva, exh. cat. Studio d'Arte Contemporanea Artivisive, Rome, Editrice Magma, March 1974.

Avelar, Ana Cândida de. "Mira Schendel: Cronologia." *Mira Schendel,* edited by Tanya Barson and Taisa Palhares, exh. cat. Pinacoteca do Estado de São Paulo, São Paulo, et al., 2014, pp. 257–279.

Brito Alves, Margarida. 2018. "Interview with Silvia Chicó." (unpublished and unrecorded interview, Lisbon, November).

Brito Alves, Margarida, and Giulia Lamoni. 2019a. "Interview with Irene Buarque." (unpublished and unrecorded interview, Lisbon, 16 April).

Brito Alves, Margarida, and Giulia Lamoni. 2019b. "Interview with Ruth Toledo." (unpublished Skype interview, 16 April).

Brito Alves, Margarida, and Patrícia Rosas. "Salette Tavares: A work of art is not a soft-crust pastry pie." *Salette Tavares: Spatial Poetry*, exh. cat. Fundação Calouste Gulbenkian, Lisbon, 2014, pp. 139–149.

Brito Alves, Margarida, et al. "Interview with Mo Toledo." (unpublished, São Paulo, 29 January 2019).

De Campos, Augusto, et al., editors. *Poesia concreta*. Serviço de Propaganda e Expansão Comercial da Embaixada do Brasil, 1962.

Farias, Agnaldo, editor. *Amélia Toledo, The Natures of Artifice*. W11, 2004.

Fialho Brandão, Inês. "What´s in Lisbon? Portuguese Sources in Nazi-era Provenance Research." *Journal of Contemporary History*, volume 52, issue 3, 2016, pp. 566–587.

França, José-Augusto. "Amélia Toledo." *Amélia Toledo, The Natures of Artifice*, edited by Agnaldo Farias, W11, 2004, p. 298. First published in 1966.

Guinle Filho, Jorge. "Mira Schendel, pintora: o espaço vazio me comove profundamente." (1981). *Mira Schendel*, edited by Tanya Barson and Taisa Palhares, exh. cat. Pinacoteca do Estado de São Paulo, São Paulo, et al., 2014, pp. 235–244.

Hatherly, Ana, and E. M. de Melo e Castro, editors. *PO.EX. Textos teóricos e documentos da poesia experimental portuguesa*. Portugal Moraes Editores, 1981.

León Ferrari and Mira Schendel: Tangled Alphabeths, edited by Luis Pérez-Oramas, exh. cat. MoMA, New York, Cosac Naify, São Paulo, 2009.

Luz, Celina. "Amélia Toledo, O Objeto: Arte e Brinquedo." *Jornal do Brasil*, 17 December 1969, Caderno b, p. 5.

Martinho, Fernando J. B. "Nota sobre 'Espelho Cego' de Salette Tavares." *Salette Tavares. Poesia Gráfica*, Casa Fernando Pessoa, 1995, pp. 8–10.

Maurício, Jayme. "O mundo tecnológico de Amélia Toledo." *Correio da Manhã*, 31 December 1969, Anexo, p. 3.

Mira Schendel, exh. cat. Galeria Buchholz, Lisbon, 1966.

Mira Schendel, edited by Tanya Barson and Taisa Palhares, exh. cat. Pinacoteca do Estado de São Paulo, São Paulo, et al., 2014.

Moles, Abraham A. *Théorie de l´information et perception esthétique*. Flammarion, 1958.

Neves, Galciani. "As escrituras do corpo e Amelia Toledo: quando o gesto se torna livro." *Tessituras e criação*, no. 2, 2011, pp. 104–112, http://revistas.pucsp.br/index.php/tessitura. Accessed 12 April 2019.

Pérez-Oramas, Luis. "León Ferrari and Mira Schendel, Tangled Alphabeths." *León Ferrari and Mira Schendel: Tangled Alphabets*, edited by Luis Pérez-Oramas, exh. cat. MoMA, New York, 2009, pp. 12–45.

Pernes, Fernando. "Mira Schendel, Exposição na galeria Buchholz." *Colóquio: Revista de Artes e de Letras*, no. 41, 1966, pp. 70f., http://coloquio.gulbenkian.pt/al/sirius.exe/artigo?1211. Accessed 12 April 2019.

Petropoulos, Jonathan. "Bridges from the Reich: The Importance of Émigré Art Dealers as Reflected in the Case Studies of Curt Valentin and Otto Kallir–Nirenstein." *Kunstgeschichte, Open Peer-Reviewed Journal*, 2001, https://www.kunstgeschichte-

ejournal.net/305/1/PETROPOULOS_Bridges_from_the_Reich.pdf. Accessed 18 April 2019.

Rosa Dias, Fernando. "Rui Mário Gonçalves: Exercícios históricos de construção de uma curadoria moderna." *Convocarte: Revista de ciências da arte*, no. 2, September 2016, p. 299.

Salette Tavares. Brincar, exh. cat. Galeria de Arte Quadrum, Lisbon, 1979.

Salzstein, Sônia. "Entrevista com Haroldo de Campos." (1996). *Mira Schendel*, edited by Tanya Barson and Taisa Palhares, exh. cat, Pinacoteca do Estado de São Paulo, São Paulo, et al., 2014, pp. 247–255.

Schendel, Mira. "Fragment of a typewritten text, not dated nor signed." Arquivo Mira Schendel. *León Ferrari and Mira Schendel: Tangled Alphabeths*, edited by Luis Pérez-Oramas, exh. cat., MoMA, New York, Cosac Naify, São Paulo, 2009, p. 60.

Schendel, Mira. "Recorded statement to the Departamento de Pesquisa e Documentação de Arte Brasileira da Fundação Armando Álvares Penteado (FAAP), São Paulo, 19 August 1977." *León Ferrari and Mira Schendel: Tangled Alphabets*, edited by Luis Pérez-Oramas, exh. cat. MoMA, New York, 2009, pp. 62 and 64.

Souza Dias, Geraldo. "Chronologie." *Mira Schendel*, edited by Françoise Bonnefoy, exh. cat. Galerie Nationale du Jeu de Paume, Paris, 2001, pp. 77–85.

Souza Dias, Geraldo. *Mira Schendel: Do Espiritual à Corporeidade*. Cosac Naify, 2009.

Tavares, Salette. "A propósito de Amélia Toledo." *Colóquio / Artes*, nº 7, April 1971, pp. 31–32.

Tavares, Salette. "Kitsch." *Expo AICA*, exh. cat. SNBA, Lisbon, 1972, p. 44.

Tavares, Salette. "Transcrição da Carta de Salette Tavares para Ana Hatherly." Idem. *Poesia Gráfica*, Casa Fernando Pessoa, 1995, pp.16f.

Yeomans, Richard. "The Pedagogy of Victor Pasmore and Richard Hamilton." *Henry Moore Institute Online Papers and Proceedings*, 4 November 2009, p. 1, https://www.henry-moore.org/research/online-papers/2009/11/04/the-pedagogy-of-victor-pasmore-and-richard-hamilton. Accessed 18 April 2019.

Exile and the Reinvention of Modernism in Rio de Janeiro and São Paulo, 1937–1964

Rafael Cardoso

The cultural scene in Brazil shifted so radically between the 1930s and 1960s that it is difficult to reconcile views of the nation before and afterwards. That is a sweeping statement, but one borne out by reflecting on how Brazilians thought of themselves and their place in the world. In the early 1930s, the country was perceived as politically fragmented, economically deprived and culturally backward. The vast majority of the population was rural and poor. The sense of nationhood was weak. Elites, largely concentrated along the coastal strip, looked to the vast hinterland as a place from which they felt divorced. Most intellectuals possessed closer bonds to Europe than to the popular culture of the regions they inhabited, much less to remote geographical reaches like the Amazon. The major questions they asked themselves revolved around ethnicity, race and the legacy of colonialism and slavery: essentially, who are we and what are we to make of ourselves? Two landmark works of the time – Gilberto Freyre's *The Masters and the Slaves*, of 1933, and Sérgio Buarque de Hollanda's *Roots of Brazil*, of 1936 – redefined how Brazilians thought about their own culture and society (Botelho 2010, 47–66; Benzaquen de Araújo 2005). Both looked inwards and to the remote past to consider how nation and people had been formed. Similar issues were being addressed in artworks like Portinari's *Mestizo* of 1934, with its peculiar tension between portrait and stereotype, empathy and confrontation with the native other.

Jump to the early 1960s. The new capital city of Brasília had just been inaugurated, possibly the most ambitious experiment in utopian urban planning in the brief history of modernism (Saboia/Derntl 2014). Brazil was riding the crest of an international wave of optimism: an emerging economic power, the first non-European nation to win the football World Cup in 1958, cradle of the Bossa Nova musical style that was then sweeping the world. Brazilianness became a source of pride. The cultural scene within the country was vibrant, with Museums of Modern Art emerging in São Paulo and Rio de Janeiro, plus the São Paulo Art Museum and the São Paulo Biennial, inaugurated in 1951 as only the second Biennial in the world after Venice (Alambert/Canhête 2004). In the field of architecture, Brazil

was widely recognised as a hotbed of modernism (Cavalcanti 2003). Literature and cinema were thriving too. The budding Cinema Novo movement gained traction, particularly after a Brazilian film, *The Given Word*, won the Palme d'Or at Cannes in 1962. Debates among intellectuals no longer focused on what had gone wrong in the past but on an exciting present and the inevitability of greatness in the future (Marques dos Santos 1997, 59–70). Thanks to improved communication and new media, these changing attitudes not only made themselves felt among elites but were embraced throughout Brazilian society.

What happened in the brief interlude of three decades that separates the comparatively provincial Brazil of 1930 from the cool cosmopolitan version of 1960? Well, quite a lot happened. This was a period of tremendous technological, political, economic and social transformation – it would be fair to say, upheaval – encompassing not only World War II, but also major demographic shifts and rapid strides in industry and agriculture. In Brazilian political history, most of this period belongs to the Vargas Era, an umbrella term for the successive governments of Getúlio Vargas from 1930 to 1945 and again from 1951 to 1954 (Pandolfi 1999). A polarising figure, loved by many, hated by some, Vargas looms large as the leader under whom Brazilian politics and identity were reshaped over the mid-20th century. He was a driving force in consolidating a strong centralised state, dismantling competing power structures, suppressing regional differences and, on the cultural level, pushing for a unified collective identity based on fierce nationalism and not a few invented traditions. Especially under the dictatorship of the Estado Novo, from 1937 to 1945, Brazil was fashioned into a nationalist corporative state reminiscent of fascist or quasi-fascist regimes in Italy, Spain and Portugal.

Despite the abundance of factors at play in the transformation of Brazilian culture over the mid-20th century, this paper aims to draw attention to one aspect that is usually overlooked. The 1937 to 1964 period witnessed an unprecedented flow of artists and intellectuals into Brazil, many as exiles or refugees from World War II, as well as its immediate prelude and ongoing repercussions in Italy, Japan, Germany, Austria, Hungary, Poland, Spain, Portugal and other countries in which cultural freedom and/or ethnic minorities were targeted by authoritarian regimes. Like in the United States and Mexico – the two other nations in the Americas that most welcomed exiled artists and intellectuals – the cultural landscape in Brazil was powerfully influenced by the influx of refugees. Unlike in the US and Mexico, however, the wider repercussions of their influence have yet to be fully digested. Most people who study exile are likely to know a lot about Weimar on the Pacific, as it has been called (Bahr 2008); at least a little about the German exile community in Mexico; and probably next to nothing about exile in Brazil. Despite the fact that

Rafael Cardoso

the topic has been studied for over three decades, no broad overview has been produced since Maria Luiza Tucci Carneiro's seminal exhibition *Brazil, a refuge in the tropics* (Tucci Carneiro 1996), which dates from around the same time as LACMA's *Exiles and Emigrés*. The contribution of exile to the modernisation of Brazilian culture during the mid-20th century is still poorly understood, in particular with regard to the interrelationship between immigration and the refashioning of urban identities. That contribution was enormous and transformative – especially in Rio de Janeiro and São Paulo, the arrival cities where the immediate impact of refugee artists and intellectuals was most powerfully felt.

Rio de Janeiro as wartime haven

Even before the outbreak of war, the rise of fascism in Europe led major intellectual figures in Europe to seek out Brazil as a place of refuge (Asmus/Eckl 2013; Furtado Kestler 1992). The most famous of these was, of course, Stefan Zweig. Zweig first visited Brazil in 1936 for only ten days, and moved there definitively in August 1941, shortly after publishing *Brasilien, ein Land der Zukunft*, which came out almost simultaneously in six languages and eight separate editions. Six months later, in February 1942, he committed suicide in Petrópolis, at the age of 60, casting a long shadow over the idea – of which he was the major proponent – that the better part of European civilisation could be successfully transplanted to South America (Dines 2006). Even before Zweig, key players in German-speaking artistic circles were already seeking out Brazil as a haven in which to weather the storm of National Socialism. The well-known sculptor Ernesto de Fiori left Berlin in 1936 and moved to São Paulo where he remained until his death in 1945 (Laudanna 2003). The young German musician and musicologist Hans-Joachim Koellreutter arrived in 1937, bringing to Brazil the principles of the 12-tone system. He played the flute in the Brazilian Symphony Orchestra, founded in 1940, whose first conductor, the Hungarian Eugen Szenkar, was also a refugee from National Socialism. Over his long life, Koellreutter was to prove hugely influential as a teacher. Among his pupils were not only some of the most important classically-trained conductors and composers in post-War Brazil, but also popular musicians like Antônio Carlos Jobim, Caetano Veloso and Tom Zé (Alencar de Brito 2015).

From the late 1930s, the trickle of notable exiles to Brazil began to swell. The renowned French writer, Georges Bernanos, arrived in 1938 and eventually settled in the town of Barbacena, in the mountains of Minas Gerais. From this unlikely location he became a leading spokesman for the Free French movement, and his book *Lettre aux anglais*, one of the rallying cries of anti-Vichy forces, was

written and first published in Brazil, in French. He wrote regularly for the Diários Associados newspaper chain, and his articles were syndicated all over the world and even broadcast by the BBC. Bernanos's unusual profile for a refugee from 1930s Europe – French, Catholic, monarchist – afforded him exceptional inroads into the conservative political establishment (Lapaque 2003). After Brazil entered the war, under intense US pressure, in August 1942, his presence became a convenient symbol that the heart of the nation had always been on the side of the Allies. That was true for a large segment of the francophile elites, but certainly not for society as a whole. Brazil was home to one of the largest NSDAP branches outside the German-speaking world. Between 1936 and 1941, parts of the Vargas government engaged openly with the regime in Berlin, turning away leftist and Jewish refugees and even deporting a few back (Souza Moraes 2005; Perazzo 1999; Lesser 1995).

The situation was perhaps most dramatic for the numerous German-language writers and intellectuals, mostly of Jewish origin, who arrived in Brazil during the years of the Estado Novo (Eckl 2010). Some were able to pick up the language, and indeed Ernst Feder and Otto Maria Carpeaux were writing and publishing in Portuguese within a few years. Not everyone was so gifted or sociable enough to make friends in the Brazilian press and literary world. Despite having spent 15 and 16 years in Brazil respectively, Richard Katz and Frank Arnau are mostly unknown to Portuguese-language readers. Their ties to Brazil are remembered only in the German-speaking world, if at all. On the other hand, Carpeaux and Anatol Rosenfeld are known in Brazil and largely forgotten in their countries of origin. Emigration affects different people in different ways, and this has a lot to do with the age at which someone becomes a refugee and what status they may or may not have had beforehand. For the younger and unknown, exile may even prove to be an opportunity to reinvent oneself completely in another language and context. Vilém Flusser is a remarkable example, fashioning an intellectual identity in the margins between his shifting allegiances in Brazil and Europe (Guldin/Bernardo 2017). Within the German-speaking exile community, political divides remained fierce during and after the war. Suspicions and intrigue ran high. Austrian exile Paul Frischauer was ostracised for writing an official biography of Vargas at the behest of the regime's Department of Press and Propaganda (DIP). Others, like Wolfgang Hoffmann-Harnisch, were viewed with mistrust, leaving them in a limbo situation in which they fitted into neither the exile community nor mainstream Brazilian society.

During World War II, Rio de Janeiro, then the capital and main port city of Brazil, became a haven for refugee artists and intellectuals. Among the most prominent exiles arriving during wartime was the artist couple Maria Helena Vieira da Silva, Portuguese by birth, and Árpád Szenes, Hungarian and Jewish.

Resident in Paris during the 1930s, they moved briefly to Lisbon at the outbreak of war and again in 1940 to Brazil, where they settled in Rio. They were to remain until 1947, residing in the district of Santa Teresa where a small community of exiled artists soon formed around two addresses: the once grand but decaying Hotel Internacional, near the world-famous statue of Christ the Redeemer, and the more modest Pensão Mauá, closer to the city centre but still fairly remote due to the hillside location of the area. This is the best-known facet of wartime exile in Brazil and was the subject of a groundbreaking exhibition in the 1980s curated by Frederico Morais (*Vieira da Silva no Brasil* 2007; *Tempos de guerra* 1986). Due to their Parisian reputation and also to the fact that Vieira da Silva's native language was Portuguese, the couple soon became well connected in the Brazilian cultural world and cultivated acquaintances with influential figures like the poets Cecília Meireles, Murilo Mendes and Carlos Drummond de Andrade. They were also surrounded by a circle of younger artists, both Brazilian and exiled.

Vieira da Silva was among the first to exhibit at the gallery opened in 1944 in Rio de Janeiro by Miecio Askanasy, also a refugee from Europe, which became a meeting place for connecting exiled artists and their Brazilian counterparts. German painter Wilhelm Wöller and Belgian Roger van Rogger both had solo exhibitions there, as did Brazilian artists with personal links to the émigré community, like Bellá Paes Leme and Lucy Citti Ferreira. In April 1945, Askanasy's gallery opened an exhibition of 150 works by major German artists entitled *Art condemned by the Third Reich* (Kern 2016, 813–826). The catalogue essay was written by exiled art historian Hanna Levy; and Ernst Feder gave a lecture at the opening. The exhibition received extensive press coverage. A few weeks after the opening it was targeted by three fascist thugs who slashed one of Wöller's works with a razor, generating further attention. Few of the more prominent names in Brazilian modernism seem to have lent support to Askanasy or to the exhibition, except for Lasar Segall who lent one work and Tomás Santa Rosa who gave a closing speech. Segall was himself Jewish and had personal ties to German expressionism. Santa Rosa was a painter and stage designer involved in communist circles. The absence of other notable figures of the art world raises interesting questions, such as whether or not the mainstream of Brazilian modernism kept itself apart from the refugee community, and if so, why.

Artists of various nationalities lived and worked in Rio de Janeiro around this time, including Polish sculptor August Zamoyski, Austrian printmaker Axl Leskoschek, Japanese painter Tadashi Kaminagai and Romanian painter Emeric Marcier, all of whom were established in their careers by the time they moved to Brazil. Polish director Zbigniew Ziembiński arrived in 1941 and is remembered today as one of the founders of modern Brazilian theatre. The artistic networks

that developed in Rio around these figures had lasting repercussions, particularly for those artists who were also active as teachers, like Zamoyski, Leskoschek, Kaminagai and Szenes. A substantial number of younger artists congregated around the courses they taught and the ateliers where they worked. They exercised a direct influence on a generation that included Almir Mavignier, Athos Bulcão, Carlos Scliar, Djanira, Flávio-Shiró, Franz Weissmann, Inimá de Paula, Ione Saldanha, Lygia Clark, Milton Dacosta and Tikashi Fukushima, some of whom would, in turn, become influential in the second wave of Brazilian modernism over the 1950s and 1960s.

The circle around Vieira da Silva and Árpád Szenes shares certain characteristics typical of wartime exile in the Americas. The part of Santa Teresa where they lived, high on a hill, is somewhat isolated from the rest of Rio. It is greener and slightly cooler and has long attracted foreign residents. Spatially and socially, it could be compared to Pacific Palisades in Los Angeles or Coyoacan in Mexico City. It is something of an enclave, contained within the wider and more turbulent fabric of the city. The Hotel Internacional/Pensão Mauá circle is also reminiscent of other exile communities because it did not endure very long beyond the end of the war. After 1947, when Vieira da Silva and Szenes returned to Europe, their influence was gradually forgotten, and they are rarely taken into account in surveys of the history of art in Brazil. Rio, with its long history of glossing over conflict, swallowed up the stories of the exiles who inhabited the city in the 1940s and 1950s. Most of them left, and those who remained remade themselves in a more domesticated image, like the Catholic converts Carpeaux and Marcier.

São Paulo as city of migrants

The situation in São Paulo was different. Until the end of the 19th century, São Paulo had been a dusty provincial town. A huge influx of immigrants – mostly Italian, but also Spanish and Portuguese, Japanese, Lebanese and Syrian, Jews from Eastern Europe, among other groups – changed the face of the city over the first decades of the 20th century. From a population of just under 65,000 in 1890, São Paulo blew up into a metropolis of over 1,000,000 inhabitants by the mid-1930s. This explosive growth – more than 15 times in less than 50 years – was driven by the prosperity of the coffee export trade centred around the city and state of São Paulo and, after World War II, by an upsurge of industrial activity. For younger refugee artists and intellectuals who did not possess established careers and reputations, this booming hub of new wealth and social mobility often proved more attractive than the comparatively stratified society of the capital, Rio de Janeiro.

Rafael Cardoso

Austrian architect Bernard Rudofksy followed a common route, arriving in Buenos Aires in 1938, moving to Rio after six weeks, then again to São Paulo, where he remained for a few very productive years before going on to New York in late 1941 (Rossi 2016). The lure of São Paulo came to be particularly intense after the war, when a new wave of immigration brought artists like Samson Flexor, Mira Schendel and Maria Bonomi, architect Lina Bo Bardi and her curator husband Pietro Maria Bardi and theatre director Gianni Ratto, the last four from Italy. In São Paulo, they encountered fledgling institutions and a class of eager patrons, among them: press magnate Assis Chateaubriand, who founded the São Paulo Museum of Art in 1947, or his arch-rival, industrialist Ciccillo Matarazzo, himself of Italian descent, who was the prime mover in establishing São Paulo's Museum of Modern Art in 1948, the São Paulo Biennial in 1951 and the Museum of Contemporary Art in 1963 (Amaral 2006; Mendes de Almeida 2014).

Historians have generally shied away from thinking about these multiple experiences of migration collectively. The motives for moving to Brazil were very different for Japanese immigrants in the 1930s, German refugees in the 1940s and Italian economic migrants in the 1950s. Without a doubt, it is essential to bear such distinctions in mind when writing these histories. However, from the vantage point of the contexts they entered, where they came from and why is less interesting than the fact of their simultaneous presence. Much more urgent questions for the 'arrival cities' are the impact of newcomers on the existing culture or how they interacted with the local mainstream and helped to transform it. There is no doubt, for instance, that foreign and immigrant artists of various origins played a prominent role in the move towards abstract painting – both geometric and informal abstraction – that shook the foundations of Brazilian modernism in the 1950s.

The 1952 exhibition entitled *Ruptura* – rupture – held at São Paulo's Museum of Modern Art marks the beginning of the Concrete Art movement in Brazil (*Concreta '56: A raiz da forma* 2006). Of the seven founding members of the Ruptura group, no fewer than four were immigrants: Swiss artist Lothar Charoux arrived in 1928; Polish artists Anatol Wladyslaw, who arrived in 1930, and Leopold Haar, who arrived in 1946; and Hungarian artist Kazmer Féjer, who arrived in 1939. A fifth member, Waldemar Cordeiro, was born and raised in Italy, though his father was Brazilian and he possessed Brazilian citizenship from birth. Revealingly, it is the Brazilian members – Cordeiro, Geraldo de Barros and Luiz Sacilotto – who went on to achieve notoriety and are usually remembered as members of the group, alongside Hermelindo Fiaminghi, Judith Lauand and Maurício Nogueira Lima, all three Brazilian, who joined later. Irrespective of the quality of their work, it is at least intriguing that the foreign artists have been consigned to the footnotes, especially

considering the importance of like-minded movements in Europe to the group's ideas. There is undoubtedly a tension between nationalism and internationalism that bubbled under the surface of Brazilian modernism for many decades and came to a head after World War II. To understand this better, we need to go back to two figures who have already made a brief appearance at the beginning of this paper: sculptor Ernesto de Fiori and musicologist Hans-Joachim Koellreutter.

De Fiori arrived in Brazil in August 1936 to visit his mother and brother, who were resident in São Paulo. He was an established artist in Berlin at the time, and was under no pressure to emigrate, being neither Jewish nor particularly political. As the situation in Germany deteriorated, however, there was less and less reason to return. When war broke out he found himself stranded in São Paulo, where he led a reduced existence as an artist until his death in April 1945. In 1938, he submitted proposals for a monumental sculpture of 'Brazilian man' that was meant to be erected at the entrance of the Ministry of Education and Health building, in Rio de Janeiro, a landmark in the history of modernist architecture, designed by Le Corbusier and executed by a team that included Lúcio Costa, Oscar Niemeyer and Roberto Burle Marx. The sculpture was an integral component of the building programme and can be seen in the original sketches. The idea for the monument was conceived by the Minister of Education himself, Gustavo Capanema, and closely overseen by a committee of scientific advisors. It was supposed to represent 'the Brazilian racial type'. De Fiori's submissions were rejected, as were those of two other sculptors; and, in the end, the project was shelved (Alves Pinto Júnior 2014; Knauss 1999). It is fascinating to consider the conflicts that this task must have posed for de Fiori – a sculptor accustomed to working on a small scale attempting to design a 12-metre high figure; a born cosmopolitan and circumstantial refugee from National Socialism charged with devising a monument to race and nation under a dictatorial regime. It is no wonder his half-hearted proposals fell short of the Minister's expectations.

The other episode fleshing out the tension between nationalism and internationalism took place after the end of the war and revolves around Koellreutter, who was the pivotal figure in a notorious controversy in 1950 that epitomises the conflict between ideas of native and imported in Brazilian modernism (Egg 2005, 60–70). In 1939, soon after his arrival in Brazil, Koellreutter formed a group called Música Viva, dedicated to promoting contemporary music. They staged concerts and published a monthly bulletin. He managed to attract a number of students, including some who became important names in the Brazilian musical world such as Cláudio Santoro and César Guerra-Peixe. He also went on to host programmes for the Ministry of Education's radio broadcaster. Cautious at first, Koellreutter became more militant in his promotion of avant-garde music by the

Rafael Cardoso

end of the Estado Novo regime, in October 1945. In the twelfth issue of the Música Viva bulletin, he published a text called "Manifesto 1946" which adopted a more radical position in favour of serial and atonal music. Debates ensued within the musical world, with Koellreutter's followers increasingly emboldened to attack the nationalism and folklorism that had dominated modernist discussions of music in Brazil since the 1920s. The backlash came in 1950 with the publication of an "Open Letter to the Musicians and Critics of Brazil" by Mozart Camargo Guarnieri, one of the country's leading composers and, up to then, a colleague on good terms with Koellreutter. In this text sent out to various leading musicians and soon made public in the press, Camargo Guarnieri violently denounced the 12-tone system as false, formalist, pernicious, anti-Brazilian and destructive of the national character. He compared it to abstraction in painting and existentialism in philosophy and linked it to a "policy of cultural degeneracy" and a "cosmopolitanism that threatens us with its deforming shadows", rhetorical tropes eerily reminiscent of the discourses around *entartete Kunst* (Egg 2006). The letter sparked a minor culture war that rocked the Brazilian musical world for three years, with repercussions in Portugal, and eventually consolidated Koellreutter's mythical status as a champion of artistic freedom.

There is not enough room here to delve more deeply into the issue of cosmopolitanism and its implications for the reinvention of modernism in Brazil. Or, for that matter, on the dialectical relationship between immigration and the development of the respective urban cultures of Rio de Janeiro and São Paulo. In lieu of a conclusion, it may be useful to cast the net even wider and underscore the inordinate influence that foreign photographers, some refugees, had on the way Brazilians viewed themselves, their nation and culture over the 1940s and 1950s. The photographic works of Alice Brill, Thomaz Farkas, Werner Haberkorn and Hildegard Rosenthal were essential in constituing the visual identity of Brazil's new metropolises, particularly São Paulo. The photographs of Marcel Gautherot and Pierre Verger helped to flesh out how urbanites in Rio or São Paulo imagined rural Brazil, its folklore and traditions. What little consensus there is about what it means to be Brazilian has been shaped, arguably, more by the gaze of newcomers than by the programmatic intentions of those who set out to define the native in written terms. To look at the images produced by immigrant photographers and reflect on the dazzling complexity of who is saying what about whom, how and why is enough to confuse any stable or predetermined notion of national identity (*Brasiliens Moderne 1940–1964* 2013). Brazil remains a multicultural country despite its newly elected wish to deny the fact; and its most important arrival cities, Rio de Janeiro and São Paulo, are still shaped by the ghosts of those who once sought refuge there.

References

Alambert, Francisco, and Polyana Canhête. *As bienais de São Paulo: Da era do museu à era dos curadores (1951–2001)*. Boitempo, 2004.

Alencar de Brito, Teca. *Hans-Joachim Koellreutter: Ideias de mundo, de música, de educação*. Peirópolis/Edusp, 2015.

Alves Pinto Júnior, Rafael. "Memórias de um monumento impossível." *19&20*, vol. 9, 2014, no page numbers.

Amaral, Aracy A. *Textos do Trópico de Capricórnio: Artigos e ensaios (1988–2005). Vol. 2: Circuitos de arte na América Latina e no Brasil*. Ed. 34, 2006.

Asmus, Sylvia, and Marlen Eckl, editors. *" … mehr vorwärts als rückwärts schauen …": das deutschsprachige Exil in Brasilien, 1933–1945*. Hentrich & Hentrich, 2013.

Bahr, Ehrhard. *Weimar on the Pacific: German Exile Culture in Los Angeles and the Crisis of Modernism*. University of California Press, 2008.

Benzaquen de Araújo, Ricardo. *Guerra e paz: "Casa grande e senzala" e a obra de Gilberto Freyre nos anos 30*. Ed. 34, 2005.

Botelho, André. "Passado e futuro das interpretações do país." *Tempo Social*, vol. 22, 2010, pp. 47–66.

Brasiliens Moderne 1940–1964: Fotografien aus dem Instituto Moreira Salles, edited by Ludger Derenthal and Samuel Titan Jr., exh. cat. Museum für Fotografie, Berlin, 2013.

Cavalcanti, Lauro. *When Brazil was Modern: a Guide to Archiecture, 1928–1960*. Princeton Architectural Press, 2003.

Concreta '56: A raiz da forma, edited by Lorenzo Mammi et al., exh. cat. Museu de Arte Moderna, São Paulo, 2006.

Dines, Alberto. *Tod im Paradies: Die Tragödie des Stefan Zweig*. Büchergilde, 2006.

Eckl, Marlen. *"Das Paradies ist überall verloren": das Brasilienbild von Flüchtlingen des Nationalsozialismus*. Vervuert, 2010.

Egg, André. "O grupo Música Viva e o nacionalismo musical." *Anais do III Fórum em Pesquisa Científica em Arte*, 2005, pp. 60–70.

Egg, André. "A carta aberta de Camargo Guarnieri." *Revista Científica/FAP*, vol. 1, 2006, pp. 1–12.

Furtado Kestler, Izabela Maria. *Die Exilliteratur und das Exil der deutschsprachigen Schriftsteller und Publizisten in Brasilien*. Peter Lang, 1992.

Guldin, Rainer, and Gustavo Bernardo. *Vilém Flusser (1920–1991): Ein Leben in der Bodenlosigkeit: Biographie*. Transcript, 2017.

Kern, Daniela Pinheiro Machado. "Hanna Levy e a exposição de Arte Condenada pelo III Reich." *Anais do 25º Encontro Anpap*, 2016, pp. 813–826.

Knauss, Paulo. "O homem brasileiro possível: Monumento da juventude brasileira." *Cidade vaidosa: Imagens urbanas do Rio de Janeiro*, edited by Paulo Knauss. Sette Letras, 1999, pp. 29–44.

Lapaque, Sébastien. *Sous le soleil de l'exil: Georges Bernanos au Brésil, 1938–1945.* Bernard Grasset, 2003.

Laudanna, Mayra. *Ernesto de Fiori.* Edusp/Imprensa Oficial, 2003.

Lesser, Jeffrey. *Welcoming the Undesirables: Brazil and the Jewish Question.* University of California Press, 1995.

Marques dos Santos, Afonso Carlos. *A invenção do Brasil: Ensaios de história e cultura.* Ed. UFRJ, 1997.

Mendes de Almeida, Paulo. *De Anita ao Museu.* Terceiro Nome, 2014.

Pandolfi, Dulce, editor. *Repensando o Estado Novo.* Ed. FGV, 1999.

Perazzo, Priscila Ferreira. *O perigo alemão e a repressão policial no Estado Novo.* Arquivo do Estado, 1999.

Rossi, Ugo. *Bernard Rudofsky Architetto.* Clean, 2016.

Saboia, Luciana, and Maria Fernanda Derntl, editors. *Brasília 50 + 50: Cidade, história e projeto.* Universidade de Brasília, 2014.

Souza Moraes, Luís Edmundo de. *Konflikt und Anerkennung: Die Ortsgruppen der NSDAP in Blumenau und Rio de Janeiro.* Metropol, 2005.

Tempos de guerra: Hotel Internacional, Pensão Mauá, edited by Frederico Morais, exh. cat. Galeria de Arte Banerj, Rio de Janeiro, 1986.

Tucci Carneiro, Maria Luiza. *Brasil, um refúgio nos trópicos: A trajetória dos refugiados do nazi-fascismo.* Estação Liberdade, 1996.

Vieira da Silva no Brasil, edited by Nelson Aguilar, exh. cat. Museu de Arte Moderna, São Paulo, 2007.

Arrival City Istanbul

Flight, Modernity and Metropolis at the Bosporus. With an Excursus on the Island Exile of Leon Trotsky

Burcu Dogramaci

Istanbul: City on the water, city of migration

At the beginning of the 20th century Istanbul was an important arrival city for migrants. Even before World War I, about 1,000,000 people lived in the Ottoman capital, including roughly 130,000 foreigners, who came primarily from countries bordering on the Mediterranean and from Russia (Keyder 2004, 34; King 2014, 77). During the Balkan wars in 1912–1913, many people also fled to Istanbul from the disputed Ottoman territories in the Balkans. After the founding of the republic in 1923 and after the embassies moved to the new capital of Ankara, many embassy employees left Istanbul. Later a law regulating the "entry and residence of foreigners in Turkey" (1938) (Guttstadt 2018, 53), the capital tax for non-Muslim inhabitants of the metropolis (1942) and riots against the Greek minority in 1955 led to an exodus from the city (Sert 2015, 219). In the meantime, after 1917 but mainly as of 1920, many who had fled the Russian Revolution had arrived in the city. The historian Hans von Rimscha writes of 50,000 Russian emigrants in 1920 (Rimscha 1924, 51); Charles King, author of a book on 'Modern Istanbul', even mentions a total of 185,000 civil war refugees from Russia who were stranded in Istanbul, raising the total population by 20 per cent (King 2014, 124). Many of them lived on the European side in the district of Galata, in the neighbourhood of the main street that was initially called the Grand Rue de Péra and later Istiklal Caddesi, which leads to Taksim Square and was located near the traditional Russian centre, Karaköy. For a while Istanbul became a "Russian Constantinople" with restaurants, pastry shops and cabarets on the Grand Rue de Péra (Vassiliev 2000, 68–72). In 1921 "Kultura" was the first Russian bookshop to open in Pera, and in the same year the "Union of Russian Artists" had its first exhibition in the Mayak Club (Bursa Sokak No. 40, see Deleon 1995, 54–62). Members of this

union included artists such as Vasily Iosifovich Ivanov, Vladimir Konstantinovich Petrov and Boris Isaevich Egiz.

What is interesting here is a comparative perspective of the second 20th-century movement of emigration to Istanbul – the arrival of emigrant artists, architects and urban planners from National Socialist Germany. Since 1927, the government of Mustafa Kemal Atatürk had been bringing increasing numbers of foreign specialists to the Turkish Republic, which had been proclaimed only a few years earlier. These were expected to speed up the reforms in society, politics, administration, science, culture and education. After 1933, emigrants who were forced to flee the National Socialists arrived in the country. Admittedly they were able to immigrate by invitation only, but largely held leading positions. Thus, they worked as professors, chaired commissions and were engaged to write textbooks in their areas of expertise (Cremer/Przytulla 1991). In Istanbul, German-speaking artists and architects taught at institutions such as the Academy of Fine Arts; these included the sculptor Rudolf Belling, the architect Bruno Taut and the urban planner Gustav Oelsner. German-speaking architects such as Clemens Holzmeister, Paul Bonatz and again Gustav Oelsner also worked at the Faculty of Architecture founded in the 1940s at the Technical University of Istanbul, located in Istanbul-Maçka not far from Taksim Square. Many of them lived in the radius of these institutions on the European continent and preferably in the neighbourhoods of Beyoğlu and Galata.

For the new arrivals the topography of the city situated on two continents and divided by a strait provided a very special experience of emigration. After his arrival, the sculptor Rudolf Belling, like many of the emigrants, was initially housed in the Park Hotel,[1] a luxury hotel in Beyoğlu-Gümüşsuyu built in the Art Deco style that had a panoramic view of the Bosporus. As Rudolf Belling wrote in early 1937:

> From my hotel window I look down at the Sea of Marmara, the Bosporus to the left, a truly Golden Horn. Vis-à-vis is the Asian coast, Skütari, Haydarpasa, Kadiköi. Then a couple of wonderful islands and all the way in the back a lovely curving mountain range. You cannot imagine how different the city can appear, what pastel shades tint the houses and water.[2]

The water separates Istanbul into two halves and not only marks the boundary between the European and the Asian continents, but affects the way people live, dwell and work in the metropolis. The Bosporus and ways of overcoming this waterway were crucial factors when looking for housing, since especially for those whose place of work was on the European side the daily commute on the Bosporus ferries was laborious.

Burcu Dogramaci

This paper addresses the question of how it was precisely the city's location by the water that inspired and challenged emigrants in the 1930s and 1940s to build.[3] To date, the work of German-speaking architects in Turkey has been studied primarily from a national perspective, in reference to individual architects and as a contribution towards modernity (Nicolai 1998; Dogramaci 2008; Akcan 2012). So far, there has been no local perspective on architectural emigration history with a focus on Istanbul, nor have there been studies of the connection between metropolis, migration and topography.[4]

For the houses built by (e)migrant architects, such as the *Ragip Devres Villa* (architect: Ernst Egli), the *Eckert House* (architect: Clemens Holzmeister) and the private home of the Berlin architect Bruno Taut, the Bosporus was an important creative point of reference. Leon Trotsky's exile on Büyükada/Prinkipo, the Princes' Island located off the coast of Istanbul, leads to concluding observations about the insular status of exile.

Designs by emigrants: Architectures at the Bosporus

During the 1930s and 1940s residences for local people and emigrants were planned in Istanbul, and some of the designs were done by German-speaking architects like Ernst Egli, Clemens Holzmeister, Margarete Schütte-Lihotzky and Bruno Taut. Particularly prestigious were buildings that were close to the water or overlooked the Bosporus or the Sea of Marmara. Described below are buildings and projects by the water – ranging from the Rumelihisari to the historic centre of Istanbul (fig. 1). Here it becomes clear that the specific topography of the city on the water represented a special challenge for developers and architects and had a very decisive influence on the construction activity of the architects. It is important to note that during the construction period of the buildings presented below none of the three Bosporus bridges was yet in existence. The opposite shore on the Asian continent could be reached only by ship.

It must be emphasised from the start that foreign *and* local architects were planning and implementing building projects by the water. Among the major 20th-century architects of Bosporus villas was the Turkish architect Sedad Hakkı Eldem, who over a period of several decades built *yalıs* (beach houses) for a well-to-do upper-class or industrial clientele. His houses are described as follows: "An Eldem yalı is, before anything else, a gesture to the Bosphorus." (Bozdoğan et al. 1987, 103). As early as 1938, with his *Ayaslı Yalı* in Istanbul-Beylerbeyi, Eldem created a prototype for a renewed traditional villa architecture; its floor plan and façade were modelled on the Ottoman palace at the Bosporus (ibid., 49). The German-

speaking architects were thus not the only ones to be engaged with building at the waterside; rather, they were working and competing within a creative local environment. Nevertheless, the following remarks will focus exclusively on the architects who had migrated to Istanbul, who – according to one thesis – expanded their repertory while addressing the water topography and the needs of their clients, and at the same time inscribed themselves in the matrix of the city.

Fig. 1: Map of Istanbul, from right to left: Holzmeister's *Eckert-Rifki Villa*, Egli's *Ragip Devres Villa*, Taut's Villa and *Alfred Heilbronn Botanical Garden* (© Google).

Following his Atatürk palace, the residence of the president in Ankara (Nicolai 1998, 64f.), the Austrian architect Clemens Holzmeister, who had worked since 1927 for Turkish Ministries and built mainly in the capital city Ankara, received many commissions for villas. Between 1932 and 1946 Holzmeister designed more than a dozen houses for the country's politicians, military men and upper crust. However, only some of the designs were actually implemented, and hardly any of the projects were nearly as radical as the functional and modern architecture of the Atatürk palace in Ankara. Thus when, in many villa designs, Holzmeister formulated a classic tiled roof, bay windows and stone base, the picture that emerges is of a residence that has been cautiously modernised. An example of this approach is the *Eckert-Rifki Villa* (1943/1944, Baltalimanı Caddesi, fig. 2)[5] in Rumeli Hısarı, situated directly on the Bosporus. While many clients did choose Europeanised floor plans with separate bedrooms for children and their parents, and a living room, the exterior architecture had to follow traditional models of the Turkish house. Particularly in the 1940s there was a striking departure from

Burcu Dogramaci

the radical modernity of functionalist designs in the wake of rising nationalism in architecture. This also indicated that a reformed lifestyle did not inevitably have to lead to the adaptation of European forms of architecture.

Fig. 2: Clemens Holzmeister, *Eckert-Rifki Villa*, Istanbul Baltalimanı, Baltalimanı Caddesi, 1943/44 (Archive Monika Knofler, Vienna).

A few kilometres in the direction of the historic centre of Istanbul was the former fishing village of Bebek. Outside the historic city centre, the prosperous elite of Kemalist Turkey built villas whose floor plans and occasionally their external form as well were positioned as progressive. In particular Ernst Egli's retreat for the engineer Ragip Devres in Istanbul Bebek (1932/33, Cevdet Paşa Caddesi No. 101, fig. 3a, b) left its mark on the Turkish villa landscape. With its wrap-around balconies, steel columns, flat roof and panoramic windows, the house follows the parameters of international architectural modernity and thus differs from the

Figs. 3a–3b: Ernst Egli, *Ragip Devres Villa*, Istanbul Bebek, Cevdet Paşa Caddesi No. 101, 1932–1933. View from the street and Interior (*Werk*, no. 25, 1938).

classic Turkish residential building. The break with tradition is also evident in the organisation of life inside the building and of its interior design. In the classic Ottoman house, women lived in the *harem* while men lived in the *selamlık*, the men's wing and the reception area. Only the closest male relatives could enter the women's house, and it was only here that the lady of the house was allowed to receive her guests (Nayman 1936, 510). Indeed as early as the end of the 19th century the Ottoman aristocracy and upper class became increasingly interested in European types of housing and interior design (Gürboğa 2003, 62). However, a radical societal change and reform of housing took place primarily only after 1923. The floor plan of the *Ragip Devres Villa* consists of two rectangles nested inside each other, where all plumbing units and private rooms were situated in the recessed wing, while a single, prestigious salon for social gatherings which opened to the garden was housed in the other half. The planning of the parents' bedroom and separate children's rooms on the top floor was a concession to European living arrangements. At the request of the clients, Egli was responsible for the garden architecture as well as the interior furnishings (Egli 1969, 51). In the dark wall panelling, the built-in wardrobes and buffets there are visible references to Viennese interiors like that of the *Moller House* by Adolf Loos, built in 1928. A European type of residence and furnishings became the expression of a lifestyle that was the antithesis of that of an Ottoman house (Ernst Egli, in: Meier 1941, 1240). Just a few years after the *Ragip Devres Villa* was built, the émigré biologists Leonore and Curt Kosswig also moved into a house in the suburb of Bebek. However, they did not build a new house, but lived in a historic wooden villa. This "House on the Hillside" (Inşirah Sokağı 32), as the Kosswigs referred to it in a photo, was a meeting place for emigrants where plays and music were performed. The Kosswigs were part of a coterie of scientists – a kind of "private academy" – headed by the economist Alexander Rüstow and the lawyer Andreas Schwarz; its members, among them the financial economist Fritz Neumark, represented various disciplines and gave lectures about their respective fields of specialisation (Neumark 1980, 180). Kosswig's residence in Bebek thus had an important social function of networking and community building within the German-speaking émigré community. The House on the Hillside formed its own island in exile and was thus an expression for strategies of community building.[6]

A second popular location and residential area outside the city centre was Ortaköy.

Here the architect Bruno Taut designed homes for himself and others, including a house for the surgeon Rudolf Nissen (Nerdinger et al. 2001, 392). Taut built his own house (Emin Vafi Korusu, fig. 4) in 1937/1938 on a hillside with a panoramic view. The one-storey building has a rectangular ground plan and sits on a cement

slab measuring six by 15 metres, resting on solid ground only to a minor extent (Aslanoğlu 1980, 144f.; Zöller-Stock 1994, 68f.).

Fig. 4: Bruno Taut, *Taut Villa*, Istanbul Ortaköy, Emin Vafi Korusu, 1937–1938 (Junghanns 1970/1983, ill. 331).

Towards the front the tiled hip roof on the elongated section of the building is completed by a three-tiered roof. A tower room which was to house Taut's studio finishes off the building at the top. Each of the storeys is pierced by ribbon windows which in the lower sections direct attention to the water. In the tower room a nearly panoramic view was even possible.

The Berlin architect Bruno Taut had arrived in Istanbul from his Japanese exile in 1936; here he was to head the architecture department at the Academy of Fine Arts and preside over the buildings department of the Turkish Ministry of Education (Nicolai 1998, 133–152; Dogramaci 2008, 151–160). The academy was thus an important reference point for Taut's professional activities after he arrived in his city of exile. However, the architect did not plan his own house in a central location and thus within walking distance of his place of work, but rather in Ortaköy, 4.2 kilometres away from the academy. In the guidebooks of those years the Ortaköy Mosque is mentioned only marginally (Baedeker 1905, 85; Mamboury 1930, 176); the Istanbul suburb held no interest for tourists. However, Ortaköy was situated close to the water and could be reached in little more than an hour on foot, or by tram or steamer. In 1973 the first bridge across the Bosporus was constructed in the immediate vicinity of Taut's house, since here the two continents are closest to each other. In other words, Taut chose a building site

close to the boundary between Asia and Europe. One can only guess whether this is to be seen as a reminiscence of his former stage of exile in Japan and therefore as his visual focussing on the Asian continent. More convincing, however, is the thesis that he was interested in the transition expressed in the form of water and the space between West and East, Europe and Asia.

Bruno Taut was the only one of the German-speaking architects in Turkey to design a house for himself there. The explanation for the reluctance to build a home for oneself can be traced to the short-term contracts of the foreign specialists, which had to be extended at regular intervals. But Taut decided to build a house of his own quite soon after his arrival. Undoubtedly this is due to his self-image as an architect. In Taut's texts, theorising about society-building forms of construction and types of housing is closely linked with his own building and dwelling practice: In 1927, his home in Dahlewitz, built in 1925/1926, becomes the subject of a comprehensive study in Taut's publication *Ein Wohnhaus* (Jaeger 1995). The book Taut wrote in Japan, *Houses and People of Japan* (Taut 1997), similarly features the Japanese house in which Taut lived with his life partner. How, then, can a place be assigned to Taut's house in a life in exile? As a figure of memory, it refers to his own building experiences, such as Berlin Dahlewitz, or to what he saw and inhabited in Japan (see Dogramaci 2019, 97–101). Here is a further interpretive approach, a brief reference once again to the ark motif which Taut invoked in his much-quoted remark: "... a new Dahlewitz arises, very different, by the deep blue Bosporus, on 15 m high concrete pillars, a 'dovecote' of Noah, who is soon to be 900 years old."[7] In the Old Testament story Noah is warned of the flood by God and told to build an ark to protect his family and the land animals (Göttlicher 1997, 13–15). The ark is then supposed to have run aground on the East Anatolian Mount Ararat; a reference to Turkey is thus established. Beside the concrete link to the original biblical text, the ark and the flood can also be used as a metaphor. For of course the ark is not a ship, but rather a 'movable container' which is placeless and rootless, both a transitory object and a refuge (Blum 1996, 50). Thus, the ark can be described as an allegory of exile existence as such.

While it can be argued that Taut uses the imagery or metaphor of the ark, the botanical garden in Istanbul Fatih (Süleymaniye Mahallesi, Fetva Yokuş No. 41, figs. 5a–d) and its diversity of plants definitely does show associations with the Garden of Eden. The Institute of Pharmaceutical Botany and the scientific botanical garden were set up above the Galata Bridge in historic Stambul in the 1930s. This was done at the suggestion of the botanist Alfred Heilbronn, whose authorisation to teach at the University of Münster was withdrawn in 1933 for 'racial' reasons. That same year, Heilbronn was invited to take a post as professor of pharmaceutical botany and genetics in Istanbul through the agency of the

Figs. 5a–5d: *Alfred Heilbronn Botanical Garden*, Istanbul Fatih, Süleymaniye Mahallesi, Fetva Yokuş No. 41, 1935 (Photos: Burcu Dogramaci, 2018).

"Notgemeinschaft deutscher Wissenschaftler im Ausland" (Emergency Association of German Scientists) refugee organization (Ludwig 2014; Raß [2014], 6). Only a short time after his arrival, Heilbronn managed to convince the relevant ministry of the necessity for a botanical garden, which was opened in 1935 as the Hortus Botanicus Istanbulensis. From the Botanical Garden there is a view of the Galata Bridge and the Golden Horn. Paths through the garden are arranged in such a way that they offer, time and time again, unexpected and uplifting views of the water. While the Botanical Institute was designed by Ernst Egli and opened in 1937 (Nicolai 1998, 31f.), it was Heilbronn who was responsible for the artistic and technical installation of the garden, designed the greenhouses, helped to plan the heating and cooling system, had a garden inspector come from Germany and personally took charge of the garden (Namal et al. 2011, 197). Today the Botanical Garden is not only an enchanted place accessible to the public above the noisy city,[8] but also a place of remembrance for the community of German émigrés to Istanbul.

Island exile: Trotsky on Büyükada/Prinkipo

From the Botanical Garden there is a view of the Bosporus – the city of Istanbul is significantly characterised by the water, which not only separates (and connects) the two halves of the city, but is also a contact zone with neighbouring countries which can be reached by way of the Sea of Marmara, the Black Sea and the Mediterranean. This fact inevitably calls to mind themes like migration, trade and tourism, which formed a central reference point for the 14th Istanbul Biennial in 2015. Entitled *Tuzlu Su* (*Saltwater*), the exhibition, curated by Carolyn Christov-Bakargiev, dealt with the mediating, connecting, transformative und metaphorical significance of water. The Biennial was spread over various venues within the city, including the nine Princes' Islands in the Sea of Marmara. On the largest Princes' Island of Büyükada (Prinkipo in Greek), in the garden and on the pier of the dilapidated *Yanaros Villa*, Adrián Villar Rojas displayed his installation *The Most Beautiful of All Mothers* with chimeric sculptures (Christov-Bakargiev 2015, 93). The place is historically significant and symbolically charged because the political exile Leon Trotsky lived in the *Yanaros Villa* from 1932 until his departure in 1933.

Trotsky's island exile lasted a total of four years, and it is significant that in Byzantine times Büyükada/Prinkipo was a place of banishment which offered undesirable princes and princesses shelter not chosen by themselves (Pinguet 2013, 29–33; Sartorius 2010, 11). Many of them were blinded and thus deprived of the ability to gaze at the shore of Constantinople, which is within sight of the island.

Büyükada/Prinkipo thus represents the two sides of an island exile between banishment and refuge. And these two sides of an archipelagic displacement are also combined in the person of the exile Leon Trotsky. Banished by Stalin not once but several times, Trotsky and his entourage were sent to Istanbul by ship in 1929. The Russian general consulate, which initially welcomed the exiles, did not seem to be a safe place in the long run. Subsequently Trotsky at first moved into the Hotel Tokatliyan in Beyoğlu on the Grand Rue du Péra, considered to be one of the city's most modern, exclusive hotels. Later the exiles settled in a furnished apartment in the district of Şişli (Izzet Paşa Sokak 29; see Heijenoort 1978, 6).[9]

Fig. 6: *Izzet Paşa Villa*, Büyükada/Prinkipo, Çankaya Sokak, residence and exile domicile of Leon Trotsky, 1929–1931 (Coşar 2010, 61).

On the largest island of the archipelago of the Princes' Islands Trotsky was able to rent the guest house of the summer residence of the Ottoman family Izzet Paşa (Çankaya Sokak, fig. 6) located on the north side of the island not far from the dock. Here Trotsky and a constantly expanding circle of family members, friends and political supporters spent the first two years on the island. Then, however, a fire on 1 March 1931 damaged the villa, which had a timber frame construction, and destroyed parts of Trotsky's library, photographs and his collection of newspaper cuttings (Pinguet 2013, 113; Service 2012, 482). After four weeks at the Hotel Savoy on Büyükada/Prinkipo, Trotsky stayed on the Asian side of Istanbul starting at the end of March and moved into an apartment in the district of Moda for a few months (Şıfa Sokak No. 22). He did not return to the island until January 1932, only finally to move to his last domicile, the *Yanaros Villa* (Nizam Mahallesi Hamlacı Sokak No. 4, fig. 7a, b). The villa was built in the 1850s by Nikola Demades on the western shore of Büyükada (Christov-Bakargiev 2015, 95).

Figs. 7a–7b: *Yanaros Villa*, Nizam Mahallesi Hamlaci Sokak No. 4, residence and exile domicile of Leon Trotsky on Büyükada/Prinkipo, 1932–1933 (Heijenoort 1978, 10).

The various addresses of Trotsky's exile attest to his nomadic existence and indicate the challenges that displacement meant for those involved, confronting them with the problem of finding suitable housing (fig. 8). In the case of Trotsky there was the added fear of assassinations. The exile was not only in constant danger of attempts on his life because he feared attacks by Stalin's agents. As of 1917, as already stated, there were also many Russian emigrants in the city who had fled from the Bolsheviks after the Russian Revolution. Since Trotsky had been one of the spokespersons of the revolution, he had to reckon with the anger of the Russian White Guard émigrés (Service 2012, 475). For a number of reasons, Büyükada/Prinkipo seemed to offer him protection: from Istanbul, the island could be reached only by boat, and thus arrivals could be easily seen. Since 1846 a regular ferry service had existed from Istanbul to the islands. After the founding of the Turkish Republic in 1923 the "Devlet Deniz Yolları Idaresi" (State Shipping Line) increased the frequency of ferry traffic to the Princes' Islands – the trip took roughly 90 minutes from the European side of Istanbul; in addition, the island could be reached by motor boat from Galata (Heijenoort 1978, 7; Deleon 2003, 154–156; Althof 2005, 193). Moreover, motorised vehicles were prohibited on the island, and movement from place to place was possible primarily by hackney cab, on donkeys or by bicycle (Deleon 2003, 150). To this day the island has preserved – especially on weekdays – its atmosphere of being out of time. Thus, for instance, Joachim Sartorius, in his book *Die Prinzeninseln*, writes:

> After our arrival we took a horse-drawn cab, for there are no
> cars on the island, and drove all the way round it once. When
> the village was behind us, including the villas and a few grand

Burcu Dogramaci

estates, the road took us uphill through green pine forests that exuded a resinous aroma. That's what I remember more than anything else, this aroma, and then later, back in the valley again, the cypresses, pines, plane trees, their deep shadows and another scent that streamed into our cab. (Sartorius 2010, 9)

In other words, potential assassins had a pretty hard time stepping foot on the island without attracting attention and leaving it again quickly without being noticed. The two villas Trotsky lived in on Büyükada/Prinkipo were surrounded by gardens and walls and thus kept their distance from their immediate neighbours. The *Yanaros Villa* had direct access to the water, and the house could be approached only by a cul-de-sac. In the garden grounds, Turkish policemen were continuously stationed (Simenon 2002, 218f.). Additional protection was provided by Trotsky's entourage, which was armed (Urgan 1998, 155f.), as can be seen in a photo of his close confidant Heijenoort (Heijenoort 1978, 19). The two-storey *Yanaros Villa* had room for numerous bedrooms and offices; Trotsky's study was set up on the second floor (ibid., 11).

Based on Trotsky's life and work on Büyükada/Prinkipo, it is possible to formulate some basic thoughts about exile as an insular space of experience. Islands can stand for both isolation and protection. The word *exile* comes from the Latin *exilium*; it means sojourn in a foreign land and is "a metaphor for alienation" (Schlink 2000, 12). In other words, exile marks a distance from a point of departure. The fact

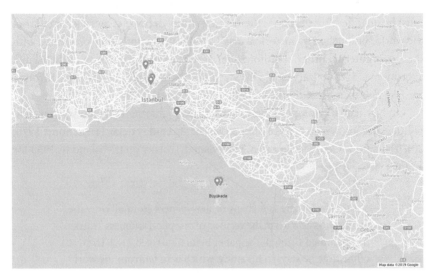

Fig. 8: Leon Trotsky's places of living during his Istanbul and Büyükada/Prinkipo exile, 1929–1933 (© Google).

that the island is a place bounded by water that cannot be reached on foot or on wheels increases the effect of this distance.

At the same time Büyükada/Prinkipo is an island in a group of islands or archipelago; in these cases Ottmar Ette makes a distinction between "Insel-Welt" ("island world") and "Inselwelt" ("archipelago world"): "Island world" means "an island that is self-contained, has clear-cut boundaries and is dominated by a clear internal order [...], forming in itself and for itself a unit that is delimited from the outside" (Ette 2011, 25). On the other hand, says Ette, "archipelago world" is associated with "the awareness of a fundamental relationality, which integrates the island 'proper' in a multitude of connections and relationships to other islands, archipelagos or atolls, but also to continents" (ibid., 26). From the perspective of the largest Princes' Island it is possible to look not only at the surrounding inhabited and uninhabited islands but also at the mainland – the Asian part closest to it and the distant European part of Istanbul. Hence Büyükada/ Prinkipo is part of an island community and exists in relation to Europe and Asia, to both halves of Istanbul and their respective histories. Between them is the sea, which is always an intermediary *and* a boundary or barrier (Wilkens 2011, 64): between the individual Princes' Islands, between islands and the city of Istanbul and between the continents. Independence, isolation, but also participation and a multi-perspective approach to the world, or at least to two continents, are thus associated with island exile.

To be sure, Trotsky in his insular seclusion was capable of acting only to a limited degree. Thus, in view of Trotsky, Wolfgang Althof's definition about islands, too, must be qualified: He describes them as a "symbol of hopelessness, isolated from the world, untouched by historical events, without any influence on events, with their own internal order" (Althof 2005, 7). For from the distance of the island, Trotsky managed to participate in world events through publications, through reading newspapers and visits by political supporters.

On Büyükada/Prinkipo, Trotsky subscribed to international daily papers and political organs, which arrived after a two- or three-day delay (Heijenoort 1978, 20). The author Georges Simenon, who visited Trotsky on the island in 1933 for an interview, writes:

> On the desk there is a chaos of newspapers from all over the world. *Paris-Soir* lies at the very top of one pile. Doubtless Trotsky has skimmed through the paper before I arrived. [...] The rest of the time he stays in his study, which is so far from the world outside and yet at the same time so close to it. "Unfortunately I get the papers with several days delay." (Simenon 2002, 223)

Moreover, photos of his desk (fig. 9), which are also evidence of a self-presentation as a politician who is still influential, show international newspapers such as *The New York Times* and the American Trotskyist paper *The Militant*. Also, Trotsky regularly read the French daily *Le Temps*, the right-wing conservative *Deutsche Allgemeine Zeitung*, received Turkish daily papers whose headlines he was able to deduce even without knowing the language, and had international papers produced in Istanbul purchased for him in the shops on the jetty (Heijenoort 1978, 20). Trotsky thus consumed a geographically and politically broad spectrum of media. It is this that probably enabled him to have as differentiated a view of the world as possible from his island exile.

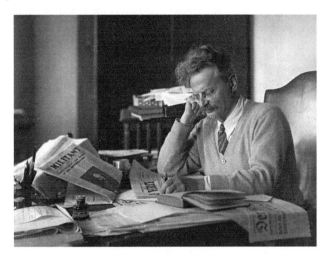

Fig. 9: Trotsky at his desk, Büyükada/Prinkipo, 1931 (Service 2012, ill. 18).

He was thus able productively to reverse the (enforced) seclusion of island life and from his exile to develop a keen and sympathetic eye for world history. Consequently, Trotsky's work in exile is not far removed from the kind of archipelagic thinking regarding which Édouard Glissant writes that it is "non-systematic but inductive, it explores the unpredictability of the world as a whole, it correlates oral and written expression, and vice versa" (Glissant 2005, 34; see also Glissant 1999, 26). Archipelagic thinking means the ability not only to see the island but rather to be aware of the connection of the particular to the larger whole (see Pearce 2014, 18f.).

In his island exile Trotsky was highly productive, wrote newspaper and magazine articles, and authored several books: During his time on the Princes' Island Trotsky

published a history of the Russian Revolution, and his autobiography; advance copies were released in international newspapers (Service 2012, 500; Deutscher 1972, 37ff.).[10] Furthermore he wrote about fascism in Europe and about National Socialism in Germany, and published articles on the political situation in Austria, on the Spanish Revolution and on Stalinism in the Soviet Union (Deutscher 1972, 97–109, 132–135, 149ff.). The library and the archival material he had brought with him from the Soviet Union and his own memories formed the basis for his publications (Service 2012, 500).

In his play *Trotsky in Exile* (1970) the writer Peter Weiss shows the revolutionary leader as an exile. In scene one, when Trotsky in 1928 is informed of his impending banishment, he instructs his secretaries and family members to put together his luggage. Weiss writes:

> Trotsky: "Diary, writing tools go in the hand luggage. Where are the dictionaries, Poznansky? English, German, French, Spanish. Are there enough pencils? Ink, pens? […] Materials on China, India. South America. Liberation movements of the colonial peoples. Struggle of black Americans. Documents on the Internationale. I still need reports on the position of the Indian Party. Smirnov, will you send it to me? and, Rankovsky, have the newspapers sent on to me as quickly as possible. […] Seryozha, have you packed the maps?" Sergei Sedov: "In a folder. With the newspaper archive." Trotsky: "For the trip, the Asia study. Geography, economy, history. Glasmann, the latest reports from China." (Weiss 2016, 10f.)

Peter Weiss presents Trotsky as an exile whose archive, library and the possibility of writing are essential prerequisites for his survival while living in banishment.

Although Trotsky hardly left the island – beside his stay in Moda, we know of a lecture tour to Copenhagen (Service 2012, 525) and only one visit to the Hagia Sophia (Althof 2005, 22) – he participated in world events. Moreover, he was regularly visited by supporters, and exchanged letters with like-minded political friends and Trotskyist followers, family members, intellectuals (Pinguet 2013, 117). In contrast with this intellectual exchange stood an island existence characterised by routine: the recurring daily cycle, with work beginning in the early hours of the morning, lunch with his household and regular boat trips to go fishing (see Coşar 2010, 148).

The caesura of exile that had hurled Trotsky out of his familiar environment was at odds with the regular rhythm of daily life. Exile on Büyükada/Prinkipo connected Trotsky with historical island exiles such as Napoleon Bonaparte, who from 1815 until 1821 was banished to the South Atlantic island of St. Helena (Willms 2007) and the writer Victor Hugo, exiled from 1855 until 1870 on the British Channel Islands of Guernsey and Jersey, who like the Russian exile became highly productive. Trotsky's island life was an exile within exile – a self-contained existence outside the world and at the same time a window on it.

Footprints: Traces of emigration in Istanbul

Istanbul was a destination city for migrants and refugees at the beginning of the 20th century that presented special challenges and opportunities for orientation or re-orientation. The city's history, its topography, its social statutes and its political structure offered new arrival experiences they could have had in no other metropolis or, to be precise, every metropolis offered different possibilities and impossibilities of arrival. Édouard Glissant even goes so far as to say that the city has a physical, active presence in the flight histories of modernity and of the contemporary era:

> The city of refuge is not like a poorhouse; it maintains connections with the guest whom it would like to welcome – connections of mutual familiarisation, progressive discovery, long-term interaction, which make this undertaking a truly militant exercise, an active participation in the general dialogue of "give" and "take". (Glissant 1999, 229)

The city demands that the new arrivals engage with it. Conversely, the new Istanbulans left their traces in the city; they altered its skyline with their buildings, they designed monuments or initiated the installation of a scientific garden. In the case of some emigrants the symbiosis with their city of exile went so far that they were laid to rest in the cemeteries of Istanbul: Their attachment to Istanbul and the history they experienced there are indicated by the fact that after their deaths both Leonore and Curt Kosswig were buried in the Istanbul graveyard of Rumeli Hısarı – even though Curt Kosswig had already been teaching at Hamburg University since 1955. Thus, this glimpse of the émigré community of the city of Istanbul ends at yet another urban location, the cemetery. Also the architect Bruno Taut was interred at the Edirnekapi Martyrs' Cemetery (Edirnekapı Şehitliği), one of the oldest cemeteries of Istanbul, in late 1938 – one of the few non-Muslims

to be buried there. On Taut's gravestone there is a footprint which, symbolically as well as physically, refers to the traces the migrants left on the urban matrix of the city at the Bosporus.

Translation: Ilze Mueller.

Notes

[1] Regarding the Park Hotel see http://www.tas-istanbul.com/portfolio-view/gumussuyu-park-otel-2/. Accessed 27 February 2019.

[2] Rudolf Belling to Alexander Amersdorfer, 23 January 1937 (Akademie der Künste, Historisches Archiv, Berlin, I/284).

[3] With a few exceptions, the term emigrant or exile refers to architects who had to leave Germany or Austria for political reasons. The essay also includes architects such as Ernst Egli and Clemens Holzmeister, who were already active in Turkey in the 1920s. At least for Holzmeister it can be postulated that he could not return to his home country for political reasons after the „Anschluss" of Austria. Holzmeister then became exiled in Turkey.

[4] The connections between Istanbul and emigration movements of the 1920s to 1940s has not yet been made, and the metropolis on the Bosporus has been mainly investigated as a laboratory for urban planning by foreign planners (see Akpınar 2003; Tanyeli 2005).

[5] I would like to thank my colleague Zeynep Kuban in Istanbul for identifying the villa, which has been considerably remodelled, for me. Further studies of this building and its history will follow.

[6] As the names of the guests in Kosswigs' house are not recorded – references to their home as a meeting place have been only sporadically recorded in a variety of memoir-type publications by some of the guests – it is not possible to make a conclusive statement about the involvement of local people in their social activities. But they spoke fluent Turkish, so it is reasonable that they had also friendships with Turks.

[7] Bruno Taut to Carl Krayl, 5 June 1938 (Junghanns 1970, 86).

[8] In 2018 the existence of the garden was threatened, since the Mufti of Istanbul laid claim to the property, http://www.arkitera.com/haber/30391/alfred-heilbronn-botanik-bahcesi-tahliye-ediliyor. Accessed 28 November 2018. However, the Turkish daily *Cumhuriyet* reported that the garden is to be kept intact after all; Egli's building, however, is to be razed, http://www.cumhuriyet.com.tr/haber/cevre/1029836/Tepkilerin_ardindan_botanik_bahce_icin_istanbul_Universitesi_nden_geri_adim.html, 17 July 2018. Accessed 26 February 2019.

[9] The building is still in existence. Today it houses an Armenian Catholic primary school. http://www.turkiyeermenileripatrikligi.org/site/bomonti-ermeni-ilkogretim-okulu-cemaat-okullari/. Accessed 24 November 2018.

[10] Trotsky's *Moya zhizn* (My Life) was published in two volumes in Berlin in 1930; his three-volume history of the Russian Revolution was published in 1932/1933 in London as *The History of the Russian Revolution* (Service 2012, 476, 501).

References

Akcan, Esra. *Architecture in Translation. Germany, Turkey, & the Modern House*. Duke University Press, 2012.

Akpınar, Ipek Yada."Pay-i Tahtı Sekülerleştirmek: 1937 Henri Prost Planı." *Istanbul*, no. 41, 2003, pp. 20–25.

Althof, Wolfgang. *Sträflingsinseln. Schauplätze der Verbannung*. E.S. Mittler & Sohn, 2005.

Altinoba, Buket. *Die Istanbuler Kunstakademie von ihrer Gründung bis heute. Moderne Kunst, Nationsbildung und Kulturtransfer in der Türkei*. Gebr. Mann, 2016.

Aslanoğlu, Inci. "Bruno Tauts Wirken als Lehrer und Architekt in der Türkei." *Bruno Taut: 1880–1938*, exh. cat. Akademie der Künste, Berlin 1980, pp. 143–150.

Baedeker, Karl. *Baedeker's Konstantinopel und Kleinasien. Handbuch für Reisende*. Baedeker, 1905.

Blum, Elisabeth. "Arche und Sintflut. Eine Herausforderung für das architektonische Denken über Ort und Weg." *Archithese*, vol. 25, no. 2, March/April 1996, pp. 50–52.

Bozdoğan, Sibel, et al., editors. *Sedad Eldem. Architect in Turkey*. Concept Media, 1987.

Christov-Bakargiev, Carolyn. *14 Istanbul Bienali Rehberi Tuzlu Su / 14th Istanbul Biennial Guidebook: Saltwater*. Yapı Kredı Yayınları, 2015.

Coşar, Ömer Sami. *Troçki İstanbul'da*. Türkiye İş Bankası Kültür Yayınları, 2010.

Cremer, Jan, and Horst Przytulla. *Exil Türkei. Deutschsprachige Emigranten in der Türkei 1933–1945*. 2nd ed., Lipp, 1991.

Deleon, Jak. *The White Russians in Istanbul*. Remzi Kitabevi, 1995.

Deleon, Jak. *Büyükada. Anıtlar Rehberi. A Guide to the Monuments*. Remzi Kitabevi, 2003. Deutscher, Isaac. *Trotzki. Der verstoßene Prophet 1929–1940*. Kohlhammer, 1972.

Dogramaci, Burcu. *Kulturtransfer und nationale Identität. Deutschsprachige Architekten, Stadtplaner und Bildhauer in der Türkei nach 1927*. Gebr. Mann, 2008.

Dogramaci, Burcu. *Fotografieren und Forschen. Wissenschaftliche Expeditionen mit der Kamera im türkischen Exil nach 1933*. Jonas, 2013.

Dogramaci, Burcu. "Home, *Heimat*, foreign land. Bruno Taut's villa on the Bosporus and the architect's house in emigration." *A Home of One's Own. Emigrierte Architekten und ihre Häuser 1920–1960 / Émigré Architects and their Houses. 1920–1960*, edited by Burcu Dogramaci and Andreas Schätzke, Edition Axel Menges, 2019, pp. 93–107.

Egli, Ernst. "Zwischen Heimat und Fremde, einst und dereinst. Erinnerungen." (unpublished manuscript, Zurich, 1969, ETH Library, Zurich, Papers of Ernst Egli, Hs 787:1)

Ette, Ottmar. "Insulare ZwischenWelten der Literatur. Inseln, Archipele und Areale aus transarealer Perspektive." *Inseln und Archipele. Kulturelle Figuren des Insularen zwischen Isolation und Entgrenzung*, edited by Anna E. Wilkens et al., transcript, 2011, pp. 13–56.

Glissant, Édouard. *Traktat über die Welt*. Wunderhorn, 1999.

Glissant, Édouard. *Kultur und Identität. Ansätze zu einer Poetik der Vielheit.* Wunderhorn, 2005.

Göttlicher, Arvid. *Die Schiffe im Alten Testament.* Gebr. Mann, 1997.

Gürboğa, Nurşen. "Evin Halleri; Erken Cumhuriyet Döneminde Evin Sembolik Çerçevesi." *Istanbul,* no. 41, 2003, pp. 58–65.

Guttstadt, Corry. "Passlos, staatenlos, rechtlos. Jüdische EmigrantInnen in Deutschland und in der Türkei zwischen antisemitischer Verfolgung durch das NS-Regime und türkischer Bevölkerungspolitik." *Ausgeschlossen. Staatsbürgerschaft, Staatenlosigkeit und Exil (Jahrbuch Exilforschung,* 36), edited by Doerte Bischoff and Miriam Rürüp, edition text + kritik, 2018, pp. 53–80.

Heijenoort, Jean van. *With Trotsky in Exile. From Prinkipo to Coyoacán.* Harvard University Press, 1978.

Jaeger, Roland. "Bau und Buch: Ein 'Wohnhaus' von Bruno Taut." *Bruno Taut: Ein Wohnhaus.* 1927. Gebr. Mann, 1995, pp. 119–147.

Junghanns, Kurt. *Bruno Taut, 1880–1938.* Henschel, 1970/1983.

Keyder, Çağlar. "Istanbul." *Call me Istanbul ist mein Name. Kunst und urbane Visionen einer Metapolis,* edited by Roger Conover et al., exh. cat. ZKM. Zentrum für Kunst und Medientechnologie Karlsruhe, Karlsruhe, 2004, pp. 33–45.

King, Charles. *Mitternacht im Pera Palace. Die Geburt des modernen Istanbul.* Propyläen, 2014.

Ludwig, Astrid. "Die Frankfurter Goethe-Universität ehrt den jüdischen Pathologen und ehemaligen Professor Philipp Schwartz mit einer Gedenkstele." *Jüdische Allgemeine,* 25 November 2014, https://www.juedische-allgemeine.de/kultur/der-vergessene-retter/. Accessed 28 November 2018.

Mamboury, Ernest. *Stambul Reiseführer.* Rizzo, 1930.

Meier, Werner. "So erlebte ein Auslandsschweizer die neue Türkei." *Schweizer Illustrierte Zeitung,* no. 37, 1941, pp. 1238–1240.

Namal, Arin, et al. "Ein deutscher Emigrant als Namensgeber des Botanischen Gartens der Universität Istanbul: Prof. Dr. Alfred Heilbronn (1885–1961) und seine Stellung in der Geschichte der Botanik der Türkei." *Botanische Gärten und botanische Forschungsreisen,* edited by Ingrid Kästner and Jürgen Kiefer, Shaker Verlag, 2011, pp. 179–212.

Nayman, Esma. "Die Stellung der Frau in der neuen Türkei." *Europäische Revue,* vol. 12, 1936, pp. 510–512.

Nerdinger, Winfried, et al., editors. *Bruno Taut 1880–1938. Architekt zwischen Tradition und Avantgarde.* DVA, 2001.

Neumark, Fritz. *Zuflucht am Bosporus. Deutsche Gelehrte, Politiker und Künstler in der Emigration 1933–1953.* Knecht, 1980.

Nicolai, Bernd. *Moderne und Exil. Deutschsprachige Architekten in der Türkei 1925–1955.* Verlag für Bauwesen, 1998.

Pearce, Marsha. "Die Welt als Archipel /The World as Archipelago." *Kulturaustausch/ Cultural Exchange: Journal for International Perspectives,* no. 2, 2014, pp. 18–19.

Pinguet, Catherine. *Les îles des Princes. Un archipel au large d'Istanbul.* Empreinte, 2013.

Raß, Oliver. "Zum Gedenken an Alfred Heilbronn." *flurgespräche*, undated [2014], http://www.flurgespraeche.de/wp-content/uploads/2017/06/Gedenkblatt_Heilbronn_Alfred.pdf. Accessed 28 November 2018.

Rimscha, Hans von. *Der russische Bürgerkrieg und die russische Emigration 1917–1921.* Frommann, 1924.

Sartorius, Joachim. *Die Prinzeninseln.* 2nd ed., mareverlag, 2010.

Schlink, Bernhard. *Heimat als Utopie.* Suhrkamp, 2000.

Service, Robert. *Trotzki. Eine Biographie.* Suhrkamp, 2012.

Sert, Deniz. "Bringing Together, Dividing Apart. Istanbul's Migration History." *Istanbul. Passione, Gioia, Furore/Passion, Joy, Fury,* edited by Hou Hanru et al., exh. cat. Museo nazionale delle arti del XXI secolo, Rome, 2015, pp. 219–222.

Simenon, George. "Besuch bei Trotzki (Paris-Soir, 16./17. Juni 1933)." Idem. *Das Simenon-Lesebuch. Erzählungen, Reportagen, Erinnerungen. Briefwechsel mit André Gide. Brief an meine Mutter.* Diogenes, 2002, pp. 215–231.

Tanyeli, Uğur. *İstanbul 1900-2000 Konutu ve Modernleşmeyi Metropolden Okumak.* Ofset Yapımevi, 2005.

Taut, Bruno. *Das japanische Haus und sein Leben.* (1937). Gebr. Mann, 1997.

Urgan, Mina. *Bir Dinozorun Anıları. Yaşantı.* Yapı Kredi Yayınları, 1998.

Vassiliev, Aleksandr. *Beauty in Exile. The Artists, Models and Nobility who Fled the Russian Revolution and Influenced the World of Fashion.* Harry N. Abrams, 2000.

Weiss, Peter. *Trotzki im Exil. Stück in 2 Akten.* 1970. Suhrkamp, 2016.

Wilkens, Anna E. "Ausstellung zeitgenössischer Kunst: Inseln – Archipele – Atolle. Figuren des Insularen." *Inseln und Archipele. Kulturelle Figuren des Insularen zwischen Isolation und Entgrenzung,* edited by Anna E. Wilkens et al. transcript, 2011, pp. 57–98.

Willms, Johannes. *St. Helena. Kleine Insel, großer Wahn.* marebuchverlag, 2007.

Zöller-Stock, Bettina. *Bruno Taut. Die Innenraumentwürfe des Berliner Architekten.* Deutsche Verlags-Anstalt, 1993.

Sites, Spaces and
Urban Representations

Mapping *Finchleystrasse*

Mitteleuropa in North West London

Rachel Dickson and Sarah MacDougall

Not so long ago if one walked from Swiss Cottage – also
known as '*Schweizer Häuschen*' – to the John Barnes store,
one could hear along the way Yiddish and every Middle
European language. The Finchley Road was the main
thoroughfare for thousands of Continental Jews who had
managed to escape from the Nazis. But time will do what
Hitler could not. The generation that got away is gradually
disappearing. (Buruma n.d.)

By the early 1940s a staggering 25,000 "aliens" lived in
Hampstead and its surrounds, i.e. about 45 per cent of
the local population. What Louis MacNiece called "the
guttural sorrow of the refugees" pervaded the district –
people as noticeable for their looks and accents as any
other immigrant group, and often similarly welcome.
(Canetti 2005, 13)

Introduction

Hampstead (NW3), a leafy, affluent and historic residential area occupying an
elevated position in north west London, has long been celebrated for its intellectual,
liberal and cultural associations. It also became, during the 1930s, well-known as
a significant site of interchange for British and continental modernism.[1] Notable
exponents included British artists Barbara Hepworth, Henry Moore and Ben
Nicholson – critic Herbert Read's so-called 'nest of gentle artists' – as well as Roland
Penrose, and his American-born wife Lee Miller; the continentals included Russian
Naum Gabo, Dutchman Piet Mondrian, German *Bauhäusler* Walter Gropius and

Marcel Breuer – housed in Wells Coates' Isokon building in Lawn Road, together with Hungarian László Moholy-Nagy – and fellow Hungarian, Ernö Goldfinger, who designed his own home at 2 Willow Road.[2] As Czech émigré art historian and critic, Prof. J.P. Hodin, resident of nearby Belsize Park, observed:

> [...] no other London Borough can pride itself upon such an influx of top brains in science and the arts. These new arrivals having fled the political holocaust on the continent in the thirties, acted as a powerful catalyst in their new surroundings, and through their activities changed the cultural scene beyond recognition. (Hodin 1974, 5)

The presence of such 'top brains' undoubtedly encouraged further émigrés to north London and recent scholarship has widened the focus beyond Hampstead to embrace the Finchley Road – *Finchleystrasse*[3] – as it was nicknamed by local bus conductors paying humorous homage to the influx of largely German-speaking refugees who, during the same period, settled along its length: from well-heeled St John's Wood in the south (NW8), to Childs Hill and Golders Green (NW11) in the north, and West Hampstead, Swiss Cottage and Belsize Park (NW6) along its eastern and western flanks. With a few exceptions, such as Oskar Kokoschka, the names of its inhabitants are generally far less well-known than those who settled in Hampstead 'proper', but their cumulative cultural contribution is now coming under greater scrutiny, most recently in the exhibition, *Finchleystrasse: German artists in exile in Great Britain and beyond, 1933–45*, held at the German Embassy, London (2018–2019).[4] Prior to this, in 2002 the Association of Jewish Refugees (AJR) curated the *Continental Britons* exhibition with an accompanying map of *Finchleystrasse* (fig. 1)[5] illustrating the significant Jewish refugee presence across a complex network of professions, institutions and activities.[6]

Drawing on published and unpublished sources, including the map of *Finchleystrasse* as a primary resource, this chapter examines the multi-faceted role played by this locale as a place of sanctuary for predominantly Jewish refugees, fleeing religious, ethnic or cultural persecution in Nazi-occupied Europe, who settled there between 1933–1945. With a particular focus on émigré contributors to the visual arts, it examines the rise of a range of social, cultural, religious and educational spaces and organisations initiated by the refugees' presence to cater for both their everyday and wider cultural needs, asking how far they were successful in providing for such a diverse and multilingual émigré community, and what led, in many cases, to their eventual demise or relocation. It also references throughout the many informal refugee networks through which the émigrés assisted one

Rachel Dickson and Sarah MacDougall

another, thereby establishing indirectly a little corner of *Mitteleuropa* in north west London.

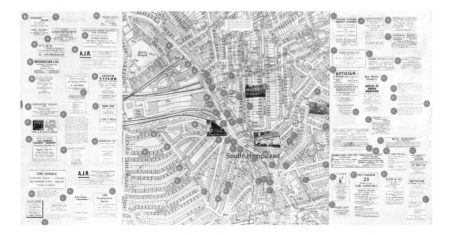

Fig. 1: Map of *Finchleystrasse*, based on content from *AJR Information* 1946–1970. Created for the *Continental Britons* exhibition, Jewish Museum, London, 2002 (Courtesy AJR. Photograph by Justin Piperger).

Refugee background

The refugee demographic was complex, primarily comprising Austrians, Germans, Hungarians, Poles and Czechoslovaks, who arrived following moments of major political crisis in their respective homelands from 1933 onwards, often via more than one country of transit. Entry was by visa and many women were admitted on domestic visas (or obtained employment as domestics) – often the only way to enter Britain legitimately. These included painter Else Meidner (wife of Expressionist Ludwig Meidner) and graphic designer Dörte ('Dodo') Bürgner, both from privileged German-Jewish backgrounds and used to having their own servants, and Annely Juda (née Anneliese Brauer), also German-Jewish, later founder of the eponymous gallery in central London. She arrived in 1937 with only £1 in her pocket and found work in a house for German-Jewish refugees in Hampstead, where she met her future husband Paul. Another German artist, Communist Margarete Klopfleisch, who fled to London from Prague in 1938, worked as a home help for Roland Penrose in Hampstead and studied sculpture at Reading University with his support.[7]

The majority of refugees were Jewish. This diverse group encompassed orthodox, liberal and non-observant Jews, although the last two groups were significantly larger. As Geoffrey Alderman has observed, these largely assimilated and highly-educated *Westjuden* distanced themselves from both established Anglo-Jewry and the traditional, more isolated *Ostjuden* who, fleeing pogroms and economic deprivation in the Russian Pale of Settlement in the late nineteenth and early twentieth centuries, had settled in London's East End 'ghetto' (Alderman 1998, 117). The new arrivals, instead, chose north west London, where they: "maintained their own distinct and discrete communal identity, […] created their own institutions (such as the AJR, Belsize Square Synagogue, and the Wiener Library), and established themselves as an independent, readily recognizable community" (Grenville 2018, 16). All struggled to retain their respective national, religious, ethnic and cultural identities while striving to fit unobtrusively into British daily life, and faced innumerable daily problems, including loss of language, culture and financial hardship, often associated with their 'forced journeys'. A guidance pamphlet for Jewish refugees issued by the German Jewish Aid Committee strongly advised that they "Refrain from speaking German in the streets and in public conveyances and in public places such as restaurants" (German Jewish Aid Committee 1939, 12). Following the outbreak of war in Britain in September 1939, the introduction of rationing in January 1940 and internment for so-called 'enemy aliens' in June 1940, these problems were further exacerbated.

Spaces of refuge, Refugee and Aid Organisations

Accommodation was the first priority for the newly arrived whose circumstances (unlike those for domestics) did not provide live-in arrangements. Within the broad demographic of *Finchleystrasse,* housing stock ranged from imposing period homes to dingy rooms with communal cooking facilities in corridors. (One refugee recalled that it was considered a step up to have a room with one's own stove ("Ode to Finchleystrasse" 2014).) A number were housed in hotels, such as the Hotel Shem-Tov in Fordwych Road, Kilburn, to the west of Finchley Road, run by the émigré parents of controversial artist Robert Lenkiewicz (1941–2002), whose numerous elderly Jewish residents included survivors from the camps.

Although predominantly middle-class, few of the so-called 'Hitler émigrés' were able to live in the style to which they had been accustomed prior to emigration (the Freud family in Hampstead's Maresfield Gardens and German-Jewish lawyer and self-taught artist, Fred Uhlman, who married into the aristocratic Croft family,[8] and lived nearby in elegant Downshire Hill, were notable exceptions). Most were

impoverished, at least upon arrival and, during the war, typically lived in single-room dwellings or small flats within divided houses, often behind architecturally imposing facades of once grand homes.

One such was Berlin-born painter, Eva Frankfurther, who fled to England with her siblings as a nine-year-old child in April 1939 (followed by her parents on one of the last flights before the onset of war). In Blitz-torn London, they endured the penetrating cold of an English winter before, in December 1941, renting a flat in a large house in Belsize Park Gardens, owned by the Freud family, which also housed other mainly German-Jewish refugees.[9] Lucie Freud (mother of Berlin-born painter, Lucian), a school friend of Eva's mother, and her architect husband, Ernst, were very helpful to the Frankfurthers after their arrival, one example of the many informal networks where émigrés helped one another.

Although the majority of refugee aid agencies were clustered around Bloomsbury in central London,[10] one of the most significant, the self-help organisation Association of Jewish Refugees (AJR), was founded in *Finchleystrasse* at Fairfax Mansions in summer 1941.[11] Aiming to appeal widely, it embraced the widest possible Jewish membership, encompassing Orthodoxy, Liberalism, Zionism and secularism. Furthermore, the breadth and depth of the AJR's activities went far beyond the local community; from its clothing depot in Broadhurst Gardens, behind Finchley Road underground station, it distributed thousands of garments to needy Jews overseas. It also gathered other agencies, including the AJR Employment Agency, United Restitution Office and Council of Jews from Germany under its many-spoked umbrella. As a campaigning organisation, it fought to have restrictions on so-called 'enemy aliens' lifted and, as the war ended, to protest against forced repatriation, latterly taking an active role in supporting restitution claims. Championing the naturalisation of many refugees in the late 1940s, it then supported them in their new homeland by "laying the foundation for a flourishing community that combined its German-Jewish social culture with a strong sense of integration into British society" (AJR website). From 1946 it also published a monthly journal, *AJR Information* (renamed *AJR Journal* in 2000), an initiative that continues today in the AJR's role as a national charity supporting Holocaust refugees and survivors living in Great Britain.

Cultural spaces

The AJR was also actively engaged in the cultural life of the community. German-Jewish émigré Werner Rosenstock who became the AJR's first General Secretary (1941–1982) also edited *AJR Information* (1946–1982), which regularly published

pieces by *Finchleystrasse* residents, as well as reviewing literature and exhibitions by members, and promoting local businesses and services (Grenville 2018, 13). The AJR's Jewish membership and apolitical stance, however, differentiated it from other, more secular refugee organisations, such as the Hampstead-founded *Freier Deutscher Kulturbund* (Free German League of Culture (FGLC) and the Austrian Centre (AC); both conceived along primarily political and national lines with many members hoping to return home after the war, they provided national solidarity while supporting members' creative endeavours. Although the AC was based in Paddington, its offshoots extended to *Finchleystrasse*: the Austrian-theatre-in-exile, *Das Laterndl* (69 Eton Avenue, NW3) which, according to Daniel Snowman, "attempted to feed the flickering flames of culture among the refugee community while providing a social centre and regular home-away-from-home entertainment" and its "hard[er]-edged" breakaway cabaret club, the Blue Danube (153 Finchley Road) (Snowman 2003, 135).

"Ambitious, radical and star-studded", the FGLC was founded in December 1938 by German-Jewish writer in exile Stefan Zweig, among others, at 47 Downshire Hill, Hampstead, the home of Fred Uhlman, and his wife, Diana (ibid., 135). Elias Canetti in his memoir *Party in the Blitz* downplayed Uhlman's role, recalling: "Summer parties in his garden were popular affairs, the Hampstead intellectuals liked to meet there, and the occasional émigré" (Canetti 2005, 148). Established, however, as a cultural and social centre for German-speaking exiles, the FGLC was in fact one of the largest exile organisations in the UK until its dissolution in 1946 (Müller-Härlin 2004, 241).[12]

Initially headed by theatre critic and essayist Alfred Kerr (father of future author-illustrator Judith Kerr) as President, succeeded in 1941 by Kokoschka, it offered space to artists (Margarete Klopfleisch was a founder member), musicians, actors, writers and scientists. Its Fine Arts section was co-chaired by Uhlman and German émigré sculptor, Paul Hamann, until both were interned as enemy aliens in June 1940, and replaced in 1941 by ex-Canadian internee, sculptor Heinz Worner. Artist members also included Austrian sculptor Georg Ehrlich and painter Ernst Neuschul. Many members also featured in the New Burlington Galleries' 1938 *Exhibition of Twentieth Century German Art*, intended as a riposte to the infamous Nazi "Degenerate Art" show the previous year.[13] Other activities included the *Children's Art from All Countries* exhibition, opened by Kokoschka on 16 August 1941 at the local Clubhouse in Upper Park Road, Belsize Park (Malet 2008, 55).

The Artists' Refugee Committee (ARC) also played a critical role. Founded in November 1938 to assist with rescuing members of the Prague-based *Oskar-Kokoschka-Bund*, it was also based at the Uhlmans' home (with Diana acting as *de facto* secretary, although Stephen Bone's name appeared in this capacity on its

Rachel Dickson and Sarah MacDougall

letterhead), initiated by their neighbour, modern art collector Margaret Gardiner and Roland Penrose. Its founders were primarily British artists including Sir Muirhead Bone, his son Stephen, Betty Rea and Richard Carline, who had lived in the house with his artist family before the Uhlmans (Müller-Härlin 2010, 54–56). As Monica Bohm-Duchen has noted, "Gardiner, Penrose and the Uhlmans were at the very heart of a network of individuals intent on lending practical and moral support to refugee artists" (Bohm-Duchen 2019, 160).

Many exiles, including Communist John Heartfield, famed for his anti-Nazi photomontage propaganda, and the art historian Francis Klingender, appeared on the Uhlmans' doorstep seeking refuge. Diana recalled the arrival of some "twenty-one or twenty-two people [...] from Prague" and, in particular:

> [O]ne artist, Fritz Feigl, knocking at the door and saying "Is this the address of Mr. Carline, the Artists' Refugee Committee and the *Kulturbund*?" He had a little notebook from which he was reading the names of these three important introductions he had been given by various different people! (Uhlman 1974, 31)

Café culture

Beyond these formal organisations, *Finchleystrasse* provided much informal cultural enrichment, particularly through social clubs and newly established continental cafés and restaurants, where émigrés gathered for cheap, nourishing meals and to recreate the atmosphere of their former European haunts. Although some Germans scorned Viennese *Kaffeehaus* culture as time-wasting, the majority were bound together by their shared enjoyment of familiar cuisine and language; they could spend the whole day in these havens "reading [...] over a single cup of coffee or consuming *Schnitzel* and *Strudel* with fellow refugees" (Snowman 2003, 227). As Anna Nyburg suggests, they could "eat familiar food at last and drink coffee made in the central European way" and "also speak German there with old and new friends".[14] As Hodin observed, since "most of the modern principles in art and literature" had been "worked out over a sociable glass of wine or cup of coffee – in Paris, in Vienna, in Prague", it was necessary to establish their equivalent in London (Hodin 1945, unpaginated).

Café society centred, in particular, on the Dorice and Cosmo restaurants, both on Finchley Road, where German language, cuisine and continental dress were the norm. The Dorice at 169a Finchley Road, which regularly advertised its "continental cuisine" in the *AJR Information*, was named after its founder and

proprietor, German refugee Doris Balacs. She had arrived in England two weeks prior to the outbreak of war in 1939, speaking hardly any English and with only half-a-crown to her name. In her first job as a domestic she received so little food that her feet swelled from malnutrition and she quickly found alternative employment as a 'nippy' (waitress) at Lyons' Corner House, before setting up her own restaurant.

At the Dorice "rootless refugees gathered to soak up the atmosphere of the country that betrayed them". According to writer Ian Buruma:

> For several decades the Dorice was *the* meeting place for
> former refugees. Furriers from Leipzig, bankers from Dresden,
> journalists from Prague and jewellers from Hamburg had their
> regular table – the German *Stammtisch* – where they discussed
> business and the kids over schnitzels and beer. (Buruma n.d)

Years later, locals still recall the distinctive "smell of roasting coffee beans [that] started outside the Dorice […] (*Gullasch, Nockerl, Wiener Gugelhupf*) and drifted across the entrance of the old swimming pool/gym and down into Finchley Road tube station" (Norman 2019).

Both the Dorice and Cosmo also provided an informal network for continental refugees at all levels, from the caterers to the clientele: the cakes – "the best in London," according to the proprietor – were "baked by a man who started life as a commercial artist in Upper Silesia.

He learnt to be a pastry chef at an international camp for 'enemy aliens' in 1940" and had been "making cakes ever since" (Buruma n.d).

There was clearly some rivalry between the two restaurants, as noted by English author Fay Weldon who briefly waitressed at the Dorice (her mother had once been a cook at Cosmo). Both, she noted, "were the haunt of refugees and intellectuals", but Cosmo (fig. 2), located close to Swiss Cottage at 4–6 Northways Parade on the Finchley Road, which originally opened as a coffee bar in 1937, later extending to include a 70-cover restaurant, was "the classier" (Weldon 2002, 237). It counted Nobel Prize-winner Elias Canetti, and "his disciples" – the young Iris Murdoch and Bernice Rubens – among its regulars, along with Sigmund Freud and German émigré vocal coach and psychotherapist Alfred Wolfsohn (Weldon 2002, 237).[15] Weldon regarded herself as "on the wrong side of the road" and struggled with the challenges of a "Berlin-style restaurant where no one but me spoke English, the orders were for dishes I did not understand, *Königsberg Klops* [*sic*] and such like and I couldn't tell a dessert from an entrée" (Weldon 2002, 237).

Rachel Dickson and Sarah MacDougall

Fig. 2: Unknown photographer, *Cosmo*, 1965 (© Marion Manheimer).

Marion Manheimer, whose parents took over Cosmo from its former Hungarian owners in 1957, described it as a symbolic "sanctuary": "My father left Berlin to escape the Nazis but lost many members of his family", recalling that "he would hire people he met on his travels and the place became full of people who had come to north London to escape fascism. It was also a great place for conversation" (Manheimer 2013). Journalist Susie Boyt, daughter of Lucian Freud, remembered it as "principally filled with men and women from Berlin and Vienna" for whom it provided "a social sanctuary" alongside the so-called "Hampstead anxious" (Boyt 2013).

The two cafés lingered on into the next generation. Surgeon Ellis Douek, a Cairo-born Jewish refugee (and brother of cookery writer Claudia Roden), whose family was uprooted by the Suez Crisis, recalled how his Viennese friends (distantly related to Mahler) frequented both cafés post-war, but favoured the Dorice for tea, owing to the presence of a piano-player. Philosopher J. J. Valberg lamented the passing of both establishments in his memoirs (Valberg 2007, xv.).

Places of Religious Worship, Small Businesses and Informal Networks

The complex makeup of the Jewish émigré community led to a need for a range of places of worship. Several synagogues with congregations of different religious affiliations sprung up around *Finchleystrasse*, with Belsize Square Synagogue as one of the most prominent.

Founded in 1939 by mainly German refugees and based on the continental liberal (or liberale) movement, it was designed by German-Jewish émigré architect Heinz Reifenberg, husband of Gabriele Tergit (pen name of Dr. Elise Reifenberg), a pioneering female court reporter in Berlin, who had achieved overnight fame for her novel critiquing the Weimar Republic, *Käsebier erobert den Kurfürstendamm* (1931). The couple fled Germany in 1933, arriving in London in 1938 (via Czechoslovakia and Palestine), where Tergit became secretary of the London PEN-Centre of German-language Authors Abroad and a frequent contributor to *AJR Information*. Her portrait (fig. 3) was painted by her sister-in-law Adèle Reifenberg, who had studied in Berlin and Weimar under Lovis Corinth, where she met her future husband, artist Julius Rosenbaum. Tergit's old-fashioned dress and hairstyle imply that the portrait was probably painted pre-migration; a faint fold down the centre further suggests that it was rolled up and probably brought to England in a suitcase, perhaps as a memento. When the Rosenbaums also fled Germany in 1939 the two sisters-in-law could not have been certain they would meet again; however, all four were subsequently reunited in north west London.

Fig. 3: Adèle Reifenberg, *Portrait of the Artist's Sister-in-Law, Elise Reifenberg (Gabriele Tergit)*, not dated, Ben Uri Collection, London (© The estate of Adèle Reifenberg).

Rachel Dickson and Sarah MacDougall

As the AJR magazine and *Finchleystrasse* map record, continental small businesses formed the backbone of the neighbourhood, often providing employment for fellow émigrés. These included German tailors, brassiere and corset makers, such as Mrs E. Sonnenfeld; estate agents Ellis and Co, who employed German émigré Mr H. Reichenbach; A. Breuer, who sold typewriters in Fairfax Road; and Ackerman's Chocolates, established by German refugee Werner Ackermann, who opened branches in both Kensington and at 9 Goldhurst Terrace, Hampstead. Graphic artist and fashion illustrator Dodo Bürgner, who arrived in London in 1936, found piecemeal work for commercial clients including Ackerman's, for whom she created packaging and advertising material decorated with the brand's distinctive 'boy' logo (fig. 4) (Krümmer 2012, 160f).

Fig. 4: Dodo Bürgner, *Design for Akerman's* [*sic*], 1940, private collection (© Dodo Estate, photograph courtesy of Clare Amsel).

Among the many informal and intersecting émigré networks, no doubt the presence of Sigmund Freud encouraged the growth of *Finchleystrasse*'s artistic and psychoanalytical circles. Local émigré psychotherapists and psychologists included Lola Paulsen, Heinz Westman, Anna Freud and husband and wife,

Philip and Eva Metman. Metman counselled Dodo after her second marriage to the noted Jungian psychoanalyst Gerhard Adler (with whom she emigrated and who established a practice in NW11)[16] ended, like her first marriage, in divorce. Emigrée textile designer Elisabeth Tomalin was also a frequent guest of the Metmans: their photographs fill her albums and they also hosted her marriage reception. After she separated from her husband, English left-wing writer Miles Tomalin,[17] he and Elisabeth each moved into a flat within the same small block in Regents Park Road (NW1), designed by Goldfinger (her former employer), where she also set up her drawing table and worked from home.

Artists' (home) studios, Art Education Spaces and Exhibiting opportunities

Home studios were very common, with struggling artists in tiny flats often only streets apart from their wealthy patrons. The freezing conditions in Ludwig and Else Meidner's attic flat in Golders Green were recorded by Ann Sidgwick, whose portrait had been commissioned from Meidner by Michael Croft (Uhlman's brother-in-law); during her sittings in the harsh winter of 1939 she kept her coat on throughout (Baer 2006, 283).

The Meidners then moved to West Heath Drive, and finally to a tiny flat at 677 Finchley Road (1947–1953), where Hodin (previously unaware of the Meidners' close proximity to his own home) visited Ludwig at the artist's invitation in May 1953 (meeting Else on his second visit). Subsequently, Hodin visited Meidner "repeatedly" in his home-cum-studio ("more the cell of a monk than the studio of a painter" with "2000 works accumulated in the dark room", representing "fourteen years of creative artistic work in a country which had no appreciation for his art, of the hard life of an exile driven from his native land for racial reasons"[18]. Hodin took numerous informal photographs of the couple (Tate Archive, London), some published after Ludwig's death in a series in the *Darmstädter Tagblatt* (winter 1966–1967) as a tribute and to commemorate the triumphant rebuilding of his career in Germany. These images additionally record the complex, intimate and enduring relationship between Hodin and both Meidners, culminating in Hodin's publications in German (on Ludwig in 1973; Else in 1989) and typifying his controversial art historical methodology.

Many émigrés established studios locally, their lives and work often intersecting like the overlapping circles of a complex venn diagram. Among them were painters Martin Bloch, Erich Kahn, Walter Nessler, Lottie Reizenstein, Arthur Segal and Marie-Louise von Motesiczky, draughtswoman Milein Cosman, and sculptors

Jussuf Abbo, Georg Ehrlich, Karel Vogel and Anna Mahler. Mahler (daughter of the composer) lived close to Kokoschka (her mother's former lover) and later sculpted young Austrian émigrée, Helga Michie (twin sister of noted writer, Ilse Aichinger), who initially stayed with the Sisters of Mercy of the Holy Cross on Fitzjohn's Avenue (NW3), overlooking the Freuds' back garden. Her later refugee circle included Canetti (Motesiczky's lover), whom she met at the small Finchley Road flat of exiled German writer Robert Neumann and his wife (Ivanovic 2018, 116).

The wider *Finchleystrasse* artistic community included: German art historian, Ernst Gombrich, in Briardale Gardens; Viennese art publisher, Walter Neurath, in Chesterford Gardens (sketched by Kokoschka); Viennese art dealer, Harry Fischer (who exhibited Kokoschka), in Lower Terrace; and Nikolaus Pevsner, author of *The Buildings of England*, in Wildwood Terrace. In addition, the Swiss Cottage area (NW6) has also been identified as a focal point "for Jews engaged in photography generally" (Berkowitz 2015, 67). Inge Ader (née Nord) opened her first studio locally in spring 1942 with Anneli Bunyard, who photographed *Das Laterndl*, as well as illustrations for children's books. Jewish wedding photographer Freddy Weitzman, who had trained under Polish-born Boris Bennett (né Boris Sochaczewska), also had a studio nearby and an upper-class English clientele.

Despite being Austria's foremost Expressionist, *Finchleystrasse*'s most notable artist resident, Oskar Kokoschka, was little known in England upon his arrival. Outspoken in his anti-Nazi views, his work had been increasingly suppressed or confiscated from German public collections, culminating in 1937 in his inclusion in the notorious *Entartete Kunst* (degenerate art) touring exhibition, and provoking his ironically titled *Portrait of a 'Degenerate Artist'* (1938); the following year, he was dismissed from the Prussian Academy. Kokoschka fled to Czechoslovakia in 1934, where he met and married Olda Palkowska, and the couple arrived in England in October 1938, living initially in Boundary Road (NW8). This also housed the bookshop run by émigré brothers, Willy and Josef Suschitzky – cousins of the sibling photographers Wolf Suschitzky and Edith Tudor-Hart – and is the present site, at 108A, of Ben Uri Gallery and Museum. Later Kokoschka moved to Eyres Court, Finchley Road (now marked by a commemorative blue plaque).

During the war Kokoschka was an important political figurehead, able – as a Czech citizen – to campaign against internment. As FGLC President, he attempted to recruit other prominent German-Jewish exiles, including physicist Albert Einstein (then resident in Princeton, New Jersey, USA), who turned down Kokoschka's "kind and honourable request. Because from a political point of view I consider it presently as erroneous to undertake anything that is suited to raise Germany's repute".[19] Einstein felt it "imperative also from the point of view of

[our] dignity", he wrote, "that we distance ourselves from all matters German" (Einstein, 9 March 1939).

Czechoslovak émigré Fred (Fritz) Feigl lived at various *Finchleystrasse* addresses while preparing for an important exhibition of émigré art at the Leicester Museum and Art Gallery (1941), which afterwards purchased four of his local watercolour landscapes including Downshire Church, Keats' Grove, Hampstead, and Hampstead Heath Pond (Sawicki 2016, 241), before settling finally in a flat at 24 Belsize Park Gardens. The émigrée sculptor Elisabeth ('Emmy') Wolff-Fuerth, who sculpted Feigl's portrait, was a close neighbour in the same street.

The sculptor Fred (Fritz) Kormis and his wife, Rachel, who arrived in England via Holland from Germany in 1934, lived initially at 41 Broadhurst Gardens (1935–1937), then at 9 Sherriff Road Studios (1938–1940). In 1938 Kormis participated in the *Exhibition of Twentieth Century German Art*, but following the loss by bombing of all of his large-scale work in September 1940 moved briefly to Hampstead Garden Suburb until rescued by a commission from the American-Jewish collector Samuel Friedenberg to make a series of medallions of prominent Jewish personalities in Britain. The Kormises settled finally in a tiny studio flat at 3b Greville Place, St. John's Wood, one of several in the former home of artist Sir Frank Dicksee and prima ballerina Madame Lydia Kyasht. Kormis, a frequent customer at the Dorice, remained here until his death some 44 years later. A photograph towards the end of his life shows the cramped space full of his sculptures (fig. 5). His major memorial sculpture group 'to the memory of prisoners of war and victims of concentration camps 1914–1945' (1967–1969) is sited nearby at Gladstone Park, Dollis Hill (NW2). Greville Place also housed: at (3i) fellow Nazi refugee, South African painter, printmaker and teacher Dolf

Fig. 5: Photograph of Fred Kormis, courtesy of Lee and Graham Archive (© Rosemary Lee).

Rachel Dickson and Sarah MacDougall

Rieser; at (3a) New Zealand émigré artist and glass engraver, John Hutton; and at (4a), in the former studio of Victorian sculptor Gilbert Bayes, Polish émigré Marek Zulawski, creator of the iconic propaganda poster 'Poland First to Fight'. From the mid-50s Kormis' close friend, Austrian émigré sculptor Willi Soukop was a near neighbour at 26 Greville Road; and Joy Fleischmann, widow of émigré sculptor Arthur Fleischmann, lived nearby.

Finchleystrasse also housed two émigré art schools: German-Jewish painters Julius Rosenbaum (who had repaired Blitz-damaged houses and worked as a china restorer during the war) and his wife, Adèle Reifenberg, established a small but flourishing private painting school (1948–1956), exhibiting with their pupils as the Belsize Group. Paul Hamann (whose works include a cast of Lee Miller's torso) and his German-Jewish artist wife, Hilde, offered life classes in their St John's Wood studio, the latter functioning as an informal network for many former internees including Erich Kahn and Hugo Dachinger. Nevertheless, there was little formalised support for visual culture until the Hampstead Arts Centre (renamed Camden Arts Centre in 1967) opened on the corner of Arkwright Road and Finchley Road in 1965, providing art and design classes. Following its first exhibition in 1966, it hosted, 20 years later, the first comprehensive exhibition of émigré artists in Britain: *Kunst im Exil in Großbritannien 1933–1945*, selected from a larger show at Schloss Charlottenburg in Berlin.

Finchleystrasse's artists also significantly enriched the exhibitions, cultural activities and collection of the Ben Uri Gallery from 1934 onwards. Founded in 1915 in the East End by Jewish émigré artisans, then closed temporarily in 1939, it had reopened in 1944 in Portman Street in central London. Yet entry forms for its annual open shows in the late 1940s reveal a roster of *Finchleystrasse* postcodes for exhibitors including the Czechoslovak brothers Jacob and Alexander Bauernfreund (Bornfriend) in Greencroft Gardens, and the Reifenberg-Rosenbaums at 53 Primrose Gardens (NW3). Today Ben Uri Gallery, which moved to Boundary Road in St John's Wood in 2001, close to the southern end of *Finchleystrasse*, displays work from its museum collection alongside a mixed exhibition programme, and its newly-launched Research Unit for the study of the Jewish and immigrant contribution to British visual culture since 1900.

Finchleystrasse as subject matter

Finchleystrasse and its environs also inspired many artworks: Hodin preserved many of Feigl's lighthearted *Finchleystrasse* sketchbook vignettes and hand-painted Christmas cards (*c.* 1957–1965) – the early signature "Frederich and Margaret"

giving way to the shorter, Anglicised "Fred and Marg" – and many of Feigl's lively local London park scenes of Regent's Park, Golder's Hill and Kenwood.

The Heath's leafy vistas appeared frequently as both subject and backdrop in works by a number of émigrés including Henry Sanders, Willi Rondas and Klaus Meyer, whose *Girl in Red* (1990, Ben Uri Collection, fig. 6) depicts his young daughter in their South Hill Park garden, backing onto the Heath. A contrasting cityscape by Austrian émigrée Marie-Louise von Motesiczky, *Finchley Road at Night* (1952), portrays a "simplified and harmonious view of the busy, modern urban life" (Schlenker 2011, 219) of north London to which she returned in 1948, after spending the war years in Amersham, taking on a flat-share at 14 Compayne Gardens, West Hampstead (where Canetti had a room, *c.* 1951–1957), later moving to Hampstead in 1960. As her cataloguer, Ines Schlenker, has commented, this part of north London became "a constant presence in her *Wahlheimat* (adopted country)" (Schlenker 2011, 220).

Fig. 6: Klaus Meyer, *Girl in Red*, 1990, Ben Uri Collection, London (© Klaus Meyer Estate).

Rachel Dickson and Sarah MacDougall

Conclusion

In conclusion, it can be seen that while *Finchleystrasse* played a vital role as a place of sanctuary for the refugees and as a locale for the social, cultural, religious and educational spaces and organisations they initiated during and immediately after the Second World War, beyond this period its support gradually diminished and the majority of the organisations either disbanded or relocated. In 2003 the AJR relocated northwards and, as the refugees themselves became more integrated or moved further out, *Finchleystrasse* gradually lost its position as a cultural 'spine'. Furthermore, although their influence had been strong, their presence had not always been welcome, as evidenced by an unsuccessful petition, signed by more than 2000 Hampstead locals in 1945, agitating for the émigrés' removal and repatriation.[20]

80 years later, the wide, tree-lined expanse of Finchley Road itself is now a noisy, traffic-choked dual carriageway with a central barrier making pedestrian crossing difficult, and the driver-only buses that travel up and down its length no longer have conductors to engage in playful banter with their passengers. Cosmo closed in the late 1990s (its unique role marked in 2013 by the AJR's commemorative blue plaque) and even the London Jewish Cultural Centre (LJCC), one of the local community's subsequent cultural hubs, housed in Anna Pavlova's former home, Ivy House, in North End Road (NW11), closed in 2015.[21] If the AJR map was redrawn today, it would be evident that many of the émigré small businesses and institutions which flourished from the 1930s onwards are long gone.

Nevertheless, they provided significant material and intangible sustenance to a refugee generation, and among their legacies is the recently opened Jewish cultural centre, JW3, whose name plays on and highlights the local NW3 postcode, tying the current generation of north London Jews firmly to this locale.

Notes

[1] Most recently at the conference entitled "Sites of Interchange: Modernism, Politics, and Culture in Britain and Germany, 1919–51", Courtauld Institute of Art, Somerset House, London, 2–3 November 2018.

[2] In 1942 it hosted the *Aid to Russia* fundraising exhibition for the National Council of Labour. Willow Road was also home to émigré couple, musicologist Hans Keller and artist Milein Cosman.

[3] Originally Finchley New Road, it opened as a turnpike in 1835, with grand homes around Fortune Green, Childs Hill and Golders Green. It is now a 7 km main road following the A41.

4 Curated by Ben Uri Gallery and Museum at the German Embassy London (February 2018 – January 2019).

5 Reproduced with kind permission of the AJR.

6 BBC Radio 4, 2014.

7 Klopfleisch exhibited in the FDKB and AIA sculpture exhibition in October 1942 and *Artists Aid Jewry* in February 1943.

8 Uhlman's wife Diana was the daughter of Henry Page Croft, 1st Baron Croft, Under-Secretary of State for War (1940–1945).

9 Other inhabitants included a Norwegian sea captain. Eva's father, Paul Frankfurther, lived here for the rest of his life.

10 Woburn House, home to the German-Jewish Aid Committee (1933–1938) was succeeded by Bloomsbury House, with subsidiary organisations including the Free Meal Service, Society for Protection of Science and Learning, Academic Assistance Council (Bihler 2018, 118–120).

11 It moved in June 1943 to 279a Finchley Road.

12 It relocated to Upper Park Road in 1939, although the Artists' Section continued to meet in Downshire Hill until 1943.

13 Among the 60-strong exhibitors were painters Max Beckmann, Oskar Kokoschka and Max Ernst, sculptors Ernst Barlach, Georg Ehrlich, Fritz Kormis and Dadaist Kurt Schwitters. Despite huge visitor attendance, it received a divided critical response (see *London 1938* 2018).

14 Anna Nyburg. "Food in Exile." *Exile and Everyday Life*, edited by Andrea Hammel and Anthony Grenville, *Yearbook of the Research Centre for German and Austrian Exile Studies*, Vol. 16 (Brill/Rodopi, 2015), 185.

15 Cosmo features in the cabaret *The Ballad of Cosmo Cafe*, Composer Carl Davis, Librettist Philip Glassborow, Director Pamela Howard, part of the nationwide year-long *Insiders/Outsiders* Festival celebrating the contribution to British culture by refugees from Nazi persecution, from March 2019. Wolfsohn fled Germany in 1939 and established a practice in Golders Green.

16 *The London Gazette* (17 October 1947, p. 4884) notes Gerhard Adler's naturalisation on 12 September 1947 at 9 Woodstock Avenue, NW11.

17 Miles Tomalin, diary entry from July 1940 (Private Collection, London).

18 J.P. Hodin, Typescript, "Portrait of the Artist Ludwig Meidner" (Tate Archives, London, *c.* 1953), TGA 20062, uncatalogued.

19 Albert Einstein to Herrn Oskar Kokoschka, 9 March 1939. Translated from the German original by Michael Ursinus, Fred Uhlman papers (Private Archive, London), by kind permission of Caroline Compton.

20 *Hampstead and Highgate Express*, 12 October 1945, p. 1.

21 Its role was partially replaced by the privately-funded JW3 Jewish community centre, which opened at 341–351 Finchley Road in 2013. Camden Art Centre exhibits contemporary art.

References

AJR website: https://ajr.org.uk/about/. Accessed 26 July 2019.

Alderman, Geoffrey. *Modern British Jewry*. Oxford University Press, 1998.

Art and Migration, edited by Jennifer Powell and Jutta Vinzent, exh. cat. The Barber Institute of Fine Arts, Birmingham, 2005.

Baer, Ann. "The Meidner Portrait". *London: City of Disappearances*, edited by Iain Sinclair. Hamish Hamilton, 2006, pp. 283–285.

Berkowitz, Michael. *Jews and Photography in Britain*. University of Texas Press, 2015.

Bihler, Lori Gemeiner. *Cities of Refuge: German Jews in London and New York, 1935–1945*. State University of New York Press, 2018.

Bohm-Duchen, Monica, editor. *Insiders/Outsiders: Refugees from Nazi Europe and their contribution to British visual culture*. Lund Humphries, 2019.

Boyt, Susie. "A Spot of Misery and Pot of Tea." *Life and Arts, Financial Times*, 16 November 2013, https://www.ft.com/content/1ffb7cd0-47e3-11e3-88be-00144feabdc0. Accessed 26 July 2019.

Bunyard, Anneli, and Margaret Fisher. *How Things Are Made: What a Thread Can Do*. Collins, 1946.

Buruma, Ian. "Memories on the Menu." (untraced publication and date, Fred Kormis papers, Ben Uri Archive, London, n.d.).

Canetti, Elias. *Party in the Blitz: the English Years*. Translated by Michael Hofmann, Preface by Jeremy Adler, The Harvill Press, 2005.

Darmstädter Tagblatt, 5–6 and 19–20 November 1966; 3–4 December 1966; *Weihnachten* 1966; 7–8 January 1967.

Dodo: Leben und Werk Life and Work 1907–1998, edited by Renate Krümmer, exh. cat. Kunstbibliothek – Staatliche Museen zu Berlin, Berlin, 2012.

Douek, Ellis. *A Middle Eastern Affair*. Halban Publishers, 2004.

Drawings of Ludwig Meidner (1920–1922 and 1935–1949), Paintings and Drawings of Else Meidner (1935–1949), exh. cat. Ben Uri Art Gallery, London, 1949.

Feigl 80th Birthday Exhibition, exh. cat. Ben Uri Art Gallery, London, 1964, n. p.

Garbarini, Alexandra et al. *Jewish Responses to Persecution: Volume II, 1938–1940*. Rowman & Littlefield, 2010.

German Jewish Aid Committee, in conjunction with the Jewish Board of Deputies. *While You are in England. Helpful Information and Guidance for Every Refugee*. 1939.

Grenville, Anthony. *Encounters with Albion: Britain and the British in texts by Jewish refugees from Nazism*. Germanic Literatures 17, Modern Humanities Research Association, Legenda, 2018.

Hodin, J.P. "A Czech Artist Looks at English Art." *Central European Observer*, 21 September 1945, cited *Feigl 80th Birthday Exhibition*, exh. cat. Ben Uri Art Gallery, London 1964, unpaginated.

Hodin, J.P. "A Study of the Cultural History of Hampstead in the Thirties." *Hampstead in the Thirties: A committed decade*, edited by Jeanette Jackson, et al., exh. cat. Camden

Arts Centre, London, 1974, pp. 5–7.

Ivanovic, Christine, editor. *I am Beginning to Want What I am: Helga Michie.* Schlebrügge Editor, 2018.

Kahn, Leo. "Profile of an Artist: Ludwig Meidner." *AJR Information,* February 1953, p. 7.

London 1938 – Defending "degenerate" Art, edited by Lucy Wasensteiner and Martin Faass, exh. cat. Wiener Library, London, and Liebermann-Villa am Wannsee, Berlin, 2018.

Ludwig and Else Meidner, exh. cat. Jüdisches Museum der Stadt Frankfurt, Frankfurt am Main, 2002.

Malet, Marian. "Oskar Kokoschka and the Freie Deutsche Kulturbund: The 'Friendly Alien' as Propagandist." *"I didn't want to float, I wanted to belong to something": Refugee organizations in Britain 193319–45, Yearbook of the Research Centre for German and Austrian Exile Studies,* Vol. 10, edited by Anthony Grenville and Andrea Reiter, Rodopi, 2008, pp. 49–66.

Manheimer, Marion. "Finchley Road restaurant remembered as 'saviour' for Jews fleeing Fascism." *Ham&High,* 30 November 2013, https://www.hamhigh.co.uk/news/finchley-road-restaurant-remembered-as-saviour-for-jews-fleeing-fascism-1-3047713. Accessed 26 July 2019.

Müller-Härlin, Anna. "'It all happened in this street, Downshire Hill': Fred Uhlman and the Free German League of Culture." *Arts in Exile in Britain 1933-1945: Politics and Cultural Identity', Yearbook of the Research Centre for German and Austrian Exile Studies,* Vol. 6, edited by Marian Malet and Shulamith Behr, Rodopi, 2004, pp. 241–265.

Müller-Härlin, Anna. "The Artists' Section." *Politics By Other Means: The Free German League of Culture in London 1939–1946,* Charmian Brinson and Richard Dove, Valentine Mitchell, 2010, pp. 54–73.

Norman. "A Town and County Miscellany – Part 1." *St Mary's Town & Country School,* www.stmarystownandcountryschool.com/misc.html. Accessed 8 March 2019.

"Ode to Finchleystrasse." *BBC Radio 4,* September 2014.

Sawicki, Nicholas, editor. *Friedrich Feigl: 1884–1965.* Arbor Vitae, 2016.

Schlenker, Ines, editor. *Marie-Louise von Motesiczky 1906–1996: A Catalogue Raisonné of the Paintings.* Issuu, 2011.

Snowman, Daniel. *The Hitler Émigrés.* Pimlico, 2003.

The Making of an Englishman: Fred Uhlman, A Retrospective, edited by Nicola Baird, exh. cat. Burgh House & Hampstead Museum, London, 2018.

Uhlman, Diana. "Hampstead in the Thirties and Forties." *Hampstead in the Thirties: A committed Decade,* edited by Jeannette Jackson, et al., exh. cat. Camden Art Centre, London, 1974, pp. 30–33.

Valberg, J. J. "Preface." *Dream, Death, and the Self.* Princeton University Press. 2007, p. xv.

Weldon, Fay. *Auto-da-Fay.* Flamingo, 2002.

Hospitable Environments

The Taj Mahal Palace Hotel and Green's Hotel as Sites of Cultural Production in Bombay

Rachel Lee

During the first half of the 20th century Bombay (now Mumbai) emerged as the centre of modern art in India: It was in Bombay that the now canonised Progressive Artists Group (hereafter Progressives) was founded in 1947, one year after the launch of *Marg*, a pathbreaking art and architecture magazine initiated by the Modern Architecture Research Group.[1] A number of factors combined to enable this. The transformation of Bombay's swampy archipelago landscape into colonial India's economically most important port created a wealthy local industrial class, who invested their fortunes in the city. They contributed hugely to both shaping the topography of the metropolis, including the artscape, and patronising the arts.[2] Late 19th-century art infrastructure including the J.J. School of Art and the Bombay Art Society, combined with the burgeoning film industry, Parsi theatre, a vigorous local print media and a lively civil society, was also an important aspect in cultivating the art scene. In the 1930s, refugees fleeing the rise of fascism in Europe began arriving in Bombay, a "migropolis" (*Migropolis* 2010) with a multicultural population. Among them were dancers, composers, screenwriters, art historians, art collectors, painters, illustrators, photographers and writers.[3] Although small in number, these exiles contributed to the development of Bombay's art scene in numerous ways: they established schools, held salons, joined societies, gave public performances, curated exhibitions, lectured and published articles. Crucially, they worked together with local artists, curators and patrons to catalyse the emergence of modern art.[4]

Rather than focus on individual figures, this essay explores specific sites in the city in which collaborations and exchanges took place between locals and exiles, where discourses developed and where art was exhibited. Within the realm of informal places that functioned as spaces of sociability – urban locations where diverse people could meet and share ideas – it investigates a largely overlooked

typology: the hotel. Drawing on diverse sources, including guidebooks, newspapers, travelogues and novels, as well as archives,[5] this essay constructs an argument for considering hotels as significant spaces of sociability that contributed to the cultural life of the local inhabitants as well as providing accommodation to transient visitors to the city. Focusing on two of Bombay's prominent hotels – the Taj Mahal Palace Hotel and Green's Hotel – it outlines the ways in which they fostered culture, generated intellectual discourse and supported the local art scene. By anchoring the exiled and local artists to the activities in the hotels, it makes a case for conceiving of hotels as contact zones. Finally, it considers whether Bombay presents an exceptional case or whether similar situations can be found in other colonial or post-colonial environments.

Situating local people within the historiography of hotels

In her recent book *Setting the Stage for Modernity,* in which she examines cafes, hotels and restaurants as spatial typologies that were "trendsetters of modernity", Franziska Bollerey presents the hotel as a cosmos, a city within a city, and compares it to an ocean liner (Bollerey 2019, 6, 68, 75, 111). Although she recognises hotels as catalysts of urbanisation and thus as key institutions within cities, they appear as autarkic entities with little connection to the urban life unfolding outside their revolving doors. By linking the development of hotels with the rise of the bourgeois leisure class and tourism, she overlooks possible relationships between the local population and the functions of the hotel, beyond their employment as staff. In fact, Bollerey suggests that the cleft between hotel users and locals was so wide that hotels produced radical forms of othering: "The locals are confronted with a civilization alien to them. [...] The hotel guests in turn regard the locals as an exoticum." (Bollerey 2019, 118) Indeed, it is not until she discusses 21st-century hotel (re)development strategies that local people are regarded as potential patrons and part of the hotel market – as Parisian hotel managers attempt to "seduce locals" through the design of their hotels' public spaces (ibid., 121).

Bollerey's analysis, which largely focuses on examples from the 'Global North', is in line with much architectural historical research on the hotel typology. In this field, hotels have been primarily understood as providers of temporary accommodation for tourists and people travelling for work, and have been examined in terms of architectural form, spatial arrangement and style, often with an additional focus on their use of new technologies.[6]

Rachel Lee

While Annabel Wharton explored hotels in terms of soft power and Americanisation (Wharton 2001), and their political significance has recently begun to be assessed (Craggs 2012), their local social and cultural functions have so far met with limited academic interest. Bernard L. Jim has investigated hotels' roles in the formation of local citizenry's individual and collective memories, noting that "hotels hosted some of the most import cultural events in their cities" and listing the users of a hotel in Cleveland as "the traveler, the meeting attendee, and Cleveland regulars" (Jim 2005, 294, 310, author's emphasis). Significantly more agency is ascribed to local people as hotel users in Karl Raitz and John Paul Jones' study of taverns and hotels on the settlement frontier of the USA. Therein hotels are credited with giving identity to the city, having a "vital function in organizing the interactions of both local residents and visitors" and being at the heart of civil life (Raitz/Jones 1988, 21).

Maurizio Peleggi's work on British Colombo and Singapore is a rare example of a study of hotels in colonial contexts. As well as "comfort zones", he defines hotels as "'contact zones' par excellence within the colonial city, where different social, ethnic, and national groups interacted" (Peleggi 2012, 125). While stating that potential patrons were rarely excluded from colonial hotels on the basis of race, he focuses his exploration of the hotel as contact zone around deeply asymmetric exchanges between foreign visitors and local staff, noting that:

> Within hotels, the comforts of domesticity were made available to colonial residents and travelers courtesy of Asian bartenders, waiters, and room servants; around hotels, doormen, guides, and rickshaw pullers domesticated the colonial city's perils, and less respectable pleasures, for the tourist's sake. (Peleggi 2012, 146)

In addition, Peleggi also briefly mentions Chinese and Eurasian women who were paid to dance with single western men at the hotels. However, he does not discuss other types of activity that may have occurred within the contact zone on a more equitable basis. In the following I expand Peleggi's notion of the colonial hotel as contact zone to include less imbalanced interactions that comprise local figures from a range of milieus, among them culture, science, business and art, as well as exiled European artists.

The Taj Mahal Palace Hotel and Green's Hotel in cosmopolitan Bombay

Although hotels had emerged as a recognisable typology in Europe and the USA around 1800 (Watkin 1984, 15), according to Dinshaw Wacha there were no "decent" hotels in Bombay until the mid-19th century (Wacha 1920, 289). Until then, visitors from abroad or other parts of India had tended to stay with friends or acquaintances. Taverns, or, as he terms them, "third-rate grog shops" were perhaps a less salubrious option, and clubs, such as the Byculla Club, a more exclusive one (Patel 2015, 131). Bombay's first hotels, Hope Hall and the Adelphi, opened in Mazagaon in 1837 and in Byculla in 1859 respectively (Wacha 1920, 287–293). Wacha credits a spate of hotel building in the late 19th century not so much to increased business brought to the port city by the cotton boom or tourism, but rather to the influx of foreigners involved in cultural production and performance in the city, such as the Italian Ballet Company and the comedian Dave Carson and his troupe (Wacha 1920, 297). And according to Simin Patel, after single male travellers and families, groups of performers were indeed the third category in need of accommodation (Patel 2015, 127).

Among those late 19th-century hotels, the Esplanade Hotel (also known as Watson's Hotel), which opened in 1871,[7] is important both architecturally and culturally. Built by John Watson on a site that became available through the demolition of the city's ramparts, the hotel was housed in an ambitiously modern prefabricated cast-iron structure imported from England. In addition to its pioneering architecture, the Esplanade boasted over 100 rooms, an in-house doctor and a steam-powered lift (Patel 2015, 141). Apart from counting Mark Twain among its guests, the Esplanade Hotel was the site of the first film screening in India: the Lumière Brothers' *Arrival of a Train, The Sea Bath, A Demolition, Leaving the Factory* and *Ladies and Soldiers on Wheels* were shown there in 1896 (Johari 2019). Charging an entry fee, yet open to the public and not just to guests, this film screening is perhaps indicative of the cultural role that this and other hotels were beginning to play in Bombay's urban society (fig. 1). The Esplanade Hotel is also significant for another reason: it is credited as catalysing the Parsi industrialist J.N. (Jamsetji Nusserwanji) Tata's decision to build the Taj Mahal Palace Hotel.

An urban legend recounts that when J.N. Tata was refused entry to the Esplanade Hotel on racial grounds, he decided to exact his revenge by founding a hotel himself.[8] While there is very little evidence to support this theory, and indeed some evidence exists to disprove it – the Esplanade Hotel recorded Indian guests as early as the year of its opening (Patel 2015, 115) – it has helped to establish Tata's Taj Mahal Palace Hotel (hereafter the Taj) within the collective imaginary

Rachel Lee

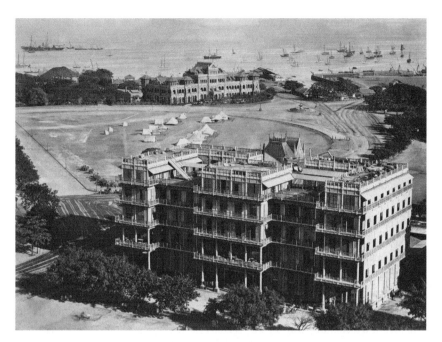

Fig. 1: Esplanade Hotel, circa 1880s (Pump Park Vintage Photography / Alamy Stock Photo).

of the city and beyond. Opening its doors in December 1903, the Taj set a new standard in hotel design in Bombay. Although its eclectic architectural expression, featuring corner cupolas, batteries of Rajput bay windows and a central segmented dome, may not have been the most progressive, the local designers D.N. Mirza and Sitaram Khanderao Vaidya, with W.A. Chambers as consultant architect, produced a hotel that was technologically superior to anything else in the city: a steam laundry, Turkish baths, electric lighting, a soda-water bottling plant and a post office were all part of the project (Denby 2002, 202). Both Chambers and Vaidya had previously worked with F.W. (Frederick William) Stevens, an English architect whose neo-Gothic public buildings made an enduring contribution to Bombay's civic landscape.

The Taj, situated on Apollo Bunder and overlooking the Arabian Sea, immediately became a landmark. For those arriving by ship, it was often the first building in the city that they saw or recognised. The American author Louis Bromfield described the experience of a passenger nearing the harbour as follows:

> [...] the city had begun to appear out of the haze – the Taj Mahal Hotel, the Readymoney Building, the Yacht Club, the Gateway of India and the green eminence of Malabar Hill dotted with bungalows and the palaces of the Maharajahs [...]. (Bromfield 1946, 13)

Perhaps the exterior's irreverent mix of traditional architectural elements from different cultural contexts and the interior's technological ambition can be seen as more characteristic of Bombay than the unequivocal modernism of the Esplanade Hotel. Authors of early 20th-century guidebooks and urban chronicles are unanimous in their praise of the city and its inhabitants as cosmopolitan, with some claiming it as the most cosmopolitan city in the world (Newell 1920, 7; Wacha 1920, 411; The Times of India 1926, II; Diqui 1927, 3; Contractor 1938, 45).[9] More than assembling difference, however, Bombay also produced hybridity; as Louis Bromfield states: "Bombay wasn't anything. It wasn't India, or East or West, but an extraordinary muddle of everything on earth" (Bromfield 1946, 14). The Taj can be seen as a reflection of this. Beyond its fusion architecture, it was founded and directed by a local industrialist, managed by Europeans and staffed in the main by Goans. Chinese mime artists, Russian dancers and American jazz bands provided entertainment (undated newspaper cuttings, Tata Central Archives). In the words of the Australian author Frank Clune, "like many other things in Bombay, it's a mixture of Eastern and Western ideas on the grand scale" (Clune 1947, 154).

The Taj's cosmopolitan flair was further augmented by the outwardly rather more unassuming hotel next door. Built by William Boyd Green as mansion flats in 1890, by November 1904 the Tata Group had purchased Green's Mansions and was operating it as part of their Indian Hotels Company Ltd, in tandem with the Taj (Sabavala 1943, 11). Defined by linear verandahs, cantilevered *chajjas* and fine balustrades, Green's Hotel's (hereafter Green's) elegant architecture may have been overshadowed by the more pompous Taj, but its capacity for sociability was not (fig. 2). During the first half of the 20th century these two hotels provided spaces within which political and cultural discourses grew, deals were made, relationships evolved and art was exhibited; spaces where people talked, dined and danced, partied and reflected.[10] The participants in these activities were not only itinerant businesspeople or tourists or colonial figures; many were locals, particularly from the English-speaking elite. Among them were the exiled artists.

Rachel Lee

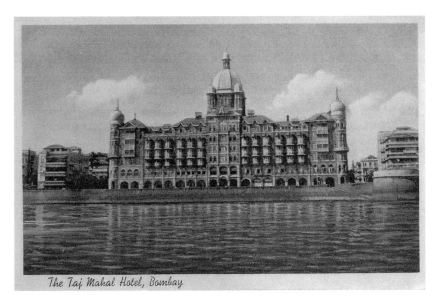

The Taj Mahal Hotel, Bombay

Fig. 2: Postcard of the Taj Mahal Palace Hotel with Green's Hotel visible on the right. Date unknown (Author's collection).

Keeping Bombay amused: The Taj and Green's as spaces of sociability

> "Vere are you staying in Bombay?"
> "The hotel, I suppose."
> "The Taj Mahal?"
> "Yes, the Taj Mahal." (Bromfield 1946, 16)

For many visitors, particularly the wealthy, the Taj was *the* hotel in Bombay (fig. 3). This was in part due to the high standard of accommodation and service it provided. Indeed, many writers have concurred with G.A. Mathews' visceral reaction to the hotel's opulence: "The Taj Hotel is on such a scale of magnificence and luxury that at first it rather took one's breath away" (Mathews 1906, 24). Others, in contrast, have compared it unfavourably to a middle western county jail (Bromfield 1946, 67), a railway station (Cook 1939, 245) and a cottage hospital (Cameron 1974, 18), indicating that beyond the public areas different qualities of spaces existed. Certainly none of the much touted luxury is present in the military professional David King's description of his room: "It was a dark and gloomy chamber, with walls of a dingy brown – ideal protective covering for the wall lizards and enormous

brown spiders one finds all over India" (King 1929, 19). Much as the Taj attempted to corner the luxury market, it also provided beds in shared rooms for those with lesser budgets. In contrast, the rooms at the much smaller Green's were described as "exceptionally commodious and comfortable" (Macmillan 1928, 195).

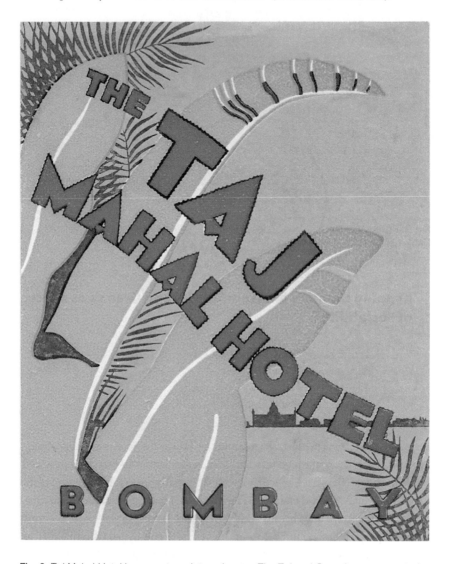

Fig. 3: Taj Mahal Hotel luggage tag, date unknown. The Taj and Green's are presented in the silhouetted cityscape (Author's collection).

Rachel Lee

Louis Bromfield described the spectacle of people in the Taj's public spaces as international, colonial and local, monied and sexualised:

> Through the hallway and the bazaar [...] came and went a procession of Arab horsedealers, British Governors and Civil Servants, Russian and German trollops, Indian princes, jewel merchants, Parsee millionaires, comic middle-aged tourists, gamblers, oil prospectors. (Bromfield 1946, 67–68)

Among those missing from this scene are Indian political figures, whose numbers included Sarojini Naidu. A prominent force in the independence movement through the Indian National Congress, she became its president in 1947. For several years she rented a suite of rooms at the Taj, in which she lived with her family on an almost permanent basis, entertained visitors and conducted meetings with a wide range of people (Venkatachalam 1966, 54). In 1915, after a meeting of Congress leaders and the Muslim League, including Muhammad Jinnah, dramatically disbanded, the participants reconvened a few hours later at the Taj (Bolitho 1954, 64). As Naidu took part in the meeting, it is possible that they gathered in her rooms. Some refugees, exiled from Europe as a consequence of the rise of national socialism, also began their stays in India at the Taj. The chemistry professor Stephen Tauber recalls arriving at the Taj on 3 October 1938 and spending several nights there before travelling on to Bikaner with his parents. The hotel rooms had cost much more than his family could comfortably afford (Tauber 2015, 292f.).

According to some accounts, Green's attracted a slightly different, edgier crowd than the Taj, which one local newspaper dubbed the "Mecca of the *haut ton* Society" (Anonymous 1939a). Referred to somewhat euphemistically by guests of the Taj as the "hotel across the garden", it was a venue where less socially acceptable encounters could take place – between lower class Europeans and Eurasians, for example (Greenwall 1933, 105). Local press carried stories of brawls between seamen at Green's (Anonymous 1948), and it was also the haunt of jockeys and the horse racing crowd during racing season (Diqui 1927, 20f.). Confirming this, Louis Bromfield conjures a vivid depiction of the multicultural scene at Green's restaurant which, while also international, colonial and local, appears poorer and more overtly sexualised than the Taj:

> [...] the people were fantastic [...] seafaring men who would have been embarrassed by the mid-Victorian imperial elegance of the Taj Mahal dining-room, English officers and Civil Servants and

clerks who were there because Green's was Bohemian and as wild a place as they dared frequent in a community where everything [...] became known; tired, plain girls shipped from the British Isles to relatives in the East to find husbands; hard girls on the verge of middle-age from Hove and Cardiff and Liverpool and London whom some strange fate had dumped into Bombay as sleazy tap dancers and members of a ladies' orchestra. And here and there a stray Russian tart or an "advanced" Parsee or Khoja woman dining alone with a man. (Bromfield 1946, 80)

Bromfield's descriptions illustrate that both hotels were clearly sites of display and public presentation; fashionable places to be seen by a diverse array of people. Beyond that, however, the various activities that they offered render them locations of social, economic, political and cultural interaction and exchange that fostered the development of communities, civil society and even education. According to Simin Patel, from the outset, J.N. Tata and the designers of the Taj integrated social spaces within the hotel that aimed to attract clients who were not residents. These included several restaurants on different floors, a billiard room and 12 shops – the bazaar mentioned in the quotation above (Patel 2015, 153). Among these shops was a hairdresser's and a bookshop, which the author Aldous Huxley interestingly noted contained a large collection of publications on gynaecology, obstetrics, sexual psychology and venereal disease, remarking that, "the hotel lounge is not specially frequented by doctors; it is the general public which buys these journals" (Huxley 1926, 9; author's emphasis). It seems that, at that time, the Taj was one of the few places in Bombay where information on sexual health was available. The hotel therefore played a role, albeit a very particular one, in local public health education, again underlining its relevance to the local population. Not to be outdone by the Taj, Green's also contributed to political discourse. According to Naresh Fernandes, *Crossroads*, a weekly Communist Party newspaper, was operated from an office under the stairs there (Fernandes 2012, 97).

Green's too offered billiards and snooker (Anonymous 1939b) and a well-reputed restaurant that also catered to external events. It was also known for its incredibly long bar and its lively evening entertainment. Similarly to the Taj, it had a large ballroom and offered dance, cabaret and live music performances. The exiled Viennese expressionist dancer Hilde Holger gave her first public performance in the Taj in 1938. She was reportedly not impressed by the spatial arrangements:

Rachel Lee

> Nobody at the Taj had ever heard of a dancer too proud to dance on the parquet between the dinners [*sic*]. Hilde Holger demanded a stage, not a cabaret artiste's arena. She had a will of iron and she got what she wanted (Lupus 1948).

During the 1930s and 1940s jazz became popular in Bombay, and a vibrant scene emerged (Fernandes 2012). While the Taj was at its centre, Green's was also an important venue in the jazz scene. Both hotels hosted residencies by international and local artists, and often combinations of both: well-known performers from the USA would team up with local musicians (Fernandes 2012, 78, 88, 91). Regular acts in the 1930s and 1940s included Crickett Smith, Teddy Weatherford and Chic Chocolate. Beyond being a performance space, Green's was also a meeting point for musicians who played at other venues in the city (Fernandes 2012, 83). Aimee (also Amy) Denton, a singer who performed at both venues, was later said to have worked as a spy for the Germans (Ghosh 2008). That a spy sought employment at Green's and the Taj perhaps underlines the centrality of the two hotels in Bombay's civic life. While Green's staged "non-stop dances" (Anonymous 1938b, 6) and "six-a-week dance nights" (Anonymous 1941, 3), the Taj held charity gala dances – a cocktail dance to aid refugees, presumably from Europe, spilled out onto the pavement outside the hotel, where the dancing continued until long after midnight (Anonymous 1939a). In addition to dances, for those who could afford it the Taj was also a popular venue for social events such as wedding parties. The exiled German illustrator and *Times of India* art critic with a doctorate in geology Rudy von Leyden held a luncheon at the Taj to celebrate his marriage to Baroness Olga Mafalda (Nena) de Belatini (Anonymous 1949b, 3).

Information about these hotel happenings was published in the local daily English-language newspaper *The Times of India*, which announced and advertised the events scheduled at the Taj and Green's alongside other listings in the city. *The Onlooker,* a local monthly newspaper, commented on what it deemed the most interesting of them. Although these newspapers may have been of interest to visitors to the city who stayed at the hotels, the majority readership was local. The listings and commentaries were aimed at English-speaking Bombayites, as they were the people who attended the events. This group included colonial figures and expats, as well as the Indian elite and the exiled artists. After outlining the upcoming events at the Taj, *The Times of India* announced, "Green's Hotel is also doing its bit to keep Bombay amused" (Anonymous 1939b). The Taj and Green's were key sites in the public cultural and social life of Bombay's educated English-speaking elites. Both hotels were contact zones that enabled the paths and social lives of travellers, locals, exiles and migrants to intersect.

Art, discourse and exiles in the hotels

Although it is likely that the exiled artists took part in the dances and parties held at the Taj and Green's, a lack of documentation makes it difficult to locate them there. However, there are records of them taking part in other events at the hotels. These events contributed to the development of public discourse in the city. The urban historian Prashant Kidambi credits the emergence of a dynamic and plural civil society in Bombay to the proliferation of associational activities, including clubs and societies (Kidambi 2007, 12–13, 158). Among these, the Rotary Club stands out as significant both for the exilic community and the art scene.

During the late 1930s and throughout the 1940s, the Rotary Club convened at Green's, having met at the Taj since its founding there in 1929 (Anonymous 1980). Several of the key figures involved in the art scene that developed around the Progressives were Rotarians, and gave lectures at the regular luncheon meetings of the men-only club: Rudy von Leyden talked about "The Indian Institute of Art in Industry" (Anonymous 1946, 5), while the exiled Viennese painter, former art professor and art director at *The Times of India* Walter Langhammer lectured on "Design for Living" (Anonymous 1949c, 9) and Homi Bhabha, a physicist, amateur artist, art patron and collector, spoke about "Atomic Energy" (Anonymous 1945a, 3). The exiled musician, composer and co-founder of the Bombay Chamber Music Society, Walter Kaufmann, presented his thoughts on "Modern Composers" (Anonymous 1938a, 13). Kekoo Gandhy, founder of the exhibition space within Chemould Frames and later of Gallery Chemould, received an achievement award for the art exhibition programme he had instigated to showcase young artists (Anonymous 1971, 5). While none of the local artists appear to have been members, the Rotary Club nonetheless provided a platform for the exiled artists and other figures involved in the local art scene to discuss their ideas on art, to network and to cultivate interest in art. As many of those who belonged to the Club were part of the local intelligentsia and economic elite, the meetings may also have served the development of an art market.

In addition to producing discourse through hosting associational activities,[11] the Taj was also an exhibition venue that played a role in the emerging art scene in the 1930s and 1940s. The art historian Yashodhara Dalmia credits the Taj with launching the Hungarian-Indian painter Amrita Sher-Gil's career. As well as staying at the hotel, she also held a breakthrough exhibition there in 1936 (Dalmia 2013). Sher-Gil's paintings were shown in the first-floor corridors together with works by Sarada Ukil, a more established artist at the time (Anonymous 1936, 18). In 1945, 75 paintings by Madhav Satwalekar were shown in the Princes' Room (Anonymous 1945b). In 1946, the Bombay Art Society curated an exhibition of

works by Shiavax Chavda, who had also studied at the J.J. School, Slade School and the Académie de la Grande Chaumière before returning to India, where he became associated with the Progressives (Anonymous 1947, 8). According to Rudy von Leyden, the record number of visitors to the show in the Princes' Room was due to the diligence of Kekoo Gandhy, then secretary of the Bombay Art Society and presumably the main curator of the exhibition (RVL 1947, 8). Here it is worth noting that both Langhammer and von Leyden were members of the board of the Bombay Art Society, and contributed to expanding it into an institution that catalysed ongoing discourse through regular salons and exhibitions, rather than just annual exhibitions, and were active in its curatorial programme (Dogramaci/ Lee 2019). An exhibition of paintings by K.K. Hebbar, another of the Progressives, was shown in the Princes' Room of the Taj in 1949. Among those who attended the vernissage were:

> Mrs Wazir Tyabji, whose white sari had an exquisite Chinese border, Mr and Mrs W. Langhammer, Mr Hubert de Limairac, the French Consul, Mrs Mehta, in a red and gold Benaras sari […] and Mahamahopadhyaya P.V. Kane, the Vice Chancellor. (Anonymous 1949a)

That *The Onlooker* deemed the Langhammers' presence worthy of note is an indication of their position in Bombay society at the time. Similarly to von Leyden, whose wedding celebration at the Taj was reported in *The Times of India* as mentioned above, the Langhammers were part of Bombay's cultural elite. As well as showcasing Indian artists, the Taj also exhibited international works, by contemporary Chinese painters for example (RVL 1946, 8).

In the Princes' Room and the corridors of the Taj Bombay's modern art scene converged. The Progressive artists showed their work in exhibitions curated by Kekoo Gandhy and the Bombay Art Society, the Langhammers supported the events with their presence, and Rudy von Leyden generated publicity and discourse through his criticism in *The Times of India*. More than a contact zone of colonial asymmetries, the associational and cultural events in the Taj and Green's produced discursive spaces actively shared between local and exiled curators, artists, writers and activists as well as colonial figures.

Nevertheless, these spaces were also exclusionary. Mainly English-speaking, they were the haunts of the local intelligentsia and cultural and monied elites – to which the exiled artists also belonged – rather than Marathi-speaking mill workers or unskilled labourers from Bihar, for example. As the Rotary Club

example illustrates, these spaces were also gendered. The rather exclusive nature of the Taj also raises questions about unwritten rules and social codes, while the public consumption of alcohol would have undoubtedly deterred the participation of people from certain religious communities. Nevertheless, the asymmetries, hierarchies and segregations at work here are far more complex than the binary of coloniser and colonised.

Hotels as Hospitable Environments

When considering the concept of hospitality, whether it be the act of welcoming an outsider into a home, a hotel, a nation or a language, Derrida defined it as an irreconcilable antinomy. Oscillating between the requirement of unconditionality and the rules of the host, hospitality becomes the threshold of itself (Derrida/ Dufourmantelle 2000). One possible socio-spatial outcome of Derrida's hospitality conundrum is the hotel lobby as a 'non-place', or, as described by Siegfried Kracauer, a desert. According to Kracauer, the "invalidation of togetherness" that hotel architecture and spatiality produce inhibits meaningful social interaction and exchange (Kracauer 1922, 4). Interpreting Kracauer and building on an analysis of the diverse functions embodied by hotels, Marc Katz posits them as "cities in microcosm" (Katz 1999, 137). These interiorised 'microcities' are peopled by transient guests; they are gated enclaves protected from the urban world outside. However, beyond these rather anti-social interpretations, hotels can articulate Derrida's hospitality threshold in different ways. Inherent in the nature of a threshold is that it is both a thing in itself and a liminal space, held in tension by the realms that border it. It is a concrete place, yet always in a state of becoming. As such, it has transformative potential. It is a space of possibilities. Hotels, with their spatial realms that move from the public street to the private bedroom through a variety of semi-public spaces including the foyer, the lobby, restaurants, bars, meeting rooms, ballrooms, conference spaces, lounges, sports and spa areas, commercial spaces, stairwells, lifts and corridors are perhaps particularly potent. Not only is the space ambiguous, but the hotel visitor is too. Perhaps, in addition to their cosmopolitan nature, this is a reason why hotels appeal as a place of exchange, including to local people and exiles.

This essay has suggested that in Bombay hotels served the local English-speaking elite population and the exile communities as spaces of sociability that enabled forms of 'togetherness'. By exploring two Bombay hotels at their intersections with art, culture and exile a vibrant if somewhat exclusionary image of pleasure, politics, interaction and exchange has emerged. For the group of exiles who became crucial

protagonists in the development of Bombay's modern art scene, the hotels provided spaces of temporary accommodation, performance, amusement, celebration, networking, discourse production and exhibition. As these findings contrast so strongly with those of Kracauer and other scholars discussed earlier, it is perhaps worth questioning whether Bombay presents a unique case, or whether similar situations could be found in hotels in other cities, perhaps particularly in colonised and formerly colonised territories. Perhaps in cities with colonial histories, where the development of social infrastructure may have been limited or inhibited by the colonial government, hotels played a particularly important role. A clue can be found in the writings of the Polish journalist and author Ryszard Kapuściński who, recounting his experiences in Tanzania in the early 1960s, described the centrality of a hotel in Dar es Salaam:

> In the very center of Dar es Salaam, halfway along Independence Avenue, stands a four-story, poured-concrete building encircled with balconies: the New Africa Hotel. There is a large terrace on the roof, with a long bar and several tables. All of Africa conspires here these days. Here gather the fugitives, refugees, and emigrants from various parts of the continent. […] In the evening, when it grows cooler and a refreshing breeze blows in from the sea, the terrace fills with people discussing, planning courses of action, calculating their strengths and assessing their chances. It becomes a command center, a temporary captain's bridge. We, the correspondents, come by here frequently, to pick up something. (Kapuściński 2001, 97)

Walter Bgoya, a Dar es Salaam-based publisher and heritage activist, reiterated Kapuściński's thoughts in an interview with me (Lee et al. 2017, 107). Somewhat further north, in Nairobi, Kenny Mann, daughter of the exiled architect and town planner Erica Mann, tells a similar story while recounting her experiences as a teenager in Kenya:

> I might drop in at the old Torrs Hotel where Granny Emma baked her famous cakes at the Cafe Vienna, and where other European exiles came for a fleeting taste of home […] On Saturday mornings I met friends at the New Stanley Hotel's world famous Thorn Tree Cafe. You could pin a note for anyone in the world on the acacia tree. Legend had it that they would eventually find it. (Mann 2014)

These anecdotes intimate that hotels in East Africa were also sites of sociability, culture and politics where local, transient, migrant and exile populations regularly convened and interacted. Whether they also functioned as exhibition venues or contributed to the development of art discourses through associational activities, as the Taj and Green's did in Bombay, however, is the subject for another essay.

Notes

[1] For more on the Progressives and *Marg* see Dalmia 2001; Kapur/Rajadhyaksha 2001; Mitter 2007; Lee/James-Chakraborty 2012; Zitzewitz 2014.

[2] For more on this see: Chopra 2011; Dogramaci/Lee 2019.

[3] For more on exiled artists in India see: Franz 2008, 2015; Singh 2017; Lee 2019b, 2019c; Dogramaci/Lee 2019.

[4] See also Margit Franz's essay "From Dinner Parties to Galleries: The Langhammer-Leyden-Schlesinger Circle in Bombay – 1940s through the 1950s", in this volume.

[5] The Tata Central Archives in Pune, India, and the Hilde Holger Archive in London, UK, were crucial here.

[6] See, for example: Denby 2002; McNeill 2008.

[7] The opening date is listed variously as 1869 in Dalvi 2019, 1870 in Wacha 1920, 299, or 1871 in Patel 2015, 115.

[8] Mehta 2004, 76; Patel 2015, 115; Prakash 2010, 327. The story also features in the Tata's own history writing: Tata Group n.d.

[9] In these writings the term cosmopolitan is understood in the sense of gathering people from diverse geographical and racial backgrounds. While criticism has been levelled at cosmopolitanism as being essentially Eurocentric and elite (Hannerz 1991) and intrinsically linked to colonialism (Mignolo 2000), it has been used as a tool for examining the effects of globalisation. Increasingly cosmopolitanism is being understood as locally differentiated and diverse (see e.g. Clifford 1992; Vertovec/Cohen 2003; Werbner 2006; Mignolo 2011; Assche/Teampău 2015.)

[10] See also: Lee 2019a.

[11] Beyond the Rotary Club, other cultural groups that convened at the Taj and Green's included the All India Fine Arts and Crafts Society, the Royal Society of Arts, the Motion Picture Society of India, the Film Journalists' luncheon and the All India Editors' Meet (fig. 3). More political gatherings were organised by the European Association, the Princely States conference, the American Women's Club, the Progressive Group, and the Australian Association of India (undated newspaper cuttings, Tata Central Archive).

References

Anonymous. "Art Exhibition at the Taj." *The Times of India*, 20 November 1936, p. 1.

Anonymous. "Defence of Modern Music." *The Times of India*, 7 December 1938a, p. 13.

Anonymous. "Non-Stop Dance at Green's." *The Times of India*, 26 February 1938b, p. 6.

Anonymous. "Charity." *The Onlooker*, August 1939a, n.p.

Anonymous. "Kennerley score 107 points in four minutes." *Times of India*, 3 June 1939b, p. 13.

Anonymous. "'Ziegfeld Night' at the Taj." *The Times of India*, 3 July 1941, p. 3.

Anonymous. "Local Engagements." *The Times of India*, 28 November 1945a, p. 1.

Anonymous. "Paintings by Madhav Satwalekar." *Bombay Chronicle*, 12 January 1945b, n.p.

Anonymous. "Local Engagements." *The Times of India*, 3 June 1946, p. 1.

Anonymous. "Mr. S. Chavda's Paintings: Bombay Exhibition." *The Times of India*, 22 November 1947, p. 8.

Anonymous. "The Rest of the News." *The Times of India*, 14 April 1948, p. 8.

Anonymous. "Art Exhibition." *The Onlooker*, March 1949a, n.p.

Anonymous. "Bombay Wedding." *The Times of India*, 6 March 1949b, p. 1.

Anonymous. "Development in Science." *The Times of India*, 22 June 1949c, p. 9.

Anonymous. "Achievement Award to the Bombay Rotary Club." *The Times of India*, 16 December 1971, p. 1.

Anonymous. "Service In Action Is Bombay Rotary Spirit For 50 Years." *The Times of India*, 8 May 1980, p. 20.

Assche, Kristof Van, and Petruța Teampău. *Local Cosmopolitanism: Imagining and (Re)Making Privileged Places*. Springer, 2015.

Augé, Marc. *Non-Places*. Second edition, Verso, 2008.

Baum, Vicki. *Hotel Shanghai*. KiWi, 1939.

Bolitho, Hector. *Jinnah: Creator of Pakistan*. John Murray, 1954.

Bollerey, Franziska. *Setting the Stage for Modernity: Cafés, Hotels, Restaurants: Places of Pleasure and Leisure*. jovis Verlag, 2019.

Bromfield, Louis. *Night in Bombay*. Bantam Books, 1946.

Cameron, James. *An Indian Summer*. Macmillan, 1974.

Chopra, Preeti. *A Joint Enterprise: Indian Elites and the Making of British Bombay*. University of Minnesota Press, 2011.

Clifford, James. "Traveling Cultures." *Cultural Studies*, edited by Paula Treichler et al., Psychology Press, 1992, pp. 96–112.

Clune, Frank. *Song of India*. Thacker & Co. Ltd, 1947.

Contractor, J. *The Bombay Guide & Directory*. Second edition, Bombay Publishing Co., 1938.

Cook, Nilla Cram. *My Road to India*. Lee Furman Inc., 1939.

Craggs, Ruth. "Towards a Political Geography of Hotels: Southern Rhodesia, 1958–1962." *Political Geography*, vol. 31, no. 4, May 2012, pp. 215–224.

Dalmia, Yashodhara. *Amrita Sher-Gil: A Life*. Penguin UK, 2013.

Dalmia, Yashodhara. *The Making of Modern Indian Art: The Progressives*. Oxford University Press, 2001.

Dalvi, Mustansir. "The State of the Esplanade Mansion – in Conversation with Vikas Dilawari." *As Any Fule Kno*, 1 June 2019, https://asanyfuleknow.blogspot.com/2019/06/the-state-of-esplanade-mansion-in.html. Accessed 18 July 2019.

Denby, Elaine. *Grand Hotels: Reality and Illusion*. Reaktion Books, 2002.

Derrida, Jacques, and Anne Dufourmantelle. *Of Hospitality*. Stanford University Press, 2000.

Diqui, Ben. *A Visit to Bombay. [A guide book]*. Watts & Co, 1927.

Dogramaci, Burcu, and Rachel Lee. "Refugee Artists, Architects and Intellectuals Beyond Europe in the 1930s and 1940s: Experiences of Exile in Istanbul and Bombay." *ABE Journal*, no. 14–15, 2019, doi: https://doi.org/10.4000/abe.5949

Fernandes, Naresh. *Taj Mahal Foxtrot: The Story of Bombay's Jazz Age*. Har/Com edition, Roli Books, 2012.

Franz, Margit. "Transnationale & transkulturelle Ansätze in der Exilforschung am Beispiel der Erforschung einer kunstpolitischen Biographie von Walter Langhammer." *Mapping Contemporary History: Zeitgeschichten im Diskurs*, edited by Margit Franz et al., Böhlau, 2008, pp. 243–272.

Franz, Margit. *Gateway India: Deutschsprachiges Exil in Indien zwischen britischer Kolonialherrschaft, Maharadschas und Gandhi,* [place]: CLIO Verein für Geschichts- & Bildungsarbeit 2015.

Ghosh, Labonita. "The Sentinel." *DNA*, 30 November 2008, p. 1.

Greenwall, Harry J. *Storm over India*. Hurst and Blackett, 1933.

Hannerz, Ulf. *Cultural Complexity: Studies in the Social Organization of Meaning*. Columbia University Press, 1991.

Huxley, Aldous. *Jesting Pilate: The Diary of a Journey*. Chatto and Windus, 1926.

Jim, Bernard L. "'Wrecking the Joint': The Razing of City Hotels in the First Half of the Twentieth Century." *The Journal of Decorative and Propaganda Arts*, vol. 25, 2005, pp. 288–315.

Johari, Aarefa. "As Site of India's First Film Screening Faces Demolition in Mumbai, Heritage Experts Are Dismayed." *Scroll.In*, 18 June. https://scroll.in/article/926082/as-site-of-indias-first-film-screening-faces-demolition-in-mumbai-heritage-experts-are-dismayed. Accessed18 July 2019.

Kapur, Geeta, and Ashish Rajadhyaksha. "Bombay/Mumbai 1992–2001." *Century City: Art and Culture in the Modern Metropolis*, edited by Iwona Blazwick, exh. cat. Tate Gallery, London, 2001, pp. 16–41.

Kapuściński, Ryszard. *The Shadow of the Sun*. Translated by Klara Glowczewska, Penguin, 2001.

Katz, M. "The Hotel Kracauer." *Differences*, vol. 11, no. 2, January 1999, pp. 134–152.

Kidambi, Prashant. *The Making of an Indian Metropolis: Colonial Governance and Public Culture in Bombay, 1890–1920*. Routledge, 2007.

King, David Wooster. *Living East*. Duffield & Co., 1929.

Kracauer, Siegfried. *The Hotel Lobby*. 1922, https://courseworks2.columbia. edu/files/604431/download?download_frd=1&verifier=s0dbD tVv1f8wqM8xdmg2nyC5GtIQq8ucX5Ur0aNW. Accessed 18 July 2019.

Lee, Rachel. "Strange Bedfellows: The Taj and Green's." *Metromod*, 9 March 2019a, https://metromod.net/2019/03/09/strange-bedfellows-the-taj-and-greens/. Accessed 18 July 2019.

Lee, Rachel. "Hilde Holger." *Metromod*, 4 April 2019b, https://metromod. net/2019/04/04/hilde-holger/. Accessed 18 July 2019.

Lee, Rachel. "Encounters on Prescott Road." *Metromod*, 5 April 2019c, https:// metromod.net/2019/04/05/encounters-on-prescott-road/. Accessed 18 July 2019.

Lee, Rachel, et al., editors. *Things Don't Really Exist Until You Give Them a Name: Unpacking Urban Heritage*. Mkuki na Nyota, 2017.

Lee, Rachel, and Kathleen James-Chakraborty. "Marg Magazine: A Tryst with Architectural Modernity." *ABE Journal. Architecture beyond Europe*, no. 1, May 2012. *abe.revues.org*, doi:10.4000/abe.623. Accessed 18 July 2019.

Lupus, Krishna. "A Heroine in Our Midst." *BLITZ*, 27 March 1948, n.p.

Macmillan, Allister. *Seaports of India and Ceylon*. W.H. & L. Collingridge, 1928.

Mann, Kenny. *Beautiful Tree, Severed Roots*. Documentary film. 2014.

Mathews, G.A. *Diary of an Indian Tour*. Morrison & Gibb, 1906.

McNeill, Donald. "The Hotel and the City." *Progress in Human Geography*, vol. 32, no. 3, June 2008, pp. 383–398.

Mehta, Suketu. *Maximum City: Bombay Lost and Found*. Viking, 2004.

Mignolo, Walter. "The Many Faces of Cosmo-Polis: Border Thinking and Critical Cosmopolitanism." *Public Culture*, vol. 12, no. 3, Fall 2000, pp. 721–748.

Mignolo, Walter. "Cosmopolitan Localism: A Decolonial Shifting of the Kantian's Legacies." *Localities*, vol. 1, 2011, pp. 11–45.

Migropolis: Venice / Atlas of a Global Situation, edited by Wolfgang Scheppe and IUAV Class on Politics of Representation, exh. cat. Fondazione Bevilacqua La Masa, Venice, 2010.

Mitter, Partha. *The Triumph of Modernism: India's Artists and the Avant-Garde, 1922– 1947*. Reaktion Books, 2007.

Narayan, Govind. *Govind Narayan's Mumbai: An Urban Biography from 1863*. Edited by Murali Ranganathan, Translated by Murali Ranganathan, Anthem Press, 2009.

Newell, Herbert Andrews. *Bombay, the Gate of India: a guide to places of interest, with map*. Second edition, HANewell, 1920.

Patel, Simin. *Cultural Intermediaries in a Colonial City: The Parsis of Bombay c. 1860– 1921*. PhD thesis, Balliol College, University of Oxford, 2015.

Peleggi, Maurizio. "The Social and Material Life of Colonial Hotels: Comfort Zones as Contact Zones in British Colombo and Singapore, ca. 1870–1930." *Journal of Social History*, vol. 46, no. 1, September 2012, pp. 124–153.

Prakash, Gyan. *Mumbai Fables*. Princeton University Press, 2010.

Raitz, Karl, and John Paul Jones. "The City Hotel as Landscape Artifact and Community Symbol." *Journal of Cultural Geography*, vol. 9, no. 1, September 1988, pp. 17–36.

RVL [Rudy von Leyden]. "Chinese Paintings At Taj." *The Times of India*, 22 February 1946, p. 8.

RVL [Rudy von Leyden]. "Captivating Drawings." *The Times of India*, 22 November 1947, p. 8.

Sabavala, A.P. *Past Present Future*. Tata Group, 1943.

Singh, Devika. "German-Speaking Exiles and the Writing of Indian Art History." *Journal of Art Historiography*, no. 17, December 2017, p. 19.

Tata Group. "Diamond By The Sea." *Tata*https://www.tata.com/newsroom/taj-diamond-by-the-sea. Accessed 30 January 2019.

Tauber, Stephen J. "Von Der Ungargasse Nach Bikaner." *Exil in Asien*, Vol 4, edited by Renate S. Meissner, Nationalfonds der Republik Österreich, 2015, pp. 254–355.

The Times of India. *Guide to Bombay*. Second edition, Times Press, 1926.

The Times of India, 24 May 1939.

Undated newspaper cuttings (Tata Central Archives, Pune, India, n.d.), IO2-CLIPP-1904-1936 and IO2-HISTORY PROJECT-CLIPP-1903-1978.

Venkatachalam, G. *My Contemporaries*. Hosali Press, 1966.

Vertovec, Steven, and Robin Cohen, editors. *Conceiving Cosmopolitanism: Theory, Context, and Practice*. First edition, Oxford University Press, 2003.

Wacha, Dinshaw Edulji. *Shells from the Sands of Bombay: Being My Recollections and Reminiscences, 1860–1875*. Bombay K.T. Anklesaria, 1920. *Internet Archive*, http://archive.org/details/shellsfromsands00wach. Accessed 18 July 2019.

Watkin, David. *Grand Hotel: The Golden Age of Palace Hotels: An Architectural and Social History*. Vendome Press, 1984.

Werbner, Pnina. "Vernacular Cosmopolitanism." *Theory, Culture & Society*, vol. 23, no. 2–3, May 2006, pp. 496–498.

Wharton, Annabel Jane. *Building the Cold War: Hilton International Hotels and Modern Architecture*. University of Chicago Press, 2001.

Zitzewitz, Karin. *The Art of Secularism: The Cultural Politics of Modernist Art in Contemporary India*. Hurst, 2014.

Tales of a City

Urban Encounters in the Travel Book *Shanghai* by Ellen Thorbecke and Friedrich Schiff

Mareike Hetschold

Shanghai – "Images shifting inside a kaleidoscope"

The travel and photo book *Shanghai* by Ellen Thorbecke and Friedrich Schiff portrays the urban topography of a modern metropolis. The book was preceded by a number of similar collaborative projects: in 1934, Thorbecke and Schiff published *Peking Studies* with Kelly & Walsh Shanghai, and *Hong Kong* in 1938 with the same publishing house. *Shanghai*, however, was published in 1941 by the *North China Daily News*, one of the largest English-language British newspapers. It was to be Thorbecke and Schiff's last joint book project on Chinese metropolises. Like the two previous books, *Shanghai* is divided into chapters which spread over 83 pages, each devoted to a selection of different locations and themes as well as to the inhabitants of Shanghai. It is aimed at an English-speaking readership and designed as a kind of alternative travel guide. Although similar topics can also be found in conventional English-speaking travel guides of the time, the way in which form and content are dealt with here is more suggestive of artistic or narrative methods.[1] The photos and text are by Thorbecke, the drawings by Schiff – together, they are embedded in a complex layout and carefully coordinated with each other. Black-and-white close-ups, panoramas, intimate portraits and lively street scenes are interspersed with colourful and humorous drawings, infographics, maps and various typesets. The graphic design is varied and appears playful.

Additionally, extreme perspectives and details as well as overlaps and a loose, versatile arrangement of text blocks contribute to a vivid reading experience (figs. 1-2). The book depicts the Shanghai of the 1930s; since then the city has undergone massive transformations that raise the question of how its urban history can be explored from a contemporary perspective. As Cary Y. Liu states in her essay, "Encountering the Dilemma of Change in the Architectural and Urban History of Shanghai",

[...] it is never possible to know completely the innumerable relationships and interactions that make up a city's architectural fabric or its continuous history, nor can anyone discern the countless ways a city is experienced and the perspectives from which it is seen. [...] How one selects the elements of that picture is informed by one's point of view, as well as influenced by one's own cultural or social context, by the sources available, and by prior narratives. Every new study adds to the multiplicity of possible narratives and pictures, resembling the shifting image inside a kaleidoscope. (Liu 2014, 119)

Fig. 1: Ellen Thorbecke and Friedrich Schiff, "Nanking Road." (*Shanghai* 1941, 33f.).

Fig. 2: Ellen Thorbecke and Friedrich Schiff, "Great World." (*Shanghai* 1941, 49f.).

Mareike Hetschold

If you set in motion the small glass mosaics within a kaleidoscope an almost endless sequence of different images emerges. Considering the almost infinite possibilities for modifying their configuration, an incalculable pool of image sequences is generated.[2] The pages of *Shanghai* and their design, as well as the text, can also be understood and parsed as such sequences of images. Thorbecke and Schiff's series of images, I argue, maps an urban space that is characterised by practices of inclusion and exclusion which play out on different levels (e.g. by the selection of motifs or the choice of language). This provokes questions about different modes of perspectivation. By choosing artists whose biographies are related to exile, flight or migration while discussing the urban cultural production in Shanghai a productive and sharpening perspective on the abovementioned questions is offered. Furthermore, it will be successively shown that Shanghai's complex and specific geopolitical structure, which is heavily shaped by conflict, borders and flight, is deeply entangled with the urban set up as well as with what emerged from it artistically at that time.

This article examines two chapters from the book, each of which extends over a double page.[3] The chapters "The Hotels" and "Fictitious Characters" are both dedicated to the exploration of specific urban topographies: the Bund, the grand hotel and its architecture, the streets, sidewalks and promenades. My analysis will focus on creative engagement with sensory and physical experiences of the urban space. Here, Shanghai comes to embody a form of "metropolitan art [that] perceives urbanity not solely as a space that creates motifs, but [as] a complex web linking creativity and environment, art theory and metropolis […]" (Dogramaci 2010, 9).[4] By selecting three comparative examples from related artistic disciplines, such as photography, poetry and literature, I intend to embed Thorbecke and Schiff's *Shanghai* within the context of a specifically urban cultural project.

But how can the experience of the city be conveyed in book form? What artistic means and procedures are used to articulate the encounters between people and city? To what extent does the relationship the authors have to the metropolis register in the book? The first of the two Shanghai chapters to be discussed here is concerned with the grand hotel and its architectural structure, the 'skyscraper'. In the second half of the 20th century, skyscrapers became a popular feature of modern metropolises. However, they can also be linked to Japanese and Euro-American imperialism in China.[5]

In the following, I will first address the geopolitical context of Shanghai as a place of production and activity in relation to both Thorbecke and Schiff. Further, I will discuss the different visual conventions and strategies which are at play in the book, to then connect them to the larger context of how urban spaces are represented in different media.

Shanghai "at this very moment of highest tension"

Shanghai is rooted in the complex geopolitical and cultural structures of a semi-colonial metropolis.[6] After the First Opium War, the signing of the Treaty of Nanking in 1843 and the "most favoured nation" clause contained therein, Shanghai's territory as one of China's five port cities was split into British and American concessions (later known as the International Settlement) as well as French and informal Japanese concessions – each with its own jurisdiction. As a result, Shanghai transformed into a capitalist world trading centre.[7] In 1934, Shanghai was the sixth largest city in the world and had ca. 3,350,570 inhabitants, of whom about 2 per cent were foreigners, representing around 48 different nations (Shih 2001, 236). The largest group of foreigners were the Japanese, followed by the British, Russians, Indians, Portuguese, Germans and French. On several occasions throughout the first half of the 20th century Shanghai would become an important place of refuge. Of the Chinese population, about 80 per cent were immigrants and fugitives from Chinese territory. The third largest foreign group, the Russians, fled to Shanghai in the wake of the Russian Revolution. In 1938, about 20,000 people from continental Europe reached the city on the Huangpu River, fleeing Nazi persecution. The city's largely immigrant population, from a variety of different places, brought with it a variety of cultural practices, formed itself into neighbourhoods and shaped their respective urban environments (Liu 2014, 236; Bergère 2009, 103). But this image "of a flexible Shanghai with significant Chinese representation should not mask our perception of inequalities in a city marked along various lines of nationality, race, gender, and class [...]" (Shih 2001, 237). The continued existence of large parts of the population was dependent on nationality, ethnicity, gender or class, and influenced by numerous uncertainties and economic emergencies. Since the so-called first Shanghai Incident in 1932 in the lead-up to the Second Sino-Japanese War (1937–1945), parts of the city had already seen use as theatres of war.[8]

Ellen Thorbecke and Friedrich Schiff travelled to Shanghai at the beginning of the 1930s for personal and professional reasons. Due to their Jewish origins, however, both were unable to return to their home countries after the Nazi takeover of power in Germany in 1933 and the annexation of Austria in 1938, and became exiles in Shanghai. In the burgeoning photo and travel journalism scene of the city, however, Thorbecke and Schiff saw an opportunity to pursue their careers as photographers and illustrators.[9] Via personal contacts and because they belonged to the wealthy middle classes, they succeeded in establishing effective professional and private networks in Shanghai. Their biographies and careers show the actual individuality behind the often collectively attributed notion of the exiled artist.

Mareike Hetschold

As mentioned above, Shanghai's population was largely made up of communities who had moved there after fleeing war and persecution of various kinds and had therefore to deal with divergent experiences of flight, arrival and survival in Shanghai. Nevertheless, I argue, it can be observed that the specific Shanghainese geopolitical situation is a common theme in much of the urban artistic production of that time.

Not much is known of Thorbecke's life. Her photographic archive as well as some – unfortunately incomplete – notes concerning her biography are housed in the Nederlands Fotomuseum in Rotterdam. Despite the gaps in them, some of these biographical notes will serve as references in the following.[10] According to them, Thorbecke was born in Berlin in 1902 and studied national economics at the University of Berlin. From 1928 on, she worked as a freelance journalist and wrote for the *Berliner Tageblatt* and *Neue Freie Presse*, among others. In 1931, she was involved in the economic restructuring of the flourishing studio of the photographer Yva. At this point in time, Yva's photo studio was expanding.[11] This expansion was carried out by the Gesellschaft für Organisation, a non-profit-making association and network for organisation and management.[12] Through her work in Yva's studio, Thorbecke most probably came into closer contact with experimental, artistic and commercial photography: in 1931, she presumably started taking her own photographs with a Rollei camera. In the same year, she travelled to China for the first time, where her second husband, Willem J. R. Thorbecke, had taken up a post as Dutch ambassador. She made further trips to Beijing and Hong Kong and stayed in Shanghai for some time. It is here that she most likely met Schiff. In Shanghai, according to the biographical notes, she also worked for the daily newspaper *Deutsch-Chinesische Presse* and supplied photographs and texts from her time in China to journals and papers in Berlin. Since Thorbecke was very well-travelled, it is not yet possible to determine exactly when she stayed where. In 1935 and 1936, for example, she journeyed to Paris and the Netherlands before returning to Shanghai. In 1941, the year *Shanghai* was published, she left the city and travelled to South Africa, Palestine and Lebanon. In 1946, she and her husband relocated to the USA and in 1960 moved to and fro between the Netherlands and the USA. She died in The Hague in 1973.

Friedrich Schiff was born in Vienna in 1908. There, he initially attended the Graphische Lehr- und Versuchsanstalt for two years and then studied at the Akademie der bildenden Künste from 1924. Schiff worked as a graphic artist for various newspapers (Kaminski 2001, 7). In 1930, he travelled to Shanghai to visit his cousin Francis Gmehling, who ran an art and antiques shop there and was able to introduce him to the city's international community. Schiff established himself as an artist and press illustrator and opened a painting school (ibid., 10–17, 29). In

1947 he emigrated to Buenos Aires, where his sister lived. In 1954, Schiff relocated to Vienna with his family, where he worked as a graphic designer for the Vienna advertising department of Unilever and where he died in 1968 (ibid., 87).

For Thorbecke and Schiff, the English language and the switch to a new environment obviously did not impose any professional restrictions. They worked in professions that allowed them to draw, photograph and write anywhere. They recorded their observations and experiences in Shanghai in different ways and through different media: Schiff drew and painted, and Thorbecke photographed and wrote. There are events, however, that both recorded in similar ways, such as their experiences on the day of the Japanese bombing of the city in 1932. Schiff wrote in his journal:

> [...], 6:00 AM
> I wake up and slowly realize that the detonations I hear are gunshots. [...]
> 1:15 Noon. From my balcony the airplane attack can be observed clearly. [...] The show ends at 2 o'clock sharp. [...] 5:00 PM. I go to the roof of the Cathay Hotel. The city lies in the twilight like a giant – stretching infinitely. It burns in six different places. [...] 5:30 PM. Tea in the hotel lounge. Salon orchestra, lipstick-decorated ladies, cocktails and extra editions. [...]
> January 31st, 9:30 in the morning [...]. Since noon yesterday there have been lots of refugees: women, children on their backs, suitcases and crates, bedding and all sorts of bits and pieces on rickshaw carts. Tchapei is being evacuated. Yesterday evening there had been no sign of all the hustle and bustle in the cabarets and Bars de Settlements.
> Just a regular Saturday evening. [...]
> February 23rd ... Visit to a refugee camp in the morning. Scenes of the most horrible misery, against which one is almost blunted by the all too often granted sight. Almost! It is impossible to describe it [...].[13] (cf. Kaminski 2001, 13–15)

Thorbecke's historical introduction to *Shanghai* contains a similar description of the events of 1932:

> [...] The situation seemed tense and unpleasant for Shanghai's foreign population and the hundred thousand Chinese refugees who had sought refuge under the foreign flags, but five years

Mareike Hetschold

later the Concessions faced a much more exciting situation when the Japanese landed strong naval units to eject Chinese military forces from the Chapei district. The fighting did not touch the foreign settlement, but from the balconies of its fashionable skyscraper people could watch the blood red sky illuminated by the raging fire and listen to the uncanny concert of the roar of shells and gunfire [...].[14] (Schiff/Thorbecke 1943, 14)

Both Schiff's contrastive, almost surrealistic portrayal and Thorbecke's description of the events reveal the different lived realities of Shanghai's heterogeneous population. For some, the bombings were a spectacle just far enough away, for others they were a cruel and threatening reality. Referring to the bombing, Thorbecke closes the introduction to her book with the following words: "To depict this city of contrast and unlimited possibilities at this very moment of high tension has been too tempting to be resisted." (Thorbecke 1943, 16) The aim of the book, however, was not to document the situation critically, but to conjure up a dazzling Shanghai whose 'fate' was uncertain and at risk, but which could nevertheless be enjoyed and consumed. This is apparent from the way the book was marketed. Offered for a generous $16, it was advertised in the *North China Daily News* as follows:[15]

> [...] delightfully-illustrated book that embraces Shanghai proper in almost every form. It commences with a concise history of Shanghai and proceeds through 83 pages of illustrations, amusingly clever sketches in a riot of colour, by Schiff and photographs [*sic!*] sepia and text dealing with trade, imports, exports, population, hotels, newspapers, exchange, shops, traffic, temples, Chinese food, places of interest, beggars, funerals, public health, etc. ending with the Cycle of the Twelve Terrestrial Branches and Chinese Zodiac. (*North China Daily News* 1943)

Shanghai was lauded as a book that "will afford not only the interest to the tourist, but will prove a veritable mine of information." (*North China Daily News* 1943). A different advertisement in the same newspaper commends it as a "Delightfully Informal Description of Shanghai Life" (ibid.) and yet another one even claims:

> Nothing like Shanghai has ever been produced in Shanghai before. The Modern Chinese girl, tea at French Club, Yates Road, Moscow Boulevard, Blood Alley, Shroffs [*sic!*] and Exchange Shops, Sikhs and Traffic Signals. They all pass by in

a kaleidoscope of colour and movement which will never grow old. Shanghai is a book which you will buy to give – and then change your mind and keep it. (*North China Daily News*, 1943)

This seemingly curious list of individual chapters and urban phenomena, such as "The Modern Chinese Girl", "Blood Alley" (a red light district) and "Sikhs and Traffic Signals," points to an "urban fabric" that is interspersed with imaginaries of the adventurous.[16] This of course raises questions about the nature of such "urban fabrics". Liu expands the concept of 'urban fabric' and understands it as "a broader phenomenon" (ibid.). This then encompasses "a set of material and immaterial connections, uniting aesthetic concepts, social relationships, traditions and beliefs, and standards of taste, exoticism, and decorum" (Liu 2014, 119). Following this understanding of the term, Thorbecke and Schiff's book can be read not only as a kind of cartography but as part of Shanghai's urban fabric itself. As a consequence, we need to ask to which "material and immaterial connections, uniting aesthetic concepts, social relationships, traditions and beliefs, and standards of taste, exoticism, and decorum" (ibid.) the design of *Shanghai*'s pages refer.

Skyscrapers and Urban Encounters

On the double page 25 and 26, *Shanghai*'s chapter entitled "The Hotels" is dedicated to the theme of grand hotels (fig. 3). On the right-hand page 25 are text and drawings by Schiff, while the left-hand page 26 features a reproduction of one of Thorbecke's photographs. The text itself is divided into two centred paragraphs which extend over two thirds of the page. The headline "The Hotels" was designed by Schiff in all capital letters and sits left justified above the text. Each of the headline's horizontal lines is drawn in a bold red colour, whereas all vertical and curved lines are set in a medium blue. The text block is framed by two small multi-figure drawings which are placed at the top right and at the bottom left of the page.

Both illustrations depict lively street scenes. Their vibrant red, medium blue, rich green, yellow and light grey tones lend them a cheerful appearance. Painted in watercolour, the figures and objects are accentuated by sparingly applied black contours. Four black lines of different lengths place the street scenes within the visual space of the page. A perpendicular and slightly thicker black line extends vertically across the entire double page from the outermost edge of the left page; another cuts the lower left-hand corner to create a pentagonal frame which is filled by Thorbecke's high-format photograph. The image axis is slightly offset and extends diagonally from the bottom left to the top right of the page. The

Mareike Hetschold

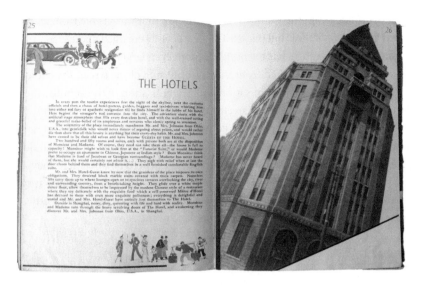

Fig. 3: Ellen Thorbecke and Friedrich Schiff, "The Hotels." (*Shanghai* 1941, 24f.).

photograph shows a skyscraper that is perilously placed in parallel to the image axis and consequently appears to be about to topple down. Cut off at the bottom and photographed from below, the building seems to lift the page's visual space off its hinges. The Nederlands Fotomuseum holds a print of the photograph in original size: here, we can see that the original photo format is square and that the image in the book was both cropped and rotated. In addition, the print in the archive reveals the hotel's urban surroundings, such as a neighbouring building currently under construction. Further details such as a flagpole and power cables running through the photograph can no longer be found in the book, suggesting that the building was cut out along its contours and then mounted on its side.

The building complex shown on these pages is easily identifiable as Sassoon House, which housed the Cathay Hotel. The building's owner, Victor Sassoon,[17] not only commissioned the architects Palmer & Turner but also the designer G.L. Wilson (Pan 2008, 220). To this day, the emblematic reinforced concrete construction, one of Shanghai's first skyscrapers, remains located directly flanking the Bund – a wide boulevard running along the western bank of the Huang Po river which, as the "entrance to the harbour", embodied "the seat of British colonial power" (Lee 1999, 8). Sassoon House was completed in 1929 and accommodated various facilities (including a theatre/cinema, shops, restaurants and a penthouse that was inhabited by the owner) as well as the Cathay Hotel. Where it faced the Bund, the hotel stretched from the fourth to the ninth floors. Furnished with a

tiered pyramidal roof, the Cathay was a landmark that was visible from afar and shaped the skyline of the Bund (fig. 4). The significantly enlarged photograph which was shot from a low angle has the building loom even larger, almost vertiginously so. Presumably photographed from the opposite side of the street, the choice of location contributes to a dynamisation and dramatisation of the architecture. In addition, this use of perspective is an effective strategy for capturing as many of the building's soaring storeys as possible. Perhaps this also required the photographer herself to act dynamically. By kneeling, for example, the point of view could be optimised to achieve an even steeper perspective. The type of camera may also have played an important role: Thorbecke photographed with a medium format camera, a Rolleiflex, which was placed centrally in front of the upper body and whose viewfinder was located on the upper side of the camera.

Fig. 4: Ellen Thorbecke and Friedrich Schiff, "The Bund." (*Shanghai* 1941, 17f.).

This way of photographing tall buildings was a common practice in modern urban photography and was used widely throughout Shanghai – as were radical perspectives and croppings. Photographs of high-rise buildings can be found in photographic press products, for example in Shanghai pictorials such as the popular *Liangyou huabao* (良友畫報). The city had a lively and rich publishing sector, located around Fochow Road, which was also home to 80 per cent of Shanghai's bookshops (ibid., 120). Innumerable magazines, periodicals were the

Mareike Hetschold

driving forces behind the urban culture of the metropolis. There were about 30 publishing houses in Shanghai, which alone published over 100 literary journals (Shih 2001, 240; Lee 1999, 129). Among these countless magazines, journals was *Liangyou huabao* published by *Liangyou tushu yinshua gongsi* (良友圖書印刷公司), which was founded by Wu Liande in 1925. It was one of the most successful pictorials of the time. Wu had previously worked for Commercial Press and had thus established excellent contacts. With *Liangyou*, Wu set up one of the first magazines in Shanghai to specialise in photography:

> Liangyou (The Young Companion) is truly unique in the history of Chinese modernity for several reasons. First, it was the longest-running Chinese-English bilingual monthly pictorial that offered a visual testimony, however indirectly, to the sea change in China from the Republican decade (politically centered in Nanjing 1927–37) through the Eight Year War of Resistance against Japan (administrative headquarters in Chongqing 1938–45). Second it was the most cosmopolitan and comprehensive periodical in the first half of the twentieth century that managed, in a significantly non-partisan way to capture almost every aspect of the kaleidoscopic life of Shanghai, a rising global metropolis at the time. Third, with its eclectic taste for visual pleasures, the lavishly designed magazine constitutes the best emporium for a retrospective investigation of a vibrant – indeed "flowering"– urban culture […]. (Pickowic et al. 2013, n.p.)

The bilingual *Liangyou* (Chinese/English) had a large reach. Newspapers and magazines were often sold in street kiosks, where they could catch the eyes of passers-by. While it is therefore possible that Thorbecke was aware of the pictorial, it is not of paramount importance here.

When browsing through some of the pictorial's editions,[18] one is struck by photographic views of Shanghai's skyscrapers, whose towering silhouettes – all differently mounted and collaged – threaten to tilt out of the pages; this becomes evident, for example, in the *Intoxicated Shanghai* or *Metropolitan Excitements* photo collage in the February issue of 1934 (fig. 5).[19] Various pictorial elements, including a young woman dressed in a sophisticated *Qipao*,[20] a cinema poster, a racecourse and an orchestra, float about in the visual space in a seemingly weightless state, lacking anchors. Two photographs, also taken from below, show the Park Hotel from different perspectives (Lee 1999, 151). The hotel was built by the immigrant Hungarian architect Ladislaus Hudec and opened to the public in

Fig. 5: Anonymous. "Intoxicated Shanghai." Photographic Collage (Lee 1999, 151).

September 1934. With its 22 floors, it was the highest building in Shanghai for a long time. In an advertisement in the American travel guide, *All About Shanghai*, it is promoted as the "Tallest Building of the Far East" (Anonymous 1934/2008, 38). Even before its official opening, *Liangyou* published a photograph of the Park Hotel (Lee 1999, 151). This shows the fascination and interest in such types of buildings at the time. The skyscraper went on to become one of modernity's central motifs: "The predominant image of Shanghai in Chinese photography, illustrated magazines, cinema, and fiction at this time was composed of art deco skyscrapers, the world of speculation and finance, modern women and modern men, and so on." (Schaefer 2007, 127) Building on this, Shu-mei Shih writes that "[l]ike its Japanese counterpart, Shanghai modernism was a product of the urban milieu" and quotes two verses from a 1928 poem by Shao Xunmei[21] entitled "The Soul of Shanghai" ("Shanghai de linghun", 上海的靈魂), reproduced here (Shih 2001, 236):

Mareike Hetschold

Ah, I stand atop the seven-story building,
Above is the unreachable sky,
Below are cars, electric wires, horse races,

Front doors to stages, backs of prostitutes,
Ah, this is the spirit of the city:
Ah this is the soul of Shanghai.

Like the *Intoxicated Shanghai* photo collage, these two verses by Shao Xunmeis address the urban landscape – its material and immaterial qualities. Both the poem and the collage evoke similar motifs (a seven-storey building, stages and a horse race) and associations (height, spectacle and tempo). The two narratives are characterised by the choice to use extreme perspectives. While the pictorial world of the collage no longer seems to adhere to gravity and suspends the logic of perspective, Shao Xunmei's lyrical I rises to lofty heights, caught somewhere between the distant hustle and bustle of the streets and the unreachable sky. These artistic and poetic articulations of perspective can be contrasted particularly well with the dizzying architecture of skyscrapers. The extreme differences in altitude make it possible to create dramatic vistas in order to narrate the encounter between people and cities. The starting point for such explorations is the author's own embodied and sensory experiences, always constituted by the surrounding urban space. Not least the choice of titles for these works, *Intoxicated Shanghai* and "The Soul of Shanghai", speaks to an intense confrontation with an intoxicating city. In a similar vein, Thorbecke chose the photograph of a skyscraper to illustrate an encounter with the city that is completely different from preceding ones.

Sensual Encounters and Urban Identities

The text positioned next to the photograph of the Cathay Hotel in the chapter entitled "The Hotels" tells the story of how the imaginary tourist couple Mr and Mrs Johnson from Ohio (USA) arrives in Shanghai. From the busy, noisy streets, they enter the interior of a large hotel and hence turn into "Mr and Mrs Hotel-Guest". Surrendering to the hotel's opulence, they find their way back to themselves only when they step out again through the mighty swing doors into the bustling street. Before this happens, however, the readers accompany the couple on a tour of the rooms:

Two hundred and fifty rooms and suites, each with private bath are at the disposition of Monsieur and Madame. […] Monsieur might look first at the "Futurist Suite," or would Madame prefer to occupy an apartment in Chinese, Japanese or Indian Style? Does Monsieur think that Madame is fond of Jacobean or Gregorian surroundings? (Madame has never heard of it, but would certainly not admit it…). (Thorbecke 1941, 25)

Accompanying "Mr and Mrs Hotel-Guest" or Madame und Monsieur alias Mr und Mrs Johnson, *Shanghai*'s readers are presented with "the artificial stage atmosphere", "spacious terraces overlooking the city, river and surrounding country, from a breathtaking height" and "heavy revolving doors" (ibid.). The real protagonist is the hotel itself. The building encompasses its guests and absorbs their identities. All that remains are "Mr and Mrs Hotel-Guest". But the street noises of Shanghai's exterior settings unleash a force that allows Mr and Mrs Johnson to rediscover themselves and regain awareness of their 'American identity'. The urban space therefore turns into an active agent – it affects bodies and senses and may even alter identities. Familiar with an outsider's perspective, with the routine of luxury hotels and the conventions and 'embarrassments' of an international 'upper class' community, Thorbecke humorously describes the encounter of wealthy American tourists with the city, which is itself a central actress in this play. Thorbecke, who is neither tourist nor Shanghai native, who did not flee there yet lives there in exile, allows her readers to participate in her observations: the grand hotel turns into a stage for negotiating different perspectives in and on urban space, as well as for the encounter between humans and city.

Schiff's drawings evoke the events taking place in front of the hotel: an impressive automobile pursues a rickshaw which is pulled by a man clad in traditional Chinese attire. Sitting on the rickshaw is a smoking sailor with a relaxed posture. Two young Chinese women dressed in sophisticated *Qipao*s glance in his direction. A Sikh in a red robe with a turban on his head is turned towards what is happening behind the car. In the foreground, an employee or businessman, briefcase firmly clamped under his arm, hurries out of the picture. Two ladies in high-heeled shoes, shapely dresses and fashionable headdresses are depicted standing at the bottom right of the page. They are joined by a smoking 'gentleman', a young child, two businessmen, a delivery man and a mother with a toddler in her arms. Reduced to certain dress conventions and ostensibly distinctive outward appearances and occupations, Schiff's colourful figures emerge as the stereotypical inventory of a 'multicultural' Shanghai.[22] Positioned as such alongside each other, they are literally presented like objects in an exhibition. The

text itself though creates a narrative connection between photograph and drawings which differ in their visual language. While Schiff reduces his protagonists to stereotypical features, Thorbecke's photography pursues other artistic strategies. As a starting point for the visualisation of urban space, the reference to physical and sensory aspects is of equal importance to both artists. These aspects are made particularly visible in another of *Shanghai*'s chapters, entitled "Fictitious Characters". I will argue in the following that it is specifically dedicated to (female) corporeality and its representation in urban space, or rather as an embodiment of the metropolis.

Physical Encounters and Urban Transformation

The double page 59/60 (fig. 6) features another of Schiff's sketches: a group of couples of different nationalities stroll across the paper. From an elevated perspective, the reader overlooks their parade. A short text explains, "Every character in this book is entirely fictitious and no reference whatsoever is intended to any person" (Schiff/Thorbecke 1941, 59). Here, too, Schiff has created stereotypical figures which follow a "racialized regime of representation" (Hall [1997] 2003, 253). Young Chinese women wear *Qipaos* and are accompanied by non-white men. Western women, on the other hand, wear Western clothing and are depicted exclusively in 'Western' company. There is also a Japanese and an Indian couple. By choosing these specific constellations and by choosing what *not* to show, these drawings reveal sexual taboos that call up novel questions concerning the entanglement of gender, ethnicity and urban space. Schiff's illustrations mark the latter, for example, as decidedly heterosexual and as ethnically mixed only within certain asymmetrical couple constellations. On the left-hand page, we find a curious photograph: two plucked chickens lie on a 'pedestal' (or book?) in an undefined (exterior) location. While the 'pedestal' and the chickens are brought into sharp focus by the camera and are shot with a stark contrast of light and dark, the surrounding space remains shadowy and diffuse.[23] Behind the chickens we can clearly make out a section of a poster which seems to advertise a magazine. The silhouette of the two plucked chickens is reproduced in the way the poster depicts a stack of magazines which fan out – thus generating a relation or parallel on the level of form. The cover of the magazine on the top of the pile depicts a couple and hence repeats the motif of Schiff's drawings. The perspective of the photo indicates that the photographer must have taken the shot from above left; the horizontal axis of the image is skewed, and the objects seem to slip out of the photograph. Schiff's couples move towards the left side of the double page, diagonally crossing the photo on top of and next

to it. I argue that photograph and drawing are unmistakably related to each other with regard to their motivic and formal elements: the illustrations trace and echo the compositional structure of the photograph. Despite these obvious connections, however, the photograph remains a mystery. It is possible to understand the photograph as a humorous, critical commentary on the drawings. Thorbecke's shot of the naked and raw chicken bodies and their ambiguity contrasts with Schiff's clichéd sketches.

Fig. 6: Ellen Thorbecke and Friedrich Schiff. "Notes." (*Shanghai* 1941, 17f.).

The double page thus produces a comical, even absurd effect – but at the same time opens up a frame of reference that alludes to the physical, sensual aspects of 'carnality'. It can therefore be assumed that the visual composition offers an ironic commentary on the sexualised portrayal of the city's female citizens.

To describe the sensory, physical experience of the metropolis and its materiality as a sexual and carnal encounter is by no means unusual. A prominent example of this is Mao Dun's novel *Ziye* (*Midnight*) (Mao 1933/1983). Its story begins with the death of old Wu, who – due to impending communist riots on the family's rural farmland – flees to Shanghai where his eldest son lives. His son works as an industrialist in the silk business. The sudden confrontation with the unknown, modern metropolis causes such a shock to the devout, ascetic old Wu that he dies a few hours after his arrival. During the drive from the Bund to his son's

Mareike Hetschold

estate, his torments in the face of such completely unfamiliar surroundings are described as follows:

> Good Heavens! the towering skyscrapers, their countless lighted windows gleaming like the eyes of devils, seemed to be rushing down on him like an avalanche at one moment and vanishing at the next. [...] A snake-like stream of black monsters, each with a pair of blinding lights for eyes, their horns blaring, bore down upon him, nearer and nearer! He closed his eyes tight in terror, trembling all over. He felt as if his head was spinning and his eyes swam before a kaleidoscope of red, yellow, green, black, shiny, square, cylindrical, leaping, dancing shapes, while his ears ran in a pandemonium of honking, hooting and jarring, till his heart was in his mouth. (Mao 1933/1938, 8)

Having arrived at his son's estate and subsequently been taken into the care of his female relatives, he is dealt the final blow as he is being accosted by

> [F]ull, pink-tipped breasts [...] bosoms, bosoms that bobbed and quivered and danced around him. [...] Suddenly, all these quivering, dancing breasts swept at Old Mr. Wu like a hail of arrows, piling up on his chest and smothering him [...] [the women were] laughing with wide-open, blood-red mouths as though they wanted to swallow him. (ibid., 13–14)

Closing this first part, or rather prelude, of the novel, one of the characters – a student called Fan – remarks:

> [...] I'm not in the least surprised. When he lived in the country he existed like a mummy. The country was his grace, in which he couldn't decompose easily. In this modern city of Shanghai, he has done. He's gone, and good riddance. One mummy of old China the less. (ibid., 24)

"[T]owering skyscrapers, their countless lighted windows gleaming like the eyes of devils" (ibid., 8) pile up above old Wu like giants and speak of an uncanny and deadly encounter between human being and city. His interaction with the female body, again to be interpreted as a personification of the metropolis, leads to Wu's

ultimate passing. As with Thorbecke and Schiff's art, skyscrapers and the sexualised female body remain essential motifs of the urban narrative.

Conclusion

Shanghai by Ellen Thorbecke and Friedrich Schiff conveys the physical experience of the metropolis. Their work offers us a unique cartography of urban space because it is not only captured viscerally and physically but also reconfigured through practices of inclusion and exclusion and through its material, cultural productions (including traffic, magazines, posters, fashion). *Shanghai*'s images simultaneously form the basis of this narrative and generate it. The visual and textual structure of the book itself forms part of the urban space.

As I have shown, *Shanghai* is composed of a kaleidoscopic mosaic of colourful drawings and artistic photographs, of stories and statistics, maps, interpretations and facts. Time and again, readers happen upon encounters with and physical experiences of the urban metropolis – which itself has turned into an active agent. In the context of publication and book formats that emerged (or experienced great popularity) in the first half of the 20th century, *Shanghai* alludes to the genres of the photo book and the travel guide. The indexing of cities through photography and publication in photo books is considered an important genre of the 1920s. Photo books appealed to travellers and collectors alike (Dogramaci 2010, 207). Their popularity and global dissemination testify to the increasing number of people who were able to travel and to the expansion, professionalisation, commercialisation and democratisation of the travel industry (ibid.; Koshar 1998, 323–26).

This is especially relevant for people who were forced by war and persecution to move and/or work internationally. In addition, *Shanghai* can be counted among newly-emerging alternative travel guides, such as the travel guides of the series *Was nicht im Baedeker steht*. This series (1927–1938, Piper Publishing Munich) understood itself as a critical alternative to the more conventional Baedeker written for a bourgeois audience.[24] *Was nicht im Baedeker steht* excelled by incorporating artistic illustrations and by reviewing alternative locations (pubs, cafés, city districts, travel routes). Thorbecke's photographs function differently from Schiff's drawings, but both are connected by the book's design and layout. Despite their contradictory nature, photographs and illustrations remain at eye level. *Shanghai* is not a homogeneous narrative, but instead contains kaleidoscopic perspectives of and on urban space.[25]

What is more, both *Shanghai* the book and Thorbecke and Schiff's experiences of exile illustrate the complex and divergent meanings behind terms such as 'emigré'

　　　　Mareike Hetschold

and 'exiled (artist)', especially against the backdrop of Shanghai's geopolitical context.

The collaboration between Thorbecke and Schiff remains largely unexplored to date. Essential and in-depth research has not yet been carried out; other joint projects or books have not yet been considered. The photographic work of Ellen Thorbecke is virtually invisible in art historical research. Shanghai as one of the largest modern cities and a hub of diverse migration movements of the 20th (and 21st) century offers new and exciting fields of research spanning urban studies, art history and the history of exile, challenging new assessments of the topography of modern art historiography.

Notes

[1] See, for example, the reissued American travel guide, *All About Shanghai* from 1934.

[2] The metaphor of the kaleidoscope has been used in a variety of contexts to describe urban perception processes. In her book *Shanghai. China's Gateway to Modernity*, Marie-Claire Bergère, for example, writes on "The Kaleidoscope of Shanghai Society" (Bergère 2009, 84). Another reference appears in the title of the book *Liangyou: Kaleidoscopic Modernity and the Shanghai Global Metropolis, 1926–1945* (Pickowicz et al. 2013).

[3] To choose just two double pages from a totality of 83 pages may seem somewhat arbitrary and unrepresentative. But since each page reflects the context of the whole book and since the book's chapters are structured in such a way that each can also stand for itself, a double page may serve as a case study. And although the page layouts may vary, they all demonstrate similar artistic strategies.

[4] "Großstadtkunst, die Urbanität nicht allein als motivstiftenden Raum wahrnimmt, sondern [als] ein komplexes Geflecht zwischen Kreativität und Umraum, zwischen Kunsttheorie und Metropole […]." Translated into English by Mareike Hetschold.

[5] Shih describes the way Chinese intellectuals and artists perceived the geopolitical and cultural situation at the time as "bifurcated". The West is perceived on the one hand as an inspiring and modern urban culture, the "metropolitan West", and on the other as a coloniser, the "colonial West": "By bifurcating the two, the intellectual could proselytise for Westernisation without being perceived as a collaborator […] The capacity to displace colonial reality through the discourse of cultural enlightenment was endemic to semicolonial cultural politics." (Shih 2001, 36).

[6] The term semi-colonial can be traced back to the 1920s and was used in Marxist criticism "as a way to describe the coexistence between the native feudal and the colonial" (Shih 2001, 31) Shih uses the term "to describe the specific impacts of multi-layered imperialist presence in China and their fragmentary colonial geography (largely confined to coastal cities) and control, as well as the resulting social and cultural formation." (ibid., 31).

[7] This contractual clause states that no nation may be favoured over another nation (Liu 2014, 188).

8 The selection of examples referring to the movement and internment of Shanghai people because of conflict and war is not intended to be complete.

9 On the connection between colonialist and imperialist strategies and the emergence of travel and photojournalism and literature see: Hadfield 1999, Granqvist 2017.

10 Handwritten notes, Evelyn Thorbecke, 7 December 2007, Collectie Ellen Thorbecke (Nederlands Fotomuseum, Rotterdam). All following biographical references are based on this source.

11 Yva (Else Ernestine Neuländer-Simon) was a photographer who ran an exceptionally successful photo studio in Berlin which employed up to ten people. Economic restructuring is a term commonly used in the business world to describe restructuring measures taken by companies to favour more efficient management. Yva worked for Ullstein Verlag, among others. On 13 June 1942 she was murdered in the Sobibor extermination camp. *Yva. Photographien 1925–1938*, edited by Marion Beckers and Elisabeth Moortgat, exh. cat. Das verborgene Museum, Berlin, 2001; *Fotografieren hieß teilnehmen: Fotografinnen der Weimarer Republik*, edited by Ute Eskildsen, exh. cat. Museum Folkwang, Essen, 1994.

12 The Gesellschaft für Organisation is a non-profit-making association, which was founded in 1922 and still exists today. https://gfo-web.de/gfo/gfo-verbindet/. Accessed 12 April 2019.

13 Original German version: […], 6 Uhr früh
Ich erwach und werde mir langsam klar, daß die gehörten Detonationen Schüsse sind. […]
1 Uhr 15 mittags. Von meinem Balkon aus lässt sich der Flugzeugangriff wunderbar beobachten. […] Um Punkt 2 Uhr ist die Vorstellung zu Ende. […]
5 Uhr. Ich gehe auf das Dach des Cathay-Hotels. Die Stadt liegt in der Dämmerung riesenhaft da – ohne Ende. Die Stadt brennt an sechs verschiedenen Stellen. […]
5 Uhr 30. Tee in der Hotellounge. Salonorchester, lippenstiftgeschmückte Damen, Cocktails und Extraausgaben. […]
31. Januar, ½ 10 Uhr früh […]. Seit gestern mittag sieht man haufenweise Flüchtlinge: Frauen, die Kinder am Rücken, Koffer und Kisten, Bettzeug und aller möglicher Krimskrams auf Karren Rikschas. Tschapei wird evakuiert. In den Kabaretts und Bars de Settlements spürte man gestern abend nichts von all dem Wirbel. Der reguläre Samstagabendbetrieb. […]
23. Februar … Vormittags Besuch in einem Flüchtlingslager. Das Bild des entsetzlichsten Elends, gegen das man durch den allzu oft gewährten Anblick fast abstumpft. Fast! Schildern kann man es nicht […]. Translated into English by Mareike Hetschold.

14 The first page of the book features a schematic world map. At the centre of the map is Shanghai. From there, the distances to other port cities such as Vladivostok, Sydney, Alexandria and Valparaiso are measured in nautical miles. This is followed by an introduction entitled "Trouble never ends in Shanghai", which addresses the history of Shanghai from a 'Western' perspective on eight pages.

15 The advertisements quoted below are part of a collection of extracts and cannot be accurately dated.

16 Definition according to the *Oxford English Dictionary*: "adventurous, adj.", "1b. Characterized by adventure; full of incident [...]; 2a. Full of risk or peril; hazardous, perilous, dangerous [...]; 4b. Of a product, activity, etc.: unconventional, innovative; characterized by experimentation or novelty."

17 The Sassoons were a distinguished family from Baghdad who migrated to Bombay in the 1830s and there established their main trading location. After the British forced the opening of five Chinese trading ports, however, the Sassoon family established two offices of David Sassoon, Sons & Co in China – the first in Hong Kong in 1943, and the second in Shanghai in 1945 – and rapidly expanded its presence along the East Coast. In the second half of the 19ᵗʰ century, its trade with China focused on the importation of Indian opium. In addition, members of the Sassoon family and the 'Baghdadi' who had settled in Shanghai established themselves in many other economic enterprises, such as banking, real property, import and export (Betta 2003, 1001–1008).

18 Liangyou editions, Municipal Library, Shanghai.

19 Photographers not specified.

20 A body-hugging dress with distinctive features developed from traditional Qing gowns.

21 Shao Xunmei was an author, artist, publisher and editor of numerous magazines and a central figure in Shanghai's salon culture of the 1930s as well as in the city's publishing sector: Bevan 2016, 53–70).

22 For a more complex discussion on racism and processes of stereotyping, cf. Hall 2002, 108–166.

23 The Thorbecke Archive does not contain a print of this photograph. The even distribution of light from the right-hand side suggests that the photograph was pre-composed and not montaged afterwards.

24 For more on Baedeker and related topics, cf. Camilla Smith, "Challenging Baedeker Through the Art of Sexual Science: An Exploration of Gay and Lesbian Subcultures in Curt Moreck's Guide to Depraved Berlin (1931)." *Oxford Art Journal*, vol. 36, no. 2, 2013, 231–256 and Rudy Koshar. "'What Ought to Be Seen': Tourists' Guidebooks and National Identities in Modern Germany and Europe." *Journal of Contemporary History*, vol. 33, no. 3, 1998, 323–340.

25 Medial representations of urban space in general, and specifically of the modern metropolis of Shanghai in the context of exile and migration, are a central leitmotif of my PhD research which I am currently conducting within the framework of the ERC project METROMOD, directed by Burcu Dogramaci at LMU Munich (2018–2021).

References

"adventurous, adj." *OED Online*, Oxford University Press, June 2019, www.oed.com/view/Entry/2940. Accessed 1 August 2019.

Anonymous. "Adverstisments *Shanghai*." *North China Daily News*, 1943, Estate of Friedrich Schiff (Österreichisches Institut für China- und Südostasienforschung, Wien).

Anonymous. *All About Shanghai and Environs* (1934). Earnshaw Books, 2008.

Bechhaus-Gerst, Marianne, and Mechthild Leutner, editors. *Frauen in den deutschen Kolonien.* H. Links, 2009.

Bickers, Robert. "Shanghailanders: The Formation and Identity of the British Settler Community in Shanghai 1843–1937." *Past & Present,* no. 159, 1998, pp. 161–211.

Bergère, Marie-Claire. *Shanghai. Gateway to Modernity.* Stanford University Press, 2009.

Betta, Chiara. "From Orientals to Imagined Britons: Baghdadi Jews in Shanghai." *Modern Asian Studies,* vol. 37, no. 4, 2003, pp. 999–1023.

Bevan, Paul. *A Modern Miscellany: Shanghai Cartoon Artist, Shao Xunmei's Circle and the Travels of Jack Chen, 1926–1938.* Brill, 2016.

Campkin, Ben, and Ger Duijzings, editors. *Engaged Urbanism: Cities & Methodologies.* I. B. Tauris & Co. Ltd., 2016.

Crow, Carl. *400 Million Customers* (1937). Soul Care Publishing, 2008.

Dirlik, Arif. "Modernity as History: Post-Revolutionary China, Globalization and the Question of Modernity." *Social History,* vol. 27, no. 1, 2002, pp. 16–39.

Dogramaci, Burcu, editor. *Großstadt: Motor der Künste in der Moderne.* Gebr. Mann, 2010.

Dogramaci, Burcu, and Simone Förster, editors. *Architektur im Buch,* Thelem, 2010.

Escobar, Arturo. *Encountering Development: The Making and Unmaking of the third World.* Princeton University Press, 1995.

Fogel, Joshua. "The Recent Boom in Shanghai Studies." *Journal of the History of Ideas,* vol. 71, no. 2, 2010, pp. 313–333.

Fotografieren hieß teilnehmen: Fotografinnen der Weimarer Republik, edited by Ute Eskildsen, exh. cat. Museum Folkwang, Essen, 1994.

Frauenobjektiv. Fotografinnen 1940 bis 1950, edited by Stiftung Haus der Geschichte der Bundesrepublik Deutschland, exh. cat. ibid., Bonn, 2001.

Gao, Bei. "The Chinese Nationalist Government's Policy toward European Jewish Refugees during World War II." *Modern China,* vol. 37, no. 2, 2011, pp. 202–237.

Goodman, Bryna. "Improvisations on a Semicolonial Theme, or, How to Read a Celebration of Transnational Urban Community." *The Journal of Asian Studies,* vol. 59, no. 4, 2000, pp. 889–926.

Granqvist, Raoul, J. *Photography and American Coloniality: Eliot Elisofon on Africa, 1942–1972,* Michigan State University Press, 2017.

Hadfield, Andrew. *Literature, Travel, and Colonial Writing in the English Renaissance 1545– 1625.* Oxford University Press, 1999.

Hall, Stuart. *Representation: Cultural Representations and Signifying Practices.* Sage, (1997) 2003.

Hall, Stuart. *Ideologie, Identität, Repräsentation: Ausgewählte Schriften 4.* Argument Verlag, 2004.

Hörner, Unda. *Scharfsichtige Frauen: Fotografinnen der 20er und 30er Jahre in Paris.* Edition Ebersbach, 2010.

Huyssen, Andreas. "Geographies of Modernism in a Globalizing World." *New German Critique*, no. 100, 2007, pp. 189–207.

Kaminski, Gerd. *Der Blick durch die Drachenhaut: Friedrich Schiff: Maler dreier Kontinente*. 2001.

Koshar, Rudy. "'What Ought to Be Seen': Tourists' Guidebooks and National Identities in Modern Germany and Europe." *Journal of Contemporary History*, vol. 33, no. 3, 1998, pp. 323–340.

Kranzler, David. "Restrictions Against German-Jewish Refugee Immigration to Shanghai in 1939." *Jewish Social Studies*, vol. 36, no. 1, 1974, pp. 40–60.

Lee, Leo Ou-fan. *Shanghai Modern: The Flowering of a New Urban Culture in China, 1930– 1945*. Harvard University Press, 1999.

Liang, Samuel Y. "Where the Courtyard Meets the Street: Spatial Culture of the Li Neighborhoods, Shanghai 1870–1900." *Journal of the Society of Architectural Historians*, vol. 67, no. 4, 2008, pp. 482–503.

Liu, Cary L. "Encountering the Dilemma of Change in the Architectural and Urban History of Shanghai." *Journal of the Society of Architectural Historians*, vol. 73, no. 1, 2014, pp. 118– 136.

Mao Dun. *Schanghai im Zwielicht* (1933). Translated by Franz Kuhn, Suhrkamp, 1983.

Mao Dun. *Midnight* (1933). Translated by Hsu Meng-hsiung, Fredonia Books, 2001.

Pan, Lynn. *Shanghai Style: Art and Design Between the Wars*. Long River Press, 2008.

Pickowicz, Paul G. et al., editors. *Liangyou: Kaleidoscopic Modernity and the Shanghai Global Metropolis, 1926–1945*. Brill Academic Pub, 2013.

Rehbein, Boike. *Kaleidoskopische Dialektik: Kritische Theorie nach dem Aufstieg des globalen Südens*. UVK Verlagsgesellschaft, 2013.

Schaefer, William. "Shadow Photographs, Ruins, and Shanghai's Projected Past." *PMLA*, vol. 122, no. 1, 2007, pp. 124–134.

Schiff, Friedrich, and Ellen Thorbecke. *Shanghai*. North China Daily News, 1941.

Shih, Shu-mei. *The Lure of the Modern: Writing Modernism in Semicolonial China, 1917–1937*. University of California Press, 2001.

Smith, Camilla. "Challenging *Baedeker* Through the Art of Sexual Science: An Exploration of Gay and Lesbian Subcultures in Curt Moreck's *Guide to 'Depraved' Berlin* (1931)." *Oxford Art Journal*, vol. 36, no. 2, 2013, pp. 231–256.

Spence, Jonathan Dermot. *Chinas Weg in die Moderne*. Dtv, 2001.

Wasserstrom, Jeffrey N. "Is Global Shanghai 'Good to Think'? Thoughts on Comparative History and Post-Socialist Cities." *Journal of World History*, vol. 18, no. 2, 2007, pp. 199– 234.

Wittrock, Björn. "Modernity: One, None, or Many? European Origins and Modernity as a Global Condition." *Daedalus*, vol. 129, no. 1, 2000, pp. 31–60.

Yva. Photographien 1925–1938, edited by Marion Beckers and Elisabeth Moortgat, exh. cat. Das verborgene Museum, Berlin, 2001.

The Bar Sammy's Bowery Follies as Microcosm and Photographic Milieu Study for Emigrated European Photographers in 1930s and 1940s New York

Helene Roth

This text begins with a photograph taken last year on a research trip to New York. After my first day at the NYPL Archives, I crossed Manhattan and walked down the Bowery to the Lower East Side to visit an exhibition at the International Center of Photography. As I was about to enter the museum, I glanced across the street where I noticed a sign above a bar: "PAULANER. CRAFT BREWERY" (fig. 1). The name of the brewery immediately evoked my home town, Munich, and triggered a feeling of connection and belonging to New York. At the same time, I thought of the METROMOD research project at LMU Munich, within which I conduct my doctoral studies on European photographers who emigrated to New York in the 1930s and 1940s, with a special focus on urban spaces. It was by chance that several months later, while searching more deeply for the meaning and function of the Paulaner Bar on the Lower East Side, that I found out that until 1969 there had been another bar in the same place, called Sammy's Bowery Follies.[1] This bar was opened in 1934 by Sammy Fuchs at 265–267 Bowery and subsequently became an important gathering place for various social and cultural groups throughout the 1940s. Interestingly, the bar and its patrons were also the subject of pictures by emigrated European photographers such as Weegee, Alfred Eisenstaedt, Erika Stone and Lisette Model, who were fascinated by the patrons of Sammy's Bowery Follies[2] and captured their impressions of them and this special place. It was clear, then, that this place and the urban environment were connected to the wider topic of emigration movements to New York in the 1930s and 1940s and also to the history of photography.

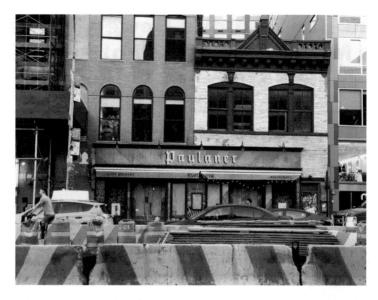

Fig. 1: *View of the Bar Paulaner, 265–267 Bowery*, New York, 2018 (Photo: Helene Roth).

In the context of the immediate urban environment of the Lower East Side, a quarter where many European emigrants lived in the 19th and 20th centuries, a number of questions arose: Why were the emigrated photographers so interested in Sammy's Bowery and its surrounding neighbourhood? How did they photograph the bar? Can the bar be seen as a photographic milieu study for these emigrated photographers and what function does photography play here? Based on photo reportages in *Life* magazine and other photographs, this essay sets out to analyse these questions in the context of exile, urban, sociology and photography studies.

The Place to Be? Sammy's Bowery Follies on 265 Bowery, New York

In December 1944, *Life* magazine published a photo reportage by Alfred Eisenstaedt entitled "Sammy's Bowery Follies. Bums and Swells Mingle at Low Down New York Cabaret" (fig. 2).[3] Across four pages, Sammy Fuchs' bar is portrayed through concisely titled photographic sequences and an introductory text (Anonymous 1944b, 57–60). The first page features a half-page photo which shows the interior of the bar: the twilight atmosphere, the luminous spots of lamplight as well as the number of customers suggest that the photograph was taken at night.

Helene Roth

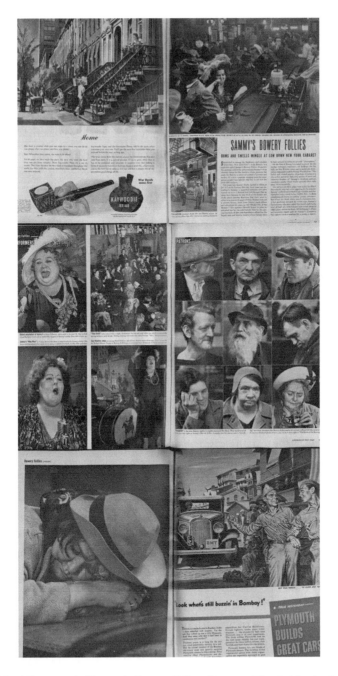

Fig. 2: Alfred Eisenstaedt, "Sammy's Bowery Follies. Bums and Swells Mingle at Low Down New York Cabaret." *Life*, vol. 17, no. 23, 1944, pp. 57–60 (Bayerische Staatsbibliothek, München).

Eisenstaedt chose an elevated point of view for his photograph in order to obtain as wide an overview as possible of the interior of the bar. This also enabled him to capture the clientele at an unobserved moment. Especially striking is the lavishly feathered hat of a woman leaning on the counter on the left, drinking from a glass. The small upright photograph to the left-hand side of the page shows an exterior shot of the bar. The text, the author of which is unknown, describes the bar's everyday reality in at times derogatory terms. Besides the "bums and swells" mentioned in the subtitle of the reportage, the bar is described as "dingy", "seedy" and as an "[…] alcoholic heaven for the derelicts whose presence has made the Bowery a universal symbol of poverty and futility" (ibid., 57). The text further states that in 1941, seven years after the bar opened, Sammy Fuchs was granted a licence to stage cabarets for which he hired some ageing vaudevillians (Anonymous 1944b, 57; see also McFadden 1970; Ferrara 2011, 104). The reader also learns that the bar was a popular spot for well-to-do people from Midtown who were drawn to the bar's rugged atmosphere:

> It is also a popular stopping point for prosperous people from uptown who like to see how the other half staggers […] The uptown clientele began to pour in, attracted less by the entertainers than by the general spectacle of dirt and degradation offered by the frowzy men and blowzy women whom Sammy likes to have around his saloon to provide "atmosphere". (Anonymous 1944b, 57)

Accompanied by the text, these two photographs provide a first insight into the bar, which is further explored on the following pages of the magazine. In sequences of four and nine photographs, the next double page focuses on the bar's artists and customers, who are divided into "performers" and "patrons" (Anonymous 1944b, 58f.). Among the "performers" are various corpulent female singers engrossed in their performances and clad in similarly conspicuous hats and gaudy costumes to the woman at the bar described above. A stark contrast to the dynamic and exuberant mood in these photographs is provided by the nine "patron" portraits on the right. These photos show the so-called regulars, described by Sammy Fuchs as "escapists" (ibid., 59), who can be found at the bar day and night, begging for beer from other customers. All of those portrayed have either turned their heads away from the camera or stare melancholically into the distance. The very last picture of the reportage consists of a shot of Tugboat Ethel, the "Queen of the Bowery", who also features in the previous series of "patron" portraits in the lower right corner. This full-page portrait shows her sleeping at the table, resting her head in her hands.

Helene Roth

Eisenstaedt photographed all his subjects in unobserved moments. His photographs directly convey the atmosphere in the bar and depict a run-of-the-mill evening at Sammy's Bowery. In a scenic progression, the photo reportage takes the viewer on a tour of the bar. The camera functions as an external observer and does not engage with the singers or patrons. Following Henry Luce, the publisher of *Life*, Eisenstaedt's work thus fulfils the photojournalistic paradigm of a certain kind of photography that honestly and authentically draws on real life, while still acting from an impartial outsider position (Luce 1980, 7). The visual impressions are complemented by the text's descriptions which create a somewhat trivial and negative image of the bar. Apparently, Sammy Fuchs had tried consciously to set himself apart from other nightclubs in Midtown Manhattan by creating a "unique" atmosphere and by advertising his bar with the slogan "Stork Club of the Bowery" (Anonymous 1944b, 57; Ferrara 2011, 103–107).

With this he was not referring to the American whiskey brand "Stork", but to the Stork Club near 5th Avenue. This upscale establishment had also been photographed by Alfred Eisenstaedt and featured in a previous edition of *Life* (Anonymous 1944a, 119–125). Similar to the piece on Sammy's Bowery, the first page of the reportage "*Life* Visits the Stork Club: Famous New York Nightclub Makes Business of Attracting Celebrities" features a half-page photograph of the interior of the club as well as a small photograph of the entrance area (fig. 3). The nightclub allowed entry to celebrities only after an admission check, thus representing the exclusive opposite of Sammy's Bowery. The camera's view is directed towards the interior of the "Cub Club" and shows well-dressed guests sitting around tables. The text further explains that the bar also attracted visitors who, despite their lack of celebrity status, hoped to attain a higher social standing by patronising the club (Anonymous 1944a, 119). Just as in the article on Sammy's Bowery, the following pages take the reader on a tour around the bar which features spacious rooms, each with a different design. The focus here is less on individual portraits but rather on ambience and the patrons' stories.

A comparison of the two photo reportages suggests that the two nightspots were frequented by contrasting social groups, each of which not only represented vastly different symbolic institutions within its respective neighbourhood in New York, but also pointed towards fundamental urban socio-cultural divergences. Both journalistic pieces, however, by way of a specific editorial constellation of text and image, direct the reader's attention towards different social classes rather than the lives of individuals.[4] What is striking here is that social groups from the Bowery were not given access to nightclubs such as the Stork Club, whereas visitors of the Stork Club could also be found in Sammy's Bowery. Despite these social divergences, both reportages also convey an ironic view of nightlife in

Fig. 3: Alfred Eisenstaedt, "*Life* Visits the Stork Club. Famous New York Nightclub Makes Business of Attracting Celebrities." *Life*, vol. 17, no. 19, 1944, pp. 119–125 (Bayerische Staatsbibliothek, München).

Manhattan. With the name "Stork Club of the Bowery", Sammy Fuchs refers to the Stork Club in Midtown Manhattan in order to distinguish himself from it while simultaneously self-consciously alluding to the social milieu of his clientele and thus gesturing towards his establishment's "identity".

The Ups and Downs of the Bowery

What the *Life* reportage on Sammy's Bowery does not mention is that the bar, which was located at 265–267 Bowery, between Huston and Stanton Streets on the Lower East Side, had an important cultural value and was perceived as an integral part of the urban cityscape. When the bar had to close in 1969, an article in the *New York Times*[5] reports the following: "[…] the [Sammy's Bowery, HR] Follies had become over the years a symbol of the city's melting pot, a place where the prosperous and the impoverished could drink elbow-to-elbow and sing along with aging, passionately prune faced vaudeville entertainers" (McFadden 1970). The Bowery is 1,600 metres long and stretches from Chatham Square in the middle of Chinatown to Astor Place (see city map, fig. 4). For many years the

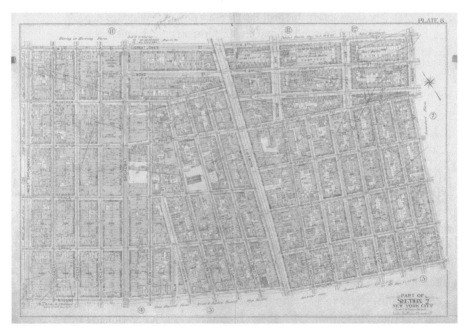

Fig. 4: Lionel Pincus and Princess Firyal Map Division, The New York Public Library, "Plate 8: Bounded by W. 3rd Street, Great Jones Street, E. 3rd Street, Avenue A, Essex Street, Broome Street and West Broadway" (New York Public Library Digital Collections).

Bowery was considered to be one of the most dangerous streets in the city and, thanks to its high rate of homelessness, poverty and adverse living conditions, was pejoratively referred to as "skid row". The large number of alcoholics living on the Bowery (estimated at more than 14,000 in the 1930s and 1940s) were subsequently dubbed "skid-row bums" (Marx 1984, 154; Howard 2013, 3–11). This negative image of the neighbourhood was exacerbated by the many criminal offenders, former patients from mental hospitals, and alcoholics, predominantly single middle-aged men, who resided there (Giamo 1989, xiii). The Bowery was also of interest to contemporary American writers such as Elwyn Brooks White. He describes the street as follows in his 1948 published book, *Here is New York*, which took its readers on an urban tour of the city:

> Walk the Bowery under the El[6] at night and all you feel is a sort of cold guilt. Touched for a dime, you try to drop the coin and not touch the hand, because the hand is dirty; you try to avoid the glance, because the glance accuses. This is not so much personal menace as universal – the cold menace of unresolved human suffering and poverty and the advanced stages of the disease alcoholism. On a summer night the drunks sleep in the open. The sidewalk is a free bed, and there are no lice. Pedestrians step along and over and around the still forms as though walking on a battlefield among the dead. Standing sentinel at each sleeper's head is the empty bottle from which he drained his release. [...] The glib barker on the sightseeing bus tells his passengers that this is the 'street of lost souls,' but the Bowery does not think of itself as lost; it meets its peculiar problem in its own way – plenty of gin mills, plenty of flophouses, plenty of indifference and always, at the end of the line, Bellevue. (White 1948, 43f.)

However, the public image of the street as a poor and alcohol-fuelled neighbourhood should not be reduced to the terms "skid row" and "Bowery bums". Instead, the Bowery needs to be interpreted within the context of historical and migratory developments and the different socio-cultural classes that populated it. The history of the Bowery in fact chronicles Manhattan's urban changes, representing both the development of the city of New York and its evolution from a Dutch settlement to a metropolis whose socio-cultural processes have not always run along straight lines (Ferrara 2011; Marx 1984, 153).[7] The street was first mentioned in 1635 as a passage to Boston, built by colonialists and leading to the farm (Dutch: *bouwerie*) of the Dutch colonial governor Pieter Stuyvesant. During the 17th century, other

wealthy Dutch merchants built their farms on the same road (Marx 1984, 154; Giamo 1989,1ff; Ferrara 2011, 24ff). At the beginning of the 19th century, the Bowery was considered a noble street with upscale restaurants, shops and hotels (Marx 1984, 156).

From the 1830s onwards, the Lower East Side gradually transformed into a residential area where predominantly German and Irish emigrants settled; from 1870 on, their numbers also included eastern and southern European emigrants. Subsequently, parts of the Lower East Side and the Bowery were called "Little Germany" and "Little Italy", each of which had its own shops, nightclubs, beer gardens and cultural institutions, while the Jewish emigrated population also created a cultural, economic and religious infrastructure (Ferrara 2011, 37–40; Stölken 2013, 25–52). Thus, the Lower East Side surrounding the Bowery grew into a densely populated and multicultural neighbourhood. To house the rapidly increasing number of emigrants, the first American apartment buildings were built in the 1890s (Stölken 2012, 28; Minetor 2015, 30ff.). These tenement houses extended over four to five floors and were divided into many small, unventilated rooms of eight to nine square metres, some without windows. The typical architectural structure of these houses consisted of shops on the ground floor and apartments on the floors above.[8] In addition to the residential and shopping areas, numerous bars and nightclubs opened along the Bowery (Giamo 1989, 31ff.). Growing rates of homelessness, crime and widespread alcoholism earned the street a bad reputation, especially after the Great Depression of the1930s (Ferrara 2011, 42). This development led to a contradictory public perception of the Bowery: on the one hand, aid projects and socio-critical photographic documentaries, including those by Jacob Riis, aimed to draw attention to the Bowery's state of poverty and destitution. On the other hand, the situation was trivialised and turned into a public "urban spectacle" (Giamo 1989, 31). As a result of sensationalist reporting and visualisation, stereotypical images of the Bowery took hold in the media (Giamo 1989, 39ff; Howard 2013). With the beginning of the 1940s and the advent of World War II, numerous musicians and artists as well as students relocated to former worker or emigrant flats on the Bowery because of its affordable rents: "Rather than shun the Bowery's marginal past, many embraced it; the Bowery fed, sheltered and inspired them, visible in the pioneering art coming out of the era [...]." (Ferrara 2011, 43)

Alfred Eisenstaedt's photo reportage must be placed in the context of these different and parallel existing social, urban and cultural structures of the Bowery. In addition to Eisenstaedt, other European and American photographers, such as Berenice Abbott and Lewis Hine, were interested in the Bowery and offered their own photographic perspectives on its social conditions and everyday life. Besides

Lisette Model, a photographer who took up exile in New York and took pictures of Sammy's Bowery, there were also emigrated photographers who had come to the US as children.[9] Erika Stone and Weegee (Arthur Felling) fled from Europe to America when they were young and later began their careers as photographers in New York.

Flashlights: Erika Stone and Weegee at Sammy's Bowery

Erika Stone, who was 12 years old when she and her family emigrated to New York in 1936, had already been taking photographs back in Germany. After arriving in New York, she quickly deepened her interest in the medium by photographing the neighbourhood children and selling the portraits to their parents. As a student at the Photo League and the New School of Social Research, she made urban exploration tours with her camera through New York and earned recognition with her photographic series on Sammy's Bowery in 1946.[10]

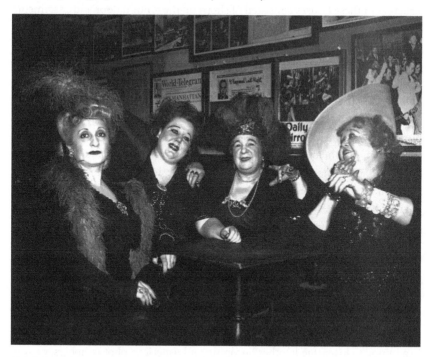

Fig. 5: Erika Stone, *Bowery Beauties*, New York, 1946 (Erika Stone, Courtesy of Katarina Doerner Photographs, Brookly, NY).

Helene Roth

In two photographs, entitled *Bowery Beauties* (fig. 5) and *Ethel, the Bowery Queen* (fig. 6), she portrayed some of the protagonists also featured in Eisenstaedt's *Life* reportage: a group of female vaudeville artists and Tugboat Ethel.[11] Unlike Eisenstadt's photographs, however, the motifs here are not captured in an unobserved moment. Rather, they are taken in agreement with the people portrayed. The *Bowery Beauties* photograph shows a close-up of four singers sitting around a table and looking directly into the camera. The women's cheerful expressions and gestures, their elegant black dresses, jewellery and feathered hats, convey a relaxed and evocative atmosphere. Ethel Tugboat in *Ethel, the Bowery Queen* is also portrayed in a front-facing shot. Seated at a table, she rests her left cheek in one hand while her other hand holds a lit cigarette over an ashtray. Ethel does not wear extravagant make-up, unlike the female vaudeville artists. She seems to want to evoke a cultivated bourgeois impression with her pearl bracelet, hat, coat and black patent handbag. The photograph not only reveals a different approach to the external physical appearance, but is also dedicated to the mental state of the subject. Ethel's sad eyes look into the camera with an empty and melancholy gaze, the corners of her mouth are turned downwards and her lips are closed, conveying depression or exhaustion in a non-verbal way. In addition to these two images, Stone has also photographed other day and night scenes inside the bar and on the street outside, which are printed in the volume *Mostly People* and include two tattooed men engaged in an arm-wrestling contest (*Mostly People* 2001, 37). Stone had a great interest in individuals regardless of their social background and tried to preserve the human dignity of her models (Heß 2001, 8).

Fig. 6: Erika Stone, *Ethel, the Bowery Queen*, New York, 1946 (*Mostly People* 2001, 41).

Stone's photographs, thus, can be viewed in contrast to Eisenstaedt's work, which recorded the artists and patrons of Sammy's Bowery in unobserved moments. Eisenstaedt also visualised scenes which raise questions concerning morality and the subject's right to privacy, such as when he photographed the sleeping Ethel Tugboat (Anonymous 1944b, 60). Nevertheless, Eisenstaedt conveyed his respect for his subjects via different technical means: as a proponent of available-light photography, he worked without a flash bulb and used naturally available light to capture the mood in the bar (Heß 2001, 11).[12] By contrast, the dark background and brightly-lit faces in Erika Stone's photographs indicate that she worked with an artificial light source (Stone 2004, 134). Her singular focus on the individual is only emphasised by the often indefinable backgrounds of her photographs.[13] It is important to note that Stone benefitted from the technical improvements in the field of flash photography that evolved throughout the 1930s and 1940s. In 1925, Paul Vierkötter patented the first photo flash bulb, which was then sold by the American company General Electric under the name Sashalite in 1930 (Price 1938, 24ff; Wakefield 1947, 9–17; Bonanos 2018, 35). Although these early flash bulbs were very expensive, bulky and could be used only once, they still offered a practical alternative to the hazardous and cumbersome flash powder which they replaced.

An important proponent of these new technologies was Weegee (Arthur Fellig), whose flash shots established a unique aesthetic of New York's day- and nightlife. Erika Stone was acquainted with the emigrated photographer through the Photo League. After emigrating in 1909 at the age of ten with his family to New York, Weegee had taught himself photography and, like Erika Stone, begun his career as a street photographer selling portraits on the Lower East Side, where he grew up and lived for several years. A variety of assistant jobs in darkrooms and publishing houses enabled him to establish himself as a respected press photographer from the 1930s onwards (Weegee 1982, 7–35; Purcell 2004; *Extra! Weegee* 2017, 9).[14] In addition, he often photographed the life and inhabitants of the Lower East Side using a speed-graphic camera and flash bulb, including the goings-on at Sammy's Bowery (Weegee 1982, 238–249; *Extra! Weegee* 2017, 15; Bonanos 2018, 141).[15] He synchronised his flash bulb so that it lit up as soon as the shutter opened. This created a particularly strong light-dark contrast, which can be seen in a photo entitled *Shorty, the Bowery Cherub, Celebrating New Year's Eve at Sammy's Bar* (Loengard 2004, 6). The photograph (fig. 7) shows the owner, Sammy Fuchs, dressed in a top hat and tie, as he stands behind the bar celebrating the end of 1942 with his customers gathered around the wooden counter. Some of the festively dressed patrons have positioned themselves for Weegee and look directly into the camera. The flash bulb illuminates metal objects and the string

of lights on the fir tree in the background as well as the faces of those in the photograph. A variety of facial expressions and gestures, a cropped hand at the right edge of the picture and a woman's body lend the shot a sense of dynamism. The focal point of the photograph is the eponymous Shorty, a small man clads only in white underpants and a hat with the inscription *1943*, who is about to drink from a full glass.

Fig. 7: Weegee, *Shorty, the Bowery Cherub, Celebrating New Year's Eve at Sammy's Bar*, New York, 1943 (*Weegee's New York* 1982, 248, International Center of Photography, New York).

Weegee had a special connection to the Lower East Side as he had grown up in one of the neighbourhood's tenement houses in impoverished circumstances. For him, photography was a means of sharing his social context with other, more privileged, social classes and of promoting tolerance and the acceptance of marginalised groups, cultures and outsiders (Bonanos 2018, 141). This socially conscious strategy can also be found in the photographs of Erika Stone who, like Weegee, grew up as a destitute emigrant in New York:

The fact is that I myself was poor. […] Therefore it was hard for me to conciliate with the fact that I have a Jewish background. But not anymore. So we were a very poor immigrant family. As I remember, I worked all throughout my childhood. I started as a babysitter, then got more serious jobs. We always had a lack of money in our family. Thus I think it's logical that I am more attracted to poor people and their lifestyle. When I became a little older I started to wander around Harlem and Lower East side and photograph poor people. There is where I found a lot of people with unconventional stories and I wanted to tell them through my photographs. I was not attracted to the posh, fancy areas such as Park Avenue. (Korbut 2015, n.p.)

Both Erika Stone and Weegee were members of the Photo League, a photography school with a focus on social documentary photography. As European emigrants who grew up in poverty, Stone and Weegee used the camera as a medium of solidarity with marginalised and socially disadvantaged people (Schaber 2005, 84f.). They portrayed life in the metropolis with its residents and urban structures as they themselves had experienced it (*Mostly People* 2001, 137).[16] The historian Jens Jäger attributes important social significance to photography that "conveys social norms and, more importantly, visualises them. It manifests what is regarded in a society as worthy of representation, as normal and deviant, as beautiful or ugly. Therefore, images are always part of the formation and shaping of public opinion" (Jäger 2009, 14).[17] He adds that in all social areas, photographs have assumed the function of expressing a certain relationship between an individual and the world. He ascribes particular importance to the medium "in the construction of ethnicity, class and gender" (ibid., 15).[18] At the same time, he argues that photographs draw the viewer's attention to these social ruptures (ibid., 154). For Stone and Weegee, photography was an important medium not only for focusing on the social life of the marginal and diverse clientele of Sammy's Bowery and the Lower East Side but also for engendering solidarity between the emigrated photographers and their subjects. Taking this a step further, Stone's and Weegee's photographs thereby follow the tradition of American social documentary photography, whose focus on marginalised social strata can already be found in Jacob Riis' work. As a 19th-century Danish emigrant, Riis documented his own experiences of exile in the East Side slums between the 1870s and 1890s, subsequently published in his book *How the Other Half Lives* (Riis 1890).

Helene Roth

Sammy's Bowery Follies: From Metropolitan Microcosm to Photographic Milieu Studies

In her book *The Death and Life of Great American Cities* (1962), the urban studies scholar Jane Jacobs puts forward the following methodology on how to respond to the complexities of social, cultural and urban structures in a metropolis. She argues for a viewpoint that considers the microcosms and everyday realities of urban life, in order to draw conclusions about the more complex contexts of cities:

> [...] we shall start, if only in a small way, adventuring the real world, ourselves. The way to get at what goes on in the seemingly mysterious and perverse behavior of cities, is, I think to look closely, and with as little previous expectation as is possible, at the most ordinary scenes and events, and attempt to see what they mean whether any threads of principle emerge among them. (Jacobs 1962, 13)

Therefore, Sammy's Bowery, as an everyday bar on the Lower East Side, can also be seen as an example of such an urban microcosm which allows a better understanding of the cultural and social urban environment, and also of the relationship between the city and emigration. The photographs of Alfred Eisenstaedt, Erika Stone and Weegee show a variety of approaches and employ different photographic techniques to emphasise their respective image narratives and picture motifs. As Alfred Eisenstaedt published his series on Sammy's Bowery in *Life* magazine, using available light technologies and a 35mm camera, he adopted the premises of specific photojournalistic practices portraying unobserved moments in and out of the bar. Erika Stone and Weegee used flash bulb technologies and thereby achieved a stronger light-dark contrast in their work. Their focus was on the individual, the customer at Sammy's Bowery, who was portrayed in a distinctive way.

The camera functions as a medium of solidarity with the Bowery's marginalised groups and outsiders. In the context of their own former living conditions as emigrants on the Lower East Side, Stone and Weegee wanted to draw attention to the cultural and social ruptures in the metropolis of New York. Focusing on everyday scenes from urban contact zones, such as Sammy's Bowery, the photographs of Stone and Weegee closely align with Jane Jacobs' approach. For Weegee, who grew up in poverty in the same neighbourhood, Sammy's Bowery provided a microstudy of the city, representing the life of the poor on the Lower East Side, where many emigrants lived. For Erika Stone, who discovered Sammy's

Bowery in her explorations of the city and perhaps rediscovered herself as an emigrant in the neighbourhood and the bar, it provided a way for her to identify with the people. Unlike Weegee, who was a press photographer, she did not focus on the "sensational" but on the people themselves and tried to preserve the human dignity of her subjects.

In sociology, milieu studies were developed to investigate the social and cultural mechanisms of urban micro-spaces such as city districts (Geiling 2006, 336ff.). Pierre Bourdieu is a representative of this approach, having developed a space-oriented milieu and class theory for approaching questions of societal conflict and socio-hierarchical relationality (ibid., 349). Bourdieu's research on social actors and their respective surroundings sought to highlight their position within their social, cultural and political environment (Bourdieu 1992, 49–79). In his volume *Photography: A Middle-Brow Art*, published in 1965, Pierre Bourdieu transferred these observations of everyday social practices to the medium of photography. He emphasised that for the analysis of cultural and social contexts, photography ought to focus on everyday social groups in order to be able to experience and interpret holistic social structures:

> [o]nly the methodological decision to make a study based primarily on 'real' groups was to allow us to perceive (or prevent us from forgetting) that the meaning and function conferred upon photography are directly related to the structure of the group, to the extent of its differentiation and particularly to its position within the social structure. (Bourdieu [1965] 1990, 8)

In film studies, too, the term milieu study is used. Here, lay actors examine the life and social conditions of a particular neighbourhood and subculture (Decker 2003, 352).[19] Therefore, the analysed photographs of Alfred Eisenstaedt, Erika Stone and Weegee can also be interpreted as milieu studies: inspired by their own urban environments as emigrants, they not only engaged with the microcosm of Sammy's Bowery Follies, but used their cameras to analyse urban multicultural and often poor milieus such as the Lower East Side and to express solidarity with those who were marginalised. In this essay urbanity and emigration are analysed through the method of a microstudy using the example of Sammy's Bowery and the images generated there by emigrated photographers.

Helene Roth

Notes

1 Cf. https://www.boweryboogie.com/2018/06/paulaners-former-bowery-brewery-seized-by-marshals/. Accessed 27 May 2019.

2 For the sake of brevity, the bar will sometimes be referred to as Sammy's Bowery.

3 The American magazine *Life*, which had appeared since 1936, considered photography – alongside text – to be an important information medium for reportage. The focus was on authentic, real-life photographs (*Kiosk* 2001, 190; Loengard 2004, 6–11; Holzer 2014, 441).

4 The two very different establishments are also presented together in Alfred Eisenstaedt's photo book, *Witness to Our Time*, thus suggesting a certain interpretational direction (Eisenstaedt 1980, 110–114).

5 The closure of the bar in 1969 was described as a loss to the neighbourhood not only by the *New York Times* but also in various other newspapers (McFadden 1970). The two apartment complexes were then sold to the city, and, until 2018, housed the aforementioned Paulaner bar.

6 "El" is the abbreviation of "Elevated Railroad" and refers to New York's high-rise railway, which was constructed between 1878 and 1894 and whose rail lines were often erected on the same level as the first and second floors of apartment buildings. The El thus considerably darkened the streets in the Bowery area (Marx 1984, 158; see also Höhne 2017, 54).

7 For an extensive history of the Bowery, see Giamo 1989, 1–30; Howard 2013; Stölken 2013, 25–58.

8 Along with Weegee and Erika Stone, photographers like Andreas Feininger and Fred Stein focused on forming a multicultural shop of European emigrants. See: Andreas Feininger, *New York*, Ziff-Davis, 1945; *Fred Stein. Dresden, Paris, New York*, edited by Erika Eschenbach and Helena Weber, exh. cat. Stadtmuseum Dresden, Dresden, 2018.

9 Lisette Model was an Austrian photographer who emigrated via Paris and Marseilles to New York. There she quickly gained a reputation as a female photographer focusing on the streets and urban life of New York, as in her series „Running Legs" and „Shop Windows". She also taught photography at the New School for Social Research and was a member of the Photo League. See for example: *Lisette Model. Fotografien 1934–1960*, edited by Monika Faber and Gerald Matt, exh. cat. Kunsthalle Wien 2000, Wien, 2000.

10 Erika Stone was born in Frankfurt am Main in 1924. As an autodidact, she learned photography from the emigrant Leo Cohn in his photo laboratory Leco. From 1941/1942 on, Stone further deepened her knowledge by attending Berenice Abbott's classes at the New School for Social Research and the Photo League (Kelley 1947; Küppers 1995; Heß 2001, 5ff.; *Mostly People* 2001, 94; Stone 2004, 134).

11 According to Erika Stone, she was commissioned by a Swedish newspaper to shoot a reportage about Sammy's Bowery (Stone 2004, 134). It is still unclear, however, when, by which magazine and for what purpose this assignment was issued.

12 Another advocate of this technique, in addition to Eisenstaedt, was Erich Salomon who, with the help of light-sensitive lenses and film materials, tried to avoid the use of flash bulbs and overly lit scenes (Eisenstaedt 1979, 15, 72; Garner 2003, 151ff.).

[13] Stone worked with a Voigtländer Superb, a two-lens medium format SLR camera. One characteristic of this camera type was the light shaft viewfinder with grid pattern, which displayed the motif mirror-inverted, but which also enabled the photographer to view it as a two-dimensional picture, thus enabling a sound assessment of the subject matter at hand. The photos were available in either square format (6 x 6 cm) or rectangular format (4.6 x 6 cm) (Cremers 1992, 12, 57–61; Maschke 1997, 94–101).

[14] For a selection of Weegee's photographs, see the online collection at the International Center of Photography (ICP): https://www.icp.org/browse/archive/constituents/weegee?all/all/all/all/0. Accessed 28 May 2019.

[15] The Speed Graphic camera, which had been sold in the USA since 1912, was upgraded in 1947; this technical update enabled easier and faster triggering. With a shutter speed of 1/100 second, the robust large-format camera, which was integrated in a wooden housing, became particularly feasible for press photographers. The term "speed" as used in a professional photographic context indicates the degree of light sensitivity of the film (Feininger 1982, 119).

[16] Other Photo League photographers such as Aaron Siskind were also interested in the Bowery (Raebrun 2006, 219–245; Blair 2007, 23–39). For a more in-depth discussion of the Photo League, please see Ya'ara Gill Glazer's chapter in this volume.

[17] "Mit ihnen werden auch gesellschaftliche Normen vermittelt und, wichtiger noch, visualisiert. In ihnen manifestiert sich, was in einer Gesellschaft als abbildungswürdig, als normal und abweichend, als schön oder hässlich angesehen wird. Bilder sind daher immer auch Bestandteil einer Meinungsbildung und -beeinflussung." Translated into English by Helene Roth.

[18] "[…] bei der Konstruktion von ethnischer Zugehörigkeit, Klasse und Geschlecht." Translated into English by Helene Roth.

[19] An example of this is the film *Dead End* (1937) by Sam Goldwyn, which explores the social environment of Goldwyn's teenage years, the Lower East Side, as well as the conditions in New York's tenement housing estates.

References

Anonymous. "*Life* Visits the Stork Club: Famous New York Nightclub Makes Business of Attracting Celebrities." *Life*, vol. 17, no. 19, 1944a, pp. 119–125.

Anonymous. "Sammy's Bowery Follies. Bums and Swells Mingle at Low Down New York Cabaret." *Life*, vol. 17, no. 23, 1944b, pp. 57–60.

Barman, Suvash Kumer. "Alfred Eisenstaedt." *Encyclopedia of Twentieth-Century Photography. Volumes I–III*, edited by Lynne Warren. Routledge, 2006, pp. 435–438.

Blair, Sara. *Harlem Crossroads. Black Writers and the Photograph in the Twentieth Century*. Princeton University Press, 2007.

Bonanos, Christopher. *Flash. The Making of WEEGEE THE FAMOUS*. Henry Holt and Company, 2018.

Bourdieu, Pierre. "Ökonomisches Kapital – Kulturelles Kapital – Soziales Kapital." *Die verborgenen Mechanismen der Macht*, edited by Pierre Bourdieu. VSA, 1992, pp. 49–79.

Bourdieu, Pierre, et al. *Photography: A Middle-Brow Art* (1965), translated by Shaun Whiteside, Polity Press, 1990.

Chauncey, George. *Gay New York: Gender, Urban Culture, and the Making of the Gay Male World, 1890–1940*. BasicBooks, 1994.

Cremers, Alf. *Moderne Mittelformat Fotografie*. Augustus Verlag, 1992.

Decker, Christof. *Hollywoods kritischer Blick: Das soziale Melodrama in der amerikanischen Kultur 1840–1950*. Campus, 2003.

Drechsler-Marx, Carin. *Bowery. Bilder einer verrufenen Straße*. Harenberg, 1984.

Eisenstaedt, Alfred. *Eisenstaedt on Eisenstaedt. A Self-Portrait*. Abbeville Press, 1942.

Eisenstaedt, Alfred. *Eisenstaedt's Album. Fifty Years of Friends and Acquaintances*. Viking Press, 1976.

Eisenstaedt, Alfred. *People*. Penguin Books, 1979, pp. 5–19.

Eisenstaedt, Alfred. *Witness to Our Time*. Viking Press, 1980.

Extra! Weegee. A Collection of 395 Vintage Photographs from 1929–1946, edited by Daniel Blau, exh. cat. Daniel Blau Galerie, München, 2017.

Feininger, Andreas: *Feiningers kleine Fotolehre. Das Geheimnis der guten Fotografie*. Knaur, 1982.

Ferrara, Eric: *The Bowery: A History of Grit, Graft and Grandeur*. History Press, 2011.

Garner, Gretchen. *Disappearing Witness. Change in Twentieth-Century American Photography*. Johns Hopkins University Press, 2003.

Geiling, Heiko. "Milieu und Stadt. Zur Theorie und Methode einer politischen Soziologie der Stadt." *Soziale Milieus und Wandel der Sozialstruktur. Die gesellschaftlichen Herausforderungen und die Strategien der sozialen Gruppen*, edited by Helmut Bremer and Andrea Lange-Veste. VS Verlag für Sozialwissenschaften, 2006, pp. 336–359.

Giamo, Benedict. *On the Bowery: Confronting Homelessness in American Society*. University of Iowa Press, 1989.

Heß, Helmut. "Mostly People. Erika Stone und die New Yorker Fotografie." *Mostly People. Fotografien einer deutschen Emigrantin in New York*, edited by Erika Stone et al., exh. cat. Zentralinstitut für Kunstgeschichte, München, 2001, pp. 4–15.

Höhne, Stefan. *New York City Subway. Die Erfindung des urbanen Passagiers*. Böhlau, 2017.

Holzer, Anton. *Rasende Reporter. Eine Kulturgeschichte der Fotojournalismus*. Primus Verlag, 2014.

Howard, Ella. *Homeless. Poverty and Place in Urban America*. University of Pennsylvania Press, 2013.

Jacobs, Jane. *The Death and Life of Great American Cities*. John Dickens and Conner, 1962.

Jäger, Jens. *Fotografie und Geschichte*. Campus Verlag, 2009.

Kelley, Etna M. "Photofinishing Plus." *Popular Photography*, vol. 20, no. 2, 1947, pp. 84–85; 192–194.

Kiosk. Eine Geschichte der Fotoreportage 1839–1973, edited by Bodo von Dewitz and Robert Lebeck, exh. cat. Museum Ludwig, Köln, 2001.

Korbut, Sasha. "Erika Stone. A Moment that Lasted a Century." Interview with Erika Stone (2015), http://www.callmesasha.com/interview/erika-stone. Accessed 21 May 2019.

Küppers, Ellen, editor. *Emigranten in New York*. Klaus Boer Verlag, 1995.

Lipton, Norman C. "20 Exciting Years With a Miniature." *Popular Photography*, vol. 25, no. 3, 1949, pp. 46–49; 144–146.

Livingston, Jane. *The New York School Photographs 1936–1963*. Tabori & Chang, 1992.

Loengard, John. "Über dieses Buch." *Die großen Life Photographen*, edited by Robert Sullivan, Schirmer Mosel, 2004, pp. 6–11.

Luce, Henry. "Foreword." *Witness to Our Time*, edited by Alfred Eisenstaedt, Viking Press, 1980.

MacFadden, Robert D. "The Bowery Follies Folds In Last Vaudevillian Fling" *New York Times*, 28 September 1970, n.p., https://www.nytimes.com/1970/09/28/archives/the-bowery-follies-folds-in-last-vaudevillian-fling-the-bowery.htm. Accessed 10 August 2019.

Marx, Henry. "Die Bowery in New York: Geschichte und Gegenwart." *Bowery. Bilder einer verrufenen Straße*, edited by Carin Drechsler-Marx, Harenberg, 1984, pp. 153–164.

Maschke, Thomas and Dieter Beckhusen, editors. *Rollei. Das große Handbuch*. Laterna magica, 1997.

Minetor, Randi. *The New York immigrant experience: trace the path of American's heritage*. Guilford, 2015.

Mostly People. Fotografien einer deutschen Emigrantin in New York, edited by Erika Stone et al., exh. cat. Zentralinstitut für Kunstgeschichte, München, 2001.

Price, Jack. "Flashbulbs in the Making." *Popular Photography*, vol. 2, no. 4, 1938, pp. 24–25.

Purcell, Kerry William. *Weegee*. Phaidon, 2004.

Raebrun, John. *A Staggering Revolution. A Cultural History of Thirties Photography*. University of Illinois Press, 2006.

Riis, Jacob A. *How the Other Half Lives*. C. Scribner's Son, 1890.

Schaber, Irme. "'Es war nicht einfach für mich, die in Berlin begonnene Arbeit fortzusetzen.' Fotografinnen im Exil der NS-Zeit." *Grenzen überschreiten. Frauen, Kunst und Exil*, edited by Ursula Hudson-Wiedenmann and Beate Schmeichel-Falkenberg, Königshausen und Neumann, 2005, pp. 75–88.

Stölken, Ilona. *Das deutsche New York: Eine Spurensuche*. Lehmstedt, 2013.

Stone, Erika. "Es war ein Schock für mich als wir erfuhren, daß wir jüdisch sind." *Emigranten in New York*, edited by Ellen Küppers. Klaus Boer Verlag, 1995, pp. 33–47.

Stone, Erika. *Especially People. Einfach Menschen. Photographien – Photographs*. Gryphon Verlag, 2004.

The Radical Camera. New York's Photo League 1936–1951, edited by Mason Klein et al., exh. cat. The Jewish Museum, New York, 2012.

Wakefield, George L., and Neville W. Smith, editors. *Synchronized Flashlight Photography*. Fountain Press, 1947.

Weegee. *Weegee's New York. 335 Photographien 1935–1960, mit einem autobiographischen Text*. Schirmer/Mosel, 1982.

White, E.B. *Here is New York*. Harper & Bros, 1948.

Women of the Photo League, edited by Lili Corbus Bezner et al., exh. cat. Light Factory Photographic Arts Center, Charlotte, N.C., 1998.

Changing Practices: Interventions in Artistic Landscapes

Temporary Exile

The White Stag Group in Dublin, 1939–1946

Kathryn Milligan

Writing on art and exile, Linda Nochlin noted that throughout art history mobility has been an intrinsic part of artistic careers, as artists have often

> […] been obliged to travel, to leave their native land, in order to learn their trade. At one time, the trip to Rome was required, or a study-voyage to Italy; at other times and under special circumstances, it might be Munich or Spain or Holland, or even North Africa; more recently, Paris was where one went to learn how to be an artist […]. (Nochlin 1996, 318)

Indeed, this pattern of international training and travel has been central to the development of art in Ireland, leading to an identification of the country as a place where artists *left* rather than as a site of arrival. More recently, scholars have sought to counter this prevailing narrative, focusing, for example, on visiting artists in Ireland during the 18th and 19th centuries (McGee 2014; Figgis 2016). In contrast to these periods of temporary migration, usually made in pursuit of pecuniary opportunity, the history of the White Stag Group is more deeply connected to a different form of artistic mobility: that is, of temporary exile during a period of conflict. Formed in London in 1935 by Basil Rakoczi and Kenneth Hall, the White Stag Group sought to bring together "notions of subjectivity and psychoanalysis in art" (Kissane 2014, 487). The two artists had come up with the name of the group, however Hall later commented that although it did not "signify much", it was a useful way for the disparate band of artists to be recognised in the press (Kennedy 2005, 23). The collaboration between the two artists had emerged out of a previous and continuing project of Rakoczi's, the School of Creative Psychology, founded in 1933 with Herbert Ingouville Williams. Both groups operated out of Rakoczi's home at 8 Fitzroy Street, London. However, in August 1939, the three men travelled by train and boat (along with Rakoczi's son of whom he had sole custody) to County Galway on the west coast of Ireland (fig.1). Hall later recalled that:

We met in Galway and as we were getting away from the war
we would get away from it and be in the country away from it
then in those days we did not know where the war was or what
it might be in Ireland any time and any place might be bombed
so Benny looked at a map for Connemara […] and we would
get away from the war […] on Killary Bay. (Kennedy 2005, 19)

Fig. 1: Kenneth Hall, *Houses on Aran*, undated, oil on board, private collection (Image
Courtesy of Whyte's, Dublin).

As pacifists, all three were anxious to avoid conscription into the army, and neutral
Ireland offered a place of sanctuary while also being within easy reach of Britain.
Although not exiled in a legal sense, Hall at least feared conscription into the
army (Kennedy 2005, 19) and Rakoczi probably wanted to raise his son away from
the capital city of a country at war: this was a self-imposed and temporary exile,
a purposeful decision to retreat from the unfolding conflict ensuring that they
could continue their endeavours in art and psychoanalysis. While the activities
and critical reception of the White Stag Group have been documented by previous
scholars, to date there has been little consideration of the influence that the Group
had on the cultural and artistic topography of Dublin. This essay will examine the
impact of the White Stag Group on the urban environment of Dublin in the 1940s,
illustrating how it contributed to the establishment of a new artistic neighbourhood

Kathryn Milligan

in the city through a series of exhibitions and social events which would have a lasting effect on the city's cultural life, as well as outlining how it influenced other artists working in the city (most of whom had little previous exposure to subjects and concepts explored by the Group). To further contextualise the presence of the White Stag Group in Dublin, this essay will also offer a brief overview of the political cultural environment of Ireland in 1939–1945.

Ireland in the 1930s and 1940s: Independence, Neutrality and Artistic Culture

After the tumultuous years of 1916–1923 in which Ireland sought to become a sovereign, independent state, the 1930s marked a period of further nation-building, witnessing the consolidation of a sense of national identity and unity as well as the continuation of diplomatic and political exertions to win further concessions from Britain. The Irish Free State, which had come into being with the signing of the Anglo-Irish Agreement in December 1921, was a dominion of the British Empire with the final secession taking place only in March 1949 with the enactment of the Republic of Ireland Act (1948). Partition, which separated the 26-county (and predominantly nationalist) Irish Free State from the six-county and predominantly unionist Northern Ireland, was a continued source of political trouble throughout the 1930s, a fact consolidated by the declaration of war by Britain in September 1939. As part of the United Kingdom, Northern Ireland was an active participant in the conflict, while (in what was largely seen as an active statement of its sovereignty) Ireland remained neutral. Of course, given its proximity to Britain and its economic dependence on the larger island, life in Ireland changed rapidly: a state of emergency was declared, and the passage of the Emergency Powers Act (1939) enacted new governmental powers, with those relating to censorship particularly relevant for cultural life.

As a result of this, the period of the war was known, and remains known, as 'The Emergency': a somewhat quaint expression which largely elides the reality of daily life in Ireland in the 1939–1945 period, which included heavy economic and social deprivation. Despite the state's neutrality, Irish people did significantly contribute to the British war effort, largely through outward migration, with around 200,000 people leaving Ireland to fill labour requirements in Britain or to join the military. The economic necessity of this migration contrasts strongly with the arrival of the White Stag Group in Ireland; however, as historian Philip Ollerenshaw has recently noted, there was something of a contradiction at play in wartime Ireland:

From a cultural perspective, there is no doubt that the Emergency brought a sense of enforced isolation, but it also fostered initiatives to palliate that isolation, even if several of these did not survive long into the postwar period. The significance of refugees, conscientious objectors, tourists, artists, musicians and others who contributed to a cosmopolitan atmosphere during the Emergency is now widely appreciated. (Ollerenshaw 2018, 354–355)

Cultural life in Dublin experienced an unexpected flourishing during the war years. Articles about the city in the British press gave an overriding impression that Dublin was a rare site of conspicuous consumption and luxury, marvelling at the literal brightness of Dublin (there were only moderate blackout restrictions) and the availability of good food, before rationing was introduced in 1942. Newspapers and magazines advertised a wide selection of drinks, from Guinness to pink gin, as well as evenings out at the cinema, theatre or at a dance, weekend excursions around Dublin bay, or the golf links (Wills 2008, 6). As Clair Wills notes, these evocations both ignored the social deprivation experienced by many of the city's less fortunate inhabitants and were also "tinged with a fairy-tale sense of unreality, as if Ireland were a fantasy refuge from the harsh outside world, a place where moral backsliding could be indulged" (Wills 2008, 6). Although speculative, it is possible that this reputation influenced Hall and Rakoczi's decision to travel to Dublin in 1940, and perhaps influenced the decision of the other artists who later joined them there from Britain and further afield.

The conditions for making, exhibiting and selling art in Ireland during the 1930s and 1940s were limited by the general economic circumstances of the period and, added to this, debates over the purpose of art continued to dominate cultural circles. Artists were often caught between their natural connection to a broad European conversation around the form and direction of artistic practice and the political expectation that art in Free State Ireland would reflect the ideals of the nation and that work by Irish artists would be recognisably 'Irish' in both its form and subject matter (Kennedy 2016, 155–156). This tendency was best expressed through representational, academic painting, for example the painting of Seán Keating which, through the late 1910s and 1920s, had tracked the ambitions of the emergent Irish state, whether through tacit expressions of support for violent action, the disillusionment created by continual warfare – actual, cultural, and psychological – and the ultimate hope found in large-scale industrial projects, which pointed to a promising future for a new, independent Ireland (O'Connor 2013).

In contrast to this, a separate strand of visual art continued to engage with continental modernism, particularly that of French analytical Cubism which had been influential in Ireland from the early 1920s. Engagement with the various modern-'isms' had been largely reliant on artists travelling from Ireland, who would return to impart new knowledge to those not in a position to travel (Halsall 2014, 297–299), rather than through inward migration. For example, the London and Paris trained Mainie Jellett, whose Cubist paintings had received a mixed reaction in 1920s Dublin, spent much of her time in the 1930s and 1940s lecturing and teaching Irish audiences about developments in modern painting (Coulter 2014b, 242–244).

Reasonably frequent loan exhibitions from the early 20th century onwards had familiarised the art-going Dublin public with impressionism, post-impressionism and cubism, but not with the more radical experimentation of, say, Dadaism or Constructivism (Marshall 2014b, 159–160). The relationship between this European-centred outlook and the aims of the national cultural revival was often fractious: proponents of the former, outward-looking approach sought to position Ireland as a contributor to European culture, with its art and literature both shaped by and contributing to a wider cultural conversation. Against this, others argued that art in Ireland should draw its inspiration solely from the life and culture of the island itself, creating a national school of painting that was seemingly unique in its subject matter, utterly identifiable as Irish (Griffith 2017, 111–112).

The Royal Hibernian Academy (RHA) remained the foremost institution connected with visual art in Ireland: it provided professional recognition for artists in Ireland and an annual exhibition akin to those at the Royal Academy, London, and the Royal Scottish Academy, Edinburgh, with which the RHA maintained close links. During the 1940s the domination of the RHA was challenged by the emergence of another annual exhibition: the *Irish Exhibition of Living Art (IELA)*, established by a group of artists in Ireland who sought to present more modernist work (Coulter 2014a, 235–239). There was a natural alliance between the *IELA* and the White Stag Group, and many of the émigré artists associated with Rakoczi and Hall contributed to the *IELA* from 1943 onwards. Commercial galleries were slow to establish in Ireland, reflecting the sluggish nature of the art market more generally: several frame makers and restorers, such as Gorry, Combridge and Egan, had nurtured small, sometimes radical salons (O'Connor 2013, 156–158), and the establishment of the Waddington Gallery in 1928 represented a new departure for art in Ireland. Waddington cultivated established and emerging artists, often hosting exhibitions in the larger artistic centres of London and New York where there was a large Irish diasporic community (Marshall 2014a, 77; Eckett 2014, 16–17).

Despite this challenging economic and cultural environment, recent scholarship has shown how, in Dublin at least, there was some sense of cultural freedom and experimentation (Allen 2006, 186). In the 1930s, one artist described the 1920s and 1930s as "the jazz age and [...] People were in a joyous mood and everywhere cabarets and dance halls were springing up" (Anonymous 1931, n.p). Michael MacLiammoir further recalled how "the Dublin 'twenties pursued their wild way, with saxophones ever waxing and skirts ever waning and Toto Cogley's cabaret [...] they discussed over their whiskey the merits of Joyce and Picasso and felt they really were nearer to the soul of things" (MacLiammoir 1932, 11). Although somewhat beleaguered by 1939, this artistic fringe in the city was poised and ready to be reinvigorated by the White Stag Group in exile.

Arrival City: The White Stag Group comes to Dublin

In March 1940 Rakoczi took rooms at 34 Lower Baggot Street, located to the south of Dublin city centre. Once settled, he established a Dublin branch of the School of Creative Psychology there and made it the temporary home of the White Stag Group. Hall rented a flat at 30 Upper Mount Street, located roughly a block away from Baggot Street. An undated watercolour by Hall may depict his Mount Street studio (fig. 2): loosely painted in a representational and illustrative style, it shows a bright and cheerful interior space filled with paintings, and a tall easel. A further study, part of a series of watercolours showing the back of a male nude (perhaps a self-portrait), is also suggestive of the artist's living arrangements in Dublin (fig. 3), but introduces a sense of introspection that becomes more fully realised in his later subjective paintings. The trio were soon joined by several other artists seeking to escape the reaches of the war, many of whom had pre-war links to the White Stag Group, the School of Creative Psychology or London art circles more generally. Nick Nicholls (1914–1991), an English-born painter, had settled in Dublin in June 1939, along with French artist Georgette Rondel (c.1915–1942) and her German husband, René Buhler: this trio had been frequenters of the Fitzroy Street studio, and had previously travelled together in Sweden. During her time in Dublin, Rondel held two exhibitions at the Victor Waddington Galleries, with many of the works depicting scenes from around the city (fig. 4). This scene, entitled *Baggot Lane towards Government Buildings,* takes its view from the laneway located close to the street where Rakoczi was based, with the style and colouring echoing one critic's praise for her "generous colour compositions" (Anonymous 1941, 4). In June 1940, the Canadian sculptor Jocelyn Chewett (1906–1979) and her Scottish husband Stephen Gilbert (1910–2007) relocated from London, remaining in Dublin until

June 1945. From 1914 Chewett had lived in London with her family and trained in Paris before establishing her career in London following her marriage in 1935. Other émigrés included Phyllis Hayward (1903–1985), a painter with an interest in psychology who had met Rakoczi and Hall in the 1930s.

Fig. 2: Kenneth Hall, *Studio Interior*, undated, watercolour, pen and ink, private collection (Image Courtesy of Whyte's, Dublin).

Fig. 3: Kenneth Hall, *Nude in a Bedroom*, undated, watercolour, private collection (Image Courtesy of Adam's, Dublin).

Fig. 4: Georgette Rondel, *Baggot Lane Towards Government Buildings*, undated, oil on board, private collection (Image Courtesy of Adam's, Dublin).

The first official exhibition of the White Stag Group in Dublin was held in Rakoczi's flat in April 1940. Hall was surprised by the number of people who attended the exhibition opening, writing to his friend, the London gallerist Lucy Carrington Wertheim (1882–1971), that "all Dublin seems to have heard of it and to be interested and the keenness about all artistic matters is certainly extraordinary to one used to London apathy" (Kennedy 2005, 21). The exhibition also included work by the Hungarian-French painter Endre Rozsda (1913–1999), whom Rakoczi had known earlier in the 1930s, and Elizabeth Ormsby, who briefly visited Dublin from London around April 1940. Works by two Irish artists were included in this exhibition: Mainie Jellett, who became an important local supporter of the Group's activities, and Patricia Wallace (1912–1973), a landscape and portrait painter who also worked as a theatre designer. A second exhibition was held in Rakoczi's home in June 1940, and over the course of the summer months the group began to plan a larger exhibition of works of White Stag and other selected artists at the

Kathryn Milligan

Dublin Painters' Gallery. However, the wartime restrictions on the movement of goods meant that this had to be deferred until the following year, demonstrating in a very real way how the Emergency impacted on cultural life (Kennedy 2005, 23). Undeterred, the group instead opted to hold a scaled down version of the exhibition at Hall's Mount Street flat. A percentage of the exhibition admission fees and commission went directly to the artist, alleviating in a small way the artist's dire financial circumstances.

Throughout 1941, the White Stag Group held exhibitions and events at Hall's address, establishing it as an important centre for artistic discourse, activity and sociability in Dublin. The programme included life classes, lecture series and public recitals of gramophone records, all of which were advertised in *Commentary*, an art journal cum 'little magazine', produced by Sean Dorman, who also ran the Contemporary Picture Galleries at 113 Lower Baggot Street. The journal now offers an important insight into the cultural life of the city described by Ollerenshaw and Wills: in addition to a monthly article by Rakoczi over the course of 1941 and 1942, *Commentary* also ran articles on Dublin theatre (chiefly relating to the Gate Theatre which had been established by Hilton Edwards and Michael MacLiammor and which represented the pinnacle of avant-garde theatre in 1940s Dublin) and on the nascent Irish Ballet company and literary events. Although *Commentary* was made for, and certainly read by, those already open to the aims and ambitions of the White Stag Group, it was important in establishing the group in Dublin and further expands our view of the interdisciplinary cultural context in which it was operating. It speaks to a broader shift through the 1940s which, despite the constrained economic and political circumstances, sought to create new, modernist work in a variety of art forms, all of which challenged the traditional view of Irish art and culture.

In February 1942, the Group moved its premises to 6 Lower Baggot Street, which would be its final location in Dublin. In operation until 1946, this was the location for all the Group's exhibitions, including solo or two-person shows, as well as lectures and soirees. The pinnacle of the White Stag Group's Irish career came in 1944, when the *Exhibition of Subjective Art* ran from 4–22 January (Kennedy 2011, 188–190). The exhibition itself featured work by several of the artists associated with the White Stag Group, including Rakoczi, Hall, Chewett, Nicholls and Gilbert, as well as Irish recruits to the cause of subjective art, Thurloe Conolly, Patrick Scott and Doreen Vanston. Hall's *Head with a Red Eye* is characteristic of the type of work he displayed at the exhibition and shows a marked stylistic change from the watercolours of Aran and his studio. The exhibition was to have been opened by the influential British art critic, Herbert Read; however a travel permit was not granted for him to travel to Ireland for the event. In lieu of this, the critic's notes

were read to the assembled crowd, with the *Irish Times* quoting Read's statement that "in Dublin one rejoices to find that not only has art found secure shelter, but even fresh vigour", and that the painting and sculpture exhibited "seem to me to belong to the main stream of European culture" (Quidnunc 1944, 3). Two lectures were also held to expand on the themes of the exhibition: Read was to have delivered the first, so once again his notes were read in his absence, and the second was given by John Hewitt (1907–1987), the Belfast poet, art critic and curator. In contrast to previous events, these lectures were not held in the White Stag Group's own gallery or premises; rather they were delivered in The Country Shop, at 23 St Stephen's Green. Founded in 1930 by Muriel Gahan of the Irish Countrywomen's Association, the Country Shop was established to promote Irish crafts and home produce, as well as for the display of fine art. Jellett had designed the signage for the shop and was involved in advising Gahan on the artistic programme: the presence of the White Stag Group is yet further illustrative of the extent to which they had become a central fixture in Dublin's artistic firmament.

Dublin's Cultural Topography: The Effect of the White Stag Group

When Rakoczi and Hall arrived in Dublin in March 1940, the artistic topography of the city had changed little since the early 19th century (fig. 5). The nation's key cultural institutions, which included the National Library of Ireland, National Museum of Ireland and the National Gallery of Ireland, remained in situ in their purpose-built 19th century structures in a central block flanking Kildare Street to the west and Merrion Square to the east. The city's main art school, the Dublin Metropolitan School of Art, later the National College of Art, was also located here. Forming a sort of campus, the institutions were gathered around Leinster House, built in the 18th century as a private home, but given over in the 19th century to the Royal Dublin Society, which worked to promote agriculture, art and industry in Ireland. However, in 1922 the building became the home of the Irish parliament, Dáil Éireann, placing the library, museums and art school near the centre of political power. Allied to this, the chief commercial galleries mentioned earlier in this chapter were also located in this district of the city, forming a cultural hub around Stephen's Green and its adjacent shopping streets.

Kathryn Milligan

Fig. 5: Map of Dublin, showing left to right: 6 Baggot Street Lower; 35 Baggot Street Lower; 30 Mount Street Upper (© Google).

Street directories for Baggot Street and Upper Mount Street suggest that these stretches of the city made for unlikely venues for an artistic enterprise. For example, the ground floor unit of 34 Lower Baggot Street was occupied by Dr Samuel Poznansky, an osteopath, while neighbouring buildings housed a range of physicians, dentists, bicycle shops and grocers. Upper Mount Street was more residential, with some small business and political offices, as well as a hotel and nursing home: Hall did also have an interesting neighbour at number 24, where the Ling Gymnasium and Swedish Institute were located. A more artistic neighbour could be found at number 42, which housed the Academy of Christian Art and was also where George Furlong, the Director of the National Gallery of Ireland, rented a flat. The locations of the Group's residence/gallery spaces mark a notable eastern shift in Dublin's cultural life through the 1940s which would continue into the 1950s. While the national and commercial galleries remained in the city centre, the area around Baggot Street became increasingly colonised by artists and writers through these decades, receiving the designation 'Baggotonia' as a mark of its emergence as a distinct neighbourhood: other notable enterprises in the area included the Pike Theatre, a short-lived venture known for presenting avant-garde material. The area provided a mix of residential and social spaces,

including a well-known row of public houses which through the 1950s became strongly associated with the poet, Patrick Kavanagh.

By presenting its exhibitions in dual-purpose residential spaces, the White Stag Group broke with the gallery hire system that prevailed elsewhere in the city, but reports show that it also offered something new in the way that art was displayed in Dublin. A preview article in *Commentary* described how the galleries at 6 Lower Baggot Street had "white walls and gay curtains of striped blue and white [to] form a fitting background for the post-surrealistic work, initiated by Picasso and Matisse, and developed in Paris, London and Dublin by the painters of the White Stag Group along their own lines" (Anonymous 1942, 15). In 1943, the *Irish Times* further commented that "many of our galleries and their exhibitors could learn a lot about how to mount an exhibition from the exhibition opened last Friday at 6 Lower Baggot street, by five members of the White Stag group [...]. Frames, handing, and spacing are all admirably done." Unfortunately, however, that was the extent of the critics' praise, as they also noted that "the pictures themselves [...] are mostly products of that dream vision in which it is difficult to follow the artists. Some of them seem to be the products of tortured minds, but without the clarity and sharpness which characterise undoubted works of art by tortured minds" (Anonymous 1943, 2).

Among the publicly held archives for the White Stag Group there also appears a suggestion of another part of Dublin's topography: that of its gay subculture during the war years. On the reverse of an invitation for the October 1940 exhibition, a previous owner (unfortunately unknown) has reused the paper to type out a few lines of poetry about attending at White Stag Group event in Upper Mount Street. The poet does not seem to have particularly enjoyed his evening lecture – perhaps that advertised on the reverse, "Since Cubism" by Rakoczi – closing with the line "Of these they talked; Would that I might have walked!". However, it is the middle section of the ditty that is the most intriguing as it reads: "Euston Road has come to town. Soho? On no, Merely Homo."[1] While homosexuality was illegal in Ireland until 1993, the limited evidence suggests that there was an active scene in Dublin throughout the earlier part of the 20th century: although, as Diarmaid Ferriter notes, this is often revealed only in police reports (Ferriter 2009, 163). In the 1940s, middle-class cultural circles seem to have been more liberal; for example, the relationship between Edwards and MacLiammor was tacitly acknowledged by those who knew them, and their involvement in the theatre often provided a sort of 'cover' for their camp behaviour. The modernist author, Flann O'Brien (writing as Myles na gCopaleen), frequently alluded to the White Stag Group in his weekly satirical column for the *The Irish Times*: it was among the groups he labelled 'corduroys', aesthetes connected with literary, theatrical and artistic

Kathryn Milligan

circles in Dublin, and who could be identified by "the stench of oil paint" and the "fearfully interesting books littered about the floor" (na gCopaleen 1941, 2). Writing in the late 1950s, Terence de Vere White continued this moniker, writing that "[a]t the outbreak of war a corduroy panzer division descended on Dublin [...] Their commissariat was 'The Country Shop' [...] where at midday their multi-coloured uniforms provided a bright contrast to the meek tweeds and sober suits of the regular customers" (de Vere White 1957, 111). As Wills notes, this language (particularly as employed by O'Brien) seems to show "a not very subtle attack on the small gay subculture that grew up around the White Stag Group, and [...] the Gate Theatre" (Wills 2008, 287). Dorman later suggested that Rackozi and Hall were themselves a couple, stating that "They made no secret of the matter, as why should they?" (Dorman 1983, 104). Whether the suggested sexual proclivities of members of the White Stag Group were true or merely gossip wrought by their being artists and foreign, and therefore somewhat exotic, this does add another aspect to their presence in Dublin.

Conclusion: The Reception and Impact of the White Stag Group

Looking at the reception of the art exhibited by the Group, the small artistic circles in which they were operating must be borne in mind: critics who were sympathetic to internationalism and experimentation in art were among the wider social circle of the group and so were unlikely to offer anything but support and praise to the Group's activities in Dublin. At the other end of the scale, critics from the more traditionalist view were already predisposed to dislike Hall, Rakoczi and their peers (Arnold 2005, 55). Reading through contemporary reports it is evident that the perceived newness of the White Stag Group, its psychological impetus and artistic technique were more likely to be commented on, rather than any robust discussion of the artwork itself. A note of interest was added by Jellett in October 1940, who, having faced significant criticism for her own Cubist paintings in the early 1920s, sought to connect the work of the White Stag Group (as she did her own) to non-representational Celtic art – such as that found in illustrated manuscripts such as a the *Book of Kells*. The press reported that at the opening of the exhibition she stated that:

> The aim of the group was to interpret the times in which they lived. It was not hidebound to any particular school or cramped by academic conventionality. [...]. In the exhibition were many

foreign members, who brought with them ideals from abroad. In the old days Irish monks were continuously going abroad, all over the Continent, and brought back with them new ideas. (Anonymous 1940, 6)

The 1944 *Exhibition of Subjective Art* attracted more vitriolic criticism than any of the exhibitions over the previous four years. This came from general press reports as well as from established art critics: for example, a somewhat satirical column in the *Irish Independent* wrote that:

> Sometime in the middle of the Great War Dada-ism was born in the Cabaret Voltaire of neutral Zurich. In the middle of the World War neutral Dublin is having its 'white stag' of subjective art. The rose by any other name smells just the same. And whether we call Dada-ism cubism, vorticism, futurism, surréalisme [*sic*], or subjective art, it is, just the same, the periodic outcropping under a new name of the fantastic and the grotesque. For it is fantastic when a few scrawls and a few daubs which resemble most the first endeavours of our tiny tots, left alone with a pencil and some colours, are presented as serious art. (Anonymous 1944, 2)

Theodore Goodman, a theatre critic and figure on the fringes of the White Stag Group's circle, also took a longer view of the Group's work in Ireland, albeit coming to quite a different conclusion: viewing the *Exhibition of Subjective Art* as the culmination of their exhibitions in Ireland to date, he noted that "Whatever one may think of their aesthetic value, Dublin should be grateful to the group for the spade-work they have done in preparing a reactionary public to receive some of the really important experimental work of the last forty years when at last it reaches these shores after the war" (Goodman 1944, 3). The lines of connection drawn between the White Stag Group and the art of the past (whether distant as in the case of Jellett's example or more recent European movements) offered a clear attempt to link their work to a broader history of art, and the invocation of neutrality by the anonymous *Independent* reviewer makes an interesting connection between the states of Ireland and Switzerland.

By the end of 1945, the artists of the White Stag Group had begun to disperse once more: Hall returned to England, along with Chewett and Gilbert, followed by Rakoczi and Nicholls in 1946. In establishing alternative venues away from the commercial galleries of St Stephen's Green, the Group expanded the artistic topography of the city, drawing artists, writers and other cultural producers towards

Kathryn Milligan

the city's southern boundary, which would increase and coalesce in the 1950s. Despite the relative brevity of their temporary exile in Ireland, the activities of the White Stag Group offered the rising generation a different vision for artistic practice in Ireland, challenging artists to move away from the constraints of the existing cultural infrastructure, whether through engagement with their activities or through likeminded artistic bodies, such as the *IELA*. The importance of the Group to younger artists such as Patrick Scott was immense: in the 1950s Scott and his cohort ushered in a new phase of modernist experimentation in Irish art, the foundations of which can be found in the path laid by the White Stag Group. Thinking about the White Stag Group in relation to art and exile in the interwar years raises several issues important for broader considerations of this topic: for example, when viewed comparatively, the distance travelled by the White Stag artists was short and the duration of their stay brief. For Hall, Rakoczi and many others of the cohort, their decision to leave Britain was largely made from a place of privilege rather than direct persecution, coercion or financial necessity: it enabled them to continue the School of Creative Psychology and the Group more generally, leading to the *Exhibition of Subjective Art* in 1944, undoubtedly the pinnacle of their achievements. In Ireland, they not only found a place of refuge, but their presence was highly valued by the cultural cognoscenti, even if this did not translate to positive press reviews. Ultimately, the impact of the White Stag Group's temporary exile in Dublin was more influential on the city and Irish artists rather than *vice versa*: at a time when the opportunity for Irish artists to travel abroad for artistic training was curtailed, it was, in many ways, brought to their doorstep instead. The case of the White Stag Group points to the two-way nature of artistic mobility, and to an instance where the impact of arrival and relocation outweighed that of exile.

Note

[1] White Stag Group Invitation, ESB Centre for the Study of Irish Art, National Gallery of Ireland.

References

Allen, Nicholas. "Cabaret, Sex and Independence: Publishing in the Early Free State." *Print Culture and Intellectual Life in Ireland 1660–1941*, edited by Martin Fanning and Raymond Gillespie, Woodfield Press, 2006, pp. 186–205.

Anonymous. "Harry Kernoff: Firebrand Artist." *Daily Express*, 23 February 1931, n.p.

Anonymous. "Exhibition of Pictures: White Stag Group's Work." *Irish Times*, 10 October 1940, p. 6.

Anonymous. "Dublin Picture Show: Twenty-Two Exhibitors." *Irish Times*, 12 December 1940, p. 4.

Anonymous. "Miss G. Rondel's Pictures." *Irish Times*, 3 October 1941, p. 4.

Anonymous. "The White Stag Group." *Commentary*, vol. 1, no. 3, 1942, p. 15.

Anonymous. "'White Stag' Show." *Irish Times*, 19 April 1943, p. 2.

Anonymous. "Spectator's Leader Page Parade." *Irish Independent*, 5 January 1944, p. 2.

Arnold, Bruce. "Irish Art and the White Stag Group." *The White Stag Group*, edited by S.B. Kennedy, exh. cat. Irish Museum of Modern Art, Dublin, 2005, pp. 50–55.

Bartlett, Thomas, editor. *Cambridge History of Ireland: Volume Four, 1800 – present*. Cambridge University Press, 2018.

Coulter, Riann. "Irish Exhibition of Living Art." *Art and Architecture of Ireland: Volume V: Twentieth Century*, edited by Catherine Marshall and Peter Murray, Yale University Press, 2014a, pp. 234–239.

Coulter, Riann. "Jellett, Mainie." *Art and Architecture of Ireland: Volume V: Twentieth Century*, edited by Catherine Marshall and Peter Murray, Yale University Press, 2014b, pp. 242–244.

de Vere White, Terence. *A Fretful Midge*. Routledge & K. Paul, 1957.

Dorman, Sean. *Limelight over the Liffey*. Raffeen Press, 1983.

Eckett, Jane. "Art Market." *Art and Architecture of Ireland: Volume V: Twentieth Century*, edited by Catherine Marshall and Peter Murray, Yale University Press, 2014, pp. 16–20.

Ferriter, Diarmaid. *Occasions of Sin: Sex and Society in Modern Ireland*. Profile Books, 2009.

Figgis, Nicola. "The Contribution of Foreign Artists to Cultural Life in Eighteenth-Century Dublin." *Irish Fine Art in the Early Modern Period: New Perspectives on Artistic Practices, 1620–1820*, edited by Jane Fenlon, Ruth Kenny, Caroline Pegum and Brendan Rooney, Irish Academic Press, 2016, pp. 198–217.

Goodman, Theodore. "Subjective Art." *Commentary*, vol. 3, no. 2, 1944, p. 3.

Griffith, Angela. "Visualizing *To-morrow*: An Irish Modernist Periodical." *BLAST at 100: A Modernist Magazine Reconsidered*, edited by Philip Coleman, Nathan O'Donnell and Kathryn Milligan, Brill, 2017, pp. 109–130.

Halsall, Francis. "Modernism and Postmodernism in Irish Visual Art." *Art and Architecture of Ireland: Volume V: Twentieth Century*, edited by Catherine Marshall and Peter Murray, Yale University Press, 2014, pp. 297–301.

Kennedy, Róisín. "The Emergency: A Turning Point in Irish Art?" *Circa*, no. 92, 2000, pp. 24–26.

Kennedy, Róisín. "Experimentalism or Mere Chaos? The White Stag Group and the Reception of Subjective Art in Ireland." *Irish Modernism: Origins, Contexts, Publics*, edited by Edwina Keown and Carol Taaffe, Peter Lang, 2011, pp. 179–194.

Kennedy, Róisín. "Art and Uncertainty: Painting in Ireland 1912–1932." *Creating History: Stories of Ireland in Art*, edited by Brendan Rooney, exh. cat. Irish Academic Press and National Gallery of Ireland, Dublin, 2016, pp. 155–171.

Kennedy, S.B. "The White Stag Group". *The White Stag Group*, exh.-cat. Irish Museum of Modern Art, Dublin, pp. 12–47.

Kissane, Sean. "White Stag Group, The." *Art and Architecture of Ireland: Volume V: Twentieth Century*, edited by Catherine Marshall and Peter Murray, Yale University Press, 2014, pp. 487–489.

Marshall, Catherine. "Commercial Galleries." *Art and Architecture of Ireland: Volume V: Twentieth Century*, edited by Catherine Marshall and Peter Murray, Yale University Press, 2014a, pp. 76–80.

Marshall, Catherine. "Exhibitions." *Art and Architecture of Ireland: Volume V: Twentieth Century*, edited by Catherine Marshall and Peter Murray, Yale University Press, 2014b, pp. 158–164.

MacLiammoir, Michael. "The Hectic Twenties." *Motley*, vol. 1, no. 7, 1932, pp. 10–12.

McGee, Caroline. "Visiting Painters in Ireland 1800–1900." *Art and Architecture of Ireland: Painting 1600–1900, Volume 2*, edited by Nicola Figgis, Yale University Press, 2014, pp. 134–137.

na gCopaleen, Myles. "Cruiskeen Lawn." *Irish Times*, 10 October 1941, p. 2.

Nochlin, Linda. "Art and the Conditions of Exile: Men/Women, Emigration/Expatriation." *Poetics Today*, vol. 17, no. 3, 1996, pp. 317–337.

O'Connor, Éimear. *Seán Keating: Art, Politics, and Building the Irish Nation*. Irish Academic Press, 2013.

Ollerenshaw, Philip. "Neutrality and Belligerence: Ireland, 1939–1945." *Cambridge History of Ireland: Volume Four, 1800 – present*, edited by Thomas Bartlett, Cambridge University Press, 2018, pp. 340–378.

Pilkington, Lionel. "The Little Theatres of the 1950s." *The Oxford Handbook of Modern Irish Theatre*, edited by Nicholas Grene and Chris Morash, Oxford University Press, 2016, pp. 286–306.

Quidnunc (Patrick Campbell). "An Irishman's Diary: Subjective Art." *Irish Times*, 6 January 1944, p. 3.

Wills, Clair. *The Neutral Island: A Cultural History of Ireland During the Second World War*. Faber and Faber, 2008.

Inner City Solidarity

Black Protest in the Eyes of the Jewish New York Photo League

Ya'ara Gil–Glazer

Introduction

The New York Photo League (1936–1951) was a collective of photographers whose members documented life in the city's lower-class neighbourhoods. Most of its leading members, including both founders – Sid Grossman and Sol Libsohn – were Jews who grew up in Manhattan's Lower East Side, the Bronx or Brooklyn, part of a large community of Yiddish-speaking working-class families who emigrated from Eastern Europe. Whereas the Jewish aspect is not central to their writings, as they tended to turn their backs on religion and tradition, their Jewish identity was reflected in a different way, through their documentation of New York's Others, including the black community in particular (Dash Moore 2008; Meyers 2003).[1]

The League's photographers, together with the better-known Resettlement Administration/Farm Security Administration (RA/FSA) photographers (1935–1942), formed one of the first visual archives made by white photographers, which represented the African-American community with respect and empathy, combined with a reformative passion (Natanson 1992; Blair 2007). While black studio photographers have been documenting their communities from the dawn of photography and while since the 1930s black photojournalists have published in newspapers and magazines addressed to black readers, before the 1960s few black photographers documented their people with a deliberate social approach or defined themselves as "graphic historians" aiming to raise social awareness (Willis 2000, xv, 85; Sengstacke, in Willis 2000, 112) – certainly not for a white audience.[2] Thus, the photographic encounter involved Jews who had replaced a traditional migrant identity with a leftist and secular one and blacks who had emigrated from the South in the beginning of the 20th century to form a lively community in Harlem.

The heart of the League was its school, established in 1938. It was the first in the US to focus on socially oriented documentary photography. Its crown jewel was the documentary workshop (Tucker 1994). The photos produced by the school's graduates and teachers, and other League members, were published in class-conscious newspapers and magazines such as *New Masses* and *PM*. Their works were also presented in community centres and libraries in the very neighbourhoods they documented, as well as in their own gallery located together with the school on 31 East 21st Street. Another major publication channel was their bulletin, *Photo Notes*, where they reported on the League's multiple activities and discussed the theory and practice of documentary photography in depth.

Part of the nationwide social documentation movement and New York's leftist milieu, League members drew their inspiration from photographers of the previous generation such as Lewis Hine and Jacob Riis and the work of the contemporary RA/FSA. Together with many other artists, intellectuals and activists who believed in the transformative power of art and photography in particular, they were branded as radicals. In 1947, the League was placed on Attorney General Tom Clark's list of 'subversive organisations', which also included the Congress of American Revolutionary Writers, the Civil Rights Congress and its affiliated organisations, the National Negro Congress, Southern Negro Youth Congress and many more (Anonymous 1947).

The literature on the League has expanded significantly in recent decades. This includes growing attention to its Jewish aspect, seen as emblematic of (Jewish) documentary photographers' historical dominance, particularly in New York, almost a third of whose inhabitants in 1940 were of Jewish origin (e.g. *New York: Capital of Photography* 2002; Meyers 2003; Trachtenberg 2003; Dash Moore 2008). Also extensively studied are Jewish-black collaborations in left-wing circles and artistic milieus, mainly in the 1930s and 1940s (e.g. Diner 1995; Adams/Bracey 1999; Philipson 2000; Hubbard 2007). This body of research has provided the basis for a contemporary cultural-historical study in diverse contexts, including music, literature and photography (e.g. Blair 2007; Goffman 2012; Katorza 2017). So far, however, relatively little attention has been devoted by this interdisciplinary literature to the work of Jewish League photographers on the 'archive' of photos documenting black people's lives, even less so in the activist context.

This article addresses a specific aspect of the photographic archive of black urbanism created by the Photo League: photographs of explicit and implicit protest against the discrimination of blacks and against racism, as well as for equality between blacks and whites, presenting complex connections between subjects, photographers and urban landscape. In particular, it is focused on images

produced by three of Grossman's Jewish students – Sonia Handelman-Meyer, Vivian Cherry and Rosalie Gwathmey. After discussing the centrality of blacks to the documentation by these and other League photographers and the ways in which they documented blacks, a photograph by each is examined through contextual analysis, including a discussion of the photographs' visual contents and their broader historical and cultural contexts.

Why did Jews photograph blacks? The Photo League and black New York

In 1993, William Meyers asked the participants in a colloquium on Jews and photography why the Jews, of all ethnic groups in New York, "took it into their heads to go to Harlem and photograph the blacks there". One of the former Photo League's milieu replied, "We weren't Jews; we were leftists" (Meyers 2003, 47). Left-wing views were indeed particularly strong among the first- and second-generation Jewish immigrants from Eastern Europe. They grew out of economic hardships and the emergence of a large Jewish working class that struggled against political oppression (Michels 2012).

The Photo League was part of the unusual dominance of Jews in American photography, mainly social documentary photography. A central reason for this phenomenon might be the role played by the medium as a vehicle of social integration. According to Eli Lederhendler (2001), Jews who had immigrated to the US adjusted to the demands of the local market and acquired new professions, which also served their social mobility. A new and popular profession that could be acquired relatively quickly and with little capital investment, photography was a perfect example. It also served to create a modern American identity for the photographers, substituting for the diasporic Jewish one.

When referring to that phenomenon, Max Kozloff and other scholars suggest a particular Jewish perspective or 'eye' in the way New York was photographed by Jews in the 20th century (*New York: Capital of Photography* 2002; Meyers 2003; Trachtenberg 2003). Sara Blair (2007) and Deborah Dash Moore (2008) consider the League photographers as belonging to the New York School, together with other contemporary Jewish photographers of the first and second generation of the huge migration movement from Eastern Europe between 1881 and 1924.[3] These photographers, most of whom were affiliated with the League, such as Lisette Model, Weegee and Helen Levitt, "began their careers working in and with Yiddish-speaking, African-American, working-class, gay and drag, and other marginalized communities" (Blair 2007, 121). The Photo League Jewish

members' focus on blacks reflects their deep faith in photography as a means for social change, which goes hand in hand with the strong Jewish affiliation with socialism. This also relates to the mutual connections and the identification of blacks and first- and second-generation Jewish immigrants in the socialist-activist arena, and to the social activism that dominated early 20th-century Harlem in particular (Michels 2012). Both minorities were among the most rejected in the US, particularly during the Depression. In New York they also shared the fact of being relative newcomers (Mendes 2014; Michels 2012). These commonalities were also expressed in political cooperation, including Jewish support for the NAACP and black trade unions. Indeed, the above-cited words echo the famous statement of the Jewish sections of the Socialist Labor Party of America: "We are not Jewish socialists, but Yiddish-speaking socialists" (Frankel 1984, 466). It also illustrates how League members, like other American Jewish photographers, replaced religion and tradition with a socialist identity (Trachtenberg 2003). As such, they felt compelled to photograph blacks as those "most vulnerable to the riptides of capitalism in a multiethnic metropolis" (Dash Moore 2008, 86).

In keeping with the League's leftist agenda and with the disproportionate involvement of American Jews in "politics for social justice" (Katorza 2017, 17), New York's blacks also reflected the Jewish photographers' own lives in the city's margins. Both blacks and Jews, despite significant differences, were Others in the big city and in American society as a whole (Katorza 2017). Both were relative newcomers: the blacks arrived following World War I and the Jews from the late 1800s, and suffered racism, discrimination and exploitation in the urban labour market, and both represented the minorities that were America's most rejected in the 1930s – the Depression era (Michels 2012; Mendes 2014; Katorza 2017). Thus, the Jewish photographers were Others who photographed other Others and at the same time looked at themselves in different and complex ways.

This shared fate and mutual identification of Jews and blacks in the early 20th century is reflected in the contemporary Yiddish-language press, mainly in left-wing newspapers such as *Forward*. These newspapers expressed support for black organisations such as the NAACP as well as for black unions (Diner 1995; Lederhendler 2016).[4] Radical black publications such as the NAACP magazine *The Crisis*, in turn, expressed solidarity with Jewish workers; for example, they endorsed a Jewish lawyer's candidacy for chief justice and denounced Nazi persecution of European Jews (Diner 1995; Salzman/West 1997).[5]

Ya'ara Gil–Glazer

In the parallel history of the Jews' and blacks' immigration to New York, the former are identified with the Lower East Side (quarter) and the latter with Harlem (e.g. Rottenberg 2013). Indeed, when the Jewish League members photographed blacks in Harlem, some of them actually saw themselves and the neighbourhoods in which they had grown as reflected in the words of Walter Rosenblum:

> […] It is true that many of our members did not concern themselves with the natural scene. […] because they were brought up in an environment of crowded tenements. […] We feel deeply about the people we photograph, because our subject matter is of our own flesh and blood. In Harlem or on the East Side, we aren't tourists spying on the quaint mannerisms of the people. We aren't interested in slums for their picturesque qualities. The people who live in them are our fathers and mothers, our brothers and sisters. The kids are our own images when we were young. (Rosenblum 1948)

However, as elaborated below, the League photographers' gaze on blacks in New York's inner-city neighbourhoods was more than just empathetic – it was diverse and complex, and differed according to two major sub-schools led by Grossman and by Aaron Siskind, another dominant League teacher. The differences between them are evident in politics, ethics and aesthetics. While Grossman's sub-school was intensely involved with its subjects in terms of interaction, authenticity and complexity of content, Siskind's sub-school was much more distant and impersonal, producing a more stylised and formalist photography.

Jewish Photo League photographers' gaze(s) on urban blacks

The League's school was the first in the US to focus on social-documentary photography, at a time when most (such as Clarence White's school, the San Francisco Institute of Art and the California School of Fine Arts (CSFA)) focused on technical and/or commercial aspects (Lee, in Tucker 2001; *The Uses of Photography* 2016).[6] The school, headed by Grossman, initially offered a basic course, a course on technique and the documentary workshop (Tucker 1994). It provided afternoon and evening classes at nominal cost, training some 1,500 photographers – some of whom became teachers – and offered a meeting place for professional and amateur photographers (VanArragon 2006). In addition to the practical courses,

its teachers also taught theoretical courses and organised public meetings and lectures thoroughly discussing documentary photography. This discourse was also articulated in the *Photo Notes* monthly, defined at the time by photographer Edward Weston as "the best photo magazine in the country" (Lyons 1977, n.p.). The non-profit-making school was defined in *Photo Notes* as "unique in [its] progressive educational method" (Anonymous 1949, 16). Its documentary classes are considered early examples of the "modern workshop" that combined independent project work with group discourse under the influence of the Bauhaus and other progressive movements. A key feature of these workshops was "education as a laboratory" of "learning through practice" (Burnett 2007, 109, 217), reflected, for example, by the League teachers' insistence that the students study on the streets, with their works subsequently being discussed in class (Klein 2011).

The modern workshop approach was optimally applied by the League's "feature groups", which included teachers and students working for extended periods in poor neighbourhoods to gain acquaintance with their inhabitants and characteristics (Tucker 1994; Warren 2005; Klein 2011).[7]

As mentioned above, the best-known feature groups were led by Grossman and Siskind. Despite sharing broad characteristics, there were significant differences between the political-ethical-aesthetical approaches of Grossman's and Siskind's sub-schools. These included the photographers' approach to the contents in terms of their sociopolitical worldview that informed their interactions with the subjects and the techniques used to capture them. The discourse shaped by Siskind's sub-school, which was responsible for the *Harlem Document* (1938–1940) – the League's most ambitious project of documenting the neighbourhood and its residents – emphasised the Harlem's poor living conditions at the expense of other, significant aspects of black culture. Their portrayal of blacks in everyday scenes was often stylised, including extreme shades and highlights, intense facial expressions and a generally dramatised atmosphere (e.g. Sol Prom, *Shoeshine Boy*, 1937; Morris Engel, *Street Showers*, 1938). Indeed, black visitors to the 1939 *Harlem Document* exhibition at the local YMCA complained that it emphasised poverty and sorrow, while neglecting other aspects of Harlem life, such as "the intellectual and cultural" (Anonymous 1939, 2). Siskind also admitted this neglect in retrospect, saying that the group's "study was definitely distorted […] there were a lot of wonderful things going on in Harlem. And we never showed most of those" (Corbus Bezner 1999, 26).

Harlem Document photographs were also exhibited in popular magazines, where they took the Siskind sub-school's approach even further by being attached to texts that underplayed or even denied the project's political aspect. For instance, a photo-essay in *Look* (1940) included an image of five children on a street bench

with the caption "Five Social Problems", describing them as typical of the "dangerous" neighbourhood where they were destined to live for the rest of their lives – creating the impression that Harlem youth were predisposed to violence (Massood 2013).

The works of Grossman and his students, on the other hand, articulate much stronger emphatic identification with their subjects, with their gaze capturing intricate layers of black lives. The street photographers of the Grossman sub-school do not isolate blacks from whites as in most images included in the *Harlem Document,* and some also document interracial street conversations or leisure activities such as dances at the Savoy Ballroom; moreover, they do not depict low class blacks differently from their depictions of low-class Jews in their own neighbourhood, as in Pitt Street (Ings 2004). This realistic and egalitarian approach can also be seen in Grossman's 1939 work for the New Deal's Works Progress Administration, in which he documented New Deal projects in the neighbourhood, such as a school and a public swimming pool. Independently of the League, in the 1940s he also produced inspiring portraits of musicians and singers such as Billie Holiday and Josh White, who represented the "intellectual and cultural fulcrum" in American black history, known as the 'Harlem Renaissance' (Wintz/Finkelman 2012, xi).

Grossman's sub-school documents black urban protest

Much unlike the spirit of the *Harlem Document*, Grossman and his students also documented black protest both overtly and covertly, as in some a message of protest is conveyed by the photographers themselves. Grossman's photos, for instance, presented local businesses that provided services whites would not provide to blacks, such as beauty salons, barbers' shops and tailors' shops (Ings 2004). A photo of the sign of the Universal Negro Improvement Association (UNIA) taken by Grossman in 1939 indicates identification with this organisation and gives it visibility. A photograph of a black "union supporter picketing the Lenox Fruit & Vegetable Market in Harlem" (1939) also expresses identification with the union he represents and its struggle. Such engaged works that also emphasised Harlem's vitality were Grossman's deliberate reaction to the emphasis on gloomy poverty by Siskind's sub-school (Davis 2016).

Whereas the protest against the discrimination of blacks and the call for equality in Grossman's photographs is expressed rather implicitly, three of his students – Sonia Handelman-Meyer, Vivian Cherry and Rosalie Gwathmey – addressed the issue more directly in a relatively late but crucial phase in the League's activity, and did so in a sophisticated and nuanced way. All three women were staunch leftists and highly aware of the subjects selected for their work, documented in

a way that blends assertiveness and sentiment. The remainder of this article is a contextual analysis of three photographs by Handelman-Meyer, Cherry and Gwathmey, documenting black protest in urban space. These photographs were created in the embryonic days of the Civil Rights Movement, foreshadowing the work of other Jewish photographers such as Danny Lyon, Bob Adelman and Richard Avedon in the 1960s with the Student Nonviolent Coordinating Committee (SNCC) side by side with black photographers and activists, such as Elaine Tomlin, Bob Fletcher and Dough Harris. As mentioned above, it was during this period, after the Second World War, that the League also fell victim to the Cold War red-baiting.

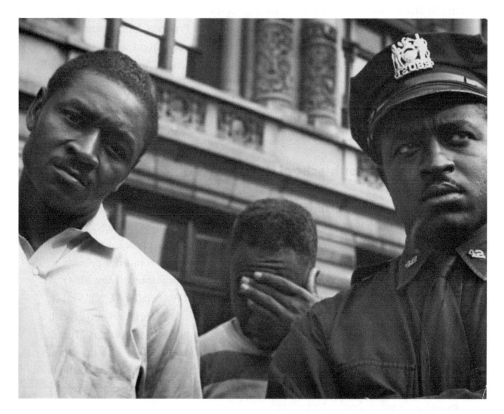

Fig. 1: Sonia Handelman-Meyer, *Anti-Lynching Rally, Madison Square Park,* 1946, 18,73 x 24,13 cm (Columbus Museum of Art, Ohio: Photo League Collection, Gift of the Artist).

Ya'ara Gil–Glazer

Handelman-Meyer's *Anti-Lynching Rally, Madison Square Park* (1946, fig. 1) and Cherry's *Playing Lynched, East Harlem* (1947, fig. 2) touch upon a painful and poignant issue in American history. During the war years, lynching became an even more shameful symbol of American racism and was harshly criticised by human rights organisations – particularly in the Jewish leftist press, which even compared the practice with Auschwitz.[8] At the same time, the issue was used by Soviet Anti-American propaganda (Walter 2005). Lynches were common mainly in the South between the end of the Civil War and the late 1960s, with the peak being between the 1890s and late 1920s (Raper 1933).[9] The perpetrators often evaded conviction.[10] Ever since the early days of photography, lynches have been documented by the perpetrators as a 'confirmation' of white supremacy and a spectacle distributed to a huge audience of newspaper readers, and sold door to door. These documentations subsequently served as evidence by anti-lynching activists (Raiford 2006; Manna 2005). In figures 1 and 2, the rural southern landscape of these spectacle images and the gazes of the white audience around the victim hanging on a tree are replaced by an urban northern landscape showing blacks' complex responses to the heinous crime.

Shot in Madison Square Park, Handelman-Meyer's photo documents a protest march to promote stricter laws against mob violence, following a lynching in Georgia that became notorious in the entire country, in which four black tenant farmers from a single family were murdered, including a young woman who was seven months pregnant (Handelman-Meyer 2009; Raiford 2009; Thiede 2015). Without its title, *Anti-Lynching Rally*, the photograph can be interpreted as documenting a violent incident or a day of mourning. A kind of triangle is created by the looks of the three black subjects: a police officer in the forefront to the right gazes upward with concern, next to him a man looks directly at the photographer/viewer in a gaze of reserved agony, and behind them is another man, his eyes covered by his hand in sorrow. Beyond the specific moment taken out of the context of the march, but still clearly situated in public space, the photo is pervaded with doom, shock and pain. Handelman-Meyer defined herself as a "radical", intellectually motivated, "emotional photographer" (Thiede 2015; Rab 2018). All these aspects come together poignantly in the photo. Catherine Evans considers it representative of "less political" photos taken by women who joined the League after the war, since its political context is implicit (Klein/Evans 2011, 52). The photographer's choice of focusing on that powerful and restrained emotional moment, however, expands the shocking event and connects it to the long and silenced history of lynching. Thus, together with its title, it becomes a powerful statement of protest, particularly if we imagine the three black men in the photo as replacing the white crowd watching the lynch events in the historical spectacle photos in the South, and demanding justice.

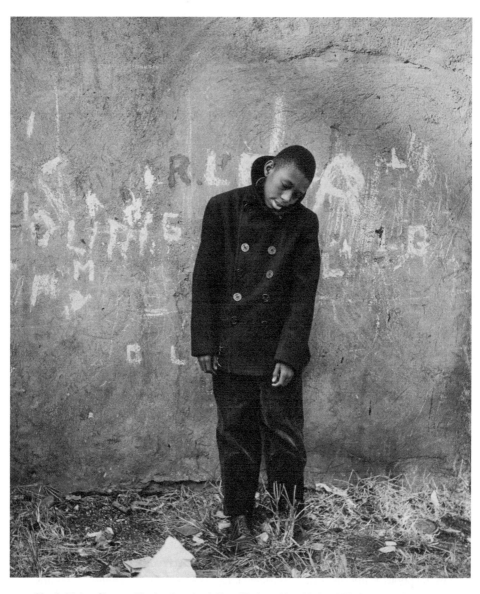

Fig. 2: Vivian Cherry, *Playing Lynched, East Harlem, New York,* 1947, 31,4 x 26,7 cm
(The Jewish Museum, New York / Art Resource, NY).

Cherry's photo is part of a series that documents a group of children playing
at 'lynching' in East Harlem, and more generally of representations of violence
in children's games, which include at least one other emotionally laden historical

Ya'ara Gil–Glazer

issue – cowboys and Indians. At the same time, in different photos, the series presents a friendly game between black, Hispanic and white children. Each in turn is the lynch victim. Unlike the broad context of Harlem street views typical of Grossman's photography, figure 2 shares with figure 1 a direct close-up, which detaches the viewer from the street context and focuses her or his gaze on the subjects and their expressions. The uniform urban landscape that serves as the backdrop for the figure in figure 2 is a derelict external wall. The graffiti painted on it seems to hint at a hangman's rope with the shut-eyed black child simulating the body and head postures familiar from the spectacle photographs documenting lynches. These have played a "crucial if unacknowledged" role in what is defined by Raiford as "the shadow archive of black representation" (Corbus Bezner 2006, 24).

It is difficult not to think that, had they been living in the South, those same black kids could have been actual lynch victims. It is hard not to think about Emmett Till, who was then almost their age and was brutally lynched less than ten years later; the distribution of the photo of his body by his mother proved to be a crucial activist protest that helped to kick-start the Civil Rights Movement.[11] *McCall's* women's magazine refused to publish Cherry's lynching series, claiming the images were too realistic and that the readership would not identify with them. Even when published in two periodicals – one and five years after being taken – the accompanying text did not address the historical violence or the poverty in Harlem, but described the images as the result of using the camera "as a tool for social research" (Evans 2011, 54). This illustrates the still widespread cultural silencing of the history of lynching (Farrell 1998; Lightweis-Goff 2011), highlighting the important and still relevant activist message delivered by images such as Cherry's.

Shout Freedom (Charlotte, North Carolina) by Rosalie Gwathmey (1948, fig. 3) looks like a classical street photo, presenting an ironic decisive moment: a black girl marching head high looking at the photographer/viewer with confidence mixed with shyness intersects with the image on the large billboard behind her, entitled "Shout Freedom". Irrespective of the original context and the knowledge that it would take almost two more decades to end racial segregation, the connection between the girl – described by Lili Corbus Bezner as trapped in "an unattractive urban space" (Corbus Bezner 2006, 54) – and the text seems like a utopian call for black equality at the height of the Jim Crow era in the South. The billboard, however, publicises a musical by LeGette Blythe, whose title refers to the freeing of white settlers from British rule. It was displayed that year near Charlotte to mark the anniversary of the signing of the Mecklenburg Declaration of Independence in that town in 1775. A widely disputed event, it is considered by some to be the first of its kind, signed a year before the official declaration of the 13 Colonies (Syfert 2014). To the right is a man in typical colonial clothes who seems to march

jovially from its right to its left in the deep background, with the girl marching forward from the left towards the front of the photo. According to Corbus Bezner, Gwathmey, herself born in Charlotte, visualises "the hypocrisy of racism" in this image (Corbus Bezner 2006, 54). The irony she captured makes the billboard

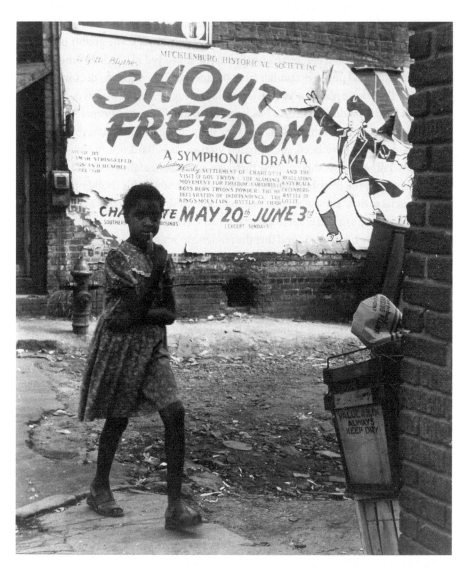

Fig. 3: Rosalie Gwathmey, *Shout Freedom, Charlotte, North Carolina,* 1948, 20 x 17 cm (Columbus Museum of Art, Ohio: Photo League Collection, Museum Purchase with funds provided by Elizabeth M. Ross, the Derby Fund, John S. and Catherine Chapin Kobacker, and the Friends of the Photo League).

Ya'ara Gil–Glazer

even more protestive. Like Handelman-Meyer's and Cherry's photos, this one also ties past and present together and compares them to cast doubt on the equality guaranteed in the American Declaration of Independence: by "placing the girl in the context of colonial men and women who fought and died […] for freedom, Gwathmey seems to ask, What about *this* girl's freedom?" (ibid., 54f.).

Conclusion and afterword

Taken between the mid-1930s and the late 1940s, photos by League photographers of blacks, and particularly of black protest in urban space, are laden with complex meanings. These include the relationship between first- and second-generation black and Jewish migrants in America at the dramatic milestone where the term racism became shockingly central in world history. Events on both sides of the Atlantic brought the histories of blacks in the US and of Jews in their countries of origin together with unprecedented intensity. It was a time when the "contradictions of fighting a war against racism abroad while maintaining segregation at home" were powerfully evident (Cashman 1998, 302; see also Farrell 1998).

The three photos discussed above represent yet another symbolic meaning. They were taken in the three consecutive years immediately following the end of Nazi horrors and World War II, which the US viewed as a "war for democracy" (Chafe 2003, 21). Ironically, these were also the years when the League, and specifically Grossman, was persecuted by the FBI, which would soon force it to close. The photos taken by Grossman's students Handelman-Mayer, Cherry and Gwathmey capture that moment, when League member Walter Rosenblum asked, "How can one be censured for being interested in one's fellow man?" (Rosenblum 1948).[12]

The direct and indirect protest in public space presented in the photos connects the historical moments described above with layers of derivative implications and contradictions. They are intensified by the gazes of the subjects, which present an emotional range stretching from pain through anger to assertiveness. The interest of the Jewish photographer in her fellow black subject reflected in them turns them into major visual harbingers of the emergence of the Civil Rights Movement in the 1950s and of the use of photography as a vehicle of visual protest by both black activists and Jewish photographers. As suggested and warned by Catherine Evans (2010), they serve as "potent reminders that many of the issues depicted in the middle decades of the twentieth century burden our world today" (n.p.).[13] Beyond their unfortunate lingering relevance, the photos of the League are not only distinctively impressive and moving, but also offer the hope and call for human solidarity in the face of racism and the violence inherent in it.

Notes

1 Among the League's founding and later prominent Jewish members were Sid Grossman, Sol Libsohn, Aaron Siskind, Sonia Handelman-Meyer, Walter Rosenblum, Morris Engel, Sol Prom, Vivian Cherry, Jerome Liebling, Arthur Leipzig and Ruth Orkin.

2 Black photographers took pictures for a black audience, particularly studio portraits that have created a collective archive of their communities, mainly in the large cities in the north. One of the leading photographers in this category active during the period under study was James Van Der Zee, who owned a photography studio in Harlem and documented black artists, boxers and other celebrities. He was also the Universal Negro Improvement Association's official photographer. The Smith brothers (Morgan and Marvin) were also prominent studio photographers in Harlem in those years. An exceptional contemporary black photojournalist who documented black protest marches and was known for documenting the exploitation of black women in the labour market was Robert H. McNeill (Willis 2000). An exception – to the rule of working for a black audience – was Gordon Parks, the only black photographer in the FSA, who was employed there only thanks to a fellowship from the Julius Rosenwald Fellowship. After the war he worked as a photojournalist for magazines such as *Vogue* and *Life* as well as for black magazines such as *Ebony* and documented harsh black lives in Harlem, as well as Black Power leaders such as Malcolm X and Stokely Carmichael (Willis 2000; *A Force for Change* 2009; Wintz/Finkelman 2012).

3 See for example Eric L. Goldstein. "The Great Wave: Eastern European Jewish Immigration to the United States, 1880–1924." *The Columbia History of Jews and Judaism in America,* edited by Marc Lee Raphael, Columbia University Press, 2009.

4 The Jewish press expressed support for the Scottsboro Boys, for example, whose case was seen as "stemming from the same source of racial hatred responsible for rising anti-Semitism and pro-fascist sympathies both at home and abroad" (Century 2007, 28).

5 Note that the relationship between blacks and Jews was not without significant tensions. Jews advanced in the local economy and politics and became building owners and employers as well as exploiters of blacks (Baldwin 1948; Salzman/ West 1997; Lederhendler 2001; Michels 2012; Katorza 2017). Reactions to these tensions can be seen in League photos: images of small black businesses could be interpreted as reclaiming the streets of Harlem, while images of poor housing conditions called for action against capitalists, including Jewish landlords.

6 The progressive New School of Social Research was also a socially oriented photography institute, and some of its teachers also taught in the League school, but the emphasis on social-documentary photography remained unique to the latter (VanArragon 2006).

7 Other teachers, including Lou Bernstein, Libsohn, Rosenblum and Siskind, subsequently moderated other courses and workshops. Members of the League's advisory committee provided lectures and texts discussed in workshop meetings; these included photographers Paul Strand and Berenice Abbott, as well as her partner, the art and photography critic Elizabeth McCausland.

8 For example, the NAACP's newspaper *The Crisis* wrote in June 1941: "America is

marching to war for the purpose of stopping brutalities overseas, but apparently our government does not choose to stop lynching within its own borders [...]." (183). See also Diner 1995; Lederhendler 2016.

[9] See also "Lynching, White and Negroes, 1882–1968." *Tuskegee University Archives*, http://192.203.127.197/archive/bitstream/handle/123456789/511/Lyching%20 1882%201968.pdf. Accessed 11 February 2019.

[10] According to senator Kamala D. Harris (2018, n.p.): "From 1882 to 1986 there have been 200 attempts that have failed to get Congress to pass federal anti-lynching legislation."

[11] Emmett Till was an African-American boy from Chicago, who was viciously murdered when visiting his relatives in Mississippi. Apparently, while there he flirted with a young white woman. A few days after he met that woman, her husband and his half-brother kidnapped Till from his relatives' house at night, and three days later his body was found floating in a lake, with severe torture marks, in addition to a bullet shot directly into his skull. This highly publicised case was one of the events leading to the creation of the Civil Rights Movement. See Goldberg 1991; Whitfield 1991; Goldsby 2006.

[12] As a result of the FBI's pressure, Gwathmey destroyed most of her negatives and stopped photographing (Davis/Emerson 2015).

[13] Significantly, this alliance has resurfaced in the intensive collaborations between black human rights activists such as SNCC members Ella Baker, Julian Bond and John Lewis and young Jewish photographers who were just as devoted to the cause as their League predecessors, including Bob Adelman, Matt Herron and Danny Lyon (Raiford 2011).

References

A Force for Change: African American Art and the Julius Rosenwald Fund, edited by Daniel Schulman, exh. cat. Spertus Museum, Chicago, 2009.

Adams, Maurianne, and John H. Bracey, editors. *Strangers & Neighbors: Relations between Blacks & Jews in the United States.* University of Massachusetts Press, 1999.

Anonymous. "Exhibitions: Feature Group's 'Toward a Harlem Document.'" *Photo Notes*, April 1939, p. 1f.

Anonymous. "Groups Called Disloyal." *New York Times*, 5 December 1947, 18.
Anonymous. "Photo League's School." *Photo Notes*, Spring 1949, p. 16.

Blair, Sara. *Harlem Crossroads: Black Writers and the Photograph in the Twentieth Century.* Princeton University Press, 2007.

Burnett, Christopher. "Photographic Workshops: A Changing Educational Practice." *The Concise Focal Encyclopedia of Photography: From the First Photo on Paper to the Digital Revolution*, edited by Michael R. Peres, Focal Press, 2007, pp. 107–116.

Cashman, Sean D. *America Ascendant: From Theodore Roosevelt to FDR in the Century of American Power, 1901–1945.* NYU Press, 1998.

Century, I. "Free the Scottsboro Boys!" *Jewish Currents*, September 2007, pp. 28–29.

Chafe, William H. *The Unfinished Journey: America since World War II.* Oxford University Press, 2003.

Corbus Bezner, Lili. *Photography and Politics in America from the New Deal into the Cold War.* Johns Hopkins University Press, 1999.

Corbus Bezner, Lili. "Picturing Charlotte: An Introduction to Rosalie Gwathmey's Photographs of African Americans in the 1940s." *Studies in Popular Culture*, vol. 29, no. 2, 2006, pp. 39–67.

Dash Moore, Deborah. "On City Streets." *Contemporary Jewry*, vol. 28, no. 1, 2008, pp. 84–108.

Davis, Anita Price, and Jimmy S. Emerson. *New Deal Art in Alabama: The Murals, Sculptures and Other Works, and Their Creators.* McFarland, 2015.

Davis, Keith F. *The Life and Work of Sid Grossman.* Steidl, 2016.

Diner, Hasia R. *In the Almost Promised Land: American Jews and Blacks, 1915–1935.* Johns Hopkins University Press, 1995.

Evans, Catherine. "Shout Freedom! Why the Photo League Matters." *The Photo League at 75*, edited by Stephen Daiter, Stephen Daiter Gallery, 2010.

Evans, Catherine. "As Good as the Guys: The Women of the Photo League." *The Radical Camera: New York's Photo League, 1936–1951*, edited by Mason Klein and Catherine Evans, Yale University Press, 2011, pp. 46–59.

Farrell, Kirby. *Post-Traumatic Culture: Injury and Interpretation in the Nineties.* Johns Hopkins University Press, 1998.

Frankel, Jonathan. *Prophecy and Politics: Socialism, Nationalism, and the Russian Jews, 1862– 1917.* Cambridge University Press, 1984.

Goffman, Ethan. *Imagining Each Other: Blacks and Jews in Contemporary American Literature.* New York University Press, 2012.

Goldberg, Vicki. *The Power of Photography: How Photographs Changed Our Lives.* Abbeville Publishing Group, 1991.

Goldsby, Jacqueline. *A spectacular secret: Lynching in American life and literature.* University of Chicago Press, 2006.

Handelman-Meyer, Sonia. *Into the Light: The Photo League Years.* Boson Books, 2009.

Harris, Kamala D. "Harris, Booker, Scott Introduce Bill to Make Lynching a Federal Crime." *Kamala D. Harris U.S. Senator for California*, 29 June 2018, www.harris.senate.gov/news/press–releases/harris–booker–scott–introduce–bill–to–make–lynching–a–federal–crime. Accessed 11 February 2019.

Hubbard, Dolan, editor. *The Souls of Black Folk: One Hundred Years Later.* University of Missouri Press, 2007.

Ings, Richard. "Making Harlem Visible: Race, Photography and the American City, 1915-1955." Unpublished PhD thesis, University of Nottingham.

Katorza, Ari. *Stairway to Paradise: Jews, Blacks and the American Music Revolution.* Resling, 2017. [Hebrew]

Klein, Mason. "Of Politics and Poetry: The Dilemma of the Photo League." *The Radical Camera: New York's Photo League, 1936–1951*, edited by Mason Klein and Catherine Evans, Yale University Press, 2011, pp. 10–29.

Klein, Mason, and Catherine Evans, editors. *The Radical Camera: New York's Photo League, 1936–1951.* Yale University Press, 2011.

Kobrin, Rebecca, editor. *Chosen Capital: The Jewish Encounter with American Capitalism.* Rutgers University Press, 2012.

Lederhendler, Eli. *New York Jews and the Decline of Urban Ethnicity: 1950–1970.* Syracuse University Press, 2001.

Lederhendler, Eli. *American Jewry: A New History.* Cambridge University Press, 2016.

Lightweis-Goff, Jennie. *Blood at the Root: Lynching as American Cultural Nucleus.* SUNY Press, 2011.

Lyons, Nathan, editor. *Photo Notes* (reprint). Visual Studies Workshop, 1977. Manna, Marcia. "Faces and Races." *San Diego Magazine,* October 2005, p. 187.

Massood, Paula J. *Making a Promised Land: Harlem in Twentieth-Century Photography and Film.* Rutgers University Press, 2013.

Meyers, William. "Jews and Photography." *Commentary,* vol. 115, no. 1, 2003, pp. 45–48.

Mendes, Philip. *Jews and the Left: The Rise and Fall of a Political Alliance.* Palgrave Macmillan, 2014.

Michels, Tony, editor. *Jewish Radicals: A Documentary History.* NYU Press, 2012. Natanson, Nicholas. *The Black Image in the New Deal: The Politics of FSA Photography.* University of Tennessee Press, 1992.

New York: Capital of Photography, edited by Max Kozloff et al., exh. cat. Jewish Museum, New York, 2002.

Philipson, Robert. *The Identity Question: Blacks and Jews in Europe and America.* University Press of Mississippi, 2000.

Rab, Lisa. "The Government Called Her Work Subversive; Now It's in Museums. What Has She Learned?" *The Charlotte Observer,* 14 February 2018, https://www.charlotteobserver.com/entertainment/arts–culture/article200166344.html. Accessed 11 February 2019.

Raiford, Leigh. "Lynching, visuality, and the un/making of Blackness." *Nka: Journal of Contemporary African Art*, vol. 20, no. 1, 2006, pp. 22–31.

Raiford, Leigh. "Photography and the Practices of Critical Black Memory." *History and Theory*, vol. 48, no. 4, 2009, pp. 112–129.

Raiford, Leigh. *Imprisoned in a Luminous Glare: Photography and the African American Freedom Struggle.* University of North Carolina Press, 2011.

Raper, Arthur. *The Tragedy of Lynching.* University of North Carolina Press, 1933.

Rosenblum, Walter. "Where Do We Go From Here?" (1948), http://web–static.nypl.org/exhibitions/league/text.html. Accessed 5 February 2019.

Rottenberg, Catherine, editor. *Black Harlem and the Jewish Lower East Side: Narratives out of Time.* SUNY Press, 2013.

Salzman, Jack, and Cornel West, editors. *Struggles in the Promised Land: Towards a History of Black-Jewish Relations in the United States.* Oxford University Press, 1997.

Syfert, Scott. *The First American Declaration of Independence? The Disputed History of the Mecklenburg Declaration of May 20, 1775.* McFarland, 2014.

The Uses of Photography: Art, Politics, and the Reinvention of a Medium, edited by Jill Dawsey et al., exh. cat. Museum of Contemporary Art San Diego, San Diego, Calif. 2016.

Thiede, Barbara. "Charlotte Woman's Photos Show Post-War America." *The Charlotte Observer,* 21 July 2015, https://www.charlotteobserver.com/news/local/community/cabarrus/article28038400.html. Accessed 11 February 2019.

Trachtenberg, Alan. "The Claim of a Jewish Eye." *Pakn Treger,* vol. 41, 2003, pp. 20–25.

Tucker, Anne W. "A History of the Photo League: The Members Speak." *History of Photography*, vol. 18, no. 2, 1994, pp. 174–184.

Tucker, Anne W. *This Was the Photo League: Compassion and the Camera from the Depression to the Cold War.* Stephen Daiter Gallery, 2001.

Van Arragon, Elizabeth, J. "The Photo League: Views of Urban Experience in the 1930's and 1940's." Unpublished PhD thesisdoctoral dissertation, University of Iowa, 2006.

Walter, Howard. *Lynchings: Extralegal Violence in Florida during the 1930s.* iUniverse, 2005.

Warren, Lynne, editor. *Encyclopedia of Twentieth-Century Photography.* Routledge, 2005.

Whitfield, Stephen. *A Death in the Delta: The story of Emmett Till.* Johns Hopkins University Press, 1991.

Wilkins, Roy. "Wartime Lynchings." *The Crisis*, June 1941, p. 183.

Willis, Deborah. *Reflections in Black: A History of Black Photographers, 1840 to the Present.* W. W. Norton & Company, 2000.

Wintz, Cary D. and Paul Finkelman. *Encyclopedia of the Harlem Renaissance.* Cambridge University Press, 2012.

Bohemians, Anarchists, and Arrabales

How Spanish Graphic Artists Reinvented the Visual Landscape of Buenos Aires, 1880–1920

Brian Bockelman

When Spanish illustrator Manuel Mayol left Buenos Aires for his "mother country" in 1919, after some three decades in Argentina, the editors of the swish *Plus Ultra* hailed their founder as "one of the great men of Argentine graphic journalism" (Anonymous 1919b, 7).[1] It was a time of summing up the work of a heroic generation. Just a year earlier Mayol's compatriot and comrade-in-arms José María Cao had died. "This noble master of pen and brush was a revolutionary, a transformer of Argentine humor", eulogized *Caras y Caretas*, the most popular and cosmopolitan of all early 20th-century Argentine cultural magazines (Anonymous 1918, 39). Then, only months before Mayol's departure, Enrique (Henri) Stein, the Frenchman whose *El Mosquito* had inaugurated the Argentine illustrated satirical press in the 1860s, also passed away. *Plus Ultra* remembered Stein as "the dean of native and foreign-born draughtsmen who cultivated the caricature in Argentina" (Anonymous 1919a, 4). It also told a revealing story about the front lines of radical *porteño* journalism in its early days:

> One time, Eduardo Sojo, rival of Stein in art and politics, was being persecuted by powerful enemies; and, with that clear intuition that fear sometimes inspires, went to ask him for help. Stein replied, 'You hide here in my house, where nobody would think to look for you' (ibid., 4).[2]

Sojo, another Spaniard, survived this scare and many others. So did his caustic broadsheet *Don Quijote*, where his countrymen Mayol and Cao also first launched their Argentine careers in the 1880s.

Those familiar with the history of Buenos Aires in the liberal era (circa 1870 to 1930) or modern Argentina more broadly will not be surprised to learn of the deep imprint that such European migrants made on the artistic life of the bourgeoning Argentine metropolis around 1900. The Spanish colonial period that stretched roughly from 1580 to 1810 in this corner of South America did little to produce native traditions in the arts (Church architecture and decoration being the principal exceptions), and local institutions promoting secular high culture along European lines were still taking shape in the final decades of the 19th century. Even the graphic arts, destined for public consumption in the form of newspaper and magazine illustrations, had a foreshortened history in Buenos Aires. Though modern Argentine dailies such as *La Nación*, *La Prensa*, *El Diario*, and *La Patria Argentina* were rife with verbal satirical barbs, a mainstay of local political culture, the field of pictorial caricature was still open for new arrivals to exploit. As for the arrivals themselves, they were legion – an average of 100,000 immigrants reached Buenos Aires each year between 1880 and 1920. Not all stayed, but enough did that around 1910 almost 50 percent of the 1.2 million *porteños* and some two-thirds of workers were foreign-born (Moya 1998, 56; Scobie 1974, 260, 263). In this context, the line between outsider and insider, especially in new realms of art, science, and industry, was wafer thin.

Nevertheless, it is ironic that three rebellious Spanish expatriates – Sojo, Cao, and Mayol – led the development of mainstream Argentine visual culture in its formative period at the turn of the 20th century. The ease with which they passed into leadership roles in Argentine graphic arts is astonishing, as is their prominence in an artistic environment still accustomed to taking its cues from France and Italy over Spain – whose local cultural reputation had plummeted after Argentine independence and still appealed most strongly among conservatives (Moya 1998, 333–353; Fernández García 1997, 26–35).[3] Yet these outsiders, raised as radical republicans and cultural anarchists during the Bourbon Restoration of the Spanish monarchy, quickly carved out a niche for anti-establishment humor in Buenos Aires. Today, as in 1919, Sojo, Cao, and Mayol are best remembered for their powerful and biting caricatures of the Argentine political elite, which graced their many covers and centerfolds (Malosetti Costa 2005). But their contribution to Argentine culture was much broader still. Surrounding themselves with other promising young illustrators from Argentina, Uruguay, Italy, Austria-Hungary, and especially Spain (Arturo Eusevi, Juan Peláez, Cándido Villalobos, Francisco Fortuny, Alejandro Sirio, etc.), they did more than any other group of visual artists to shape the look of modern Argentina – especially Buenos Aires – in the eyes of the average reader or newsstand browser.[4] Thanks to this mélange of cosmopolitan émigrés, Argentines discovered and often laughed at the characteristic sights of

Brian Bockelman

their rapidly modernizing capital, and they encountered two new marginal urban landscapes that would soon become central to Argentine modernism: the *arrabales* (outskirts) and the bohemian underground.

Such a satirical, intimate, and resolutely popular vision of Buenos Aires marked a clear departure from previous attempts to depict the city, which since the 1820s had emphasized picturesque landscapes and exotic habits – anything that artists, mostly foreign-born or simply passing by, found amusingly quaint or distinctive about *porteño* traditions from a European perspective. The waterfront was the chief panorama in this old 'views and customs' tradition, of interest to outsiders because of its difficult landing (requiring an awkward transfer from boat to skiff to marine wagon) and its antiquated occupants, from water sellers collecting their product to Afro-Argentine washerwomen doing their masters' laundry. Inland, street scenes invariably focused on outlandish fashions and atavistic characters, of which the 'beggar on horseback' was the most notorious example (Outes 1940; González Garaño 1947; Del Carril/Aguirre Saravia 1982; Moores 1945). Eager to record such sights before they were lost to urban modernization, the earliest photographers of Buenos Aires only perpetuated this approach with their own 'views and customs' albums in the 1860s and 1870s (Priamo 2000; Junior 2002). Shortly thereafter, local painters began to train with academic masters in Europe, an experience that would eventually infuse Argentine art with a realism privileging urban social themes – principally the quotidian tribulations of the laboring classes. But before this artistic trajectory could become dominant, Sojo, Cao, and Mayol took the visual culture of Buenos Aires by storm, creating an irreverent image of the modern city and its many inhabitants – *for* its many inhabitants. One might even say that these expatriate artists were the first to laugh with *porteños*, rather than at them.

Sojo came first and threw the loudest bombs with his unsparing brand of political satire, which he developed as a young artist and rebel in Madrid during the 1870s, just as Spain's brief republican experiment – the 'Sexenio Democrático' – was unraveling. A fierce opponent of both Church and Crown in the pages of radical Spanish journals such as *El Buñuelo* and *El Motín*, he wasted little time after arriving in Buenos Aires in late 1881 redirecting his anti-authoritarian polemics toward the liberal but undemocratic Partido Autonomista Nacional (PAN). Aspiring writer José Sixto Álvarez ("Fray Mocho") later remembered helping Sojo secure the finances to launch *Don Quijote* in 1884 and escorting him around "the streets, showing him the things and the men of this country" (Fray Mocho c. 1890). It was the men who stood out to him the most. In the four weekly pages of *Don Quijote*, the inner two of which were reserved for a large lithograph, Sojo's alter-ego "Demócrito" took aim at national and local officials in elaborate and

often grotesque caricatures. Sometimes he set them in mock historical and biblical scenes, intended to deflate the pretense of Argentine politicians; at other times he hung them in effigy, animalized them, or exaggerated their most embarrassing physical characteristics. The pictures were intended to offend – and they did. Always afoul of the law, by 1887 Sojo found himself in and out of jail regularly. Nothing delighted him more or sold his paper better.[5]

Although *Don Quijote* remained committed to political caricature over its 18-year run in Buenos Aires, its illustrations were often set on the streets of the Argentine capital and occasionally featured typical urban characters as part of its anarchic dramaturgy. At first this occurred because "Demócrito" was an inveterate critic of mayor Torcuato de Alvear, whom he regularly lampooned as "Palmerín" for his much-ridiculed decision to plant palm trees around the central Plaza de Mayo in 1883. But Sojo and his assistants also employed city scenes as backdrops for a wide variety of satirical images, as can be seen in his lithograph for the February 20, 1887 issue (fig. 1). Here "Palmerín" is joined in a mock *carnaval* parade by caricatures of President Miguel Juárez Celman and his ministers, who violently force the residents on the "Street of the Evicted" to cough up their cash – symbolizing the destructive effects of elite speculation and graft on national productivity. Meanwhile, the caption alludes ironically to official efforts to curtail the free expression of popular carnival traditions on the streets of Buenos Aires that year. The "most rich" (*mas caras*), it seethes, could still wear their "masks" (*máscaras*) and enjoy their own festival of greed at the public's expense. "We are living a full-on carnival all year long", Sojo complained in the accompanying column, "and [yet] they do not want to give the people its little bit!" (Anonymous 1887, 1).

In lampooning the country's leaders, *Don Quijote* always presented itself as the champion of ordinary Argentines, and Sojo's main contribution to Argentine culture was to visualize Buenos Aires as a politicized space that threatened the average inhabitant but could be countered by acerbic laughter. This perspective guided his frequent representation of the capital city as a place of arbitrary authority and a thousand risks and deceits. "Personal security in Buenos Aires is a myth", ran the caption under a street scene showing the assassination of former provincial rebel Ricardo López Jordán in 1889 (Demócrito 1889, 2). Nor could the police be trusted to make life safer for the ordinary *porteño*. Time and again *Don Quijote* depicted officers harassing people or otherwise curtailing individual liberties on sidewalks and street corners. The official lottery was another favorite target, ridiculed as a con job from which few city dwellers could escape. Yet behind all these dangers stood the omnipresent menace of the PAN state. "Here he comes! Here he comes!", shout the frightened people in one 1890 image as they flee the approaching President Juárez Celman, whom Sojo routinely caricatured as a donkey

Brian Bockelman

(Demócrito 1890, 2–3). In another urban caricature from 1888, a little girl asks if the building across from her academy on "Liberty Street" is also a school. "For the love of the mayor!", replies her mother, shuttling her away from the brothel; "don't look over there" (Demócrito 1888, 2–3). If the authorities turn a blind eye to vice, goes this joke, why not the rest of us?

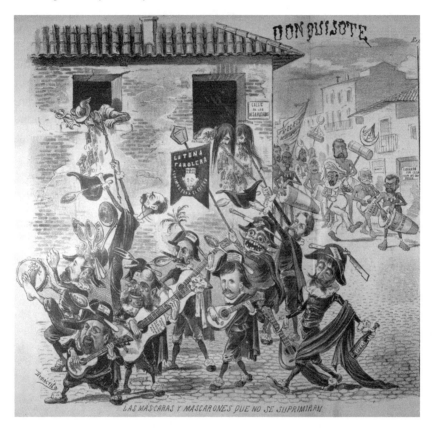

Fig. 1: Demócrito (Eduardo Sojo). "Las más:caras y mascarones que no se suprimirán." *Don Quijote*, vol. 3, no. 27, 20 February 1887, pp. 2–3 (The Rare Book & Manuscript Library, University of Illinois at Urbana-Champaign).

While such drawings used typical but imagined *porteño* streets to stage their satire, in other instances *Don Quijote* referred quite precisely to well-known urban places and landmarks. The Plaza de Mayo, surrounded by the executive Casa Rosada and other government buildings, was an obvious setting for the denunciation of PAN leadership. In a spread from January 29, 1893, the plaza

hosts a satirical allegory of the ruling coalition, whose efforts to hold power in the face of the repeated popular uprisings since 1890 have shredded its legitimacy and reduced everything it touches – its members, its policies, its press backers – to rubble (fig. 2). "Load it up!", shouts a *gaucho* (cowboy) on horseback, personifying the Argentine people, to a wagon driver preparing a trip to the city dump. The message is clear: these authentic Argentines, who so far have had no place in the epicenter of national politics, will soon be coming to the main square of Buenos Aires to clean up the mess left by the PAN and inaugurate a new era. As it turned out, a second Radical revolution would be crushed later that year, repeating the experience of the 1890 'Revolution of the Park', a rebellion against the Juárez Celman administration that *Don Quijote* long claimed to have helped instigate (Biagini 1991, 103–110). Many of its later portrayals of specific locales in the Argentine capital celebrated this event in the Plaza del Parque or subsequent demonstrations in its honor downtown.

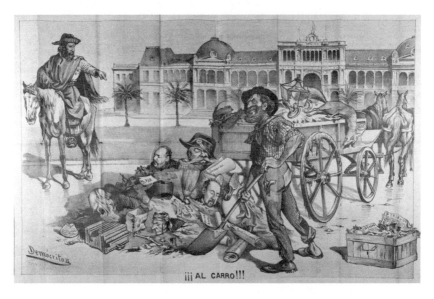

Fig. 2: Demócrito II (José María Cao). "¡¡¡Al carro!!!" *Don Quijote*, vol. 9, no. 24, 29 January 1893, pp. 2–3 (The Rare Book & Manuscript Library, University of Illinois at Urbana-Champaign).

The 1893 Plaza de Mayo caricature is significant for another reason. It was made not by Sojo, but by Cao, who arrived in Buenos Aires in 1886 and began collaborating in *Don Quijote* as "Sancho Panza" the following year – while Sojo was in an Argentine jail for the first time. By this point the rebellious director had

Brian Bockelman

launched a version of *Don Quijote* in Montevideo as well, and in 1892 he would leave Buenos Aires for a few years to do the same back in Madrid. In the meantime Mayol also joined their ranks after landing on Argentine shores in 1888, likewise in search of both a political escape from the conservative atmosphere of Spain after the Restoration and a personal opportunity to '*hacer la America*'. His contributions to *Don Quijote*, which began in 1890, appeared under the pseudonym "Heráclito". The following year Cao switched to "Demócrito II". As the names suggest, the hand of the founder often guided the pens of these newcomers – and indeed many of their illustrations were co-signed by "Demócrito". Perhaps due to their influence, however, by the mid-1890s *Don Quijote* began to flirt with satirizing everyday life in the Argentine capital. For instance, "The Plagues of Buenos Aires", an image cycle from August 30, 1896, neatly pans the many hazards of the street, from predatory lending to hanging electrical wires to toxic medications to a deathly slow judicial system (fig. 3). Although the corrosive *Don Quijote* never fully exploited the potential of social satire, the growing city now beckoned as a subject to be lampooned in its own right.

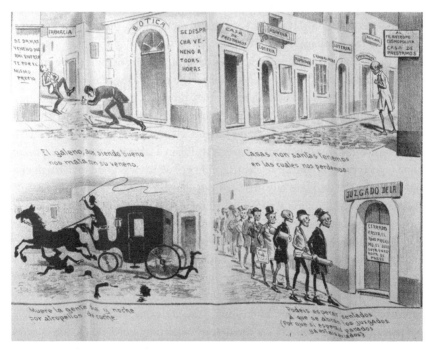

Fig. 3: Demócrito (Eduardo Sojo). "Las plagas de Buenos Aires" (detail). *Don Quijote*, vol. 13, no. 3, 30 August 1896, p. 2 (The Rare Book & Manuscript Library, University of Illinois at Urbana-Champaign).

If Sojo was the bomb-thrower, reducing the Argentine political landscape to rubble, his erstwhile assistants Cao and Mayol became the architects of modern Buenos Aires in images. Their vehicle was the 'festive' illustrated magazine *Caras y Caretas* (*Faces and Masks*), launched in 1898 under the editorship of yet another Spaniard, Eustaquio Pellicer, who had migrated to South America after a failed republican uprising in 1886. Mayol became the artistic director, which ensured that his vision governed much more than his own pictures for the publication. Alongside Cao, he assembled a crack team of illustrators, mostly expatriates and many of them fellow Spanish immigrants. Together they produced dozens of drawings for each weekly issue (which had 20 to 40 pages of content, not counting the copious advertisements), only a small number of which were political caricatures. Although still prominently placed on covers and full pages, none of these send-ups of prominent politicians and policy blunders approached the Juvenalian savagery of their predecessors in *Don Quijote*. In fact, as the editors of *Caras y Caretas* explained in its first anniversary issue, the use of satire as "a vengeful weapon and tool of castigation" was "excessive for the times" and in "decline" (Anonymous 1899a, 18). Its new purpose, they said, should be to "crack smiles" on the faces of readers as they confronted the novelties of modern life, never becoming "too serious" or "too flippant" (ibid., 18–19).[6]

In the quest for this humorous middle ground, a "satire of mores", the pictures of Cao and company would be essential. So too the portrayal of Buenos Aires, whose restless change and bewildering variety now took precedence over politics. Not that politics disappeared entirely, of course; it just became a subsidiary folly of urban modernity. The focus of *Caras y Caretas* fell instead on the many characters, situations, and sights that made up everyday life in a large metropolis – anything knowingly typical or typically eccentric, either of which was good for a laugh or a sigh or both. The standard fare included cartoonish vignettes of the daily travails of ordinary *porteños*, comical street dialogues between people of different walks of life, and exaggerated portraits of unusual but characteristic urban occupations – or even a lack thereof. Whereas earlier artists in the 'views and customs' tradition had highlighted the horse-riding beggar as representative of the city's incongruent backwardness, the illustrators of *Caras y Caretas* fixated on the *atorrante*, a modern bum with a penchant for philosophy and irreverence, as an archetype of the newly heterogeneous Buenos Aires. Interestingly, the *atorrante* was also one of the few popular urban types to have captured Sojo's attention, but *Don Quijote* always disparaged him as a stooge of PAN rule. *Caras y Caretas*, by contrast, envisioned him as a worldly-wise rebel, quick of tongue and beholden to no man (cf. Vidal 1820, 50ff; Demócrito 1886, 2; Cao 1905, 28; Giménez 1905, 35).

Brian Bockelman

There was practically no part of Buenos Aires that Mayol and his assistants would fail to visualize over the next two decades, and their attention to the specificity of urban streets and neighborhoods far exceeded anything that had come before in Argentine art or popular culture, including Sojo's *Don Quijote*. That fact alone would make the Spanish and other expatriate illustrators of *Caras y Caretas* pioneers in the artistic reimagination of the Argentine port city as a modern metropolis. Not all was meant to be funny, either. Leading by his own example, Mayol encouraged his contributors to submit paintings and sketches of poignant urban landscapes for recurring full-page sections such as "Páginas artísticas" ("Artistic Pages"), "Buenos Aires pintoresco" ("Picturesque Buenos Aires"), and "Escenas callejeras" ("Street Scenes"), which offered some aesthetic relief from the wit and whimsy of their drawings for the regular "Sinfonía" ("Symphony") and "Chafalonía" ("Trinkets") columns, as well as for countless one-off spoofs. Another way these draughtsmen brought the new city to life was through their many illustrations for short stories and poems featuring home life and other intimate urban settings – the patio, the street corner, the balcony by day, the world beneath the lamppost by night. These too shaded more towards the sentimental than the satirical, though either mode could be used depending on the character of the literature to be adorned.

What held all these disparate strands of urban portraiture together was an emphasis on the eccentric and evanescent details of Buenos Aires as seen from an insider's perspective. Although the graphic artists who spearheaded this revolution in representing the city were mostly foreign-born, so too were many of their readers. It was difficult to say who was a *porteño* and who was not in this heavily immigrant context, and no doubt for many recent arrivals the images of *Caras y Caretas* fostered a quick if superficial knowledge of their new Argentine home. The illustrators were themselves just a few steps ahead on this learning curve, but unlike previous traveling artists their pictures were not meant to exoticize the Argentine capital for audiences abroad. They expected their local readership to be able to relate to the sights they captured, such as the affecting familiarity of well-trod city streets, plazas, and parks at transitional moments such as dusk or dawn, the humorous but slightly intimidating look of the *compadrito*, a tough but fashionable neighborhood swell, the ridiculous contortions of local political figures (including national leaders, who were based in Buenos Aires), and the often absurd situations *porteños* found themselves in while trying to eke out a living in a sprawling and not always welcoming capital. For instance, Mayol's "Aid for the Flooded", published in the September 2, 1899 issue, manages to satirize the ill fit between the city's modern aspirations and the often precarious existence of its less fortunate inhabitants (fig. 4).

Fig. 4: Manuel Mayol. "El socorro á los inundados." *Caras y Caretas*, no. 48, 2 September 1899, p. 16 (The Rare Book & Manuscript Library, University of Illinois at Urbana-Champaign).

As this example suggests, *Caras y Caretas* was often literal in its pursuit of the eccentric side of Buenos Aires. Among its many metropolitan explorations and excavations, the representation of the urban outskirts – a place soon to be known in Argentine cultural history as the *arrabales* – stands out as both an innovation and a persistent subject. Neither clearly city nor clearly country, home to makeshift housing and marginal residents, and above all distant from the centers of Argentine politics, commerce, culture, and society downtown, this ramshackle periphery captivated the illustrators of *Caras y Caretas* as an oddly mysterious modern landscape – both a harbinger of the metropolis to come and a reminder of the humble lives swept up in or cast off by its expansion. Although the city edge had long fascinated artists of Buenos Aires, the dominant view in the 'views and customs' tradition was a waterfront panorama, executed from a distant point along the *ribera* (shoreline) and anchored by the church spires in the center of town (Bockelman 2012). It was, in essence, a portrait of the city's 'front' side, considered from a European or Atlantic perspective. Assuming its readers were already residents, *Caras y Caretas* took them instead to its 'back' side, where the open *pampas* (plains) met the outbuildings of the Argentine capital, the modest plateau of the central city fell off into low-lying *barrancas* (ravines), and several small waterways, such as the Arroyo Maldonado and Riachuelo, still stood guard against the restless westward advance of urban modernity.

Brian Bockelman

Mayol, who like many of his fellow expatriate illustrators harbored grander ambitions as a painter, arguably deserves credit as the first artist of the Argentine *arrabales*. Carlos Pellegrini had executed a landscape or two on the southwestern corner of Buenos Aires in the 1840s, yet these were mainly rural images. Ernesto de la Cárcova's much-admired oil painting *Without Bread nor Work* (1894), showed the defiance of those suffering the economic downturn of the 1890s in the growing factory belt on the city's south side. But Mayol discovered the urban outskirts as a unique metropolitan territory. His showpiece was "A Homestead in the Suburbs", which likely began on canvas but appeared in *Caras y Caretas* as a full-page color lithograph on May 6, 1899 (fig. 5). It depicts, from behind, a rustic *porteño* returning home with his horse after a day of labor in town. A cluster of dilapidated but resolute shacks awaits him, as do two silently expectant figures, probably his parents, eager to hear if he met with good fortune. They could use a break – the brick is crumbling, plaster is peeling off walls, and their land is but hardened mud. And yet they are hanging on here at the edge of Buenos Aires, whose inescapable presence is shown by a solitary smokestack in the distance. Its natural counterpoint is the slender but towering tree that occasionally shades their home, ultimately lending the scene a sense of hope amid the hardship.

Taking this outlying and unpolished landscape seriously as an artistic subject was highly unusual when Mayol made "A Homestead in the Suburbs". It would be another decade or more before celebrated Argentine painters such as Pío Collivadino and Benito Quinquela Martín and the rebellious printmaking collective Aristas del Pueblo began to make the *arrabales* the focal point of modern art in Argentina. But of course *Caras y Caretas* never wanted to be "too serious", and so its image of the urban fringe could be comical too. Even though he inclined toward the sentimental in his own cityscapes, Mayol also made satirical scenes like "Aid for the Flooded", which makes almost as much fun of the outskirts as of those in town who have failed to understand what it needs. More importantly, as artistic director he encouraged others on the magazine's staff to exploit the humorous incongruence of the *arrabales*. When the wealthy Anchorena family donated its ex-urban estate in Olivos to be the new presidential mansion in 1899, Cao created a spoof of President Julio Roca trying to reach the property, only to be stopped at the city limits by an officer upholding the law that the Argentine head of state "cannot absent himself from the capital without the permission of Congress" (Anonymous 1898b, 13). Years later, for a July 1906 issue, he mocked a proposal to rename a sorry peripheral street after another president. "This is how we honor our illustrious men", says a shabbily dressed booster of the idea, ignoring the dead cat in the road (Cao 1906, 36).

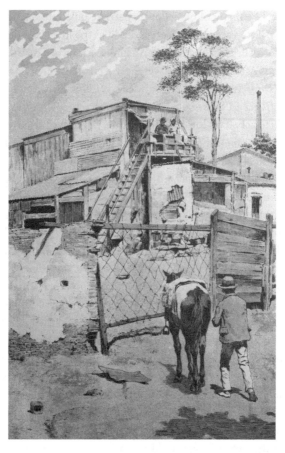

Fig. 5: Manuel Mayol. "Un caserío de los suburbios." *Caras y Caretas*, no. 31, 6 May 1899, p. 12 (The Rare Book & Manuscript Library, University of Illinois at Urbana-Champaign).

For all the attention that *Caras y Caretas* gave to the indeterminate outskirts, it also specialized in detailing and satirizing other marginal haunts in the city center – in particular the new bohemian world of aspiring poets, philosophers, and painters that began to take shape in downtown Buenos Aires in the 1890s. Already in the first issue we find a witty advertisement, almost certainly drawn in-house, for Aue's Keller, a cheap restaurant known for its beer and tolerance of tight-pursed intellectual vagabonds. The image shows two such men enjoying the smell of food from the street – enough, the establishment half-promises, "to experience the illusion of having eaten" (Anonymous 1898a, 6). Many scenes of the bohemian literati sitting around sparsely-served café tables, debating artistic ideals lost on the general public, would follow, most commonly as illustrations to

Brian Bockelman

poems and short stories that alternately promoted, pitied, or parodied this set. A good example, drawn by Fortuny, comes from the 1904 story "Opiniones artísticas" ("Artistic Opinions") by Carlos de Soussens, who was himself considered one of the great bohemians of his day.[7] Here a nervous aspirant to the world of letters stumbles haltingly through a prepared discourse, interrupted by laughter and protestations as he tries to prove himself "well-read" (Soussens 1904, 35). Cao tried to offer a more celebratory take in his illustration for "Versos de año nuevo" ("New Year Verses"), poet Rubén Darío's 1910 paean to earlier bohemian nights in Buenos Aires. But the papers and books falling forgotten to the floor as the assembled dreamers get drunk betray a more ironic view of their gatherings (fig. 6).

Fig. 6: José María Cao. Illustration for Rubén Darío, "Versos de año nuevo." *Caras y Caretas*, no. 587, 1 January 1910, p. 138 (The Rare Book & Manuscript Library, University of Illinois at Urbana-Champaign).

Beyond this café counterculture, readers of *Caras y Caretas* were constantly introduced to artistic souls and creative rebels tucked away in hidden corners of the metropolis. So, for instance, on October 4, 1902 we find Mayol's vision of a

bohemian artist at work in his studio, made for Fray Mocho's story "¡Modernista!" ("Modernist!"). Paint splattered on the floor, he looks on defiantly, cigarette in mouth, with the cultivated air of a laborer – an appropriate image for a decade in which many young poets, painters, and printmakers in Buenos Aires identified as cultural anarchists (fig. 7).[8] Among them was Eusevi, another Spanish émigré working for the magazine, to whom Cao dedicated a memorable caricature on October 7, 1899. Bearded and emaciated like some artistic ascetic, he sits cross-legged before his latest composition, so absorbed in work that he does not even notice his humble lunch, a tin of sardines. Mayol's mock portrait of Cao for the same issue imagines him quixotically reading his favorite book, *The Kreutzer Sonata* (1899) by Russian anarcho-spiritualist Leo Tolstoy (Anonymous 1899b, 33, 38). As these examples indicate, the illustrators of *Caras y Caretas* considered themselves urban eccentrics too, not terribly different from the many anonymous artists they were asked to draw. The fine line between success and failure, between the self-appointed bohemian and the one who had no choice, is nicely captured by Aurelio Giménez's fictional portrait of a dejected writer drinking himself to death, made for a 1906 short story by Antonio Monteavaro. Though the police find a working poem in his pocket, they decide to list the deceased as an "atorrante" on their report (Monteavaro 1906, 51).

Fig. 7: Manuel Mayol. Illustration for Fray Mocho (José Sixto Álvarez), "¡Modernista!" *Caras y Caretas*, no. 209, 4 October 1902, p. 39 (The Rare Book & Manuscript Library, University of Illinois at Urbana-Champaign).

Brian Bockelman

Such scenes of urban margins were so commonplace in Argentine publications by the time *Plus Ultra* appeared in 1916 that newly arriving Spanish graphic artists such as Alejandro Sirio were quickly initiated into the tradition (Ballesteros 1916, 28; García-Landa 1918, 58). Gone were the heroic days when migrants such as Sojo, Cao, and Mayol could simply import the style of satirical illustrations learned back in Europe and use them to interpret *porteño* affairs. Also gone was the bombast of *Don Quijote*, which had done so much to reorient the depiction of Buenos Aires away from the picturesque 'views and customs' that long delighted outsiders and toward an unapologetically popular perspective on the city and its failings. What it did not really do, paradoxically, was to portray the ordinary people it sought to reach as readers nor the places where they lived. With *Caras y Caretas*, Mayol, Cao, and a host of other Spanish illustrators deepened the application of caricature to the many-sided Argentine metropolis, and so they discovered, alongside their increasingly cosmopolitan audience, the eccentricities and follies of their new home. Who is to say what modern Buenos Aires would have looked like, in the mind's eye, without them?

Notes

[1] Many turn-of-the-century Argentine cultural publications were unpaginated. In such instances, the page numbers cited are estimates, with the front cover or front page counted as 1.

[2] The common Argentine label '*porteño*' refers to anything or anyone from the port city of Buenos Aires.

[3] As the Spanish immigrant population of Buenos Aires grew, Argentine *hispanismo* became both more culturally mainstream *and* more ideologically reactionary after 1900. In this diversifying context, Spanish artists were able to make gradual inroads into the *porteño* art market. See Karp Lugo 2016.

[4] For a brief overview of the various activities of these and other Spanish caricaturists in Buenos Aires, see Gutiérrez Viñuales 1997. Biographical portraits can be found in the appendix to Fernández García 1997, 215–270.

[5] For more on Sojo's transatlantic career, see Laguna Platero et al. 2016.

[6] Sojo took these words as an attack and *Don Quijote* responded with an extended polemic against the upstart magazine. See Rogers 2008, 69–94.

[7] On Soussens and his milieu, see Galtier 1973.

[8] Compare with Cao's more whimsical take on the bohemian artist for Montero Zamora 1901, 31.

References

Anonymous. "Carnaval." *Don Quijote*, vol. 3, no. 27, 20 February 1887, p. 1.

Anonymous. "Aue's Keller" (advertisement). *Caras y Caretas*, no. 1, 19 August 1898a, p. 6.

Anonymous. "La quinta de Los Olivos, donación Anchorena." *Caras y Caretas*, no. 7, 11 November 1898b, p. 13.

Anonymous. "Caras." *Caras y Caretas*, no. 53, 7 October 1899a, pp. 18–24.

Anonymous. "Caretas." *Caras y Caretas*, no. 53, 7 October 1899b, pp. 31–38.

Anonymous. "José María Cao." *Caras y Caretas*, no. 1009, 2 February 1918, p. 39.

Anonymous. "Enrique Stein." *Plus Ultra*, no. 33, January 1919a, p. 4.

Anonymous. "Manuel Mayol." *Plus Ultra*, no. 36, April 1919b, p. 7.

Ballesteros, Montiel. "Vida bohemia." *Plus Ultra*, no. 4, July 1916, p. 28.

Biagini, Hugo E. "La revolución del 90 y el semanario *Don Quijote*." *Cuadernos hispanomericanos*, no. 487, 1991, pp. 103–110.

Bockelman, Brian. "Along the Waterfront: Alejandro Malaspina, Fernando Brambila, and the Invention of the Buenos Aires Cityscape, 1789–1809." *Journal of Latin American Geography*, vol. 11, no. Special, 2012, pp. 61–88.

Cao, José María. "Chafalonía: Oí decir que han falsificado los billetes." *Caras y Caretas*, no. 328, 14 January 1905, p. 28.

Cao, José María. "La Calle Pellegrini." *Caras y Caretas*, no. 408, 28 July 1906, p. 36.

Del Carril, Bonifacio, and Aníbal G. Aguirre Saravia. *Iconografía de Buenos Aires: La ciudad de Garay hasta 1852*. Municipalidad de la Ciudad de Buenos Aires, 1982.

Demócrito (Eduardo Sojo). "La distinguida colonia de atorrantes suplica que no renuncies." *Don Quijote*, vol. 2, no. 93, 2 January 1886, p. 2.

Demócrito (Eduardo Sojo). "Niña." *Don Quijote*, vol. 4, no. 50, 29 July 1888, p. 2.

Demócrito (Eduardo Sojo). "Asesinato de Ricardo López Jordán." *Don Quijote* vol. 5, no. 46, 30 June 1889, p. 2.

Demócrito (Eduardo Sojo). "¡Qué viene!" *Don Quijote*, vol. 6, no. 29, 2 March 1890, pp. 2–3.

Fernández García, Ana María. *Arte y emigración: La pintura española en Buenos Aires (1880– 1930)*. Universidad de Oviedo, Servicio de Publicaciones, 1997.

Fray Mocho (José Sixto Álvarez). "El socio de Sojo: Interesante revelaciones." José S. Álvarez Papers, Benson Latin America Collection (University of Texas-Austin, c. 1890), Scrapbook 1.2.

Galtier, Lysandro Z.D. *Carlos de Soussens y la bohemia porteña*. Ediciones Culturales Argentinas, 1973.

García-Landa, Carlos. "Saturno (De la vida bohemia)." *Caras y Caretas*, no. 1032, 13 July 1918, p. 58.

Giménez, Aurelio. "Chafalonía: Soy del gremio de los atorrantes." *Caras y Caretas*, no. 346, 20 May 1905, p. 35.

González Garaño, Alejo B. *Iconografía argentina: Anterior a 1820*. Emecé, 1947.

Gutiérrez Viñuales, Rodrigo. "Presencia de España en la Argentina: Dibujo, caricatura y humorismo (1870–1930)." *Cuadernos de Arte de la Universidad de Granada*, no. 28, 1997, pp. 113–124.

Junior, Christiano. *Un país en transición: Fotografías de Buenos Aires, Cuyo y el Noroeste, 1867–1883.* Fundación Antorchas, 2002.

Laguna Platero, Antonio, et al. "Eduardo Sojo: El artífice del periodismo satírico en España y Argentina." *Historia y Comunicación Social*, vol. 21, no. 2, 2016, pp. 433–461.

Karp Lugo, Laura. "L'art espagnol de l'Europe à l'Argentine: mobilités, transferts et réceptions (1890–1920)." *Artl@s Bulletin*, vol. 5, no. 1, 2016, pp. 38–49.

Malosetti Costa, Laura. "Los 'gallegos', el arte y el poder de la risa. El papel de los inmigrantes españoles en la historia de la caricatura política en Buenos Aires (1880–1890)." *La memoria compartida: España y Argentina en la construcción de un imaginario cultural (1898–1950)*, edited by Yayo Aznar and Diana B. Wechsler, Paidós, 2005, pp. 245–270.

Monteavaro, Antonio. "Canto de cisne." *Caras y Caretas*, no. 416, 22 September 1906, 51.

Montero Zamora, M. "Affiche 566." *Caras y Caretas*, no. 162, 9 November 1901, p. 31.

Moores, Guillermo H. *Estampas y vistas de la ciudad de Buenos Aires, 1599–1895.* Municipalidad de la Ciudad de Buenos Aires, 1945.

Moya, Jose C. *Cousins and Strangers: Spanish Immigrants to Buenos Aires, 1850–1930.* University of California Press, 1998.

Outes, Félix. *Iconografía de Buenos Aires colonial.* Coni, 1940.

Priamo, Luis. *Buenos Aires, ciudad y campaña, 1860–1870: Las fotografías de Esteban Gonnet, Benito Panunzi y otros.* Fundación Antorchas, 2000.

Rogers, Geraldine. *Caras y Caretas: Cultura, política y espectáculo en los inicios del siglo XX argentino.* Editorial de la Universidad Nacional de La Plata, 2008.

Scobie, James R. *Buenos Aires: Plaza to Suburb, 1870–1910.* Oxford University Press, 1974.

Soussens, Carlos de. "Opiniones artísticas." *Caras y Caretas*, no. 308, 27 August 1904, p. 35.

Vidal, E.E. *Picturesque Illustrations of Buenos Ayres and Montevideo.* Ackermann, 1820.

The City of Plovdiv as a New Latin American Metropolis

The Artistic Activity of Latin American Exiles in Communist Bulgaria

Katarzyna Cytlak

Compared to other global – and especially transatlantic – migration movements, the case of Latin American immigrants in Bulgaria can be approached as an exception, indeed even a counter-example to traditional diaspora studies. First, the direction of migration in this case runs counter to usual routes: during the 20th century. Eastern European countries – which had become part of the Soviet bloc after World War II – were typically perceived not as destinations of exile but instead as countries whose citizens constantly and heroically strove to escape (Scheller 2018). For that reason, the example of Latin American refugees in Bulgaria constitutes an exception in the history of East European migration. Second, I argue that the cultural production and the creation of "new political spaces" by migrants and refugees is not merely, as Saloni Mathur states, "precarious and dialectically positioned in relation to the forces of assimilation and normalization" (Mathur 2011, ix). Migrant art is usually confronted with the stereotype of unprofessionalism: in Eurocentric and hegemonic art historiographies, migrant art is consistently considered to be not only 'different' but also 'less skilled' compared to the art created by local artists – originating from cities of asylum. It is an art of the periphery, even if it emerges in the cultural centres. It is never seen as canonical and instead perceived as always relating back to the artistic canons produced by the centre. In the Eurocentric and hegemonic narrations in art history, a migrant's experience of living in a cultural capital not only influences one's artistic perception but it makes one's artistic production able to aspire to be part of 'high' art.

The example of Latin American artists exiled in Plovdiv helps us to revise narrations of migrant art. It offers us an antithesis and alternative version of global art history, not only because the artists who arrived in Plovdiv were already graduates of art schools in their home countries, but also because they were successful and recognised artists – both in their own artistic milieus and abroad.

They were well educated, socially and politically engaged left-wing Latin American intellectuals. Moreover, they had more contacts to international art scenes than the Bulgarian artists at the time, who instead were living on the other side of the iron curtain and whose contact with Western artistic milieus was practically non-existent.

A Profile of Latin American Migrants

The micro-diaspora of Latin American refugees in Plovdiv included the Uruguayan Armando González and the Chilean Guillermo Deisler. Not only could they be described as intellectuals and militants, they were also regarded as esteemed artists in their local artistic milieus and taught at local universities. Their reasons for becoming refugees were political. González and Deisler were members of the Communist parties in their respective countries. Both suffered repercussions and were imprisoned after the establishment of authoritarian rule in Uruguay and Chile. Both escaped from their countries in order to save their lives. They found refuge in Bulgaria because the country was a part of the Soviet bloc. To migrate to Bulgaria, however, was not an individual choice, but rather the result of an agreement between the nations' respective Communist parties. As political refugees, González and Deisler thus had help in finding work and accommodation in Plovdiv.

Armando González Ferrando, known as "Gonzalito", was 28 years older than Guillermo Deisler. He was born in Montevideo on 6 March 1912 (La Fundación Arismendi 2011, 1–5; Méndez García 2007). Widely talented, he was a prolific artist, especially when it came to sculpture. Between 1926 and 1929 he studied drawing, graphic design and sculpture at the Círculo de Bellas Artes (Circle of Fine Arts) in Montevideo. His studio in the Malvín district in Montevideo became a meeting place for several Uruguayan and Latin American artists, among them: two muralists, the Mexican David Alfaro Siqueiros and the Argentinian Demetrio Urruchúa; the Argentinian painter Antonio Berni; the Uruguayan sculptor Bernabé Michelena; and the Uruguayan painters and graphic artists Luis Mazzey and Carlos González (La Fundación Rodney Arismendi 2011, 2). Throughout his artistic career in Uruguay, González was a highly recognised and awarded artist. Following his second place in the *Exhibition of National Industries* in 1926, he received more than 30 awards tendered for Uruguayan artists. He exhibited regularly at the National Salon of Fine Arts which was organised annually in Montevideo. In 1956 he was awarded the Grand Prize in Sculpture,

a Gold Medal for his clay sculpture *Niña (Girl)*. In 1953 he won the First Prize in the competition for a monument of General José Gervasio Artigas Arnal, a Uruguayan national hero of the anti-Spanish uprising between 1808 and 1811 (Argul 1966, 226–227). González was also active as a teacher: He was professor at the Popular University Barrio Olímpico (1935– 1937), founder and professor at the Central Popular University (1937–1940), a professor at the National School of Fine Arts (1955–1959) and a professor at the University of Labour of Uruguay (1970–1974) (La Fundación Rodney Arismendi 2011, 6).

Luis Guillermo Deisler González was born in Santiago de Chile on 15 June 1940 (Deisler et al. 2014, 202). In 1954 he started to study metallurgy at the School of Arts and Crafts, and subsequently continued his education in the programme for Applied Arts, Ceramics and Engraving and later in Theatre Design and Lighting at the School for Theatre at the University of Chile in Santiago. This multi-faceted education was reflected in Deisler's multiple creative activities as an artist, graphic designer, stage designer, editor and writer. In the early 1960s he designed the scenography for various theatres in Santiago. In 1963 he founded the *Ediciones Mimbre,* an independent editorial poetry project which was based on the principles of artisan editorial work (García 2007, 113). During the ten years of its existence, *Mimbre* issued about 50 publications and folders with texts by young Chilean poets and writers and became the most recognised editorial of experimental and visual poetry in the country. Deisler's first book, entitled *¡GRRR!,* is considered the earliest collection of visual poetry ever to be produced in Chile (Deisler 1969). Deisler was also a member of various international visual poetry and mail art networks. As early as in the mid-1960s he took part in the first exchanges between visual and experimental poets and editors of reviews, such as *Los Huevos del Plata* and *OVUM 10,* both published in Montevideo by Clemente Padín; *La Pata de Palo,* founded and directed by Dámaso Ogaz in Venezuela; the reviews *Ponto* and *Processo,* edited by the Brazilian Poema/Proceso group; and *Diagonal Cero,* edited in La Plata (Argentina) by Edgardo Antonio Vigo between 1962 and 1968 (Varas 2014, 72–75).

Deisler's book *Poemas visivos y proposiciones a realizar (Visual Poems and Propositions to be Made)* was the first anthology of visual poetry published in Latin America (Deisler 1972). Like González, Deisler was an art teacher: between 1967 and 1973 he worked as a graphic teacher at the University of Chile in Antofagasta, a city in Northern Chile.

Repercussions in Latin America and Settlement in Plovdiv

The brilliant artistic careers of both Armando González and Guillermo Deisler were interrupted in 1973 by the *coups d'état* and the advent of military dictatorships in their home countries. On 27 June 1973, Uruguay's democratically elected Parliament was suspended and a civic-military dictatorship, which lasted until 1985, was implemented. Burgeoning state terrorism at that time was characterised by massive violations of human rights, the use of torture and unexplained disappearances of Uruguayans. During the dictatorship, more than 5,000 people were arrested for political reasons (Greising et al. 2011). Torture was effectively used to collect information which was then wielded to break up MLN-T, the Tupamaros National Liberation Movement, a Uruguayan urban guerilla organisation of the radical left. Torture was also inflicted on activists, members of the Communist Party of Uruguay, and even regular citizens. Armando González was captured on 14 January 1975. He recalled:

> Four or five armed guys with submachine guns and transmitters raided my workshop and moved me to Maldonado Street [...]. They behaved like true raiders. The sculptor Ramos Paz is already sitting in the truck [...]. They pull us out and move us to the first floor of the building [...]. Military personnel with submachine guns watch and give orders [...]. A few hours later [...]. Transfer and questions [...]. They take out our personal belongings and they search us. They put on the famous hood and the work of these guys begins. (La Fundación Rodney Arismendi 2011, 30–31)[1]

It is not clear when González travelled to Bulgaria (Battegazzore 2018). He was possibly one of the Communist Party members hidden in the Mexican Embassy in Carrasco in Montevideo in 1976 and later sent to Mexico by the Mexican ambassador at the time, Vicente Muñiz Arroyo (Greising et al. 2011, 31). However, he did not adapt well to his new environment (Israel 2006, 299). Because of the high number of Uruguayan refugees in Mexico, the Communist party sent González – together with other Communist militants –to Eastern Europe, in this case to Bulgaria (Greising et al. 2011, 32). Once installed in Plovdiv, he became friends with Guillermo Deisler and his family. Encouraged by the Bulgarian Communist Party officials, who promoted a traditional model of life, he married his Mexican

companion (Padín 1985). He continued his artistic activity as a sculptor and graphic designer.

Guillermo Deisler's history of exile is better documented (Archivo Guillermo Deisler 2015; Coll 2018). A husband and father of four children, he was arrested along with other professors from the University of Chile in Antofagasta after the Chilean *coup d'état* on 11 September 1973, which overthrew the socialist president Salvador Allende. He was imprisoned in Antofagasta for two months. Later, he managed to leave the city and go into exile along with several Chilean Communist Party members. In early 1974, he travelled first to Paris and then to East Berlin, hoping to find refuge and work in East Germany. As the grandson of a German immigrant into Chile – his paternal grandfather – he spoke fluent German. His family joined him once he was settled in the GDR. It is only because of the decision made by the German Communist party that Deisler's family – along with other Chilean refugees who had arrived in the GDR in those months – was sent to Bulgaria in May 1974 and later settled down in Plovdiv. As political refugees, the family had assistance in finding an apartment and work. Deisler's children went to Bulgarian schools.

Affectionate Integration into Plovdiv's Artistic Milieu

In the 1970s, Plovdiv was the second most populous city in Bulgaria, after its capital Sofia. It was an important cultural and educational centre. Plovdiv is known for being a bicultural city, founded at the time of the Roman Empire and influenced by Ottoman Rule, as well as by Slavic cultures. Its population is predominantly Bulgarian, although minorities such as Gypsies, Turks, Jews and Armenians have also inhabited the city (Bugajski 1994, 235–265). In the early 1970s Plovdiv was characterised by an active local artistic milieu (Stanev 2001, 43). But it differed from the art scene of other satellite countries of the Soviet Union. In his seminal book *In the Shadow of Yalta: Art and the Avant-garde in Eastern Europe,* the Polish art historian Piotr Piotrowski provides hardly any analysis of Bulgarian post-1945 artistic production (Piotrowski 2009). Piotrowski merely observes that Bulgarian artists of the post-war period did not create art that could be described as "experimental" or "neo-avant-gardist" (ibid.). The Bulgarian art historian Irina Genova, instead, in her recent analysis of 20th- and 21st-century Bulgarian art, stresses the inadequacy of Eurocentric categories, of the concept of European modernity, and of European aesthetics in general (Genova 2007, 297–298; Genova 2013). Even if Slavic Bulgaria, as Donald Egbert posits, "had closer cultural links with Slavic Russia than any of the other countries that fell under Soviet political domination" (Egbert 1967, 204), and even if the aesthetic formula of socialist realism was thus

much more prevalent than for example in Poland or Czechoslovakia (Egbert 1967), those factors did not invalidate the artistic creativity of Bulgarian artistic milieus. Moreover, the doctrine of socialist realism was not as orthodox in the 1970s as it was in the 1950s. Still, Bulgarian art of that time was a lot more figurative than abstract, and, in a way, it remained largely untouched by (Western) avant-garde ambitions to break with older traditions and styles.

González's and Deisler's processes of assimilation within the local art scene differed from the typical situation of migrants. In their case, the conditions of alienation and exclusion, often linked to experiences of statelessness and political dispossession, were reduced by a national Communist administration which aimed to integrate its citizens fully. Before World War II, East European countries were multicultural, with linguistically, culturally and religiously diverse populations. After 1945, the ideology of a culturally homogenous, one-nation state permeated the entire Soviet bloc, including Bulgaria (Savova-Mahon Borden 2001, 43–47). Homogenisation and assimilation of East European citizens aimed not only to erase "hostile national differences" (Savova-Mahon Borden 2001, 43) and to mitigate potential future conflicts, but also to increase the control and disciplining of East European societies. While this integrationist policy (reinforced by the propaganda of internationalising Communism) had negative effects on these countries' cultural landscapes – see, for example, when the Bulgarian government "refused to accept Macedonians as a legitimate minority" even after 1989 (Bugajski 1994, 243) – it had a positive effect on newly-arriving migrants. Both Deisler and González were immediately integrated within Plovdiv's social structures. They were not part of a diasporic community living in the suburbs, but instead were granted apartments in the civic centre of the city; they were also allowed to practise their art. Both artists became members of the Bulgarian Communist Party, as well as active participants in the Union of Bulgarian Artists (Israel 2006, 299, 302). Both had their own art studios. Moreover, as Bulgaria did not participate directly in the European colonisation of the Americas, the relationship between Latin American refugees and the local population was free from racial and cultural prejudices – potential remnants from a time of colonial domination. Deisler and González, two refugee artists escaping right-wing military regimes, were considered by the local population as comrades. They did not experience the feeling of "dislocation and non-belonging" which are common characteristics, as Saloni Mathur has stated, of refugee artists (Mathur 2011, ix).

As emphasised by the article on González published in the Uruguayan press in 2010, Bulgaria was "the country that received him affectionately" (La Fundación Rodney Arismendi 2010). During his exile in Plovdiv, he continued his work as a sculptor. His figurative style corresponded well to the aesthetics of Bulgarian art

at the time. González's early graphic works were even considered the Uruguayan version of socialist realism (*Realismo Social en el Arte Uruguayo* 1992, 24) – this only deepened the affinities between his artistic approach and that of Bulgarian artists in the 1970s. Between 1977 and 1978, González created a series of sculptures portraying soldiers and prisoners entitled *Torturas de los presos políticos (Tortures of political prisoners)*, which allowed him to illustrate the scenes of torture he had experienced during his detention. These series of sculptures were González's response to his own traumatic story (fig.1).

Fig. 1: Armando González, *Pequeñas esculturas* (*Little Sculptures*), 1977–1978, Plaster, unknown dimensions, Black and white photography, 10,5 x 15 cm (Fundación Rodney Arismendi, Montevideo).

Like González's, Deisler's art was perceived as more 'modern' and 'international' than that of Bulgarian artists. During their settlement in Plovdiv, Deisler and González did not need to 'modernize' their art, culture or vernacular customs in order to become part of the host city's culture – in contrast to more conventional narratives of migrant art in metropolitan centres, they did not need to adapt and abandon their 'provincial customs'. Deisler, instead, was received as a pioneer of experimental and visual poetry, an active participant in international artistic networks, and he was recognised and published internationally.[2] He was considered a 'master' by the Bulgarian artists living in cultural isolation behind the Iron Curtain. Therefore, Deisler's relationship with the local artists was completely

antithetical to how relationships between migrant and native metropolitan artists would usually play out. Deisler's cosmopolitan art was the role model local artists could follow (fig. 2).

Fig. 2: Armando González, *La Fuente de la vida* (*The source of life*), not dated, Plaster model, unknown dimensions, Black and white photography, 10,5 x 15 cm (Fundación Rodney Arismendi, Montevideo).

Younger than González, Deisler was able very quickly to integrate into the local artistic milieu. In 1974, after his arrival in Plovdiv, he presented his graphic works at the Old Town, and he continued to exhibit his graphic work in Plovdiv and in Sofia practically every year. He was working as a graphic and theatre designer and became friends with several Bulgarian artists (Coll 2018). In 2001, Stefan Stanev – a Bulgarian professor of biology, Deisler's friend and an art writer – published his book, *Под знака на Седемте тепета. Спомени, Портрети* (*Under the Sign of the Seven Hills. Memories. Portraits*), in which he describes the lives of 14 artists from Plovdiv (Stanev 2001). Deisler is portrayed in a separate chapter under the significant subtitle "Гилермо, Пловдив още те помни!" ["Guillermo, Plovdiv

Katarzyna Cytlak

still remembers you!"] (Stanev 2001, 41–56).[3] As Stanev recalls, his Bulgarian colleagues "received him cordially" (Stanev 2001, 43). Specifically, he writes that Deisler was part of a group of artists and scientists who met at lunchtime at the Млечен бар (Mlechen bar – Milk Bar) in Plovdiv in the late 1970s (Stanev 2001, 45). Sometimes accompanied by his friends (probably including González), he shared a table with Bulgarian visual artists such as Petar Dramov, Atanas Zgalevski, Chavdar Pashev, Dimitar Pavlov (Tochkata) and Viktor Todorov (Stanev 2001, 45). Deisler became an esteemed artist, even though his art did not correspond exactly to the contemporary trends in Bulgarian art and was seen as 'exotic' by his Bulgarian cohort. As his friend and artist Petar Dramov recalled, "Guillermo came to Plovdiv with his South American temperament and with another style in art, other images in his art, close to the primitive Latin Americans, reminiscent of the art of the Maya. He was making them graphically: rounded figures, thick black contours, like you can see in the decorative compositions of the Mayan stone reliefs." (Stanev 2001, 44).

Resistance in the public space

The integration of migrant artists into the artistic, social and political life of their new homelands could be measured by their presence in the public space. Artistic projects which interface with public spaces bring to the fore issues of visibility, civil rights and diasporic politics. They also mark the presence of migrant artists in the local sphere, even if "becoming visible" in the cosmopolis might also mean to be "constructed and recognized as different" (Hatziprokopiou 2009, 14–27). Furthermore, any authorised or unauthorised artistic project carried out in the public spaces of East European countries during Communist rule became especially relevant: public space in the countries that formed the Soviet bloc was a space where ideological discourse materialised; it was the sphere where this discourse was physically present. Such discourse could become manifest, among other things, through official demonstrations, festivities, monuments or architectural designs. Public spaces, however, were also spheres of constant control and discipline. Any tiny (private) gesture performed without the official permission of the authorities could at once turn political, potentially perceived as an act of social and political resistance. If so, it became "a weak, transcendental artistic gesture" (Groys 2010) – a public gesture of "weak visibility" (ibid.). As Boris Groys observes, such gestures contrasted with the "strong images and texts" of the official propaganda promoting the Socialist project so omnipresent in the public sphere (Groys 2010).

A photograph taken in 1981 shows Guillermo Deisler using a public phone in Plovdiv's main plaza (Plaza of Plovdiv). Deisler's gaze is clearly directed towards a relief portrait of Lenin which is situated just above the public phone, indicating the recipient of his phone call. Here, Deisler's artistic gesture has taken on some characteristics of classical migrant art. His gesture is "dialectically positioned in relation to the forces of normalization" (Mathur 2011, ix), as his conversation with Lenin is not public (collective, ideological), but of a direct, 'real' and private nature. One could speculate on the subject of such a conversation. It may, for example, have alluded to the current state of Chile under military dictatorship. As this artistic intervention took place seven years after Deisler's move to Bulgaria, the artist could also have expressed his disillusionment with socialism. As his friend and artist Petar Dramov recalls, the art produced by Deisler in early 1980s Bulgaria reflected his growing disappointment with the Communist project and, with time, transformed into a depoliticised style. Dramov describes how "[a]t first, Guillermo drew graphical compositions of raised heads and fists, intruded phrases by Pablo Neruda, the image of Ernesto 'Che' Guevara, he sang 'Venceremos' [We will win]. Later, when his revolutionary passions were extinguished, his graphics became more conditional and more decorative" (Stanev 2001, 44–45) (fig. 3). Deisler's phone call could be seen as an act of resistance because of its private character. It implies a personal relationship with Lenin that was not only impossible, but, above all, unthinkable and inappropriate in an extremely hierarchical East European communist society. With his "phone call to Lenin" – published later as a postcard and distributed by artists via mail art networks – Deisler started to act as an East European artist. His work, for example, closely resembles the Czechoslovakian artist Jiří Kovanda's modest and reticent performances in public space which were based on ordinary gestures and staged in the same decade (Havránek 2007). Deisler's phone call also shares some parallels with *Lenin in Budapest* by the Hungarian artist Bálint Szombathy: in order to create tension between the public image of the Father of the Bolshevik Revolution and the "trivial daily life of a real-socialism" (Šuvaković 2005, 178), Szombathy had performed a private May Day demonstration in 1972 with a signboard picturing a portrait of Lenin. Deisler's creative endeavour can be read as an articulation of political criticism. His unauthorised and audacious call to Lenin challenged the Bulgarian Communist Party and its desire to control and simplify each and every thought, and undermined its ideological machinery and its institutions of censorship.

Katarzyna Cytlak

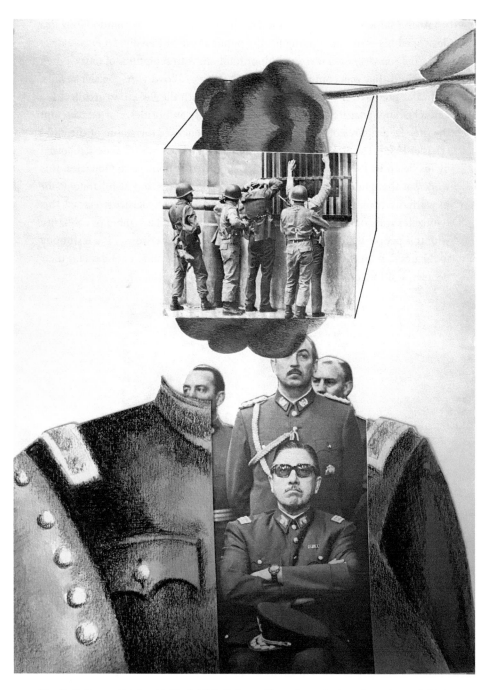

Fig. 3: Guillermo Deisler, *Untitled*, 1975, Collage, Magazine cutouts, coloured pencil, thick cardboard, 33 x 24 cm (Archivo Guillermo Deisler, Santiago de Chile, no. AD-03530).

At the same time as Guillermo Deisler called Lenin, Armando González developed his own undertaking for the public space of Plovdiv. *La Fuente de la vida* (*The Source of Life*) was an outdoor fountain with sculptures of four women and a child that was commissioned by the city of Plovdiv. As Deisler recalls, González prepared the project in collaboration with the Bulgarian architect Ivo Covachef and, after its official approval by the city authorities, started to sculpt the life-sized figures of the women that would encircle the statue of the child (Deisler 1985). The project was never completed due to González's illness, followed by his death in 1981. As Guillermo Deisler writes in homage to González, this work was thought of as a thank you to the city of Plovdiv and its inhabitants for its warm welcoming of Latin American political refugees. Deisler stresses: "This [González's] incomplete work – which would have been a symbol of solidarity with this people who welcomed us, a group of Latin Americans – is a testimony to the ties that unite our nations in their struggle for life and better days for their peoples, waiting for the executing hand." (Deisler 1985) (fig. 4).

Fig. 4: Guillermo Deisler, *Hablando con Lenin* (*Talking with Lenin*), n.d., Photograph on matte paper, 10,5 x 15 cm (Archivo Guillermo Deisler, Santiago de Chile, no. AD-00795).

Katarzyna Cytlak

However, when examining the photograph of the fountain's model, it becomes clear that González's project is very different from other public monuments created in the Soviet bloc. One common interpretation is that the four female figures could have symbolised the four cardinal points of the fountain's base whose plinth then takes the form of a stylised cloud or a fragmented cartographic landscape. They also evoke the classical iconographic motif of women in varying stages of age, prevalent in European art of the time. González's fountain could also have been interpreted as the sculpted version of Albrecht Dürer's engraving, *The Four Witches* (1497), which shows four women who form a similar circle. Aside from these references, González's project can also be compared to and contrasted with other monumental sculptures that were commissioned in Bulgarian art at the time. These commissions can be subsumed under two categories: the first featured figurative representations which tended to follow the rules of socialist realism, equipped with a certain primitivistic touch; the second encouraged more innovative, geometrical and futuristic forms using reinforced concrete. In the first case, women were represented as strong and masculinised, they had a peasant's or a worker's body and were always dressed in a rather modest and simple way. An example of this is the relief which decorates the *Alyosha Monument* – an 11-metre tall concrete statue of a Soviet soldier, constructed between 1954 and 1958 on Bunarjik Hill in Plovdiv (Tepljakov 2007). The second category, in contrast, featured female figures that were geometrised and synthetised. This is exemplified by the emblematic *Memorial Complex Hillock of Fraternity,* which glorifies Bulgarian and Soviet friendship and was built in Plovdiv in 1974 by Lubomir Chinkov and Vladimir Rangelov (Richter 2014). In both cases the representation of nudity was accepted. Compared to these monuments which were built in the Bulgarian public sphere during the Communist period, González's *Source of Life* was unprecedented and announced an important aesthetic shift in the sculptural practice of his new homeland. González's naked, harmonious, beautiful and sensual female statues could not only have potentially caused controversy but could also have evoked admiration for a different kind of artistic sensibility from that promoted by socialist realism (fig. 5).

Just like Guillermo Deisler's *Hablando con Lenin* (*Talking with Lenin*), González's monument could be considered an act of resistance: a gesture questioning the main aesthetic rules which dominated Bulgarian official art, a demand to express individual sensibility, or an appraisal of the more sensual side of women which was so neglected in Communist iconographies. As in Deisler's case, González would have performed a silent act of disobedience, critical of the ideology and the aesthetic directives in Bulgaria under Communist rule. If *Source of Life* had been completed, it could have given González more visibility and attention among the inhabitants of Plovdiv. The monument would also have contributed to a change

in the official perception of women in Bulgarian society. Both artists' additions to Plovdiv's public space expressed, in an elusive way, their disillusionment with their experience of living in the Eastern bloc.

2.-

Armando Gonzalez, tenia un perfil romano, de sus antepasados. Su
perfil, el volumen de su cabeza me lo sigo encontrando en las ca-
lles de Plovdiv, en este exilio que se va tornando simplemente
interminable.
Con Armando hubieron asados, tertulias y discusiones interminables.
Gardel, el tango, Artigas, las provincias unidas del rio de la Pla-
ta, la plasticas de los aztecas, mayas, etc, los caballos de San
Marcos en Venezia, la lucha de clases, el fascismo, la republica
espanola eran los temas interminables ya en su casa ya en su taller
donde trabajaba en la plastica y en la grafica. Retratos de los de-
saparecidos de su pais, de las torturas, relieves de Artigas y la
muchacha de la paloma que era su orgullo. Y en medio de los vaciados,
los moldes, herramientas y materiales de trabajo una foto que guar-
daba con mucho carino, la visita que nuestro poeta Pablo Neruda le
habia hecho en su taller en Montevideo. En ella aparecen abrazados
junto a la escultura ecuestre que por entonces trabajaba para Arti-
gas y que ganara un concurso.
Lo vimos tomar con entusiasmo y seriedad el proyecto de fuente pu-
blica que le encargara la ciudad. En el queria expresar la vida, a
cuatro mujeres en ronda con un nino de caracter monumental. Junto
al arquitecto Ivo Covachef habian presentado los proyectos a escala,
los que habian sido aprovado y ya habia iniciado los trabajos por
levantar las figuras al tamano real cuando primero un preinfarto lo
obligo a detener el ritmo de su paso, despues de una breve recupera-
cion, luego un leve ataque cerebral que lograra apenas sobrellevar
atacado por una de las formas mas agudas de la epatitis que, sin
fuerzas, no pudo sobrellevar. Esta obra suya incompleta, que bien
hubiera sido el simbolo a la solidaridad con que este pueblo nos
acogio a nosotros un grupo de latinoamericanos y el testimonio a
traves de ella de los lazos que unen nuestros pueblos en su lucha
por la vida y dias mejores para sus pueblos, espera aun la mano
ejecutora.
Escribir de Armando Gonzalez es hasta cierto punto algo alegre, li-
viano, cargado de vida y esperanzas. A traves de el, hoy Uruguay
nos es mas caro y cercano.
Regularmente, en mi camino al correo, la fuente de elixires de vida
para los que viven lejos de la patria y deben mantener vivos los
contactos con sus raices, me topo con "Bai Kolio", Nicola Sotirof,
picapedrero de profesion y tambien amigo comun con Armando Gonzalez,
ademas de haber estado en el Uruguay por los anos 30 y 31 en La Paz,
Canelones y haber trabajado en la Cantera "De Marco". Decir "Bai
Kolio", es una forma de respeto familiar comun de aca y equivalente
a nuestro "Don Nicolas" o "No". Asi se entrecruzan recuerdos comunes
y de su pasado en Canelones, Montevideo, Buenos Aires, etc. Este
amigo, con letras mayusculas, que hoy bordea los 80 anos, le ofrecio
en prueba de solidaridad y le grabo la piedra que hoy decora su tum-
ba numero, con un simple texto que lo dice todo, Armando Gonzalez,
1912-1981, Escultor Uruguayo.
Cuando nos informamos de la vuelta al sistema democratico en el Uru-
guay recientem junto con la alegria que compartiamos con los que
sabiamos regresaban a su patria, sentimos la alegria que hubiera
experimentado Armando de estar junto a los suyos. Y porque no decir-
lo sentimos profundamente que no hubiera sido asi. En ningun momen-
to de los anos que compartimos habia dejado de trabajar por la espe-
ranza de todos nosotros y ahora ella entraba triunfando por las ca-
lles y barriadas de su pais.
Quedo hoy por completar su simple mensaje de paz y de vida.

29.7.85 Guillermo Deisler, Plovdiv.

Fig. 5: Guillermo Deisler, "2. Armando González [...] Plovdiv, 29.07.1985", Unpublished text, one unnumbered page (Archivo Guillermo Deisler, Santiago de Chile).

Katarzyna Cytlak

Deisler and González, thus, as I have shown, tried to reinvent the concept of an artistic intervention in public space and attempted to proffer notions of public monuments different from those promoted by the Bulgarian Communist Ministry of the Arts at the time. Even if *Talking with Lenin* and *Source of Life* have frequently been considered as marginal to the artists' oeuvres, they nevertheless mark an important shift in their artistic approaches. Both projects could also be interpreted as proof of González's and Deisler's full integration within the East European art scene. By inserting *Talking with Lenin* and *Source of Life* into Plovdiv's public space, both artists became East European artists. In other words, they became closer to East European neo-avant-garde artists who were critical of the biopolitics and the overwhelming ideology of the Communist State. Deisler and González's interventions in public space confirm their belonging to the Bulgarian and East European culture – but not the official one. *Talking with Lenin* and *Source of Life* correlate to the art of East European 'internal dissidents' who initiated unofficial and non-conformist artistic productions throughout the Eastern bloc. The two projects especially speak to the masterpieces of Soviet "romantic Conceptualism" of the late 1970s that critically appropriated the images disseminated by Communist propaganda (Groys 1979). Deisler's and González's "weak gestures" in public space (Groys 2010) thus defy the strong images which dominated Plovdiv's public sphere and which illustrated the widespread ideological discursive formations at play in the People's Republic of Bulgaria.

Notes

[1] Translated from Spanish by Katarzyna Cytlak.

[2] In 1975, after Deisler's family had moved to Plovdiv, his book *Le Cerveau* (*The Brain*), a homage to Salvador Allende, was published in France (Deisler 1975). One year later, his *Le Monde comme il va* (*The World as it goes*) was published in Uruguay (Deisler 1976).

[3] Translated from Bulgarian by Ruzhka Miteva Nicolova.

References

Argul, José Pedro. *Las Artes Plásticas del Uruguay: desde la época indígena al momento contemporáneo*. Barreiro y Ramos S.A., 1966.

Battegazzore, María Luisa. "Author's interview with María Luisa Battegazzore, vice-president of the Fundación Rodney Arismendi, Montevideo." (unpublished, Montevideo, 2 November 2018)

Bugajski, Janusz. *Ethnic Politics in Eastern Europe: A Guide to Nationality Policies, Organizations, and Parties*. M. E. Sharpe, 1994.

Coll, Laura. "Author's interview with Guillermo Deisler's widow Laura Coll." (unpublished, Santiago de Chile, 30 July 2018)

Deisler, Guillermo. *¡GRRR!*. Ediciones Mimbre, 1969.

Deisler, Guillermo. *Poemas visivos y proposiciones a realizar*. Ediciones Mimbre, 1972.

Deisler, Guillermo. *Le Cerveau. Manuel des instructions et de jeux*. Les Nouvelles Éditions Polaires, 1975.

Deisler, Guillermo. *Le Monde comme il va*. Ediciones Ovum, 1976.

Deisler, Guillermo. "2. Armando González […] Plovdiv, 29.07.1985" (unpublished text, one unnumbered page, Archivo Guillermo Deisler, Santiago de Chile, 1985)

Deisler, Mariana, et al. *Archivo Guillermo Deisler: Textos e imágenes en acción*. Ocho Libro Editores, 2014.

Egbert, Donald D. "Politics and the Arts in Communist Bulgaria." *Slavic Review*, vol. 26, no. 2, 1967, pp. 204–216.

García, Francisca. "Los atributos de la Poetry Factory." *Exclusivo hecho para usted! Obras de Guillermo Deisler*, edited by Francisca García, exh. cat. Sala Puntángeles, Valparaíso, 2007, pp. 113–117.

Genova, Irina. *Tempus fugit / Time is Flying: On Contemporary Art and Visual Image*. Altera/Zeugma, 2007.

Genova, Irina. *Modern Art in Bulgaria: First Histories and Present Narratives Beyond the Paradigm of Modernity*. New Bulgarian University Press, 2013.

Greising, Carolina, et al. *Historia Uruguaya 11. La dictadura 1973–1984*. Ediciones de la Banda Oriental, 2011.

Groys, Boris. "Moscow Romantic Conceptualism." *A-Ya*, no. 1, 1979, pp. 1–13.

Groys, Boris. "The Weak Universalism." *e-flux Journal*, no. 15, April 2010, https://www.e-flux.com/journal/15/61294/the-weak-universalism/. Accessed 14 February 2019.

"Guillermo Deisler. Cronología biográfica." *Archivo Guillermo Deisler. Sitio oficial del artista visual chileno Guillermo Deisler (1940–1995)*, 2015, www.guillermodeisler.cl/el-archivo/cronologia-biografica-del-artista-visual-guillermo-deisler/. Accessed 14 February 2019.

Hatziprokopiou, Panos. "Strangers as Neighbours in the Cosmopolis: New Migrants in London, Diversity, and Place." *Branding Cities: Cosmopolitanism, Parochialism, and Social Change*, edited by Stephanie Hemelryk Donald, et al., Routledge, 2009, pp. 14–27.

Havránek, Vít. *Jiří Kovanda: Actions and Installations, 1975–2006*. JRP|Ringier/Tranzit, 2007.

Israel, Sergio. "En el socialismo real." *El Uruguay del exilio: Gente, circunstancias, escenarios*, edited by Silvia Dutrénit Bielous, Trilce, 2006, pp. 295–317.

La Fundación Rodney Arismendi. "Sobre Gonzalito." *UYPRESS*, 6 December 2010, www.uypress.net/auc.aspx?10765. Accessed 14 February 2019.

La Fundación Rodney Arismendi. *Centenario Armando González, "Gonzalito" 1912–2012*. La Fundación Rodney Arismendi, 2011. www.fundacionrodneyarismendi.org/pdf/gonzalito.pdf. Accessed 14 February 2019.

Katarzyna Cytlak

Mathur, Saloni. "Introduction." *The Migrant's Time: Rethinking Art History and Diaspora,* edited by Saloni Mathur, Sterling and Francine Clark Art Institute, 2011, pp. vii–xix.

Méndez García, Álvaro. "Armando González." *Anuario de la Fundación Rodney Arismendi,* 2007, pp. 64–75.

Padín, Clemente. "El Charrua González." *El Popular,* 27 September 1985, one unnumbered page.

Piotrowski, Piotr. *In the Shadow of Yalta: Art and the Avant-garde in Eastern Europe, 1945– 1989.* Reaktion Books Ltd., 2009. First edited by Dom Wydawniczy Rebis, 2005.

Realismo Social en el Arte Uruguayo 1930–1950, edited by Gabriel Peluffo Linari, exh. cat. Museo Municipal de Bellas Artes Juan Manuel Blanes, Montevideo, 1992.

Richter, Darmon. "Forgotten Communist Monoliths of Bulgaria." *Atlas Obscura,* 14 July 2014, www.atlasobscura.com/articles/the-forgotten-communist-monoliths-of-bulgaria. Accessed 14 February 2019.

Savova-Mahon Borden, Milena. *The Politics of Nationalism under Communism in Bulgaria: Myths, Memories, and Minorities.* PhD thesis, University of London, 2001.

Scheller, Jörg. "Eastern Europeanizing Globalization: Polish Artists at the Venice Art Biennale and the Historical Microcosms of Globalization." *Globalizing East European Art Histories: Past and Present,* edited by Beáta Hock, and Anu Allas, Routledge, 2018, pp. 98– 112.

Šuvaković, Miško. "Performing of Politics in Art – Transitional Fluxes of Conflict." *Szombathy Art,* edited by Nebjoša Milenković, exh. cat. Museum of Contemporary Art of Vojvodina, 2005.

Станев, Стефан [Stanev, Stefan]. *Под знака на Седемте тепета. Спомени, Портрети* [*Under the Sign of the Seven Hills. Memories. Portraits*]. Nova Teamcompact, 2001.

Тепляков, Сергей [Tepljakov, Sergej]. "Болгарский Алеша живет на Алтае [Bolgarskij Alesha zhivet na Altae; The Bulgarian Alyosha lives in the Altai]." *известия* [*Izvestia, News*], 8 April 2007, www.izvestia.ru/news/323849. Accessed 14 February 2019.

Varas, Paulina. "Cuerpo postal colectivo, la red de arte correo." *Archivo Guillermo Deisler: Textos e imágenes en acción,* edited by Mariana Deisler, et al., Ocho Libro Editores, 2014, pp. 72–75.

Hedda Sterne and
the Lure of New York

Frauke V. Josenhans

When Romanian-born artist Hedda Sterne arrived in New York in October 1941, she had fled from her native country and traveled across Europe to Portugal to board a ship to the United States.[1] The American metropolis became a new home for Sterne, and her name became associated with it, although she had grown up in Bucharest and spent time studying in Vienna, and then sojourned frequently in Paris from 1932 to 1939. Especially in the 1950s her abstract style was closely associated with that of the New York School. Her oeuvre has been considered in the context of Abstract Expressionism, with publications on the movement emphasizing her status as being one of the few female artists being part of it. Similarly, her marriage to Saul Steinberg, also a Romanian émigré, often caused critics to refer to her as 'the wife of' or 'the muse of'. Considering her work purely within the canon of modern art, and subscribing to a mere biographical approach can easily overshadow Sterne's artistic achievements and simply reduce her art by way of 'influence', or neglect its role altogether, as has been done in the past (Anfam 2015, 14). Thus, this article will focus on her artistic evolution during the first decade of her life in the United States in order to examine the inherent aesthetic and philosophical aspects of her work, and point out the originality and sensibility that she applied to her work. It will scrutinize the impact that the physical environment of New York City had on Sterne and her work. Questioning the notion of the metropolis as only limited in space, this text will rather argue for a concept of the metropolis, both physical and metaphysical, that transcends Sterne's work.

American Artists Paint the City

Katharine Kuh, curator at the Art Institute of Chicago, had in 1956 assembled an exhibition for the Venice Biennale on the topic of the "City" as an inspiration for modern American artists. Sterne's painting *New York* (1955) (fig. 1) was included at the American Pavilion exhibition of the XXVIIIth Venice Biennale, *American Artists Paint the City,* curated by Kuh. The exhibition catalogue featured the painting

New York prominently opposite the title page (*American Artists Paint the City* 1956). Organizing the exhibition around the topic of the metropolis, the curator claimed that the image of the city had become the quintessential American icon in the 20th century, making it a symbol of modern urbanism, progress, architectural endeavors, traffic, and communication (ibid., 7). Kuh differentiated this new, modern approach from that of the previous century when artists were still mostly drawn to the European cultural capitals, and stressed how, in the 20th century, artists came to draw inspiration from modern streets, lighting, and transportation. She argued that the new generation of artists had substituted Notre Dame and Sacré Coeur with the Brooklyn Bridge and towering skyscrapers in Manhattan (ibid., 8).

Indeed, various artists identified skyscrapers as a quintessential American symbol, which for most was embodied by New York itself. Artists such as Lyonel Feininger, Norman Lewis, and Joseph Stella transformed these buildings into modern-day cathedrals, emphasizing the towering verticality of these structures. Sterne, however, focused less on the buildings that symbolize the city than on what they conveyed: monumentality, speed, motion. Kuh in her essay for the Biennale publication likewise insisted on the apparent visual chaos as a hallmark of the American city. And she selected Sterne's work as she considered that her bold contours "capture some of New York's staccato excitement" (ibid., 22). Furthermore, Kuh reasoned that the abstract character of many of the American artists was actually based on a realistic observation of their environment, notably the sense of light and the attention to structure that she thought visible in Sterne's paintings of the metropolis (ibid., 30). Kuh finished her essay for the catalogue of the Biennale by pointing out that whether the artists selected for the American pavilion were indeed native or non-natives, they all had in common the inspiration they drew from their environment (ibid., 31). In order to establish how Sterne in the early 1950s could be considered incarnating an American style that was inspired by the metropolis, and to be chosen to represent it on an international stage, it is necessary to go back in time to her very beginnings in the United States.

Surrealism in New York

Sterne was not the only foreign-born artist to be enticed by New York: many other European exiles who had arrived before World War II made the metropolis a recurrent topic of their work. Understanding the Eurocentric milieu and context in which Sterne arrived in 1941 is crucial to fully appreciating her artistic evolution.

Frauke V. Josenhans

Fig. 1: Hedda Sterne, *New York*, 1955, Oil and spray paint on canvas, 86 x 50 inches (218,5 x 127 cm), Baltimore Museum of Art, Baltimore, Anonymous Gift, 1988.1367 (© The Hedda Sterne Foundation, Inc. | Licensed by ARS, New York, NY).

Sterne was one of many Europeans that had fled the war-torn continent for North or South America. Various artists from Nazi-occupied countries had settled in the big cities, attracted by a dynamic art market, teaching opportunities at American art schools or universities, or because of personal contacts.[2] The Surrealists especially chose to settle in New York, where effectively a new Surrealist circle came to life around André Breton, Max Ernst, and Marcel Duchamp. When Sterne arrived in New York, she was first introduced to the 'European' New York, thanks to several contacts she had previously made in Europe, such as art dealer and collector Peggy Guggenheim. Sterne's work had been shown in different exhibitions, both in Bucharest and in Paris in the late 1930s (*Uninterrupted Flux* 2006, 117f.; Nasui 2015, 44–50). Indeed, the French-German artist Jean Arp had seen Sterne's work in Paris at the Salon des Surindépendants, and had then made Guggenheim aware of it, and the collector subsequently showed Sterne in her London gallery (*Uninterrupted Flux* 2006, 5). Her acquaintance with Guggenheim allowed Sterne to encounter several members of the European avant-garde who had fled to the US and had settled in New York as well, among whom were Max Ernst (Guggenheim's then husband), Piet Mondrian, Friedrich Kiesler, and Marcel Duchamp. In 1943, she met the Romanian-born artist Saul Steinberg, whom she married in October 1944, and who then introduced her to even more European artists.

Thanks to her friendship with Peggy Guggenheim, Sterne's work was shown at her Art of This Century Gallery. She was also among the artists included in the *First Paper of Surrealism* exhibition in 1942, organized by André Breton and Marcel Duchamp. But her collage work inspired by Surrealist sources quickly evolved into something different, incorporating all the new sensations that Sterne experienced in New York. As art critic Dore Ashton described in the 1985 retrospective of Sterne's work:

> It came as a thunderbolt that the whole country of America was more surrealist than Surrealism. She brought an innocent eye to bear on the cavernous phenomenon of New York [...], and on the industrial prodigies of skyscrapers, highways, and the mammoth machines that made America hum. (Ashton 1985, 10)

However the transition to a new style began with an introspective approach. Sterne's early works executed in the United States drew from her memories of Europe, "to get rid of the past" (ibid.). These 'memory' pieces convey intimate views of places, people, and objects that the artist grew up with. Sterne, for instance, painted *Sill Life – Memory of My Childhood*[3] (1944) as a way to merge her past and present. In this painting the artist represented herself in her parents' bedroom; a

Frauke V. Josenhans

curious environment without any walls where exterior and interior merge, and where memories of Romania overlap with her experience in New York. Such works from the early American period shiver between the real and the imagined, building her own world where objects and people seem to float in the air, no longer dictated by laws of physicality or a truthful depiction of reality. Oddly, elements of the domestic setting such as the stove and the jug are more dominant than the figures themselves, illustrating the meaning that Sterne ascribes to objects in her immediate surroundings. Her focus during the next phase of her work shifted to more tangible objects, everyday tools and settings from her apartment in New York, as in *Interior – Kitchen* (1945, fig. 2). She first focused on her immediate surroundings, drawing compulsively the interiors she lived in equipped with stove, bathroom, window, telephone, kitchen. And yet in these paintings these appliances form a separate world, where interior and exterior merge. The fascination with her immediate environment, first the interior and then transposed to the exterior, appears as a constant fixture in her work, and she recalled this early exposure and experience of New York in various interviews, even drawing parallels to pop art and calling herself a "premature pop artist" (*Uninterrupted Flux* 2006, 16). Sterne explained in 1981 how the physical experience in the early years of her American life opened her up to becoming a visual artist, drawing from the real as opposed to the subconscious. She stated:

> When I came here, I became totally enthralled visually with the United States so I became like a premature pop artist. I started painting my kitchen, the kitchen stove, the bathroom appliances, everything where we lived. Then I went out and I painted Ford cars and the elevators. And then I went to the country and I started painting industrial machines, and then I painted roads. I became visual when I came here. (ibid.)[4]

The physical and visual experience of the urban landscape was crucial for Sterne, as it allowed her to observe both her surroundings and herself in them. These first years of her life in New York clearly shaped her vision of it through bus trips in the city, as well as drives in the countryside, as Sterne recalled in a later interview:

> Because my whole experience of coming to a new continent was so extraordinary, so bizarre, so absorbing. […] For months after I came, the thing I liked to do most was to take a double-decker they had on 5th Avenue, and the top was open like a terrace. […] And I would take it and go from Washington Square to

Fig. 2: Hedda Sterne, *Interior-Kitchen XIX*, 1945, Oil on canvas, 42 x 30 ¼ inches (106,7 x 76,8 cm), Hedda Sterne Foundation, New York (© The Hedda Sterne Foundation, Inc. | Licensed by ARS, New York, NY).

Frauke V. Josenhans

125^th back. And look, and look, and look, and I couldn't have enough. Delighted with everything. Tiffany had airplane parts instead of jewels in the window. […] And I looked at stores, in and out, and looked, and looked. I was absolutely enthralled by New York. […] I had to train myself to find beauty where I hadn't learned how to find beauty. For me, a city was a body of water, bridges, cathedrals, churches, palaces. […] alleys with trees. That was a city. And New York with skyscrapers, I had to educate myself to see the beauty of New York. Which I did promptly, by the way. (Sterne 2005)

Painting 'the Speed and Glare of City Traffic'

In the second half of the 1940s, Sterne found a new vector for transcribing her experience of the metropolis on canvas. In an interview with *Art in America*, she explained how she and Saul Steinberg would drive around sightseeing first through New York, and then ventured to the countryside and became fascinated with machines.

> We looked at everything, everything. Every Sunday when there was no traffic, we went motoring through New York. I was crazy about New York. Then in '47, I went to the country and I discovered agricultural machines. I had a feeling that machines are unconscious self-portraits of people's psyches: the grasping, the wanting, the aggression that's in a machine. That's why I was interested to paint them. And I called them "anthropographs" —maybe it was pretentious thinking. (Sterne, in Simon 2007, 116)

Sterne began to focus on the anthropomorphic qualities of machinery, from rural farm equipment in Vermont to massive contraction cranes in New York. These anthropomorphic forms in her so-called 'machine' paintings expressed in her eyes "the speed and glare of city traffic", as she told *Life* Magazine in 1951 (Sterne, in Anonymous 1951, 54). They evolved out of her 'memory paintings', and she depicted these machines almost like self-portraits or portraits of society. Some of them express comical characteristics, with face-like features stressing the resemblance with humans. Her involvement with painting machines triggered her interest in motion that became a special focus of her work in the early 1950s. The same 1951 article in *Life* Magazine on Sterne and her husband Saul Steinberg explained

how both artists aimed to capture their new home country, but in quite different ways:

> As artists the Steinbergs pursue their separate ways. [...] Hedda works in their apartment amid pebbles and firemen's hats. Both are fascinated by the U.S.; he by the habits of people; she by machines and towering structures. Both want to create a new picture of America, but not the same picture. (Anonymous 1951, 51)

The article featured three more machine paintings by Sterne and a statement by her on the quality of mystery she finds contained in the particularly American landscape of "mechanized power" (ibid., 54). The article almost amusingly pointed out how Sterne turned away from more feminine themes to instead depict "engineering projects and battleships, airports and city streets" (ibid.). It further stressed the part of mystery that Sterne saw in these creations and that she embedded her paintings with: "If there were no mystery [...] I could not paint." (ibid.) The mystical or enchanted character is integral in her works, visible in the earlier Memory paintings, as well as in the Machine or later New York paintings. Seeing her surroundings similar to a child discovering the world, Sterne was capable of seeing wonder and mystery in the everyday, and in the symbols of progress, be it engines, roads, or trains. And yet, a nearly spiritual approach is evident in these works, and indeed Sterne referred to the English philosopher Alfred North Whitehead and his thoughts on religion in a 1954 *Art Digest* article to further stress the mystical part of her art: "[...] the vision of something which stands beyond, behind, and within the passing flux of immediate things, something which is real yet is waiting to be realized; something which is a remote possibility yet the greatest of facts, something that gives meaning to all that passes and yet eludes apprehension." (Sterne 1954, 4)

'An Intricate Ballet of Reflections and Sounds' – the New York Series

From the focus on the actual engine Sterne shifted her interest to the power and speed associated with these machines, and in a larger sense embodied by the metropolis. "[...] New York seemed to me at the time like a gigantic carousel in continuous motion [...] lines approaching swiftly and curving back again forming an intricate ballet of reflections and sounds" (Sterne, in *Contemporary*

Urban Visions 1966, 15), as she explained it later. The works that she created in the 1950s are titled *New York* and many of them numbered. Some canvases are horizontal, others vertical, and they shift in scale from monumental to more intimate sizes. They transitioned from the earlier 'machine paintings' in that instead of depicting actual engines and tools, they captured the motion and power behind the technology. And yet, Sterne's artistic progress remained the same as in her previous works. Dore Ashton stressed the emphasis on the visual observation as an essential part of Sterne's process: "[I]t begins indeed with the objective scanning of an object, as already visible in her Memories and Machine series. She then transforms the object into a visual philosophical inquiry using art primarily as technique of understanding for her." (Ashton 1985, 17f.) Or, as Sterne described it many decades later in her own words:

> […] when the thought becomes image and the image suggests a thought. That's why I call them "wordless thoughts." […] That the things wanted to exist, the paintings. They had wanted to exist and used me, not – you know, when you talk with people who are 20th century – the psychology, you know, the psychoanalysts. People think they have the idea. And I think of myself as an optical instrument. And what I feel and see is out there and I perceive it. It's not something that I fabricate out of nothing. (Sterne 2001)

The painting *New York #2* from 1953 (fig. 3) conveys the process of "wordless thoughts" that Sterne described: the vertical structure echoes the towering constructions of New York, while the circular bright form with its halo effect suggests diffused light, as maybe from street lighting or the lights of a car . The grid-like structure at the bottom suggests an urban landscape with traffic lanes or railroads. This new focus on the metropolis called for new means to describe it, and triggered a change in Sterne's technique. In many of these canvases, beginning in the early 1950s, Sterne used commercial spray paint in addition to oil paint. Examining the surface of the canvases, one also remarks how she manipulated the painted surface with various tools, scraping parts of the paint off, and painting over them (Josenhans/Schwarz 2019). She explained in a later interview how the exterior sensations informed her practice: "In order to show the feeling I had of cars moving at high speed and blurring, I used to spray paint, which is a speedy way of working. You know, there are certain subjects that suggest the technique to do them in. Those highway subjects suggested the spray […]." (Sterne, in Simon 2007, 116)

Fig. 3: Hedda Sterne, *New York #2,* 1953, Oil on canvas, 78 × 34 1/8 inches (198,1 × 86,7 cm), The Metropolitan Museum of Art, New York, Purchase, Gift of Samuel Dretzin, by exchange, Bequest of Gioconda King, by exchange, Rogers Fund, by exchange, Funds from various donors, by exchange, and Gift of Chauncey Stillman, by exchange, 2017, 2017.99 (© The Hedda Sterne Foundation, Inc. | Licensed by ARS, New York, NY).

Frauke V. Josenhans

The paintings done in the early 1950s illustrate how Sterne grappled with understanding the city; her way of turning the wealth of sensations and images into something that made sense was by way of painting. These canvases seem at first approach completely abstract without any tangible base or source. But Sterne gave indications in the titles; most of them have a direct reference to New York. Indeed, upon close inspection, one makes out forms and patterns that reflect those of the urban structure of New York: railroads; streets; trains; cars; skyscrapers; the Brooklyn Bridge, and other landmarks. The painting *3rd Avenue El* from 1952–1953 (fig. 4), represents the 3rd Avenue Elevated Line, a railroad that was constructed between 1875 and 1878 and offered above-ground transportation from the South Ferry up to the Bronx.[5] The line was the last elevated line to operate in Manhattan, but it eventually declined and demolition began in the 1950s. Sterne had represented this train line in an earlier painting.[6] In the later work, she revisited the motif of the tracks, but this time capturing the huge elevated steel structures, and the motion of the moving trains in dynamic lines and an explosion of colors. Although elevated train lines fell out of favor with the public and hindered urban development – one reason for their eventual demolition – Sterne saw the hidden beauty in these metal constructions, ascribing them a sense of mystery.

They shiver between abstraction and representation, and Sterne uses the bold, painterly strokes of black and blue-gray to convey actual New York landmarks as well as the dynamic, kinetic, and dominating feeling of this intensely urban environment. However the soft grayish haze gives it a mysterious ambiance, and obliterates any recognizable features. *New York, No. 1 – 1957*, done in 1957 (fig. 5), shows yet another variation of the metropolis, this time completely abstract, with dynamic lines that traverse the canvas, conveying the sense of speed and motion. The bright colors add to the visual cacophony expressed in this work. These abstract canvases from the early 1950s encountered an important success, as they seemed to fit well into the aesthetic canon as represented by the New York School (*Uninterrupted Flux* 2006, 7).

Fig. 4: Hedda Sterne, *3rd Avenue El*, 1952–1953, Oil and spray enamel on canvas, 40 3/8 x 31 7/8 inches (102,5 x 80,9 cm), The Metropolitan Museum of Art, New York, Gift of Mr. and Mrs. Daniel H. Silberberg, 1964, 64.123.4 (© The Hedda Sterne Foundation, Inc. | Licensed by ARS, New York, NY).

Frauke V. Josenhans

Fig. 5: Hedda Sterne, *New York No. 1 – 1957*, 1957, Oil and spray paint on canvas, 76 5/8 x 51 1/4 inches (194,6 x 130,2 cm), Wadsworth Atheneum Museum of Art Hartford, CT; Gift of Susan Morse Hilles, 1959.88 (© The Hedda Sterne Foundation, Inc. | Licensed by ARS, New York, NY).

Hedda Sterne and the New York School

Discussing Hedda Sterne and New York leads inevitably to her association with the New York School. This connotation is mostly due to the now famous photograph of *The Irascibles* taken by Nina Leen and published in 1951 by *Life* Magazine. The photo itself was a misunderstanding, but one that shaped the perception of Sterne's work for the rest of her life and until today. Inspired by a three-day artists' roundtable in April of 1950 titled "Artists' Session at Studio 35" (an active artists' space in New York), numerous artists wrote a letter to the Board President of the Metropolitan Museum complaining about the reactionary curatorial biases of their upcoming survey of American art. The list of participants included various artists from the era, notably Willem de Kooning, Adolph Gottlieb, Hans Hofman, Norman Lewis, Robert Motherwell, Barnett Newman, as well as Janice Biala, Louise Bourgeois, and Hedda Sterne. However the day that the picture was taken, Sterne was the only woman artist present, and thus ended up on the picture, positioned above all the male artists. Sterne knew and socialized with many of the artists, and she certainly admired and genuinely liked many of them, whom she referred to as "my friends, the abstract expressionists" (ibid., 10). They also shared the championship of Betty Parsons for some time, and were shown at her gallery (Hall 1991, 77–97). However Sterne rejected the idea of an artist being limited to "one image" with corporate branding (Eckhardt 2012, 51). She later explained: "my friends, the abstract expressionists would always tell me, 'one image, one image' and I said, 'I don't paint logos.'" (Sterne 2001).[7] And yet, despite the difference both in style, practice, and vision, her abstract spray paintings from the 1950s were the ones that were actively collected from the mid 1950s to the mid 1960s and shown alongside the Abstract Expressionists: The Museum of Modern Art, New York, The Whitney Museum of American Art, The Metropolitan Museum of Art, The Art Institute of Chicago, and The Toledo Museum of Art all own spray paintings by Sterne from that period. These were the works that critics could easily make sense of, inscribing them in a larger aesthetic context (Eckhardt 2012, 82, 84).

And yet, more than the New York School, or any school really, it was the encounters that informed Sterne's work. Indeed New York was not only a physical place but also a concept that included encounters with people. The metropolis generated the acquaintance and friendship with other émigré artists, notably Saul Steinberg, Costantino Nivola, and John Graham. She depicted these artists in drawings and paintings, and often became close friends with their respective families as well. But New York also triggered the encounter with many other avant-garde artists and critics, such as Barnett Newman and Annalee Newman, Elaine de Kooning, Harold Rosenberg, and, of course, Betty Parsons, or her later

dealer Clara Sujo. Both her practice and her private life mirrored each other, with one protruding into the other. Her apartment in the Upper East Side served as a place of encounter, bringing various artists and writers together over dinner parties (*Uninterrupted Flux* 2006, 9f.). But Sterne's New York extended to other places outside Manhattan, notably her house in the Hamptons that was close to those of many other artists who had taken residency there, such as Costantino Nivola or Jackson Pollock and Lee Krasner. How the people that she frequented represented New York to her is equally visible in her numerous portraits that she drew and painted throughout her life. Next to self-portraits, one finds several portraits of Saul Steinberg, but also of Barnett and Annalee Newman, Elaine de Kooning, Joan Mitchell, Harold Rosenberg, John Graham, and others. The apogee of this might be the *Everyone Series*, a suite of various faces that were shown at Betty Parsons' Gallery in 1970.

Hedda Sterne's association with New York had long been considered only in the context of Abstract Expressionism. However, as previously laid out, to arrive at her depiction of the metropolis Sterne had to go through a long and complex evolution that had her transition from the interior to the exterior, from her own private sphere to the metropolis. She did not simply immerse herself in American culture and adopted an abstract style that became the trade mark of the New York School. Hers was a slow, gradual evolution that was always fueled by an intellectual approach to transcribing the visual. Although at first glance similar to the works of the Abstract Expressionist, her work embodies a highly personal approach, shaped by her migration experience, which was then fueled by the impetus of new technologies and progress that she encountered in New York and that informed her subject matter as well as her technique and choice of material. Her unique and singular approach with regard to the urban space asks for a new reconsideration of her place in post-war American art.

The author wishes to thank Shaina Larrivee from the Hedda Sterne Foundation, Isabelle Duvernois from the Metropolitan Museum of Art, as well as Patricia Hickson from the Wadsworth Atheneum Museum of Art, for their gracious help and assistance regarding research and resources.

Notes

[1] Her departure and visa were facilitated by her then husband, Fritz Stern, whom she had married in 1932, and who, once she arrived in New York City, helped her to find an apartment at 410 East 50ᵗʰ Street (see *Uninterrupted Flux* 2006, 118).

[2] The emigration to the US was mentioned in various catalogues, see *The Golden Door: Artist-Immigrants of America, 1876–1976* 1976; *Exiles + Emigrés: The Flight of European Artists from Hitler* 1997; *In Wonderland: The Surrealist Adventures of Women Artists in Mexico and the United States* 2012; *Artists in Exile: Expressions of Loss and Hope* 2017.

[3] *Still Life – Memory of My Childhood*, 1944, Oil on masonite, 50,8 x 61 cm, Rhode Island School of Design Museum, Providence, Gift of Mrs. Peggy Guggenheim, 54.190. Another version, gouache on paperboard, is in the collection of the Hedda Sterne Foundation.

[4] Interview of Sterne conducted by Phyllis Tuchman, 17 December 1981. *Mark Rothko and His Times oral history project*, Archives of American Art, Smithsonian Institution, p. 22f.; quoted after *Uninterrupted Flux* 2006, 16.

[5] The 3ʳᵈ Avenue Elevated line in Manhattan was constructed between 1875 and 1878 by the New York Elevated Railway Company. It offered above-ground service from South Ferry to Grand Central Depot, eventually extending service all the way up to 133ʳᵈ Street in The Bronx.

[6] Hedda Sterne, *New York, N.Y. I (The El)*, c. 1945, Oil on canvas, 88,9 x 115,6 cm. Hedda Sterne Foundation, New York.

[7] Variations have appeared in several conversations with the author as well as in Gibson 1999, 95; Eckhardt 2012, 51; *Uninterrupted Flux* 2006, 10.

References

American Artists Paint the City, assembled by Katharine Kuh, exh. cat. XXVIIIth Biennale, Venice, 1956.

Anfam, David. *Abstract Expressionism*. Second edition. Thames & Hudson, 2015.

Anonymous. "Steinberg and Sterne: Romanian-Born Cartoonist and Artist-Wife Ambush the World with Pen and Paintbrush." *Life*, 27 August 1951, pp. 50–54.

Artists in Exile: Expressions of Loss and Hope, edited by Frauke V. Josenhans, exh. cat. Yale University Art Gallery, New Haven, 2017.

Ashton, Dore. "A Cosmopolitan of the Imagination." *Hedda Sterne: Forty Years*, exh. cat. Queens Museum of Art, Queens, 1985, pp. 6–23.

Contemporary Urban Visions, exh. cat. Wollman Hall, New School Art Center, New York City, 1966.

Eckhardt, Sarah Louise. "Hedda Sterne and the Abstract Expressionist Context." Unpublished PhD thesis, University of Illinois at Urbana-Champaign, 2012.

Exiles + Emigrés: The Flight of European Artists from Hitler, edited by Stephanie Barron and Sabine Eckmann, exh. cat. Los Angeles County Museum of Art, Los Angeles, 1997.

Gibson, Ann Eden. *Abstract Expressionism: Other Politics*. Yale University Press, 1999.

Hall, Lee. *Betty Parsons: Artist, Dealer, Collector*. Harry N. Abrams, Inc., 1991.

Hedda Sterne: Forty Years, exh. cat. Queens Museum of Art, Queens, 1985.

In Wonderland: The Surrealist Adventures of Women Artists in Mexico and the United States, edited by Ilene Susan Fort and Teresa Arcq, exh. cat. Los Angeles County Museum of Art, Los Angeles, 2012.

Josenhans, Frauke V., and Cynthia Schwarz. "The Importance of the Spaces 'Inbetween' in Painting: A Close Look at Hedda Sterne's Artistic Process." *Yale University Art Gallery Bulletin,* 2019, pp. 18–27.

Nasui, Cosmin. *Hedda Sterne: The Discovery of the Early Years, 1910–1941*, PostModernism Museum Publishing House, 2015.

Simon, Joan. "Patterns of Thought: Hedda Sterne." *Art in America*, no. 2, February 2007, pp. 110–119. Republished online *Art in America*, 15 April 2011, https://www.artinamericamagazine.com/news-features/magazines/hedda-sterne/. Accessed 10 May 2019.

Sterne, Hedda. "Documents: From Studio to Gallery." *Art Digest*, vol. 29, no. 2, 15 October 1954, p. 4.

Sterne, Hedda. "Interview with Josef Helfenstein, 6 September 2001." Unpublished manuscript, Courtesy Hedda Sterne Foundation, New York.

Sterne, Hedda. "Interview, 2005." Transcript prepared from digital audio files in 2018 by The Hedda Sterne Foundation, New York. Archives of American Art, Smithsonian Institution. Courtesy of The Hedda Sterne Foundation.

The Golden Door: Artist-Immigrants of America, 1876–1976, edited by Cynthia Jaffee MacCabe, exh. cat. Hirshhorn Museum and Sculpture Garden, Washington, D.C., 1976.

Uninterrupted Flux: Hedda Sterne, edited by Sarah L. Eckhardt, exh. cat. Krannert Art Museum, Champaign, 2006.

Arrival Cities:
A Roundtable

Arrival Cities

A Conversation with Rafael Cardoso, Partha Mitter, Elana Shapira and Elvan Zabunyan

Laura Karp Lugo and Rachel Lee

To close the conference, four of the researchers who had participated in the two days of exchange as presenters and moderators were invited to take part in a roundtable discussion: Rafael Cardoso, Partha Mitter, Elana Shapira and Elvan Zabunyan. With the roundtable discussion we intended to consider more deeply particular themes and issues that had emerged during the conference. Three questions were put to the participants as starting points for further reflections on exile and migration in art. The first question related to the type of person that had been at the centre of most of the research presented during the conference: the elite. In fact, in all the geographical areas studied during these two intense days, the vast majority of exiled artists examined belonged to a social and economic elite. Indeed, this seems to be a determining factor of our research, perhaps mainly because of the nature of the documentation and available sources. But it is worth questioning this situation and trying to find out how we can problematise this aspect by being aware of the existence of less visible social strata. The second point we chose to address was that of generations. How should we deal with the different experiences of exile of those who arrived as adults, already trained in their artistic fields, compared to others who arrived as children or even those who were born in their parents' adopted country but who grew up in a communitarian environment, perhaps scarred by the foreign languages spoken, the specific customs, and the difficulty of accessing social and professional local networks? The last question was oriented to the art produced by the exiled artists and its potential theorisation. Can we make generalisations about how exile affects the production of art? Is it possible to theorise an aesthetic of exile? Can common characteristics be defined in the works of newly arrived individuals? The intense and rich debate which closed the conference, and follows here, opened up new perspectives for the study of the "Arrival Cities", perhaps pointing to directions that future research could take.

Rachel Lee: I'm going to begin with a question for Partha which is about elites. Many of the exiled artists we discussed at the "Arrival Cities. Migrating Artists and New Metropolitan Topographies" conference belonged to economic or social elites. How do we address this in our research?

Partha Mitter: Of course, the class of the actors is an important factor that we might think about, because others that come to a new country are a very different kind of people –that is difficult to record; personal testimony is not often available. So that's one thing. But then there's the wider issue of nationalism. I'm thinking of Brazil but also other nationalisms. Asia and so on. I mean, usually the focus of nationhood is elite-based, intellectual, educated.

Elvan Zabunyan: The question of elites is interesting because it is also linked to languages. To be educated means you are able to speak the language if you're arriving in a city or decide to go somewhere. And if we speak about art or an intellectual context, the position you occupied in your own country before going somewhere else is also important. The French photographer Marcel Gautherot was not from the elite. He decided to go to Brazil because of the ethnographic research he was doing in the context of indigenous Amazonia. He decided to stay there and to belong to the country. It is very important to consider this question of elites at different periods of time in different locations. I think that there are many examples of people in the arts that don't belong to an elite today.

Partha Mitter: But are you thinking about simply the European elite?

Elvan Zabunyan: Not only the European elite but the elite who speak the European languages. And of course in the former colonies.

Partha Mitter: Can I briefly make a point about Britain? Indian artists, predominantly, came to Britain and they were from the elite strata; in other words, they were educated, but they were not given recognition as artists. Even academics had a lot of difficulties. It's only recently, in the last eight or ten years, that a lot of research has been done on the 'ordinary' people; there's a lot of material on the labourers and so on, from the late 19th century to the 1940s. And only as late as 2010 a joint universities project examined the contribution of the Indian elite in Britain.

Elana Shapira: I would differentiate between social elite and cultural elite. I think the social elite included refugees who came with financial support or kept some of their property. And there were those who had the extra financing to build up the gallery networks like the Askanasy Gallery in Rio de Janeiro. The friendships within this elite also turned it into a cultural elite. Education is a critical part of the cultural elite. The immigrants whom I worked on, Austrian émigrés, arrived

in New York almost completely broke. But they came from different cultural and social circles that allowed them to develop and promote their careers. Either they connected with institutions like the MoMA or they connected with universities. But I don't think they ever became rich. None of them. Bernard Rudofsky, Frederick Kiesler and Josef Frank in New York were no doubt part of the canon, part of the bohemian elite, but they were not regarded as successful. Kiesler was not successful although he exhibited his works in prominent exhibitions at the MoMA. Rudofsky was successful to a certain extent, yet his ground-breaking exhibitions at the MoMA, *Are Clothes Modern?* and *Architecture Without Architects,* and his books contributed mainly to the public discourse. He did not succeed in becoming a major participant in mainstream modernism. So there was this tension. Being part of the elite did not mean financial success.

RAFAEL CARDOSO: I would echo that. Elitism is a wonderful term of abuse. I use it all the time, but we have to be really careful about what we mean by elite, what the definitions are. I can certainly say from the Brazilian experience that several of the refugees I talked about did not come from an elite background in Europe and, in a way, going to Brazil was an opportunity to reinvent themselves, because in some parts of Brazilian society a European is always seen as someone coming from the elite, whether it is true or not. So, for some with a working-class background in Europe, coming to Brazil was a chance to become part of a social and economic elite that they never belonged to at home. On the other hand, some of the refugee artists like August Zamoyski, who came from an aristocratic background, couldn't pay their bills in Brazil. He was teaching because he had no money. So, I think we have to be really careful. Whenever you have refugees, you have a situation where people are in trouble. This is an emergency situation where some people have gained, and some people have lost, and many people have been pushed out of their homes. When you're dealing with refugees you really have to go case by case when you say whether these people are ascending or descending the social scale, and which social scale, because to be an elite Brazilian is certainly not to be an elite member of the European elite. It's completely different. So, yes, elitism is a nice word to abuse people with, but let's be careful with it.

PARTHA MITTER: I'm thinking about social and economic status, which of course can vary enormously, but can we use another criterion, of literacy? A generalisation, I know, but that criterion would be useful.

RAFAEL CARDOSO: Not for a visual artist though. Some of the painters and photographers had no real formal literary education and yet managed to achieve something as artists.

ELANA SHAPIRA: I think that literacy is very important. In many cases that I have researched, those who 'made it' as designers and architects were published. Take Victor Papanek, for example; it's his texts that people refer to rather than the actual designs. Josef Frank failed to integrate into the American scene because he couldn't find a publishing house for his book. Bernard Rudofsky advanced his career by publishing in journals. Of course, this is only an American example.

ELVAN ZABUNYAN: It's also interesting to emphasise that wherever you go you always stay a foreigner, even if you belong to the elite. If you are, for example, from a very wealthy family in an African country and you go to study in a country where there is racism, because you have money you will maybe be involved in circles where you are privileged, but still the difference in identity will be emphasised. I would like to mention the experience of Edward Said who said he was always in this very schizophrenic situation, and his biography was called *Out of Place*, so it was always a question of 'Where should I be?'

PARTHA MITTER: But he always belonged to a very privileged class, even in America. No doubt he was deeply conscious of the Palestinian question. However wealthy he was – his father had a lot of money – he still felt deeply insecure about that.

ELVAN ZABUNYAN: You said the word 'insecurity'. I think this is part of displacement, even cultural displacement. When you come from abroad or wherever you experience migration, even if it's a long, long time ago, a different generation, there's always a feeling of insecurity. But artists can transform this insecurity into strength with their production.

LAURA KARP LUGO: I would like to turn to the question of generation. Most of the artists we have been discussing left their countries after having studied or practised in their homeland. However, we wonder how to approach the work of artists who went into exile when they were young. You mentioned, Rafael, that half of your family have been in Brazil for many generations and the other half immigrated much more recently. Our question is, should we make distinctions before generations become local? And we were wondering if it depends on the degree of integration, or is it a matter of opportunity or context?

RAFAEL CARDOSO: Yes, I think this is very important. Considering World War II, which is the period that I'm most familiar with, there was a hierarchy, a pecking order, of where refugees went. So, for example, Shanghai was open, but it was very difficult to get a visa, especially an immigrant visa, for the US. So, most of the highest level exiles and émigrés from Germany, for instance, ended up in the US. Thomas Mann and many of the rich and successful established writers and artists went to the US, except for the Communists, of course. The Communists

couldn't get into the US, so they went to Mexico because the government was open to receiving Communist exiles. Brazil was neither a top destination nor a bottom destination, but somewhere in the middle. Young artists and people who couldn't get an affidavit to go to the US, people who couldn't get an immigrant visa, settled for Brazil or Argentina, and this is interesting because a lot of the artists who went to Brazil and Argentina went young, completely unrecognised in the countries they were coming from, and became successful or noteworthy while they were in South America. We have wonderful examples, like the painter Mira Schendel and the architect Lina Bo Bardi, who are being reclaimed by the countries they came from. They obviously are not Swiss or Italian, it's not that simple, they are complicated cases. Mira Schendel is usually labelled Swiss/Brazilian. Where did the artist become an artist? When did the artist become an artist? When do you start being something else? I think that has a lot to do with generation. And of course, as Partha said, the problems of success. If an artist goes to a country and is not successful there, does that make them less of an artist?

PARTHA MITTER: It raises the question of the second generation. What happens? Minorities are very seldom secure. In India, Muslims can never feel secure because at any time they can be attacked. I'm thinking particularly of Britain, second generation, third generation. Indians do integrate, some more successfully than others, but are they treated as equals? The majority always makes the claim that they inherited their country, and so the invention of tradition, nationalism etc. We need to think about that. But then a lot of Indian artists have been forgotten. They came and didn't succeed. Rasheed Araeen was a very important figure though hardly known in Britain until his exhibition *The Other Story*. At the other end of the scale is the world figure Anish Kapoor, for example.

ELVAN ZABUNYAN: But I think this question of generation is complex. It is not just a question of belonging to a family with children and grandchildren and that sort of thing. Think about the context of Senegal, or Algeria, or particularly Martinique, as the main thinkers of the 20th century are from Martinique – Frantz Fanon, Aimé Césaire and Édouard Glissant. However currently no artists are really working with that because the cultural, social and economic structures are completely decadent due to the quasi-colonial situation the French Antilles are experiencing. The Dakar biennial became something more visible, particularly at the moment it opened to African-American artists, in 2006, when the national African approach started to dissolve, becoming a diasporic feeling which opened other doors in the global world. A young generation of contemporary artists started to have different models within the continent or abroad. I think it's very important to see the generations, for it's very complex. It's not about what you give to your own family or to your

spiritual or artistic or cultural family; it's also the heritage of what happened to a major intellectual and literary movement. I think the question of generation is also a question of heritage and legacy of what were at some points the highlights of intellectual life and what remain afterwards as tools to think about all this.

ELANA SHAPIRA: Thinking about those who emigrated from Austria to America, there is the first generation of established professionals who had to restart their careers, and their children and grandchildren. Those who immigrated as mature people, as professionals, those who had to restart their professional life in New York or Chicago or Boston, those who came as teenagers, studied and finished high school and started careers as designers, and their children. What were their relationships to the place where they came from? They adapted their socialist Viennese heritage in a different manner and in a different context and passed it on to the next generation. They constantly reworked their heritage and passed it on to the next generation.

RACHEL LEE: I would like to move now from a focus on the artists themselves to their productions. Thinking about aesthetics, we were wondering if it is possible to theorise an aesthetics of exile or if there are any commonalities that many exile artists share? We were thinking, for example, of Bruno Taut's work in Istanbul which combines German Modernism and Japanese architecture, as well as an understanding of local building practices. Is this kind of hybridity perhaps typical? At the conference issues of portability and small-scale interventions were mentioned – is that something we should think about more? And in my own research I have also explored more gender-based aspects. I found that women architects and town planners that were in exile or emigrated abroad often engaged with regionalism and vernacular in a way that male architects and town planners possibly did not.

ELANA SHAPIRA: It's a challenge. If you start with the painter Hedda Sterne, you have to take the psychological process of integrating into the scene into account, the networks, the language after Expressionism and her personal experience. The exilic aesthetic would be a kind of combination. You can't see her alone as an individual figure, but did she create her own specific language? I think it's a lot about the language she creates. With regard to hybridity, I think immigrants translate. Their work relies on translations of earlier experiences, psychological experiences, earlier impressions of cities, like we heard today. Émigrés translate these and reclaim their own cultural language, intellectual language and education language. But they can't live in a bubble. The idea of exilic aesthetics results from these processes that they have to go through. They have to communicate because they can't live in a vacuum or they would not be accepted or be able to sell their

work or allowed to be presented to the public because locals need to have an echo of what they know already or what they expect from émigrés, according to the cultural stereotypes of émigrés selling their exoticism or specific language. There is a mutual need for dialogue. So émigrés rework a kind of 'intellectual luggage', and psychological impressions and translate them in such a way that the people within their specific environment – Bombay, New York, Lisbon – can understand them.

Partha Mitter: We need to think a little bit more about, let's say, the Viennese and other architects and artists we've been thinking about. They belong within a broad spectrum of Western culture. And it's very interesting, they have their own heritage which they're translating and they're interacting with the local situation. But you have generations of South Asians in America. Think of Shahzia Sikander's case – she doesn't use her Muslim identity very much, but goes back to South Asian Hindu identity. She became very unpopular in Pakistan. She wanted to create something new in New York and she said, no I'm not a Pakistani artist. What she was doing was not exactly what people in Pakistan would do, like miniature painting. I mean she's transforming miniature painting and doing something very different – videos. She's one of the finest artists in the diaspora. You don't always have to be under the same umbrella. It's a wider issue.

Rafael Cardoso: I'm not completely convinced by this idea of an immigrant aesthetic. I think it has a lot to do with expectations. When we have a displaced artist there's going to be a first moment of impact where there's a clash. Someone's coming from one culture to another culture so there are going to be misunderstandings, problems of translation. Then it really depends who's moving where from where. A European artist moving to the Americas in the 1930s or 1940s is going to be received as a civilising influence, whereas if that same artist is moving to Asia they are not perceived as the same civilising influence. They are perceived as maybe someone useful for diplomatic reasons, but certainly not a superior culture moving in. We have the situation of what are the expectations, what does the local culture expect of these people who are coming in? And then, most of the artists – and I can only speak knowledgeably about the Brazilian experience – most of the artists who went to São Paulo or Rio de Janeiro took one of two roads. Either they tried to become Brazilian, act Brazilian, they often changed their names, converted to religions, tried to adopt an attitude where they would be embraced, some successfully. Others stood as outsiders. They said, this is what I do, like it or not. And, often, it wasn't liked. A lot of those artists that we now see as canonical were certainly not canonical within their lifetime. They were actually floating around the margins and fringes of the art world in Brazil. And many of them disappeared. Actually in the Brazilian situation most people either assimilate or stand as outsiders.

ELVAN ZABUNYAN: In literature the narrative is often linked to the author's experience of displacement. But the words themselves, the aesthetic of writing itself, stays the same. If you come back to Creole, it's the invention of language, but it doesn't mean that it's exile. It's also a possibility to resist. The Beat Generation also invented a new language. It depends on what language you decide to use as an artist, as a writer, as a musician, and then how the art historians or the critics look at it. Even now, in France, when Picasso is mentioned he is still regarded as Spanish. So it makes things very complicated. The French did not give French nationality to Picasso. Another example could be Constantin Brancusi, as the French state refused to receive his work when he decided to donate it all after he had been living in Paris for decades. I think this is still discrimination. How to categorise someone's identity? Why does one need to categorise it? But look at the case of an artist, like Adel Abdessemed, for example. He was born in Algeria. He left in 1995 when the director of his art school was assassinated in front of him. In 1995 he came to study in France, and in a decade he became famous because his work was bought by big collectors. When he is discussed in mainstream magazines he is not seen as an artist from Algeria. They write that he is Parisian.

PARTHA MITTER: Picasso remained Spanish.

ELVAN ZABUNYAN: Yes.

RAFAEL CARDOSO: There is one artist in Brazil who is definitely exile aesthetic and that would be Lasar Segall. When he was in Germany, in the Novembergruppe, he completely integrated into the Expressionist movement and aesthetic. Yet he was not treated as German but as Russian or Jewish or Lithuanian. He went to Brazil in 1923 and there he became Russian again and sometimes German, but always stayed Jewish. When the war began he became obsessed with exile themes and started painting a lot of Jewish themes. He's never treated as a Brazilian artist; he's always treated as Jewish-Brazilian, Lithuanian-Brazilian, an émigré artist, he's never treated in any historiography as a local artist, and that's very interesting because it reflects on his work. He goes through phases where he tries to be Brazilian and you can see critic-pleasing pictures which are very colourful with exotic animals.

ELANA SHAPIRA: When I was speaking about the designers I was speaking specifically about their testimonies when they arrived in New York or Chicago or London, and their impressions of the place and how they perceived the city as 'a foreigner.' So we start with what we call in literature their 'authorial intent' which develops and changes. But there is this first experience of observing a new place with an anthropological gaze. What is regarded as foreign and how it is absorbed into the work? Their criticism was patronising. Many Europeans came to the USA and

Laura Karp Lugo and Rachel Lee

thought, 'Look, no culture, no history. Look at the mass-consumption, the cheap production'. They were filled with criticism and they were working to subvert it. We have to be careful about the exilic reference here. I speak about a specific conscious reference to subverting. Was it a question of taste, good, bad taste, opening the discussion globally, their design for the new world, opening the perspective? It's very interesting to me that some cities offered new identities for exiled artists. Vienna is one of these cities, and London, New York – the refugees are seen as New Yorkers, for example. They will attach themselves to the city and not to the state and this is all part of the processes they go through.

PARTHA MITTER: This is very interesting because Paris is like that. Many foreign artists don't think of themselves as French, but as Parisians. So is there something specifically interesting about the cosmopolitan-ness of the big metropolises where you have your own identity within the urban environment that you don't really have outside the city? This is probably true of New York. I'm not sure. You wouldn't have something like that in Brazil. In São Paulo.

RAFAEL CARDOSO: I think there's a tension between Rio and São Paulo. It is definitely much harder to become an honorary citizen of Rio. The only way to become an honorary *Carioca* is to completely embrace the culture and become more *Carioca* than the *Cariocas*. You have to totally turn your back on everything you've ever been and become something else, whereas São Paulo is a little bit historically the opposite. It's a little bit needy, it feels a little bit culturally deprived, so if anybody comes from outside and invests in it, they are embraced by the city. That is perhaps one reason why the São Paulo refugee experience is so well known internationally and the Rio refugee experience is not.

ELVAN ZABUNYAN: It's not just about exiles but also women artists or any non-Western artist. There is the question of the fragment. A lot of artists are working like diptychs, in the space in between, in the fragments, and a lot of women artists during the feminist years in the 1970s were working the fragment. And it is true that literature or language helps a lot with thinking about how you learn a language, and how you write in this new language. Kafka wrote in German. For me this was always a political statement, in a way, this notion of fragment, how you appropriate a foreign language to try to create with that language. It's true that maybe if there is an aesthetic of displacement, the notion of fragment is important, for several fragments can unite and become one unity.

RAFAEL CARDOSO: Can I ask, are you approximating the refugee experience to the condition of being a minority within your own culture? Like women and homosexuals?

ELVAN ZABUNYAN: No, not at all. It's just that I work a lot on white feminist women in the 1970s. The notion of fragment was very important and this came also with the structure of language. I mentioned the Beat Generation, for example, the idea of cutting, how you put two images together.

PARTHA MITTER: But there is a distinction. And Kafka was an internal exile, of course.

ELANA SHAPIRA: Stuart Hall spoke about 'diaspora identity'. He refers to the fact that people in the diaspora need to rework the past in order to look into the future. They need to come to terms with the past. He speaks about narratives of the past and positioning yourself in narratives of the past.

ELVAN ZABUNYAN: The notion of diaspora is first linked to the Jewish experience, then you have the Armenians, the Greeks, the Africans, the Palestinians – so this experience of displacement becomes like a position to think about your own identity linked to a global situation. So I think what is interesting about diaspora is, you have people from one country everywhere, from one continent everywhere, with the possibility to create a global network.

RAFAEL CARDOSO: This is called strategic essentialism. If you don't have a story you have to make one up, and I have a really interesting example which is one of the artists I showed, Emeric Marcier, who is Romanian and Jewish. He went first to France, then he went to Brazil where he converted to Catholicism. He had a twin brother who was also an artist and who went to New York and stopped speaking to him because he couldn't accept the fact that he had become a Catholic. So you have these two people, two Romanian artists, Jewish, twins, who go to two different places and take two completely different directions, and can you call that diaspora? Would it be wrong to call it diaspora?

ELANA SHAPIRA: You have to go to the individual case, and the individual case study. In a group that developed a collective aesthetics, you have to examine their writings, their interpretations of art, then you consider the specific individual and see if these have any echo in his or her works. But it's about concrete experiences – people left one place under certain conditions. They fled or were forced or they wanted to go for economic reasons, these are concrete experiences shaping their 'authorial intent'. Do we regard those who came like any other person or do we try to figure out the neighbourhood they lived in, the positions, the connections? Did they connect with other émigrés? Did locals in America or in Europe or Istanbul or Bombay want these émigrés as émigrés or did they welcome them because of their talents? The Americans searched for émigrés that 'spoke' the modernist language – a certain language that they wanted to 'hear', a progressive language. They wanted the émigrés that brought a certain heritage with them, a

Laura Karp Lugo and Rachel Lee

certain language with them, and they wanted to transform it according to their own interests. This was part of émigré culture. I'm not going to essentialise the experience of the exile or the émigré, but I do think that the concrete historical experiences are relevant here, that people left a place under certain conditions and they were also stereotyped as émigrés.

ELVAN ZABUNYAN: I wanted to talk about terminology. Cosmopolitanism, transnational, global, local – all these words we're using in the context of our post-colonial global art history today. I want to speak about this methodology because it is really part of the way we name artists, artworks, or even writers. The terminology is linked to the translation of the way you understand a certain word. And, for example, it was interesting to me that we did not speak a lot about universalism, for example, in the last two days of the conference, when universalism is really the main question. Or internationalism. This still belongs to a Eurocentric terminology, but still it's interesting for some cities, for example Istanbul. Istanbul has always been a very cosmopolitan city and in some maps in the early 20th century Turkey was in Europe. But in recent discussions about Turkey in Europe everybody forgot that Istanbul was a cosmopolitan city. You cannot compare the experience in New York with an experience in another city – it's also how you write the historiographies, how you write art histories and it comes back to regionalism and to vernacular. I think it is also a question of scale and strategy and also of power. It is a question of institutional power.

RACHEL LEE: This discussion has underlined the importance of essentializing neither exilic and migratory experiences nor the artworks that were produced through them. Because of their heterogenous and individual nature it seems crucial to explore them from a situated perspective, with a focus on the contexts in which they developed. As you have described, the urban contexts in which the exiled artists practised seem particularly key in this regard. However, as the cases are all so different, it makes theorising artistic exile a challenge. Perhaps it is easier to theorise the places than the artists themselves? This is something to keep thinking about. Thank you all very much for your thought-provoking inputs!

LAURA KARP LUGO: Finally, I wanted to come back to what was said on the generational issue when we observe situations of exile. The exile experience is lived differently by each individual, depending on a multitude of conditions, related to language as well as social, economic and professional situations before departure. But above all, it was underlined in the discussion to what extent the experience of exile is transmitted from generation to generation, a heritage that conditions trajectories and exilic production. This raises questions about the consequences of exile for the second and third generation: What's the impact of this heritage in the place that

exiles' descendants occupy in their own society, which is not that of their parents or grandparents? What's the impact of this heritage on their artistic production? Every life path will have its own answer. We are all contributing to these histories of exile. Thank you all for participating in this challenging conversation on a highly significant topic from any epoch.

Biographies of the Authors

Brian Bockelman is Associate Professor and Chair of the Department of History at Ripon College in Wisconsin. His writings on Argentine cultural and intellectual history have appeared in journals such as the *American Historical Review, Modernism/Modernity, Clio* and the *Journal of Latin American Geography*. Thanks to a Franklin Research Grant from the American Philosophical Society and a Fellowship from the National Endowment for the Humanities, he is nearing completion of a microhistory tentatively called *'Down with the Palms of the Plaza!': Replanting the Seeds of Discord in the Argentine Capital, c. 1883*.

Laura Bohnenblust is an art historian and a PhD candidate at the Institute of Art History, University of Bern, Switzerland. Bohnenblust studied art history and German literature at the University of Bern. She is a member of the Walter Benjamin-Kolleg Global Studies Programme (University of Bern) and the Swiss School of Latin American Studies (SSLAS). In October 2017, she was a fellow at the "Mobility: Objects, Materials, Concepts, Actors" Transregional Academy in Buenos Aires. Recent publications include "Tracing the Routes of Floating Exhibitions: A Fluid Cartography of Post-war Modernism around 1956", Artl@s Bulletin 8, no. 3 (2019): Article 3, https://docs.lib.purdue.edu/artlas/vol8/iss3/3/.

Margarida Brito Alves is a Contemporary Art Researcher and an Assistant Professor at the Department of Art History at the Faculty of Human Sciences and Humanities of Nova University of Lisbon. She is Deputy Director of the Art History Institute of UNL, being the coordinator of the Contemporary Art Studies research group and the "Spatial Practices in Contemporary Art" research line. She is the author of *A Revista Colóquio / Artes,* Colibri, 2007 and *O Espaço na Criação Artística do Século XX. Heterogeneidade. Tridimensionalidade. Performatividade,* Colibri, 2012.

Rafael Cardoso is a writer and art historian, based in Berlin. He is the author of numerous books on the history of Brazilian art and design, including the forthcoming Modernity in Black and White: Art and Image, Race and Identity in Brazil, 1890-1945 (Cambridge University Press, 2020). He is a member of the postgraduate faculty in art history at Universidade do Estado do Rio de Janeiro (Instituto de Artes) and a research fellow at the Freie Universität Berlin (Lateinamerika-Institut).

Katarzyna Cytlak is a Polish art historian based in Buenos Aires, Argentina. Her research focuses on the artistic creation of Central Europe and Latin America in the second half of the 20th century. From a trans-modern and transnational perspective, she studies conceptual art, radical and utopian architecture, socially engaged art and art theory in relation to post-socialist countries. In 2012 she received a PhD from the University Paris 1 Panthéon-Sorbonne, France. Cytlak was a post-doctoral fellow at the Consejo Nacional de Investigaciones Científicas y Técnicas, Argentina, and she is currently working at the University of San Martín, Argentina. Selected publications include articles in *Umění/Art*, *Eadem Utraque Europa*, *Telón de Fondo*, *Third Text* and the *RIHA Journal*.

Rachel Dickson (MA Courtauld), Senior Researcher, Ben Uri Research Unit for the Study of the Jewish and Immigrant Contribution to Visual Arts in Britain since 1900, focusses on Jewish and non-Jewish émigré artists. Her recent publications include: "Fred Uhlman in Wales – the making of an Anglo-German Welshman." *Fred Uhlman*, Burgh House and Hampstead Museum, 2018; "'Our Horizon is the Barbed Wire': Artistic Life in the British Internment Camps." *Insiders Outsiders: Refugees from Nazi Europe and their Contribution to British Visual Culture,* Lund Humphries, 2019; "'The Man from the Bauhaus': The Lost Career of Werner 'Jacky' Jackson." *Applied Arts in British Exile from 1933,* Yearbook 19, Research Centre for German and Austrian Exile Studies, Brill/Rodopi, 2019, which she also co-edited.

Burcu Dogramaci is Professor of Art History at the Ludwig-Maximilians-Universität (LMU) Munich. She is the co-founder of the "Art Production and Art Theory in the Age of Global Migration" working group established in 2013, and a member of the "Entangled Histories of Art and Migration: Forms, Visibilities, Agents" (funded by the DFG, 2017–2022) and "Wege – Methoden – Kritiken: Kunsthistorikerinnen 1880–1970" (funded by the DFG 2020–2023) research networks. She leads the ERC Consolidator Project, "Relocating Modernism: Global Metropolises, Modern Art and Exile (METROMOD)" (2017–2022) at the LMU Munich. Her research areas are: exile, migration and flight, urbanity and architecture, photography, fashion, sculpture and live art. Current publications include: *Heimat. Eine künstlerische Spurensuche.* Böhlau, 2016; *A Home of One's Own. Emigrierte Architekten und ihre Häuser 1920–1960. Émigré Architects and their Houses. 1920–1960*, Edition Axel Menges, 2019 (co-edited with Andreas Schätzke); *Nomadic* Camera. *Fotografie, Exil und Migration*, special issue of *Fotogeschichte. Beiträge zur Geschichte und Ästhetik der Fotografie*, no. 151, 2019 (co-edited with Helene Roth); *Handbook of Art and Global Migration Theories, Practices, and Challenges,* De Gruyter, 2019 (co-edited with Birgit Mersmann).

Margit Franz is a research fellow and lecturer at the Department of History at the Karl-Franzens University in Graz, Austria. The focus of her research in the field of contemporary history includes the history of exile between 1933 and 1945 in Asia and Africa, with special emphasis on British India. Her main publications include *Gateway India. Deutschsprachiges Exil in Indien zwischen britischer Kolonialherrschaft, Maharadschas und Gandhi*, Clio, 2015; "Exile in Transit: Austrians in Exile in South, South East and East Asia." *Exil in Asien (Erinnerungen. Lebensgeschichten von Opfern des Nationalsozialismus, Bd. 4)*, edited by Renate S. Meissner, Nationalfonds, 2015 (German and English); and *Going East – Going South. Österreichisches Exil in Asien und Afrika*, Clio, 2014 (co-edited with Heimo Halbrainer).

Ya'ara Gil-Glazer is the Head of the Education through Art programme, Department of Education, and also teaches at the History Unit of the Department of Interdisciplinary Studies, Tel-Hai Academic College, Israel. She teaches and researches photography – history and theory, visual culture and art education in critical-social contexts. She authored *The Documentary Photobook: Social-Cultural Criticism in the U.S. during the Great Depression and the New Deal* published in June 2013 by Resling (Hebrew). She received her PhD (summa cum laude) from the University of Haifa, Israel, in 2010.

Mareike Hetschold graduated with a master's degree in Art History at the Ludwig-Maximilians-Universität Munich. Her master's thesis explores the work of the Swiss architect Elsa Burckhardt-Blum (1900–1974). She is currently a doctoral researcher with the ERC project entitled "Relocating Modernism: Global Metropolises, Modern Art and Exile (METROMOD)". Her research explores the visual culture in Shanghai between 1930 and 1950 in the context of exile and migration, tracing artistic practice, urban transformations and contact zones. Publications include: "Die Städtische Galerie Rosenheim – ein architekturhistorischer Blick". *Vermacht, verfallen, verdrängt. Kunst und Nationalsozialismus: Die Sammlung der Städtischen Galerie Rosenheim in der Zeit des Nationalsozialismus und in den Nachkriegsjahren*, edited by Christian Fuhrmeister et al., Michael Imhof Verlag, 2017; (with Sonja Hull), "A Case Study of the Architect's Home: Haus Goldfinger, 2 Willow Road, Hampstead, London, Großbritannien". *A Home of One's Own. Émigré Architects and their Houses. 1920–1950*, edited by Burcu Dogramaci and Andreas Schätzke, Edition Axel Menges, 2019.

Frauke V. Josenhans is Associate Curator, Moody Center for the Arts at Rice University, and a university lecturer. Previously she worked at several cultural institutions and museums in Europe and the United States, notably at the Los

Angeles County Museum of Art, and the Yale University Art Gallery. She holds graduate degrees from the Sorbonne and the École du Louvre, and a PhD from the Aix-Marseille Université. She has curated and co-curated various exhibitions, and authored and contributed to numerous English, French and German art-historical journals, books and catalogues, focusing on global modern and contemporary art. At Yale she organised the *Artists in Exile: Expressions of Loss and Hope* exhibition, and was the editor and primary author of the accompanying scholarly catalogue (Yale University Art Gallery, 2017).

Laura Karp Lugo is an art historian with a PhD from Panthéon-Sorbonne University, whose research interests focus on the intersection of exile and art, from the late 19th to the middle of the 20th centuries. Awarded the Prize of the Musée d'Orsay, her dissertation is about to be published. From 2007 she has worked in several international research institutions, including the Institut national d'Histoire de l'art (INHA, Paris), the Universidad Nacional de Tres de Febrero (UNTREF, Buenos Aires), the Universitat Oberta de Catalunya (UOC-Barcelona) and the Deutsches Forum für Kunstgeschichte (DFK Paris). She is currently a post-doctoral researcher at the Ludwig-Maximilians-Universität (LMU, Munich) in the ERC project entitled "Relocating Modernism: Global Metropolises, Modern Art and Exile (METROMOD)". Within this project, she works on Buenos Aires as an arrival city for exiled artists in the first half of the 20th century. Recent publications include "L'art espagnol de l'Europe à l'Argentine: mobilités Nord-Sud, transferts et réceptions (1890–1920)." *Artl@s Bulletin*, vol. 5, no. 1, article 4, p. 38–49, 13 June 2016, http://docs.lib.purdue.edu/artlas/vol5/iss1/4.

Daniela Kern is a professor at Universidade Federal do Rio Grande do Sul (UFRGS), where she teaches art history. Her main areas of interest include Art Historiography, Feminism and Art History, Exiled Artists and Art Historians in Brazil. She graduated in Visual Arts – History, Art Theory and Criticism from UFRGS. She holds a master's degree and a PhD in Theory of Literature from Pontifícia Universidade Católica do Rio Grande do Sul. She has published *And now us! Romantic poetics versus realist poetics in Balzac's Father Goriot* (EdUNISC, 2004), *Modern Landscape: Baudelaire and Ruskin,* Editora Sulina, 2010, and several articles in academic journals. She translated into Portuguese Ernst Gombrich's *The sense of order*, Bookman, 2012, Pierre Bourdieu's *The distinction*, EDUSP, Zouk, 2007, and Raymonde Moulin's *The art market,* Zouk, 2007.

Eduard Kögel studied at the faculty of Architecture, Urban and Landscape Planning at the University of Kassel in Germany. In 2007 he completed his PhD thesis at the Bauhaus University in Weimar. He regularly lectures there and works as Research

Advisor and Programme Curator for Aedes Network Campus Berlin. For further information see www.eduardkoegel.de. Recent publications include *The Grand Documentation, Ernst Boerschmann and Chinese Religious Architecture, 1906–1931*, De Gruyter, 2015; "Feng Shui in Germany. The Transculturation of an Exotic Concept by Hugo Häring, Hans Scharoun and Chen Kuen Lee." *Feng Shui (Kan Yu) and Architecture*, edited by Florian Reiter, Harrassowitz, 2011; and "Modern Vernacular – Walter Gropius and Chinese Architecture." *Bauhaus Imaginista Journal 2018*, http://www.bauhaus-imaginista.org/articles/343/modern-vernacular.

Giulia Lamoni is FCT Researcher at the Art History Institute, Faculty of Human Sciences and Humanities of Nova University of Lisbon. She co-coordinates the Institute's "Cultural Transfers in a Global Perspective" research line and coordinates the "Artists and Radical Education in Latin America: 1960s–1970s" research project as Principal Researcher. She is also a member of the project "Decentralized Modernities: Art, politics and counterculture in the transatlantic axis during the Cold War" MODE(S) (HAR2017-82755-P). Her texts have appeared in journals including *Third Text* and *Manifesta Journal: Around Curatorial Practices*, and in exhibition catalogues and books of museums such as the Gulbenkian Foundation, Centre Pompidou and Tate Modern.

Rachel Lee works at the interface of architectural and urban research, teaching, curating and art practice. Her research explores the histories of colonial and post-colonial architecture and urbanism at their intersections with migration and exile, transnational practice, mobility and gender. She currently holds a post-doctoral position at the LMU Munich on the research project titled "Relocating Modernism: Global Metropolises, Modern Art and Exile (METROMOD)". Recent publications include "Refugee Artists, Architects and Intellectuals Beyond Europe in the 1930s and 1940s: Experiences of Exile in Istanbul and Bombay." *ABE Journal*, no. 14– 15, 2019 (co-authored with Burcu Dogramaci); the co-edited volume *Things Don't Really Exist Until You Give Them a Name: Unpacking Urban Heritage*, Mkuki na Nyota, 2017; and 'A Transnational Assemblage'. *AA Women in Architecture, 1917–2017*, edited by Elizabeth Darling and Lynne Walker, AA Press, 2017.

Sarah MacDougall (MA University of Reading) is Head of Ben Uri Collections and Head of Ben Uri Research Unit for the Study of the Jewish and Immigrant Contribution to the Visual Arts in Britain since 1900 and specialises in Jewish and émigré artists in Britain. Her recent publications include: "'Meine Heimat is in my heart and my head': Women artists in exile: Susan Einzig (1922–2009) and Eva Frankfurther (1930–1959)." *Exile and Gender II: Politics and the Arts*, Brill/Rodopi, 2018; "'Seen by the Eye and Felt by the Heart': the émigrés as art

teachers". *Insiders Outsiders: Refugees from Nazi Europe and their Contribution to British Visual Culture,* Lund Humphries, 2019; and "'The Craftsman's Sympathy': Bernhard Baer, Ganymed and Oskar Kokoschka's *King Lear'." Applied Arts in British Exile from 1933,* Yearbook 19, Research Centre for German and Austrian Exile Studies, Brill/Rodopi, 2019, which she also co-edited.

Kathryn Milligan is an art historian specialising in the history of nineteenth- and twentieth-century art in Ireland. Research for this chapter was undertaken during an Irish Research Council Postdoctoral Fellowship at University College Dublin, 2017–2019. Her first monograph, *Painting Dublin, 1886–1949,* is with Manchester University Press. Recent publications include: "A Venetian mystery: Two paintings by Walter Osborne in the Kildare Street and University Club, Dublin." *Journal of the History of Collections* (2018) and "Harry Clarke and the Dublin Magazine", *Harry Clarke and Artistic Visions of the New Irish State,* edited by Angela Griffith et al., Irish Academic Press, 2018.

Partha Mitter is a writer and historian of art and culture, specialising in the reception of Indian art in the West, as well as in modernity, art and identity in India, and more recently in global modernism. He studied history at London University and did his doctorate with E.H. Gombrich. He began his career as Junior Research Fellow at Churchill College, Cambridge, and Research Fellow at Clare Hall, Cambridge. In 1974 he joined Sussex as a Lecturer in Indian History, retiring in 2002 as Professor in Art History. His publications include *Much Maligned Monsters: History of European Reactions to Indian Art,* Clarendon Press, Oxford, 1977, Chicago University Press Paperback, 1992, Oxford University Press, New Delhi, 2013; *Art and Nationalism in Colonial India 1850–1922: Occidental Orientations,* Cambridge University Press, 1994; and *The Triumph of Modernism: India's Artists and the Avant-Garde – 1922– 1947,* Reaktion Books/Oxford University Press, 2007.

Helene Roth is Research Assistant in Art History at the Ludwig-Maximilians-Universität (LMU) in Munich and member of the Gesellschaft für Exilforschung eV (Society for Exile Studies). Since September 2017 she has been associated with the ERC Project entitled "Relocating Modernism: Global Metropolises, Modern Art and Exile (METROMOD)" under the direction of Burcu Dogramaci. Her research areas are art and photography of the 20th and 21st century with a focus on exile, migration, urbanity, architecture and fashion. Her publications include *Nomadic Camera. Fotografie, Exil und Migration,* special issue of the *Zeitschrift für Fotogeschichte. Beiträge zur Geschichte und Ästhetik der Fotografie,* co-edited with Burcu Dogramaci, no.151, 2019.

Elana Shapira is a cultural and design historian. She is the Project Leader of the Austrian Science Fund research project entitled "Visionary Vienna: Design and Society 1918–1934" (2017– 2021) and lecturer at the Design History and Theory department at the University of Applied Arts Vienna. Shapira is the author of the book *Style and Seduction: Jewish Patrons, Architecture and Design in Fin de Siècle Vienna*, Brandeis University Press, 2016; editor of *Design Dialogue: Jews, Culture and Viennese Modernism*, Böhlau, 2018; and co-editor of *Émigré Cultures in Design and Architecture*, Bloomsbury 2017 and of *Freud and the Émigré*, Palgrave 2020. She recently organised the International Symposium "Designing Transformation: Jews and Cultural Identity in Central European Modernism" (Vienna, 2019).

Christina Tejo is an independent Brazilian curator who holds a PhD in Sociology (UFPE) and a master's degree in Communication from UFPE. She is an integrated member of the Contemporary Art cluster of Instituto de História da Arte of Universidade Nova de Lisboa. She was the co-founder of Espaço Fonte – Centre of Art Investigation and co-curated the 32nd Panorama of Arte Brasileira, MAM-SP (2011). She is the former director of MAMAM in Recife (2007–2008), and was the curator of Rumos Artes Visuais of Itaú Cultural (2005–2006). She was curator of the special room of Paulo Bruscky at Havana's Biennial (2009). Cristiana served on many juries such as those of BACA (Maastricht 2014), Prêmio Marcantônio Vilaça CNI-SESI (2006), Salão Arte Pará (2007), Salão de Arte of MAM-BA (2007) and Salão de Goiás (2006). She is a member of IKT – International Association of Curators of Contemporary Art. She lives between Lisbon and Recife.

Joseph L. Underwood is Assistant Professor of Art History for Africa and its Diaspora, Kent State University (PhD, Stony Brook University). His research fields include Modern & Contemporary African art, transnationalism, biennialism, exhibition histories. He is curator of *The View From Here: Contemporary Perspectives From Senegal* (2018–2019); *TEXTURES: The history and art of Black Hair* (2020–2021). He is a Tyson Fellow at Crystal Bridges Museum of Art (2020). His recent publications include: *ar•chi•pel•a•go: Trends in Contemporary Art from Africa and its Diaspora*, Oxford University Press, expected 2020; *Views Across the Atlantic: William Greaves and the First World Festival of Negro Arts*, Columbia University Press, expected 2020; "Tendances et Confrontations: An Experimental Space for Defining Art from Africa." *World Art*, 2019.

Elvan Zabunyan, contemporary art historian and art critic based in Paris, is a professor at the University of Rennes. For over 20 years her work has focused on North American (and mainly African American) contemporary art history,

investigating its political, cultural, social, racial and gendered modalities. Her current book project addresses cultural production since the 1960s and the memory of slavery in the US and in the Caribbean, and investigates routes for a global art history. She is the author of numerous articles in periodicals and essays in books and exhibition catalogues. Her book *Black is A Color, a History of African American Contemporary Art* published in French (Dis Voir, 2004) and English (Dis Voir, 2005) won the 2005 SAES/AFEA research prize. From 2016 to 2017 she was the co-director of the annual programme of Deutsches Forum für Kunstgeschichte in Paris centring on the plural decolonial perspectives of historiographies deconstructing the colonial hegemony of the Western world. She is the leader of the "Artists and Citizens" work package for the European ECHOES (European Colonial Heritage Modalities in Entangled Cities) research programme.

Index

Page numbers in italics refer to illustrations.

L

Laclos, Pierre-Ambroise-François Choderlos de 165
Lam, Wifredo 172
Lange, Melita 39
Langhammer, Walter 73, 75–77, *78*, 79–82, *81*, *83*, 85, *86*, 87, 260, 261
Langhammer, Käthe [Käther Urbach] 73, 75–77, *78*, 79, 87, 261
Larssen, Tryggve 103
Lauand, Judith 199
Le Corbusier 200
Leen, Nina 402
Leipzig, Arthur 348
Lemos, Fernando 188
Lenin, Wladimir Iljitsch 380, 382, *382*, 383
Lenkiewicz, Robert 232
Leskoschek, Axl 111, 112, 197, 198
Levitt, Helen 337
Levy, Hanna 111, 117, 119, 197
Levy, Julien 125, 127, 134, 139
Lewis, John 349
Lewis, Norman 390, 402
Libsohn, Sol 335, 348
Liebermann, Max 88, 115
Liebling, Jerome 348
Lindskog, Bengt J. 103
Lispector, Clarice 116
Li Yuanhong 94
Lods, Pierre 163, 168
Loos, Adolf 92, 210
López Jordán, Ricardo 356
Lumière Brothers 252
Lyon, Danny 342, 349

M

MacLiammor, Michael 325, 328
Madame Koré [Irmgard Burchard] 111, 115–117
Mahler, Anna 241
Mahler, Gustav 237
Malandrino, Giuseppe 44
Malcolm X 348
Maldonado, Tomás 55, 60, 62, 64–66, 69
Malfatti, Anita 110
Mancoba, Ernest 172, 173
Mann, Erica 263
Mann, Hans 44

Mann, Kenny 263
Mann, Thomas 412
Mao Dun 284
Marcier, Emeric 113, 197, 198, 418
Martim, Eros 113
Martínez Baroja, Leonor 47, 51
Marx, Karl 150
Matarazzo, Ciccillo 199
Matisse, Henri 117, 328
Matisse, Pierre 127
Mauá, Pensão 109, 113, 197, 198
Mavignier, Almir 112, 198
Mayer, Ilse 44
Mayol, Manuel 25, 353–355, 359–361, *362*, *363*, *364*, 365–367, *366*
Mazzey, Luis 372
McCausland, Elizabeth 348
McDonnell, Polly 112
McNeill, Robert H. 348
Mehta, Tyeb 79
Meidner, Else 231, 240
Meidner, Ludwig 231, 240
Meireles, Cecília 113, 197
Meitner, Laszlo 111, 113
Mendes, Murilo 113, 197
Merleau-Ponty, Maurice 186
Metman, Eva 240
Metman, Philip 240
Meyer, Carl Theodor 97
Meyer, Gisela 97
Meyer, Judith 166
Meyer, Klaus 244, *244*
Michelena, Bernabé 372
Michie, Helga 241
Mies van der Rohe, Ludwig 20
Miller, Lee 229, 243
Mindlin, Vera 112
Miranda, Nicanor 117
Mirza, D.N. 253
Mitchell, Joan 403
Model, Lisette 293, 302, 309, 337
Moholy-Nagy, László 230
Moles, Abraham 186
Molnár, Farkas 100, 105
Mondrian, Piet 229, 392
Monteavaro, Antonio 366
Moore, Henry 229
Morais, Frederico 197